COVER PORTRAITURE
BY BILLY BENGTSON

Gladys Nilsson

Helen Goldenberg

Ray Yoshida

THE

Don Baum

CHICAGO

Edward Paschke

Marianne Deson

Karl Wirsum

ART

Frederick Brown

REVIEW

Barbara Rossi

Les Krantz

AN ILLUSTRATED SURVEY OF THE
CITY'S MUSEUMS, GALLERIES
AND LEADING ARTISTS

LES KRANTZ

AMERICAN REFERENCES, INC.
919 N. MICHIGAN AVENUE
CHICAGO, IL 60611

Editor & Publisher: **Les Krantz**

Managing Editor: **Jean Lyons**
Manuscript Editor: **Mark Mravic**
Museum Editor: **Charley Custer**
Gallery Editors: **Barb Koenen, Peter Kime**
Associate Editors: **Penny Berkman, Lisa Leavitt, Randy Leavitt,
Eric Wadell, Karen Vaccaro**
Contributing Editors: **Joe Doeble, Eric Hoffmann, Janis Hunt-Haney,
Gordon Mayer, Martha Schoolman**
Writers: **Garrison Beik, Barbara Bowen, Alan Enzer, Caroline Honig, Debra
Latourette, Jonathan Silber, Chuck Sklar, Jordan Wankoff**

Editorial Director: **Mark Harris**
Project Director: **Lyn Pusztai**

Production Director: **Carol J. Bast**
Production Manager: **Suzanne E. Hampson**
Production Assistants: **Mary Dean, Geoffrey Lantz, Tina Matlock, Eve Pickford,
Oliver Steck, Elizabeth Trask**
Art Director: **Ron Richter**

Staff Manager: **Debra Swank**
Administrative Assistants: **Constance Cherry, Randy Allbright, Mary Jo Drungil**

Business Manager: **Carol Green**

American References Publishing Corporation
919 N. Michigan Avenue
Chicago, IL 60611

Library of Congress Cataloging-in-Publication Data

The Chicago art review
 Includes index.
 1. Art museums — Illinois — Chicago — Directories 2.Museums — Illinois — Chicago — Directories. 3. Art galleries, Commercial Illinois — Chicago — Directories. 4. Artists — Illinois — Chicago — Biography. I. Krantz, Les
N6535.C5C467 1989 702'.5'77311 89-6877
ISBN 0-913765-18-X
ISBN 0-913765-17-1 (pbk.)

To Lyn Pusztai, from the staff:
Thank you for your dedication
and special contributions

TABLE OF CONTENTS

Foreword, by Mark Mravic ..7
Museums and Public Spaces ...10
 The Art Institute of Chicago ..10
 Balzekas Museum of Lithuanian Culture18
 Mary and Leigh Block Gallery20
 Chicago Historical Society ...20
 The Chicago Public Library Cultural Center Galleries20
 The Martin D'Arcy Gallery of Art21
 The Du Sable Museum of African American History21
 The Evanston Art Center ...21
 Field Museum of Natural History22
 The Freeport Art Museum and Cultural Center22
 The Hyde Park Art Center ..22
 The Lizzadro Museum of Lapidary Art24
 The Mexican Fine Arts Center Museum24
 Mitchell Indian Museum at Dendall College24
 The Museum of Contemporary Art26
 The Museum of Contemporary Photography28
 The Museum of Science and Industry28
 The Museum of the Fine Arts Research and Holographic Center30
 The Oriental Institute Museum of the University of Chicago30
 The Peace Museum ...32
 The Renaissance Society at the University of Chicago32
 The David and Alfred Smart Gallery32
 Spertus Museum of Judaica ..34
 The State of Illinois Art Gallery34
 The Terra Museum of American Art34
 The Ukrainian Institute of Modern Art35
Galleries ...36
 AES Fine Art Galleries ...36
 ARC Gallery ...36
 AD-Infinitum ..36
 Aiko's ..36
 American West ...36
 W. Graham Arader III Gallery37
 Artemisia Gallery ...37
 Artifacts ..37
 Artphase I ..37
 Jacques Baruch Gallery, Ltd37
 Beacon Street Gallery & Performance Company38
 Mary Bell Galleries ...38
 Cain Gallery ..38
 Campanile-Capponi Art Consultants38
 Campanile Galleries, Inc ..38
 Center for Contemporary Art40
 Chiaroscuro ...40
 Chicago Center for the Print/Hunt-Wulkowicz Graphics40
 Jan Cicero ..40

TABLE OF CONTENTS

Eva Cohon Gallery . 40
Compass Rose Gallery . 41
Contemporary Art Workshop . 41
Corporate Art Source, Inc. 41
Crane Gallery . 41
Dart Gallery . 41
Douglas Dawson Gallery . 42
De Graaf Fine Art, Inc. 42
Deson-Saunders Gallery . 42
Catherine Edelman Gallery . 42
Ehlers Caudill Gallery Inc . 42
Fabrile Gallery Ltd. 43
Fairweather Hardin . 43
Fermilab Gallery . 43
Wally Findlay Galleries . 43
Fly By Nite . 43
Gilman/Gruen Galleries . 44
Goldman-Kraft Gallery, Ltd . 44
Richard Gray Gallery . 44
The Grayson Gallery . 44
Grove St. Gallery . 46
Habatat Galleries . 46
Carl Hammer Gallery . 46
Hoffman Gallery . 46
Hokin Kaufman Gallery . 47
B.C. Holland . 47
Billy Hork Galleries . 47
Joy Horwich Galleries . 47
Edwynn Houk Gallery . 47
Janice S. Hunt Galleries, Ltd . 48
Illinois Artisan Shop . 48
Gwenda Jay Gallery . 48
R.S. Johnson International . 48
Kass/Meridian . 66
Phyllis Kind Gallery . 66
Klein Gallery . 66
Landfall Press, Inc. 66
Larew's Gallery . 66
Sybil Larney Gallery . 67
Latino Arts Coalition Gallery . 67
Robin Lockett Gallery . 67
R. H. Love Galleries, Inc.. 67
Mercaldo Gallery . 67
Merrill Chase Galleries . 68
Peter Miller Gallery . 68
Mindscape Gallery . 68
Mo Ming Gallery . 68
Mongerson-Wunderlich Galleries . 68

TABLE OF CONTENTS

More By Far . 69
N.A.M.E. Gallery . 69
Isobel Neal Gallery, Ltd . 69
Needlman Gallery . 69
Neville-Sargent Gallery . 69
Nicole Gallery, The Art of Haiti . 70
O'Grady Galleries, Inc. 70
Objects Gallery . 70
Nina Owen . 70
Paper Press Gallery and Studio . 70
Parenteau Studios Antiques Gallery . 70
Perimeter Gallery . 72
Prairie Lee Gallery . 72
Prestige Galleries . 72
Prince Gallery . 72
Printworks Gallery . 73
Ramsay Gallery . 73
Randolph Street Gallery . 73
Rezac Gallery . 73
Rizzoli Gallery . 74
Betsy Rosenfield Gallery . 74
J. Rosenthal Fine Arts, Ltd . 74
Esther Saks Gallery . 74
Sazama/Brauer Gallery . 75
The School of the Art Institute of Chicago Columbus Drive Gallery 75
The School fo the Art Institure of Chicago Gallery 75
Lloyd Shin Gallery . 75
Skokie Public Library Gallery . 76
State of Illinois Art Gallery, Chicago . 76
Galleries Maurice Sternberg . 76
Struve Gallery . 76
Tower Park Gallery . 78
Upstart Gallery . 78
Vahlkamp & Probst Gallery, Inc . 78
Van Straaten Gallery . 78
Ruth Volid Gallery, Ltd . 78
Walton Street Gallery . 79
Worthington Gallery . 79
Michael Wyman Gallery . 79
Yolanda Gallery of Naive Art . 79
Donald Young Gallery . 80
The Zaks Gallery . 80
Zolla/Lieberman Gallery . 80
Artist Profiles . 88
Organizations . 397
Galleries Cross-Referenced by Specialties . 400
Museum Personnel . 402
Index (Please read "How to use..." at top of page) 404

FOREWORD

Ever since someone stuck Chicago with the tag "Second City," the town has been trying to live down that moniker. We construct the tallest buildings, operate the busiest airport, nurture the liveliest, most chaotic city government. And for one week each year, Chicago is *the* center of the contemporary art world.

Each spring, galleries and dealers from around the world converge on Chicago's crusty but venerable Navy Pier for an art exposition that is rivaled only by the great fairs in Basel, Cologne and Paris. After ten years, the Chicago International Art Expo is the premier show of its kind in the country, if not the world. It attracts some 200 national and international galleries, including dozens from Chicago, who come to display and sell the works of the established masters of contemporary art — Picasso, Matisse, Dubuffet, Calder — as well as the new and emerging stars.

The stimulus for the Chicago Art Expo came in the late '70s. There was much discussion about a major contemporary art expo in the U.S. that would improve on the faltering fair in Washington called "WashArt". Chicago rarely was mentioned as a possible host city. But John Wilson of the Lakeside Group, the expo's sponsor, had faith in the city. He gathered together a group of dedicated art dealers and aficionados to work up interest in the idea of Chicago as a site, and to form a distinguished selection committee that would choose the dealers in the show. They searched for a location, eventually coming across Navy Pier almost by accident. Wilson was at first dissuaded by the Pier's warehouse-like atmosphere, but when he saw the rotunda area, the search was over. The first Chicago International Art Exposition was born.

That first show contained 65 dealers of varying quality; the key to assuring its success was attracting a number of top dealers, including the likes of Leo Castelli and Holly Solomon. And a success it was. Critics raved. Crowds mobbed the pier. Sales were good. The only drawbacks were the token horrible storm and the financial situation, which led Wilson "to mortgage almost everything."

The show has expanded annually in both size and scope, incorporating innovations such as the "Mile of Sculpture" and drawing growing national and international acclaim. By 1983, with the show under the directorship of Tom Blackman, art critics around the world were agreeing that, as the *Washington Post* acknowledged, the Chicago Art Expo was "the biggest — and by overwhelming consensus the best — art fair ever organized in the Western Hemisphere;" by 1987, the *New York Times* proclaimed that Chicago's fair was "now considered more important than its counterparts in Basel, Cologne and Paris."

And the show's success parallels the burst of growth in the Chicago art community in general. The rise of the River North gallery area has been almost concurrent with that of the Expo. The fair's high quality concentrates an incredible array of dealers in Chicago, dealers who simultaneously contribute to and become exposed to the vitality of the Chicago art scene.

What draws the greatest contemporary art dealers in the world back to Chicago each year? Money is certainly one factor: Sales at the 1988 Expo reached approximately $45 million. Another is the quality of the participating dealers and the art they bring,

FOREWORD

a quality assured by the distinguished selection committee; a third is the site, Navy Pier: There may be no other hall like it in the world, right in the heart of the city, except possibly the Grand Palais in Paris. They both leak.

But finally, the success of the show, and the general boom in Chicago's art world over the past ten years, must be credited to the city itself and its art community. It would be hard to find another city in the U.S. that participates as actively with its art community. Even the union crews who handle the art for the show become quasi-experts in large-scale sculpture. And the crowds are fantastic. The first year, the dealers were taken by storm. Many couldn't believe the response from the articulate and knowledgeable people who came out to the pier that year, and continue to come in growing numbers — another legacy of the city's great cultural heritage.

From hog-butcher to the world to art dealer to the world in ten years. Not bad for the Second City.

Mark Mravic
Chicago, 1989

May 11 through 16, 1989 Navy Pier

Chicago International Art Exposition

Grisha Brushkin, Original Print, Chicago International Art Exposition, 1989. Courtesy: Landfall Press

THE ART INSTITUTE OF CHICAGO
Michigan at Adams, Chicago, IL 60603

Phone: 443-3600 *Hours:* Monday, Wednesday, Thursday and Friday, 10:30-4:30, Tuesday 10:30-8, Saturday 10-5, Sundays and holidays 12-5; Closed Christmas *Admission*: Discretionary admission, suggested fee: $5 adults; $1.50 students, senior citizens and children

For almost a century, the Art Institute on South Michigan Avenue has been a Chicago landmark. Since the 1933 Century of Progress Exhibition, it has belonged to all the world, recognized as one of America's great museums.

The Art Institute's curatorial assets are famous: its extraordinary Impressionist and post-Impressionist collections, its broad, deep twentieth-century American collections, its prints and drawings from across the world and time. Less widely acknowledged is the Art Institute's unique identity as arguably the greatest provincial museum in the world. Great as the Art Institute is, it is not the Metropolitan, not the Louvre, not the National Gallery: it is not necessary to get blood transfusions at the mezzanine when dragging oneself from age to age; one isn't benumbed with the task of coming to terms with everything in the history of anything before breaking for lunch.

Yet what the Art Institute does it does peerlessly, almost intimately, without the least compromise. The Art Institute has very intelligently and sensitively played to this strength in the renovations and additions that clarify its mission into the next century.

From its beginnings as the Chicago Academy of Fine Arts in 1879, the Art Institute has been dedicated to cultivating, as well as collecting, the arts of the world. The School of the Art Institute of Chicago, which today has 1700 students and 300 teachers, is even older than the mother museum. A long-standing Art Institute tradition of national exhibitions and prizes, modeled after the European biennials, has made the Art Institute an important arbiter of American art standards and a significant collector since the days when most Americans thought great art had to be imported.

Grant Wood's *American Gothic* is the most famous American Exhibition prizewinner to become part of the permanent collection. Grant Wood himself was a School of the Art Institute alumnus, and not the most famous one--that prize would go to Georgia O'Keeffe, or perhaps Claes Oldenburg.

As befits such a dynamic institution, the Art Institute has been outgrowing its Beaux Arts home in Grant Park almost since it was built in 1893. Just a year later the landmark bronze lions were given to the museum, and within 10 years the 500 seat Fullerton Hall and Ryerson Library were added to the original structure, which was never formally finished: a grand dome over the existing central staircase died on the drafting table in 1929. Meanwhile, in 1916 Gunsaulus Hall leaped the Illinois Central Railroad tracks that bordered the museum to the east, and in 1924 that eastern frontier was secured with McKinlock Court and a suite of galleries that still encircle the outdoor fountain and luncheon garden.

In 1925 the Goodman Theatre was the last major museum addition to be built for more than 30 years, as depression and war commanded the nation's resources. But all through this period and beyond, the collections continued to multiply as Chicago's first generation of great plutocrats aged and bequeathed both money and Rembrandts, Seurats and Renoirs.

In the mid-1950s, construction began with a fresh fervor, but postwar architectural orthodoxy forbade pandering to old buildings. Within 10 years the Ferguson Building for administration and the Morton Wing each hunkered awkwardly north and south against the main building, very frankly new, very plain, and plainly faced with limestone as a sop to the Beaux Arts palace they were said to complement. It's an unhappy marriage which more recent designs are rectifying.

The museum interior too was thoroughly and as successfully "modernized," but a 1987 restoration has beautifully undone the damage of the 1950s. The Skidmore Owings and Merrill renovation has essentially returned the old galleries to their original designs and intentions, while covering the whole with a high-tech yet marvelously unobtrusive new roof.

The galleries, which display European holdings grouped by period, were designed by a Boston firm in the high Beaux Arts tradition as an airy, graceful and rational suite of large display rooms ringed by smaller corridors in which related, smaller pieces were to be hung. The so-called ring gallery was closed off on three sides in the 1950s to provide storage room and space for heating and air conditioning ducts. Most of the larger galleries lost their Beaux Arts detailing and orientation in order to create "period rooms" that gave a minimal flavor of the centuries displayed in them.

Discussing the effect of these changes, Museum Director James Wood observed that "The basic rectangles of the galleries are brilliant, but when you strip them of their moldings and proper door jambs, when the doors get moved out of axis, what was a clear, rational, welcoming, logical system begins to degenerate into a maze of ill-defined spaces. Doors get blocked off, corridors get blocked off, and you move from clear, rational, understandable galleries to confusing, disorienting space."

A courageous and accurate characterization. Now the museum has scrapped that piecemeal period-room approach and restored its harmonious skylit suite of grand galleries ringed with smaller galleries. In these smaller galleries, the museum's print and drawing collection is brought into deserved light for the first time. Prints, drawings, pastels and even photographs that compliment the paintings and sculptures in the grand galleries can now be seen with them. At any moment one may step from the massive works in the main galleries into the intimate scale and detail of the ring gallery. The effect is both peaceful and invigorating, and fully worthy of the museum's superb European collection.

The museum's other great change, the 1988 South Wing, is no less successful as an apology to the ages for the recent past. Architect Thomas Beeby, who shortly went on to design Chicago's new Main Library, set himself the task of harmonizing 100 years of jumbled building with--what else?--another building. It might have seemed an impossible challenge. Early in the design of the South Wing, he said, "we did comparative wall sections of the original building, the Morton Wing, the Ferguson Wing, and our building. That was especially interesting--you could see that there had been a kind of loss of memory about what classical architecture is supposed to do. Our building is an attempt to go back to the original model."

The South Wing is built around a sunlit open court, lightly scattered with statuary on the ground floor and open through a balcony to the skylight. With his airy reverence, his high fluted columns and long sight-lines

Grant Wood, *American Gothic,* 30 x 25, oil on beaverboard, 1930. Courtesy: The Art Institute of Chicago

THE ART INSTITUTE OF CHICAGO

orienting and refreshing the weary culture-goer, Beeby lets us forget to wonder whether his space is neo-classical or post-modern. It is the expression of its tasks and identity, here at the end of a long walk through a magnificent traditional museum. Many people will assume that this room too is 100 years old, and Beeby has said that would please him. Just past the sculpture court is the huge temporary exhibition space where block-buster shows or several smaller exhibits are displayed, and on either side are the new locations for the American Arts, 20th-Century Painting and Sculpture, and European Decorative Arts and Sculpture. The Textile Department has received adjacent new space.

Across the tracks at Columbus Drive, the arch-Modernist East Building, completed in 1977, is safely segregated from this developing classical revival. The huge wing, which contains the School of the Art Institute, Louis Sullivan's rebuilt Trading Room from the old Midwest Stock Exchange, the cafeteria and the members' dining room in addition to important gallery space, was officially dedicated at the Art Institute's Centennial celebration in 1979.

There are three libraries in the Art Institute. The Ryerson Library is one of the most complete art reference libraries in the city and a treasure of interior design. The Burnham Library of Architecture specializes in original works by major Chicago architects. Both libraries are open to Art Institute members, scholars, and museum staff.

On the other hand the Little Library in the basement Junior Museum is open to little people of all sizes. Games that introduce museum holdings and a "Heritage Hike" around the Loop are among the browsers' treats. On weekends, family workshops combine gallery visits with art activities like drawing and kite-making. Just down the hall from the Junior Museum are the 68 miniature Thorne Rooms, which display architectural and interior design from the thirteenth century to the 1930s.

The Art Institute has 10 curatorial departments whose collections number almost 200,000 works of art:

European Painting: This collection ranges from the Middle Ages to 1900 and numbers roughly 1,000 works. The greatest strength of the department is in French painting of the nineteenth century--in addition to its famous Impressionists the museum since its renovation has room for a much more thorough display of salon, Symbolist and Barbizon works that were more popular in their day than any of the Impressionist pieces. Though unfashionable at the moment, these collections include beautiful and moving works of art. The museum also has particularly important eighteenth-century holdings from all nations, and noteworthy seventeenth-century collections from the Spanish, French and Italian schools.

Twentieth-Century Painting and Sculpture: The collection includes some 900 paintings and 400 sculptures representing every significant movement in Europe and America from 1900 to the present. This department has curated frequent American Exhibitions under various names since the last century, and among the highest juried prizes in these shows is the honor of purchase for the museum's permanent collection. In the most recent, 75th American Show, the prizewinner was Frank Stella's "Gobba, Zoppa, e Collotorro."

American Arts: This department includes paintings and sculpture from the colonial period through 1900, and such decorative arts as furniture, silver, glass and ceramics from the seventeenth century to the present.

The collection numbers some 10,000 objects, including an eye-opening assortment of historic ships' mastheads. Located in the new South Wing, this collection presents an original jumble of art, some of it brilliant, with furnishings and random surprises in rough chronological order.

European Decorative Arts and Sculpture: These 16,000 objects include decorative arts of all media--furniture, ceramics, metalwork, glass, enamels, ivory--and sculpture from 1100 to the present. There's particular strength in English ceramics, English eighteenth-century silver, and Continental glass, along with the unique Arthur Rubloff Paperweight Collection.

Prints and Drawings: With holdings of 10,000 drawings and 50,000 prints, the department has an outstanding collection of: French nineteenth-century prints and eighteenth- and nineteenth-century drawings; Italian eighteenth-century drawings; Old Master prints from the early Northern and Italian schools; and a fine representation of works on paper by Dürer, Rembrandt and Goya, as well as extensive twentieth- century holdings.

Architecture: Formed around the archive of approximately 50,000 drawings in the Art Institute's Burnham Library of Architecture, the collection concentrates on drawings by Chicago architects and for Chicago buildings. It also features exhibit models, many architectural fragments, and the reconstructed Adler and Sullivan Trading Room of the Chicago Stock Exchange.

Photography: Although the first exhibition took place in 1900, a photography collection wasn't begun until 1949, when Georgia O'Keeffe donated a major portion of the Alfred Stieglitz collection. Since then this department has become one of the strongest in the world in the work of the modern masters. The collection numbers some 15,000 works, ranging from photographs by William Henry Fox Talbot and Julia Margaret Cameron to Robert Frank and Joel Meyerowitz.

Oriental and Classical Art: This collection of 30,000 objects includes comprehensive holdings of Chinese bronzes, the Russell Tyson Collection of Chinese ceramics, the Sonnenschein Collection of archaic Chinese jades, Chinese and Japanese textiles, Japanese screens, paintings, Turkish and Greek Island embroideries, Indian and Persian miniature paintings, and Indian and Southeast Asian sculpture. The Clarence Buckingham Collection of Japanese prints is of outstanding range and quality. The department also houses 6,000 classical objects: a strong collection of Greek vases, Greek and Roman coins, stone sculpture, and jewelry. Other holdings include Egyptian beads, scarabs, amulets and statuettes; Romano-Syrian glass vessels; terra-cotta statuettes and fragments; and Syrian mosaics.

Africa, Oceania and the Americas: This collection of some 2,000 objects is especially strong in ceramics from the principal ancient civilizations of the Southwest, Meso-America and Andean South America. Fine goldwork and sculpture is also represented. West African sculpture includes especially good examples of Yoruba, Bambara and Kuba art.

Textiles: Containing about 11,000 textiles ranging from 100 A.D. to the present, the collection represents Europe, Peru, Mexico, Guatemala, North America and Africa. It also features a number of choice costumes and accessories. The department has strong holdings in sixteenth- and seventeenth-century English needlework,

Charles Percier & Pierre Fontain, *Londonberry Vase ,* hardpaste porcelain, 1813. Courtesy: The Art Institute of Chicago

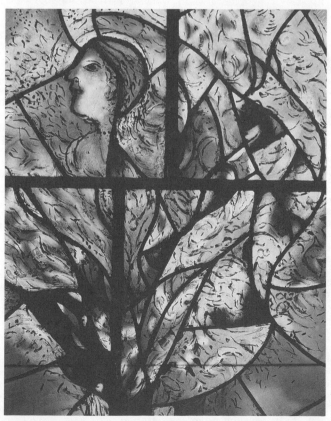

Marc Chagall, *America Windows (detail): Top of Actor Coming Out of Tree,* stained glass, 1977. Courtesy: The Art Institute of Chicago

THE ART INSTITUTE OF CHICAGO

printed and woven materials of the eighteenth and nineteenth centuries, and an extensive American woven coverlet collection.

The School of the Art Institute of Chicago: The Art Institute began not as a museum but as a school. In continuous operation since 1866 (although variously named), the art school was the first in the United States to offer degrees, starting in 1933, and was first to be accredited three years later. During the '40s the school was a leader in the movement to bring studio programs into the mainstream of American higher education. In 1948, along with 22 other charter members, the School founded the National Association of Schools of Art and Design, which is the professional accrediting body for visual arts colleges.

The School operates as an independent college, with a student body of 1,700 and a faculty of 300. It is accredited to confer the Bachelor of Fine Arts and the Master of Fine Arts degrees, and offers additional Masters degrees in Modern Art History, Theory and Criticism, and in Art Therapy, along with various graduate and professional certificates.

Students develop their own curricula from a wide array of courses and instructional areas. Studio areas include painting and drawing, photography, printmaking, visual communication, ceramics, fashion design, fiber, interior architecture, sculpture, art and technology, performance, filmmaking, sound and video. Students are encouraged to explore more than one area and are not required to declare a major area of study.

The School of the Art Institute of Chicago has been committed to energetic outreach since its earliest days. Its public information telephone number is 443-3710. Programs that welcome the public include:

The Film Center: This very active and well-attended program features films premieres, classic revivals, retrospectives, independent productions, and visits from actors, directors and scholars. Screenings are held in the School auditorium at Columbus Drive and Jackson Boulevard. For information call 443-3735.

The Studios Program: More than 100 years old, the Program offers weekend and summer classes to the public taught by School of the Art Institute faculty, roughly 20 classes each term. The non-degree program also offers extension and early college classes. There's also a student-at-large program for taking regular SAIC classes. Call 443-3777

The Video Databank: The School's Video Databank is the nation's largest national distributor of videos by and about artists, containing more than 300 tapes in its collection. In addition to its regular distribution services, the VD also houses a screening room that is open to the public. It produced the home video series "What Does She Want," by women video artists. Monthly screenings from the Databank are held at the School's Gallery II, and many videos may be purchased. Call 443-3943

SAIC Gallery and Gallery II: The School maintains two Galleries in which (usually) School-related art is displayed to the public free of charge. Gallery II is located in River West at 1040 W. Huron, and tends to feature graduate students at the School. The other Gallery on campus at Jackson and Columbus Drive focuses student and faculty work in all disciplines and undisciplines, such as an exhibition of selected objects from SAIC faculty collections. Call 443-3703

Visiting Artist Program: Every year this program brings to campus 70 to 80 critics, historians and artists in all media. Their presentations usually include slide lectures of artists' work, followed by discussion. They may also meet with students and critique student work. The lectures and programs are open to the public and free of charge, and are usually held in the School auditorium at Columbus and Jackson. Call 443-3711

Other Attractions:

The Art Institute's *Department of Museum Education* offers a variety of programs for visitors and members, including free half-hour gallery talks at 12:15 Monday through Friday, and a program of one-hour lectures Tuesday evenings at 6. Locations are posted in the lobbies.

Museum Membership entitles members to additional educational programs, such as members-only tours and previews of major exhibitions and special shows. Annual dues are $35 individual, $45 family. Members have unlimited access to the Members' Lounge and the museum libraries, as well as Museum Shop and Goodman Theatre discounts, and other advantages.

The Goodman Theatre is adjacent to the Columbus Drive facilities. The Goodman's celebrated professional repertory company presents a stimulating range of contemporary and classical theatre from September to July. The smaller Studio Theatre presents cutting-edge productions which sometimes become main-stage smashes. For information and schedules call 443-3800

Restaurants come in four varieties, all located in the East Wing: the basement Cafeteria, the Dining Room upstairs, La Promenade French cafe in the window bays overlooking Grant Park and Columbus Drive, and the refreshing Garden Restaurant in McKinlock Court, open June through September.

The collections:

Especially since the adding and renovating, the Art Institute offers a well-articulated and coherent display of the best in humankind. The museum hasn't attempted comprehensively to cover all that the world offers. When the University of Chicago's Oriental Institute came into its own at the turn of the century, for example, the Art Institute wisely decided not to compete with the region's other glorious offerings. So the museum doesn't have quite as many departments and cul-de-sacs and wings and things as one might fear. What's here is usually well-organized and thoughtfully presented, sometimes extraordinarily so.

The museum collections go back more than four thousand years, representing mankind in a multitude of possibilities and achievements. They bring history to life in utterly unexpectable ways, if we only bring to them our open minds and eyes. Every work of art is a universe of possibilities expressed. We are privileged to watch these possibilities succeed one another when, say, we round the corner from the post-Impressionists and pass into the ramifying jumble of twentieth-century painting. Walking toward McKinlock Court, we can see, feel and be touched by the succession of spirits that our century made, that made our century and are making us. These artists have broad-stroked what we see and all that we imagine, and they've whispered to us from cradle to grave what we'll see next.

But any corner, any gallery will speak the same truths in its own tongue. The spirits of many places and times are alive and awake in every gallery of this wonderful museum. Their lessons, recognitions and truths call to us everywhere we stand and listen.

Following are brief descriptions of selected works:

THE ART INSTITUTE OF CHICAGO

Earlier paintings, sculpture and art

Master of the Bigallo Crucifix, Crucifix, circa 1260, tempera on panel, 75 1/2" x 50 1/4". Painted in the mid-thirteenth century in or near Florence, this rich, solemn work tells familiar themes surpassingly well. The unknown painter seems to have been influenced by the Luccese painter Berlinghiero Berlinghieri. In a strongly linear Romanesque style, this crucifix is one of the oldest items in the European decorative arts collection.

Ayala Altarpiece, 1396, tempera on panel, antependium 33 1/4" x 102", altarpiece 99 3/4" x 251 3/4". Magnificent in detail and history as well as size, the Ayala Altarpiece and its antependium or pulpit cloth are among the most important works of Medieval Spanish art outside of Spain. Painted in 1396 for the Chancellor of Castile, Pedro Lopez de Ayala, and more precisely for his mortuary chapel, it remained in that setting for 520 years. The eight-yard altarpiece was divided into three parts for its removal from the original chapel.

The altarpiece shows the Annunciation, the Visitation, the Nativity, the Epiphany, the Purification and the Flight into Egypt in its lower tier. Above are the Crucifixion, the Ascension, Pentecost and the Assumption. On the antependium are the Angel Appearing to the Shepherds, the Nativity and the Epiphany. The careful use of gold on the white background is noteworthy.

The Master of Moulins, *Annunciation*, oil on panel, c. 1500, 29" x 20". The Master of Moulins is an important transitional figure in the late Middle Ages who was especially masterful at painting beautiful women. His work shows traces of the awakening Renaissance.

Lucas Cranach the Elder (1472-1553) *Eve Tempted by the Serpent*, oil on panel, c. 1530, 42 1/2" x 14 1/2". In 1500, Cranach the Elder lived in Vienna and carried on an active artist's life, producing woodcuts as well as portraits and holy pictures. Cranach typically portrayed slim blond women with curving stomachs, and *Eve Tempted by the Serpent* is one such delightful evocation of the universal woman. Adam and Eve were popular subjects in Cranach's day; he's reputed to have painted Eve 31 times, Venus 32 times and Lucretia 35 times.

Domenico Theotocopuli, El Greco (1542-1614) *The Assumption of the Virgin*, 1577, oil on canvas 158" x 90". The *Assumption* is one of seven paintings El Greco did for his first Spanish commission, a monumental altarpiece in the royal Castilian city of Toledo. The *Assumption* was removed from its convent home in the early nineteenth century, and the new owner evidently had a larger frame that he wanted El Greco's first masterpiece to go into. Four or five inches of additional painting were added to El Greco's original work on every side, which drastically altered its dimensions and impact. After 60 years in the museum, the painting was cut back to its original dimensions and reframed by Art Institute curators in 1987, with no trauma.

The composition divides into two zones, earthy and heavenly, connected by a complex network of gestures and poses and silvery, supernatural colors and tones. The first El Greco to enter an American museum, the *Assumption* is considered his greatest work outside Spain.

Peter Paul Rubens (1577-1640) *Holy Family with St. Elizabeth and St. John the Baptist*, c. 1615, oil on panel, 46" x 35 1/2". Rubens was one of the most celebrated artists in northern Europe in the seventeenth century. Unlike many others, he richly profited from his talent, and had so many apprentices working under him that this work is very distinctive in being painted by Rubens himself.

Diego Rodriquez de Silva y Velazquez (1599-1660) *Isabella of Spain*, c. 1632, oil on canvas, 49 3/4" x 40". The painting is dark but elegant. Created by one of Spain's great portraitists, this work delivers subtle truths powerfully. Isabella's face and hands are particular technical achievements, and it's supposed that the master himself must have worked on these portions.

Rembrandt van Rijn (1696-1669) *Young Girl at an Open Half-Door*, 1645, oil on canvas, 40 1/2" x 33 1/4". This painting is a particularly good example of Rembrandt's magnificent use of form, color and light. Though the 'young girl' is wearing the uniform of the Amsterdam Municipal Orphanage, she seems to be a more mature young woman, and may in fact be one of Rembrandt's wives. He evokes her spirit very sensitively.

Giovanni Battista Tiepolo (1696-1770) *Madonna and Child with St. Dominic and St. Hyacinth*, oil on canvas, 108" x 58". The majesty of this painting, done by one of the last Venetian old masters, is in the maturity of its execution and the Madonna's great beauty.

Sir Thomas Lawrence (1769-1830) *Mrs. Jens Wolff*, 1803, 1815, oil on canvas, 50 1/2" x 40 1/4". One of the most elegant portraits in the museum's collection, Mrs. Wolff's pose here is taken from a figure in the Sistine Chapel. This is an excellent painting by one of England's best portraitists.

J.B.C. Corot (1796-1875) *Interrupted Reading*, c. 1870, oil on canvas, 36 1/2" x 25 3/4". This exciting portrait of a woman in Italian clothes was painted by a man known primarily for his landscapes. Recognition for his portraits has been slower in coming, though this work, one of the earliest French acquisitions in the museum collection, has long been celebrated.

J.M.W. Turner (1775-1851) *Valley of Aosta -- Snowstorm, Avalanche, and Thunderstorm*, 1836-37, oil on canvas, 36" x 48 1/2". Turner's dramatic painting isn't only a study in light, it is a study of nature as well, which reflects late Romantic sensibilities even as it pushes them passionately along. Though the work gives the impression of being done at the scene, it was actually completed from a series of sketches and watercolors done as much as a year earlier.

Gustave Courbet (1819-1877) *The Rock of Hautepierre*, c. 1869, oil on canvas, 31" x 39 1/2". A clear and colorfully exciting painter, as this work demonstrates, Courbet was criticized by his peers for his attempts to paint "honestly" the simple scenes of country life. This scene and many more come from the countryside he loved, near the painter's birthplace in France.

Edouard Manet (1832-1883) *Still Life With Carp*, 1864, oil on canvas, 27 3/4" x 36 1/4". Formal in its approach, this work locates Manet in his historical role of confronting the French nineteenth-century mainstream in its own terms.

Manet's awareness of artistic conventions and the way they tend to take a life of their own, however brief, made him a pivotal figure in immediate pre-Impressionist French painting.

Following are some of the many significant Impressionist holdings.

Impressionists and post-Impressionists

Claude Monet (1840-1926) *The Beach at Sainte-Adresse*, 1867, oil on canvas, 29 1/2" x 39 3/4". An early work, this calm and beautiful painting doesn't display the fascination with light for which Monet later became famous.

THE ART INSTITUTE OF CHICAGO

Impressionism was named from a painting Monet made in 1874 called *Impression, Soleil Levant* (Impression, Sunrise). Monet was one of the first Impressionists to paint landscapes on location.

Claude Monet (1840-1926) *The River,* 1868, oil on canvas, 31 3/4" x 39 1/2". This picture of Monet's mistress Camille shows her sitting on the banks of the Seine. The work is considered especially important because Monet broke a 200-year artistic tradition in painting his perceptions and feelings rather than a formal representation of the scene.

Claude Monet (1840-1926) *Old Saint-Lazare Station,* 1877, oil on canvas, 23 1/2" x 31 1/2". By now Monet was more assured of his ideas and painted a wider variety of subjects. This painting, the inside of a Paris train station, is composed in much freer brush strokes to convey the feeling of the smoky station. His use of light, too, gives fresh truth to the scene.

Pierre August Renoir (1841-1919) *Two Little Circus Girls,* 1879, oil on canvas, 51 1/2" x 38 3/4". Simple and direct, this painting is one of Renoir's masterpieces. Given to the Art Institute by Mrs. Potter Palmer upon her death in 1922, this was such a favorite painting that she carried it with her wherever she traveled. It's a delightful example of Renoir's skill at observing and recording the world around him.

Pierre August Renoir (1841-1919) *On the Terrace,* 1881, oil on canvas, 39 1/2" x 31 3/4". Rich with the color and glory of a beautiful summer day, this painting is as popular as it is famous. It simply shows a young mother and daughter enjoying their terrace.

Jules Breton (1827-1906) *The Song of the Lark,* 1884, oil on canvas, 43 1/2" x 33 3/4". Breton was an immensely successful artist in his day, during the time Impressionists were largely ignored. The tables today are thoroughly turned, but Breton's craftsmanship and sensitivity are still evident to those who care to see it in this sincere evocation of the mood, tone and color of country life at sunset. Now beginning to move admirers again, this was one of the most popular paintings exhibited at the Columbian Exposition of 1893.

Georges Seurat (1859-1891) *Sunday Afternoon on the Island of La Grande Jatte,* 1884-86, oil on canvas, 81" x 120 1/2". One of the most celebrated and important works of art in the Art Institute, and perhaps the only one to inspire an upscale Broadway musical, this huge painting is done in Seurat's revolutionary *pointillist* style which employs many small dots of many colors that resolve into objects when seen from a distance. It grew out of Seurat's long-standing interest in optical theory, and was exhibited to warm controversy and acclaim. Though quite a bit of activity is portrayed in the painting, it has a peaceful, stopped-action feeling that makes it almost dreamlike.

Vincent van Gogh (1853-1890) *Bedroom at Arles,* 1888, oil on canvas, 28 3/4" x 36". Painted near the end of van Gogh's pain-filled life, *Bedroom at Arles* is beautiful. His rented bedroom, assumed to be old and shabby, is bright and cheerful in this wonderful work that is awash in van Gogh's famous light and color.

Vincent van Gogh (1853-1890) *Self-Portrait,* 1886-88, oil on canvas, 28 3/4" x 36". This is one of 24 self-portraits that van Gogh painted while living in Paris. Intrigued by the *pointillist* work of Seurat and others, he tried to incorporate it into this piece. But he didn't achieve their effects because his own approach was so much more emotional.

Gustave Caillebotte (1848-1894) *The Place de l'Europe on a Rainy Day,* 1877, oil on canvas, 83 1/2" x 108 3/4". Caillebotte's painting, so intense and precisely constructed, highlights his considerable skill as a civil engineer, as well as his painting technique. Perspective is carefully manipulated in this famous work, which becomes even more powerful with observation.

Jean-Francois Millet (1814-1875) *Horse,* 1841, oil on canvas, 65 1/2" x 77 1/2". Millet was from a small town in northwestern France and studied in Paris. His paintings of rural life were very popular in the nineteenth century. This intense, exciting painting of a horse was commissioned by a veterinarian, and is very different from his other works of the period.

Henri de Toulouse-Lautrec (1864- 1901) *At the Moulin Rouge,* 1892, oil on canvas, 48 3/4" x 55 1/4". The celebrated Moulin Rouge dance hall drew many different sorts of people for habitué Toulouse-Lautrec to paint, and this is one of his most celebrated treatments of the famous subject.

Paul Cezanne (1839-1906) *The Vase of Tulips,* 1890-94, oil on canvas, 48 3/4" x 16 1/2". This still life is a fine example of Cezanne's gift for presenting fragile subjects in a way that gives them strength and substance. Still lifes were a favorite subject of this famous Impressionist.

American art

Mary Cassatt (1844-1926) *The Bath,* 1891- 92, oil on canvas, 39 1/2" x 26". Mary Cassatt has a rising reputation as one of the premiere American artists of her day. Her well-composed work shows influences from Degas and also Japanese printmakers. Her formal approach, and a distance between subject and viewer, characterize her work.

Winslow Homer (1836-1910) *The Herring Net,* 1885, oil on canvas, 29 1/2" x 47 1/2". Winslow Homer was a reporter and illustrator as well as a distinguished American painter. He was aware of the Impressionists' work and traveled to England and France, but he didn't share their fascination with light--most of his paintings focus on action, with a very specific style.

Grant Wood (1892-1942) *American Gothic,* 1930, oil on beaverboard, 29 3/4" x 24 3/4". School of the Art Institute graduate Wood went to Paris to study in 1920. Disillusioned there, he moved to Munich in 1928 and radically changed his style, becoming apparently satirical though he intended an effect perhaps closer to Socialist Realism. This famous picture actually portrays Wood's sister and their town dentist. They were intended to represent a widower and his spinster daughter, though the public has always seen them as man and wife.

Twentieth-century painting and sculpture

Pablo Picasso (1881-1973) *The Old Guitarist,* 1903, oil on panel, 48 1/4" x 32 1/2". An early painting from the famous "blue period," *The Old Guitarist* depicts its sad subject in tones of gloom and despair. Despite the brown and green hues in the guitar, the painting's cold, severe blues carry and define the whole.

Pablo Picasso (1881-1973) *Man With a Pipe,* 1915, oil on canvas, 51 1/4" x 35 1/4". An example of Synthetic Cubism, the painting is a reproduction of Picasso's earlier experiments in Analytic Cubism where he first created collages. These art works made of paper, newspaper, wire, wood and other materials on a two-dimensional surface were meant to suggest the third dimension by their arrangement. This painting follows the same idea, done in paint with the goal of achieving

Henri de Toulouse - Lautrec, *At the Moulin Rouge*, oil on canvas, 49x55, 1892. Courtesy: The Art Institute of Chicago

Claude Monet, *Saint-Lazare Train Station, The Normandy Train*, oil on canvas, 1877. Courtesy: The Art Institute of Chicago

the same effect. In his Synthetic Cubist works Picasso uses a heavily gray and umber palette in soft hues.

Wassily Kandinsky (1866-1944) *Improvisation With Green Center (No. 176),* 1913, oil on canvas, 43 1/4" x 47 1/2". Kandinsky is one of the first abstract artists, and many people consider him the founder of the abstract art that transformed art in the twentieth century. This painting is a movement of shapes and colors on the canvas, which is filled with action.

Henri Matisse (1869-1954) *Bathers by a River,* 1916-17, oil on canvas, 103" x 154". *Bathers* is one of Matisse's greatest paintings in its use of color and composition. The forms become ideas more than definite figures, and this work helped Matisse rank as a great innovator in French painting.

Henri Matisse (1869-1954) *Interior at Nice,* 1921, oil on canvas, 52" x 35". Colorful and airy, this was painted toward the end of a period when Matisse was interested in color, both formally and simply, for its natural effects. It also shows Matisse's dawning interest in decoration, which many of his later paintings from the 1920s develop.

Prints & drawings

Pieter Brueghel the Elder *(c. 1525-1569) The Hare Hunters,* 1566, etching, 8 1/2" x 11 1/2". A wonderfully detailed work, this print is apparently the only one extant by the master himself. It's filled with information about life in the Low Countries in the sixteenth century and is a fine example of how light can be used in etchings.

Paul Gauguin (1848-1903) *Women at the River (Auti te Pape),* 1893-95, colored woodcut, 8" x 14". Celebrated as a painter, Gauguin is also ranked as a master of woodcuts, equal to the German Renaissance masters. Wielding the wood-engraver's knife with great skill, he also experimented with overlays, offsets and calculated blurring to great effect.

Rembrandt van Rijn (1696-1669) *Noah's Ark,* reed pen and wash, 7 3/4" x 9 1/2". Rembrandt's interpretation of the Bible story is simple and clear. In the background is a huge barge with a shed on top. At the gangplank is the patriarch, and before him his sons and several hesitant animals.

Pierre August Renoir (1841-1919) *Nude* (Study for *The Great Bathers),* 1884-85, pastel and wash, 39" x 25". A study for the great painting *The Great Bathers* at the Philadelphia Museum of Art, this sketch is a lovely study of a young girl's body.

Vincent van Gogh (1853-1890) *Grove of Cypresses,* 1889, ink and reed pen over pencil, 25 1/2" x 18 1/4". This seems to have been a passing fancy of van Gogh's, drawn quickly and on impulse. But he had to put a fair amount of time into it, as it's first drawn in pencil and then executed in pen and ink. It shows the influence, then fashionable in France, of Japanese printmakers, and was done a year before van Gogh died.

Piet Mondrian (1872-1944) *Composition,* 1913-14, black chalk, 24 3/4" x 19". Mondrian was a Dutchman who began his career as a scene painter. His work became not only abstract, but non-objective as well. Several years after Kandinsky developed similar ideas, Mondrian also removed all representational reference to the external world from his work. This drawing is a significant beginning to much of the work Mondrian completed in the '20s and '30s.

Asian art

T'ang Dynasty (618-906) *Tomb Figure of a Horse,* glazed pottery, 30 1/2" high. Of all ceramic grave goods produced in ancient China, most popular among collectors have been large-scale animals, particularly horses. This is a unique, splendid example which combines the techniques of glazed and fired coloring with hand painting in several colors. It has an extraordinary intensity and truth in the potter's observation of natural life.

Sesson Shukei (1504-1589) *Landscape of the Four Seasons,* six-fold screen, ink and color on paper, 61 1/2" x 133". The screen pictures a beautiful scene of mountains, a harbor and village life. Weather conditions and other phenomena of nature are recorded, even described, in this creation of a self-taught artist.

Primitive art

Aztec (after 900 A.D.) *Standing Male Figure, the God Xipe,* terra cotta with traces of pigment, 23 1/4" high. Xipe is the god of renewed growth of flowers and vegetation. He's shown wearing the flayed skin of a sacrificial victim who symbolizes regeneration.

Chimu culture (c. 1200-1500 A.D.) *Ceremonial Knife,* gold with turquoise inlays, 13 1/2" high. Used for rituals by the Chimu of pre-Columbian Peru, this gold knife has a figure of the legendary hero Naym-Lap from northern Peru. Its technique and workmanship are very elaborate.

Location and transportation

Accessible by many routes, in this as in many ways the Art Institute lends itself to many visits. Parking is available east and north of the museum at the Chicago City Underground and the Monroe garages at reasonable rates, and street parking can often be found along Columbus Drive. Many private garages are also at hand. Located in the southern part of downtown just east of the Loop, the Art Institute is well served by CTA lines from all over the city and from the major commuter stations. It is adjacent to the Illinois Central and South Shore commuter trains that serve the South Side and northwest Indiana.

BALZEKAS MUSEUM OF LITHUANIAN CULTURE
6500 S. Pulaski Rd. Chicago, IL 60629

Phone: 582-6500 *Hours:* Saturday-Thursday: 10-4; Friday: 10-8 *Admission:* $2.00 adults, $1.50 seniors and students, $1.00 children under 12. Closed Christmas, Easter and New Year's Day

Opened in 1966, this ethnic museum and cultural center is devoted to the exhibition of Lithuanian art and artifacts and the preservation of Lithuanian history. Stanley P. Balzekas, a Lithuanian immigrant who came to America in 1912, is the founder and major benefactor of the museum. His son Stanley, Jr. is the current president.

The diverse art collection includes paintings, textiles, folk art, rare maps, dolls, national costumes, arms and armor, stamps and coins, and a selection of hand-decorated Easter eggs, among other artifacts, dating primarily from the sixteenth century to the present. Among the highlights of the museum is its collection of rare amber, including a Baltic amber necklace, c. 2700-1600 B.C. Other pieces date back as far as 5000 B.C.

In addition to its permanent exhibit, titled "Lithuania Through the Ages," the museum also mounts about six exhibitions of art each year by Lithuanian and Lithuanian-American artists. There is also a children's museum, various art workshops and a class on making Christmas ornaments from straw. Classes are held throughout the year for a nominal fee.

The Balzekas Museum also maintains an extensive archival collection of photographs and negatives, as well as various books, periodicals and other items pertaining

Petras Rimsa, *The Ploughman,* bronze, 1922. Courtesy: Balzekas Museum of Lithuanian Culture. Photograph: Ed Mankus

Franz Kline, *Contrada,* 92x79, oil, 1968. Courtesy: The Art Institute of Chicago

to Lithuania and prominent Lithuanians, which is also open to the public.

A wide variety of items are available in the museum's gift shop, including jewelry, glassware and reference books.

MARY AND LEIGH BLOCK GALLERY
1967 N. Sheridan Rd, Evanston, IL 60201

Phone: 491-4000 *Hours:* Tuesday-Saturday 10:30-5, Sunday 12-5, evenings one hour before concerts *Admission:* free

Founded in 1980, the Mary and Leigh Block Gallery is the focal point of the arts at Northwestern University. Devoted to the presentation of thematically unique, high-quality exhibitions documenting new ideas in the history of art, the Gallery presents five exhibitions per year and is the center of many other art-related activities. Located in the "arts circle" on the Evanston campus, the Gallery is situated beside the Barber Stage Thrust Theater, the Louis Dance Theater, and the 1,000 seat Pick-Staiger Auditorium.

Exhibitions have covered everything from the beginnings of history to the most recent trends in contemporary art. As a university museum, the Block Gallery is devoted not only to research and exhibition but also to teaching, both on campus and in the community. Therefore each exhibition is accompanied by a series of interpretive programs designed to stimulate both the novice and the connoisseur--and to attract and reward the students who wander through. These programs stress the cultural and aesthetic contexts in which the art on view was created. Lectures, symposia, concerts, films, tours and special events are all free and open to the public.

Recent exhibits and related programs have included "Five Centuries of Landscape Drawings, 1400-1900," "ARTisrael," "The Presence of Abstraction," and "Supreme Instants: The Photography of Edward Weston."

The Gallery's collections are small but choice. Works of art on paper dating from the fifteenth through twentieth centuries are particularly strong, as are holdings in monumental outdoor sculpture. The Gallery is installing on several acres a monumental sculpture garden with works by Henry Moore, Barbara Hepworth, Jean Ipousteguy, Jacques Lipshitz, Joan Miro, Arnaldo Pomodoro, Kenneth Snelson and Peter Reginato. Special courses are offered to high school and elementary teachers in conjunction with all exhibitions. An effort is made each year to develop programs and information that use the Gallery as a key resource for teaching core curricula in the public schools.

CHICAGO HISTORICAL SOCIETY
Clark Street at North Avenue, Chicago, IL 60614

Phone: 642-4600 *Hours:* Monday-Saturday: 9:30-4:30; Sunday: 12-5 *Research collections:* Tuesday-Saturday: 9:30-4:30 Closed Thanksgiving, Christmas, New Year's Day *Admission:* Adults: $1.50; Children (ages 6-17) and senior citizens $.50 Mondays free

Founded in 1856, the Chicago Historical Society is the oldest cultural institution in Chicago. This privately endowed museum is devoted to the collection, preservation and exhibition of the history of the city of Chicago, the state of Illinois, and selected areas of American history. Located in Lincoln Park, the museum recently underwent a $15 million renovation and expansion. All three floors are open to the public. The first two floors are dedicated to permanent and traveling exhibitions, while library and museum collections are located on the top floor.

The permanent exhibitions include the Illinois Pioneer Life Gallery, where visitors can watch daily demonstrations of the pioneer crafts of spinning, weaving, dyeing, quilting and candle dipping. Of particular interest to Chicagoans are the Fort Dearborn and Frontier Chicago exhibit and the "Chicago History" galleries, which are filled with a potpourri of Chicago-related artifacts. Among the interesting items on display are the *Pioneer,* Chicago's first locomotive; Chicago's first fire engine; miscellaneous mementos and souvenirs documenting the "Century of Progress Exposition" of 1933-34; and a recreation of a typical Chicago parlor of the mid-19th century. A free slide show about the Great Chicago Fire is available continuously.

"We the People: Creating a New Nation, 1765-1820" is a new permanent exhibition and the first installation of the Society's American History Wing. Visitors will see a unique collection of first printings of many of the nation's most important documents. A rare broadside of the Declaration of Independence, the first newspaper printing of the United States Constitution, and the first official printing of the Bill of Rights, as well as the Northwest Ordinance of 1787 and the Treaty of Greenville are featured. More than 300 original artifacts--including portraits and paintings, manuscripts, costumes, books, maps, furniture, prints and engravings--help reveal the human dimension in these historic documents. The second installation of the American History Wing, "America in the Age of Lincoln," opens in January 1990.

The new "Hands-On Gallery" has an expanded collection of artifacts that can be handled by visitors--items ranging from historic photographs, clothing and newspapers to tools and equipment associated with a wide range of trades and occupations. Four special environments are featured: a fur trader's cabin, an early 20th-century factory setting, a turn-of-the-century Chicago "streetscape" and a 1930s radio broadcasting studio.

The Society hosts a wide range of temporary and traveling exhibits as well as its permanent displays. Recent exhibitions have run the gamut from "William Wordsworth and the Age of English Romanticism" to "'Say it Ain't So, Joe'--The Black Sox Scandal of 1919." Other recent topics: "Frank Lloyd Wright and the Johnson Building: Creating a Corporate Cathedral" and "'The Whole World is Watching': Inside and Outside the 1968 Democratic Convention."

The Prints and Photographs collection includes a large selection of early photographs and posters. Other research collections include Archives and Manuscripts, Architecture, and Costumes. An assortment of books and periodicals on Chicago and Illinois as well as unusual gift items and posters are available in the expanded Museum Store on the first floor.

THE CHICAGO PUBLIC LIBRARY CULTURAL CENTER GALLERIES
78 E. Washington, Chicago, IL 60602

Phone: 346-3278 or 744-6630 *Hours:* Monday-Thursday: 9-7; Friday 9-6; Saturday: 9-5

Scattered among the magnificent mosaics of the Cultural Center are a museum and four galleries in which a wide range and variety of exhibits is presented. Exhibitions under the auspices of the Chicago Office of Fine Arts, Department of Cultural Affairs and The Chicago Public Library help to create an atmosphere in which

the arts can flourish in Chicago. They are free and open to the public.

Exhibitions have been in a wide range of media, including painting, sculpture, photography, graphics, crafts, architecture and design. The largest exhibition space is the Exhibit Hall on the fourth floor. This enormous space with high ceilings offers a range of exhibitions, from handmade quilts by artisans of southern Illinois to contemporary painting and sculpture from Spain. Other important shows have been "The Black Photographer: An American View," "Contemporary Italian Masters," "Martin Puryear: Public and Personal," and "The Eloquent Object." Exhibitions include national traveling exhibitions and major shows organized by staff or guest curators.

The Randolph Gallery is located on the first floor and is an open space easily approached from the Randolph St. entrance. Exhibits seen here are often unusual, encompassing an enjoyable sampling of the arts. A recent exhibition of contemporary baskets by prominent American artists, for example, brought in visitors of all ages.

Also located on the first floor is the West Gallery, which primarily exhibits two-dimensional pieces. Photography exhibits often grace this quiet space, which is slightly separated from the mainstream activity.

The East Gallery is also located on the first floor and can easily be viewed as it is located along a well-traveled corridor that runs north and south through the building. Photographs and original works of high quality are displayed here.

There is also a recurring exhibit of the library's Civil War Collection in the Grand Army of the Republic Memorial Hall. Call 269-2926.

The goal of the Cultural Center Galleries is to exhibit unknown as well as known artists and to give exposure to many artists working in various media and styles. There is much to learn in this beautiful building, and the art galleries are a delightful place to start.

THE MARTIN D'ARCY GALLERY OF ART,
Loyola University (Lake Shore Campus) 6525 N. Sheridan, Chicago, IL 60626

Phone: 508-2679 *Hours:* Monday-Friday: 12-4 Sunday: 1-4; Tuesday and Thursday evenings: 6:30-9:30 Closed when the University is not in session *Admission:* free

The Martin D'Arcy Gallery is located in the Elizabeth M. Cudahy Library of Loyola University. This small museum of the Jesuit university contains a fine collection of Medieval, Renaissance and Baroque art dating from the twelfth through the eighteenth centuries. Established in 1969 by Father Donald F. Rowe, who is also the museum's director, the Gallery is named after Martin D'Arcy (1888-1976), an English Jesuit philosopher, professor and author under whom Father Rowe studied.

It is a remarkable achievement that this specialized collection was formed only in the last two decades. It consists of approximately 150 works (paintings, sculpture, enamels and decorative art objects) representing various regions and periods. Among the highlights of the collection are an early fifteenth-century alabaster mourning figure from the tomb of Fernando de Antequara, King of Aragon; a sumptuously decorated jewel chest made for Queen Christina of Sweden from ebony, lapis lazuli, amethyst, bloodstone and silver gilt; and a seventeenth-century terra-cotta of the Madonna and Child with St. John, by Luisa Roldan, made for the chapel of the King of Spain.

Of interest to the Chicago community is the annual Christmas tree that is displayed in the Gallery from Thanksgiving through Christmas, which contains more than 1,200 lights and 850 handmade ornaments.

A detailed catalogue of the collection is available at the museum.

Please note: The Martin D'Arcy Gallery of Art is closed for Thanksgiving, Christmas, New Year's Day, and Easter Sunday, and is also closed when the University is not in session. It's therefore recommended that visitors call the museum before planning a visit.

THE DUSABLE MUSEUM OF AFRICAN AMERICAN HISTORY
740 E. 56th Pl., Chicago, IL 60637

Phone 947-0600 *Hours* Monday-Friday 9-5, Weekends and Holidays 12-5 *Admission* $2, Students and Seniors $1, Children to age 12 $.50

In 25 years, the DuSable Museum of African American History has grown from the home of a Chicago art teacher to fill a neo-Palladian palace in Washington Park that overlooks its own sculpture garden. The first non-profit museum dedicated to the history, art and culture of black Americans in the Midwest, its permanent collection includes more than 800 works of art covering seminal WPA pieces from the 1930s through the black arts movement of the 60s and the present day.

The museum has many holdings in traditional African art as well as historic memorabilia, more than 10,000 pieces in all. Highlights include 56 paintings of "Blacks in Early Illinois," a spectacular piece by Chicago sculptor Richard Hunt, and a bust of Dr. Martin Luther King, Jr. donated by Governor James Thompson.

The museum sponsors eight special exhibitions per year. Titles include "Afro-Brazil;" "Blacks in America: A Photographic Record;" "Generations in Struggle;" and "RaRa: Carnival in Haiti."

The museum has a long-standing commitment to outreach and education, with extensive community programming. It also offers a library of more than 10,000 volumes on the subjects of Africa and African-American life, history and culture.

THE EVANSTON ART CENTER
2603 Sheridan Rd., Evanston, IL 60201

Phone: 475-5300 *Hours:* Monday-Saturday 10-4, Thursday 7-10, Sunday 2-5 *Admission:* $2 donation suggested

The Evanston Art Center was formed in 1929 by delegates from more than 20 North Shore civic organizations. In 1942 it was incorporated, and quickly outgrew its first home in the basement of the Evanston Public Library. Since 1966 it's been housed in a historic lakefront mansion owned by the city of Evanston just north of Northwestern University and amidst a lakefront garden designed by the pioneering natural landscape architect Jens Jensen.

The Evanston Art Center's exhibition program showcases contemporary art and artists from the Midwest. Fifteen to 20 exhibitions and related programs are presented annually. Gallery exhibitions range from one-person shows and installations to theme exhibitions of 20 or more artists. The Center is sensitive to the currents and trends of contemporary art and reflects them in its exhibition program. In addition to the main exhibition program, the Center coordinates two exhibition programs in annex galleries in Evanston and supports an active 24-member Co-Op Gallery.

Recent exhibitions have included: "Jay King: 25 Years of Street Photography," "Selections from Midwest Pastel '88," the annual "Evanston and Vicinity Exhibition," and "Personal Histories and Fictitious Selves." Its diverse gallery spaces also feature student work from the Center--more than 50 classes per semester are offered to 1,200 students annually. The Center also has an active travel and lecture and workshop program.

FIELD MUSEUM OF NATURAL HISTORY
Roosevelt Road at Lake Shore Drive, Chicago, IL 60605

Phone: 922-9410 *Hours:* Daily: 9-5; Closed Christmas and New Year's Day *Admission:* $3.00; young people, seniors and students $2.00; families $10.00; Free admission for museum members and their families, U.S. military personnel in uniform, teachers, children under six, eligible preregistered groups of 10 or more

At a breathtaking bend in Chicago's Lake Shore Drive stands the Field Museum, one of the world's finest collections of artifacts and specimens of natural history. In a marble-faced, far larger-than-life copy of an ancient Greek temple, the museum houses more than 19 million unusual items. Less than 1% of this extraordinary collection is on public display in the 10 acres of floor space given to public exhibitions. Stanley Field Hall, the main exhibition area, serves as focal point for the 42 exhibition halls and 6 exhibit galleries that line either side of the huge open hall. The museum's famous "trademark" exhibits are here--the fighting wild elephants of Africa, the free-standing dinosaur skeleton, and two spectacular totem poles from British Columbia. In each corner of the hall at second-floor height stands a statue symbolizing the principal aims and purposes of the museum: Natural Science, Dissemination of Knowledge, Research, and Record.

Some of the world's great traveling exhibits pass through the Field Museum. Recent famous ones include the "Treasures of Tutankhamen" King Tut exhibit, the huge "Great Bronze Age of China" sponsored by the Chinese government in its first great overseas exhibition, and the dazzling "Tiffany: 150 Years of Gems and Jewelry."

There are many smaller traveling and curated exhibits as well. "Mothers and Daughters" showed the work of 80 photographers against a background of associated text. The annual juried exhibit "Birds in Art" features paintings, sculptures and graphics. Other exhibit titles: "Mexican Textiles: Color, Texture, Tradition," and "Traditions in Japanese Art: The Boone Collection."

The Field Museum celebrates its centennial in 1993. As part of the celebration it is completely renovating 96% of its public displays, which means that if you haven't seen the museum lately, you haven't seen it. True family adventure lurks "Inside Ancient Egypt," where visitors follow the tracks of grave robbers through an ancient burial tomb. Children can try on the world's largest pair of blue jeans in "Sizes," a fun-filled exhibit that explores the concepts of size and scale. Native American cultures come alive through seven different exhibition halls, a life-size Pawnee earth lodge and the new Weber Resource Center for Cultures of the Americas. Adult courses, children's programs, family activities and special performances are scheduled year-round.

THE FREEPORT ART MUSEUM AND CULTURAL CENTER
121 N. Harlem Ave. Freeport IL 61032

Phone: (815) 235-9755 *Hours:* 12-5 Wednesday-Sunday, closed major holidays *Admission:* free, donation requested

The Freeport Art Museum and Cultural Center was founded in 1975 with a bequest from W.T. Rawleigh, a spice trader in the 1920s and 1930s who collected art from the areas in which he and his traders searched for raw materials. These many diverse journeys are reflected in the variety and scope of his collection, which has since been augmented with other significant donations and acquisitions.

The Native American gallery contains superb Southwestern basketry and pottery, including work by the famous Hopi potter Nampeyo. The Oriental gallery contains Islamic tiles from the Rawleigh collection and a 10-fold Chinese screen, among other holdings. The European gallery has an extensive collection of peitra dura, fine nineteenth-century bronzes and sculptures, and an interesting selection of nineteenth-century genre paintings.

There are now many holdings in addition to the Rawleigh pieces. An anonymous donation of ancient art and artifacts made in memory of Kenneth Parvin in 1979 has grown into a major collection. Especially noteworthy are a red-figured archaic Greek amphora, a collection of Roman glass, and a large collection of ancient gold jewelry.

The museum also displays on extended loan the collection of art professor Philip Dedrick, a Freeport native. Primarily primitive art and sculpture, it includes an extensive collection of pre-Columbian American pottery as well as Oceanic and African pieces. But it includes a large group of contemporary prints too, with works by Braque, Chagall, Miro and many others.

The museum also has a contemporary collection consisting primarily of recent acquisitions and gifts. One gallery is set aside for temporary exhibitions which change monthly. These exhibits vary widely, from the latest in contemporary art to an annual exhibit of children's work, to traveling exhibits sponsored by the Illinois Arts Council--which incidentally provides matching grants for some of the museum's recent acquisitions. Openings are held on the first Sunday of each exhibit, usually with the artist or a speaker present.

The Cultural Center side of the museum sponsors music and dance events--one major production each year on the order of "The Nutcracker," and several smaller recitals. Classes and workshops teach crafts, drama, writing, art, and dance of both the classical and Broadway persuasions. There is also an active volunteer and docent program.

THE HYDE PARK ART CENTER
Del Prado Hotel, 1701 E. 53rd St., Chicago, IL 60615

Phone: 324-5520 *Hours:* Tuesday-Saturday 11-5, Sunday 12-5 *Admission:* free

The Hyde Park Art Center is a not-for-profit visual arts organization established in 1939. Located on the South Side in the neighborhood of the University of Chicago, the independent Art Center maintains both a gallery and a school.

The Art Center has played a prominent role in the cultural life of the city. Nationally recognized by practicing artists as well as the art-viewing public, the Center features the most significant emerging artists and craftspeople in Illinois. Among the artists in the Center's first exhibition, "Work of the 57th Street Art Colony," were Emil Armin, Gertrude Abercrombie and Roff Beman. More recently the center's tradition of recognizing excellence gave birth, in the 1960s and 1970s, to the Chicago Imagist school, and participants in such shows as "The Hairy Who," "False Image," and "Marriage

Twin Mummy (detail), 300 B.C. - 30 B.C. Courtesy: The Field Museum, Chicago

Summerian Statue, Stone, from Tell Asmar, Iraq, c., 2900-2775 B.C. Courtesy: Oriental Institute Museum, University of Chicago

Chicago Style" went on to achieve national and even international renown.

The Art Center was also early to recognize and encourage native artists, exhibiting the work of area artists Aldo Piacenza, William Dawson, Henry Darger and Lee Godie. And the Center was the first Chicago gallery to approach furniture as art, in "Chicago Furniture, 1982" which featured the gamut from traditional furnishings to constructivist and postmodern designs. National touring exhibitions also are featured from time to time, as well as ceramics, photography, prints and sculpture. Though it's off the established tourist circuit, the Hyde Park Art Center is a focal point for whatever is happening next.

The Center's school offers four terms of classes per year, with more than 20 courses offered each term. It also conducts outreach art workshops in area elementary schools under the City Arts II Grants program. More than 1,000 public-school students benefit from these hands-on workshops each year.

THE LIZZADRO MUSEUM OF LAPIDARY ART
220 Cottage Hill, Elmhurst, IL 60126

Phone: 833-1616 *Hours:* Tuesday-Saturday 10-5, Sunday 1-5 *Admission:* $1.00 adults, $.50 seniors and teenagers; teachers, soldiers and children under 13 free; Fridays free for all, Closed Mondays and major holidays

The Lizzadro Museum's unique collection of jade carvings, gems and mineral specimens opened in 1962. In 1985 the lower level was completely renovated to suit its new name, "The Rock and Mineral Experience." But the museum's appeal isn't at all limited to rockhounds.

Founder Joseph Lizzadro, a jeweler and businessman long resident in Elmhurst, took an interest in working in raw jade in the 1930s. He learned that it was actually cheaper to buy and carve up large Chinese jade artworks than it was to purchase raw American jade. He ordered one such Chinese piece, intending to cut it up into cufflinks. But he was so taken with its beauty that his interest turned to preservation and collection of such hardstone works, in quartz, lapis and agate as well as jade.

His collection includes intarsias and mosaics from Florence, carvings from the ancient stonecraft centers of Germany, Mexican and Australian opals, Baltic amber pieces, and art objects and specimen gem materials from every continent, along with fossils, meteorites and rough mineral displays. His many beautiful jade and hardstone carvings, however, remain at the center of the museum.

Chinese pieces include an eighteenth-century cinnabar screen covered with carved gemstones which was a birthday gift for the Chinese Emperor, and a jade ceremonial incense burner from the Imperial Palace in Peking which is in the shape of a pagoda, with 12 tiny bells in the corners. Upstairs are 25 dioramas depicting nature scenes or circuses in which hardstone animals are posed. A northwoods bear family is carved from obsidian, a timber wolf from agate, against correct ecological backdrops. All these diorama animals were carved by traditional German master craftsmen.

Every Sunday at 3 the half-hour video "Gems of the Americas" traces gemstones from their formation to their final facet polish. Slide lectures are presented twice a month and there is a regular program of children's events and video presentations.

THE MEXICAN FINE ARTS CENTER MUSEUM
1852 W. 19th St., Chicago, IL 60608

Phone: 738-1503 *Hours:* Tuesday-Sunday 10-5, Closed Mondays *Admission:* free

The Mexican Fine Arts Center Museum is one of our most recent and vibrant additions to Chicago's arts community. Located in Pilsen, a neighborhood that has long been home to economizing Chicago artists of all backgrounds, the museum is the first of its type in the Midwest. Its aims are to sponsor events and exhibits that exemplify the rich variety of visual and performing arts found in Mexican life; to develop a significant permanent collection of Mexican art; to encourage the development of Mexican artists; and to offer classes in the arts.

This mission is conceived broadly enough in practice that Latino artists from many countries are exhibited. The museum opened with "Latina Art: Showcase '87," which included a great variety of women's work from across the Western hemisphere. Other exhibits: "The Barrio Murals;" "Living Maya: The Art of Ancient Dreams;" "Prints by Mexican Masters;" and "Day of the Dead."

The museum's permanent collection is focused on prints by Mexican masters, photography, Mexican folk and decorative art, and work by Mexican-Americans from Chicago and across the country.

MITCHELL INDIAN MUSEUM AT KENDALL COLLEGE
2408 Orrington Avenue, Evanston, IL 60201

Phone: 866-1395 *Hours:* Monday-Friday: 10-4; Sunday: 1-4, Closed on Kendall College holidays *Admission:* free, donations appreciated

Since 1977 the Mitchell Indian Museum has grown from the original collection of John and Betty Kendall into a museum of more than 3000 items from many donors. John Mitchell is a retired realtor and businessman who has collected Indian art for 60 years among many North American tribes.

The newly remodeled permanent collections room contains art and artifacts from four American Indian cultures. Highlights include a birch-bark canoe, bead and quillwork from the Woodlands/Great Lakes culture; rugs, silverwork and sandpainting of the Navajo; pottery, kachina dolls, baskets and jewelry of the Pueblo people; pipes, pipebags, quill and beadwork, and tools and instruments of the Plains. There is representative clothing from each area as well as new murals, differentiating the landscapes, housing, activities, dress and lifestyles of each group of Native Americans.

Exhibits are arranged by geographic area in one gallery, making it easier to compare different cultures. There are models of Indian dwellings and a "touching table" for each of four regions where visitors can feel a furry buffalo robe, heft a 3500-year-old axe, smell sweet grass and examine pots, quillwork and other characteristic objects from each area. In all, the art and culture of six areas are represented: the Plains, Great Lakes, Southwest (both Navajo and Pueblo), Northwest Coast, and the Arctic Eskimo peoples. There are two new permanent exhibits: "Prehistoric Peoples of Illinois" and "Contemporary American Indians;" temporary exhibits are mounted as well, in conjunction with lectures by national scholars and demonstrations by Indian artists. Recent temporary exhibit titles and topics: "The Power

Art Science, Courtesy: Museum of Science and Industry

Obsidian Butterfly & Street Dances , performance. Courtesy: The Mexican Fine Arts Center

of Navajo Ceremonial Art," "People of Cedar and Salmon," "Navajo Pictorial Weavings," and "Kachinas: An Evolving Ethnic Art" on Hopi ceremonial dolls and how to carve them.

Educational programs are provided by the museum staff for school children and adult groups. A library of related books and periodicals, and loan boxes and other materials, are available for study and to assist teachers.

THE MUSEUM OF CONTEMPORARY ART
237 E. Ontario, Chicago, IL 60611

Phone: 280-5161 *Hours:* Tuesday-Saturday 10-5, Sunday 12-5, closed Monday *Admission:* \$4, general; students, 2; seniors and children under 16, \$2; Tuesdays free

The Museum of Contemporary Art was founded in 1967 by a group of culturally concerned Chicagoans who responded to the need for an internationally oriented contemporary art forum in the Second City. Since then the MCA has established a unique track record of presenting the finest and most provocative of contemporary visual and related arts--painting, sculpture, photography, video, dance, music and performance are offered. Located on Ontario Street between Michigan Avenue and the lake, the museum is situated in the middle of Chicago's thriving shopping, business and tourist district.

Exhibitions

Exhibitions feature the work of established artists, emerging ones, and those who are experimenting with new media and concepts. Recent developments in painting, sculpture, graphics, video, performance, crafts, architecture, and installation works are all represented. MCA exhibits often put contemporary art into historical perspective and reassess art, concepts and movements. The museum also frequently organizes surveys of the careers of individuals who are shaping contemporary art. Given the rich diversity that characterizes the field, it isn't surprising to find the MCA filled with unexpected, provocative and challenging exhibitions.

The exhibition schedule is highly diverse, balancing ground-breaking MCA-organized retrospectives and internationally acclaimed group exhibitions with the presentation of major traveling exhibitions from elsewhere. Among the artists who have exhibited at the MCA: Claes Oldenburg, Dan Flavin, Tom Wesselman, Roy Lichtenstein, Andy Warhol, Diane Arbus, Robert Rauschenberg, Lucas Samaras, Jasper Johns, David Salle, David Hockney, Jenny Holzer, Donald Sultan and Eric Fischl.

In recent years the MCA has organized several important retrospectives that introduced Chicago audiences to major figures in European art who are little known in the United States. Among them were the first North American retrospectives of the work of Polish fiber artist Magdalena Abakanowicz, Greek-born Jannis Kounellis, French artist Christian Boltanski, and German painter Gerhard Richter. These shows are all traveling to major cities nationwide, extending the vision of Chicago's MCA to tens of thousands of people across America.

The MCA has also brought important traveling exhibitions to the Midwest, including a survey of the work of six British sculptors, and the landmark international loan exhibition "The Spiritual in Art: Abstract Painting 1890-1985," which demonstrated that the development and continuation of abstract art was tied to spiritual and mystical ideas.

The MCA has also served as a forum for local artists, and for the presentation of Chicago collections of contemporary art and Chicago architecture. The Borg-Warner Gallery of Chicago and Vicinity Art on the museum's second floor is devoted primarily to works of Chicago-area artists, with regularly changing exhibitions that illustrate the vitality and variety characteristic of our expanding creative community. From time to time large-scale exhibitions, such as "Chicago Imagist Art" and "Chicago Artists in the European Tradition" showcase Chicago's native talent.

The Museum of Contemporary Art makes every effort to broaden visitors' knowledge and appreciation of the works on view. An Orientation Space, located on the main floor, offers continuous showings of videotapes and introduces visitors to the museum and its current exhibitions. Informal guided tours are offered daily. In addition, exhibitions at the MCA are accompanied by a variety of lectures, artists' talks, panel discussions and mini-courses designed to stimulate an understanding of contemporary art.

The permanent collection

The MCA's permanent collection includes painting, sculpture, drawings, prints, photography, film, video, audio works installations and artists' books. This unusually diverse collection provides a historical context for examining changes in contemporary art. More than 3,300 pieces are included in the permanent collection, including art from the region, the nation and abroad. Among those represented by important works are Francis Bacon, Georges Braque, Alexander Calder, Christo, Jean Dubuffet, Marcel Duchamp, Rene Magritte, Claes Oldenburg, Ed Paschke, Robert Rauschenberg and George Segal. The MCA is especially noted for its collection of artists' books, numbering nearly 2,000.

Selections from the permanent collection are often on view, either as theme shows or complements to one of the temporary exhibitions. One recent permanent collection show, "Word and Image," explored the use of language in, as, or in place of imagery in visual art. Another explored the roots of minimal art. One piece always on exhibit is, in fact, invisible: located in the west wing stairwell is a four-story sound sculpture by Max Neuhaus, the first work of its kind commissioned for any museum's permanent collection.

Occasionally the museum building itself becomes an exhibit. In 1969 Christo wrapped the MCA in canvas and two miles of rope. In 1979 Gordon Matta-Clark used power saws to cut through the walls, roof and floors of what is now the west wing, temporarily turning the four stories into a three-dimensional architectural drawing. Other conceptual exhibitions have included Chris Burden's lying under an angled piece of glass for 45 hours, and the "White on White" exhibition, where sixty white works of art were hung on all-white walls and opened during the winter's first snowfall.

Allied arts

Developments in the performing arts are closely allied to those in the visual arts. The Museum of Contemporary Art tries to present a wide spectrum of both. Occasionally, the museum's galleries become a concert hall for new music and jazz, or a stage for theater, dance and poetry readings, or a space for video and film. Special programs are sometimes held outside the building, sponsored by the MCA and open to the public with reduced or free admission for members. Phillip Glass, Anthony Braxton, John Cage and Laurie Anderson are

Art Freund, *Reaching for Tomorrow,* hologram. Courtesy: Museum of The Fine
Arts Research & Holographic Center

Nathan Lerner, *Eye on Window,* 16x20, Silver gelatin print, 1943. Courtesy: Museum of
Contemporary Photography

leading composers who have performed here, as have many of the city's classical and jazz musicians.

Performance is another vital part of the MCA's exhibition schedule. In 1986 the MCA commissioned three works known overall as "The Electronic Language": Ping Chong's *Angels of Swedenborg,* Robert Ashley's *Atlanta (Acts of God),* and Squat Theatre's *Dreamland Burns.* These works received funding from the National Endowment for the Arts and traveled nationally under the auspices of the MCA.

Community programming

The MCA is dedicated to promoting an understanding of contemporary art and making it accessible to an ever-widening audience. To this end, the MCA has established several outreach programs through its education department. These include a school outreach program that offers guided tours of MCA exhibitions to Chicago-area students, along with a pre-visit slide package, a teacher orientation, and bus service to and from the museum; an innovative senior outreach program consisting of two on-site visits to given seniors' facilities and transportation to and from the museum for a tour; and a traveling exhibition titled "Eleven Chicago Artists" that transports original works of art to area schools and senior citizens' facilities for one- and two-week periods, accompanied by an explanatory package and video of the artists at work in their studios.

Events and programs

Throughout the year the MCA presents special events that offer opportunities to meet people of like interests and share with them the experience of contemporary art. Regularly scheduled programs include lectures, mini-courses, readings and book signings, and visits to galleries, special collections and artists' studios. The museum has several benefits per year that combine entertainment and art in a festive and lively way.

The MCA offers several membership groups that meet the individual needs of its varied and diverse audience. The New Group is designed to introduce people to contemporary art through a series of informal, creative programs that are also imaginative social gatherings. Evening and weekend programs are planned to accommodate the schedules of working people. The six conveniently located Affiliate Groups offer museum members a chance to get more involved with art in their own neighborhoods.

Members and visitors alike enjoy the unique and unusual gifts for sale in the MCA Store. It offers an excellent selection of exhibition catalogs and features items such as posters, toys, artist-designed jewelry, accessories for home and office, and videotapes by artists. The Site Cafe Bookstore on the MCA's lower level offers a fresh, moderately priced menu amidst an extensive selection of art books, magazines and cards. A special feature of the Site Cafe Bookstore is the unique permanent installation *Dwellings,* created by Charles Simonds. Extending the full length of the brick wall, Simonds has sculpted the evolution of a miniature yet highly detailed imaginary civilization.

THE MUSEUM OF CONTEMPORARY PHOTOGRAPHY

600 S. Michigan Ave. Chicago, IL 60605

Phone: 663-5554 *Hours:* Monday-Friday 10-5 (September-May), Saturdays 12-5; closed one hour earlier June-July; Closed August *Admission:* free

The Museum of Contemporary Photography was founded in 1984 by Columbia College, with which it shares its ground and mezzanine floors. The museum was an outgrowth of the Chicago Center for Contemporary Photography, established in 1976 to exhibit, collect and promote contemporary photography. The museum's exclusive commitment to photography is unique in the Midwest. Begun as a visual resource and study center for students of Columbia College, the museum takes its educational mandate very broadly. Diverse exhibitions, all open to the public, aim to recognize photography's many roles and uses—as a medium for communication and artistic expression, a document of life and environment, a commercial industry, a tool of science and technology.

The permanent collection of the museum focuses on American photography since Robert Frank's seminal 1959 work, *The Americans.* Earlier works are maintained in the collection if they support work by photographers already represented, or if they contribute to teaching programs at the college.

The museum also has an active special exhibits program, often tied to lecture programs and interpretive catalogues. Such exhibits have included "Explorations," in which a half-dozen photographers altered their photos in various ways—painting them, incorporating them into sculpture and collage, lacing them with neon, and transforming them with computer imagery. "Public/Private" presented the work of commercial photographers, juxtaposing personal and commercial work. Other titles: "25 Years of Space Photography;" "Trains, Planes and Automobiles;" "The Eternal Body;" and "Robert Frank: The Americans."

The museum fosters research and appreciation of contemporary photography by making the photographs in the the the permanent collection and its Print Study Room accessible to the public through exhibitions, publications and first-hand contact. Orientation sessions on the use of the museum facilities and programs are available to visitors. Appointments are recommended.

THE MUSEUM OF SCIENCE AND INDUSTRY

Lake Shore Drive and 57th St., Chicago, IL 60637

Phone: 684-1414 *Hours:* 9:30-5:30 daily through Labor Day; 9:30-4 Monday-Friday, 9:30-5:30 Saturdays, Sundays and holidays after Labor Day *Admission:* free

Housed in an historic structure built for the Columbian Exposition of 1893, Chicago's Museum of Science and Industry offers a vast collection of contemporary exhibits representing the most significant scientific and industrial achievements of our age.

There's intriguing room for the arts in this rich mix. As Chicago's number-one tourist attraction, the museum is best known for old favorites like the coal mine, the U-505 submarine, and the recently renovated 16-foot heart. But there's much more. The ArtScience exhibit displays artworks born out of advanced technologies, such as lasers, holographs and video computers, as realized by such artists as M. C. Escher, Alexander Calder, Feliciano Bejar—and the General Motors Research Laboratory Physics Department. In the Henry Crown Space Center—added to the museum in 1986—museum-goers can see the actual Apollo 8 and Mercury space capsules, as well as equipment used to train astronauts for moon landings. Shows at the Omnimax Theater, featuring a domed screen, are presented daily, and these panoramas of the natural world can be as beautiful as they are spectacular.

Since its opening in 1933, the museum has attracted more than 130 million visitors from around the world. More than 2,000 exhibits are contained in 75 major

Bruce Davidson, *From East 100th St.*, 11x14, silver gelatin print, 1970. Courtesy: Museum of Contemporary Photography

Anne Noggle, *Reminiscence: Portrait with My Sister*, 14x17, silver gelatin print, 1980. Courtesy: The Museum of Contemporary Photography

exhibit halls spread over 14 acres of space. Exhibit topics include computers, communications, electricity, nuclear energy, automobiles, photography, chemicals, physics, natural gas, money and banking, agriculture and much more.

There are many temporary displays as well, many of an artistic bent. "The Well-Built Elephant" was a photographic exhibit of pop architecture, featuring structures built in the shape of an apple, a wicker basket, a cowboy hat, and of course an elephant. The annual "IR-100" exhibition displays the top 100 technical products and processes of the year. Other titles: "Photojournalism in America;" "Black Creativity;" and of course the annual "Christmas Around the World" festival with its famous collection of national Christmas trees and associated delights. Although the museum offers a serious look at scientific developments, displays are entertaining as well as enlightening. Most are three-dimensional and feature interactive devices including cranks to turn, buttons to push, films and recorded messages.

THE MUSEUM OF THE FINE ARTS RESEARCH AND HOLOGRAPHIC CENTER
1134 W. Washington Boulevard, Chicago, IL 60607
Phone: 226-1007 *Hours:* Wednesday-Sunday 12:30-5 *Admission:* $2.50, $3.50 assisted; group discounts and special days and times available

The Fine Arts Research and Holographic Center was founded in 1976 to display holography in the museum and to encourage its advancement through teaching and research facilities founded at the same time. This broad commitment makes the Center the world's most complete institution devoted to holography.

Holography in its simplest terms is a representation of an object in all its dimensions, with unprecedented exactness. The idea is barely 30 years old, and its realization only dates from the early 1960s, when workable lasers were developed. In the short time since, holography's scientific and commercial applications have scarcely been addressed, but artists have already used holographic processes to create objects of extraordinary beauty and power. The Holographic Museum contains 10,000 feet of exhibition space. It features special exhibitions and maintains a permanent display of holograms for public viewing, many of them of historic importance, including works by American holographers, European and Asian works, and some produced by the Center's own laboratories.

The museum conducts a regular series of workshops and lectures, as well as curating traveling exhibitions that criss-cross the city and the world. More than 600 students have studied in the associated holographic school, and alumni often give museum lectures and public demonstrations. The research branch of the center has done pioneering work in large-format and full-color holography and is doing seminal work in holographic animation. Their computer-generated animations can now be transferred into three-dimensional holograms, and this work has brought them into collaboration with the makers of such special-effects movie masterpieces as "Star Wars" and "Tron." They do rather more dignified research with and for many other institutions, among them Digital Effects, the Museum of Science and Industry, and IBM.

Special exhibits have included "Equus Under Water," a scheme for theatrical staging using 3-D holograms; "Stations of the Cross," a display of the traditional church symbols done in holography for Coventry Cathedral in England; and "Holography and Animation," which sums up the exciting work that makes computer imagery three-dimensional. The main gallery exhibit completely changes every four months to make room for the constant innovations in this emerging and exciting field.

THE ORIENTAL INSTITUTE MUSEUM OF THE UNIVERSITY OF CHICAGO
1155 E. 58th St., Chicago, IL 60637
Phone: 702-9521 *Hours:* Tuesday-Saturday: 10-4; Sunday: 12-4 Closed holidays *Admission:* free

The Oriental Institute Museum of the University of Chicago is in a sense a vast archaeological theater, providing the staff with a stage on which man tells his own story through an incredible array of artifacts dating from prehistoric to Islamic times.

The Institute's staff used the talents of historians, archaeologists, linguists, and many other specialists to unearth, record and analyze the mass of materials gathered from more than 20 archaeological expeditions sent to Near Eastern sites of ancient civilizations in such countries as Egypt, Iraq, Tunisia, Libya, Israel, Saudi Arabia, North Yemen and Turkey.

The story is told through the civilizations that flowered in five distinct areas: (1) Egypt, (2) Mesopotamia, (3) Anatolia-Syria, (4) Iran, and (5) Palestine.

In the Egyptian Hall, the story of the Nile Valley unfolds through the largest collection in the institute; it is the tale of a stable and rather practical culture that believed that the pleasures of this life could be enjoyed in the next. Pottery, stoneware, statuettes, tools (stone and metal), amulets, games, a schoolboy's writing board, an ostrich egg, and linens were recovered from the "diggings." A massive statue of King Tut dominates the exhibit, seeming to symbolize the important role played by the pharaohs.

At the end of the Egyptian Hall stands the magnificent Assyrian Winged Bull, a formidable work some 16 feet high, weighing 40,000 pounds, which guarded the entrance to the palace of King Sargon II, who ruled this area and compelled conquered cities to pay tribute.

The story of Mesopotamia covers a period from 5500 B.C. to 227 A.D. This gallery tells the story of this immense area through displays that dramatically show how various city-states – Babylonia, Ninevah, Ur and Persepolis – handled such universal problems as gathering food, building shelter, worshipping their gods and conducting commerce. With the imaginative use of photomurals, dioramas and descriptive texts, the staff provides an intense experience to scholar and layperson alike. One of the most revealing displays consists of the 200 cylinder seals that were used to identify legal documents and other items of importance. Their importance and beauty become apparent when one realizes how few people of that day and place could read.

Central to the Palestinian gallery is Megiddon – better known by its biblical name, Armageddon – which is an ancient region rich in history and tradition. Numerous civilizations succeeded one another very quickly as various peoples struggled to control this key region of northern Palestine, located at the crossroads of trade routes to Galilee, Jerusalem and Egypt.

Research, the all-important, silent partner of the institute, continues with much the same intensity that the founder, James Hall Breasted, inspired. Today more than 50 scholars are actively involved in various research projects. An Assyrian and Hittite dictionary soon will be published. The Epigraphic Survey continues to make

Christina Ramberg, *Wrapped Ticklers*, 19x45 acrylic on masonite. Courtesy: The Renaissance Society at The University of Chicago

Samuel F.B. Morse, *Gallery of the Louvre*, 74x108 oil on canvas, 1831-33. Courtesy: Daniel J. Terra Collection

THE PEACE MUSEUM – DAVID AND ALFRED SMART GALLERY

facsimiles of inscriptions on monuments in Egypt. Teacher kits are available to encourage schools to pay a visit to the museum as part of their curriculum. Guides and special lectures are available.

THE PEACE MUSEUM
430 W. Erie, Chicago, IL 60610

Phone: 440-1860 *Hours:* Tuesday-Sunday 12-5, Thursday 12-8 *Admission:* $2.00, students and seniors $.50; Closed Monday

The only museum of its kind in the nation, The Peace Museum provides peace education through the arts and humanities, presenting exhibitions and programs on issues related to war and peace.

The museum generally presents four major exhibitions each year, which completely change every three months. In addition to these temporary shows, the Peace Museum maintains a permanent collection that includes items ranging from nineteenth-century antiwar prints by Honore Daumier to John Lennon's guitar – one of several gifts from Yoko Ono.

Since its opening in 1981, the Peace Museum has built a large local following as well as a national reputation for excellence. It has developed more than 25 exhibitions on topics ranging from the life of Dr. Martin Luther King, Jr. to the role of popular music in efforts for social change to the effects of war toys on children, always with a strong arts emphasis. Many of these exhibits have been seen in cities around the world through the museum's Traveling Exhibits Program. In the first few years of the program its exhibits were seen in more than 80 cities.

Among the recent and traveling exhibits: "The Unforgettable Fire: Drawings by Hiroshima Survivors"; "Gimme Shelter," winning drawings from a satirical bomb shelter design competition; "John Heartfield: Photomontages of the Nazi Era," that featured the prominent German satirist's pioneering photomontage work; and "Play Fair," a hands-on, interactive exhibit for children on cooperation, communication and peacemaking.

THE RENAISSANCE SOCIETY AT THE UNIVERSITY OF CHICAGO
Cobb Hall, Rom 418, 5811 S. Ellis Avenue, Chicago, IL 60637

Phone: 702-8670 *Hours:* Tuesday-Friday: 10-4; Saturday and Sunday: 12-4 Closed Monday *Admission:* free

For 73 years, The Renaissance Society in the Bergman Gallery of Cobb Hall has been devoted to discovering and displaying the most innovative contemporary art. In the 1930s, 1940s and 1950s, the Society was among the first American museums to show such artists as Paul Klee, Ludwig Mies van der Rohe, Fernand Leger, Isamu Noguchi and Moholy Nagy.

Recent shows have included Mike Kelley, whose artworks exaggerate and challenge American society's contradictory traditions of "value," especially as they weigh upon childhood and religion. An exhibition of Irish artist James Coleman in 1985 questioned notions of the artist as author and creator. Coleman's elusive films, slide projections and mesmerizing videos engulfed the viewer in spiraling, cryptic narratives.

"Whitewalls: Words as Images" was a collaboration between The Renaissance Society and "Whitewalls," a publication of artists' writings that featured contemporary artists who juxtaposed language with images of their work. In a similar vein, "CalArts, Skeptical Belief(s)" presented more than 50 graduates of the conceptually stringent California Institute of the Arts,

many of whom use media tools and tactics to challenge the systematic and institutional consumption of Art.

A Jean-Luc Godard film festival provided a quite extensive look at the early works of this film director whose works have been compared to Eisenstein's.

The Renaissance Society offers five exhibitions a year from October through June. It also focuses on the work of Chicago and Midwestern artists such as Very Klement, Phyllis Bramson, Christina Ramberg and Hirsch Perlman. Past one-person exhibitions include a retrospective of the paintings of Ed Paschke and the drawings of Eva Hesse.

Each year the Society co-sponsors "Performance Chicago" with the State of Illinois Gallery and Uptown Hull House, a multi-evening performance event featuring performance artists from both the local and national scene. Each fall the Society organizes a lecture series that addresses current issues in contemporary art. It also publishes seminal catalogs on its exhibiting artists, often the first such critical examinations of the artists' career and work.

THE DAVID AND ALFRED SMART GALLERY
5550 S. Greenwood Ave., Chicago, IL 60637

Phone: 702-0200 *Hours:* Tuesday, Wednesday, Friday and Saturday: 10-4; Thursday 10-7:45; Sunday 10-4; Closed Mondays and holidays *Admission:* free

The David and Alfred Smart Gallery is the fine arts museum of the University of Chicago, with displays from the university's own extensive collections and many traveling and curated exhibits as well. Designed by distinguished museum architect Edward Larrabee Barnes and opened in 1974, the museum is part of an architectural ensemble which also includes the university's Department of Art, an enclosed sculpture garden, and professional theater complex.

The Smart Gallery's permanent collection of 7,000 works spans nearly a century of artistic and scholarly activity at the university. Classical ceramics and statuary, early Christian and Byzantine artifacts, and drawings and prints from the sixteenth to nineteenth century have long distinguished the university's holdings. Since the founding of the Smart Gallery, its holdings have greatly expanded. Gifts have included distinguished paintings, sculptures and objects d'arts from the medieval, Renaissance and early baroque periods, and more contemporary drawings and sculptures by such masters as Matisse, Rodin, Degas and Moore. Recently, a university professor gave the gallery his major collection of ancient Chinese ritual bronze vessels, with related bronze-age implements. The collection also includes such American classics as Andy Warhol's series on Chairman Mao, Chuck Close's portrait of John, and wrought-iron doors designed by Louis Sullivan.

Roughly half of the gallery's major paintings and sculptures are on view at any one time, along with selections of decorative arts – for example its important collection of Frank Lloyd Wright furniture.

The Smart Gallery presents four special exhibitions each year in addition to smaller rotating displays. Often drawing on the skills and interests of university faculty and graduate students, these major exhibitions have included "The Documentary Photograph as a Work of Art: 1860-1876," "German and Austrian Painting of the Eighteenth Century," and the retrospective "Jean Dubuffet: Forty Years of His Art." The gallery also hosts traveling exhibits, which are often of particular interest to the artists, scholars and diverse ethnic communities of Chicago. Among the most memorable of these have

Exhibit Hall, Fourth Floor, The Chicago Public Library Cultural Center

Terra Museum of American Art, *Interior*. Photograph: Wayne Cable Studios.

been "Art of the Insane: Selected Works from the Prinzhorn Collection," "Russia, The Land, The People," and "Tradition and Conflict," a survey of Black American art from the 1960s.

The gallery often presents symposia, panel discussions and lecture series in conjunction with its special exhibitions. Gallery talks about exhibitions are also open and free to the public.

SPERTUS MUSEUM OF JUDAICA
618 S. Michigan Ave., Chicago, IL 60605

Phone: 922-9012 *Hours:* Monday-Thursday and Sunday 10-5, Friday 10-3, closed Saturday *Admission:* General public, $3.50; seniors, $2; students and children, $2

This interesting and sensitive museum was founded by Maurice Spertus, a trustee of the Spertus College of Judaica. It is the most comprehensive Jewish museum in the Midwest, housing an excellent permanent collection while offering special exhibitions on many themes related to Jewish art and life.

The permanent collection includes 3,000 works that span 3,500 years of Jewish migration and settlement, including ceremonial objects and textiles, costumes, jewelry, coins and artifacts, and paintings, sculpture and graphics in rotating display. The Bernard and Rochelle Zell Holocaust Memorial features six tall pillars inscribed with the names of Holocaust victims who were relatives and friends of Chicagoans. Under soft light, a collection of evocative photographs and artifacts are displayed. The theme of the exhibit is "the plight of the individual striving to maintain a sense of human dignity in the face of overwhelming adversity."

The main gallery features ancient and medieval art objects of religious and educational as well as artistic interest, which are used to exhibit the history and culture of Jews through the ages.

The new Field Gallery of Contemporary Art is an open-minded, open space in which artists consider the modern Jewish experience, and much more besides, in changing displays.

The museum's new Artifact Center is a place where children can dig into the past through games, activities and displays about biblical archaeology. Children under six have their own Israelite House, complete with a junior dig and an overstuffed camel in the courtyard. Special programs abound. In addition to guided tours, there are study workshops, lectures, and holiday and exhibition celebrations. Special exhibitions have included "Paintings for the Mouton Rothschild Labels," "Ten Prominent Jews of the Twentieth Century by Andy Warhol," "Anne Frank in the World: 1929- 1945," "Play it Again, Solomon," and "The Jews of Ethiopia."

THE STATE OF ILLINOIS ART GALLERY
State of Illinois Center, Second Floor, 100 W. Randolph, Chicago, IL 60601

Phone: 917-5322 *Hours:* 10-6 Monday-Friday; Illinois Artisans Shop (next door) 917-5321 *Hours* 9-5 Monday-Friday Both closed weekends *Admission:* free

The State of Illinois Art Gallery is located in the monumental new State of Illinois Center, designed by Chicago's world-class wunderkind Helmut Jahn. Just what – or who – he's built this monument *to* is a subject of lively discussion in the striking, airy atrium. Just outside stands Jean Dubuffet's sculpture "Monument with Standing Beast"; on the top floor is the governor's office. On the mezzanine is Chicago's only gallery dedicated to exhibiting the finest Illinois art, both past and present, with the purpose of promoting awareness of the variety of art found and made in Illinois. Exhibits change regularly, and include a wide variety of art media – painting, sculpture, drawing, printmaking, video, ceramics, photography, textiles and more. Both historic and contemporary Illinois art are featured.

Exhibits are produced by the Illinois State Museum and the Illinois Arts Council. Recent exhibits include "LIARS: A Question of Reason," which examined the role of art as commodity; "Upon a Quiet Landscape: The Photographs of Frank Sadorus, 1908-1912"; and decorative works by Frank Lloyd Wright. The gallery sponsors frequent lectures and programs as well.

Just down the mezzanine from the gallery is the retail Illinois Artisans Shop, which features Illinois art for sale in its many guises. Contemporary, traditional, folk and ethnic works by more than 400 Illinois artists and craftspeople are on display. All are selected by a jury of art experts and richly represent the diversity and vitality of our state's folk roots. In addition to traditional prairie crafts on display – quilts, baskets, carved decoys and more – newer cultural arrivals also are welcome – Japanese and igami embroidery, Polish paper cutting, and Latvian jewelry, for example. Visitors are encouraged to browse and are free to closely examine all works on display.

As an exercise in economic development as well as cultural display, the Artisans Shop often forwards commission requests to artists, typically for works on a larger scale than can be displayed in the crowded shop. The shop sponsors a lively program of monthly craft demonstrations on the concourse level of the State of Illinois Center, on such topics as "Spring Jewelry" and "Folk and Ethnic Weaving," and has monthly featured artists of special interest – recently "Skeleton Quilt" and "Mythic Masks" were featured together for Halloween.

THE TERRA MUSEUM OF AMERICAN ART
664 N. Michigan Ave, Chicago, IL 60611

Phone: 664-3939 *Hours:* Wednesday-Saturday 10-5, Tuesday 12-8, Sunday 12-5 *Admission:* $4.00, $2.50 seniors and students, children under 12 free

Daniel J. Terra, founder and chairman of the Terra Museum and a Chicago printing executive, has amassed one of the country's pre-eminent collections of American art from the seventeenth to the twentieth century, more than 500 fine examples so far. In 1981, having just opened an intimate and delightful Evanston museum in which to display his collection, Terra was appointed Ambassador at Large for Cultural Affairs by President Reagan. In 1987, his Evanston museum, much expanded both in size and in mission, moved to award-winning new quarters on North Michigan Avenue.

For a time the museum was given over to large and prestigious traveling exhibitions such as "An American Vision: Three Generations of Wyeth Art," which showcased that famous painting dynasty, and "In Nature's Ways: American Landscape Painting of the Late Nineteenth Century"; there were locally curated shows as well. These temporary exhibits were permitted to entirely crowd out Terra's own collection. Luckily, protests were fast and firm – a sampling of Terra's delightful holdings are now on permanent display.

His most famous piece is Samuel F.B. Morse's *Gallery of the Louvre,* which presented Civilization's Greatest Hits to 1830s America. Other highlights include George Bingham's *Jolly Flatboatman* and a spectacular concentration of American Impressionist painting. Other artists include Whistler, O'Keeffe, Sargent, Cassat, Wyeth, Stella, and of course hundreds more.

UKRAINIAN INSTITUTE OF MODERN ART

Traveling and curated shows will continue to play an important role for the museum, which also presents public lectures, workshops, symposia and gallery tours as well as publications. A staff of more than 60 volunteer docents is trained to accompany visitors through the exhibits as requested. And highlighted each month is a Collection Cameo – one piece from the permanent collection that is featured and accompanied by a one-page information guide. All in all, North Michigan Avenue will never be the same.

UKRAINIAN INSTITUTE OF MODERN ART

2320 W. Chicago, Chicago, IL 60622

Phone: 227-5522 *Hours:* Tuesday-Thursday 12-4 Closed Mondays *Admission:* free

This small neighborhood museum specializes in the work of contemporary Ukrainian artists. It is located in an attractive storefront space that was renovated by architect Stanley Tigerman. Founded in 1971 by Dr. and Mrs. Achilles Chreptowsky, over the years the institute has broadened its scope to include exhibitions by non-Ukrainian artists as well.

The institute mounts four special exhibitions annually, in a wide variety of media and subject matter, for example "Spiritual Aspects of Contemporary Ukrainian Art: Commemorating the Millennium of Christianity in Ukraine"; "The Element of Land" from Winnepeg, Canada; and "Nine from Newcastle" in northern England, as well as many exhibitions of individual artists.

The permanent collection consists of contemporary abstract paintings and sculpture by Alexander Hunenko, Peter Kolisnyk, Konstantin Milonadis, Mykhojlo Urban, Jurij Strutynsky, Lesia Borniak and others.

Under the direction of Oleh Kowerko, the Ukrainian Institute serves as both a museum and cultural center. It sponsors various concerts, poetry readings and other art-related activities.

[001] AES FINE ART GALLERIES

2352 N. Clybourn Ave., Chicago, IL 60614

Phone: (312) 281-0002 *Hours:* Tues-Fri: 11-5, Sat: 12-4
Owner/Dir: Susan Pertl and Cheryl Pertl

Contemporary painters and sculptors working primarily in abstract modes can be found at this gallery. Of the local and national artists represented, the work of sculptor Robert Winslow is featured. Working primarily in granite and marble, Winslow's organic abstractions are frequently site-specific, such as *Altered Planes*, which clings to the ground in which it is laid. The light and kinetic paintings of Steve Waldeck are also available.

[002] ARC GALLERY

1040 W. Huron St., Chicago, IL 60622

Phone: (312) 733-2787 *Hours:* Tues-Sat: 11-5; August: closed *Dir:* Fern Samuels

ARC (Artists, Residents of Chicago) was established in 1973 as an artist-run alternative space for women to show and critique their work and share ideas. Since that time, the gallery has expanded its goals, instituting new programs to embrace the community at large. Recently relocating to its current Huron Street address, ARC holds monthly exhibitions of work by members, as well as providing "raw space" for temporary experimental and site- specific installations by members and non-members alike. Artists' proposals for the raw space are reviewed annually.

Lectures and discussions of art-related issues are sponsored by the ARC Educational Foundation; the 1989 series is entitled "Informal Dialogues with Chicago Art Writers" and will include speakers such as Alan Artner, Colin Westerbeck and James Yood. Additionally, ARC features programs of performance art and new music. Most, though not all, of the artists work in nontraditional modes. Cyrilla Power's recent series of figurative wooden constructions, "Flying Women," and Beth Turk's room-sized installation, "Spider Art," consisting of a large spider within a wooden web, are among the works recently exhibited at the gallery. Other members include painters Janet Pines Bender, Mildred Lachman, Beverly Kedzior, Fern Samuels, Charlotte Segal and Laurie Wohl, who work abstractly, and Frances Cox, Sheila Finnigan, Suzanne Flemens, Joan Lyon, Sue Mart, Maureen Miller, and Estelle Richman, who work figuratively. Sculptors include ceramist Karen Ami, Marilyn Schulenburg, and Dorothy Vagnieres. Papermaker Gayle Fitzpatrick and photographers Caroline Ausman, Marilyn Weitzman and Jane Stevens are also represented.

ARC is funded by the Illinois Arts Council and the National Endowment for the Arts.

[003] AD-INFINITUM

2736 N. Lincoln Ave., Chicago, IL 60614

Phone: (312) 281-2659 Wed-Sun: 11-6:30 or by appointment. *Owner/Dir:* Eduardo Soler, Dori Soler

A microcosm of the Philippines can be found in this intimate gallery, which carries primitive and contemporary Philippine art and artifacts. Paintings done by contemporary Philippine artists include the expressionistic oils and constructions in antique wood of Angelito Antonio and the tropically colored figurative works of Norma Belleza. Istella Bonoan's medium-scale expressionist paintings are also represented.

Among the museum-quality ethnographic arts are ceremonial containers, religious icons such as granary gods, handwoven fabric of the Isneg tribe, and jewelry composed of glass beads, silver, mother of pearl, jade, and copper from the northern Ifugao and southern Mandaya peoples.

[004] AIKO'S

3347 N. Clark St., Chicago, IL 60657

Phone: (312) 943-0745 *Hours:* Tues-Sat: 10-5 *Owner:* Aiko Nakane *Dir:* Chuck Izui

A fixture in Chicago for more than thirty years, Aiko's is one of the few places in the Midwest specializing in contemporary Japanese prints, authenticated reproductions of old Japanese prints, and Japanese folk pottery. Ryohei Tanaka's etchings of traditional country landscapes, Hiroyuki Tajima's abstract woodblock prints, and the calligraphic abstractions of printmaker Rikio Takahashi are among the works of contemporary artists to be found at Aiko's. Serigraphs based on festival themes are done by Masaaki Tanaka, more traditional landscapes are done by Toshi Yoshida and Teruko Mogi, and prints on Biblical themes are made by the reknowned stencil dye printer Sadao Watanabe.

Recently moving to its spacious Clark Street address, Aiko's has expanded both its exhibition space and its Oriental paper and supply store, adjacent to the gallery. Materials available include handmade paper and Japanese art supplies such as sumi brushes, inks in different forms, and fabric dyes from Japan, as well as decorated paper from Japan, Italy, Sweden, France, Korea, Mexico, and China. There is a section devoted to bookbinding supplies as well as a book section surveying Oriental arts and papermaking. Much of the business is mail-order.

[005] AMERICAN WEST

2110 N. Halsted St., Chicago, IL 60614

Phone: (312) 871-0040; *Hours:* Tues-Fri: 12-6, Sat: 10-6, Sun: 12-5; *Owner/Dir:* Alan Edison

Showing a broad selection of contemporary art from the American Southwest, the works tend to be primarily paintings and graphics based on Indian and landscape themes.

Tony Abayta's paintings of *Kachina,* or *Indian Spirits,* are semi-abstract, while David Bradley paints realistic satires of Indian life. R. C. Gorman is noted for his lithographs of Navajo women. Hispanic American Amado Pena's lithographs and acrylic paintings are stylized, imagistic family portraits; Joe Baker creates expressive paintings of dogs and Southwestern images, and Hal and Fran Larsen's pastel watercolors interpret adobe structures and the landscape.

The gallery maintains a large collection of Native American artifacts dating from 1860 to 1900 which include Navajo textiles, Plains Indian beadwork, pottery, and baskets. Contemporary work in three dimensions includes Santa Fe folk art sculpture and wood masks of the Northwest Coast.

[006] W. GRAHAM ARADER III GALLERY

620 N. Michigan Ave. Ste. 470, Chicago, IL 60611

Phone: (312) 337-6033; *Hours:* Tue-Sat: 10-6:00 *Dir:* Esther Sparks

With six locations from New York to San Francisco, the Arader Galleries have become the premier dealer in natural history prints, maps, and Americana. The Chicago gallery features antique prints with original handcoloring by such artists as Pierre-Joseph Redoute (known as the "Raphael of Flowers"), *The Temple of Flora* mezzotints of Dr. Robert John Thornton, the seventeenth-century florilegium of Basil Besler, and other important names in the history of botanical illustration. In the field of natural history, birds by John James Audubon and John Gould are the most popular.

There is a fine selection of American material: maps dating from the seventeenth century, a broad selection of Midwestern material, and prints of the Western Expansion by Karl Bodmer and George Catlin. Lithographs by Currier and Ives as well as other nineteenth-century publishers are available, either in Chicago or through the other Arader galleries.

The Director, Esther Sparks (former Acting Curator of Prints and Drawings at the Art Institute), has started a department of American master print in Chicago. Classics of American printmaking such as Grant Wood and Thomas Hart Benton can be found, as well as more modest prints for the beginning collector. Ms. Sparks, an authority on Illinois artists, always has an interesting selection of Chicago artists, especially those working from the 1920s to the 1950s.

[007] ARTEMISIA GALLERY

700 N. Carpenter, Chicago, IL 60622

Phone: (312) 751-2016; *Hours:* Tues-Sat: 11-5; Aug: closed; *Dir:* Fern Shaffer

Celebrating its fifteen-year anniversary in 1988, Artemisia is a women's cooperative gallery and an educational organization. Its principal ambition is to promote public awareness of women artists. Aside from regular exhibitions of the work of its sixteen members, the gallery mounts special theme, group, and invitational shows. Funded by grants, Artemisia makes a special point of providing low-cost space for emerging artists, three or four of whom are selected by a review committee for monthly exhibits.

The members' work is diverse. Iris Adler creates tabletop kinetic sculptures that use light and sound in representations of biblical and mythological themes tinged with macabre humor. Also dealing with biblical and political themes are the large impastoed wooden wall pieces of Christine O'Connor. Joan Livingstone's matte, coffin-like sculptures are made of felt and mixed media, while Carol Block makes painted constructions of flowers.

Figurative artists include painters Susan Bloch, Diane Levesque, Margaret Lass- Gardiner and Maureen Warren, sculptor Nancy Plotkin, and photographer Melissa Pinney. Abstractions ranging from the expressionistic to the minimal are done by MiSook Ahn, Marlene Bauer, Sidney O. Burroughs, Lorri Gunn, Fern Shaffer, Jill Ziccardi and Patty Castner.

[008] ARTIFACTS

1105 Central, Wilmette, IL 60091

Phone: (312) 251-7707 *Hours:* Tues-Sat: 10-5; *Owner/Dir:* Joyce Lyn Merchant, Charles Kroon

Hand-crafted one-of-a-kind and designer jewelry from artists across the country is the focus of this gallery. The original wearable art ranges from the sterling and gold earrings derived from casts of various grasses to natural forms done by Pennsylvania artists Barbara Mail and Rod McCormick to the funky animals and new wave populace of the colored Lucite pieces by New York artist Jane Carpenter. Other works include the geometric rings of Lee Marraccini and the sterling, gold-fill, and patinated copper pieces based on ginko leaves by Joyce Lyn.

[009] ARTPHASE I

859 W. Armitage, Chicago, IL 60614

Phone: (312) 348-3500 *Hours:* Tues-Fri: 12-7, Sat: 11-5, Sun: 12-5; *Owner/Dir:* Adele Wangler and Elizabeth Wangler

Specializing in contemporary American art by living artists, the exhibitions at Artphase I change monthly and include paintings, drawings, prints, sculpture, ceramics, and jewelry. The gallery does not focus on a permanent stable of artists, preferring a more flexible inventory.

Artphase I serves private collectors, corporations, designers, and architects. Consulting services are available and a large slide registry is maintained for clients.

[010] JACQUES BARUCH GALLERY, LTD.

40 E. Delaware Pl., Penthouse B, Chicago, IL 60611

Phone: (312) 944-3377; *Hours:* Tue-Sat: 10-5:30 *Dir:* Anne Baruch

Located in a penthouse near Michigan Avenue, the Baruch Gallery has established a reputation for more than twenty-two years as the place to see exceptional art from Eastern Europe. Anne Baruch has introduced artists from Poland, Czechoslovakia, Hungary, and Yugoslavia to Chicago. Styles and expressions in prints, drawings, tapestries, photographs, paintings, and sculpture vary greatly among the countries, but the quality, strength, and technical perfection of the works have brought these artists international recognition. Since 1972 the gallery has been known for its outstanding fiber art exhibitions featuring renowned artists from the United States and Europe.

Among the notable artists presented are Czech painters and graphic artists Jiri Anderle and Jiri Balcar. Anderle's work, unlike the graphic, visually organized work of Balcar, features intuitively painted figures. While Balcar's pieces derive their potency from a stark comic irony and social commentary, Anderle's work, with its decapitated and distorted figures, makes a visceral impact. The wood and iron sculpture of Czech Ales Vesely, in its material and handling, suggests medieval ornamentation, while in its content, coiled spikes, handles, levers, and bolts suggests the devastation of modern war. The gallery represents many other skilled artists working in fiber, photography, sculpture, and painting. Loan exhibitions to museums, universities, and other institutions are circulated throughout

the United States and abroad.

[011] BEACON STREET GALLERY & PERFORMANCE COMPANY

4520 N. Beacon St., Chicago, IL 60640

Phone: (312) 561-3500; *Hours:* Wed-Sat: 12-6; *Dir:* Pat Murphy

This community-based, not-for-profit artspace is located in the Uptown neighborhood and is affiliated with the Hull House Association. Folk and contemporary art of local and international artists is selected to address the diverse backgrounds and heritages of Uptown, ranging from Afro-American, Latin American, and Asian to Appalachian and American Indian. Free classes for children are offered in drawing, painting, photography, and dance. Exhibitions change every two months.

Recent shows have featured Ethiopian weavings, Laotian crafts and dance, Chinese peasant paintings, and contemporary textiles done by Laotian, Mung, American Indian, Appalachian, and Polish artisans. Artists in residence include Catherine Hemmingway-Jones, who works with installation and performance, and Anita Stickley, whose work addresses the historical and feminist context of contemporary painting and sculpture.

The performance company includes a resident playwright and choreographer. Its multidisclipinary offerings include poetry, visual art, musical installations, and Sunday programs featuring talks with various artists.

[012] MARY BELL GALLERIES

215 W. Superior St., Chicago, IL 60610

Phone: (312) 642-0202 *Hours:* Mon-Fri 9-5; Sat 11-5 *Owner/Dir:* Mary Bell

Mary Bell Galleries handles paintings, sculpture, wall hangings, prints, and unique paper works by established and upcoming contemporary artists. The gallery specializes in working with corporate clients and also works with private collectors. The works displayed are both abstract and realistic.

Among the artists who create large canvas works are Richard Carter, George KozMon, Mark Dickson, Arlene Harris, Edward Evans, and Larry Thomas. Included among the unique paper works are folded monoprints by Esther Brenner- Pullman, paper constructions by Alice Welton, large-scale pastel landscapes by David Gibson, and chine colle by Gloria Fischer.

The gallery also handles bronze sculpture by James Knowles, Dennis Westwood, and Yvonne Tofthagen.

[013] CAIN GALLERY

1016 North Blvd., Oak Park, IL 60301

Phone: (312) 383-9393 *Hours:* Mon-Sat:12-5, Mon & Thur: 7-9 *Owner/Dir:* John & Priscilla Cain

This comfortable gallery has for the past fifteen years offered a variety of original art for traditional and contemporary tastes. In addition to the five exhibitions scheduled annually, the gallery has on display paintings, sculptural pottery, and blown glass.

Landscapes and seascapes done in an impressionistic style bordering on pointilism are done by William Tacke, while Ric Benda creates abstract expressionistic collages of burned paper, tissue, and paint in brilliant colors. Serigraphs of Colorado landscapes by Ron Hoeksma and intricate intaglio prints of old architecture and automobiles by Bruce McCombs are among the prints featured. Dramatic rough-hewn wooden sculptures of a tribal nature are done by Carla Tye, while her husband, William Tye, makes classical bronze figures.

The gallery has an additional summer location in Saugatauk, Michigan.

[014] CAMPANILE-CAPPONI ART CONSULTANTS

1252 N. State Parkway, Chicago, IL 60611

Phone: (312) 642-3869; *Hours:* by appointment *Owner:* Mrs. E. Campanile *Dir:* Howard Capponi

Campanile-Capponi Art Consultants caters to designers, architects, and corporate collectors, specializing in painting, sculpture, and prints by Chicago and Midwest Regionalist artists.

Because the gallery represents artists practicing a wide variety of styles, "Regionalists," is perhaps the only comprehensive classification. Major artists include Robert Gadomski, Carl Schwartz and other artists such as Joel Smith, who paints in an abstract expressionist mode, as well as sculptors Renee Zelenka, who incorporates large floral motifs into her pieces, Preston Jackson, whose medium is cast bronze, and Leslie Scruggs, working in wood.

The gallery also features a selection of printmakers from around the world, including the sensual, expressive images of Czechoslovakian Dagmar Mezricky and the textural play between color and form seen in the work of Gilberto Lopez Gasca of Mexico. Area printmakers complete the inventory.

[015] CAMPANILE GALLERIES, INC.

200 S. Michigan Ave., Chicago, IL 60604

Phone: (312) 663- 3885; *Hours:* Mon-Fri: 9-5:30, Sat: 9:30- 4; *Owner:* Mrs. G. L. Campanile *Dir:* Howard B. Capponi

Located across the street from the Art Institute for the past twenty-two years, Campanile Galleries offers American paintings from the late eighteenth to the twentieth century, French Impressionist paintings, and one contemporary show a year. The gallery, which also handles drawings and some small sculpture, is beautifully appointed with antique and period furniture and collectibles, some of which are for sale.

Their major exhibition is an annual show of American Impressionists. Included are works by members of *The Ten*, a group of painters, mostly Easterners, who studied in France and brought the *plein air* style back to the United States. These include Maurice Pendergast, John Sloan, George Bellows and F. C. Friefeke. Also shown are works of *The Eight,* or Ashcan School, who employed Impressionist technique in the service of social realism. Works are available by Robert Henri, George Luks and Everett Shinn of the Ashcan School as well as from the estate of James P. Butler, grandson of Claude Monet.

Robert Winslow, *Stone Fabric*, black marble. Courtesy: AES Gallery

Geraldine McCullough, *Cresent Tower*, 108" brass & polyester resin. Photograph: Bob Ebert. Courtesy Isobel Neal Gallery

[016] CENTER FOR CONTEMPORARY ART

325 W. Huron, Suite 208, Chicago, IL 60610

Phone: (312) 944-0094; *Hours:* Tues-Sat: 10-5 or by appointment; *Owner:* Steven Berkowitz *Dir:* Kathy Cottong

The wide range of works by emerging and established artists, both national and international, focusses on drawing and painting with an occasional bow to sculpture, prints, and installations.

Landscape elements juxtaposed in a variety of ways comprise the paintings of Edward Henderson, John Beerman and Matt Brown. Betsy Kaufman paints intimate dislocated maps, Greg Drasler paints everyday objects with a surrealist perspective. Figurative artists include Judie Bamber, who deals with psychoanalysis and repression; Jody Mussoff, whose autobiographical works are done in odd colored pencil; Antonia Contro and Josef Felix Muller. Biomorphic abstractions emerge from the painterly surfaces of Susan Laufer's paintings, while a restrained geometry is characteristic of the abstractions of Donald McLaughlin. Fred Stonehouse's paintings on old encyclopedia pages are influenced by Haitian art. Other painters include Vicki Teague-Cooper, Royce Howes, John Mandel, Wayne Toepp and Rodney White.

Installations by JonMarc Edwards and Michael Hardesty have recently been featured, and sculpture by Steve Currie, Zizi Raymond and Joe Smith is also available. In addition, the gallery carries prints by well-established artists such as Richard Estes, Eric Fischl, Howard Hodgkin, Sean Scully, Jose Maria Sicilia, Wayne Thiebaud and David True.

[017] CHIAROSCURO

750 N. Orleans, Chicago, IL 60610

Phone: (312) 988-9253 *Hours:* Mon-Sat: 10-5:30 *Owner/Dir:* Peggy Wolf, Ronna Isaacs

Affordable art for the beginning collector in virtually every medium may be found in this young River North gallery. Jewelry, furniture, functional objects, wearable accessories, cards, and paper products are available in addition to painting and sculpture.

Mixed-media wall pieces are done by Lousi Recchia, Pam Jacobs, Marilyn Weitzman and Lex Loeb, while paintings in traditional media are available by Zoa Ace, Marguerite Takvorian-Holms, Amanda Watt, Cordula Volkening and Cheryl Gross. Sculptural furniture pieces are created by Jim Rose, Neil Kraus and Muebles de Taos. Old furniture is "recreated" through paint and embellishment by Stephanie Murphy, Nancy Brown, Amy Alter, and Mitchell Gantz.

Ceramic and glass work from the traditional to the whimsical are produced by Sarah Fredericks, Ted Saito, Katie Freedman, Toni and Jay Mann, Nancy Hlavacek, Chris Lazzo, James McKelvey, and Noble Effort, among others.

[018] CHICAGO CENTER FOR THE PRINT/HUNT-WULKOWICZ GRAPHICS

1509-13 W. Fullerton Ave., Chicago, IL 60614

Phone: (312) 477-1585 *Hours:* Tues-Sun: 12-8 *Owner:* Susan Hunt-Wulkowicz & Dennis McWilliams *Dir:* Betty Ann Mocek

Original prints by contemporary artists are the focus of this gallery, including etchings, woodcuts, lithographs, silkscreens, monoprints, engravings, and collagraphs. In addition, the gallery teaches printmaking techniques and offers a browsing library.

More than 175 local, national, and international printmakers are represented, with work ranging from realistic to abstract. One featured artist is Susan Hunt-Wulkowicz, who makes meticulously detailed, hand-colored etchings and lithographs of seasonal country landscapes and interiors. Because of the large numbers of artists represented, the gallery does not have an overall "look," but instead offers something for every taste.

[019] JAN CICERO

221 W. Erie St., Chicago, IL 60610

Phone: (312) 440-1904

Hours: Tue-Sat 11-5 *Owner/Dir:* Jan Cicero

Jan Cicero has been an art dealer for fifteen years. Beginning with just five abstract artists, the gallery today represents about thirty artists, both regionally and nationally known, who work in a wide range of styles from abstract to realist.

Many local and regional artists are exhibited, including Ted Halkin, Robert Skaggs, Debra Yoo, Kathleen King, Bernard Palchick, Joel Jaecks, Bill Kohn, Arthur Lerner, Bonnie Hartenstein, Corey Postiglione, Owen McHugh, Evelyn Statsinger, Connie Cohen, Fern Valfer, Annette Turow, Martin Prekop, and Roxie Tremonto.

Artists from other parts of the country include Budd Hopkins, Frances Barth, Peter Plagena, James Juszczyk, Karen Kunc, Bryan Harrington, Diane Meyer Melton, Carl Schwartz, Ernest Viveiros, Matthew Daub, Linda Bastian, Deborah Brown, and DeAnn Melton.

[020] EVA COHON GALLERY

301 W. Superior St., Chicago, IL 60610

Phone: (312) 664-3669 *Hours:* Tues-Fri: 10:30-5, Sat: 11-5; *Owner:* Eva Cohon; *Dir:* Alison Weirick; *Also:* 2057 Green Bay Rd., Highland Park, IL 60035 *Phone:* (312) 432-7310 *Hours:* Mon-Sat: 10-4; *Dir:* Sheila Klemperer

Contemporary abstract art done by American artists from outside the Chicago area is featured at both locations of the Eva Cohon Gallery. Established in Highland Park in 1976, the Superior Street location was opened in 1987. From its stable of more than fifty artists, including some Europeans, ten solo shows are scheduled annually, featuring painting, sculpture, and works on paper. Exhibitions are split between the two galleries, larger works being featured at the Highland Park location.

Among the artists represented are Hugh O'Donnell, who makes painterly geometric abstractions of emblems and simple shapes on canvas, wood, and paper; Kikuo Saito and Stewart Waltzer, both minimalists who display the influence of Kenneth Noland; South Carolinian Philip Mullen, whose pastel-colored acrylics refer to the landscape; and Kenjito Nanao, who paints small hidden geometric images with a

monochromatic palette. Brightly colored wooden relief sculptures with a tropical flavor are done by Agnes Jacobs.

In addition to works by gallery artists, master prints by artists such as Miro and Calder are also available.

[021] COMPASS ROSE GALLERY
325 W. Huron, Chicago, IL 60610

Phone: (312) 266-0434; *Hours:* Tue-Sat: 10:00-5:30; *Dir:* Deven Golden

Splitting its focus between Chicago and New York, the gallery represents eight Chicago artists and annually hosts ten shows of New York artists. The eight Chicago artists find a range from emerging to well-established in the Chicago area while those from New York are nationally and internationally known.

Best known for her sculpture (she also draws), Chicago's Elizabeth Newman transforms found objects and commonplace materials such as salt and wax. Painter Susan Doremus, also well known in the Chicago area, provides the gallery with abstract paintings noted for their exploration in surface textures. Less well-known is the work of Joan Binkley. Working in delicately layered porcelain, she sculpts pieces that can be worn as well as displayed. Emerging artist Dave Richards is represented with his mixed media constructions. Also new to art acclaim are painters Risa Sekiquchi, creating small figurative paintings, and Stephen E. Williams, working in oil on paper to produce small (either 8-by-10-inch or 10-by-8-inch) abstract works.

Recent exhibitions of the gallery's Chicago core have included the work of Gary Justis. Well known for his monumental pieces in aluminum and semiprecious metals, he has shifted from his early kinetic work to more subtle explorations of movement. The exhibition, "The Causal Garden," he calls a "blending of the mechanical and the organic." Chicago photographer Paul Rosin was also featured in a recent show. Manipulating photographs with various emulsions and hand-painting, he constructs scenarios that range from the erotic to the mythical.

[022] CONTEMPORARY ART WORKSHOP
542 W. Grant Place, Chicago, IL 60614

Phone: (312) 525-9624 *Hours:* Mon-Fri 9:30-5:30; Sat 12-5 Nonprofit *Dir:* Lynn Kearney

Contemporary Art Workshop was the first artist-created, artist-run alternative gallery in the country. Founded in 1950 by artists John Kearney, Leon Golub, Cosmo Campoli, Ray Fink, and Al Kwitz, the workshop has hosted shows of such Chicago artists as June Leaf, Leon Golub, Seymour Rosofsky, Emerson Woelffer, and Robert MacCauley.

The spacious remodeled dairy where the Contemporary Art Workshop has been housed since 1960 offers studio, class, and gallery space on three floors. The workshop seeks out the best young Chicago and Midwestern artists to give them a forum for new visual concepts. The workshop also bridges the gap between art school and the world of the professional artists by offering advice and guidance in the practical aspects of a professional career.

Artists recently exhibited at the workshop include John Kearney, Tony Vevers, B. Suarez, Joe Houston, Didier Nolet, Paula Pia Martinez, Michele Hemsoth, Tim Lowly, Lewis Toby, Nicholas Blosser, Arnaldo Roche Rabel, Tom Walsh, Peter Roos, Tom Gengler, Bruce Riley, Scott Sandusky, Matt Williams, Leo Fuentes, Roger Columbik, Mary Lou Zelasny, Dennis Angel, Terry Killips, and Gonzalo Jesse Sadia. Hundreds of emerging artists have exhibited here.

[023] CORPORATE ART SOURCE, INC.
900 N. Franklin St., Chicago, IL 60610

Phone: (312) 751-1300 *Hours:* Mon-Fri: 9:30-5 *Owner/Dir:* Kathleen Bernhardt

The focus of this gallery is on painting, sculpture, fiber and paper art forms by contemporary artists, as well as a wide variety of contemporary prints.

Among the works are the abstracted landscapes of John Gary Brown. Drawn from his travels in Europe and America, Brown's paintings create a spiritual, monumental world of placidity and timelessness. Also available are works by sculptor Jean-Jacques Porret and painter Stan Weiderspan.

[024] CRANE GALLERY
1040 W. Huron St., Chicago, IL 60622

Phone: (312) 243-1171; *Hours:* Tues-Sat: 11-5, Fri: 11-8 *Dir:* Donna Sue van Cleaf, Saher Saman

An alternative, private gallery, Crane debuted in 1988 and is searching for an identity. Its large space houses bi-weekly performances as well as exhibitions ranging from the conceptual to the traditional by emerging international artists. Preferring to remain flexible, the gallery maintains no stable of permanent artists and instead features monthly group shows, frequently centered around a theme.

Recent shows include "Image Retrieved," featuring the commodity-oriented multiples and paintings of Panayotis and Saher Saman as well as the paintings of Graham Stewart, which address contemporary social issues through architectural imagery. Also exhibited recently were the mixed-media lithographs and pastels of Obaji Nyambi, the large-scale photographs of Kathy Pilat, the interactive videos of Wayne Fielding, kinetic installations by Alphons Koller and the mixed-media sculpture of Phil Rosenbloom, which combines popular images with materials such as wood and wax.

[025] DART GALLERY
750 N. Orleans Ct., Suite 303, Chicago, IL 60610

Phone: (312) 787-6366 *Hours:* Tue-Fri 10-5:30; Sat 11-5:30 *Dir:* Andree Stone

Since 1975 Dart Gallery has exhibited contemporary art in all media by established and emerging artists from the United States and Europe, presenting a broad spectrum of art works including representational, abstract, and conceptual styles. Important figurative artists from the Chicago area include Nicholas Africano, Hollis Sigler, Phyllis Bramson, and Robert Lostutter. Young artists from the area (such as Jim Lutes, Donald McFayden, and David Snyder) whose works involve psychological narrative, are also shown. More conceptually based sculptors from the region associated with Dart are Frances Whitehead, Greg Green, and Don Harvey. Besides introducing new ar-

tists, the gallery shows many artists who have been recognized for their contributions to contemporary American art. These include Joe Andoe, John Beerman, Lynda Benglis, Richard Bosman, John Coplans, Glenn Goldberg, Jack Goldstein, Karla Knight, Nic Nicosia, John Obuck, Garnett Puett, Judith Shea, Gary Stephan, John Torreano, William Wegman, Stephen Whisler, Rob Wynne, and Michael Young. Dart is also beginning to present works by several European artists such as Olivier Mosset, Eberhard Bosslet, John Armleder, and Christian Boltanski. Along with works by regularly affiliated artists, the gallery often presents pieces by major contemporary artists in group or theme exhibitions. Dart continues to feature works by twentieth- century masters from Picasso to Frank Stella and Anslem Kiefer.

[026] DOUGLAS DAWSON GALLERY
814 N. Franklin St., Chicago, IL 60610

Phone: (312) 751-1961; *Hours:* Tues-Sat: 10-5:30; *Owner/Dir:* Douglas Dawson

Douglas Dawson specializes in ancient and antique textiles and related ethnographic arts from all the continents except Europe. The gallery's focus is on the aesthetic as opposed to the ethnographic, supplying pieces of compelling beauty in ceramics, sculpture, jewelry, and furniture.

In addition to textiles, the gallery carries wearable African and pre-Columbian jewelry, historic African vessels, and ceramics from Indonesia, Japan, the Himalayas, meso-America, and South America.

Six theme shows are held each year. Recent exhibitions include "Beauty to Kill," featuring knives, clubs, and spears with great aesthetic properties, and an exhibition of African textiles.

[027] DEGRAAF FINE ART, INC.
300 W. Superior St., Chicago, IL 60610

Phone: (312) 951-5180 *Hours:* Tues-Sat: 11-5:30; Fri: 11-8 *Owner:* Daniel L. DeGraaf *Dir:* Kevin Zuzich

Contemporary painting, sculpture, and graphic works by living American, Latin American, European, and Chinese artists living in the Western Hemisphere can be seen at De Graaf. The works, primarily paintings, are diverse.

Painters include Clayton Pond, Harry Borby, Chuang Che, Stefan Davidek, G. Sherman Kirtlow, William A. Lewis, David Miretsky, Kevin O'Brien, Chris Stoffel Overvoorde, Fernando Ramos Prida, Alejandro Romero, Michael Scott and watercolorist Lee Weiss. Among the sculptors are Bill Barrett, Charlie Brouwer, Susan Falkman, Alexa Grodner, Wendell Heers, Richard Hunt and Kurt Metzler.

The gallery also features tapestry, including the traditional French tapestries of G. Elyane Bick and the sculpted tapestries of Dorothy Hughes.

[028] DESON-SAUNDERS GALLERY
750 N. Orleans, Second Floor, Chicago, IL 60610

Phone: (312) 787-0005 *Dir:* Marianne Deson Herstein

The Deson-Saunders Gallery has maintained a reputation for always being in the avant-garde. Beginning in the sixties, the gallery featured exhibitions by emerging and established Italian and Spanish artists including Fontana Baj, Castellani, Adami, Canogar, Genoves and Pijuan. The gallery's inaugural exhibition featured Futurist work.

Also in the sixties and then in the seventies, Chia, Cucchis, Clemente, Merz De Maria, Zorio, Kounellis, Ontani and Paladino exhibited at this gallery as they were just breaking into the scene on American shores. In the eighties, the gallery extended its commitment to the Italians by introducing the members of the San Lorenzo school to America, as well as Bianchi, Ceccobelli, Dessi, and Gallo.

Deson reaches beyond Southern Europe in its search for the extraordinary. Early on the gallery mounted important exhibitions of German art, "Artists Use Photographs" (Baldessari, Prince, Gilbert, and George, among them), and site-specific installation (Nauman, Oppenheim, and Steir). The gallery has also worked closely with some of the very best Chicago artists, introducing Paschke, Lostutter, and Ramirez, among others. Currently the gallery represents several Chicagoans whose impact is now being felt on the national scene--Michiko Itatani, Bill Cass, David Klamen, Mary Ahrendt and Michael Brakke.

[029] CATHERINE EDELMAN GALLERY
300 W. Superior St., Chicago, IL 60610

Phone: (312) 266-2350; *Hours:* Tue-Sat: 10-5:30 *Owner/Dir:* Catherine Edelman

The only gallery in Chicago exclusively dedicated to the exhibition and sale of contemporary art; it features both internationally recognized and emerging talents. Among the renowned are Barbara Crane of Chicago, Bea Nettles and Barbara DeGenevieve of Champaign, Illinois, John Reuter of New York, and Tony Mendoa from Cuba. Of recent acclaim, Joe Ziolkowski and his provocative images of nude men suspended in air were part of a recent exhibition entitled "Men on Men," which also featured the work of Duane Michals and John Reuter. Other emerging artists include Chicago's Joan Moss and Karen Glazer. From outside Illinois come Jeff Millikan of Minneapolis, David Lebe of Philadelphia, and Noriaki Yokosuka of Tokyo.

[030] EHLERS CAUDILL GALLERY INC.
1306 W. Byron St., Chicago, IL 60613

Phone: (312) 883-0888; *Hours:* by appointment *Dir:* Carol Ehlers, Sashi Caudill

Vintage photographs from the 1920s and 1930s and works of contemporary American photographers are presented by this gallery. Among the masters represented are Eugene Atget, the prodigious photographer of the streets of Paris; Laszlo Moholy-nagy, Hungarian sculptor and painter associated with the Bauhaus, the Constructivists, and the New Bauhaus at the Chicago Institute of Design who experimented with photomontage and photography; Man Ray, an American surrealist in Paris famed as a fashion photographer as well as an innovator of new photographic techniques; and Edward Weston, early master of poetic naturalism.

Contemporary photographers include Ruth Thorne-Thompson, whose surreal vignettes are done in black

and white; Patty Carroll, an extravagant colorist who explores the uses and effects of neon in American landscapes; and Lewis Koch, who groups black and white Midwestern images into wall pieces that politically and conceptually address American priorities.

[031] FABRILE GALLERY LTD.

2945 N. Broadway Ave., Chicago, IL 60657

Phone: (312) 929-7471 *Hours:* Mon-Fri: 12-7, Sat- Sun: 12-5; 224 S. Michigan Ave., Chicago, IL 60604 *Phone:* (312) 427-1510 *Hours:* Mon-Sat: 10-5:30, Sun: 12-5 *Owner:* David Perkovich

Deriving its name from the Old English word for *handmade,* Fabrile Gallery Ltd. is the only gallery in Chicago to feature exclusively the work of craftspersons from across the country. Decorative arts, art glass, and designer crafts as well as some ceramic works can be seen at the original Broadway Avenue gallery and the newer location on Michigan Avenue.

A sampling of the work of the more than fifty artists represented by Fabrile might include paperweights and vases in an Art Nouveau style made by Robert Eickholt and the blown-glass paperweights, vases, and perfume bottles of the Denver cooperative Blake Street Glass, which works in the more modern concentric wrap style. Iowan Tom Benesh's abstractions are of hand-carved, unglazed porcelain, while the kinetic sculptures by David Roy of Vermont are finely crafted in different woods and resemble the inner machinations of a Colonial timepiece.

[032] FAIRWEATHER HARDIN

101 E. Ontario Ave., Chicago, IL 60611

Phone: (312) 642-0007 *Hours:* Tue-Sat: 10-5:30; closed August *Owner/Director:* Shirley Hardin, Sally Fairweather

Established in 1947, the gallery has developed a reputation for exhibiting the work of major artists. Not limited in scope to an exact style or time period, the gallery tends to show contemporary American art from Chicago and the Midwest, and from throughout the United States, by both established and relatively unknown artists.

The work of sculptor Harry Bertoia is prominently displayed in the gallery. Bertoia's work ranges from large architectural works to smaller pieces based on organic forms--particularly flowers, plants, and seeds. Bertoia is known for his sound sculptures of flexible metal rods that produce non- repetitive chiming.

Recent one-person exhibitions featured Joyce Treiman, Tom Fricano and Lillian Florsheim. Theme shows have included such varied artists as Barbara Aubin, Po Kim, George Buehr and Francis Chapin.

[033] FERMILAB GALLERY

Pine Street & Kirk Road, P.O. Box 500, Batavia, IL 60510

Phone: (312) 840-3211 *Hours:* Daily: 9-5 *Owner:* Universities Research Association, Inc. *Dir:* Saundra Poces

Located in the main building at the Fermi National Accelerator Laboratory, the gallery presents art exhibits of various media from collections of museums, galleries, private collectors and Chicago-area artists. Each show lasts approximately six weeks. The gallery emphasizes a variety of artwork for Fermilab's employees and visitors.

Concepts for potential exhibits frequently come from a committee. Past exhibitions have included fifth-century Greek vases from the Art Institute of Chicago, paintings by Martyl Langsdorf, prints from the Joseph Randall Shapiro collection, the photographs of Elliott Porter and samples from the Mae Weber collection of traditional African art.

[034] WALLY FINDLAY GALLERIES

814 N. Michigan Ave., Chicago, IL 60611

Phone: (312) 649-1500 *Hours:* Mon-Fri: 9:30-5:30, Sat: 9:30-5 *Dir:* Helen Findlay

At the age of 120, Findlay Galleries is Chicago's oldest commercial gallery and the third oldest in the United States. In 1870 William Wadsworth Findlay established the original gallery, and today there are four branches--Paris, New York, Palm Beach, and Beverly Hills. The Chicago gallery is still the business base.

The collection is primarily contemporary European Impressionist and Post-Impressionist, with an emphasis on French painters.

Some impressive original paintings by nineteenth- and twentieth- century artists like Monet, Renoir, Braque, and Matisse have added character to the gallery. Other artists whose works are more abundant include Nicola Simbari, a painter of semi-abstract works; David Holmes, who paints quiet scenes of the outdoors; and French Impressionist Andrew Hambourg. Add to this list Constantin Kluge, Ardissone, Nessi, Andre Vignoles, and Fabien. Although styles differ, the essential statement is Impressionist.

The first floor displays samples of each artist's work, with full exhibits throughout the four-story gallery. The monthly exhibitions are usually held on the second floor.

[035] FLY BY NITE

714 N. Wells St., Chicago, IL 60610

Phone: (312) 664-8136 *Hours:* Mon-Fri: 10-6, Sat: 10-5, Sun: by appointment *Owner:* Thomas Tome *Dir:* Stuart Tome

Hearkening back to the Left Bank of Paris in the twenties, Fly By Nite specializes in European decorative and applied arts dating from 1890 to 1930. The first decorative arts gallery in Chicago and the first gallery in the River North area, twenty- five-year- old Fly By Nite is more like a private museum than a store. Objects are displayed salon style, often staying on the shelf for several years before being placed in a collection. Fly By Nite emphasizes aesthetic value rather than the name of the artist--to the point where a viewer may have to voice his or her appreciation of a piece in order to be told its history.

Original Art Deco and Art Nouveau ceramics, metalwork, and other objects are highlighted along with arts and crafts from France, England, and America. Pieces from the German Jugendstil movement are also a specialty. In addition to decorative objects, original period jewelry is available.

[036] GILMAN/GRUEN GALLERIES
226 W. Superior St., Chicago, IL 60610

Phone: (312) 337-6262 *Hours:* Tue-Sat: 10-5:30 Contemporary *Dir:* Mack Gilman African *Dir:* Erwin Gruen

Mack Gilman is a veteran art dealer, having represented contemporary artists for thirty years. The works cover a variety of media, styles, and ideas, sometimes humorous and sometimes realistic, contemplative, or clever.

Erwin Gruen has been exhibiting primitive art for fifteen years, with an emphasis on African art. Also among his selections are Haitian and Oceanic art.

The size of the gallery lends itself to the many sculptures that Gilman shows. The epoxy resin work of Emily Kaufman and Frank Gallo, the granite and marble sculptures of Charles Herndon, Kay Hofmann, and Frank Swanson, and the papier mache works of Steven Hansen and Phillip Dusenbury have an important place in the gallery. Other sculptors include Fred Schmidt, Isabella Pera, and Rick Harney.

Painting and handmade paper share equal importance with the sculpture Gilman shows. Chicago and area painters include Morris Barazani, Walter Fydryck, Lee Grantham, Fay Peck, Adair Peck, Rex Sexton, Bob Novak, Roland Poska, Barbara Frith, Karen Butler, Erika Bajuk and Lu Dickens. Among other painter list Audrey Ushenko, Lowell Boileau, Tom Balbo, Leslie Poole, Catherine Perehudoff, Tom Parish, Alba Corrado, Ines Smrz, and Pat Hidson.

[037] GOLDMAN-KRAFT GALLERY, LTD.
300 W. Superior St., Chicago, IL 60610

Phone: (312) 943-9088 *Hours:* Mon: by appointment, Tue-Fri: 10-5:30, Sat: 11-5 *Owner:* Goldman/Kraft *Dir:* Jeffrey Kraft

The concentration of the gallery is on twentieth-century contemporary paintings, graphics, and sculpture. The gallery collection includes important international and Israeli artists.

Internationally acclaimed artists include Italian painter Valerio Adami, famous for his ironic treatment of historic and philosophic subjects; two major comprehensive exhibitions of works by Karel Appel; retrospective exhibitions of works by Jean Dubuffet and of Matta; exhibitions of Rene Magritte and Paul Delvaux, as well as Viennese Fantastic Realist Arik Bauer. Other international work includes that of Marc Chagall, Joan Miro, Henry Moore and recently sculptor Lynn Chadwick. American painter Mark Tobey's work can also be viewed, a survey exhibition revealing the figurative as well as calligraphic roots of his style. Another highly influential American painter handled by the gallery is Frank Stella, whose earliest work categorically rejected the tenets of Abstract Expressionism in favor of a Minimalist style, but whose recent works combine geometric construction with gesture painting. Other recent exhibitions of American painters include the work of Cathy Halstead Lester Johnson.

Israeli artists featured include sculptor Aharon Bezalel,who makes interchangeable sculpture in wood and bronze, as well as Michael Eisemann, Manashe Kadishman, Reuven Rubin, Heinz Seelig, Yevgeni Abeshaus and Moshe Castel. With two exhibitions of the sculpture of Gidon Graetz, they also placed several of his sculptures in public spaces around Chicago, among them Ravinia Park and the Botanic Garden in Glencoe.

[038] RICHARD GRAY GALLERY
620 N. Michigan Ave., Chicago, IL 60611

Phone: (312) 642-8847 *Hours:* Tue-Sat: 10-5:30 *Dir:* Paul L. Gray

Richard Gray Gallery specializes in twentieth-century paintings, sculpture, drawings, and prints, with a strong emphasis on major modern artists. The gallery has exhibitions of major contemporary artists about three times a year. The gallery installations resemble a museum collection, representing major artists from this century. On permanent display are works by such prominent modern and contemporary artists as Pablo Picasso, Roy Lichtenstein, Franz Kline and Alexander Calder. The gallery maintains a large collection of the work of Jean Dubuffet including his painting series "Psycho-sites," as well as his series of prints "Hourloupe." Also displayed are the large flat paintings by Hans Hofmann, a fourteen-color woodcut by Jim Dine, prints and photo collage by David Hockney, among them *Telephone Pole Los Angeles* and *The Scrabble Game.* Other artists include Fernand Leger, Barbara Hepworth, Sam Francis, Nancy Graves, and Frank Stella.

Recent exhibitions have showcased new paintings by abstract expressionist Willem de Kooning, who continues to create large, subtly colored gestural pieces. George Segal, known for his plaster figures, featured his new, abstract cubist wall reliefs in a recent show, while the large monochromatic figurative work of Mimmo Paladino, a young Italian neo- expressionist, made up yet another recent one-man exhibition.

[039] THE GRAYSON GALLERY
833 N. Orleans Ct., Chicago, IL 60610

Phone: (312) 266-1336 *Hours:* Tues-Sat: 10-5:30 *Owner/Dir:* Gael Grayson

Modern and contemporary painting and sculpture share space with ancient and primitive art at this recently relocated gallery. Concentration is on diverse exhibitions of international scope, rather than the cultivation of a stable of artists. Recent thematic exhibitions included one of the first gallery exhibitions of classical antiquities in the Chicago area in twenty-five years, a show of Brazilian feather headdresses, and an exhibit of pre-Columbian art.

Among the contemporary artists exhibited are minimalist Korean sculptor Moon-Seup Shim, whose biomorphically abstracted Buddhist dieties are made of carved wood and metal; David Jokinen, whose paintings and sculpture are made of concrete; and Nathan Slate Joseph, whose contained, pastel- hued paintings are done on galvanized steel supports up to six inches deep. The several rooms of the gallery may house different artists or types of art, as was the case during a recent exhibition of two Basque sculptors.

Bruce Charlesworth, *untitled*, 23x23 cibachrome print. Courtesy: Deson-Saunders
Gallery

Jonathan Waterbury, *untitled*, 120x240, latex paint on wall. Courtesy: Deson-Saunders Gallery

[040] GROVE ST. GALLERY
919 Grove St., Evanston, IL 60201

Phone: (312) 866-7340 *Hours:* Mon-Fri: 11-7 Sat-Sun: 11-4 *Owner:* Italo Botti *Dir:* Chris Botti

The gallery specializes in exhibiting work by contemporary American artists, particularly painters working in oils and palette knife within the impressionistic tradition. Contemporary American sculpture is also represented. In most instances the work is by established artists.

Palette knife painters include Henrietta Milan from Texas, Italo Botti from Evanston, Illinois, and recent paintings by eighty-two-year- old William Collier from Lake Forest, Illinois. Collier's paintings are executed in printers ink and take up to eight months to complete. Sculptor Charles Keigher is a Chicago artist working in limestone and marble to create medium- to large-sized abstract pieces; some of his work uses a variety of woods. Shirley Finkel offers semi- abstract figures in cast concrete and cast paper.

In addition to representing individual artists on a regular basis, the gallery occasionally presents group shows. Recently one show, "Impressions," featured the work of new artists including watercolor painter Robert Barnum.

[041] HABATAT GALLERIES
The gallery was destroyed by fire at press time.

Phone: (312) 337-1355 *Owner:* Ferdinand Hampson, Thomas Boone *Dir:* Keith D. Church

Habatat Galleries concentrates on noted international sculptors working in mixed media with glass as a primary material. Habatat produced a show in Darmstadt, West Germany, (with Darmstadt Gallery) of important American artists working in glass, hoping to create a market in Europe for American glass artists. The gallery also created glass collections for major museums and collectors throughout the country. Habatat's galleries (a second and third are in Detroit and Harbor Island, Florida) generally feature intricate, complex, moody, and reflective works, though they also feature humorous pieces such as the cartoonish figures of Rick Bernstein.

From the work of Ireland's Clifford Rainey to the decorative forms of Claus Moyet, international sculpture includes the mysterious architectural pieces of Steven Weinberg, that of Steve Linn, David Huchthausen, and Kreg Kallenberger. From Czechloslovakia comes the art of Stanislav Lebenski, one of the most important Czech sculptors working in glass in a figurative style. Breteslar Novak is also a Czech and one of the most important artists in glass in the United States.

A second interest at Habatat is to exhibit innovative, provocative artists who have not yet been recognized. These artists include Mary van Cline, KeKe Cribbs, Danny Perkins, Jon Wolfe, and Ginny Ruffner.

[042] CARL HAMMER GALLERY
200 W. Superior St., Chicago, IL 60610

Phone: (312) 266-8512 *Hours:* Tue-Sat: 10-5:30 *Owner/Dir:* Carl Hammer

The pieces shown at the Carl Hammer Gallery are bound to look familiar--they are the stuff of the American experience, made by naive or untrained artists both historical and contemporary. Works by mainstream artists are also exhibited, with an emphasis on work that relates to the "outsider" aesthetic; artists who strive for the "naive" or "folk" look, however, are not included. Master visionary outsider artists regularly exhibited include Bill Traylor, Henry Darger, Joseph Yoakum, Simon Sparrow, and others. Works by Chicago artists Mr. Imagination, Lee Godie and Matt Lamb are also frequently displayed. Also found are works by Mose Tolliver, S. L. Jones, Lonnie Holley, William Hawkins, Alex Maldonado, David Montgomery, Eddie Arning, John Ferris, Yuri Krochmaluk, and Frank Jones, as well as anonymous examples of American material culture of the highest quality, with an emphasis on eccentric vision.

[043] HOFFMAN GALLERY
215 W. Superior St., Chicago, IL 60610

Phone: (312) 951-8828 *Hours:* Mon: by appointment, Tue-Sat: 10:30-5:30 Sun: 11-5:30; Jul-Aug: closed Sat *Owner/Dir:* Rhona Hoffman

Showing emerging and established American and European artists, the Hoffman Gallery rewards the visitor with a glimpse of some of the most provocative art being made today. The painting, drawings, and sculpture exhibited cover a wide range of styles, and confront both aesthetic and social problems with integrity. The gallery also handles outdoor sculpture commissions.

Works in realist styles include the paintings of Leon Golub, drawings by *trompe-l'oeil* muralist Richard Haas, and Sylvia Plimack Mangold's illusionistic inquiries into the nature of the painting process. Artists associated with minimalism include painters Robert Mangold and Robert Ryman, and sculptors Sol LeWitt, Donald Judd, and Richard Artschwager. In contrast with the purely abstract forms of these other artists, Artschwager's sculpture refers to furniture as formal objects. Jenny Holzer, Barbara Kruger and Nancy Spero all use texts in various ways. Holzer's texts are put on industrially produced signs and installed in contexts that create an ironic tension about their meaning. Kruger couples texts with found images to reveal the hidden workings of contemporary social iconography. Spero's paintings and drawings of female figures and anthropomorphic monsters question the part sex roles play in social history, particularly their bearing on war and peace. Other artists exhibited include performance artist and sculptor Jene Highstein, and fiber artist Claire Zeisler.

Most recent artists include Nancy Dwyer, Peter Halley, Kenneth Josephson, Jannis Kounellis, Joseph Kosuth, and Gordon Matta-Clark.

[044] HOKIN KAUFMAN GALLERY

210 W. Superior St., Chicago, IL 60610

Phone: (312) 266-1211 *Hours:* Tue-Fri: 10-5, Sat: 11-4:30 *Owner:* Lori Kaufman *Dir:* Gary Metzner

Specializing in contemporary painting and sculpture by nationally recognized artists, the Hokin Kaufman Gallery also handles an extensive selection of artist-designed furniture.

The paintings generally fall into either abstract or realist modes. Illusionists George Green and Jack Lembeck, colorists Sigrid Burton, Ronnie Landfield, and Tony DeBlasi, Ida Kohlmeyer, and textural color field painter Stanley Boxer provide a rich inventory of abstract work, while Joseph Reboli, Ruth Bauer, Randall Deihl, Paul Giovanopoulos, and still life artists Mary Ann Currier and Anneke van Brussel provide an inventory of contemporary realism. Sculpture by William King, Boaz Vaadia, Kazuma Oshita and Jonathan Bonner is also available at the gallery. It has recently shown the work of Frederick Brown.

Local artists exhibited include well-known figurative painters Claire Prussian, James Mesple, Robert Donley, and ceramicist Burton Isenstein.

The Art Furniture Collection shows considerable breadth and includes America's premier furniture designer, Wendell Castle, California artist Peter Shire, and Midwestern designers John McNaughton, Andrew Pawlan, and Lee Weitzman.

[045] B. C. HOLLAND

222 West Superior St., Chicago, IL 60610

Phone: (312) 664-5000 *Hours:* by appointment *Owner/Dir:* B. C. Holland

B. C. Holland essentially works as a private art dealer. The gallery offers visitors the opportunity to view important twentieth-century works in settings set up for private showings and consultations.

The inventory revolves around European and American art to the 1960s, with excellent representation of New York School paintings. Holland deals in such internationally reknowned artists as Picasso, Balthus, Dubuffet, Rothko, Kline, de Kooning, Rivers and Johns. As a rule, Holland emphasizes individual works rather than the oeuvre of a particular artist.

An additional specialty of the gallery is a collection of classical modern furniture, especially Viennese, French, and Italian designs from 1890 through 1940, as well as more eccentric designs from African nations.

[046] BILLY HORK GALLERIES

109 E. Oak St., Chicago, IL 60611

Phone: (312) 337-1199 1621 Chicago Ave., Evanston, IL 60201 *Phone:* (312) 492-1600; 3015 N. Broadway Ave., Chicago 60657 *Phone:* (312) 528-7800; 272 E. Golf Rd., Arlington Heights, IL 60005 *Phone:* (312) 640-7272; 3033 N. Clark St., Chicago, IL 60657 *Phone:* (312) 528-9090; *Hours:* Mon- Sat: 10-6, Sun 12-5 *Owner/Dir:* Billy Hork

Since 1972, Billy Hork Galleries has been known for its volume and variety of contemporary art. There are now five locations, each displaying original graphics and unique works by more than one-hundred artists. For those looking for large-scale artworks, the Clark Street loft offers an expanded and diversified selection of affordable mixed-media works and paintings done in a broad range of styles. The loft gallery also serves the interior design trade, with offerings suitable for residential or contract applications.

All of the locations offer posters from museums and other major publishers from around the world, with selections constantly re- inventoried. Artists featured include Harold Altman, Marco Sassone, Daniel Lencioni, Greg Ochocki, Neil Loeb, Craig Reheis, Beryl Cook, Melanie Taylor Kent, Jean Richardson and R. C. Gorman.

[047] JOY HORWICH GALLERY

226 E. Ontario St., Chicago, IL 60611

Phone: (312) 787-0171 *Hours:* Tue-Sat: 10-5:30 *Owner/Dir:* Joy Horwich

Opened in 1974, the Joy Horwich Gallery represents considerable experience working in art in Chicago. All of the art is contemporary, but a wide variety of media and styles is used by the emerging and mid-career artists shown. Director Horwich's intent is to display work she likes, whether the artist is well- established or not. Paintings, sculptures, and fiber pieces by abstract, realist, and folk artists are all part of the gallery's offerings, which have long included quilts, ceramics, and hand- painted silk hangings as art forms.

One can view the work of Darryl Halbrooks, both narrative paintings and illusionist geometric images on cutout Masonite board. Barbara Frets paints scenes of beaches and bus stops in a realist manner, while Jan Miller paints contemporary still lifes. Also represented are the brightly colored *Tropical Tropes* of Raymond Olivero. In mixed media, James Michael Smith works with natural wood, fabric, and paper. Also here are the mixed-media constructions of Joseph Rozman. Chick Schwartz provides the gallery with ceramic wall-reliefs, (of note, his cityscape series, "Looking Down"), as well as bronze figures. Gretchen Sigmund brings both painting and mixed-media work to the gallery, from large-scale abstract paintings to tiny colorful books incorporating pictures and memorabilia.

Most recently the gallery has exhibited the works of Nancy Steinmeyer, Nancy Drew, and Charlotte Brown. Working with found objects and paper, Steinmeyer creates three- dimensional, life-sized wall hangings of people. Complete with a high degree of detail are Cubs fans sitting in the bleachers, airport passageways, and other such American scenes. Nancy Drew is prolific on a variety of surfaces, her colorful figures and animals appearing on chairs, tables, mirrors, t-shirts, and ties, as well as the more conventional settings. Charlotte Brown combines handmade paper with 3M collage presses.

[048] EDWYNN HOUK GALLERY

200 W. Superior St., Chicago, IL 60610

Phone: (312) 943-0698 *Hours:* Tues-Sat: 10-5:30 *Owner/Dir:* Edwynn Houk

Vintage photographs of the twentieth century by American and European masters are shown by this gallery, with an emphasis on the photography of the

twenties and thirties.

One can see works by distinguished American photographer Alfred Stieglitz, who was instrumental in proving photography was independent of painting. Stieglitz is also remembered as the director of the "Photo-Secession Gallery" in New York, where he introduced the best work of the European avant-garde to this country. Photographs by precisionist painter Charles Sheeler of industrial vistas are also available, as are works by Man Ray, an influential American photographer active in the Parisian avant- garde in the thirties. Man Ray contributed solarization to the technical processes of photography, and experimented with the use of objects placed directly on photographic paper to make images in his "Rayograms." There are also photographs by Andre Kertesz, a European photographer who has long lived in New York City.

Exhibitions in 1989 include a retrospective of the works of Dorothea Lange, reknowned for her grim portraits of the migrant workers in California in the thirties and forties; and vintage prints by German photographer Ilse Bing, a contemporary of Man Ray and Kertesz who now lives in New York City. Bing's photographs capture moments of everyday life, ranging from the candid abstractions of machine and nature to fragments of often incidental objects.

[049] JANICE S. HUNT GALLERIES, LTD.
207 W. Superior St., Chicago, IL 60610

Phone: (312) 951-5213 *Hours:* Mon-Sat: 10-5:00 & by appointment *Owner:* J. S. Hunt *Dir:* Ben Walby

Concentrating in twentieth-century painting, the gallery represents some fifteen artists from around the world. The gamut of styles runs from figurative to abstract, from minimalist to photorealist. Both well-established and emerging artists are among the fifteen.

From Chicago comes William Nelson and his surrealistic paintings and lithographs; emerging artist Frank Lindner, once an illustrator for *Playboy,* still uses illustrative techniques when painting on the wrecked fenders, hoods, and panels of fancy automobiles. Robert Kabak, from Sante Fe, working in oil on canvas, shows his abstract geometric impressions of the American Southwest while Reed Farrington, from Carmel, California, presents his figures in bold abstract brushstrokes.

From outside the United States, the "selectivist" work of London's Willow Winston is exhibited. In a series of abstract scenes, Neal Fettling from Australia offers his sociopolitical impressions of Chicago.

Located in a rehabbed townhouse, the natural lighting in the gallery gives these works much the same light found in a buyer's home.

[050] ILLINOIS ARTISAN SHOP
State of Illinois Center, 100 W. Randolph St., Chicago, IL 60601

Phone: (312) 917-5321 *Hours:* Mon-Fri: 9-5 *Adm. Mgr.:* Ellen Gantner

The first of its kind in Illinois, the Illinois Artisan Shop focuses on some of the finest crafted artwork made in the state. Functioning as a showcase and sales gallery, it provides a one- stop opportunity to view and purchase the work of more than 400 Illinois craft artists. The diversity of the crafts reflects the rich cultural history of the regions of the state. Ceramics, jewelry, prints, quilts, sculpture, baskets, photography, and fine examples of folk and ethnic art are among the many crafts found at the shop. Sculpted pottery vessels and urban photographs represent aspects of contemporary Illinois art, while baskets, quilts, and carved decoys exemplify ageless state traditions. Ethnic cultures are represented by Japanese origami, Lithuanian wood carving, Polish paper cutting, and Latvian jewelry. All items are available for purchase at prices ranging from $1 to $5,000.

A not-for-profit enterprise, the shop is sponsored by the Illinois State Museum Society. Call for information about demonstrations and special events.

[051] GWENDA JAY GALLERY
301 W. Superior St., Second Floor, Chicago, IL 60610

Phone: (312) 664-3406 *Hours:* Tue-Sat 10:30-5 *Owner:* Gwenda J. Klein *Dir:* Michael Wier

The gallery represents the young and mid-career work of contemporary artists and sculptors. Featured artwork exhibits strong emotional, intellectual, and spiritual qualities. The gallery presents artwork from three basic genres. Natural themes and landscapes are presented by Sam Cady, Eric Shuttis, Cameron Zebrun, Susan Michod, Diane Cox, and Graham Harles. Paul Sierra, Sam Richardson, Ellen Frank, Damian Bird, and Margaret Lazzari deal with images of cultural history and human experience. Abstract artists associated with the gallery include Margeaux Klein, Julie Lichtenberg, Mary Anne Davis, and Jim Chlopecki. Works by Page Allen and Russell Gordon, among others, are also exhibited.

[052] R. S. JOHNSON INTERNATIONAL
645 N. Michigan Ave., Chicago, IL 60611

Phone: (312) 943-1661 *Hours:* Mon-Sat: 9-5:30 *Dir:* R. Stanley Johnson

A spacious exhibition space accessible through the Erie Street entrance of the modern Blair Building, this second-floor gallery offers works from historical and contemporary periods. Director R. Stanley Johnson is one of the world's major dealers in Old Master prints. The gallery has acquired works by French impressionists and expressionists, including Honore Daumier, Maurice Vlaminck and Jacques Villion, as well as Georges Rouault, Odilon Redon and Felix Vallotton. The German expressionists breathed new life into printmaking, particularly woodcuts, and there are distinguished works by Emil Nolde, Ernst Kirchner, Max Beckmann and others. Prints by master artist Picasso are also available. American printmakers from 1860 to 1950 have been featured in a special exhibition. Other such exhibitions featured the works of Felix Buhot, and European prints and drawings from 1890 to 1980.

Although graphics are clearly the emphasis of the gallery, Johnson also carries paintings and drawings. Gallery exhibitions have included paintings and drawings by Leger, works from Giorgio de Chirico's realist period, four Picasso shows, and the charming works of American Impressionist Mary Cassatt.

Marcia Muth, *Ned's Diner,* 36 x 48, acrylic on canvas. Courtesy: Yolanda Gallery of Naive Art, Chicago

Paul Giovanopoulos, *Chair B,* 63 x 60, mixed media on canvas. Courtesy: Hokin Kaufman Gallery, Chicago

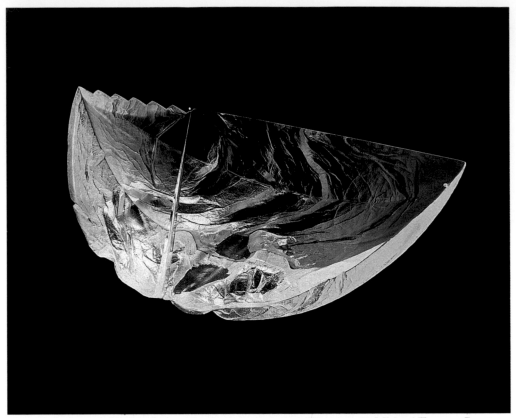

Kreg Kallenberger, *Titanic Series,* 19 x 7 x 5, optical glass. Photograph: Michael Tropea. Courtesy: Habatat Galleries, Chicago

Calvin B. Jones, *Welcome To My World,* 60 x 90, mixed media.
Photograph: Ted Gray. Courtesy: Isobel Neal Ltd., Chicago

Leon Golub, *Man and Woman,* 41 x 29, lithograph. Courtesy: Printworks Gallery, Chicago

Dan Mills, *Big Long Faced Facade,* 62 x 50 x 3, found polychromed wood & nails. Courtesy: Sybil Larney Gallery, Chicago

William Quinn, *Damme,* 14 x 21, gouache, Courtesy: Sazama / Brauer Gallery, Chicago

David Klamen, *untitled,* 72 x 96, oil on canvas. Courtesy: Deson-Saunders Gallery, Chicago

Aaron Bohrod, *A Game of Pears,* 24 x 20, oil, board. Courtesy: Sazama / Brauer Gallery, Chicago

Alan Larkin, *The Arrival of the Suitors,* 22 x 30, color pencil. Courtesy: Printworks Gallery

Elizabeth Collins Lewis, *Assembled at the Spectacle,*
44 x 30, pastels on paper. Courtesy: Zaks Gallery

Robert Winslow, *Plane (Moving to Symbolic),* 94 x 71, mixed media on canvas. Courtesy: AES Gallery,
Chicago

Eleanor Spiess-Ferris, *Puppet,* 76 x 97, oil on canvas. Courtesy: Zaks Gallery, Chicago

Bruce Thayer, *Manual-Labor,* 48 x 86, mixed media on paper. Courtesy: Zaks Gallery, Chicago

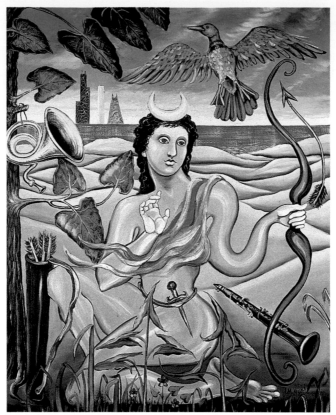

J. M. Mesplé, *Diana of the Dunes,* 60 x 48, oil on canvas. Photograph: Michael Tropea. Courtesy: Hokin/Kaufman Gallery

Mona Waterhouse, *Spirit House,* 35 x 47, handmade paper & mixed media. Courtesy: Mindscape Gallery, Evanston, IL

Roger Adams, *Chrysanthemum Garden,* 26 x 34, oil on canvas

Ani Afshar, *Enchanted Garden,* wool and silk. Courtesy: Dorothy & Alan Press Collection

Roger Brown, *Ferdinand & Emelda,* 72 x 48, oil on canvas.
Courtesy: Phyllis Kind Gallery

Jose Andreu, *Chicaboatola,* 44 x 96, acrylic on canvas

D. Buttram Sr., *Wade Park,* 24 x 36, oil on canvas

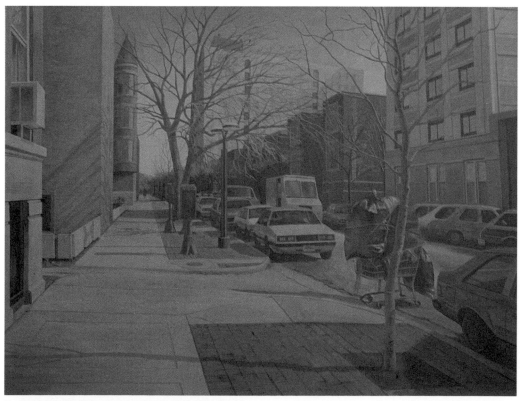

E. Brooks, *Dickens & Cleveland,* 39 x 50, acrylic

Mildred Armato, *Oriental Chairs,* 15 x 15 x 59, oil & glaze on hardwood

Robert Barnum, *Boogie Boards,* 21 x 15, watercolor

Robert Amft, *Clouds,* 60 x70, acrylic

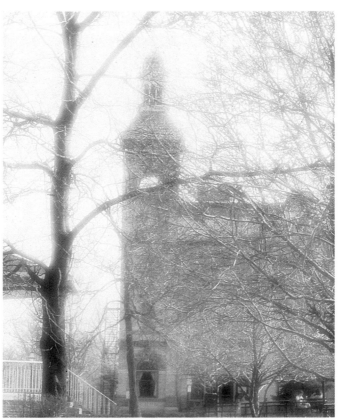

Steven Berkowitz, *Woodstock Opera House,* 30 x 35, photograph.
Courtesy: Grove Street Gallery, Evanston, IL

R. R. Benda, *Sea Wall,* 44 x 45, mixed media & collage

Ulla-May Berggren, *untitled,* 54 x 54, fiber, linen gobelin. Courtesy: Ruth Volid Gallery, Chicago

Craig A. Anderson, *Maelstrom Float,* 48 x 76, acrylic, oil.
Courtesy: Sybil Larney Gallery, Chicago

Alan M. Bolle, *Ocean Cruise,* 14 x 21, mixed media. Photographer: Paul Meridith

Ronald Bovard, *Rainbow Lands,* 28 x 46, acrylic on canvas. Photographer: Bob Stone

Sandi Blank, *Summer in Samos,* 48 x 60, acrylic. Courtesy: Schiff, Hardin & Waite, Sears Tower, Chicago

Between the four main exhibitions per year, the gallery shows work from its inventory of approximately 500 pieces. The 3,000- square-foot gallery lends itself to shows approaching a small exhibit in a museum.

[053] KASS/MERIDIAN
215 W. Superior St., Chicago, IL 60610

Phone: (312) 266-5999 *Hours:* Tue-Sat: 11-5 & by appointment; *Owner:* Alan and Gace Kass *Dir:* Holly Johnson

Although the gallery focuses on presenting prints and work on paper by master modern and contemporary artists, it also displays painting and sculture.

Exhibiting work by artists who are nationally and internationally known, the gallery features the "Myths" portfolio by Andy Warhol, Robert Motherwell's *French Revolution Suite,* Roy Lichtenstein's *Still Life with Apples* series, and Keith Haring's 1989 portfolio. Other major American artists include Sam Francis, Charles Arnoldi, Helen Frankenthaler, Louise Nevelson, and Jim Dine. Major European artists are also represented. David Hockney, Henry Moore, Pablo Picasso, Jean Dubuffet, Joan Miro, and Marino Marini are among a longer list of master artists.

Recent exhibitions have brought the "Wave" series by Frank Stella to Chicago. The brightly colored works of epoxy on aluminum by Tom Holland, a California artist, were featured in a January exhibition. In an anniversary show, the gallery showcased unique monotypes and drawings by Andy Warhol.

[054] PHYLLIS KIND GALLERY
313 W. Superior St., Chicago, IL 60610

Phone: (312) 642-6302 *Hours:* Tue-Wed, Fri-Sat: 10-5:30 Thu: 10-8; July-Aug: Tue-Fri: 10-5:30 only *Owner:* Phyllis Kind *Dir:* William H. Bengtson

While initially focusing on American artists from Chicago and New York, the Phyllis Kind gallery has gained a controversial reputation for exhibiting unusual art. Kind now offers distinctive pieces from across the United States and Europe. The gallery also emphasizes contemporary naive artists.

After establishing a gallery in Chicago, Ms. Kind opened a branch in New York, to which she brought a selected group of young Chicago artists, many of whom later came to be known as the Chicago Imagists. Roger Brown's mysterious curtained skies hang over stylized scenes with a humorous or political intent. Gladys Nilsson's organic figures are sensitively painted, usually in watercolor. Ed Paschke's drawings and paintings, which lately are modeled after video imagery, reflect the anxiety of the computer age. Jim Nutt paints scenes that have an air of surreal burlesque. Painter Karl Wirsum, who uses the figure structurally, is also included among the Chicago Imagists.

Other prominent gallery artists are William Copley, Cham Hendon, and Spanish figurative artist Zush. Artists working in three dimensions include Tom Nussbaum, Luis Jimenez, and Martin Johnson. Sculptor Margaret Wharton uses chairs as a source of structural elements and associated meanings.

Naive works by gallery artists include Howard Finster's

intricate narratives, the fantastic geographical landscapes of Joseph Yoakum, and the obsessive linear drawings of Martin Ramirez. The gallery also shows the sculptural mask-like forms by Mary Stoppert and abstract oil paintings by Myoko Ito.

[055] KLEIN GALLERY
The gallery was destroyed by fire at press time.

Phone: (312) 787-0400 *Dir:* Paul Klein, Robbie Klein

Klein Gallery is committed to contemporary abstraction and to examining issues of dimensional art. Of the approximately twenty artists the gallery represents, several are Japanese, and most have international reputations.

Among the artists represented are Charles Arnoldi, William S. Burroughs, Sam Gilliam, Allan Graham, Mineko Grimmer, Jun Kaneko, Jonathan Santlofer, and Michael Todd.

[056] LANDFALL PRESS, INC.
311 W. Superior St., Suite 314, Chicago, IL 60610

Phone: (312) 787-2578 *Hours:* Tue-Fri: 10-5, Sat: 12-4; Aug: closed *Dir:* Jack and Ethel Lemon *Sales Dir:* Timothy Williams

Publishers of hand-pulled lithographs, etchings, and woodcuts, Jack and Ethel Lemon have been in Chicago since 1970. The internationally recognized artists published include Vito Acconci, William Allan, Terry Allen, Robert Arneson, Chuck Arnoldi, Roger Brown, Lynda Benglis, Phyllis Bramson, Grisha Bruskin, John Buck, Dan Christensen, Christo, Robert Cottingham, Peter Dean, Laddie John Dill, Martha Erlebacher, Vernon Fisher, Ron Gorchov, Charles Gaines, Denise Green, Richard Haas, Luis Jimenex, Peter Julian, James Juszczyk, Ellen Lanyon, Ed Larson, Alfred Leslie, June Leaf, Sol LeWitt, David Ligare, Tony Naponic, Don Nice, Claes Oldenburg, Ed Paschke, Philip Pearlstein, Joseph Piccillo, Martin Puryear, Pat Steir, Jack Tworkov, Bernar Venet, and William T. Wiley.

Landfall also has a showroom in New York City (see listing for downtown New York City).

[057] LAREW'S GALLERY
1417 Sherman Ave., Evanston, IL 60201

Phone: (312) 475-4214 *Hours:* Mon-Sat: 10-5:15 *Owner/Dir:* John Larew

In business now for some twenty-five years, Larew's Gallery offers oils, acrylics, and watercolors by local artists. At any given time he features, in addition to his own work, the work of three other artists. His own works are landscapes in oil and acrylic in the impressionist tradition; find here Illinois landscapes and seascapes of Cape Cod.

Judy Hladic provides photorealist acrylics of Evanston scenes. Carol Wilson, working oil and watercolor, paints a range of impressionist works from still lifes to scenes of Paris. While John Eckert creates character studies with his pencil drawings, his photography takes us outside to the landscape.

In addition to providing exhibition space, the gallery operates a custom framing and painting restoration service.

[058] SYBIL LARNEY GALLERY

118 N. Peoria Ave., Chicago, IL 60607

Phone: (312) 829-3915 *Dir:* Sybil Larney

Sybil Larney Gallery opened in 1986 in the Haymarket area known as River West, a neighborhood of artists, photographers, and printers living in converted industrial lofts amid the remaining meat packers and fruit wholesalers. Larney Gallery hosts a mix of contemporary figurative and abstract work, both in painting and sculpture. Working within the tension between what's realistic and what's abstract, the gallery leans toward showing more "colorist" work.

The gallery exhibits work primarily of Chicago-area artists including Vivian Nunley's bold acrylic, large-scale, richly painted pieces; Mary Bourke's haunting, realistic oils; Jeff Whipple's mix of exaggerated personalities amidst nonobjective backgrounds; Rick Lange's expressionistic underwater imagery; and Craig Anderson's energetic interwoven bars of color. Works of oriental paper and painting collages by Anne Farley Gaines can be found, as well as Pamela Gilford Levin's space and design explorations and Gail Skudera's woven paintings. Sculpture includes wood and stone pieces by Terrence Karpowicz and the found- object building facades of Dan Mills.

Additional artists are Pamela Matiosian, Roger Colombik, Woods Davy, John van Alstine, Keith Downie, and Tony Giliberto. The gallery features one-artist and group shows.

[059] LATINO ARTS COALITION GALLERY

850 N. Milwaukee Ave., Chicago, IL 60622

Phone (312) 243-3777 *Hours* Tues.-Sat. 1-6 and by appointment *Exec. Director* Deanna Bertoncini

This not-for-profit gallery devotes itself to presenting the work of contemporary, cutting-edge Latino artists from the Chicago area, as well as national and international Latino artists painters, sculptors and installation artists. Recent exhibitions have included a one-woman show by painter Paula Pia Martinez, winner of the Illinois Arts Council Scholarship; a presentation of the work of Brazilian painter Alex Fleming; and "Waiting for Man to Evolve," featuring the work of Puerto Rican painter and sculptor Nicolas Rodriguez. The coalition presents lecture series by Chicago art luminaries in conjunction with the subject matter of shows and the ethnicity of the artist.

[060] ROBIN LOCKETT GALLERY

703 N. Wells St., Chicago, IL 60610

Phone: (312) 649-1230 *Hours:* Tue-Sat: 12-6 *Owner/Dir:* Robin Lockett

Robin Lockett Gallery presents innovative work often described as postmodern and neoconceptual by younger Chicago, New York, and Los Angeles artists. Not exclusive to emerging artists, the gallery also represents those more established from New York, Los Angeles, and Canada. Many different media can be found here, though much of it has in common a strong conceptual basis. In addition to paintings, sculpture, photography, and mixed media (a large percentage of the pieces are mixed media), installation pieces are a very important part of the gallery.

The artists Jennifer Bolande, David French, Ken Lum, Mitchell Kane, and Alan Belcher construct work in response to what the gallery calls our "media-intoxicated culture." They use photography, sculpture, paint, and industrially fabricated and printed materials. Questions of representation are explored by Pamela Golden in paintings depicting the posturing of "other" cultures and peoples. Other questions of representation are raised by Judy Ledgerwood's large pictorial landscapes and by Gaylen Gerber in repeated "almost-duplicate" still lifes.

The paintings of Julia Fish, Tim Ebner, and Christopher Wool and the sculptures of Vincent Shine are examinations of the purity of form, abstraction, and the gesture, using the transformation of images and patterns from everyday life. Both Michael Ryan's and Stephen Prina's work is based on conceptual studies: Ryan's are the result of intensive visual studies of trees or fossils; Prina discovers alternate methods of interpretations for existing systems.

[061] R. H. LOVE GALLERIES, INC.

100 E. Ohio St., Chicago, IL 60611

Phone: (312) 664-9620 *Hours:* Mon-Fri:9-5:30, Sat: 9-5; 400 S. Financial Pl., Chicago, IL 60605 *Phone:* (312) 427-8040 *Hours:* Mon- Thu: 8:30-5:30, Fri: 8:30-5 *Owner/Dir:* Richard Love

With a second gallery near the Chicago Board of Trade, the Ohio Street location is two galleries under one roof. Specializing in art by American masters from Colonial to contemporary times, the main gallery features work from the eighteenth, nineteenth, and early twentieth centuries. The second space presents twentieth- century art from both established artists and young contemporary artists from the United States.

Although the gallery has handled more than 2,000 artists, the primary collections feature the most well known. As an art historian and former professor of art, Mr. Love maintains an inventory of textbook art. Works by Benjamin West, the first American painter to achieve an international reputation, and Gilbert Stuart, the famous American portrait painter, are part of the gallery's collections. Equally impressive are paintings from the Hudson River School, works by genre painters, and works by American impressionists Theodore Robinson, Childe Hassam, and John Twachtman.

The twentieth-century collection ranges from works of the Ashcan School to contemporary art, including paintings by Hans Hoffman, the father of abstract expressionism. Other major painters represented are Robert Goodnough, Walter Darby Bannard, and Kenneth Noland, famous for his "Target" series.

[062] MERCALDO GALLERY

311 W. Superior St., Chicago, IL 60610

Phone: (312) 266-2855 *Hours:* Mon-Fri: 9-5, Sat: 11- 4 *Dir:* Paige Heid

While the gallery carries some contemporary prints by Francesco Scavullo, it is exclusively devoted to offering the prints of Andy Warhol. Of the works represented are authentic hand-signed, limited-edition screen prints. From a large inventory, one can find pieces from

Rick Bernstein, *How's About Here Honey?*, 60x84x10, glass on aluminum. Courtesy: Habatat Galleries

Boaz Vaadia, *Gad with Dog*, 13x21x15, slate, bluestone. Courtesy: Hokin Kaufman Gallery

various suites including his "Electric Chair" series, "Jews of the twentieth Century," "Myth," and "Ads."

[063] MERRILL CHASE GALLERIES

835 N. Michigan Ave., Chicago, IL 60611

Phone: (312) 337-6600; *Hours:* Mon-Fri: 10-8:00; Sat: 10-6:00 Sun: 10-5:00 *Dir:* Albert Sanford

Located in downtown Chicago's Water Tower Place, as well as in suburban locations at the Woodfield Mall, Schaumburg, and Oak Brook Center, Oak Brook, Merrill Chase Galleries handles a wide variety of fine prints and *objets d'art*.

The extensive collection of fine prints boasts examples by Old Master Rembrandt, masters of the nineteenth-century from both Europe and American in works by Renoir, Robbe, and Tissot, Cassatt and Whistler. Twentieth-century masters include Picasso, Miro, Chagall, and Dali. Examples from Picasso's acclaimed *Suite Vollard* and Dali's *Les Chants de Maldoror* are available.

Merrill Chase Galleries offers the work of contemporary artists such as the brilliantly colored pictures of LeRoy Neiman; works by artist and designer Peter Max; and wall sculpture by Bill Mack. Works by Nierman, Kipniss, McCormick, Altman, Likan, Erte, Addison, and sculptor Frederick Hart can be found.

An addition to the galleries is the "ARTique," a specialty department at all locations offering a glittering array of art-inspired items and fanciful bibelots, as well as books, notecards, and posters.

[064] PETER MILLER GALLERY

The gallery was destroyed by fire at press time.

Phone: (312) 951-0252 *Owner/Dir:* Peter Miller

The Peter Miller Gallery shows contemporary painting and sculpture by the following artists: Chris Costan, Michael Dubina, Floyd Gompf, John Henry, Walt Myers, Margaret Prill, Maurice Wilson, Mark Schwartz, Joshua Simons, Chuck Walker, Kevin Walsh, Bob Winslow, Mary Lou Zelazny, and Andre Ferrella. Both Chuck Walker and Mary Lou Zelazny have had museum exposure. John Henry's sculpture is nationally known and is now featured in a one-man traveling exhibition.

The gallery also features photography, and works by other painters and sculptors are regularly included in group shows.

[065] MINDSCAPE GALLERY

1521 Sherman Ave., Evanston, IL 60201

Phone: (312) 864-2660 *Hours:* Tue-Sat: 10-6 Thu: 12-9 & by appointment *Owner/Dir:* Ron Isaacson, Deborah Farber-Issacson

Private and corporate collectors have bought from Mindscape Gallery since 1974. Today, Mindscape represents nationally known and emerging artists specializing in contemporary American art and fine crafts, including functional and sculptural studio glass, ceramics, jewelry, fiber and paper wall pieces, woodwares, and metals.

Mindscape's showroom is 4000 square feet, containing art from all over the United States.

Currently Mindscape features the Midwest's largest collection of contemporary designer jewelry and hand-blown art glass. These ongoing presentations are enhanced by four to six major invitational shows per year. Recent exhibits have included Mindscape's well-established "Adornments," "Collectors' Showcase," and "A Gather of Glass." Artists include Catherine Butler, Heinz Brummel, Frank Kudla, Carrie Adell, Thomas Mann, Richard Marquis, Mark Peiser, Steve Maslach, and Chris Hawthorne.

[066] MOMING GALLERY

1034 W. Barry Ave., Chicago, IL 60657

Phone: (312) 472-7662 *Hours:* Mon-Sat: 10-5 Ad Curator: Lys Martin

Part of a dance and art center, Mo Ming Gallery focuses on providing opportunities for contemporary emerging artists while also providing space for special projects by well-established artists. On occasion guest curators are brought in to design shows. The gamut in art can be found here, from performance and video art to installation, painting, prints, and sculpture.

Recent special exhibits included "Visual Art by Performing Artists," which featured works by New York performing artists Meridith Monk, Laury Dean, and Lucinda Childs as well as Chicago's Sharon Evans, Jackie Radis, Shawn Gilmore, Martha Channer, Woody Haid, and Michael Myers. A premiere video work by Ping Chong made up another.

Chicago artists are often exhibited. "Reclaiming Childhood" featured an installation by John Ploof and photographs by Howard Seth Miller. "Detritus," a show made up of performance-art artifacts, contained collection pieces, props, costumes, and backdrops from various performances, many of them by Chicago artists Sharon Evans, James Grigsby, and Lynn Book.

[067] MONGERSON-WUNDERLICH GALLERIES

704 N. Wells St., Chicago, IL 60610

Phone: (312) 943-2354 *Hours:* Tue-Sat: 9:30-5:30; *Summer hours:* Mon-Fri: 9:30-5:30 only *Owner/Dir:* Susan Mongerson, Rudy Wunderlich

A specialist in American art with fifty years in the field, Rudolf G. Wunderlich has worked with major museums and collections nationally. He appraises as much as $300,000,000 in American art annually for private and corporate clients.

Mongerson-Wunderlich maintains inventory in many areas, including the Hudson River School, Ashcan School, Taos Founders, American Impressionist, nineteenth- and twentieth-century Western art, and sporting and marine paintings. The gallery also makes available works from its department of fine prints. Mongerson-Wunderlich claims an outstanding selection of nineteenth-century subject matter including city views, historical events, sporting subjects, and a stock of Currier and Ives.

Beyond providing paintings, prints, and sculpture, the gallery operates *The Country Store,* which features original designs in sterling silver by James Reid of Santa Fe. The store also sells weavings, pottery, twig furniture, plastic purses from the 1950s, antique beaded

purses, eccentric furniture, lamps, and tables from around the world, birdcages, and cowboy chaps. The gallery also offers appraisals, restorations, and framing.

[068] MORE BY FAR

615 N. Wells St., Chicago, IL 60610

Phone: (312) 664-7066 *Hours:* Tue-Sat: 11-8 & by appointment *Owner/Dir:* Kimberlie

While founder Frank A. Rosa no longer runs the operation, his self-taught work as a silversmith established the tone and style that are still in place today. Both a gallery and working studio, More By Far offers artists space to create and sell their pieces. Director Kimberlie is a silversmith who works in ferrous and nonferrous metals. Other artists work in glass, oils, and photography and are provided a place for shooting portfolios.

More by Far's artists demonstrate skill, schooling, and dedication and tout reasonable prices. The gallery also offers tours of studio space and hosts fundraisers for a variety of art- related efforts. Despite its modest attitude, the gallery features the work of internationally known sculptor Lloyd Altea, providing the visitor a choice of granite, marble, slate, wood, and gold-leaf sculpture ranging from realistic to abstract to oriental.

[069] N.A.M.E. GALLERY

700 N. Carpenter St., Chicago, IL 60622

Phone: (312) 226-0671 *Hours:* Tue-Sat: 11-5 *Dir:* Christine Montgomery

One of Chicago's first artist-run alternative spaces, this not- for-profit enterprise is dedicated to innovative and current art. The large renovated-factory gallery appears noncommercial but is equipped to show paintings, sculpture, and installations.

In 1973, eight artists ventured into the organization which has continued to change and develop both in concept and direction. Their goal was to provide a place for art and for artists to interact.

Monthly exhibitions include works by emerging artists, many of whom have gone on to establish solid reputations nationally and internationally. Performance, film/video, panel discussions, slide lectures, and guest speakers are an integral part of the gallery's schedule. Recent exhibitions have included a "Mid- Career Review" by artists Esther Parada and Edith Altman, an exhibition of work by artists working with science, entitled "Colliding Fronts: Art & Science," and a group exhibition of works by collage artists.

[070] ISOBEL NEAL GALLERY, LTD.

200 W. Superior St., Chicago, IL 60610

Phone: (312) 944-1570 *Hours:* Tue-Sat: 10-5 *Owner/Dir:* Isobel Neal

The Isobel Neal Gallery has a special missionto present a variety of original paintings, prints, and sculpture by African- American visual artists in a fashion consistent with other commercial galleries. The Neal Gallery represents a wide range of local Chicago artists, as well as nationally and internationally recognized artists.

The artists who exhibit in the gallery can be separated into two artistic avenues, painting and sculpture. The painters and sculptors shown express a number of artistic styles and schools of thought in their various media. Painters Calvin B. Jones, Willie L. Carter, Mary Reed Daniel, Michael Barlow, John Rozelle, Evelyn P. Terry and Bryan McFarlane, while having their own distinct and individual approaches to painting, are largely conceptual artists expressing their passions in figurative and abstract visual terms. Robert P. Dilworth relies heavily upon formal and traditional figurative based solutions to the visual challenges. The work of Edward Clark and Alonzo Davis is solely devoted to the abstract. The sculptors represented, Geraldine McCullough, Herbert House, Preston Jackson, Muneer Bahauddeen and Ausbra Ford, express the spiritual in their hybrid sculptural forms and mediums. Milton Sherrill's work refers to the spiritual and the African and black American cultural heritage in a formal and traditional approach to sculpture.

The gallery also carries lithographs, collagraphs and silk screen prints by emerging and leading artists, including Romare Bearden, Jacob Lawrence, Charles White, Emma Amos and Jeff Donaldson.

[071] NEEDLMAN GALLERY

1515 N. Astor St., Chicago, IL 60610

Phone: (312) 642-7929 *Hours:* By appointment only *Owner:* Phyllis Needlman

Phyllis Needlman showcases Latin and emerging American artists--works ranging from prints to crystal and wood, floor- and table- sized sculpture to monumental outdoor steel or bronze pieces.

Pedro Friedeberg, one of three Mexican artists featured, supplies the gallery with a variety of work. Pieces include his famous "hand" chair, sculpted airplanes and astrological images, and silk screens. The work of Felicino Bejar stands in contrast to Friedeberg's. A Mexican Indian, he sculpts crystal disks and other crystal pieces. Bejar's forms are organic, and his tapestries and prints made of foil repeat the patterns of microscopic cross sections of trees. Enrica Sebastian constructs monumental painted steel sculpture. The work is geometric, the colors primary. In two dimensions, Needlman has the work of Baruj Salinas and Rufino Tamayo. From Spain, Salinas brings his celestial acrylic paintings. Mexican master Tamayo provides etchings and "mixographs," prints made in a multistepped process. While his early work was characterized by its primitive figuration and rich color ("Tamayo Red," for example), his recent work is more abstracted, with muted colors, though one can always discern a human form.

Nancy Jackson and Klint Houlberg make up the gallery's American contingent, Jackson with her drawings of fanciful figures and Houlberg with his whimsical figures sculpted in wood.

[072] NEVILLE-SARGENT GALLERY

215 W. Superior St., Chicago, IL 60610

Phone: (312) 664-2787 *Hours:* Mon-Sat: 10-5 *Owner:* Jane and Don Neville; *Dir:* Kim Goldfarb

In its fifteenth year of business, Neville-Sargent is a well- regarded gallery in the River North area exhibiting emerging and established artists, both national and international. The gallery specializes in contemporary

painting, sculpture, and mixed-media works, with an increasing emphasis on sculpture.

The gallery shows a large group of painters including Marge Allegretti, Shahla Arbabi, Jay Paul Bell, Glenn Bradshaw, Lamar Briggs, Clint Stoddard, and Mary Jane Schmidt. David Greenwood, David Hayes, Hans Kooi, and Lou Pearson, are among Neville-Sargent's sculptors. Lu Dickens, Susan Dunshee, David Faber, Kim Goldfarb, and Daniel Goldstein provide some of their mixed- media pieces. Not limited in scope, style or medium, Neville- Sargent works with both the individual and corporate client.

[073] NICOLE GALLERY, THE ART OF HAITI

734 N. Wells St., Chicago, IL 60610

Phone: (312) 787-7716 *Hours:* Tue-Fri: 10-5, Sat: 10:30-4:30 *Owner/Dir:* Nicole Smith

Nicole Gallery specializes in the painting and sculpture of contemporary Haitian and African artists. Haitian artists Rigaud Benoit, Wilson Bigaud, Prefete Duffaut, Gerar Valcin, and Pierre Augustin are a group of naive painters who nurture responsibility for defining the culture. Other Haitians, such as Franck Louissaint and Edouard Duval Carrie, are mainly concerned with an exploration of figurative images. A third group, made up of Andre Pierre, Edner St. Hubert, Lionel Laurenceau, and St. Elot, concentrate on biblical themes and other religious subjects.

[074] O'GRADY GALLERIES, INC.

333 N. Michigan Ave., Chicago IL 60601

Phone: (312) 726-9833 *Hours:* Mon-Fri: 9:30-4:30 *Owner:* Jack O'Grady *Dir:* Carol O'Grady

O'Grady Galleries specializes in contemporary American painters and sculptors. In bronze are the small to large (four- foot) figures of George Carlson and animals of Kenneth Bunn. Painters Mark English and Bernie Fuchs provide the gallery with a range of realist works while Martha Slaymaker offers her muted abstracts. Bill Papass' figures are characterized as cartoonish; Peggy Hopper paints images of Hawaiian women. Western painter Paul Dyck is known for his Indian figures. Darine Jellerson (an artist new to the gallery) and Jo Sickert work in primitive/naive modes-to paintings of their people and places.

[075] OBJECTS GALLERY

The gallery was destroyed by fire at press time.

Phone: (312) 664-6622 *Owner:* Ann Nathan; *Dir:* Mary Donaldson

Objects is devoted to the presentation of clay, painted wood, and mixed-media sculpture and furniture.

The artists represented are, in part, young or emerging. Michael Gross, Arnold Zimmerman and Kevin Hanna work in clay, creating pieces that range from visual narratives to colossal vessels. Richard Kooyman uses rich outdoor imagery on his hand-built and hand-painted wooden furniture. Peter Gourfain, though an established artist, comments on the world issues ranging from political upheaval to the environment.

Others represented include Liz Wolf, Karon Doherty, Tom Uebelherr, Don Pollack, Chris Berti, Brian Suave,

Chris Gustin, Lynn Sweet, and Brian Monaghan.

[076] NINA OWEN

620 N. Michigan Ave., Chicago, IL 60611

Phone: (312) 664-0474 *Hours:* Tue-Fri: 10-5, Sat: 12-5 *Owner/Dir:* Nina and Audrey Owen

Nina Owen is one of a rare breed of gallery--it is devoted exclusively to sculpture. The gallery functions as a dealer, an agent pursuing commissions, and a curator for rotating outdoor exhibitions. Specializing in architectural scale outdoor work, the gallery has supervised outdoor exhibitions in Dallas, Indianapolis, and Chicago. They currently represent sixty to sixty-five sculptors, with most of the work being either abstract, minimalist, or conceptual.

From New York come the large-scale aluminum and bronze abstract pieces of Bill Barrett, the minimalist wood works of Tom Doyle, and Casper Henselmann's conceptual pieces made of corten steel. From the west coast, San Francisco's Bruce Johnson is represented with monumental redwood forms reminiscent of Stonehenge. Ed McCullough, from Chicago, has abstract works in corten steel based on natural forms. The almost tree- like, cast bronze pieces of Roger Blakely are also among the works.

[077] PAPER PRESS GALLERY AND STUDIO

1017 W. Jackson Blvd., Chicago, IL 60607

Phone: (312) 226-6300 *Hours:* Tue-Fri: 11-4 & by appointment *Owner/Dir:* Linda Sorkin-Eisenberg, Marilyn Sward

Paper Press was founded to provide working and instructional space for artists interested in experimenting with handmade paper. Special papers for printmaking, watercolor, drawing, calligraphy, and bookbinding are produced together with works using handmade paper as the medium. Special collaborations with artists, intensive workshops, guest lectures, courses, and programs for children are offered throughout the year.

Among the ongoing classes are beginning papermaking, oriental papermaking, three-dimensional papermaking, and techniques in decorative and novelty papers. In addition to offering tours of Paper Press, its artists' spaces, a working studio, and the gallery, Paper Press has an educational video on hand-papermaking and on the operations of this cooperative artists' space and gallery available for school and special groups. As a not-for- profit operation, the gallery secures grants from the National Endowment for the Arts, the Illinois Arts Council, and City Arts.

The gallery at Paper Press features work done in handmade paper or fibers. The gallery is available on a rental basis; shows, usually opening every eight weeks, are selected by an outside jury.

[078] PARENTEAU STUDIOS ANTIQUES GALLERY

230 W. Huron St., Chicago, IL 60610

Phone: (312) 337-8015 *Hours:* Mon-Fri: 10-5, Sat: 10-4, Sun: by appointment *Owner:* Paul A. Parenteau *Dir:* June Hostetter

Parenteau Studios is thirty years old in 1989. The

Lynne Cohen, *Racquet Club,* 20x24, limited edition black and white photograph. Courtesy: Printworks Gallery, Chicago

Keith Downie, *Mourning Beat,* 48x75, acrylic on canvas. Courtesy: Sybil Larney Gallery

business was founded as a drapery and upholstery shop; in late 1985 and early 1986, Mr. Parenteau opened a 4100-square-foot showroom for eighteenth- and nineteenth-century French antiques. Available are commodes, armoirs, mirrors, tables, consols (cornertables), brass candlesticks, and clocks. Also featured are various sets of china, including a twelve-piece tea set.

One can find, displayed in either one of the front bays or the vignettes, unique individual pieces as well as coordinated sets. Mahogany beds and dressers arranged in an enviornment complete with paintings of the furniture's period are available.

While the furniture is French eighteenth and nineteenth century, paintings from earlier periods are also available.

[079] PERIMETER GALLERY
356 W. Huron St., Chicago, IL 60610

Phone: (312) 266-9473 *Hours:* Tue-Sat: 11-5:30 *Owner:* Karen Johnson Boyd *Dir:* Frank Paluch

The Perimeter Gallery carries work by established and emerging contemporary artists, including painting, drawing, prints, and sculpture in both abstract and representational modes.

The work presented by the gallery is eclectic, ranging from figurative drawing and painting by Paul Caster to artist's furniture by Dick Wickman. John Wilde paints highly finished still lifes and personal allegories. Painter and printmaker Warrington Colescott is a social satirist. Figurative ceramic sculptures by Jack Earl and ceramic vessels by Toshiko Takaezu and Harvey Sadow are also featured. Other artists represented include Bruce Metcalf, metalsmithing and drawings; Ken Loeber and Eleanor Moty, jewelry; Walter Hamady, collage/assemblage; Dona Look, birch bark baskets; Keiko Hara, abstract paintings and works on paper; George Wardlaw, large painted aluminum sculpture; and Kathy Holder, pastel drawings.

[080] PRAIRIE LEE GALLERY
301 W. Superior St., Chicago, IL 60610

Phone: (312) 266-7113 *Hours:* Tue-Sat: 10-5:30 *Dir:* Thomas Reilly

Specializing in contemporary American Indian and Southwestern art, Prairie Lee Gallery presents paintings, drawings, graphics, and sculpture in exhibitions that change throughout the year. Indian artists include Bob Haozous, Frank Bigbear Jr., David Bradley, Roger Broer, Walt Wooten, and Theodore Villa. Southwestern artists include Stephen Rosser, Russel Hamilton, Rhett Lynch, Frederick Prescott, Howard Hersh, Patrick Coffaro, Jeff Sippel, Steve Britko, Howard Post, Bill Schenck, Nicole Christenson, and Frank Romero, with ceramic vessels by Andrew Baird.

The gallery also presents Pueblo Indian potter, Southwestern and Navajo textiles, folk carvings from New Mexico, and Southwestern and American Indian jewelry. The inventory of pottery includes works by Jody Folwell, Polly Rose Folwell, Dorothy Torivio, Rebecca Luccario, Ray Tafoya, LuAnn Tafoya, Robert Tenario, and Effie Garcia. The carvings of Jim Davila are featured among the textiles.

[081] PRESTIGE GALLERIES
3909 W. Howard St., Skokie, IL 60076

Phone: (312) 679-2555 *Hours:* Mon-Wed: 10-9, Sat-Sun: 11-5:00, Thu-Fri: by appointment *Owner/Dir:* Bernard & Betty Schutz, Louis Schutz

Located in a modest section of Skokie, this family-run gallery offers three floors of paintings, prints, sculptures, and assorted *objets d'art*.

When it opened more than twenty-five years ago, the gallery dealt exclusively in eighteenth- and nineteenth-century art. Today the "museum" on the gallery's lower level carries an extensive collection of antique paintings. The mostly romantic, narrative canvases are painted by such artists as Harry Campotosts, Arthur Trevor Haddon, James Thom, G. Sheridan, C. Payan, Luigi Zuccoli, P. Fligny, and several Dutch masters. The gallery also features a host of bronzes and other objects.

The first-floor gallery features contemporary work, particularly original graphics and painting. The graphics collection, by Louis Schutz,includes works by Erte, Thomas McKnight, Norman Rockwell, Leroy Nieman, Yamagatta, Alvar, Altman, Alvarez, and Young, among others. Most of the original oil paintings are figurative, with many contemporary impressionistic talents, too. A few of the better-known names are Jacques LaLande, Karin Schaefers, Dennis Lewan, and Lawrence. The soft impressionistic works of Edna Hibel are given a special space in the gallery.

Prestige is the exclusive agent for "The Surrealistic World of Tito Salomoni," presenting his internationally known paintings, prints, and bronzes. The gallery also handles Erte bronzes, as well as graphics, posters, and jewelry by the French art nouveau designer.

A gallery on the upper floor houses a private collection that ranges from museum-listed antique paintings to works by contemporary masters. Louis Schutz also offers a new graphic broker service to locate nearly any work of art.

[082] PRINCE GALLERY
357 W. Erie St., Chicago, IL 60610

Phone: (312) 266-9663 *Hours:* Mon-Sat: 10-5 *Owner/Dir:* Marilyn Forbes

Focusing on seventeenth-, eighteenth-, and nineteenth-century European art, Prince Gallery offers both painting and sculpture from these periods. Paintings run the gamut from portraits to cityscapes, animals, landscapes, and seascapes. Among the seascape artists are Peter Monany, who exhibited in European museums from 1681 to 1749, and Gustave de Breanski, who from 1856 to 1898 exhibited in European museums as well. Among other notables are nineteenth-century painters Gene Baptiste, Henri Durand-Brager, and George Callow, famous for his ship portraits.

While the gallery concentrates on works from the earlier centuries, two contemporary Chicago painters are also represented. Winiford Godfrey is noted for her flower painting while Herbert Davidson offers his Southwestern oils.

[083] PRINTWORKS GALLERY

311 W. Superior St., Suite 105, Chicago, IL 60610

Phone: (312) 664-9407 *Hours:* Tue-Sat: 11-5 *Owners:* Sidney Block, Bob Hiebert

Printworks is primarily a works on paper gallery that specializes in contemporary prints, drawings, photographs, and artists' books. Established in 1980 and a member of the Chicago Art Dealers Association, the gallery serves collectors, corporations, museums, universities, and the general public.

Although some of the more than forty artists represented by Printworks are from the Chicago area, the gallery handles works by East Coast and West Coast artists, too, as well as some from Canada, Great Britain, and Italy.

Major artists represented by Printworks include Leon Golub, Ellen Lanyon, Philip Pearlstein, Vera Berdich, Robert Heinecken, Berenice Abbott, Hollis Sigler and Seymour Rosofsky. Other well-known artists include Ray Martin and Ray George, both of whom have received major National Endowment for the Arts awards; Scott Mutter, a master of photomontage; and photographer Lynne Cohen, whose unoccupied rooms are filled with ironies and oddities.

Printworks showcases emerging artists, including photographers Elio Ciol, Pepi Merisio, Anne Fishbein, Jane Calvin, Karen Savage, and Gail Kaplan; bookmakers Jim Koss and Audrey Niffenegger; and graphic artists Dan Leary, Hugh Merrill, Marvin Lowe, Doug Huston, Fred Wessel, Leslie Dahlgren, and Alan Larkin.

[084] RAMSAY GALLERY

212 W. Superior St., Suite 503, Chicago, IL 60610

Phone: (312) 337-4678 *Hours:* Tue-Sat: 10-6 *Owner:* Roger Ramsay

Providing an alternative to the New York scene, Ramsay Gallery introduces reknowned Europeans who still need exposure in America. Though it concentrates on painting and works on paper, the gallery also displays sculpture and prints. All the artists are contemporary and, whether European or American, have established themselves in their genre.

Ramsay Gallery's offerings range from figures to landscapes to abstracts. Herman Albert, working and teaching in Berlin, paints in something of a classical mode. He works in a highly structured symbolism, and his figures are monumental in scale. His student Stephanus Heidacker also works with symbols and the themes of mother and child but in a less structured manner. His figures are more distorted, with objects suggesting not so much a symbolic narrative as creating a mood. Landscape paintings are represented by Keith Jacobshagen's *Big Sky,* pieces of Nebraska landscape (or, rather, skyscape); Elen Feinberg's Southwest desert scenes, and Peggy Macnamara's botanical images. Richard Sheehan provides thickly painted abstract landscapes of highway overpasses.

Works on paper feature Hannelore Baron's collages of fabric, paper, and string as well as Fulvio Testa's small watercolors of Italian landscapes. Robert Bourdon provides the gallery with his wall-mounted tinted wood carvings, while John Pittman works with natural and painted wood to create both free-standing constructions and shadow boxes.

Recent exhibitions showcased work of photorealist painters Robert Cottingham and Randy Dudley. Cottingham, famous for his paintings of signs, particularly neon signs, recently featured new paintings of the sides of boxcars. Randy Dudley exhibited both drawings and paintings. He renders urban landscapes with a high degree of realism; recently featured was his last series of a canal in New Jersey at different times of the day.

Other recent exhibitions include the semiabstract night scenes with fire by Leslie Lerner and the large paintings and works on paper by internationally known Per Kirkeby.

[085] RANDOLPH STREET GALLERY

756 N. Milwaukee Ave., Chicago, IL 60622

Phone: (312) 666-7737 *Hours:* Tue-Sat: 12-6 *Ex Dir:* Peter Taub

Randolph Street Gallery is a multidisciplinary arts organization dedicated to new and innovative art. Gallery programs include monthly exhibitions; weekly time-arts events like performance art, videos, films, literature, and music; publications and forums held in conjunction with exhibitions or time-arts events; and a re- granting program which funds interdisciplinary artists' projects.

Randolph Street Gallery is also an information source for artists, curators, and other members of the art community. The gallery supports young artists and more established artists working on experimental projects. Program committees of artists and arts professionals, receiving proposals from artists in all media, select artists and develop curatorial themes. The committees stress the relation of art and artmaking to culture and current cultural issues.

Some noteworthy events have been a public projection by Polish- born artist Krzysztof Wodiczko; WOA, a performance series that explored artists' reactions to AIDS; "Out of Eastern Europe," an exhibition of photography by "unofficial" artists in Eastern Europe; and "The Whole World Is Still Watching," an invitational exhibition commemorating the twentieth anniversary of the 1968 Democratic National Convention in Chicago. The spring of 1989 marks the gallery's tenth anniversary.

[086] REZAC GALLERY

301 W. Superior St. Second Floor, Chicago, IL 60610

Phone: (312) 751-0481 *Hours:* Tue-Sat: 11-5 *Owner/Dir:* Susan Rezac

A goldsmith herself, owner/director Susan Rezac presents the exploratory edge in avant-garde jewelry. Finding her artists in Europe and the United States, she represents both well- established and emerging artists. The scope of the gallery is not limited to jewelry, however. Fascinated by the gray area between decorative art and fine art, Ms. Rezac displays decorative pieces, fine art, and works that resist either label. During the year she alternates between group and individual exhibitions.

From the United States, jeweler Joan Parcher works

with a system of enameling and a unique sense of color to create intimate, sensitive pieces. Kevin Maginnis, an up-and-coming American artist versed in all media, produces installation pieces, paintings, and sculpture (his primary medium) that explore scientific themes. His work will be featured in a solo show in January and February of 1990. Sheila Klein is a sculptor of a different ilk. Traditionally, jewelers look to sculpture for inspiration. Klein turns the table, making ornaments based on jewelry, rings, bracelets, and necklaces--for buildings. An exhibition of her work is planned for September and October of 1989.

Three European goldsmiths were recently featured in solo exhibitions and are represented by the gallery. Otto Kunzli produces highly conceptual pieces in both sculpture and wearable art. His armpiece *Gold makes blind*, for example, hides a gold ball in a matte-black rubber tube. Daniel Kruger utilizes a variety of materials, from tin to gold to found objects, in pieces that range from organic to architectural. Gerd Rothman also combines conceptual and tactile concerns in his work, etching his geometric shapes with random fingerprints.

Other artists represented include sculptor Jacqueline Ott, Taro Suzuki, Lldebrando, Gabriele Dziuba, Bruno Martinazzi, and Cindy Bernard.

[087] RIZZOLI GALLERY
Water Tower Place, 835 N. Michigan Ave., Chicago, IL 60611

Phone: (312) 642-3500 *Hours:* Mon-Sat: 10-10, Sun: 10-8 Mgr: Steven Schulze

Located inside Rizzoli Bookstore, Rizzoli Gallery is housed in a simple, low-ceilinged exhibition room. The art is usually tied to promotions in the bookstore (Rizzoli publishes books as well as sells them) or is especially significant to Chicago culture. The gallery shows many photographers, ranging from international masters to local talent. Other than works by Santi Visalli, whose photography is on permanent display throughout the store, only works currently in exhibition are inventoried and available to the public. Featured in the past have been Ruth Orkin, O. E. Goldbeck, Monte Nagler, Jaye King, and Emily Grimes. After several successful shows, painter Nancy Swan is a frequent Rizzoli attraction.

On occasion work by designers and graphic artists is shown. Exhibitions have included "Made in Chicago," a collection of phantasmagoric lamps, furniture, and paintings by Corky Neuhaus; and Paul Punke's *trompel'oeil* style paintings and unique designs.

[088] BETSY ROSENFIELD GALLERY
212 W. Superior St., Chicago, IL 60610

Phone: (312) 787- 8020 *Hours:* Tues-Fri: 10-5:30, Sat: 11-4:30 *Owner/Dir:* Betsy Rosenfield

Founded in 1980, this diverse contemporary art gallery is notable for auspicious exhibitions of glass and photography. Its painting and sculpture exhibition schedule features both national and international artists.

Among the Chicago artists represented by the gallery are Neraldo de la Paz, whose most recent works address moral and social issues using Christian iconography and erotica to pose questions about contemporary culture, and Don Baum, who has exhibited widely since the 1950s and is known for his constructions of houses from found objects: paint-by-number imagery, linoleum, and vintage cartoon characters. The disjunctive narratives created by these sculptures invite interpretation.

Painting and sculpture exhibitions have included works by New York based artists Gregory Amenoff, Alphonse Borysewicz, Adam Cvijanovic, Martha Diamond, Jane Dickson, Jack Gilbert, Robert Greene, Roberto Juarez, Wade Saunders, and Chihung Yang. Others represented are David Bates, Joseph Piccillo, Leo Sewell, and Italo Scanga.

Summer group shows of Chicago's emerging artists, such as the 1988 Photoshow, spotlight unrepresented artists working within a particular theme or medium. Additional photographers represented include Jan Groover, Francois Robert, and Robert Mapplethorpe, all of whom have exhibited internationally.

Glass artists include Hank Murta Adams, William Carlson, Dale Chihuly, Dan Dailey, Bernard K'-Onofrio, William Morris, Joel Philip Myers, Michael Pavlik, Bertil Vallien, Steven Weinberg, and Toots Zynsky. The works range from blown glass--small, nonfunctional vessels and large, complex groupings--to cast glass in geometric or representational shapes. The gallery also represents ceramic artists Tom Rippon and Peter VandenBerge.

[089] J. ROSENTHAL FINE ARTS, LTD.
212 W. Superior St., Suite 200, Chicago, IL 60610

Phone: (312) 642-2966 *Hours:* Tue-Fri: 11-5, Sat: 12-5, *Owner:* Dennis Rosenthal *Dir:* Ruth Hall Daly

The focus of Rosenthal Fine Arts is on painting and works on paper by contemporary artists. The majority of the artwork shown is figurative with an inclination toward realistic representation. Artists included in this group are Robert Birmelin, Bernard Chaet, Manon Cleary, Don Cooper, John Deom, Martha Erlebacher, Sidney Goodman, Dan Gustin, James McElhinney, Mark Stock, Harold Sudman, and Dennis Wotjkiewicz. Kim Mendenhall concerns herself with elaborate still-life painting while Cathryn Murphy is known for her exquisite interiors and landscapes. A second group of artists--Debra Weir, Cindy Kane, David Geiser, and Richard Sedivy--deal with elements of representational or symbolic abstraction. Conceptual artist Dan Kaplan is also exhibited.

The inventory includes multiples and original works by such major artists as Claes Oldenburg, Andy Warhol, Robert Rauschenberg, Larry Rivers, and David Hockney.

[090] ESTHER SAKS GALLERY
311 W. Superior St., Chicago, IL 60611

Phone: (312) 751-0911 *Hours:* Tues-Sat: 10-5 *Owner/Dir:* Esther Saks

Focusing for the past five years on fine art made from craft material, the gallery has recently widened its scope to include painters with an emphasis on figurative work. Content and accessibility are stressed in both areas.

Large spiritual figures and heads are made by ceramicist Daniel Rhodes. Other sculptors working with clay are Richard Notkin, Christine Federighi, Ken Ferguson and Robert Speri, while Amanda Pierce and Janusz Walentynowicz work with cast glass.

Karen Gunderman's large-scale wall reliefs refer to the architecture and landscape of Bolivia, while Pia Stern's richly layered paintings host images that emerge and recede as if in a dream. Jennifer Berringer creates large, surreal monotype collages, while the oil pastels and watercolors of Phyllis Plattner are photorealistic. Expressive figurative paintings are done by Bill Albright and William Hawk, while Jim Bird and Judy Foosaner work abstractly.

Additional artists featured include Paul Soldner, Indira Johnson, Freitas Johnson, Christopher Davis Benivedes, Philip Cornelius, Bennett Bean, Beverly Mageri, Yih-Wen Kuo, Mike Moran, Judy Kasen, and Harris Deller.

[091] SAZAMA/BRAUER GALLERY

The gallery was destroyed by fire at press time.

Phone: (312) 787-1884 *Dir:* Susan Sazama, Charlotte Brauer

After eight years as an art dealer and consultant in Indiana, Charlotte Brauer teamed up with Susan Sazama to codirect the gallery. Located in the River North neighborhood, the gallery exhibits the paintings, drawings, and sculpture of some thirty American artists from across the country. Conceptual realism is the primary direction of the gallery, although abstract, expressionist, and surrealist works are also exhibited.

Outstanding among the gallery's realist artists is Aaron Bohrod. His works are in most major museum collections in the United States, and the gallery features his early social realist paintings as well as his present *trompe l'oeil* paintings. Other realist works exhibited are the *trompe l'oeil* painted constructions of Ron Issacs, the still-life watercolors of John Bayalis, and the architectural watercolors of Sheldon Helfman. The pastel landscapes of Jane Everhart and Nancy Newman Rice emphasize line and pattern.

Sculptor Elaine Danzig portrays the human image in both terra cotta and bronze.

Two Chicago artists, Susanna Coffey and Marilyn Propp, exhibit expressionist work in the gallery. Coffey's large canvases, painted with thick, gestural strokes, are inspired by Greek mythology; Propp's pastel drawings of figures explore the mystery and power of human emotion. A rich, jewel-like palette and convincing sense of space characterize the abstract works of Jil Evans, while Barbara Jaffee executes abstract painting on a three-dimensional surface. Georgia Strange's sculpture explores the idea- matter of human existence. Richard George, Joel Pace, Sandra Perlow, and Christine Perri work in a surrealist style.

[092] THE SCHOOL OF THE ART INSTITUTE OF CHICAGO COLUMBUS DRIVE GALLERY

Columbus Dr. at Jackson Blvd., Chicago, IL 60603

Phone: (312) 443-3703 *Hours:* Mon-Sat: *Hours:* Mon-Wed, Sat: 8:30-4:30, Thu: 8:30-7:45, Sun: 12-5 *Owner:*

Art Institute of Chicago *Dir:* Joyce Fernandes

The School of the Art Institute of Chicago (SAIC) Gallery presents works by students and faculty of this distinguished art school, as well as special exhibitions. A stream of imaginative and experimental works fills the light, airy space adjacent to the Art Institute. Entrance is easiest through the Columbus Drive East Wing--the gallery lies past the Louis Sullivan Trading Room. The gallery was established in 1976. The exhibitions are curated jointly by the director and a faculty committee. Although many exhibitions draw on the talent that abounds in the school's studios, some bring in work from outside the institute. Curated by two faculty members, Park Chambers and Marilyn Houlberg, a recent exhibition highlighted voodoo ritual objects from Haiti. The objects, predominantly sequined flags, calabash rattles, crosses, and dolls, were displayed in the fashion of a museum, to better show their functions in voodoo rituals.

[093] THE SCHOOL OF THE ART INSTITUTE OF CHICAGO GALLERY 2

1040 W. Huron St., Chicago, IL 60622

Phone: (312) 226-1449 *Hours:* Tue-Sat: 11-6 *Dir:* Joyce Fernandes

Located in what some call Chicago's alternative gallery district--west of River West and River North--the SAIC Gallery 2 focuses on the work of Master of Fine Arts degree candidates at the School of the Art Institute of Chicago. Small group shows are selected by a faculty committee and Chicago curators, dealers, or critics.

The Institute's excellent MFA program is highlighted at Gallery 2. While traditional media may be used, Gallery 2 is a place where new idioms are being forged and honed by public exposure. Performance, film, and video art are regularly scheduled.

The gallery is staffed by graduate students.

[094] LLOYD SHIN GALLERY

300 W. Superior St., Suite 203, Chicago, IL 60610

Phone: (312) 943-0064 *Hours:* Tue, Wed, Sat: 10- 5:30, Fri: 10-7 *Owner:* Lloyd Shin *Dir:* Roberta Milston

Lloyd Shin Gallery specializes in international modern and contemporary artwork with galleries in Chicago and Seoul, Korea. While showing paintings, prints, drawings, and sculpture by renowned artists, Shin Gallery also promotes young artists who have yet to achieve worldwide recognition.

Shin Gallery features works from both East and West in a variety of styles and schools. Master works by such well-known artists as Joan Miro and Henry Moore are exhibited regularly. Introducing prominent Korean artists to America, the gallery highlights among others painter Nam Kwan.

Lloyd Shin Gallery was commissioned to assemble a series of fine- art prints to tour one-hundred cities in commemorating the 1988 Olympic Games in Seoul. Twenty-four world-renowned artists were chosen from fifteen countries for this project.

Among the works at Lloyd Shin are pieces by Rufino Tamayo, Christo, Jim Dine, Mimmo Paladino, Nam Kwan, and A. R. Penck.

[095] SKOKIE PUBLIC LIBRARY GALLERY
5215 Oakton St., Skokie, IL 60077

Phone: (312) 673-7774 *Hours:* Mon-Fri: 9-9, Sat: 9- 5, Sun: 1-5 *Coordinator:* Lydia Stux

Part of the Skokie Public Library, the gallery is an extension of the library's mission to provide cultural and humanities programming to Chicago's northern suburbs. With lobby space and a showroom, the gallery offers a flexible setting for its ongoing exhibits, with sculptural works appearing in the lobby, hanging from the ceiling, on pedestals, and in cases.

Exhibits fall into three categories, the first being individual artists--primarily painters, photographers, and artisans. For example, one exhibition featured the irridescent nonfigurative panels of Jim Chlopecki. More recently an exhibition showcased the photographs of Chiam Kanner, one of only a few Hasidic artists. Sandra Newbury provided the gallery with her large (30 by 40 inch) nonfigurative photographs. Using a range of camera movements, her photographs of everyday objects and scenes are studies in light and texture.

The second category is made up of traveling exhibitions. "An Exhibition on Vision," organized by Forecast in cooperation with the Minnesota Museum of Art, featured works made by visually disabled artists. A second such traveling exhibition, sponsored by the Illinois Arts Council, displayed a retrospective of the photographs of Chicago journalist Mickey Pallas from 1945 to 1960.

A third group of exhibitions showcases local arts organizations. The gallery put on the premiere of the Hmong Folk Art Center, a group of female Laotian artists. The women, working in fabric in *pandau,* a mix of embroidery and applique, create figurative narratives based on life experiences, often of their plight as refugees, as well as geometric and pattern images. Other exhibited groups include the Skokie Art Guild, the Skokie Photographic Society, the Skokie Fine Arts Commission, and Skokie schools.

Unlike commercial galleries, the Skokie Public Library is likely to represent a broad range of art exhibits from natural history to contemporary works to children's exhibits.

[096] STATE OF ILLINOIS ART GALLERY, CHICAGO
100 W. Randolph St., Suite 2-100, Chicago, IL 60601

Phone: (312) 917-5322 *Hours:* Mon-Fri: 10-6 *Adm:* Debora Donato

The State of Illinois Art Gallery features changing exhibitions of both historic and contemporary Illinois art. To promote an awareness of the variety of art found and produced in Illinois, the gallery's exhibits include a wide range of art media--painting, sculpture, drawing, printmaking, video, ceramics, photography, and textiles--by "blue chip" artists and those less well known.

Located in the State of Illinois Center, three large galleries and two smaller ones provide space for a diverse exhibition program. Curators present group shows, theme shows, and retrospectives. Each show becomes part of a series of traveling exhibits that tour the state, including stops in the Illinois State Museum and its satellite museums. The shows are often made up of work from both museum collections and private collections.

The State of Illinois Art Gallery is the only gallery in Chicago whose sole purpose is to exhibit Illinois art both past and present.

[097] SAMUEL STEIN FINE ARTS
620 N. Michigan Ave., Chicago, IL 60611

Phone: (312) 337-1782 *Hours:* Mon-Fri: 10-5:30, Sat: 10:30-5 *Owner/Dir:* Samuel Stein

Initially Stein Fine Arts placed its emphasis on twentieth- century graphics. While still housing aquatints, etchings, lithographs, and serigraphs, the gallery also carries paints and sculpture. Most of the relatively few works on display are by the masters, though young and lesser-known artists are represented.

Original graphics by such major artists as Chagall, Miro, Picasso, Moore, Motherwell, Renoir, Magritte, and Marini are part of the gallery's inventory. Other graphic pieces by Botero, Baynard, and Carol Summers are also carried. Painters include John Caster, Steven Kozar, and Doug Hatch, while sculptor George Segal provides the gallery with his famous plaster-of- paris figures. Also available are works by Trova and the painted, squared-aluminum shafts of sculptor John Henry.

Recent quarterly exhibitions included Wesselmann's serigraphs, paintings, and laser-cut steel pieces (among them *Bedroom Blonde.*) Other recent shows have featured paintings by Paul Jenkins, an American abstract artist who, using veils of overlapping color, creates vivid abstractions suggesting both chance and control; works by Chagall, and paintings by Svehla.

The gallery is uncluttered and has an inviting atmosphere. Browsers are welcome, although of course one must request to see items not on display.

[098] GALLERIES MAURICE STERNBERG
111 E. Oak St., Chicago, IL 60611

Phone: (312) 642-1700 *Owner:* M. Sternberg *Dir:* J. Sternberg

Specialists in American and European painters of the nineteenth and twentieth centuries, Galleries Maurice Sternberg has been likened to a small museum. Impressionist schools from Europe and America are especially well represented.

The gallery carries French paintings by George Stein, Victor Gilbert, Henri Martin, Firmin-Girard, and Lhermitte, with scenes of Paris boulevards by Edouard Cortes and Eugene Galien Laloue. The gallery is also a source for French Impressionist Henri Le Sidaner, famous for his paintings of Versailles.

The American collection includes *The Shoeshine Boy* by John George Brown and paintings by Edward Potthaste, including *The Blacksmith.* Other American artists include Harry Roseland and Reginald Marsh.

[099] STRUVE GALLERY
309 W. Superior St., Chicago, IL 60610

Phone: (312) 787-0563 *Hours:* Mon-Fri: 10-5:30, Sat: 10-5:30 *Owner:* William Struve *Dir:* Keith Struve

A large gallery with five public exhibition spaces as well

Jane Everhart, *Field Across from the Chorten*, 28x40, pastel on paper. Courtesy; Sazama/Brauer Gallery

William Quinn, *In The Garden,* 48x34, oil on canvas. Courtesy: Sazama/Brauer Gallery

as private viewing spaces, Struve Gallery focuses on American works of the twentieth century, although work from the Soviet Union is also represented. The American work is dominated by contemporary paintings, drawings, and sculpture, pieces from the American avant-garde of the thirties and forties, and twentieth-century American architectural and decorative arts. Most of the work is by established artists.

Contemporary art is represented by Midwestern realist landscape painters James Butler, Tom Uttech, and James Winn as well as Bay Area artists Robert Arneson, Roy de Forest, and William T. Wiley. Also known as "California Funky," the pieces fall somewhere between representational and abstract painting. Pieces of the avant-garde include the hard-edged geometric abstractions of Burgoyne Diller, Byron Browne, and John Sennhauser. Turn-of-the-century architectural and decorative art includes drawings, leaded glass windows, and furniture designed by Gustav Stickley, Frank Lloyd Wright, and Louis Sullivan. Recent exhibitions included a retrospective of paintings and drawings by John Sennhauser and objects by Frank Lloyd Wright for sale, among them architectural renderings and a dining room set of table and chairs.

In their first showing outside the USSR, Soviet artists Grisha Bruskin and Dimitri Prigov supply the gallery with their paintings and drawings. Generally the works are representational, with Bruskin's drawings continuing the Judaic visual tradition.

[100] TOWER PARK GALLERY

4709 N. Prospect Rd., Peoria Heights, Il 61614

(309) 682-8932 *Hours:* Tue-Fri: 10-6, Sat: 10-5. Sun: 1-5, *Owner/Dir:* Jacqueline Buster

Twentieth-century painting and graphics, primarily in representational modes, are Tower Park's specialty. Artists include American realists Robert Kipniss, Harold Altman, Philip Pearlstein, and Randall Higdon. Kipniss is known for his landscapes. Altman, in his small-format, impressionistic lithographs, demonstrates a precise and luminous modeling of volume with hatched lines. His color lithographs, notably of park scenes, continue his preoccupation with light. Chicago artist Susan Hunt-Wulkowicz works in graphic media, creating imaginary landscapes and interiors in a realist style. The expressionistic works of Tho Kapheim, whose pastel drawings portray figures and animals in the same settings, are also featured.

[101] UPSTART GALLERY

1712 N. Halsted Ave., Chicago, IL 60614

Phone: (312) 266-1230 *Hours:* Tue-Fri: 12:30-8, Sat & Sun: 1-5 *Owner/Dir:* Suzanne Musikantow, Susan Berman

Upstart Gallery is dedicated to the works of cutting-edge Chicago artists. The gallery features nonobjective, original pieces by about fifteen artists in a number of media, including oils, watercolor, acrylics, pencil, paper collage, sculpture, ceramics, and mixed media. Works range from dramatic black-and-white ceramics to large, boldly colored oils to the delicate colors of paper collage and oil pastel works.

Upstart looks for inspiring, provocative, or amusing works. The gallery's clean-lined, casual atmosphere encourages browsing by beginning art enthusiasts as well as serious collectors.

A recent exhibition was divided roughly into four groups. The first group included work by Joseph Folise, Mary Reed Daniel, Lois Coren, and Caroline Bagenal with pieces concerned with archeology and with African, Indian, and Haitian cultures. The second group, consisting of Deborah Gadiel, Ghita Hardimon, Joe Rodgers, Dawn Agostinellis, and Mary Ann Contro, investigated geometric forms and spacial relationships as they move.

Robert Klunk, Inese Liepins, Kathy Chan Barnes, Bill Hattendorf, Jay Schiff, and Fern Samuels provided work concerned with objective and nonobjective studies of nature, outer space, and natural phenomena. The last group focused on fantasy, relationships, and historical imagery. Included were Diane Grams, Floyd Gompf, Lenore Sollo, George Ronsholt, Jeff Moore, Phyllis Edelstein, B. J. Cohen, and James Petran.

[102] VAHLKAMP & PROBST GALLERY, INC.

620 N. Michigan Ave., Suite 320, Chicago, IL 60611

Phone: (312) 440-0900 *Hours:* Mon-Sat: 11-5:30 & by appointment *Owner/Dir:* Nicholas Vahlkamp, Kenneth A. Probst

Vahlkamp and Probst Gallery deals in rare and unique works, with particular expertise in late nineteenth- and early twentieth-century American painters, expatriate American painters, and European painters of the Munich, Berlin, and Vienna Secession. The gallery also is interested in symbolist painters of France and Belgium, as well as French, German, and Italian post-impressionists.

[103] VAN STRAATEN GALLERY

The gallery was destroyed by fire at press time.

Phone: (312) 642-2900 *Owner/Dir:* Wiliam van Straaten

Van Straaten Gallery has original prints and works on paper, as well as contemporary paintings, from more than 500 artists. A wide variety of styles and statements can be found by these nationally and internationally known artists. Works by some new and relatively unknown artists are also exhibited.

Van Straaten carries works by such major artists as David Hockney, Jasper Johns, Helen Frankenthaler, Jim Dine, Robert Motherwell, Claes Oldenburg, James Rosenquist, Pat Steir, T. L. Solien, and Robert Rauschenberg, whose work has been called a wrecking ball to the traditions of painting.

Recent shows include the postmodern, multipaneled prints and paintings of Soviet artists Komar and Melamid. Highly intellectual, the pieces are a parody of social realism with an undercurrent of the artists' deeply felt and deeply suffered vision of history. Also of note was an exhibition of the abstract paintings of Michele Stuart which take as their subject and material the natural world.

[104] RUTH VOLID GALLERY, LTD.

225 W. Illinois St., Chicago, IL 60610

Phone: (312) 644-3180 *Hours:* Mon-Fri: 9-5, Sat: 11- 4
Dir: Susan Meneley

Located in the River North area, Volid Gallery was a pioneer in the art consulting field and has been in business for nearly twenty years. The gallery caters to architects, designers, and corporations, selecting or supervising work for buildings and site-specific commissions. The gallery's resources extend to some 200 artists from all over the world. Projects have included the Chicago Hilton and Tower, the Marriott Lincolnshire Resort, the John F. Kennedy Medical Center, and United States Gypsum Co.

Sculpture, murals, paintings, mixed-media pieces, and photographs are among the works the gallery offers. Berit Engen creates tapestries with lyrical Nordic themes. Mark Balma executed a fresco entitled *The Mediatrix* for the new theatre complex at St. Mary's College in Winona, Minnesota. Measuring 14 by 50 feet, the fresco employs early Renaissance traditional techniques and materials. Sculptor John Barlow Hudson created two large-scale sculptures in stainless steel for World Expo '88 in Brisbane, Australia: *Morning Star,* a mirror stainless and *Paradigm,* standing one-hundred feet and incorporating computerized lights. A new artist for the gallery, Sally Weber produces site-specific works in holography.

[105] WALTON STREET GALLERY
58 E. Walton St., Chicago, IL 60611

Phone: (312) 943-1793 *Hours:* Mon-Thu: 10-7 Fri & Sat: 12-8 Sun: 12-6 *Dir:* Robert Patrick

Walton Street Gallery features paintings, sculpture, art-to-wear, and limited edition graphics by contemporary international artists. Representing more than a hundred artists, the gallery focuses on about twenty each month. Owned by Circle Fine Art Corporation, a publicly held company, the gallery also holds philanthropic events.

A broad range of genres and media is represented. Optical and kinetic pieces are created by artists Vasarely and Agam. Calman Shemi, one of Israel's most respected artists, provides the gallery with his "soft paintings," brightly colored collages of fabric, many based on his personal experiences as a member of Kabbutz Carmia. Animation is displayed by Disney Studios, Chuck Jones, and Friz Freleng. Artists who express themselves in the naive manner are Jan Balet, Judith Bledsoe, Beryl Cook, and Carol Jablonsky, an artist who works in watercolor, etchings, drypoint, lithographs, and casein tempera painting. The Vietnamese, Paris-based artist Lebadang creates limited edition sculpted paper collages with etching and watercolor.

[106] WORTHINGTON GALLERY
620 N. Michigan Ave., Chicago, IL 60611

Phone: (312) 266-2424 *Hours:* Tue-Sat: 10-5:30
Owner/Dir: Eva-Maria Worthington

Showing international artists exclusively, the gallery's twentieth-century styles come in several media, mostly paintings, drawings, and prints.

German Expressionism is a strong area of interest at the gallery, particularly works by artists associated with the Blaue Reiter group. Founded by Wassily Kandinsky, Franz Marc, Gabriele Munter, August Macke, and Alfred Kubin, this group showed works by many European artists in its exhibitions, including French colorist Robert Delaunay, before disbanding during the First World War, following the deaths of Marc and Macke. Among the one-man shows at the gallery have been Beckmann, Klee, Kandinsky, Kirchner, and Dix.

The gallery also carries sculpture by the expressionists. Contemporary artists shown include German artist Horst Janssen, whose books, drawings, graphics, and posters are in a New Expressionist style; Ynez Johnston, sculpture, paintings, and graphics; Hildegard Auer, oil painting; Marc Velten, watercolors; and Paul Fontaine, abstract paintings and drawings.

[107] MICHAEL WYMAN GALLERY
750 N. Orleans Ct., Chicago, IL 60610

Phone: (312) 787-3961 *Hours:* Mon-Sat: 12-5:30

Wyman Gallery is perhaps Chicago's only specialist in primitive art: the traditional arts of tribal Africa, Oceania, and Southeast Asia. Exhibitions range from ancestral fetishes of nineteenth century Zaire and Dogon sculpture from archaic Mali, to Thai archeological bronzes and Batak divination staffs.

The gallery's modern layout and design could make the visitor rethink his or her sense of artistic sophistication: arrayed against severe white walls and isolated on a pedestal, each sculpture creates its own air of the world from which it belonged. Mute testimony to other ways of seeing and understanding the world, the objects reveal an art of ceremonial purity energized by ritual and myth.

A reference library aids in research, documentation, and informal discussion with clients. The gallery provides appraisal, authentication and consulting.

[108] YOLANDA GALLERY OF NAIVE ART
300 W. Superior St., Chicago, IL 60610

Phone: (312) 664-3436 *Hours:* Tue-Sat: 10-5:30 & by appointment *Owner/Dir:* Yolanda Saul

Yolanda Gallery of Naive Art specializes in twentieth-century naive--untrained and unschooled--and folk painters from America, Europe, and Asia.

The featured artists work in fabric, carved wood, oil on canvas, watercolor, acrylic on canvas and board, and mixed media collage and assemblage. The collection includes decorative and "outsider" (also known as "Art Brut") pieces depicting such subjects as work and leisure on farms and in villages and cities; animal imagery; biblical, mythological, legendary, and personal allegories; and fantasies and memories. Artists include Andre Duranton, Josephus Farmer, Cilly Gascard, Marcia Muth, Low O'Kelly, Julian Parada, and Judith Neville. A catalog with resumes of the artists is available.

Also featured are the Jinshan Peasant Painters of the People's Republic of China. Their colorful paintings portray modern rural life in China. The gallery also handles ceramics by Picasso, who was powerfully influenced by primitive and folk art.

[109] DONALD YOUNG GALLERY

325 W. Huron St., Chicago, IL 60610

Phone: (312) 664-2151 *Hours:* Tues-Fri: 10-5:30, Sat: 11-5:30 *Owner/Dir:* Donald Young

Recently relocated to an elegantly spare space, Donald Young Gallery features contemporary art, primarily sculpture. Focusing on minimal and conceptual work, its internationally known stable includes Bruce Nauman, known for his neon aphorisms; Jannis Kounellis, a Greek who makes mixed-media constructions and poetic installations; Rosemarie Troeckel, whose machine- knit images address political, feminist, and technological issues; and Jeff Koons, whose large-scale fabricated sculptures speak to American kitsch.

Chicagoan Martin Puryear creates large, artificially natural objects of natural materials, including a variety of unusual woods, while Dan Flavin's installations of stripes and mirrors restructure the spaces they inhabit. Other major artists include Sherrie Levine, known for her appropriations of art historical images and gold-leaf plywood knots; Minimalists Donald Judd and Richard Serra; and Ulrich Ruckriem. Recent exhibitions also featured the corrugated cardboard furniture of California architect Frank Gehry.

[110] THE ZAKS GALLERY

620 N. Michigan Ave., Chicago, IL 60611

Phone: (312) 943-8440 *Hours:* Tue-Fri: 11-5:30, Sat: 12-5; July: closed Sat; Aug: closed *Dir:* Sonia Zaks

A small but active gallery founded in 1967, the Zaks Gallery exhibits work by contemporary American painters and sculptors. Most of the artists featured are from the Chicago area or New York. The work in some cases has been identified with the city itself stylistically, as Chicago imagists and New Expressionists have gained national prominence.

Painter Paul LaMantia's strongly colored, distorted, and fragmentary figures recall images dredged from the subconscious.

David Sharpe, another artist identified with Chicago, also paints the human figure, but with distortions and textures that recall cubist analysis rather than psychoanlysis. Other accomplished painters shown in the gallery are Mike Baur, Donna Essig, Tom Gibbs, Ben Mahmoud, Jerry Savage, Sylvia Sleigh, Joan Weinger, Richard Wetzel, and William Itter.

Provocative environments by George Klauba and limestone sculpture by William Willers can also be viewed in the Zaks Gallery.

[111] ZOLLA/LIEBERMAN GALLERY

The gallery was destroyed by fire at press time.

Phone: (312) 944-1990 *Owner/Dir:* Robert Zolla, Roberta Lieberman

Located in a converted factory space, Zolla/Lieberman shows all forms of contemporary art.

The gallery represents a host of young, increasingly well-known artists, presenting a wide variety of styles, materials, and techniques. Tom Czarnopys' abstracted figures are formed of both organic materials--bark and sticks and leaves--and synthetic materials. Laddie John Dill has several pieces constructed of glass, cement emulsion, and pigment. Internationally known sculptor Loren Madsen works with timber and cables in creating large pieces that paradoxically defy and define space. Horses of sticks, mud, papier-mache, painted steel, lead, and cast bronze with patina by Deborah Butterfield can also be found. Steven Heyman paints surreal landscapes involving motion and mechanization, while Michael Nakoneczny makes small paintings of colorful personal, autobiographical images. Dennis Neckvatal splits his work between landscapes and abstract, somewhat androgynous portraits of himself and his wife.

The gallery also features John Buck's paintings on wood. New additions include Terence La Noue's luxuriously painted hanging canvases and neo-expressionist Chema Cobo's figurative works. The political and satirical picture quilts and wind toys of Edward Larsen are also on show.

Madge Gill, *untitled,* 38x33, pen and ink. Courtesy: Yolanda Gallery of Naive Art

Karl Wirsum, *Things Are Not Always What They Splits the Seams,* 50x38, acrylic on canvas. Photographer: William H. Bengtson. Courtesy: Phyllis Kind Gallery

ABBIE, LYNN (Painter, Photographer)
823 Lake, Oak Park, IL 60301

Born: 1934 *Awards:* 1st Place, WSAG Show *Collections:* Neo Deco Gallery, Chicago; Goldman Sacks *Exhibitions:* Neo Deco Gallery *Dealer:* Phillip Ross, Neo Deco Gallery, Chicago

In the early 1970s biomorphic shapes were a strong influence in her work. She used photography and experimental techniques with materials such as dechirage, acrylic, and styrofoam cut-outs. By 1980 she had developed a distinctive style, working on large canvases and linen supports. In the 1980s her work has centered around Cibachrome prints of photographic representations of the Art Deco aspects of Chicago. She founded the Chicago Art Deco Society in 1983 and has spent much time searching for lost examples of the style. She is now in Guadalajara working on a project about Orozco.

ABBORENO, ANTHONY (Painter)
512 S. Oak Park Ave., Oak Park, IL

Born: 1947 *Collections:* Mr. Nick DiBenedetto, Chicago; Mr. Robert McDermot, Chicago *Exhibitions:* Campanile Gallery, Chicago; Oak Park Art League *Education:* Northeastern Illinois U. *Dealer:* Campanile Gallery, Chicago

Influenced in his earliest work by Cezanne's post-impressionist organization of the picture plane, he incorporated this with the heightened colors of Matisse in developing his technique as a hard-edged colorist. Working at first with small areas of broken color, his work now has begun to include large, modulated areas with softened edges. Drawing on his experiences as a cross-country driver, his current work deals with the experience of speed and with the atmosphere of color changes in the temporal landscape. Working with shapes such as starbursts, arrows, and circles, he creates a sense of long shadows and early mornings through the variation of colors. Relationships of shapes and patterns are in the cubist context.

ACCONCI, VITO (Sculptor, Performance Artist)
c/o Sonnabend Gallery, 420 W. Broadway, New York, NY 10013

Born: 1940 *Awards:* NEA Grant *Collections:* Museum of Modern Art, NYC; Los Angeles County Museum of Art *Exhibitions:* Sonnabend Gallery, NYC; Museum of Modern Art, NYC *Education:* Holy Cross College; U. of Iowa *Dealer:* Sonnabend Gallery, NYC

Originally a poet, he has divided his time between producing mixed media sculpture, installations, and performance pieces since 1969. In 1970 he began to use use his own body as ground for making art, initially producing performances and video tapes that capitalized on his own, often times confrontational, presence. Soon therafter he began to re-examine the traditional contexts for performance and video, and undertook performances in public places dealing with socially "taboo" issues. By 1974 he had removed himself entirely from his installations and transmitted his human presence or "power sphere" entirely through audio and video tapes. While language still remains a very important part of his video pieces and performances, he has concentrated more recently on large-scale mixed media installations that utilize both formal and real tensions to communicate their social and political context.

ADAMS, ROGER (Painter, Sculptor)
6019 W. Addison St., Chicago, IL 60634

Born: 1936 *Awards:* 1st Prize, State of Illinois; Honorable Mention, School of the Art Institute of Chicago *Exhibitions:* Art Institute of Chicago; Block Gallery, Northwestern University *Education:* U. of Chicago; School of the Art Institute of Chicago

Collectively, Romanticism, Impressionism, Cubism, Abstract Expressionism, and even Imagism have at one time or another influenced his work. Even with so many influences, though, none has laid claim on his style. Working in a variety of media--watercolor, oil, ink, and sculpture--he takes as his reference point a particular experience or emotion from his life and what it demands stylistically. Currently his work reflects his feelings for nature and for persons who possess a spiritual presence. In this work he alludes to influences from both East and West--each with its own historical and cultural development. The treatment of materials in these paintings reflects this integration, with flat areas rendered in a traditional palette and sporadic impastoed patches of rich, "impressionistic" mixes of color. The images are rendered realistically, but the intention is to create a symbolic statement.

AFRICANO, NICOLAS (Painter)
c/o Dart Gallery, 212 W. Superior, No. 203, Chicago, IL 60610

Born: 1948 *Exhibitions:* Walker Art Center, Minneapolis; Institute of Contemporary Art, Boston *Education:* Illinois State U. *Dealer:* Holly Solomon Gallery, NYC; Asher/Faure, Los Angeles

A former poet, his interest in narrative art has always played a predominant role in his oil and acrylic paintings. Small figures playing whimsical, theatrical roles are often the center of his large canvases with additional work being created for gallery walls as well as on canvas. These "New Imagist" works are about human experience, so subject matter is a primary concern. The physical and painterly concerns are minimized, "with the singular purpose of burdening the work with clear intent."

AFSHAR, ANI (Weaver)
2602 Park Place, Evanston, IL 60201

Born: 1946 *Exhibitions:* Norris Gallery, St. Charles, IL; Merchandise Mart Gallery of Design, Chicago; Evanston Art Center, Evanston, IL

She learned weaving while living in Iran from 1973 to 1979, and the designs of the Near East recur throughout her work. Familiar also with modern art, her pieces--wool hangings, shawls, bed spreads, pillows, tablecloths, beaded or woven jewelry--appear both traditional and avant-garde, created within a cultural framework by an individual vision. Subject matter includes trees, gardens and flowers, all rendered in full range of colors. Fibers and threads are chosen for sensual as well as aesthetic reasons. Beads, feathers and other items are woven in as the piece is created. She

Roger Adams, *The Apiarist,* 26 x 38,watercolor

Ani Afshar, *Dream Flower,* 68 x 65

works by choosing her subject and colors, then creates objects characterized by her unified, identifiable style. With technical skill and artistic sensibility, her weaving bridges the gulf between functional and decorative art.

AGNEW, THERESE M. (Sculptor)
3827 S. 74th St., Milwaukee, WI 53220

Born: 1959 *Awards:* Milwaukee Arts Commission 1987 Distinguished Artist of the Year; Wisconsin Arts Board Grant *Collections:* Anderson Industries; Joseph Behr & Sons *Exhibitions:* Rockford Art Museum; Aristoi Gallery, Milwaukee *Education:* Wartburg College, Iowa; U. of Wisconsin, Milwaukee *Dealer:* Dean Jensen, Milwaukee

Drawing from influences as diverse as 13th- and 14th-century manuscript illuminations, Christo's environmental collaborations, and Batman comic books, the artist constructs fanciful, site-specific works that purposely involve a wide and unlikely cross-section of the public in the art-making process. Using imagery consisting of mythical possesssors of power, she has draped a 30-foot dragon around an historic water tower, constructed a "visitation" of 11 angels and superheros descending upon a street corner, and created four red granite "Rockmen" that emerge from the Rock River in Rockford, Illinois.

AHLSTROM, RONALD (Collage Maker, Painter)
121 W. Park Dr., Lombard, IL 60148

Born: 1922 *Awards:* Clyde Carr Prize, Art Institute of Chicago; Ford Foundation Purchase Prize, Seattle Art Museum *Collections:* Art Institute of Chicago; Barat College Collection, Lake Forest, IL *Exhibitions:* Zriny Galleries, Chicago; Rodger Wilson Gallery, Chicago *Education:* School of the Art Institute of Chicago; DePaul U., Chicago *Dealer:* Campanile-Capponi Contemporary Gallery, Chicago

After studying at the School of the Art Institute of Chicago, where he was influenced by the works of the Bauhaus, Paul Klee, Kurt Schwitters and Kandinsky, he developed a collage/mixed media approach to painting. Over the years he has refined the approach he developed in the 1950s and used a great variety of found and assisted materials. Although he worked for many years in a large format, he has recently been doing smaller collages, refining the amount of collage and increasing his use of paints, inks and drawing.

ALBRECHT, B. (Painter, Performance Artist)
3110 Grove Ave., Berwyn, IL 60402

Born: 1960 *Awards:* Outstanding Achievement, Art Department at U. of Missouri, Kansas City *Collections:* Lally-Benedetto *Exhibitions:* Hampton House, Chicago; Randolph Street Gallery, Chicago *Education:* U. of Missouri, Kansas City; School of the Art Institute of Chicago

After studying with a student of Joseph Beuys, he became involved with the ideas of the Fluxus group. In his static collage, he layers and juxtaposes imagery, using the inherent qualities of the media. His performances are metaphorical tableaux set around common objects in which he observes action, skews audience

boundaries, and makes social commentary. He primes his burlap paintings with a broad and immediate coat of spray paint. He then layers on oil paint in thin washes and thick lines, producing images of common objects or human figures in action. In his prints he mixes intaglio, woodblock, and photo plates, creating an image that is both degenerating and whole.

ALLEGRETTI, MARJORIE (Painter)
528 Linden Ave., Lake Forest, IL 60045

Born: 1930 *Collections:* Union League Club of Chicago; Hilton Hotel Corp., Chicago *Exhibitions:* Illinois State Museum, Springfield; Neville/Sargent Gallery, Chicago *Education:* George Washington U.; Corcoran School of Art *Dealers:* Van Straaten Gallery, Chicago; Neville/Sargent Gallery, Chicago

Influenced by William Merrit Chase and George Innes, she began painting realistic landscapes upon completion of her studies at Corcoran School of Art. In the early 1960s she became aware of the work of Morris Lewis and Richard Diebenkorn. During that time she painted increasingly abstract works that contained strong references to landscape. The surfaces of these gestural pieces were often heavily textured. In the late 1970s she became increasingly interested in more specific imagery and returned to painting realistic landscapes with oil on canvas, oil on paper, and pastel on paper. Although the short, calligraphic gesture of her stroke is stil noticeable, the surface is no longer textured and the gesture is at the surface of the image.

ALLEN, LESLIE (Painter)
410 1/2 Phoenix, Bloomington, IL 61701

Born: 1954 *Exhibitions:* Rockford (IL) Art Museum; Klein Gallery, Chicago *Education:* Western Kentucky U.; Illinois State U.

Beginning in the early 1980s, she painted and collaged small shrine-like constructions. These scrap wood objects are painted with acrylic, embedded with little objects such as plastic beads, buttons, toys, found objects, and broken glass, and collaged with fabric, plastic, and fake fur. Her current, more traditional paintings are made up of two or three wooden panels with shapes cut into their edges or out of their centers. She uses acrylics and oils and breaks up the painted ground with abstract shapes and forms. These works may be read as painted relief objects or as painted surfaces activated by forms and shapes.

ALTMAN, EDITH (Mixed-Media Artist)
811 W. 16th St., Chicago, IL 60608

Born: 1931 *Awards:* Illinois Arts Council Fellowship; Artist in Residence, U. of Nebraska *Collections:* Museum of Contemporary Art, Chicago; State of Illinois *Exhibitions:* Museum of Contemporary Art, Chicago; Art Institute of Chicago *Education:* Wayne State U. *Dealer:* Marianne Deson Gallery, Chicago

Her abstract painting of the 1960s was influenced by de Kooning, Gorky, and Rothko. In 1970 she began making installations and for the past two decades has addressed the problem of the sacred through a variety of media. The highly polished, rearrangeable wood constructions of her 1970 "Obuli" series began an inter-

Robert Amft, *Christ Taken Captive, (Bosh),* 18 x 24

Craig Anderson, *Prairie Winds,* 108 x 144, acrylic on canvas. Courtesy: Kishwaukee College (Malta, IL)

est in nature and modularity. In 1974 she sifted blue pigment on the shore of Lake Michigan and let the particles vanish in the wind. In the late 1970s she suggested the sacred and meditative quality of time by subtitling her paintings with the time they took to create and by accompanying them with chanted recordings of seconds. Her recent oil-stick drawings suggest multiple readings and often include text developed through automatic writing.

AMATO, CHESELYN (Installation Artist)
3255 N. Greenview, Chicago, IL 60657

Born: 1958 *Collections:* Private *Exhibitions:* Contemporary Art Workshop, Chicago; Prairie Ave. Gallery, Chicago *Education:* Brown U.; Tyler School of Art

The act of drawing is at the core of her work; it functions for her as a means of questioning, answering, positioning and reasoning. Her early drawn palimpsets are records of a process of studying. In them she uses written language as a tool to make marks, arriving at an imagery that first coalesced into figuration, then dispersed. She currently combines drawn and sculpted elements to create spectacular, participatory installations, each an inspirational inward-looking event which is both to be observed and acted within. Her large multi-media installation *The Sixth Day* is an exploration of the implications of the biblical theme of creation.

AMFT, ROBERT (Painter, Photographer)
7340 N. Ridge, Chicago, IL 60645

Born: 1916 *Awards:* Renaissance Prize, Chicago Artists & Vicinity Show; 1st Prize, New Horizons *Collections:* HFC Company; Butler Institute of American Art *Exhibitions:* Hammer Gallery, Chicago; Joy Horwich Gallery, Chicago *Education:* School of the Art Institute of Chicago *Dealers:* Joy Horwich Gallery, Chicago; Prism Gallery, Evanston, IL

His photography has won numerous awards and has been reproduced in *Graphis, New York Art Director Annuals, California Magazine, Playboy* and *Photo-Graphis*. The works move in several different directions: one series is based on a die-cut shape resembling a face, another series, entitled "Crossings," consists of large paintings of pure abstract bands of color transversed with luminous vertical bars suggesting light. Many of his larger-than-life paintings incorporate direct quotations from works by Da Vinci, Van Gogh, Seurat and others. Recent work includes a group of erotic watercolors and a series of acrylics based on clouds.

AMM, SOPHIA (Painter)
1109 Briarcliff Dr., Appleton, WI 54915

Awards: Award of Excellence; Best in Show *Exhibitions:* Neville Public Museum, Green Bay, WI; Consilium Place, Scarborough, Ontario *Education:* York U.; U. of Toronto *Dealer:* Michael Haven, Toronto

She expresses the hype, excitement, and speed of life in the chaotic man-made urban environment of the 1980s. Information, mass media, networking, the interrelation of governments, the complexities of problem solving, and the entrapment of the individual are all subjects for her acrylic on paper paintings. She often paints her works as diptychs and triptychs. She now plans to do more large work on canvas, further clarifying and defining her ideas.

ANDERSON, CRAIG A. (Painter)
118 N. Peoria, Chicago, IL 60607

Born: 1947 *Awards:* Pougialis Mentor Fellowship; Illinois Pioneer Award *Collections:* ARCO of California; Illinois Institute of Technology *Exhibitions:* Art Junction International, Nice, France; Art Institute of Chicago *Education:* Northern Illinois U.; U. of Illinois, Chicago *Dealer:* Sybil Larney Gallery, Chicago

Beginning as a building engineer, he began painting in 1967. The expressive and spiritual work of Rothko, Gottlieb and de Kooning had a lasting influence at this time. He worked in gestural colorfields that eventually were refined into irreducible marks. By this process of breaking down each painting into its prime components, he began to build structures of space through overlap. This simple idea allowed him to juxtapose an illusion of space with an architecturally real space, making the "real" space seem to disappear. Recently, he has begun to explore figurative abstracts within this context, creating and further deepening a relationship to space and form itself.

ANDERSON, JOY A. (Painter)
6356 N. Lakewood Ave., Chicago, IL 60660

Born: 1930 *Awards:* Grant, Illinois Arts Council; 1st Place Award, Mask Exhibit, Spertus Museum, Chicago *Collections:* Spertus Museum, Chicago *Exhibitions:* Steiner Gallery, Chicago; Dittmar Gallery, Evanston, IL *Education:* School of the Art Institute of Chicago *Dealer:* Co-op Gallery, Evanston Art Center

She has studied the figure since childhood and has developed her own distinctive integration of realistic line, cubist concerns, and fauvist colors. Impressed by Picasso's range of media, she began incorporating sculptural elements into her paintings of mythical humans in the 1970s. Presently her subjects are real people, and her paintings are often narrative depictions of their relationships. Over the years her figures have grown larger and more dynamic, and she now emphasizes line as a way of binding her disperate compositional elements and bold acrylic colors into strong artistic statements.

ANDERSON, LORRAINE (Draughtsperson)
5242 Fossil Creek, Ft. Collins, CO 80526

Born: 1942 *Awards:* Visiting Artist, Michigan State U. *Collections:* The Development Group, Denver; City of Ft. Collins, CO *Exhibitions:* ARC Gallery, Chicago; Artists Society International, San Francisco *Education:* Colorado State U. *Dealer:* Greenberg/Nussbaum, St. Louis

Formally trained in sculpture and influenced both by Inca sun rituals and by the sun's dazzling effects on medieval stained glass, she made human- and large-scale plexiglass and steel sculptures during the late 1970s and early 1980s. This work led to drawings in which she depicted the effect of harsh sunlight on an environment and its occupants. Using reflective metal-

Jose Andreu, *Time Prime Event,* 34 x 37, acrylic, beads on canvas

Mildred Armato, *Oriental Chair,* 15 x 15
x 59, oil & glaze on hardwood

lics in contrast with light-absorbing charcoal and pastels, she reduced her forms to geometric shapes. Currently she creates mythical places where a more than real dramatic light effects physical perspective, balance, and isolation.

ANDERSON, OTHELLO (Painter, Photographer)
4746 N. Malden, Chicago, IL 60640

Born: 1944 *Awards:* Illinois Arts Council, Fellowship and Technical Assistance Grant *Collections:* Art Institute of Chicago; Museum of Contemporary Art, Chicago *Exhibitions:* Museum of Contemporary Art, Chicago; Fine Arts Gallery, NYC *Education:* School of the Art Institute of Chicago; U. of Chicago

Space, in both senses of the word, is his main concern. His stark and striking drawings are attempts at capturing the speeding bodies of deep space as they plunge to and fro across unimaginable distances. In these drawings he seeks to stop the unstoppable and to describe the mysterious realm of violent, little understood movement and cataclysmic forces. His paintings are an organization of the space in which we live, and in them he deals with the ambiguous way we see the world. His illusionistic forms seem to move forward and backwards as the viewer looks at them.

ANDRE, CARL (Sculptor)
P.O. Box 1001, Cooper Station, New York, NY 10276

Born: 1935 *Collections:* Museum of Modern Art, NYC; Art Institute of Chicago *Exhibitions:* Solomon R. Guggenheim Museum, NYC; Museum of Modern Art, NYC *Education:* Phillips Academy *Dealer:* Paula Cooper, NYC

After studying with Hollis Frampton and Patrick Morgan, he met Frank Stella and subsequently developed his own minimalist theories during the late 1950s. Wood and plexiglass, into which he carved geometrical patterns, were his media then. He emphasized architectural design until 1964, when after working on a railroad he decided to make his work "more like roads than like buildings." Considering himself a "post-studio artist," he placed bricks, metal strips and other industrial products of standard size in random arrangements on the floor. The identity of these pieces would change as the elements were stored and later rearranged elsewhere. Currently, using only one medium in each piece, he leaves materials in their natural state, leaving time and the elements to change the surfaces. He questions the notion that art is unique and precious, and seeks to explore the interactions of space with the gravity, mass, weight and placement of forms.

ANDREU, JOSE (Painter)
4813 N. Ashland Ave., #1-W, Chicago, IL 60640

Born: 1954 *Exhibitions:* Mexican Fine Arts Center, Chicago; Museum of Modern Art, Mexico City *Education:* U. of Wisconsin, Madison

Influenced by surrealism and muralist traditions, he left site-specific subjects to those created on canvas. Working with expressionistic color and the effects of technology on perceptions, his imagery became more distilled and object oriented, settling on a visual exploration of an object changed by subjective and intellectual approaches. This proposition evolved into paintings which manifest a unique and distinct perception of an object in its own context. A variety of materials are used including plastics, metals, cloth, and mulch. Drawn to Chicago's tradition of individualistic expression, his work now is a hybrid of traditional Western, Eastern, and pre-Colombian influences. Done primarily in acrylic color, the work explores change in dimensions, materials, and textures.

ANDRIS, RUTH INGEBORG (Sculptor)
4106 N. Ozark Ave., Norridge, IL 60634

Born: 1935 *Awards:* Grant, Illinois Arts Council; Award for Sculpture, Chicago Women's Caucus for Art *Collections:* Marcel Marceau; Standard Oil Company *Exhibitions:* Art Institute of Chicago; Ceres Gallery, NYC *Education:* School of the Art Institute of Chicago

Influenced by primitive art, Eskimo sculpture, and Surrealism, she explores nature's beauty and mystery in stone sculptures. She contrasts satin finishes with raw chiseled areas and gives her work sensuous feminine contours and connotations. The sculptures convey a sense of fruitfulness and hint at the erotic. The complex form of the hornet's nest was the inspiration for a recent series and one work, *Radioactive Embryo* is a glowing orange alabaster piece with specific political content. She also works in bronze and is beginning a series of life-size three-dimensional works in handmade paper.

APGAR, JEAN (Printmaker)
2513 Knight Ave., Rockford, IL 61103

Born: 1949 *Collections:* Solar Flame, Genoa, IL; Grace Methodist Church, Rockford, IL *Exhibitions:* Freeport Art Museum, Freeport, IL; Rockford Council for Arts & Sciences *Education:* Northern Illinois U.

Influenced by baroque composition and minimalist ideas of space, she began making serigraphs with floral themes in 1978. The stencils for these early, intimately sized, hand pulled small editions were cut entirely by hand. She works from detailed pencil renderings and continues to hand cut her stencils. These define areas of specific color, and she uses numerous layers of ink to produce a textural quality. She has recently begun painting florals in watercolor.

APPEL, KAREL (Painter, Sculptor)
c/o Martha Jackson Gallery, 521 W. 57th St., New York, NY 10019

Born: 1921 *Awards:* Venice Biennale; First Prize for Painting, Guggenheim International Exhibition *Collections:* Museum of Modern Art, NYC; Museum of Fine Arts, Boston *Exhibitions:* Solomon R. Guggenheim Museum, NYC; Museum of Modern Art, NYC *Education:* Royal Academy of Fine Arts, Amsterdam *Dealer:* Martha Jackson Gallery, NYC

As a founding member of the International Association for Experimental Art and of the COBRA group in 1948, this Abstract Expressionist created violent, forceful images with thickly applied paint. Often he applied paint straight from the tube, making many layers of color. He said about his work: "The paint expresses

itself. In the mass of paint, I find my imagination." For a time he applied objects to the canvases, but soon returned to two-dimensional work. Since COBRA disbanded, he has continued as a prolific artist, active as a graphic artist and as a sculptor. His sculpture, large and bulky like the thickly applied paint of his canvases and accented with lurid colors, is a three-dimensional counterpart to his paintings.

ARAKAWA, SHUSAKU (Painter)
124 W. Houston St., New York, NY 10012

Born: 1936 *Awards:* D.A.A.D. Fellowship, W. Berlin *Collections:* Museum of Modern Art, NYC; Walker Art Center, Minneapolis *Exhibitions:* Museum of Modern Art, NYC; Kennedy Center for the Performing Arts, Washington D.C. *Education:* Musashino College of Art, Tokyo *Dealer:* Margo Leavin Gallery, Los Angeles; Galerie Maeght Le Long, NYC

He left his homeland of Japan before completing a degree and in 1960 started a Neo-Dada group. Through "happenings" he explored man's physical bounds, and later gained recognition with his series "Boxes." In 1962 he came to New York and created a new series, "Diagram," in which the silhouettes of such objects as tennis rackets, combs, footprints, arrows, and refrigerators were arranged on canvas. Gradually he replaced the silhouettes of forms with words only, in an attempt "to pictorialize the state before the imagination begins to work" in a "pregnant vacuum" out of which innumerable pictures could arise from the canvas to the observer. Recently he has searched for new ways to define the human consciousness through a systematic investigation of language, and has produced two experimental films.

ARCHER, CYNTHIA (Printmaker, Painter)
1604 Greenleaf, Evanston, IL 60202

Born: 1953 *Awards:* President's Purchase, Bradley Print Annual; Kemper Purchase, NSAL Midwest Print Show *Collections:* Illinois State Museum; National Museum of Art, New Zealand *Exhibitions:* Chicago International New Art Forms Expo; Malton Gallery, Cincinnati *Dealer:* Lyman/Heizer, Chicago

Master lithographer and co-founder of Plucked Chicken Press, she characterizes her prints by hundreds of markings: little crosses, dots, and checks over washed solids of color. The surface treatment brings to mind the rich surfaces of quilts and intricate needlework. The lively colors are further animated by the presence of fish, camels, crocodiles, flowers, stars, Assyrian archers, Egyptian graces, horses and birds, words, mathematical symbols, musical notations, maps, and astronomical calculations. She has recently been decorating pots in a similar manner, using acrylic paint, a fine brush, colored pencil, and collage and sealing the surface with varnish.

ARDELL, JACK (Painter, Mixed Media Artist)
2524 East Ave., NE, Cedar Rapids, IA 52402

Born: 1936 *Awards:* Award, Truman College, Chicago; Award, Loyola U. *Exhibitions:* Natalini Galleries, Chicago; Artemisia Gallery, Chicago *Education:* Columbia College, Chicago; School of the Art Institute

of Chicago *Dealer:* Fine Arts Acquisitions

A painter and mixed media artist, he is known primarily for his series compositions, which include works focusing on American folk art, art history, and fantasy. The oil paintings and mixed media pieces of the "Art History Series" (1986) depict different artistic movements, including Dadaism, Surrealism, and Art Deco. In these works he attempts to revitalize the concept of art history, through his energy, unique style, and varied palette, while utilizing the symbols, icons, and designs of each period. In the "American Folk Art Series" he attempts to create a nostalgia for a time in American history when life was simpler and families closer.

ARMATO, MILDRED (Painter)
1632 1/2 N. Sheridan Rd., Evanston, IL 60201

Born: 1923 *Awards:* 1st Award, N.S. Art League *Collections:* Northwestern U.; AT&T, Chicago *Exhibitions:* Gilman Gallery, Chicago *Education:* School of the Art Institute of Chicago, Instituto de Allende, San Miguel De Allende, Mexico

Formally trained at the Art Institute of Chicago, she studied with Louis Ritman, John Fabian, Paul Wieghardt and Seymour Rosofsky. Later her vocation of teaching Japanese-style figurative wood-block printing influenced her exploration of design, figure painting and relief printing. She now creates surreal chair pieces, painting them boldly with brightly colored patterns and Japanese wood block style figures. Working from plans she draws on kraft paper, the hardwood chairs she fabricates and paints can also be viewed on a sculptural level.

ARMATO, PATRICIA (Sculptor)
6007 N. Sheridan Rd., Chicago, IL 60660

Exhibitions: Deerpath Gallery, Lake Forest, IL; Campanile Gallery, Chicago *Education:* Illinois State U., Normal; School of the Art Institute of Chicago

"I like to think my sculpture is enriched with form and spirit," the artist says of her work. After painting for several years, she began making figurative sculpture from clay, sculpting for several years, but became dissatisfied with the medium. She began working with stones such as alabaster and steatite. Influenced by Henry Moore and Naum Gabo, she abstracts and simplifies her subjects. Her aim is to instill in the viewer a desire to touch her metamorphic substances.

ARNDT, THOMAS FREDERICK (Photographer)
2427 3rd Ave. S., B-13, Minneapolis, MN 55404

Born: 1944 *Collections:* Museum of Modern Art, NY; Art Institute of Chicago *Exhibitions:* Art Institute of Chicago *Education:* Minneapolis College of Art and Design *Dealer:* Edwynn Houk Gallery, Chicago

The photographs of Robert Frank and Walker Evans were early and lasting influences on his work. His interest in politics and the struggle for survival in urban environments inspired his early works, which pay technical homage to Frank and Evans. Since then, he has traveled from Los Angeles to East Berlin--walking, watching, and photographing various versions of

modern life. Over time, his images have focused more and more on the individual, the body, and the face--ranging from shots of the homeless to depictions of the affluent. He continues to experiment with film and photographic papers.

ARNOLDI, CHARLES ARTHUR (Painter, Sculptor)
11A Brooks Ave., Venice, CA 90291

Born: 1946 *Awards:* Wittkowsky Award, Art Institute of Chicago; N.E.A. Fellowship *Collections:* Los Angeles County Museum of Art *Exhibitions:* Museum of Contemporary Art, Chicago *Education:* Chouinard Art Institute *Dealer:* James Corcoran Gallery, Los Angeles

Originally intent on becoming a commercial illustrator, he quickly turned to painting. He is known for large-scale paintings made of two panels, one resembling an intricate mesh of painted twig shapes and the other consisting of actual twigs affixed to the canvas and painted, as in *Plummet* and *Volcano--Log Jam*. These wood and oil pieces are boldly colored and full of explosive energy. Recently he has begun working in sculpture on its own. "I have become interested in wood as an alternative to painting," he says. "I especially like tree branches, which have a very distinct line quality. They feel hand-drawn, they have a certain gestural quality, a naturalness....It provides a solution to my desire for subject matter." The pieces are made of wood and bronze.

ARSENEAU, GARY (Painter, Printmaker)
5613 Franconia Rd., #301, Alexandria, VA 22310

Born: 1953 *Awards:* 1st in Painting, Coconut Grove Art Festival; Merit Award, Cocoa Beach Space Coast Art Show *Collections:* Chrysler Museum; Prudential Petroleum of Ohio *Exhibitions:* Ann Arbor State Street Fair; Coconut Grove Art Festival

While studying painting under Van Duesen, he gained a basic understanding of line and color. Later while studying printmaking under Penny Barringer and Ed Bordett, he added stone lithography, screen printing, and monotypes to his ever-increasing number of media. Vibrant monotypes and serigraphs, "wicked" lithograph images, acrylic paintings with a rich paint quality, and surrealistic oils characterize the work of this artist. High ethical standards and a strong work ethic have resulted in a prodigious volume of art in many mediums and styles.

ARTSCHWAGER, RICHARD ERNST (Painter, Sculptor)
P.O. Box 99, Charlotteville, NY 12036

Born: 1923 *Awards:* NEA; Cassandra Award, NYC *Collections:* Whitney Museum of American Art, NYC; Museum of Modern Art, NYC *Exhibitions:* Venice Biennale; Whitney Museum of American Art, NYC *Education:* Cornell U. *Dealer:* Leo Castelli Gallery, NYC

After helping Claes Oldenberg put together *Bedroom Ensemble*, he gained recognition with pseudo-furniture of formica on wood, such as *Table with Tablecloth*, and later with urban views, such as *High Rise Apartment*,

made of liquitex on celotex with formica. These Pop works questioned the utility of art and its place in American culture. Recent paintings use photographs as their base; synthetic-looking hand-execution distorts the photograph's description of reality, and often the frame (the "furniture") becomes an integral part of the work, as in *Left Pinch*, in which space is expanded through the addition of a mirror to the frame.

ATKINSON, ELIZABETH ANN (Painter)
1115 Wesley, 1st Floor, Evanston, IL 60202

Born: 1949 *Exhibitions:* Chicago Academy of Fine Art; N.A.B. New Member's Show, Chicago *Education:* School of the Art Institute of Chicago

In 1984 she first acquired a studio space. Over the next two years she produced several Monet-influenced still lifes. She painted a few outdoors and a few figure studies based on snapshots. These works are reminiscent of impressionism and post-impressionism. In 1986, she "hit the wall" and began painting abstractions with acrylic on paper. She is fascinated by the question of whether a single brush stroke can stand alone on a canvas, and she has been heavily influenced by the extreme simplicity and borderline abstraction of Georgia O'Keeffe, Miro, Matisse, and Tapies.

AVISON, DAVID (Photographer)
421 W. Melrose St., Chicago, IL 60657

Born: 1937 *Awards:* NEA Fellowship; Grant, Focus/Infinity Fund, Chicago *Collections:* Art Institute of Chicago, Museum of Modern Art *Exhibitions:* Art Institute of Chicago; Birmingham (AL) Museum of Art *Education:* Institute of Design, Illinois Institute of Technology; Brown U. *Dealer:* Afterimage, Dallas; Middendorf Gallery, Washington, D.C.

After a career in physics, he studied photography with Gary Winogrand, Frederick Sommer, Aaron Siskind, and Arthur Siegel at the Illinois Institute of Technology's Institute of Design. While at the Institute, he became intrigued with wide-angle/wide-format photographs, exploring this area with a special prototype camera he designed and built himself. He has since built a more agile camera and used it to develop his panoramic vision. Although the bulk of his work is in black and white, he recently made a major commitment to color. His subject matter continues to be people in landscape or cityscape. His most recent work is the "City Beach Series."

BAEHMANN, SUSAN (Printmaker)
6925 N. Barnett Ln., Milwaukee, WI 53217

Born: 1945 *Awards:* Exceptional Achievement Award, U. of Wisconsin, Milwaukee Alumni Assoc. Art Show; Catherine Lorillard Wolfe Certificate of Merit, NYC *Collections:* 3M Company, Minneapolis; Harvard U. School of Business *Exhibitions:* Wisconsin Arts Biennial; Art Institute of Chicago *Education:* U. of Wisconsin, Milwaukee *Dealer:* Bradley Galleries, Milwaukee

Impressionists and the painters of the Barbizon and Hudson River Schools influenced the artist's early realistic landscapes. In 1974 she began her current work with black and white experiments in etching and aquatint, also exploring such techniques as blended

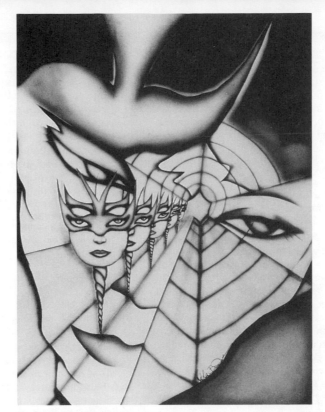

Natalia Bandura, *untitled,* 38 x 28, acrylic

Robert Barnum, *Alley Cats,* 21 x 15, watercolor

roll, *a la paupie*, and viscosity. She now draws her imagery from the interaction of form, design, color and light which she finds in nature, and transposes personal and literary interests into visual symbols. Since 1983 she has divided her time between etchings and monoprints, periodically returning since 1987 to drawing with pastels.

BAKER, GLORIA (Painter)
1016 N. Fairlawn Cir. W., Evansville, IN 47711

Born: 1943 *Awards:* Purchase Award, Kentucky Watercolor Society *Exhibitions:* Evansville Museum of Arts and Sciences; U. of Evansville *Education:* Ivy Tech Commercial Art

She studied painting with Jeanne Dobie, Christopher Schink, Miles Batt, and other professionals. She developed an egg tempera technique on her own and her early wet-on-wet realistic paintings in that medium were heavily influenced by the work of Andrew Wyeth. She now uses watercolors to convey religious themes in a semi-abstract manner. The loose and fluid browns and greens of her large paintings have a hint of reality in them. A misty backdrop lies behind her center of interest which is normally the simplified image of a priest or nun. In *The Ceremony*, she broke the picture into rectangular segments separated by bisecting planes of white paper.

BALA, PAUL (Painter)
6622 S. Washtenaw, Chicago, IL 60629

Born: 1957 *Collections:* Gottlieb & Schwartz Corporate Collection *Exhibitions:* Institute of Contemporary Art, Boston; Artemisia Gallery, Chicago *Education:* Art Institute of Chicago; Harvard U.

Earlier works from the 1970s are characterized by rapid gestural movements on flatly painted grounds. The command over spatial dimensions reveals the influence of the artist's study of Oriental painting. His approach to painting is technically innovative, with large previously painted fragments of paint collaged into a new compositional whole on the flat canvas background. Visually the paint appears to be projecting off the canvas into space. Current pieces continue to experiment with the perception of spatial progressions with abstract imagery. Pieces on canvas are often layered panels of changing colors with collaged acrylic paint and subtle oil glazes. Paper and slate stone are also often used as the ground for paintings. Paper is reformed into a weighted sculptural "stone-like" relief and impregnated with contrasting airy overglazes of color. Titles such as *Open Harbor, Landfall, Mainland Series,* and *Seated Tide,* challenge the viewer to find the landscape amidst the abstraction.

BALDESSARI, JOHN ANTHONY (Photographer, Conceptual Artist)
3552 Beethoven St., Los Angeles, CA 90066

Born: 1931 *Awards:* NEA Grants *Collections:* Museum of Modern Art, NYC; Los Angeles County Museum of Art *Exhibitions:* Museum of Modern Art, NYC; Documenta 5 and 7, Kassel, Germany *Education:* San Diego State U.; Otis Art Institute, Los Angeles *Dealer:* Sonnabend Gallery, NYC

Originally a painter, his work of the 1960s reflected an interest in Minimalism and the formal and semantic applications of words in the manner of Rene Magritte. *A Work with Only One Property*, created in 1966, was a blank white canvas with only the title of the piece professionally lettered upon the pristine surface.

As a conceptual photographer, his interests have been similar to those explored in his paintings. He photographed words out of context from various pages of text, with an anonymous finger pointing to a phrase, as in *Scenario (Scripts)* (1972-73). His film loops also repeat words, objects, or actions. In photography and in films, he hypothesizes about what art can be, expanding the definition of Conceptual Art.

BAKKER, GABRIELLE (Painter)
1836 S. Halsted, Chicago, IL 60608

Born: 1958 *Collections:* HBO; private *Exhibitions:* State of Illinois Gallery, Chicago; Dart Gallery, Chicago *Education:* School of the Art Institute of Chicago; Yale U. *Dealer:* Dart Gallery, Chicago

Influenced by the Western tradition of painting from Pompeiic painting to the work of Rembrandt and Picasso, all of her pieces are painted in many layers, each layer being applied as if it were the final one. Currently working on a series of idealized cityscapes with an Italian feel to them, she spent several years painting self-portraits exclusively, later widening her repertoire of subjects to include figure compositions and still lifes. Her images are expressed in an intensely focused way, reflecting her studies of painting by the old masters. Her choice of color is conceptualized and based on the palettes of early Renaissance as well as Northern Baroque painters.

BANDURA, NATALIA (Painter)
2205 W. Walton, Chicago, IL 60622

Born: 1964 *Exhibitions:* Limelight, Chicago; Ukrainian Institute of Modern Art, Chicago *Education:* Loyola U., Chicago; School of Airbrush Arts, Chicago

Using a mix of techniques, from airbrush to pastels to oils, while concentrating in acrylics, she creates images in the surrealist traditions of Dali and Ernst. The colors in the portraits are hot and bright, the details sharp, the backgrounds fantastic. The work is mostly figurative, expressing various moods and attitudes. Presently, she is exploring the images of her childhood memories of peasants, flamenco and tango dancers, and gypsies from Argentina.

BANDY, RON F. (Painter)
10271 Napoleon Rd., Bowling Green, OH 43402

Born: 1936 Collections; Weatherhead Foundation, Ft. Wayne, IN; Owens-Corning, Toledo, OH *Exhibitions:* J. Rosenthal Fine Arts, Chicago; The Mobius, Boston *Education:* U. of Florida; Ohio U. *Dealer:* J. Rosenthal Fine Arts, Chicago

Trained in sculpture and influenced by Francis Bacon, he began serious production of sculpture in 1960. In 1966 he took up painting and drawing. At the time, he made primarily impressionist works, using air brush and collage. In 1974 he became interested in the human

figure, of which he has since made increasing use. At the same time he began applying tissue and collage to paper. This work has since expanded to the use of alkyds on unstretched linen. He currently makes statements about the state of our world through his very large political works.

BANNARD, WALTER DARBY (Painter)
Box 296, Rocky Hill, NJ 08553

Born: 1934 *Awards:* Guggenheim Fellowship; NEA Fellowship *Collections:* Metropolitan Museum of Art, NYC; Museum of Modern Art, NYC *Exhibitions:* Baltimore Museum of Art; Salander-O'Reilly Galleries, NYC *Education:* Princeton U. *Dealer:* M. Knoedler Gallery, NYC

Early influences include Theodoros Stamos and William Baziotes. Works from the late 1950s to the mid-1960s are executed in hard-edged pastel colors, with circles and rectangular shapes as their focus. Color fields are motionless and easy to read, emphasizing their interrelatedness. During the late 1960s larger color fields overlap to form varying layers of pigment, as in *China Spring No. 3*. Gradually the paths of brushstrokes become more apparent, as in *Satin Rafters*. Recent paintings use acrylics, polymers, and gels which are thickly applied and moved around with squeegees, sticks, and rakes. He has also written about the effects of color.

BANYS, NYOLE (Painter)
5327 Franklin, Western Springs, IL 60558

Born: 1934 *Collections:* Vincent Price Collection; Ciurlionis Gallery, Chicago *Exhibitions:* Ciurlionis Gallery, Chicago; Ukranian Institute of Modern Art, Chicago *Education:* U. of Illinois; School of the Art Institute of Chicago

Born in Lithuania, she has exhibited professionally since 1959. In the 1960's she showed her works at the Religious Art Exhibit in Chicago and at the exhibits of the Lithuanian-American Young Artists League at Chicago's Ciurlionis Gallery. In preparation for a 1981 "Lithuanian Mythology" exhibit, she studied Algirdas Greimas' book *About Gods and People*. The book influenced her to switch from the oils she had always used to a spectra color pencil technique. She is a member of the La Grange Art League and the Lithuanian-American Women Artists Association.

BARAZANI, MORRIS (Painter)
601 S. Morgan, Chicago, IL 60680

Born: 1924 *Collections:* Blue Cross/Blue Shield *Exhibitions:* Art Institute of Chicago; Detroit Institute of Art *Education:* Cranbrook Academy of Art *Dealer:* Gilman Galleries, Chicago

During his early education as an artist, he was preoccupied with the Constructivists and Mondrian and as a result developed a strong sense of order in his work. As he evolved he became influenced by aspects of surrealism and expressionism. Automatic writing and a free approach to paint was dominant over design during this period.

Recently he has attempted to fuse both approaches into a unified expression. He is ordering and clarifying his personal vocabulary at present, finding the structural elements that are characteristically his own.

BARBIER, ANNETTE (Video Artist)
2074 N. Hoyne, Chicago, IL 60647

Born: 1950 *Awards:* Silver Hugo & Silver Plaque, Chicago International Film Festival *Collections:* State of Illinois Gallery; Chicago Cultural Center *Exhibitions:* American Film Institute National Video Festival, Los Angeles; WTTW-TV *Education:* School of the Art Institute of Chicago *Dealer:* Video Data Bank, School of the Art Institute of Chicago

Her work ranges from multi-channel video installations to videotapes that are partly mystical, partly psychological in character. Occasionally, plexiglass sheets and rods are used to extend and deform the television image as well as to abstract the medium from its usual context. One recent work, *Table of Silence*, uses the artist's family to talk about estrangement and tenderness and the way our relationship to food expresses who we are. Another piece, a video wall entitled *Women's Movements*, examines the process of looking at another culture, using material from India and images of women performing various kinds of rhythmic movements, such as working and dancing.

BARNARD, JAMEY (Draughtsperson, Cut-out Artist)
2256 N. Lincoln Ave., Chicago, IL 60614

Born: 1958 *Awards:* 2nd Place, Macworld Computer Art Contest *Collections:* Private *Exhibitions:* Illinois Artisan Shop; Chicago Peace Museum *Education:* Drake U. *Dealer:* Towata Gallery, Alton, IL

His early interests included James Thurber, Picasso, Matisse and Indian and African art. With constant doodling, he refined a simple style. After discovering ceramics of Mimbres and the works of David Hockney he began making theatre masks and sets. He sold hand-drawn T-shirts to fund his interest in comedy prop designs and plywood cutouts. His T-shirts were featured at the Art Institute of Chicago and at Chicago's Museum of Contemporary Art. Their success gave him the freedom to explore paper cut-outs, pen and ink drawings, wood cut-outs, jewelry, and painting. He is currently planing a series of oil paintings based on his 1988 travels as a recording artist.

BARNUM, ROBERT L. (Painter)
312 Elmwood, Romeoville, IL 60441

Born: 1951 *Awards:* 1st Place, Fine Arts Institute; Governor's Purchase Award, IL *Collections:* Illinois State Museum, Springfield; Fasson Corporation, IN *Exhibitions:* Fine Arts Institute Annual; Midwest Watercolor Society Annual *Education:* Idaho State U.; Southern Oregon State

Trained as a printmaker, he initially created socially conscious multiple stone and plate lithographs and multiple plate intaglios which were executed in a figurative style influenced by Goya and Daumier. His colors were muted and subtle, and his drawings were split between strict representation and figurative distortion. After moving to the Midwest from the West Coast, he

began painting in watercolor, and his interest switched from the figure to the unique landscape and weather of the Midwest. "Trying to catch a visual piece of this violent weather and rock-and-roll landscape has become my challenge," he says.

BARRETT, BILL (Sculptor)
11 Worth St., New York, NY 10013

Born: 1934 *Collections:* Hitachi Corp., Kanda, Japan; Guild Hall Musuem of Art, Long Island *Exhibitions:* Houros Gallery, NYC; Sid Deutsch Gallery, NYC *Education:* U. of Michigan *Dealer:* Kouros Gallery, NYC

Aluminum sculptures from the 1970s comprise a series of minimalistic "bridges" pieces. Monumental in scale, his works are geometric and symmetrical and rather somber in mood. Drawn to human imagery, he began a series of totem-like vertical pieces combining machinery-like elements with references to human anatomy. The 1980s have seen an organic eclipse of the geometric and the influence of de Kooning and the modernist method of combining forms in collage or assemblage. Through a somewhat neo-Baroque emphasis, he creates aluminum sculptures that seek to lift, stride, stand, and dance, combining the seriousness of the material with the levity of the subject.

BARRON, WILLIAM C. (Painter)
834 S. Beloit Ave., Forest Park, IL 60130

Born: 1939 *Awards:* Massachusetts Arts and Humanities Foundation *Collections:* Borg-Warner Corp.; Kemper Group *Exhibitions:* 2 Illinois Center, Chicago; Chicago State U. *Education:* Rutgers U. *Dealer:* Struve Gallery, Chicago; Mary Bell Gallery, Chicago

He began art studies at an early age, studying oil painting and *plein air* landscape techniques as an adolescent. As an undergraduate he painted large, nature-derived organic abstractions that showed the influence of Archile Gorky and Matta. Through the 1960s and graduate school, he became influenced by the New Realists, Rauschenberg, Rosenquist and Dine. His current oil paintings are large, realistic images of the Midwestern landscape. His colors are naturalistic and his paintings uncompromising in their boldness of design and image. Part of the underlying strength of the work comes from Edward Hopper's silent, disquieting spaces.

BARTEL, MARVIN (Ceramist)
1708 Lincoln Way E., Goshen, IN 46526

Born: 1937 *Collections:* Midwest Museum of American Art, Elkhart, IN; NE Missouri State U. *Exhibitions:* Goshen College Art Gallery; Ceramics International, Edmonton, Alberta *Education:* U. of Kansas

An artist-craftsman, he produces stoneware vessel forms, sculpture, murals, fountains, sinks and pottery. During the early 1970s he developed a process of incorporating photographic images on ceramic relief surfaces. The scale of his free-standing pieces ranges up to three or four feet in height, murals being larger. The forms incorporate classical proportions with expressive detail and elaboration frequently including figurative fragments. Current work in process includes a collection of sculptural stoneware table bases fabricated by combining wheel thrown forms in unique ways to support glass tops. As an inventor he has been granted a US patent on a ceramic heat exchanger used to save fuel in pottery kilns.

BARTH, CHARLES (Printmaker)
1307 Elmhurst Dr., N.E., Cedar Rapids, IA 52402

Born: 1942 *Awards:* 1st Place in Printmaking, Artists Society International, San Francisco;1st Place in Printmaking, International Exhibit, Massaui Gallery, NYC *Collections:* Art Institute of Chicago; Philadelphia Museum of Art *Exhibitions:* Ohio State U., Newark; Artemisia Gallery, Chicago *Education:* Illinois Institute of Technology; Illinois State U. *Dealer:* Chicago Center for the Print

He gave his early figurative collographs character by using metal collage printing plates. His current intaglio prints are filled with kitsch images from Mexican and American popular culture (television, magazines, fads, films, and music). He abstracts, exaggerates, and satirizes culture, making prints that are fantastic and festive. His "brassy" colors and lighting reflect a subject matter of which a fascination with Mexico's "Dia de los Muertos" is one example. An outgrowth of the print work is wearable art; after printing on paper, he weaves pieces together into vests that can be either worn or displayed.

BARTMAN, MARYANN BODNAR (Painter)
5427 Carolina St., Merrillville, IN 46410

Born: 1951 *Awards:* Certificate of Merit, Art Institute of Chicago *Collections:* Chesterton State Bank *Exhibitions:* Horizon Gallery; Art Institute of Chicago *Education:* American Academy of Art; School of the Art Institute of Chicago

Influenced by American Western artists Russell and Remington, her work has involved intensive research of the ceremonial customs and the clothing of American Indian tribes. Based on this research, she has created paintings that authentically reflect the inner strength of Native Americans. She was originally trained as an illustrator and graphic designer, and her work is photorealistic and tightly detailed, allowing the viewer to interpret her composition and use of color. Working in casein and gouache, she combines reds and browns with some blues and yellows to reflect the desert environment of the American West as well as the brightly colored costumes of contemporary Indian dancers.

BAUM, DON (Sculptor, Assemblage Artist)
5530 S. Shore Dr., Chicago, IL 60637

Born: 1922 *Awards:* Honorary D.F.A., Art Institute of Chicago; NEA Grant *Collections:* Museum of Contemporary Art, Chicago; Art Institute of Chicago *Exhibitions:* Art Institute of Chicago; Museum of Contemporary Art, Chicago *Education:* Michigan State U. East Lansing, MI; School of the Art Institute of Chicago *Dealer:* Betsy Rosenfeld Gallery, Chicago

Early work of the 1950s reflected an expressionist vocabulary. In the following decade, dolls and doll parts

Maryann Bodnar Bartman, *Two Moons Cheyenne,*
16 x 11, casein. Courtesy: Chesterton State Bank

Joanne Bauman, *untitled #50,* 30 x 40, mixed media on prepared paper

were combined with other materials to create expressive three-dimensional assemblages. Unrelated materials such as bones, skulls, shells and dolls were often juxtaposed to sexual images, as in *Bernard and Betty*. Relief constructions made of weathered wood were fetishistic or masklike. Later constructions of weathered wood became more delicate, without a loss of evocative power. Many featured decals covering the surfaces, as in *The Decal Chair*. Recent sculpture includes miniature houses and barns made of such media as wood, tar paper, twigs, and feathers. Although he has experienced several stylistic changes, one can see an underlying interest in fantasy and evocation in all the works.

BAUMAN, JOANNE E. (Mixed Media Artist)
1950 Heather Lane, Northbrook, IL 60062

Born: 1936 *Collections:* The Kemper Group, Long Grove, IL *Exhibitions:* Skokie Public Library, Skokie, IL; Paper Press Gallery, Chicago *Education:* U. of Nebraska *Dealer:* Van Straaten Gallery, Chicago

Microscopic views of highly charged cellular forms probe, plunge into, dance and float across complex color fields comprised of hundreds of undulating warps of intense colors. Working in prismacolor, pencil and craypas on pastel, she creates a meticulously choreographed event that emerges where the interaction of layered patterns function as a metaphoric language. It is through this language that the psychological factors and emotional climate of human relationships is expressed. Grotesquely poetic, sexually charged, theatrical and menacing, aloof and playful, these works display a dynamic tension skillfully interwoven.

BAYALIS, JOHN (Painter)
c/o Sazama/Brauer Gallery, 361 W. Superior, Chicago, IL 60610

Born: 1950 *Awards:* Delaware State Arts Council Fellowship Collections; Transco Energy Corp, Cigna Art Collection *Exhibitions:* Butler Institute of American Art, Youngstown, OH; Sazama/Brauer Gallery, Chicago *Education:* U. of Delaware *Dealer:* Sazama/Brauer Gallery, Chicago

Edward Hopper and Winslow Homer were strong influences in his early landscape work. Over the past several years he has taken contemporary objects and nature-derived images as the subjects of his large format paintings. His primary concern is with the image, devoid of subjective interpretation. Through cropping, magnification, and frontality, he uncovers the aesthetic appeal of everyday objects. He derives this "new realism" from the modernist movements of the recent past. Beginning with carefully composed and meticulously reproduced photographs, he softens his subjects by painting with watercolors.

BAYER, ROBERT B. (Printmaker)
3650 Rose St., Franklin Park, IL 60131

Born: 1954 *Exhibitions:* Printmakers 33 Show, Washington, DC; Northeastern College Library, Boston *Education:* Elmhurst College; Oakton Community College

The ancient technique of hand engraving on copper plates is used by this artist, whose influences range from Albrecht Dürer to Rene Magritte. Early in his career he concentrated almost exclusively on images of headstones, which he placed in different interior settings and occasionally manipulated to reproduce the effect of a fish-eye lens. Eventually finding this too confining, he began using abstracted imagery based on landscapes, figures, animals and masks. Although he has experimented rigorously with other printmaking techniques, including aquatint, open biting, and the combination of roulette and cut-outs, he finds pure line engraving the most challenging and satisfying form for his work.

BEALL, NINA (Painter)
1461 W. Summerdale, Chicago, IL 60640

Born: 1955 *Awards:* 1985 NEA Grant; 1984, '85 & '87 Illinois Arts Council Grants *Collections:* Coca Cola Co., Atlanta; Prudential Life Insurance, Newark, NJ *Exhibitions;* Rockford Art Museum; Graham Modern Gallery, New York *Education:* U. of Texas, Austin; School of the Art Institute of Chicago *Dealer:* Graham Modern Gallery, New York

Autobiographical in their reflection of childhood in a small salt-mining town in Texas, the expressionistic paintings of this artist depict landscapes that are harsh and forboding. Based on places she has visited, the landscapes combine real and imaginary elements using a heavy acrylic impasto in which vibrant and eerily synthetic colors contrast with black and white imagery. Influenced by early American painting and by the work of Van Gogh, her method is instinctive and the paintings filled with visual metaphors, such as the pattern and repetition of tree trunks and corn stalks, suggestive of cycles of birth and decay.

BECKER, ARLENE (Sculptor)
549 W. Fulton St., Chicago, IL 60606

Awards: Yaddo Fellowship; Whirlpool Foundation National Sculpture Award *Collections:* T.W. Florsheim; Al Talbot *Exhibitions:* Museum of Contemporary Art, Chicago; State of Illinois Gallery, Chicago *Education:* School of the Art Institute of Chicago; U. of Wisconsin, Madison

In the late 1970s and early 1980s, her work consisted of installations, mainly of earth and glass rooms' that served as metaphors for inner states of consciousness. The underlying wood structures of the works became tables and then wall constructions. She subsequently expanded her repertoire of media to include wire mesh, mirror, rock salt, pine cones, and painted plastic. Her current series, "Solitude Made Visible," uses mummy-like forms to explore solitude, an endangered species in our technological society. The sculptures are wall-mounted, ceiling-hung, and freestanding, and they may also serve as installations.

BEEKMAN, JAN (Painter)
731 W. 18th St., No. 9, Chicago, IL 60616

Born: 1929 *Awards:* Distinction, Prix D'Europa *Collections:* Belgian State Collection; R. Wislow Collection, Chicago *Exhibitions:* Museum of Art, Ann Arbor, MI; Zaks Gallery, Chicago *Education:* Academie Royale de

Leslie Bell, *Man with Surrounding Space,* 53 x 53, acrylic on canvas. Courtesy: Davenport Museum of Art

R. R. Benda, *Hi Rise,* 44 x 60, mixed media

Beaux Arts, Brussels *Dealer:* Sonia Zaks, Chicago

Following a period of figurative social and anti-war painting in the 1960s, he turned to experiments with space and landscape. He makes no pretensions to realism, being preoccupied rather with space, light and suggestions of three-dimensionality. A Belgian by birth, the discovery of America's wide-open spaces inspired him to add a geological accent to his abstract paintings. He has experimented with non-traditional uses of paint and, while he still paints on canvas, his earlier integration of materials such as copper, zinc and wool finally led to his current three- dimensional use of paper. "Light," the artist says, "makes a space."

BEHRENS, SUSAN (Ceramics)
270 N. George St., Whitewater, WI 53190

Born: 1958 *Collections:* Permanent Art Collection, U. of Wisconsin, Whitewater *Exhibitions:* Crossman Gallery, Center of Arts Building, U. of Wisconsin, Whitewater *Education:* U. of Wisconsin, Whitewater

In 1982, her ceramics instructors introduced her to raku clay. She also experimented with the saggar firing process, observing its effects on raku, porcelain and stoneware clay. Combining her two interests, she began throwing non-functional vessels made from raku clay, which were then bisqued, sprayed with carbonates, packed in saggars with combustible materials and fired. Her most recent vessels are larger, and she has moved on to explore pit-firing. Pots are bisqued, then brushed with sulphate washes. For the firing, they are stuffed with sawdust, placed in the pit and surrounded with colemanite-soaked straw, bones, kindling and other materials. This process produces unique vessels with various colorings.

BELL, LESLIE (Painter, Photographer)
338 W. Garfield St., Davenport, IA 52803

Born: 1947 *Awards:* Purchase Award, Alternatives Gallery, Athens, OH; 1st Place, Davenport Museum of Art *Collections:* Society of Contemporary Photographers, Kansas City, MO; Erie Art Center, Erie, PA *Exhibitions:* U. of California; Halsted Street Gallery, Chicago *Dealer:* Mimzi Ross, Davenport, IA

As a painter, his work in the 1970s was influenced by de Kooning. Work with abstract figures led to color-field experimentation and abstract landscapes. Returning recently to the figure, his work has grown expressionistic. Narratives with nude and clothed figures are played out, usually in close, interior settings. Drawing on his work as a photographer, the activities of his figures are caught, snapshot style, in progress and appear ambiguous and symbolic. He creates this effect with brushy scumbles and washed stains in acrylic to achieve lighting effects. His photography has continually concentrated on people, including halloween portraits and nudes. Most recently, a turn to still lifes combining those photographs and three dimensional objects has brought a starkly expressionistic sense to the work.

BELLEVANCE, LESLIE (Photographer, Mixed Media Artist)
1132 E. Pleasant #1, Milwaukee, WI 53202

Born: 1954 *Awards:* Wisconsin Arts Board Fellowship *Collections:* First Bank, Minneapolis; Madison Art Center *Exhibitions:* Rockford Art Museum, Rockford, IL; Randolph St. Gallery, Chicago *Education:* U. of Chicago; Tyler School of Art, Elkins Park, PA *Dealer:* Michael Lord, Milwaukee

Since 1978 she has combined photographs, drawings, and text to create sequential narratives. In "Natural Wonders," her installation at the Rockford, IL Art Museum, she depicted a wilderness that was less natural than artfully cultural. She used the vicarious enjoyment of nature as a metaphor for the experience of art, juxtaposing images of insects, animals, and people with those of horrific war atrocities and implying an idea of nature that included a totality of events. The artist also addressed didactic issues by including books, text and plaster casts of eyes.

BENDA, RIC (Painter, Printmaker)
4207 N. Elston Ave., Chicago, IL 60618

Born: 1934 *Collections:* Museum of Modern Art, Mexico City; Downey Museum of Art, CA *Education:* Chicago Academy of Fine Arts; Art Institue of Chicago; *Dealer:* Art Institute of Chicago's Sales Gallery; Janice S. Hunt Galleries, Ltd.

After formal training in realism, his interests progressed toward abstraction, though it would be some time before he would develop the abstract style of his current work. Early influences include Picasso, Avery, and De Kooning. Current work is influenced primarily by the great Oriental artists and Mexican muralists. Either on large canvases or rolls of Arches paper, he explores a variety of media including watercolor, acrylic, oil and ink, as well as collage. His more recent works consist of creating large colorful abstracts, many conceived as landscapes, seascapes, and now lead him into a figurative influence.

BENDER, JANET PINES (Painter)
593 Orchard Ln., Glencoe, IL 60022

Awards: Illinois Arts Council Fellowships; Award in Abstraction, Chautauqua National *Collections:* Nugent-Wenkus Corp., Chicago; Louis Zahn Drug Co., Melrose Park, IL *Exhibitions:* N.A.M.E. Gallery, Chicago; American Annual at Newport *Education:* Northwestern U.; U. of Wisconsin *Dealer:* ARC Gallery, Chicago

Influenced by German Expressionism, Jackson Pollock, and the Washington Color School, her early acrylic architectural abstractions integrated geometric and organic relationships, yielding deep frontal space in differing weights of pain, energy, and clarification. These works developed into a series of large, physical, exuberant, and passionate paintings, in which three-dimensional elements protruded from and flowed freely off the canvas. Currently, her media include roplex,

Vera Berdich, *The Flying Dutchman,* 20 x 23, photo etching with mezzotint & drypoint. Courtesy: Art Institute of Chicago & Printworks

Ulla-May Berggren, *Golden Flight,* 36 x 64, fiber, linen gobelin. Courtesy: Ruth Volid Gallery, (Chicago)

oils, oil stick, acrylics, latex, enamels, and varnish. Light is painted into the paintings, hybrid bird-like forms acting as conduits for investigations into myth, allegory, symbol, and art-historical allusion. Her work, which creates a relief effect by her media, remains committed to exploring the multiple layers of meaning, energy, and emotion in the non-verbal universe.

BENGEN, BERIT (Fiber Artist)
612 S. Cuyler, Oak Park, IL 60304

Born: 1955 *Awards:* Government Grant for Young Artists, Oslo, Norway *Collections:* National Association of Independent Insurers; N. Frank Commercial Interiors *Exhibitions:* Evanston Art Center Co-op Gallery; American Craft Council Craft Fair, Baltimore *Dealer:* Ruth Volid Gallery, Chicago

Born in Norway, she learned the craft of weaving as a child. She began making tapestries in 1978 and combines the traditions of Scandinavian textile art with Southern European and Egyptian influences. Her images, executed in Swedish linen, are either non-objective or abstracted from nature. Since moving to Chicago in 1985, her non-figurative work has been simpler, clearer and more contrastive. She is currently working on seven different series, including "Village," inspired by Greek Village landscapes; "Misa Criolla," her version of the Latin American church banner; "Stargsler," Norwegian for barriers; "YR," an old Norseword for both "light spring rain" and "giddy anticipation," and others.

BENINATI, CARLO (Painter)
420 W. Huron, Chicago, IL 60610

Born: 1942 *Collections:* Smithsonian Institute, Washington, D.C.; The White House *Education:* American and Chicago Academies of Art

A member of Chicago's Pallet and Chisel Academy of Fine Arts and past director of the Village Art School in Skokie, he has been commissioned by numerous Fortune 500 companies, publishers, advertising and government agencies, political and entertainment personalities, celebrities, corporate executives, professional athletes and coaches. Specializing in portraiture, his portrait of great Italian sports figures hangs in the Smithsonian Institute in Washington, D.C. Other sports portraits include Chicago Bears coach Mike Ditka and running back Walter Payton. Distinctive is his montage technique by which he includes portrayals of the important scenes and persons from his subject's life. Used and arranged symbolically, these images arise around and sometimes from within the central figure, creating not just a portrait but a life. Select paintings are also released in limited edition prints.

BENSON, VALERIE (Painter, Sculptor)
3 South 504 Batavia Rd., Warrenville, IL 60555

Awards: Warrenville Sesquicentennial Mural Award; Malamud Fine Arts Award, Ecublens, Switzerland *Exhibitions:* Gallery of Mennecy, Mennecy, France; Campanile Gallery, Chicago *Education:* Columbia Pacific U.; Northern Illinois U.

A surrealist whose visionary roots might be traced back to the tradition of Hieronymous Bosch, she paints the polyphony of contemporary agonies. Her powerful narratives, characterized by nightmarish images and stunning draftsmanship, serve as symbols of our disordered times.

BENT, GEOFFREY (Painter)
450 W. Melrose, Apt. 428, Chicago, IL 60657

Born: 1950 Collection: St. John's Lutheran Church *Exhibitions:* Art Expo, Chicago; Beverly Art Center, Chicago *Education:* Northeastern Illinois U.;Loyola U.

While his painterly influences have been linear and expressionistic (Van Gogh, Beckmann, Goya), his images owe much to the great photographers (Atget, Kertesz, Cartier-Bresson). His canvases resonate like poetry: a luminous Santa on a dark porch, a cripple child on the knee of a clown at a fund raiser, a string of street lights at dusk narrowing into a car's lit tail-lights. He is obsessed by the rhythmic and expressive qualities of line and he creates tension by superimposing brittle linear structures over strong color masses. His current voyeuristic series is an exploration of the debris people leave in their windows.

BERCAW, RUTH BOWLES (Painter)
2636 Lakeview Ave., Cleveland, OH 44116

Born: 1932 Awards: 1st Place in Painting *Exhibitions:* Bonfoey's, Cleveland *Dealer:* Bonfoey's, Cleveland

Disgusted by what she perceived as the intentionally abstruse writings and art criticism of the 1950s, she resisted virtually all modern ideas and trends. By 1970, after working through a variety of subject matter in a traditional way, she had developed an expressive watercolor approach to nature and environmental subjects. In 1983 she turned completely to abstraction and devised a slab-sided image based on tree roots and geological formations. Influenced by de Kooning's spirited paint-handling, she painted illusion of her image, as structure and form, operating in a real space. In her recent works she has pulled the image out of the painting, stretched the canvas over constructed slab-sided shapes, and made the work into painted wall sculptures and free-standing painted monoliths.

BERDICH, DR. VERA (Painter, Printmaker)
3126 N. Christiana, Chicago, IL 60618

Born: 1915 *Awards:* Logan Prizes, Art Institute of Chicago; Print Prize, San Francisco *Collections:* Albert Museum, London; Museum of Modern Art, NYC *Exhibitions:* Library of Congress, Washington, DC; Yamada Gallery, Tokyo *Education:* School of the Art Institute of Chicago *Dealer:* Print Works, Ltd. Gallery, Chicago; Robert Hellbert, Chicago

Her paintings and prints reflect her many interests and influences, including the work of the Pre-Raphaelites, the Symbolists, the Romantics, and the Surrealists. As far back as the forties, she was considered one of the earliest Surrealists in Chicago, and although her work content has changed, the treatment remains surrealistic. During the course of her career, she has introduced several innovations in technique. One innovation was photo-etching on plates; another was transferring images from magazine reproductions onto paper and canvas (which she refers to as print collage). She also

Steven Berkowitz, *Country Walk,* 25 x 32, photograph. Courtesy: Grove Street Gallery, (Evanston, IL)

Sandi Blank, *Cairo Market,* 48 x 48, acrylic

was instrumental in reviving *cliche verre* and extending its possibilities.

BERGGREN, ULLA-MAY (Fibre Artist)
314 S. Elmwood, Oak Park, IL 60302

Born: 1935 *Collections:* Art Institute of Chicago; Marshall Field and Company *Exhibitions:* Art Institute of Chicago; Ruth Volid Gallery, Chicago *Education:* Konstfack Skolan, Stockholm *Dealer:* Ruth Volid Gallery, Chicago

Historical traditions, a strict training in weaving, and the influence of her studies with Barbro Nilsson and Marianne Richter provided the background for her work. She combines both the Gobelin technique and other older Swedish patterns such as *Dukagang*. She creates shadows and highlights with the natural sheen of the linenyarns to enhance the visual perception of her tapestries.

BERKOWITZ, STEVEN (Photographer)
6252 N. Avers Ave., Chicago, IL 60659

Born: 1953 *Awards:* Award of Excellence, Glenview Art League; Award of Excellence, American Association of University Women *Collections:* American Can Corporation; Felician College *Exhibitions:* Barrington (IL) Area Arts Council; Northern Illinois Medical Center *Education:* Mayfair College *Dealer:* Grove Street Gallery, Evanston, IL

Initially influenced by such photographic masters as Elliot Porter and Cole Weston, his early work was straightforward and full of color and contrast, but lacked the grace and emotion he was trying to achieve. He then became influenced by photographer David Hamilton, whose diffusely lit work allowed for a softening of colors and an accentuation of highlights and shadows. Berkowitz began experimenting with many different diffusion techniques in order to evoke the emotion Hamilton was able to capture. Without giving up sharp light and detailed shadow, he now achieves a detailed yet impressionist look through filters or by sometimes simply breathing on the lens. His nostalgic cityscapes and rural landscapes are sensitive, peaceful, and ethereal, evoking comparisons to Monet. He has worked for a Chicago area retail photographic company since the early 1970s.

BERMAN, ZEKE (Photographer)
c/o Edwynn Houk Gallery, 200 W. Superior, Chicago, IL 60610

Born: 1951 *Awards:* Guggenheim Fellowship; NEA Fellowship *Collections:* Museum of Modern Art, NYC; Art Institute of Chicago *Exhibitions:* Art Institute of Chicago; Edwynn Houk Gallery, Chicago *Education:* Philadelphia College of Art *Dealer:* Edwynn Houk Gallery, Chicago

Working through the medium of photography, he explores and challenges visual perceptions and spatial relationships. His black and white still lifes present obscure arrangements of objects which defy the laws of gravity, create optical illusions, and appear out of context of their functional purpose. His still lifes are also unique in that he fabricates many of the objects he photographs. An examination of his work reveals his curiosity about the ability of photography to mirror reality. This fascination leads to his manipulations of the three-dimensionality of his subjects. For example, at first glance, *Interior, 1982* is a simple still life: a book, bottle and glass, a vase with plant, all placed on a table in the middle of a room. Looking more closely one sees that the table is lying flat on the floor and that the bottle is only a molded outline. A real cat in the corner of the picture and a beam rising from the floor establish references for the "true" three-dimensional space

BEVIER, EVANS R. (Painter, Printmaker)
467 Provident Ave., Winnetka, IL 60093

Born: 1939 *Awards:* Scholarship, Illinois Wesleyan U.; Scholarship, Art Institute of Chicago *Collections:* Gaslight Club; Red Cross, Chicago *Exhibitions:* Artspace, Chicago; Randolph St. Gallery, Chicago *Education:* American Academy of Art; Art Institute of Chicago *Dealers:* Studio 40, Chicago; Artspace, Chicago

He combines fine art with restorations. His styles include realism, neorealism, and impressionism. Subjects include multi-media portraits, figures, and landscapes. With his partner Erladine Kanaves, he often designs and executes murals such as one they did for the restaurant Chateau Louise. He also cleans and restores antique paintings and antique tapestries.

BEYER, JOHN (Painter)
c/o Oculus Gallery, 605 Dempster St., Evanston, IL 60201

Born: 1955 *Exhibitions:* Oculus Gallery, Evanston *Education:* U. of London, Heatherly School of Fine Art *Dealer:* Oculus Gallery, Evanston, IL

After a fine art education that primarily emphasized abstract painting, he pursued figurative and symbolic themes, utilizing his education and the expanded expressive freedom it provided. Subject matter such as landscapes, interiors, and nudes gradually evolved into variations on a construction site motif. This enabled him to focus on the rhythmic compositions found in the interplay of light and shadow and the psychological impact of color; among major themes are myths such as the mother goddess and other legendary or mystical subjects. There is a contemporary flavor to the paintings, many of which are large, and a bright palette is employed with an emphasis on cadmium reds and oranges. Work is also done in charcoal, watercolor and pastels.

BIADHOLM, SHARON ANN (Glassworker)
3449 N. Sheffield, Chicago, IL 60657

Born: 1958 *Awards:* 2nd Place, Delphi Glass National Design Competition *Collections:* John Hancock; Undersea Window *Exhibitions:* Northern Illinois U., Dekalb; Prairie Ave. Gallery, Chicago

In the early 1970s she made highly detailed copperfoil lampshades with botanical and medieval subjects. The artist followed these Tiffany- and O'Shannessy-influenced works with a more modern approach to glass. Influenced by Narcissus Quagliata and the new glass movement, she set up a permanent studio in Chicago and took commissions for larger windows and round installations. Her nature-based subjects became less

detailed. Plants, animals, and undersea life were common, as were designs she took from the human face and body after extensive nude studies. In recent works she has explored the interrelation of geometry and insect life. Other media include drawings and prints.

BIGBEAR, FRANK JR. (Draughtsperson)
c/o Prairie Lee Gallery, 301 W. Superior St., Chicago, IL 60610

Born: 1953 *Awards:* Jerome Foundation Winner; Bush Foundation Fellowship *Exhibitions:* Prairie Lee, Chicago; Bockley Gallery, New York City *Education:* U. of Minnesota *Dealer:* Prairie Lee Gallery, Chicago

Employing a meticulous technique of colored pencil patterning, he unites a phatasmagorical landscape of figuration and decoration. Just as a shaman often dances wildly in order to effect a vision, so do his drawings generate a sensation of religious fervor. In an effort to enlighten rather than simply entertain, he explores the language and imagery of his native Indian people. Taking as his central theme the impact of the white culture upon the Indian way of life, he fuses the contemporary-present and the traditional-past to open up a view of the traditional-present. "The center," writes critic Melissa Stang, "is the mythic moment, original time, leaving past and present events superimposed upon each other as layers of reality or possibility."

BISHOP, LEON (Painter)
1150 N. LaSalle, Chicago, IL 60610

Born: 1923 *Exhibtions:* Art Institute of Chicago; Gilman Gallery, Chicago *Education:* School of the Art Institute of Chicago; Chouinard Art Institute, Los Angeles *Dealer:* Obsession Gallery, Santa Fe, NM

Influenced by Klee, Picasso, and others, his early semi-abstract oils are highly personal, well-thought-out views of objects and landscapes. For some works he has used pure plastic to paint canvases of cool elegance. He essentially left fine arts in the early 1960s, but now is anxious to return. He is currently making large watercolors which he assembles, jigsaw-like, from several pieces of watercolor paper. The subjects continue to be semi-abstract renderings of the outdoor subjects he remembers, imagines, or finds in sketchbooks.

BLADES, BARBARA (Painter)
2111 Maple, Evanston, IL 60201

Born: 1938 *Awards:* Illinois Arts Council Project Completion Grant; Purchase Award, Illinois State Museum *Collections:* Illinois State Museum; State of Illinois Building, Chicago *Exhibitions:* Artemisia Gallery, Chicago; 81st Chicago & Vicinity Show *Education:* Webster U. *Dealer:* Jan Cicero, Chicago

After learning the technique of papermaking, she began to include sculptural components to accompany her paintings. From there, her interests expanded to environmental installations. In each case, the works are abstract and geometric, combined with floral motifs. More recently the work has evolved from room installations to works which are self-contained installations, combining paintings with sculptural elements. These works are architectonic in structure and synthesize abstract geometric and representational imagery. For example, in a recent painting, *To be part of the mainstream you have to swim like hell,* one finds a red and golden dreamscape of seven receding dissimilar arches with a tiny hand set deep in the composition, presumably of a drowning person, waving.

BLANK, SANDI (Painter)
2660 Prince St., Northbrook, IL 60062

Born: 1947 *Collections:* Schiff, Hardin and Waite, Chicago; Sears Tower, Chicago *Exhibitions:* I. Magnin, Northbrook, IL *Education:* School of the Art Institute of Chicago; Barat College *Dealer:* Alter & Associates, Highland Park, IL

Studying Jungian psychology and art therapy brought a new perspective to her art. As a student of the School of the Art Institute in the 1960s, she became aware of the importance of emotion in artistic creation. The result is a bold, confident style. Under Imefrede Hogan's guidance, she exchanged soft, muted colors for powerful primary ones. For a period, the work was in the abstract expressionist tradition, but her most recent work is moving toward realism. In these more recent paintings, scenes from the landscape, mountains, and harbors have replaced pure abstraction; however, her vivid palette and expressive brushwork remain.

BLATCHFORD, JAQUI (Painter)
1411 Estate Ln., Lake Forest, IL 60045

Born: 1936 *Collections:* Abbot Laboratories; Good Shepherd Hospital, Barrington *Exhibitions:* Dakota Art Gallery, Rapid City *Education:* Rusking School of Art, Oxford U., England; Slade School of Art, London University *Dealer:* Art Institute of Chicago Gallery; Richard Love Gallery, Chicago

After completing her formal training, she painted what she calls semi-abstract art. She says, "Then, when I married and had children, I turned to realism." She is known best for her landscapes, particularly for the Autumn and Winter scenes painted on location, where she is able to put onto canvas the full realism of nature with the range of color, precise design, and subtle shades of light that cannot be captured on photographic film. Her style is distinctive through her application of color, and she creates bright and sparkling surfaces rich in texture. Each painting conveys to the viewer a feeling of nostalgia for places and scenes familiar and remembered.

BLOCK, CAROL (Draughtsperson, Sculptor)
722 W. Briar Pl., Chicago, IL

Born: 1934 *Awards:* Grant, Chicago Office of Fine Arts *Collections:* Hesterberg Collection; Guttfreund Collection *Exhibitions:* Artemisia Gallery, Chicago; Pleiades Gallery, NYC *Education:* School of the Art Institute of Chicago; Institute of Design Dealers: Phoenix Gallery, NYC; Artemisia Gallery, Chicago

Her interest in the effect of light on paint led to work in three dimensions. At first she cut brushstrokes from wood and then began somewhat improvised "drawings" with a bandsaw. Because of the limits of the medium her forms were rectangular at first but soon evolved into her current floating forms. Aspiring to a timeless, spiritual quality, she layers plexiglass on gessoed and

painted wood panels, shaping them into floating forms which angle out from the wall.

BLUE, ROBERT (Ceramist)
P.O. Box 72, Woodstock, IL 60098

Born: 1948 *Awards:* Geneva (IL) Swedish Days; Award of Excellence, Yorktown Craft Showcase, Lombard, IL *Exhibitions:* Art Independent Gallery, Lake Geneva, WI; Illinois Artisan Shop, State of Illinois Building

A former student of Bauhaus-influenced artist Cecil Strawn, he has received a heritage which insists on an intimate relationship between form and function. His work is a unique blending of the styles of European and Eastern masters. Rhythmic form and clarity of utility and function are his guiding principles. He is currently working on neutral-colored functional stoneware and interior design pieces with matt blue, rust, and black landscape accents. "My work embodies skill, insight, and respect for the material and process. It will be useful in the kitchen and on the table. The warmth and beauty crafted into each pot will touch those who use it."

BOBBE, JUDITH (Painter, Sculptor)
1427 W. Birchwood Ave., Chicago, IL 60626

Born: 1950 *Exhibitions:* Evanston Art Center *Education:* School of the Art Institute of Chicago

Concerns with the movement of thick paint across a canvas and the creation of texture, light and shadow through the physicality of paint are the impetus for this artist's progression from shaped relief paintings to current mixed media pieces. Allusions to cloud and land formations gave way to thickly-painted shapes reminiscent of plant and animal forms. Canvases are built out of mixed media and encrusted with modeling paste, beads and other textural elements, resulting in the formation of patterns reminiscent of animal camouflage. Frequently the canvases project up to three inches from the wall. Other works are made from molding or hand-shaping clay and collaging the pieces together.

BOESCHE, JOHN (Installation Artist)
2222 W. Giddings, Chicago, IL 60625

Born: 1953 *Awards:* Joseph Jefferson Special Award For Expanding the Visual Artistry of Chicago Theatre; Best of Fest, Association for Multi Image *Collections:* Carson's International; United Terminal, O'Hare Airport, Chicago *Exhibitions:* State of Illinois Art Gallery; One Financial Place, Chicago *Education:* School of the Art Institute of Chicago

He sculpts with light. With training in interior architecture and experience in projected stagecraft, he combines a consciousness of large interior volumes and an interactive, almost theatrical sensibility. He constructed his early pieces entirely of light, either with lasers or slide projections in smoky rooms. In the work that followed the viewer was required to walk through a projection and cast a shadow on a complex image. His current work includes computer-controlled multi-projector installations with electronic sound and a programmed projected scenery for theatrical events. He created a permanent installation for the United Airlines' terminal at O'Hare Airport.

BOHROD, AARON (Painter)
c/o Sazama Brauer Gallery, 361 W. Superior Ave., Chicago, IL 60610

Born: 1907 *Awards:* Guggenheim Fellowship; Art Institute of Chicago; Metropolitan Museum of Art *Collections:* Metropolitan Museum of Art, NYC; Whitney Museum of Art, NYC *Exhibitions:* Milwaukee Art Museum; Sazama/Brauer Gallery, Chicago *Education:* School of the Art Institute of Chicago; Art Students League *Dealer:* Sazama/Brauer Galley, Chicago

Following his studies in New York City, he returned to Chicago to "enter the professional art life of the city." He quickly gained notoriety for his realistic landscapes and cityscapes of such scenes as skylines, tenement houses and scenes of rural America. As a soldier with the Army Corp of Engineers and as an artistic correspondent for *Life* magazine during World War II, he created works depicting the suffering resulting from war. Many of these paintings are in the Pentagon collection. He then joined the faculty of the University of Wisconsin in the late 1940s, during which time he became enamored with the realism of the works of 17th century Dutch still life painters and 19th century Americans such as Harnet and Haberle. His work is characterized by symbolic still lifes on both serious and light-hearted themes, centering around historic or current events. Visual and verbal puns and a certain wit are evident, as are careful composition and a close attention to detail.

BOGLE, MAUREEN (Enamelist)
6719 N. Ionia, Chicago, IL 60646

Born: 1924 *Awards:* Art in the Barn at Barrington Purchase Awards; NSAL Award of Excellence *Exhibitions:* International Enamel Show, Montreal; Oakbrook Craft Invitational *Education:* School of the Art Institute of Chicago; Otis Art Institute, Los Angeles

Single and multiple groupings of copper enamel wall panels depict intertidal and coral reef sea forms and forest floor or fell field flora and fauna with a realism that draws from the artist's previous experience in scientific illustration. Having explored rarely used methods of enameling--limoges, camaieu, and grisaille---she developed a technique which enables her to represent a luminous three dimensionality. Beginning with a *sgraffito* of the drawing, she applies a first coat of transparent glass on copper, and the plate then undergoes subsequent applications of opaque, translucent, and transparant glasses that are flash-fired as many as 20 times.

BOLLE, ALAN M. (Painter)
3823 N. Paulina St., Chicago, IL 60613

Born: 1958 *Exhibitions:* Randolph Street Gallery, Chicago; Axe St. Arena, Chicago *Education:* Maryland Institute; California College of Arts and Crafts

Breaking away from his traditional education in fine arts, he began to explore the notion of transforming a two-dimensional picture plane into a volumetric space, creating a painting that becomes a physical environ-

Maureen Bogle, *Forest Floor & Thrush,* 20 x 36, vitreous enamel on copper. Courtesy: Lu Sandburg Memorial

Alan M. Bolle, *Waterfall of Convenience Accessories Falling into the Grasping Hand of Desire,* 324 x 96, mixed media. Courtesy: Steven Gross

ment. He started by drawing from works of European theatre design of the early 1900s and from such expressionist films as *The Cabinet of Doctor Caligari*, noting the use of geometry to animate the stage environment. Further influences include more contemporary artists such as Eva Hesse, whose sculpture and installations of the 1960s and '70s create tactile environments. He has produced functional stage sets as well as outdoor installations such as *Waterfall of Convenience Accessories*. Most recently, he has been combining found objects, creating standing forms and collaged panels.

BOLTANSKI, CHRISTIAN (Photographer, Painter)

6 Passage Darceau, 75014 Paris, France

Born: 1944 *Collections:* Art Institute of Chicago; Israel Museum, Jerusalem *Exhibitions:* Musee d'Art Moderne, Paris, France; Carpenter Art Center, Harvard University *Dealer:* Galerie Sonnabend, Paris; Sonnabend Gallery, New York

"The work of art as magic, the work of art as naive and childish play, the work of art as a fiction definitively removed from the empirical reality," writes art critic Annelie Pohlen, "from the outset these ideas have formed the coordinates of Boltanski's production." His early work is composed of photo albums, reconstructions of objects and articles of clothing from childhood, and "other allegedly historical traces." Today he makes small, delicate, puppetlike figures and masks. These objects are not themselves displayed but "merely" photographed. The resulting images are monumental prints (78 by 90 inches) which he calls paintings, in which figures float against a deep black ground. Of the images, Pohlen comments further, "Against the impenetrable black of the ground, they acquire the insistent reality of a dream, seeming both superior to the banality of life and a denial of life's proximity to dissolution and death."

BOOTH, GEORGE WARREN (Painter)

1771 S.W. 55th Rd., Ocala, FL 32674

Born: 1917 *Awards:* Gold Medal, New York Art Directors' Club; Kerwin H. Fulton Medal *Collections:* Phillip Morris Corporation; Art In Embassies, Washington, DC *Exhibitions:* American Watercolor Society, NYC; Los Angeles Museum of Art *Education:* Ohio U.; Chouinard School of Art *Dealers:* Cross Roads of Sport, NYC; Paddock Room, Ocala

In addition to his career as an illustrator and art director in New York City, he paints traditional figurative and landscape works in watercolor, oil, and acrylic. His focus for the last 20 years has been on equine art, including racing, polo, eventing, fox hunting, and cutting horses. With a direct, almost "alla Prima" approach, he emphasizes strong and simple composition and color. Contemporary abstract color and design have influenced these works, including a series of paintings for Ralph Lauren's *Polo* line of merchandise introduced at Saks Fifth Avenue.

BORSTEIN, ELENA (Painter)

c/o Sazama/Brauer Gallery, 361 W. Superior, Chicago, IL 60610

Born: 1946 *Awards:* CAPS & NEA Grants *Collections:* Museum of Modern Art; Everson Museum, Syracuse *Exhibitions:* San Francisco Museum of Modern Art; Bronx Museum *Education:* Skidmore College; U. of Pennsylvania *Dealers:* Charlotte Brauer/Susan Sazama, Chicago

From the mid-1970s to the mid-1980s her acrylic paintings and pastel studies were depictions of Mediterranean architectural spaces in a light-drenched haze. In these works she combined a cool, hard-edged beauty with a discomforting feeling of emptiness. Since the mid-1980s she has shifted her focus closer to home and engaged the inner city landscape. From the barren, burnt-out buildings of the Bronx to the small neighborhood bodegas, she deals with poverty, social decay, human resilience, the natural beauty of the light and landscape, and the fading beauty of the architecture of an earlier period. She uses her formal and geometric sensibilities to change not only how the viewer sees the painting but also how he or she sees the world.

BOSCHULTE, RICHARD R. (Painter)

620 1/2 S. Lee, Apt. #1, Bloomington, IL 61701

Born: 1958 *Awards:* Illinois Small Painting Competition *Collections:* Western Illinois University; Illinois State University *Exhibitions:* Up Front Gallery, Bloomington, IL; Illinois State University *Dealer:* Up Front Gallery, Bloomington IL

Recent landscape works are realistic in their rendering and contemplative in mood, stressing contemporary concerns. These works constitute a radical departure from his earlier color field paintings, which mixed oil and acrylic paint solutions, abstracting impressions of the land. Earliest works were abstract expressionist in style. His current works feature 20th-century landmarks that depart from traditional landscapes.

BOVARD, RON (Painter)

52 E. Briggs, Fairfield, Iowa 52556

Born: 1948 *Collections:* Childrens Hospital, Pittsburgh *Exhibitions:* Carnegie Museum; West Broadway Gallery, NYC *Education:* Slippery Rock U.

As a student in the 1960s, his primary influences were the Bauhaus painters, Klee and Kandinsky. During the first decade of his career in the 1970s, his watercolor and acrylic paintings were created from thin layers of primary transparent color, the result being abstract personages and landscapes in rich multiple textures of lavish colors. In 1982 he moved from the urban Northeast to the rural Midwest, and the effect on his art was immediate and profound. The rapture of vast open space permeates these more recent canvases. Innocent images of sky, sun, flowers, trees, hills, corn, and lakes appear. A perpetual Spring bursts forth. But these paintings are neither naive nor primitive. While charming and innocent, they reveal the spacial concepts of

Ronald Bovard, *Venus in the Sky,* 44 x 34, acrylic on canvas.
Photograph: Bob Stone

Constance C. Bradshaw, *Cooling Out,* 4 x 5, pen & ink

minimal art and display patterns verging on the conceptual.

BOWEN, KENNETH P. (Lighting Designer)
5137 N. Oakley, Chicago, IL 60625

Born: 1950 *Awards:* 1985 Ruth Page Award for Artistic Excellence *Exhibitions:* World Expo '88, Brisbane, Australia; Wisdom Bridge Theatre, Chicago *Education:* Carleton College

Concentrating on the lighting of modern dance since 1976, he has also done selected costume and scenery designs as well as theatrical, trade show, and video lighting. His current work is focused on time phenomena. Using equipment controlled by computer and synthesizer, he continually changes the modeling of form and the shape of the space through contrasts in intensity, color, and texture. His use of color saturation and afterimage is tied to his time-structures. Fluency in lasers and other optical techniques facilitates the creation of dynamic light sculptures that respond to air currents, water waves, abstract mathematical wave forms, and computer-randomized commands.

THE BOYLE FAMILY, (Sculptors, Painters)
Red Lion House, Chiswick Mall, London W 4, England

Born: 1934 (Mark) *Awards:* Painting Prize, 5th Biennale de Paris; Painting Prize, 15th Premio Lissone, Italy *Collections:* Tate Gallery, London; British Council, London *Exhibitions:* Gray Gallery, Chicago Charles Cowles Gallery, New York

In something like a photo-realist "On the Road," the Boyle Family, made up of Mark Boyle and wife Joan Hills, son and daughter, have been working since 1970 on "earthprobes." Working from sites choosen by visitors to their studio throwing darts at a large Mercator projection map of the world, they painstakingly recreate 6-ft square sections of topography. The resulting fiberglass "three-dimensional paintings," each detail down to tread marks, pocks, and cigarette butts rendered faithfully, make even the most ordinary stretch of double yellow no-parking lines exotic. Full documentation includes the surface casting, a cast vertical sampling of the substrata, and photographic enlargements of microscopic details of plants and insects gathered on-site, hair, and fluid wastes from the artist's body, all revealed as crustaceous or crystalline molecular patterns of structure.

BRADSHAW, CONSTANCE C. (Painter)
#7 Deacon Dr., St. Louis, MO 63112

Born: 1935 *Awards:* Cash Award Springfield (MO) Art Museum; The Herb Olsen Award for a Transparent Watercolor, American Watercolor Society, NYC *Collections:* Springfield (MO) Art Museum; Centerre Bank, St. Louis *Exhibitions:* Metropolitan Museum of Art; Watercolor U.S.A., Springfield, MO *Education:* Washington U.; Stephens College

Influenced in line and brushwork by Sargent, Homer, Munnings, and her principal teacher and mentor, Fred Conway, she has won recognition for her watercolor still lifes, landscapes, and portraits. Throughout her career her primary subject has been the horse and the racing scene. The running horse represents a metaphor that is present in all of her work. Using a carbon pencil and bristol board, she is able to create freehand "photographic likenesses" of the equine subject. Since 1976 she has been involved in breeding and raising horses and occasionally doing commissioned pieces involving horses.

BRADSHAW, GLENN R. (Painting)
906 Sunnycrest, Urbana, IL 61801

Born: 1922 *Awards:* Newman Medal, 33rd Casein Society Annual, NY; William A. Paten Prize, National Academy of Design, NY *Collections:* State of Illinois Collection; Hollister Corporation *Exhibitions:* U. of San Diego; Albuquerque Museum *Education:* Illinois State U.; U. of Illinois *Dealer:* Neville-Sargent, Chicago

His intuitive abstractions were developed without regard to art trends. He works by applying dilute casein tempura paint to both sides of Japanese rice paper, building each painting layer upon layer. He creates lyrical, romantic, abstract land- and waterscapes based on Northwoods subjects. Through a lengthy evolution, representational images have been eliminated in favor of fixed geometric and fluid gestural marks. The resulting paintings are non-objective, richly hued, tightly composed, complex improvisations on this theme.

BRAMS, KRIMMER (Painter)
1304 Birchwood, Chicago, IL 60626

Born: 1930 *Awards:* Laura Slobe Memorial Award, Art Institute of Chicago; 1st Prize, Chicago Arts Festival *Collections:* Art Institute of Chicago; Embassy in Addis Ababa, Ethiopia *Exhibitions:* Smithsonian Institute; National Museum of American Art *Education:* Illinois Inst. of Technology; U. of Illinois

After working in printmaking for ten years, the artist began painting modular investigations of natural subjects, including a series of literal and minimal interpretations of Lake Michigan. The works reflect the influence of color field painting and are done on small canvases stained and glazed with oil and acrylic. Arranged in groups, they express ideas about sequential time, mood, and space. Recent pieces sometimes place hard-edged borders around the fluid, ethereal painting, emphasizing the distance between the viewer and the subject.

BRAMSON, PHYLLIS HALPERIN (Painter)
300 Flora Ave., Glenview, IL 60025

Born: 1941 *Awards:* NEA Craft Grant; Louis C. Tiffany Grant *Collections:* Art Institute of Chicago; Museum of Contemporary Art, Chicago *Exhibitions:* Art Institute of Chicago; Smithsonian Institute *Education:* U. of Wisconsin; School of the Art Institute of Chicago *Dealer:* Monique Knowlton Gallery, NYC; Dart Gallery, Chicago

Seeking to depict a "private mythology" that is "fraught with magical and mystical powers," she expresses "philosophical views about life and one's role as an artist/observer." A quasi-representational artist influenced by Oriental philosophy, she employs mixed media on paper to depict a new kind of surrealism which deals with personal narrative and lush decorative motifs. During the late 1970s she studied of mime and

E. Brooks, *Broadway & Buckingham,* 48 x 36, acrylic on canvas

David Brugioni, *Departure,* 24 x 24, oil

theater which proved influential in later work. Recent drawings and paintings feature voluptuous women in such theatrical roles as artist, actress, acrobat and magician. *P.G. and the Holy Sparks* (1982) is a rectangular space divided into four diagonal sections, each containing fragments of figures and unknown objects engaged in strange dramas.

BRANBERG, CHRISTINA (Painter)
3454 N. Damen, Chicago IL 60618

Born: 1946 *Awards:* National Endowment for the Humanities Grants *Collections:* Whitney Museum of American Art, NYC; Art Institute of Chicago *Exhibitions:* Whitney Museum Annual, NYC; Sao Paulo Biennial *Education:* School of the Art Institute of Chicago *Dealer:* Phyllis Kind Gallery, Chicago

This Chicago Imagist paints upon Masonite the wrapped torsos of sinister figures—the combination of flesh and clothing creating an enigmatic tension. Paintings of the early 1970s suggest a woman in lingerie, bound by silk and lace. Subsequent works become less discernible, such as *Sedimentary Disturbance*, which is collage-like in its depiction of various textured garments and undefined surfaces. His female-looking figures are usually headless; if the head is included, the face is obstructed by hair, as in *Layered Disorder*. Agressively surrealistic and hallucinatory imagery gives the works an iconic weight symbolizing victimization and fetishism.

BRAUER, ARIK (or Erich) (Painter)
c/o Joram Harel Management, P.O. Box 145, Vienna 1013, Austria

Born: 1929 *Collections:* Aviv Museum, Israel; Historisches Museum der Stadt Wien, Vienna *Exhibitions:* Galerie Facchetti, Paris; Aberbach Fine Art, NYC *Education:* Academy of Fine Arts, Vienna; City Conservatory, Vienna

"I have been painting ever since I can remember, and I have done so from seven to eight hours a day over the past 30 years. Even though I have painted more or less always the same, painting has never lost its fascination for me," he writes by way of introduction. Working in the tradition of the Vienna School of Fantastic Realism, he has always executed figurative and literary paintings. Like "mischetechnik," a kind of melding of the ancient painting craft and antique lore and alchemies, his work is populated with elements of a magico-medieval culture despite the fact that many of his paintings, watercolors, and etchings have titles that suggest the mundane (*Naomi on a Friday Evening*, for example). "Every image," writes critic Sheldon Williams, "sprouts vegetally, whether through its limbs or its garments or out of the landscape itself. A world of articulated turkish delight, except that everything is more delicately rendered and the colors are not the pale evanescences of pastel, but the burnished hues expanded in an imaginative furnace."

BRENNAN, DEBORAH A. (Painter)
1022 Timberlane Dr., Indianapolis, IN 46260

Born: 1949 *Exhibitions:* 431 Gallery, Indianapolis; Indianapolis Public Library *Education:* John Herron School of Art

She was influenced by Andy Warhol and Frank Stella. In the late 1960s she painted single objects from everyday life using brightly colored acrylics on geometric-shaped canvases. By the early 1980s she was painting non-referential wedge forms that were rooted in the phenomenal world by a sense of weight. Her cool and sophisticated forms of the mid-1980s existed in a non-realistic, painterly atmosphere. Currently, she paints two- and three-dimensional "spatial landscapes" with bright, vibrating acrylics and overglazes them with subdued oils. She then adds styrofoam and masonite, creating twisting and turning representations of her Chicago youth.

BREWER, KATHLEEN J. (Sculptor)
203 Asbury Ave., Greenville, IL 62246

Born: 1954 *Collections:* American Indian Museum, Cody, WY; Museum of Westward Expansion, St. Louis *Exhibitions:* American West Gallery, Chicago; Buffalo Chips Trading Post & Gallery, Cody, WY *Education:* Greenville College *Dealer:* American West Gallery, Chicago

Working in conjunction with William T. Brewer, she is a specialist in the recreation of Plains Indian artifacts. She uses mixed media which reflect the traditions of the Indians—leather, fiber, paint, glass beads, wood, feathers, porcupine quills—and she emphasizes beadwork and the assembly of the finished piece. Objects include painted rawhide *parfleche* pieces, beaded bag forms, clothing, dolls, and wall hangings suggestive of shields and dance bustles. All show the influence of actual Indian decorated cultural artifacts in museum collections. The works are done primarily on a commission basis.

BREWER, WILLIAM T. (Sculptor)
203 Asbury Ave., Greenville, IL 62246

Born: 1953 *Awards:* Greenville College Senior Art Award *Collections:* American Indian Museum, Cody, WY; Museum of Westward Expansion, St. Louis *Exhibitions:* American West Gallery, Chicago; Buffalo Chips Trading Post & Gallery, Cody, WY *Dealer:* American West Gallery, Chicago

A self-taught specialist in the recreation of Plains Indian cultural artifacts of all kinds, including sculptural forms of wood, antler, and bone, he creates wall hangings suggestive of shields and dance bustles, horse effigies carved from cottonwood, dolls, bows, arrows, drums, clothing and accessories of hand-scraped rawhide, and many other objects reflective of the Native Americans. The materials he uses include buckskin and commerical leathers and wool or muslin cloth to which he applies glass beads, porcupine quills, feathers,

teeth, and claws. He works entirely in conjunction with Kathleen J. Brewer, and they frequently provide replicas for museums, commercial display, and motion pictures.

BROOKS, EDWARD (Painter)
13115 S. Brandon, Chicago, IL 60633

Born: 1961 *Awards:* Buckingham Fountain Art Fair; North Aide High School Art Competition, Truman College *Exhibitions:* Union League Club of Chicago; School of the Art Institute Gallery *Education:* School of the Art Institute of Chicago

Large urban landscapes in oil and acrylic are rendered in a painterly realistic style. Working from small pencil or watercolor sketches and field photos he transforms his images with muted hues and values to create a grayish, subdued quality of light. Influences include the painters of the Ashcan School of American painters from the early part of the century, as well as such artist's as Edward Hopper, Charles Sheeler, Richard Estes and Rackstraw Downes.

BROWN, FREDERICK J. (Painter)
c/o Hokin Kaufman Gallery, 210 W. Superior, Chicago IL 60610

Born: 1945 *Awards:* Award, New York State Council on the Arts *Collections:* Metropolitan Museum of Art; The Aldrich Museum of Contemporary Art *Exhibitions:* Hokin Kaufman Gallery, Chicago; Aldrich Museum of Contemporary Art *Education:* Southern Illinois U. *Dealer:* Marlborough Gallery, NYC; Hokin Kaufman Gallery, Chicago

Older works are in an abstract expressionist vein, with the artist citing the strong influence of Pollock and de Kooning. Many works use brush techniques as well to relate perspective in the spirit of New York School of Action painting. Current works have been exclusively representational. Religious themes dominate the figurative realism painted on large-scale canvases. Perspective now takes the form of spiritual levels, not easily recognizable due to their conceptual nature. He is the first American artist to hold a retrospective in Mainland China.

BROWN, LAURA (Painter)
2951 N. Clark St., Chicago, IL 60657

Born: 1949 *Exhibitions:* Prairie State College, Chicago Heights, IL; Three Illinois Center, Chicago *Education:* U. of Illinois; Carnegie-Mellon U. *Dealer:* Lyman/Heizer, Northbrook, IL

Her earlier large-scale abstract oil paintings were non-objective. While she has retained a strong sense of abstraction, she now incorporates referential materials into her mixed-media paintings; ideas of contrast, conflict, and the interrelationship of disparate parts continue through all her work. Prehistoric cultures are of special interest to the artist. The simple beauty and enigmatic nature of primitive tools, survival skills and earthworks have inspired many of her recent paintings. She sprays, rolls, pours, incises and monoprints paint on canvas and adds a wide variety of materials such as clay, powdered pigment, and metal.

BROWN, ROGER (Painter)
c/o Phyllis Kind Gallery, 313 W. Superior, Chicago, IL 60610

Born: 1941 *Collections:* Museum of Modern Art, NYC; Whitney Museum, NYC *Exhibitions:* Museum of Contemporary Art, Chicago; Hirshhorn Museum and Sculpture Garden, Washington, DC *Education:* School of the Art Institute of Chicago *Dealer:* Phyllis Kind Gallery, Chicago

Known for "Chicago Imagist" paintings in which small, silhouetted figures populate cityscapes and rural landscapes, he uses bilateral symmetry to an obsessive degree and foreshortened, often layered compositions to create enigmatic narratives that tell of disasters and reflect current events. Influenced in the early 1970s by discussions of vernacular architecture in Robert Venturi's *Complexity and Contradiction in Architecture,* he reexamined and accepted his own roots and art; subsequent sources for inspiration have come from naive and folk art, cartoons, and "ordinary" non-art found objects. Recent works range from the highly political in content, such as *Guilt Without Trial! Protected by the Bill of Rights/The Modern American Press Marches to Defend Us From the Tyranny by Government but Who or What Will Defend Us From the Tyranny of the Press?*, which was painted after Gary Hart withdrew from the presidential race, to the humourous *Imelda Building,* which is in the shape of a huge inhabited shoe, to the nightmarish *Chain Reaction (When You Hear This Sound You Will Be Dead.)*

BROWN-WAGNER, ALICE (Painter)
171 W. 400 N. #3, Logan, UT 84321

Born: 1953 *Awards:* Ford Foundation Grant, U. of Iowa; Artist's Honorarium, Contemporary Art Workshop, Chicago *Collections:* Fort Hays State U.; U. of Iowa *Exhibitions:* ARC Gallery, Chicago; School of the Art Institute of Chicago *Education:* U. of Iowa; Utah State U. *Dealer:* Sonia Zaks, Chicago

Ten years ago she began experimenting with constructing images that present multiple perspectives and eye levels. The early pieces are non-objective fields of graphite marks on paper. Among the most important influences at this time were early German cinema, such as the films *The Cabinet of Dr. Caligari* and *Imaginary Prisons,* as well as the extreme perspective in the work of Andrea Mantagna, in particular *The Dead Christ.* Gradually a rigorously articulated yet logically irreconcilable architectural space evolved. Identifiable images appear in the later works, as her interest in narrative grew. Attempting to develop an iconography, she incorporates maps of the world, windows that create a visual leap into another space, solitary chairs, domesticated animals, cars, televisions, and electric fans into more recent works. Toward the end of 1986 she introduced the figure to act as an intermediary, a witness, along with the viewer, as one to survey the jumbled, disoriented world of the painting.

BRUBAKER, JACK (Metalsmith)
R.R. 2 Box 102A, Nashville, IN 47448

Born: 1944 *Awards:* NEA Grant; Honorable Mention, National Ornamental Metal Museum *Collections:* Joseph Hirshhorn Collection *Exhibitions:* Art Institute of Chicago; California Craft Museum, San Francisco *Education:* Indiana U.; School of the Art Institute of Chicago

He started with a formal background in painting and printmaking and moved into metalcraft in 1970 as one of the first wave of new-generation artist blacksmiths. In blacksmithing, he was able to combine the various elements of his family's traditions in design and metalwork with a plastic media that allowed a high degree of spontaneity. He subsequently made a conscious decision to begin blacksmithing as a folk artist, absorbing the rich tradition in forged iron work; five years ago, he began a series of contemporary candle holders that have become very successful. His new work includes a series of sculptural pieces that explore combinations of forged metals and polychrome brushwork. In his works, he uses aluminum, stainless steel, steel, and brass in organic forms. Some pieces are sandblasted, while others have a hand-rubbed finish; some are functional, others nonfunctional.

BRUGIONI, DAVID, (Painter)
2509 Hess Ave., Wheeling, WV 26003

Born: 1956 *Awards:* Merit Award in Oils, Valley Art Association, St. Clairsville, OH *Exhibitions:* West Virginia Northern Community College; Sparkling New Year Art Exhibit, St. Clairsville, OH *Education:* West Virginia Northern Community College

In 1975 he moved to California where he acquired an interest in the works of Salvador Dali, Max Ernst and other Surrealists. There he drew with pen and ink and colored pencils. In 1976 he relocated to West Virginia and began experimenting and learning from instructional booklets. He now paints images from his dreams, emotions, and imagination. The turbulent night skies that appear often in his work are created by simultaneously dragging and twirling a loaded brush of white paint against a wet, deep, dark colored background. He has lately adopted a more visceral attitude in his painting and in his present style he "dilutes three parts Surrealism with one part Naturalism."

BRULC, LILLIAN (Painter, Sculptor)
909 Summit St., Joliet, IL 60435

Awards: George D. Brown Foreign Travel Fellowship, School of the Art Institute of Chicago; Artist-in-Residence, San Miguelito, Panama City, Panama *Collections:* Interpretive Center Museum, Chisholm, MN; A. Solom Collection, Los Angeles *Exhibitions:* Art Institute of Chicago Biennial Print Show; Cankarjev Dom, Ljubljana, Yugoslavia *Education:* School of the Art Institute of Chicago; U. of Chicago

She developed her early interest in the figure through formal study and travel in Europe. Her early paintings were oils, though she now works in acrylic. Although her sculptures are in a variety of media, current large commissions are bronzes and terracottas. She combines architecture, sculpture, painting and mosaic into a unified figurative ambient. On a smaller scale, she produces lithographs and woodcuts for use in book illustrations. Over the years she has increased the intensity and clarity of her colors, but she continues to create a sense of space and solidity through underlying forms, giving an architectural sense to even genre subjects.

BUCHER, SUZANNE M. (Jeweler)
91 Dartmouth, Williams Bay, MI 53191

Born: 1948 *Collections:* Art Institute of Chicago; Chicago Historical Society *Exhibitions:* Mindscape, Evanston, IL *Education:* Rosary College; Chicago State U. *Dealer:* Mindscape, Evanston

Self-taught in jewelry design and construction, in 1972 she began working with clay, feathers, beads, and precious metals. This first work was influenced by Native American and art deco designs. In 1978 she began using non-precious metals to execute large scale shapes she found in nature. In 1982 a desire to work in color led her to explore the use of plastic laminates and solid core plastics. Her experiences with these lightweight and flexible materials has led her to design her very wearable large and boldly geometric pieces.

BUDD, ERIK (Painter)
402 9th St. N.W., Fosston, MN 56542

Born: 1949 *Awards:* Grant, Minnesota State Arts Board; Bronze Medal in Oil and Acrylic Painting, International Art Competition, Los Angeles *Collections:* Plains Art Museum, Moorhead, MN; U. of Minnesota, Duluth *Exhibitions:* Minneapolis Institute of Art; Kansas State U., Manhattan *Education:* U. of N. Dakota *Dealer:* Thomas Barry Fine Arts, Minneapolis; Gilman/Gruen Gallery, Chicago

His subject is motion. Themes of animals caught in mid-gesture, at a moment of growing awareness, recur in many of his canvasses. His blurred animals resemble movie stills; they form uneasy relationships with their environment. His narrative triptychs are slightly out of sequence. He paints on a large scale with an assortment of putty knives, house paintbrushes, whisk brooms and razor blades. By building up layers of paint and scraping back through them he creates the abstract patterns and textures that appear when the work is viewed at close range. Trusting his intuition and the subconscious, he reacts to what is happening on the surface.

BUJNOWSKI, JOEL (Painter, Printmaker)
2439 W. Armitage Ave., Chicago, IL 60647

Born: 1949 *Awards:* Award of Excellence, NSAL Midwest Print Exhibition; President's Purchase Award, Bradley National *Collections:* Kemper Group; State of Illinois Center *Exhibitions:* International Biennial Print Exhibit, Republic of China; North River Community Gallery, Chicago *Education:* Northern Illinois U; Western Illinois U. *Dealer:* Chicago Center for the Print

During his academic training his greatest influences were Dürer, Henry Moore, the German Expressionists, and Mauricio Lansansky. In the mid-1970s he began to concentrate on intaglio printmaking and started his

D. Buttram Sr., *Rainy Day in the City,* 24 x 36, oil on canvas

Nancy Carrigan, *Her Fates Hold Her in the Balance,*
(sphere), scuptamold & acrylic. Courtesy: Prism Gallery (Evanston, IL)

collection of pre-Columbian flatback figures. The image is of utmost importance to him, and to represent it better, he has invented a highly accurate method of registering intaglio plates. In his current work he employs a non-racial black figure to illustrate the agoraphobic, black comedic angst of big city life. There are three main influences evident in the intense color and isometric or oblique projected space of his prints, paintings and sculptures: *ukiyoye* prints, pre-Columbian sculpture and Warner Brothers Cartoons.

BUNSTER, CARMEN MAYORAL (Weaver)
1864 Sherman Ave., Evanston, IL 60201

Born: 1921 *Exhibitions:* Botti Studio, Evanston; Larew's Galleries, Evanston *Dealer:* Galeria Mira, Spain

Recalling the art of her native Madrid, the artist designs and creates tapestries and wall hangings in both contemporary and neo-medieval styles. Combinations of silks, satins, velvets, and gold embroidery create a feeling of luxury in the pieces, which range in size from 8 by 14 inches to eight feet square. Subject matter ranges from a single, gem-encrusted bird to variations on three medieval dancers and also includes pure abstraction. Originally working exclusively by hand, she now does the basic layout construction on a machine, leaving for hand the intricate finishing embellishments.

BURKHART, KENNETH C. (Photographer)
803 S. Leavitt, Chicago, IL 60612

Born: 1951 *Awards:* Illinois Arts Council Fellowship *Collections:* Museum of Contemporary Photography; Illinois State Museum, Springfield *Exhibitions:* Illinois State Museum State of Illinois Art Gallery *Education:* U. of Chicago; Mercyhurst College *Dealer:* Ruth Volid Gallery, Chicago

Since he purchased his first Widelux camera in 1979 he has concentrated almost exclusively on panoramic images. Space and extended vision are the photographer's primary concerns. His landscapes are influenced by the early western landscape photographers. On the other hand, photographs of people are little vignettes or short stories which explore ideas of space and extended vision. Because of his street shooting style and panoramic format, the viewer must scan the picture plane in order to piece together the information, mimicking actual human vision. He is currently Curator of Photography at the Chicago Public Library Cultural Center.

BURNS, SHARON (Painter)
275 Highland Dr. NW, Cedar Rapids, IA 52405

Born: 1948 *Awards:* Kirkwood College Purchase Award, Cedar Rapids; 1st Place, Fort Hayes State U. *Collections:* Joslyn Art Museum, Omaha; U. of Northern Iowa *Exhibitions:* Peter Miller Gallery, Chicago; National Watercolor Society Traveling Show, Los Angeles *Education:* U. of Iowa *Dealer:* Lumina Gallery, San Francisco

She studied the work of Kandinsky, Munter, and other Blue Rider artists in depth at Murnau after completing her education. Originally centered on brightly-colored landscapes in oil crayon, chosen for its intense blues

and greens, her work changed radically to a study of fantasy-dream-landscapes, which are rendered in oil using very little turpentine and worked in patches. Fragmented and resembling stained glass windows, her compositions use deep colors and primitively rendered figures which fit together with a slighty distorted symmetry, mirroring the dream world they explore. Working on printer's paper covered with ink and a clear medium, she paints disengaged, pale faces, simplified animal figures, forests of elegant trees and humorous, invented beings. The paintings are distinctly narrative within a deeply personal vocabulary and are childlike in their direct, spontaneous compostions and active, vital concern with line. The work continues to increase in both fragmentation and richness of color, drawing more and more on subconcious dreaming rather than on the outright fantasy of earlier work, reflecting the influence of her two young children.

BURROUGHS, WILLIAM S. (Writer, Painter)
c/o Klein Gallery, 356 W. Huron, Chicago, IL 60610

Born: 1914 *Exhibitions:* Klein Gallery, Chicago; The October Gallery, London *Dealer:* Klein Gallery, Chicago

Famous first as a writer (he is the author of *Naked Lunch*, among many other books), in 1982 he began painting. Self-taught as an artist, currently he spends all his time at work in the studio. His pieces are generally small, 18 by 24 inches, and for the most part in watercolor and acrylic. The surfaces are covered with brush strokes, some of red and gold and orange, with small bits of white left at the edges, others of black and white and grey. A minority of works incorporate collage elements. In one, a photograph of skulls appears in a landscape of blue and grey brush strokes. Other times a photograph of the painting itself is incorporated.

Perhaps most interesting is his work "painted" with a shotgun. Ever since his accidental shooting of his wife, Burroughs has been associated with guns; in his shotgun paintings, Burroughs uses one to blast paint over plywood. The results are interesting and sometimes beautiful, the wood complementing the spray of the paint with its own texture. For example, in "Snow Leopards" in addition to the run of the "grain," a straight horizontal groove traverses the top, and three faint circular indentations can be seen on close inspection. But most dramatic is the tear in the ply in a field of silver paint with dark reds and blacks beneath it, which could be--if one were to tell a story--a wound.

BUSHMAN, DAVID F. (Painter, Draughtsperson)
P.O. Box 2151, Champaign, IL 61820

Born: 1945 *Awards:* Ford Foundation Grant *Collections:* Art Institute of Chicago; Madison (WI) Art Center *Exhibitions:* Art Institute of Chicago; Smithsonian Institution *Education:* U. of Wisconsin *Dealer:* Gilman/Gruen Galleries, Chicago

He expresses the psychological presence of excess, opulence, and indulgence, using a literal narrative of still life, figure and environment. His works also convey a less tangible sensual content. Their complex

metaphorical framework is bounded by a formal control of space and a mastery of illusionism and organization. The artist describes himself as compulsive and obsessive in his desire to execute lushly visual, entertaining works.

BUTH-FURNESS, CHRISTINE (Painter)
3480 Cherry Hill Dr., Brookfield, WI 53005

Born: 1953 *Awards:* Springfield Art Museum Cash Award, Watercolor USA; Watercolor USA Honor Society *Collections:* Ralston Purina, St. Louis; IBM Corp., Minneapolis *Exhibitions:* Wisconsin Academy of Sciences, Arts and Letters, Madison; Springfield Art Museum *Education:* School of the Art Institute of Chicago; U. of Wisconsin, Milwaukee

Formally trained in intaglio, she now works exclusively with watercolor and pastel on paper, focusing on abstracted landscapes. Wet on wet and dry techniques, with many layers of washes, are combined with oil and dry pastel in pictures of imaginary places. Employing a broad palette, she uses color as well as design to carry the abstraction. Inspiration for the works is derived from travels across the country and Europe. Previous work included a series based on abstract geometric images and spirals, reflecting the rhythmic movements of line and color. Among her influences are Marsden Hartley, Georgia O'Keeffe, Arthur Dove, and Milton Avery.

BUTTERFIELD, DEBORAH KAY (Sculptor)
11229 Cottonwood Rd., Bozeman, MT 59715

Born: 1949 *Awards:* NEA Fellowship; Guggenheim Fellowship *Collections:* Whitney Museum; San Francisco Museum of Modern Art *Exhibitions:* Edward Throop Gallery, NYC; Zolla Lieberman Gallery, Chicago *Education:* U. of California, Davis *Dealer:* Edward Throop Gallery, NYC

Training in ceramics and sculpture triggered an interest in crafts, ethnography, and archaeology, which in turn resulted in horse images that recall tribal art. As a substitute for self- portraits, she began portraying horses, large, gentle mares made of plaster. The next several series of horses are comprised of mud and sticks, materials used to suggest that horses are both figure and ground, connecting the external world with the subject. Later horses appear to consist of branches and dirt, but they are actually made from such materials as plaster, tar, fiberglass, steel, and papier-mache, each horse representing "a framework or presence that defines a specific energy at a precise moment."

BUTTRAM, DAVID SR. (Painter, Illustrator)
2183 Jackson Blvd., Cleveland, OH 44118

Born: 1947 *Awards:* Individual Artist Fellowship Award, Ohio Arts Council; Best of Category, Museum of Science and Industry, Chicago *Exhibitions:* Kettering Government Center Gallery, Kettering, OH; Museum of Science and Industry, Chicago *Education:* Cleveland Institute of Art; Cooper School of Art

After formal training in fine arts at Cooper School of Art, he became inspired by the Impressionists' style, and the work of post-impressionist Van Gogh. His work as a painter was then interrupted by three years in the Marine Corps, part of which he served in Vietnam. When he returned he set to painting again. What he brings to the canvas in large brush strokes, cool tones and contrasting oranges is a commitment to depicting the lives of blacks in the inner city. His desire is that the paintings educate the public as well as acknowledge the everyday lives of those depicted.

BYRNE, FRANCIS (Photographer)
1224 N. Oak Park Ave., Oak Park, IL 60302

Born: 1956 Collections: State of Illinois Building, Chicago *Exhibitions:* Lahr Gallery Inc., Lafayette, IN; Artown, Oak Park *Education:* School of the Art Institute of Chicago

Inspired by Bauhaus composition and Maholy Nagy's light rendering and influenced by the works of Ruth Barnhardt and Paul Outerbridge, he first used classical straight photography to recontextualize common objects. His heavy emphasis on light modulation helped him point out the forgotten form and utility of tools. He has now moved on to show the effect of man on the environment and the environment on man-made objects. He gives an animated quality to dilapidated buildings being reclaimed by the earth and shows the signature of man on objects like chairs that are normally overlooked. He continues to use straight photography in both color and monochrome.

BYWATERS, DIANE CANFIELD (Painter)
c/o Jan Cicero Gallery, 221 W. Erie, Chicago, IL 60610

Born: 1957 *Awards:* Purchase Award, Color 1986, Chicago *Collections:* Harris Bank, Hinsdale, IL; Arthur Andersen Company, Minneapolis, MN *Exhibitions:* Columbus Museum of Art, Columbus, OH; Butler Institute of American Art, Youngstown, OH *Dealer:* Jan Cicero Gallery, Chicago

Though her work has grown in richness and subtlety, throughout her career she has been consistently concerned with landscape in oil and paste. Her paintings and drawings call upon the traditions of four centuries of art without, however, replicating the effects of any particular artist or group of artists, historical or contemporary. Nor is she interested in subscribing to any current movement. In both media, her work is gestural, using brush and pastel marks to suggest the form, light, and movement in a particular place at a particular time. Her oils are *plein air* works, small enough to allow her to capture fleeting conditions; her pastels, based loosely on her oils, are built up with layers of color which cover the entire page to suggest a painterly surface.

CALLAHAN, DENNIS (Painter, Sculptor)
1270 N. Milwaukee Ave., Chicago, IL 60622

Born: 1962 *Exhibitions:* The Non-Spiritual in Art Show, Chicago; South Haven Center for the Arts, South Haven, MI *Education:* School of the Art Institute of Chicago *Dealer:* Lynn Kearney, Contemporary Art Workshop, Chicago

Assemblages, framed and stretched like a boxing ring and incorporating television sets, circuitry, and wooden figures, investigate the purpose and relationship of the picture in modern American society. Reflecting the influence of Duchamp, concepts such as illusion,

memory, and the "fine art" world are the foundations of the overtly optical images in which content is ironically camouflaged by the language itself. Recent work includes an "extension" of painting—a set of eight record players attached to a wall which spin disks to produce the illusion of three dimensional space, as well as a series of electrical fans similarily displayed, the whole of which serves as metaphor for famous art auction houses.

CALVIN, JANE L. (Photographer)
722 W. Buckingham Pl., Chicago, IL 60657

Born: 1938 *Awards:* NEA Grant; Illinois Arts Council Fellowship *Collections:* Polaroid International Collection, Cologne; Art Institute of Chicago *Exhibitions:* Art Institute of Chicago; Virginia Museum, Richmond *Education:* School of the Art Institute of Chicago; Bryn Mawr College *Dealer:* Printworks, Ltd., Chicago

She attempts to subvert the ordinary expectations of photography as a documentation of reality through intimate images evoking fantasy, shifting memories and the passage of time. Small, dark and rich with objects as varied as old gowns, toys and animal viscera, the Polacolor works invite the viewer to participate in experiences of hidden sexuality, violence, decadence and chaos. Based on a private allegory, they are nonetheless designed to evoke universal responses. Assemblages measuring approximately three feet square are created using collected objects and slide projections, which are then photographed as the finished piece. The artist's metaphysical view of the world is communicated by means of the structure of the images. No single reality is portrayed at one time or on one level; the details accumulate to form the whole. She is currently working on several collaborative installations.

CAMERON, BROOKE BULOVSKY (Printmaker)
923 College Park Dr., Columbia, MO 65203

Born: 1941 Exhibitions: Chicago Center for the Print; Lakeside Studios, Lakeside, MI Education: U. of Wisconsin; U. of Indiana Dealer: Chicago Center For The Print

Beginning with traditional renaissance methods, she has worked toward the 20th century technologies of photo intaglio and viscosity-printed intaglio. A recent sabbatical gave her the opportunity to live and study in New York. While there, she studied with Krishna Reddy at N.Y.U.'s Pratt Manhattan Graphic Center. The subjects of her recent figurative but non-realistic works have been travel, immediate surroundings, and a sense of place. Technically she is combining her renaissance training and graphic sense with contemporary techniques. She is currently an Associate Professor of Fine Art at the University of Missouri at Columbia.

CANNETO, STEPHEN (Sculptor)
794 Franklin Ave., Columbus, OH 43205

Born: 1943 *Awards:* Greater Columbus Arts Council Technical Assistance Grant *Collections:* Cardinal Industries, Inc.; The Borror Corp. *Exhibitions:* Gilman Gallery, Chicago; Heritage Village, Columbus *Educa-*

tion: Hebrew University, Jerusalem; Ohio State U. *Dealer:* Soufer Gallery, New York

Seeking to reconcile technology with nature, history with progress, and ritual with innovation, the artist's site-engendered sculptures combine metals such as bronze and stainless steel with stone, earth, water, and occasionally, glass and plastics. The monumental pieces juxtapose soaring organic curvilinear shapes with rigid geometric elements and are intended to reflect the qualities of the site and/or the client for which they are made. Also skilled in enameling, goldsmithery, painting, graphic techniques, and holography, the artist works from both pre-existing symbols, such as the Biblical burning bush, and self-generated images.

CANNON, CATHERINE ELLEN (Portrait Artist)
100 S. A St., Elwood, IN 46036

Born: 1945 *Awards:* Best of Show, Tipton Art Festival; Best of Show, Anderson Fine Arts Exhibit *Exhibitions:* Hoosier Salon, Indianapolis, IN

After formal training in sculpture, watercolor, graphite, and oils, she chose to emphasize work in graphite. Through the course of her commissioned portraits in pencil, she developed a unique style in shading and contrast. Gradually, though, she progressed from graphite to oils. Influenced by Mary Cassatt's portraits, she now specializes in portraits, particularly of children. Though she works almost entirely from photographs, the pieces are painterly, with strong brush strokes and palette knife applications. The mother of three small children, she finds working from photographs to be more convenient for both artist and subject.

CARD, SUSAN B. (Sculptor)
255 E. Kellogg Blvd., Studio 508, St. Paul, MN 55101

Born: 1952 *Awards:* Metropolitan Arts Council Award to the Regional Citizen of the Year *Collections:* Waldorf Corp. *Exhibitions:* Nelson Rockefeller Collection, Inc.; International Invitational, Imprimatur Galleries *Education:* Gustavus Adolphus College *Dealer:* Doris Rasche, Deephaven, MN

The creative and transforming qualities of casting and molding have been her elusive challenge. Museums hold many of the ancient examples of this medium and both the museum environment and the pieces themselves have been very influential for her. Since 1974, she has fabricated bronze or paper castings around objects she would have liked to find. More recently, the work has become eclectic. She gathers, combines, and molds objects from the environment and casts in any material available. Many of these designs have been used in clothing. Others could be landscapes or archeological site locations. Her imagery includes mysterious graphics and shapes reminiscent of ancient cultures.

CARLSON, CLAIR (Painter)
9410 S. 51st Ave., Oak Lawn, IL 60453

Born: 1937 *Awards:* Best of Show, La Grange, IL; Artist's Choice, Tolentine *Exhibitions:* Daley Civic Center, Chicago; Art Chicago Gallery *Education:* School of the Art Institute of Chicago; Chicago Academy of Fine Art

Maryrose Carroll, *Night*, 77x48x32, aluminum. Courtesy: Ward-Nasse Gallery, Soho, NY

Willie L. Carter, *Blind Woman,* 18x24, China marker pencil drawing. Courtesy: Illinois Collection, State of Illinois Center

Primarily influenced by Frederick Wong's quiet water-colors, and Louis Tiffany's use of color and design, she first painted the visual and visceral experiences she felt while working as an underwater scuba diver. She establishes mood by applying rhythmic washes of two or three transparent hues. Then using aquamedia on cold press paper, oriental paper, or sized canvas, she develops her subject matter by allowing impressions to fill her mind. Areas of sharp and soft focus alternate in a manner akin to the mind's fragmentary memory process. Subjects include life, nature, architecture, cityscapes, landscapes, and underwater scenes.

CARLSON, LYNN (Drawing)
285 Grove St., Crystal Lake, IL 60014

Born: 1946 *Awards:* 1st Place, Mixed Media NAAL Show; Purchase Award, Woodstock Art Fair *Collections:* Private Collections in North America & Europe *Exhibitions:* Gazebo Gallery, Algonquin, IL; McHenry County College *Education:* Northern Illinois U.; Iowa Wesleyan

While she has been influenced by the expressed silence of Khnopff and Magritte, the intimacy of Vuillard and Munch, the mystery of Redon, and the composition of Whistler and Klimt, it is the message of line that she finds most compelling. Since 1983, she has used the recognizable symbols of figure and landscape to express abstraction. Painting flatly with acrylics, pencil, and conte crayon on paper, she uses a palette that tends toward tints of warm colors. Whites are toned with yellow ochre, and she favors warm graphite pencil grays. Her current portraits are based on real women. Line remains important, but she has begun delving into color and is now exploring the use of cooler tones including blue.

CARO, ANTHONY (Sculptor)
111 Frognal, London NW3, England

Born: 1924 *Awards:* Prize for Sculpture, Biennial, Sao Paulo; Prize for Sculpture, Paris Bienniale *Collections:* Tate Gallery, London; National Gallery of Art, Washington, D.C. *Exhibitions:* Richard Gray Gallery, Chicago; Galerie Andre, Berlin *Education:* Farnham School of Art, Great Britain; Royal Academy Schools, London

Early work features a "purist" approach to surface; whenever there is a mark in these pieces, it was found not created. Today, he is aggressively engaged in fashioning his surfaces--painting, grinding, then painting again, sometimes even writing on them. Information is left on the metallic works--imprinted numbers and points of origin, such as "Gt. Britain 200 200." Many of the pieces feature one round concave bell or cauldron-like shape as part of the constructed assemblage; *The Soldier's Tale* is bolted, cut, assembled, and interlocked together, and includes another of the cauldron-like domes and a small roller on the bottom. *Pine Lift*, on the other hand, is a petite work, an abstraction of an imbroglio, with a small steel dish in the middle. "Because of the size of these sculptures," writes critic Andre Emmerich, "they have the sense of the prehistoric, and because of their remoteness, an

acceleration to the future."

CARRIGAN, NANCY JEAN (Sculptor)
2 S. 526 Williams Rd., Warrenville, IL 60555

Born: 1933 *Awards:* Award of Excellence, *New Horizons in Art* Chicago Cultural Center *Exhibitions:* The Gallery, College of DuPage, Glen Ellyn, IL; Doederlein Gallery, Chicago *Education:* U. of Illinois, Champaign-Urbana; Carnegie-Mellon U., Pittsburgh *Dealer:* Prism Gallery

Although early training in abstract and non-objective art influenced her approach to basic visual relationships, her work has always involved figures, often dancers. Inspired by Henry Moore's sculpture and draughting, she has explored many media outside of traditional sculpture, including toys, drawings and paintings. Her recent series, "Choreographer Dreams," includes paintings, drawings and sculptures. Another series places dancing figures on top of balanced spheres titled "Social Spheres." These are the outcome of a recent intensive study of the dancing figure, executed at a high level of expressiveness.

CARROLL, MARYROSE (Sculptor)
1682 N. Ada, Chicago, IL 60622

Born: 1944 *Awards:* NEA matching purchase; IAC Fellowship Grant *Collections:* Dennis Adrian, Walter and Dawn Clark Netsch *Exhibitions:* Hudson River Museum, NY; Ward-Nasse Gallery, NY *Education:* Illinois State U.; U. of Illiniois, Urbana *Dealer:* Ward-Nasse Gallery, NY

Reviewing a 1977 show of small-scale sculptures, critic Dennis Adrian wrote of her abstract, highly polished and interlocking planes of metal: "The activation of the space around and within her pieces . . . gave [them] unusual distinction." The following year, she exhibited a very large-scale work on the Chicago campus of Northwestern University. Abstract, white, and linear, this work responded to both specific architectural sites and the natural environment. Sections of welded aluminum in tapering dimensions moved up, into, and around a tree and bounced off of the architecture. In the early 1980s, her repertoire became more referential. A 45-foot abstracted tree was followed by a medium-sized apple and carrot. These were also welded, textured, and colored metals. They defied gravity--hanging off of walls and tipping off of their bases.

CARROLL, PATTY (Photographer)
860 Lake Shore Dr., Chicago, IL 60611

Born: 1946 *Awards:* Illinois Arts Council Fellowship; Purchase Prize, Illinois State Museum *Collections:* Museum of Modern Art, NYC; Museum of Contemporary Art, Chicago *Exhibitions:* Art Institute of Chicago; Carpenter Center for the Visual Arts, Harvard U. *Education:* Institute of Design, Illinois Inst. of Technology; U. of Illinois, Champaign-Urbana *Dealer:* Carol Ehlers Photos, Chicago

After studying photography with Garry Winogrand and Arthur Siegel at IIT's Institute of Design, she developed an expressionistic use of color in photographs of resort areas at night. The color sen-

Roy Cartwright, *Zanesville Strata,* 13x18x12, clay. Photographer: Cal Kowal

Mary Chersonsky, *Pursuit of Excellence,* 13x13, carbon pencil

sibility in these shots is highly charged, the hues bright and saturated. She followed the night series with a study of colored light on the nude, which resulted in a nude collage series. Currently, she is working on a series of documentary photographs of hot dog stands in Chicago, a series which evolved from her ongoing night series. These photographs are also characterized by highly charged colors and strong graphics. She is concurrently photographing many of Chicago's artists in a manner that reflects the imagery in their work. These essentially are portraits in collaboration with the artists.

CARSWELL, RODNEY (Painter)
602 S. Euclid Ave., Oak Park, IL 60304

Born: 1946 *Awards:* Fellowship, Illinois Arts Council; Viehler Award, Art Institute of Chicago *Collections:* Illinois State Museum; Evansville Museum of Arts and Sciences *Exhibitions:* Terra Museum of American Art, Chicago; Roy Boyd Gallery, Chicago *Education:* U. of New Mexico; U. of Colorado *Dealer:* Roy Boyd, Chicago, Los Angeles

The subject of his geometric abstract painting is the formal relationship between support, surface material, and image. This dynamic is used as a way of conveying expressive and symbolic meaning. His integrated pictorial objects are both physical structures and painted surfaces. He plays with painting's conventions, folding over the edges of his canvas or painting a black rectangular border around an image on a non-rectangular canvas. He currently uses successive layers of pigmented wax medium to paint simple geometric forms on multi-panelled canvas covered planes projected from simple wooden architectural forms.

CARTER, WILLIE L. (Painter)
1035 N. Avers Ave, Chicago, IL 60651

Born: 1944 *Awards:* Black Creativity, Museum of Science and Industry *Collections:* Illinois Collection for the State of Illinois Center, Chicago, *Exhibitions:* Art Institute of Chicago, Junior Museum; College of Lake County, Grays Lake, IL *Education:* School of the Art Institute of Chicago; U. of Chicago *Dealer:* Isobel Neal Gallery, Ltd., Chicago

Interpretations of contemporary urban life are produced using a wide range of media such as acrylic, oil, and china markers. Early portraits, genre scenes, and urbanscapes contained literal images. Critic Robert Dilworth described these as portraying the "bruises endured by the urban downtrodden." In current works, these images have been abstracted in favor of an increasing attention to formal concerns such as surface/ground interplay, shadow and light, pattern and color. The lack of direct social commentary does not, however, signal a waning concern. On the contrary, the more abstract work signals an intention to probe beneath appearances and to explore the underlying foundations of his earlier images.

CARTWRIGHT, ROY (Ceramicist)
2307 Ohio Ave., Cincinnati, OH 45219

Born: 1937 *Awards:* 1st Prize, 1970 Cincinnati Biennial *Collections:* Cleveland Museum of Art; Everson Museum, Syracuse, NY *Exhibitions:* 1987 Chicago &

Vicinity Show; Allegheny College, Meadville, PA *Education:* California College of Arts & Crafts; Rochester Institute of Technology

After initial training in architecture, he became interested in the interaction of sculpture and environment, as well as the importance of history as evolution. Images suggested artifacts, tools, animal fetuses, and other paleolithic discoveries. Current works employ botanical and geological references; the sculptures are hand-built using traditional ceramic techniques resulting in a variety of surfaces. Color, as an intuitive and emotional response to form and content, is integrated into the work at an early stage, to be reappraised and modified as the piece progresses.

CASTLE, WENDELL KEITH (Designer, Sculptor)
18 Maple St., Scottsville, NY 14546

Born: 1932 *Awards:* Louis C. Tiffany Grant; NEA Fellowship *Collections:* Museum of Modern Art, NYC; Metropolitan Museum of Art, NYC *Exhibitions:* Renwick Gallery, Washington, DC; Taft Museum, Cincinnati *Education:* U. of Kansas *Dealer:* Alexander Milliken Gallery, NYC

During the late 1960s and early 1970s, he experimented with laminated plastic, making flowing organic forms. However, he is primarily known for his art-furniture pieces in laminated fine woods such as mahogany and maple, ornamented with inlays of ivory or silver leaf. Recent work, such as *Hat and Scarf on a Chest*, includes life-size furniture pieces on which articles of clothing appear to have been casually draped, although upon closer examination one discovers that these apparently soft objects are actually made of wood. In *Shearling Coat* a coat is hanging on a coat rack.

CEDRINS, INARA (Painter, Printmaker)
1810 W. 17th St., Chicago, IL 60608

Born: 1952 *Awards:* Translation Center Fellowship, Honorable Mention, Columbia U. *Collections:* Urban Traditions, Chicago; Porter County Arts Commission, IN *Exhibitions:* Latvian Cultural Centers, Michigan, Toronto; Guild Bookstore, Chicago

She has used her wood engravings and linoleum block prints as illustrations for her own writings and the writings of others. In "Chicago Facades," her series of linoleum block prints, she depicted, among other things, the Hispanic neighborhood of Pilsen where she lives and works. Her wood engravings and linocuts are often tied to the theme of music. Her rich watercolor landscapes are color-saturated, and semi-abstract. She creates these flat yet dimensional paintings by overlaying color washes. She is currently working on a series of "Grand Canyon" paintings. She has published three volumes of verse including *Beating Dead Horses, Live Poems*, and *Starpa (In Between)*.

CEMIN, SAINT CLAIR (Sculptor)

Working with an array of materials such as stone, plaster, and gold-plated hydrocal, he mines the kitsch potential of mass-produced objects, fashioning by hand objects that are more commonly produced by

machines. Find here lawn ornaments, decorative planters, and ashtrays, but with a twist--*Granny Ashtray* portrays a spread-legged woman with a skinless skull. One of his clay sculptures of a reclining nude cherub reading a book might be the kind of plaster ornament found in some suburban garden. Other objects resemble Aztec or Mayan artifacts (on close inspection, they too are found to be ashtrays). Art critic Daniel Newburg writes, "Cemin refuses to believe that mass-produced objects, which help to form consciousness in capitalist society, are totally devoid of the potential for individual intervention. His attempt to remake such objects by hand represents a strategy that is not as much oppositional to the machinery of the capitalist culture industry as it is an ironically subversive affirmation of it."

CHADWICK, LYNN (Sculptor)

Lypiatt Park, Stroud, Gloucestershire, England

Born: 1914 *Awards:* International Sculpture Prize, Biennale, Venice; First Prize, Corso Internationale de Bronzetto, Padua *Collections:* Art Institute of Chicago; Tate Gallery, London *Exhibitions:* Hokin Gallery, Chicago; JPL Fine Arts, London

With gallery exposure alongside the works of Henry Moore, he has established himself as a sculptor in the abstract figurative tradition. *Dancers* (1967) best demonstrates his style with its groupings of figures made up of pyramidal masses assembled in rough approximation of the principal forms of the human body. "Like Moore's work, Chadwick's is abstracted without being abstract," writes David Lewinson of *The Nation.* "The angular geometry of the forms generates an aggressive strength that gives these works a haunting expressiveness evocative of the impact of the machine age on modern life and thought."

CHARLESWORTH, BRUCE (Photographer, Performance Artist)

c/o Deson-Sanders Gallery, 750 N. Orleans, Chicago, IL 60610

Exhibitions: Museum of Contemporary Art, Chicago; International Center for Photography, NYC; Deson-Sanders Gallery, Chicago *Dealer:* Deson-Sanders Gallery, Chicago

Wit, humor, and social satire characterize the works of this Minneapolis artist. Originally trained as a painter, he has expanded his range to include work in a number of media, including photography, set design, and installations--this in addition to his work as a writer and director. Photographic narratives from the late 1970s incorporate Polaroid snapshots and text, examining what one critic calls "suburban angst." In these pictures a Kafkaesque persona is the object of conspiracies real or imagined or the butt of harassment. In *Snap,* a man reading the morning paper at breakfast is soon to be attacked by his "killer cereal," suggesting that even everyday routines are no escape from a hostile world.

CHEATLE, ESTHER L. (Cibachrome Photographer)

21 Whippoorwill Rd., Springfield, IL 62707

Born: 1915 *Exhibitions:* Illinois State Museum,

Springfield; Southern Illinois U. School of Medicine Gallery *Education:* Sangamon State U.

In 1978, she began exploring the photogram medium. Placing leaves, grasses, small objects, and torn opaque and translucent paper on photographic print paper, she exposed the combination to white, and later colored, lights. Much of this early work was inspired by Georgia O'Keeffe. She then began using colored gels to produce brilliantly colored landscapes. In 1987, she attended a workshop given by cibachrome artist Henry Shull, and currently she arranges objects from nature in a way similar to but much more sophisticated than her early work. Her multi-colored 8" x 10" and 11" x 14" cibachrome prints resemble landscapes, portraits, or abstract designs. She also makes marionettes and puppets.

CHERRY, HERMAN (Painter)

121 Mercer St. New York, NY 10012

Born: 1909 *Awards:* Gottlieb Foundation; Longview Foundation *Collections:* Brooklyn Museum; University of Texas Museum, Austin *Exhibitions:* Museum of Modern Art, NYC; Metropolitan Museum of Art, NYC *Education:* Otis Arts Institute, CA; Students Art League, Los Angeles & New York *Dealer:* White Pine, Chicago

One of the first generation American Abstract Expressionists, he arrived in New York shortly after World War II, leaving Los Angeles where he had spent his early years as an artist. He was employed by the art projects of both the WPA in the 1930s and the CETA Program of the late 1970s and early 1980s. Today he brings the skill and experience of a career that has traveled the abstract terrain. Beginning in the 1950s, he explored his preoccupation with texture, often introducing foreign material such as coffee grounds into his primarily dark, dense pigments. Lightening his palette in the following decade, distinct motifs began to emerge either in flowing or jagged outline. In these paintings, line is the dominant compositional element. By the mid-1960s he had shifted to more complex tonal layerings. In the 1980s, the moods he creates remain intense. "The high energy of the edges where areas of color meet is notable," writes critic Edmund Leites, "and matches the vitality of Rothko's edges." While his paintings are "pensive and grand," his monotypes, a medium he has concurrently experimented in, achieve a pleasant, light and airy feeling.

CHERSONSKY, MARY M. (Painter)

1857 Olive Road, Homewood, IL 60430

Born: 1944 *Collections:* Rectisel Corp. *Exhibitions:* Century Center Gallery, South Bend, IN; Natilini Gallery, Chicago *Education:* Governors State U., IL; Drisi Studio Academy of Fine Art

Early formal training centered upon learning the principles, techniques, and theory of traditional realist painting. A disciple of master portrait painter Mohamed Drisi, she is trained in the application of his unique color theory, which consists of the blending of numerous colors in a single work. Current works attempt to incorporate aspects of these traditions within

a contemporary realist style in which figures are esoterically colored. Dedicated to a philosophy of excellence, the works are linked to ethical and spiritual experience.

CHEVILLON, VIVIAN (Painter)
111 W. Washington Blvd., Lombard, IL 60148

Born: 1923 *Awards:* Merit Award, 11th Annual Midwest Watercolor Society Open National Show of Transparent Watercolors; Lawrence Purchase Prize, San Diego *Collections:* Anchorage Fine Arts Museum, AK; McDonalds Corp. *Exhibitions:* I. Magnin, Chicago; HM Inveresk Paper Co. Juried Exhibition, New York *Education:* Cornish Institute, Seattle

Upon studying with notable watercolorists from across the country, including Rex Brandt, Millard Sheets, George Post and Dong Kingman, she has created a reputation based on her diverse representations of recognizable objects. Boldly colored landscapes, both realistic and fantastic, are the emphasis; however, she also does still lifes and abstractions on occasion. Although formerly working open air, she now finds studio work enables her to discover what each piece is actually saying. Techniques vary from wet on wet to hard edge, but her preferred method is hard edged overlapping forms with calligraphic textures added. An active member and past president of the Midwest Watercolor Society, she devotes her time to all aspects of the arts, including teaching, jurying, writing and performing many volunteer activities.

CHICAGO, JUDY (Mixed Media Artist)
938 Tyler St., P.O. Box 834, Benicia, CA 94510

Born: 1939 *Collections:* Brooklyn Museum, NYC; San Francisco Museum of Modern Art *Exhibitions:* ACA Galleries, NYC; Whitney Museum of Art, NYC *Education:* University of California, Los Angeles

Judy Chicago's art events center on women's experience. *The Birth Project*, a recent 5-year collaborative piece, involved needleworkers who donated their time to embroider large images of pregnant, birthing or nursing women. "I have approached the subject of birth with awe, terror, and fascination and have tried to present different aspects of this universal experience," writes Chicago. In the 1970s, Chicago's *Red Flag* poster and *Menstruation Bathroom* environment used graphic images of menstruation to explore attitudes toward the female body. The needlework technique is precise, and the materials are opulent, honoring women's lives and experiences. Many people, especially women, have been mesmerized by Chicago's work, although she remains an outsider to the art world.

CHIHULY, DALE PATRICK (Glass Artist)
1124 Eastlake East, Seattle, WA 98109

Born: 1941 *Awards:* Louis C. Tiffany Foundation Award; Fulbright Fellowship *Collections:* Metropolitan Museum of Art, NYC; Philadelphia Museum of Art *Exhibitions:* Seattle Art Museum; St. Louis Art Museum *Education:* U. of Washington; Rhode Island School of Design *Dealer:* Walter/White Fine Arts, Carmel, CA; Charles Cowles Gallery, NYC

The blown studio glass of this decorative artist is well-known. Work of the 1960s trapped the illuminating action of gases like neon and argon to produce an element of movement. Utility was subordinated by lyrical imagery. Later, radiant laminated colors in liquid and flowery shapes that looked molten and alive were often fused together in "clusters." Many of the recent small pieces with fluted rims have been both functional or sculptural, resembling sea urchins, shells and other natural forms from the Pacific coast where he now lives. Tradition and innovation blend in bowl-like objects with fluid irregularities, often with contrasting colors inside and outside. Glowing milky hues, starfish red, jewelweed yellow and other colors from the sea adorn his blown glass forms.

CHINN, MICHAEL S. (Furniture Maker)
158 College of Design, Iowa State University, Ames IA 50011

Born: 1950 *Awards:* The Wichita National, 1986 & 1987 *Collections:* Wichita Art Association; private *Exhibitions:* American Craft Museum, NYC; Esther Saks Gallery, Chicago *Education:* California State U.; San Jose U. *Dealer:* PRO-ART, St. Louis

A formalist in approach, the artist constructs streamlined sculptural variations of furniture, primarily tables. Utilizing plastic laminates, exotic hardwoods and simple contrasting color schemes, the high style furnishings expand the formal relationships between the elements integral to furniture forms. Through the manipulation of universal geometrical forms, the artist seeks to tame the static and dynamic forces found in geometry. Although all the objects are functional, this is a secondary consideration which serves as a counterpoint to the architectural, aesthetic and formal aspects of the work.

CHRISTO (Environmental Artist, Sculptor)
48 Howard St., New York, NY 10013

Born: 1935 *Collections:* Museum of Modern Art, NYC; National Museum of Art, Osaka, Japan *Exhibitions:* *Wrapped Coast*, Little Bay, Australia; *Wrapped Walkways*, Kansas City *Education:* Fine Arts Academy, Sofia; Vienna Fine Arts Academy *Dealer:* Jeanne-Claude Christo, NYC

Born in Bulgaria, he came to Paris in 1958 and began to wrap objects and packages. In the early 1960s, he gained recognition with huge assemblages of oil barrels and upon moving to New York City in 1964 completed a series of "Store Fronts." Since then, he has wrapped monuments, buildings, and landscapes all over the world, redefining the meaning and scope of art. He is best known for *Running Fence 1972-76*, an 18-foot high, 24-1/2-mile-long fabric fence that ran across the California countryside. The recent *Surrounded Islands, Biscayne Bay, Greater Miami, Florida, 1980-1983* used 6 1/2 million square feet of pink, woven polypropylene fabric. Works in progress include *The Umbrellas, Joint Project for Japan and the U.S.A.*, *Wrapped Reichstag, Project for Berlin*, and *The Mastaba of Abu Dhabi, Project for the United Arab Emigrates*.

CHRISTOPHER, JAN (Painter)
1214 Washington, Evanston, IL 60202

Born: 1957 *Awards:* 1st Place, 65th Annual Chicago

Grace Cole, *Mr. Frank Schabel,* 30 x 40, oil. Courtesy: Mrs. F. Schnabel

Area Artists Exhibition; 1st Place, Municipal Art League of Chicago *Exhibitions:* Natalini Galleries, Chicago; Evanston Art Center *Dealer:* Natalini Galleries

Her early still lifes focused on glass and glass-like objects, utilizing a non-traditional approach to watercolor that employed its translucent properties to capture specific visual properties. A contemporary realist, her primary concern was the effect of reflected light and its influence on colors. Recently, her work has begun to incorporate still life in landscapes. Comparing and contrasting glass-like properties with color and light, new paintings use tropical flora set against backgrounds of water. Striving to capture a feeling or event, she depicts places and times somewhat mysteriously, suggesting spirituality and mysticism.

CITRIN, JUDITH (Draughtsperson)
423 Greenleaf Ave., Wilmette, IL 60091

Born: 1934 *Awards:* Grant, Illinois Arts Council; Artist-In-Residence, Marrakech, Morocco *Collections:* Ruth Page Foundation; Anais Nin Collection, UCLA *Exhibitions:* Moroccan National Museum, Rabat; C.G. Jung Center, Chicago *Dealer:* Zaks Gallery, Chicago

She uses art as a visual diary. Her mixed-media boxes are "Vessels of the Dream," her porcelain and whiteware sculptures depictions of life passages, and prismacolor drawings regard the spiritual tensions of the Moroccan and Californian deserts. The latter mirror an inner journey she has been making since a near-death experience in 1975. Current three by four foot prismacolor drawings are depictions of transformational talismans, portraits of the highest expression of self. The artist's work in transformational psychology and healing has deepened her vision and ability to catalyze change for the subjects of her portraits.

CIUREJ, BARBARA (Photographer)
2020 N. Orleans St., Chicago, IL 60614

Born: 1956 *Exhibitions:* Art Institute of Chicago; Los Angeles Municipal Art Gallery *Education:* Institute of Design, Illinois Institute of Technology; U. of Illinois, Champaign-Urbana

Since 1978 she has collaborated with Lindsay Lochman to create fantasies in photography. Twice a year the two set out across the country in search of the setting for the "perfect fantasy." The pictures explore both the inner and outer landscapes of human experience, with photographs that journey into the realms of sensuality and others that place humanity against the vast background of the physical universe. Serious as these themes may be, the photographs strike a note of satire that encompasses both the subject and the artifice of the presentation. Critic Abigail Foernstner notes, "Playing a fantasy scene for all its allegorical worth but sifting it with offkey clues that tell us not to take it too seriously is part of the appeal of Ciurej and Lochman."

CLARK, JAMES MITCHELL (Photographer, Media Artist)
927 E. 1st North St., Carlinville, IL 62626

Born: 1936 *Awards:* 1st Place in Photography, Illinois State Fair *Collections:* Southern Illinois U. Museum

Exhibitions: Louis K. Meisel Gallery, NYC; State of Illinois Art Gallery *Education:* Texas Christian U.

He restructures the stream of experience in a variety of media. In the 1950s he was influenced by Milton Resnick, Lester Johnson and other artists of the Second Generation New York School, but the Beat Generation writers and the idea of stream of consciousness were equally important. His media have always included oil paints, charcoal drawing, inkwash, welded steel assembly and street photography. However, over the years he has shifted many times between the schematic and the figurative, with different media dominating each phase. He presently uses a camera to restructure time in the studio, and plays out his thoughts in paintings, drawings, sculptures and models.

CLARK, JOHN W. (Painter)
3445 N. Cramer St., Milwaukee, WI 53211

Born: 1943 *Collections:* Smithsonian National Air and Space Museum; U.S. Air Force Art Program *Exhibitions:* Argonne National Laboratory; New York Society of Illustrations *Education:* U. of Wisconsin, Milwaukee

Since childhood, he has harbored a great interest in both art and flight. The main influence on his painting has been from 19th-century French and English painters, while the miraculous flying machines continue to be his subject. As a jet aircraft mechanic in the Air Force from 1964-68, he experienced firsthand what it was to work with the parts and designs of airplanes. He also has been in the cockpit, hitching rides in F-105 and F-4 fighter jets, which are capable of speeds approaching three times the sound barrier. It is with such intimate knowledge that he renders realistic paintings of great aircraft. His goal is not mere illustration, however; he is fascinated with the phenomena of flight--the sense of power, the speed, the high performance, and the world from a vantage of 1,000 feet--and his work strives to recreate its essence.

CLEMENTE, FRANCESCO (Painter)
c/o Sperone Westwater, 142 Greene St., New York, NY 10012

Born: 1952 *Exhibitions:* Sperone Westwater, NYC *Dealer:* Sperone Westwater, NYC

Early work involves photographic media with conceptual concerns. He turned to drawing and became interested in traditional painting techniques after spending time in India. A self-taught artist, he has developed a stylistic eclecticism in which schematized, symbolic figures, and the elaboration upon the idea of self are recurrent themes. Paintings evoke a sense of vulnerability and sexuality as a child might experience them. His archetypal imagery, erotized phantasmagoria, and self portraits have been described as psychologically picturesque because they suggest the unconscious drama of dreams or memories.

CLOSE, CHUCK (Painter)
271 Central Park West, New York, NY 10024

Born: 1940 *Awards:* Fulbright Fellowship; NEA Grant *Collections:* Museum of Modern Art, NYC; Whitney Museum of American Art, NYC *Exhibitions:* Van Straaten Gallery, Chicago; Whitney Museum of

American Art, NYC *Education:* Yale University School of Art; Academy of Fine Arts, Vienna *Dealer:* Pace Gallery, NYC

Large-scale photo-realist portraits of faces in black-and-white gained him recognition in 1967. A grid system was used to transfer the photographic image as accurately as possible to the canvas. Similar giant faces were also painted in color, employing layers of the three primary colors much like the color-printing process of photography, as in *Mark.* Since 1972 grid systems have often been left on the finished product in order to emphasize the artistic process. A large variety of media have been employed in the execution of these works, including pastels, watercolors, oil, "fingerprint drawings" in which the image is composed of his own thumbprints, as well as printmaking and collage and varying techniques that use a highly intricate grid system which creates the look of a computer-generated drawing. These innovative experiments have turned portraits into icons, thus expanding the concept of portraiture.

COLE, GRACE (Painter)
4342 N. Clark, Chicago, IL 60613

Born: 1945 *Collections:* Episcopal Diocese of Chicago; Rockford College *Exhibitions:* Butler Institute of American Art; Clementi House, London *Education:* Prairie State College *Dealer:* Galleria Renata, Chicago

Best known for her thoughtful portrait work, the artist is also continuing a series of contemporary still life paintings using time, space, reflections, and mood to convey ideas. She is influenced by the transcendent quality in works of artists such as Leonardo da Vinci, Rembrandt, and Titian, and she works in oil on prepared linen from her sketches and drawings. In both portraits and still lifes, she achieves dramatic lighting and chiaroscuro effects through a meticulous glazing process and an oriental-influenced use of space. She recently completed a series commissioned by golfing's Hall of Fame.

COLEMAN, GEORGE (Painter)
1401 E. 35th Ct., Gary, IN 46409

Born: 1954 *Awards:* Award of Highest Excellence, Glen Ellyn (IL) Fine Art Fest *Exhibitions:* DuSable Museum of Black History, Chicago; Glen Ellyn Fine Art Fest *Dealer:* Charlesetta Umolu, Yester Year, Michigan City, IN

Early in his career he studied Caravaggio's dramatic use of light and shadow. His own early paintings, pastels, and pencil works were studies of how light, color, and design effected the rendering of objects. At the same early point, he became interested in art's technical advances and the airbrushed canvases of Japanese artist, Kneung Szeato. This led him to experiment with abstract illusions and hyper-realism. He has continued with both strands of his work and his current hyper-realist objects and shapes appear to exist on a two-dimensional surface while his pastel mood paintings (still lifes and portraits) are undetailed and impres-

sionistic. His media include watercolor, acrylic, pastel, pencil, dyes, and mixed-media.

COLESCOTT, ROBERT (Painter)

Born: 1925 *Exhibitions:* Institute of Contemporary Art, U. of Pennsylvania; Semaphore Gallery, NYC *Education:* U. of California, Berkeley

Interested in "the meeting of white and black culture," his paintings take up the issue in a series entitled "At the Bather's Pool." In his comments he states, "Sometimes I wake up in the morning with my head full of the Bather's Pool, and am absolutely certain that the Bather's Pool is only a swimming hole at the edge of town where black girls swim in the afternoon, and white boys come to look at their bodies and harass them." In most of the paintings, a blonde woman mixes with others who are black. And while the black/white dynamic is the one that strikes the viewer first, a second equally potent one arrives. Painted with full, bulging bodies, the female nudes are presented in a stereotypical male vision of women, engaging us in yet another scenario of dominance and oppression.

COLLINGS, BETTY (Sculptor)
1991 Hillside Dr., Columbus, OH 43221

Born: 1934 *Awards:* Ohio Arts Council Fellowship; Columbus (OH) Art League Distinguished Service Award for Contributions to the Visual Arts *Exhibitions:* Columbus (OH) Gallery of Fine Art; Wright State U. *Education:* Ohio State U. *Dealer:* Bertha Urdang, NYC

She is an artist, curator, and writer who looks to Europeans of the first quarter of the century and the conceptual artists of the 1960s as role models. She works with flexible vinyl and has used geometry to observe the growth of her own intellectual processes and to communicate to professionals in other disciplines. She has an interest in biology and she was inspired by cells and other life-like forms that come together to create spirals, to build a 9-x 60-foot inflated spiral, called *St. Sophie.* When writing, her tone is modulated by our era's all pervasive ironic stance. "Living in a conservative region of a consumer society as an artist/intellectual is a political act."

COLLINS, AUSTIN I. (Sculptor)
Corby Hall, Notre Dame, IN 46556

Born: 1954 *Awards:* Sculpture Fellow, Karolyi Foundation, Vence, France; Grant, Indiana Arts Commission *Collections:* U. of Notre Dame; U. of California, Hayward *Exhibitions:* Reicher Gallery; Worth Ryder Gallery, Berkeley, CA *Education:* U. of California, Berkeley; Claremont Graduate School *Dealer:* 14 Sculptors Gallery, NYC

He explored ceramic sculpture while studying with Peter Voulkos at Berkeley, but feeling confined by the medium, began making large wood sculptures and installations while doing graduate work at the Claremont Graduate School, work greatly influenced by Roland Reiss. His current steel and marble work resembles the earlier wood work. He is currently an assistant professor at the University of Notre Dame.

COLLINS, RAYMONDE W. (Painter, Sculptor)
1418 Brown Ave., Evanston IL 60201

Born: 1954 *Exhibitions:* Chicago Public Library Cultural Center *Education:* School of the Art Institute of Chicago *Dealer:* Struve Gallery, Chicago

After formal training in Visionary Surrealism, he developed a highly decorative style that was influenced by Salvador Dali, Ed Paschke, Abdul Matti, and the Reverend Howard Finster. His painting/constructions reveal a vast and colorful imaginary world. Abstraction, landscape, portraiture, and words all figure into the works he creates from woods, plastics, and found objects. His constructions share much with the works of Finster and other Visionary artists.

CONGER, WILLIAM (Painter)
3014 W. Hollywood Ave., Chicago, IL 60659

Born: 1937 *Awards:* Clusman Prize; Bartels Prize, Art Institute of Chicago *Collections:* Art Institute of Chicago; IBM *Exhibitions:* Roy Boyd Gallery, Chicago; Block Gallery, Evanston, IL *Education:* U. of Chicago *Dealer:* Roy Boyd Galleries, Chicago, Santa Monica

In the 1960s, influenced by his teachers Elaine de Kooning and Robert Mallery, his work was surreal and figurative. By the 1970s he had arrived at the crisp-edged shapes that have characterized his style as an Organic Abstractionist. He takes most of his subjects from the Chicago landscape of his boyhood. His curved and jagged forms are expressions of intense emotional experiences. His smoothly applied colors seem to emanate city lights of different hues. This decorous veneer is an attempt to camouflage earthier interests. Recently he has hinted at illusionistic space by pushing his forms into suggestive configurations.

CONNAN, GLORIA (Painter, Sculptor)
P.O. Box 124, Kenilworth, IL

Born: 1928 *Awards:* 1st Prize, Civic Art Show, Galesburg, IL; 1st Prize, Naples Art Gallery Invitational, Naples, FL *Collections:* Francois Mitterand; Luciano Pavarotti *Exhibitions:* The Tavern Club, Chicago; East-West Contemporary Gallery, Chicago *Education:* Knox College; U. of Iowa

Well-received in both Europe and the United States, her paintings are characterized by their bold, bright colors and range from flower motifs to abstract expressions of nature. She also does copper wall pieces and murals, including a series of 400 murals at a children's hospital in Florida. Her sculptures are large-scale and frequently reflect the historic background of her hometown, Galesburg. A recent piece, *Americana*, consists of thousands of railroad spikes individually welded to a core, twisting up to a height of 25 feet and representing the contribution of Chinese laborers to the building of the American rail system.

CONWAY, ROSE MARIE (Printmaker)
1919 S. Ashland Ave., Chicago, IL 60608

Born: 1930 *Awards:* Purchase Award, Illinois Print and Drawing Exhibition, Harper College *Exhibitions:* Chicago Center for The Print; Villa Schifanoia, Florence, Italy *Education:* Northern Illinois U.

She mixes a gentle sense of humor with acute powers of observation in her intaglio work. Beginning with sketches she makes on the streets of Uptown, a lower class, multiracial neighborhood on Chicago's North Side, she refines a drawing to the exact size of a prepared zinc plate. The resulting simplified but not spartan prints are reminiscent of the work of Warrington Colescott. She accents her work by rolling colored inks on the surface of the inked plate, arranging pieces of colored paper on the inked plate as in the Chine Colle method, or by hand coloring the print with watercolor or pencil. The artist is a sister in the Sinsinawa order.

COOK, EDWARD C. (Painter)
1385 Kingsdale Rd., Hoffman Estates, IL 60194

Born: 1932 *Awards:* 1st Place, Missouri International Miniature Show; Whiskey Painters of America *Collections:* Kenosha (WI) Museum; Private *Exhibitions:* Oakbrook (IL) Fine Arts Promenade; Edgewood Orchard Gallery, Fish Creek, WI *Dealer:* Peel Gallery, Danby, VT; Edgewood Orchard Gallery, Fish Creek, WI; Kaleidoscope Gallery, Barrington, IL

After a successfull corporate career, he began painting seriously in 1980. Since 1983 he has painted miniatures and these small jewel-like works are almost photo-realistic. Current works, executed in both opaque and transparent acrylic and watercolor are of a solitary rural nature and have a warm, intimate appeal. The remarkable aspect of his work is his sense of light and dark and his primary subjects are barns and old buildings. Sometimes he emphasizes the surrounding landscape other times it is the patina rusted metal or the forms, shapes, and shadows of warped boards.

COOPER, BARBARA (Sculptor)
1921 W. North Ave., Chicago, IL 60622

Born: 1949 *Awards:* Ragdale, Yaddo, and Montalvo Fellowships *Exhibitions:* Contemporary Art Workshop, Chicago; Artemisia Gallery, Chicago *Education:* Cleveland Institute of Art; Cranbrook Academy of Art

Concerned with themes of integration and polarities, she constructed her earlier room-sized installations from wood, steel, cast metal, and found organic materials (branches). She then began to reduce the scale of her work and to make "environments around the self" from steel rod and small pieces of wood which she glued and dowelled together. In the 1980s she continued to develop the concept of polarities but further reduced the size of her work. The shape of her pieces has evolved into ideas of tools or functional objects from other cultures, past or future. She makes these pieces from parts of plants which she assembles with wax, casts into bronze, and then patinates and paints.

COOPER, C.E. (Painter)
P.O. Box 268530, Chicago, IL 60627

Born: 1922 *Awards:* Maurice Spertus Award; Leon Garland Award *Collections:* Spertus Museum, Chicago; Rifkin Collection, Los Angeles *Exhibitions:* Campanile Gallery, Chicago; Steiner Gallery, Chicago *Education:* School of the Art Institute of Chicago;

Michelle Corazzo, *Desert Flower,* 60x48x144, clay, brass grill, wood

Susan Crocker, *untitled,* 16 x 20, silver gelatin print

Corcoran School of Art, DC *Dealer:* Steiner Gallery, Chicago

Following academic training, he studied under Laszlo Moholy-Nagy and Emerson Woelfer at the Insitute of Design and discovered the excitement of mixed media. A love of drawing with the brush and of the human figure kept him from pursuing total abstraction. Compositions were planned abstractly, but drawn academically. His love of surface led him to develop textures that frequently class him among the expressionists. Color is of interest primarily as a mood-enhancing device. Technically, he often uses an acrylic underpainting and a surface of oils; at times collage is part of the composition. All of his major works are preceded by numerous preliminary studies in other media. As a result he exhibits watercolors, goauches, inks, pastels and a mixing of these media, including the overworking of photographs of his original compositions.

CORAN, SCOTT H. (Sculptor)
160 University Ave. West, St. Paul, MN 55103

Born: 1952 *Exhibitions:* Honeywell World Headquarters; Minnesota State Capitol *Education:* Minneapolis College of Art and Design

While many early 20th-century architects adopted theories from the "Prairie School" of architecture, this sculptor has adopted them for his own uses, designing pieces using fluorescent bulbs. Where formerly wood, glass, and acrylics were the media, here we find white light. The added dimension of light gives these works more than just a three-dimensional form. The high voltage used to illuminate the bulbs creates a kinetic dimension as well: actual electric current can be seen traveling through each bulb in the form of "light-rings." As a known local sculptor, his works have been in demand for both public and private spaces. He is known most widely for his large-scale works.

CORAZZO, MICHELE (Sculptor)
822 W. 19th St., Chicago, IL 60608

Born: 1951 *Collections:* Continental Bank, Chicago *Exhibitions:* NAME Gallery, Chicago; University of Illinois, Chicago Gallery *Education:* U. of Chicago; Indiana U.

Sculpture is done in ceramics, using abstraction as a metaphor to explore the tensions and uneasy relationships between geometric structures and amorphic forms. The artist is influenced by the simple orders and spiritualism of medieval art as well as the dynamic structure of Japanese art. Modern technology, i.e. engineered forms, and human psychology also play a role in her art. Tiles glazed in earth tones and subtle colors are given stamped textures, torn and bent. Representing an aerial view of the earth, the pieces often include architectural motifs to signify rigidity, rationalism, order and the presence of man juxtaposed with such organic distortions as are inherent in the natural landscape. Much of the pieces, constructed of slabs, take the form of reliefs.

COREN, LOIS (Sculptor)
2613 Lincolnwood Dr., Evanston, IL 60201

Born: 1931 *Collections:* Museum of the Univ. of Southern Illinois, Edwardsville; Kemper Insurance *Exhibitions:* Hyde Park Art Center, Chicago; Nina Owen Sculpture Gallery, Chicago *Education:* Art Institute of Chicago; Evanston Art Center *Dealer:* Goldman-Kraft Gallery, Chicago

She studied the sculpture of the Maya, Inca, and Aymara Indians during several trips to Central and South America and travelled to Northwest Canada to see the totems of the Kwakiutl Indians. The Native American-inspired painted totems she makes are filled with shamans and symbols. Beginning with a wood base, she gels or screw cuts wood shapes, found objects, and molded clay to the framed sheet of plywood or shaped board she uses for the totem. She then paints the piece with one or many colors, using acrylics. With her husband, Clyde, she has successfully applied this technique to furniture making.

CORTEZ, CARLOS (Printmaker)
2654 N. Marshfield Ave., Chicago, IL 60614

Born: 1923 *Exhibitions:* Mexican Fine Arts Center Museum, Chicago; Artemisia Gallery, Chicago *Dealer:* Wild Horse Gallery, Chicago

Largely a self-taught artist, he creates woodbock prints which have a raw poetic-expressive quality, in contrast to his linoleum prints which are stronger, more straightforward and stylized. He began as a painter and turned to linoleum prints in the late 1950s. Recently, due to the high cost of linoleum and difficult accessibility, he has turned to making woodcuts using whatever wood is available. The challenge presented by the differing consistencies of the wood has resulted in a finer line and more graphic detail. Principal influences in his aesthetic development have been the Mexican muralists and the German Expressionists.

COULTER, CYNTHIA (Sculptor)
1839 N. Leavitt, Chicago, IL 60647

Born: 1951 *Awards:* Visual Artists Grant, Illinois Arts Council; "Chicago Artists Abroad Grant," Columbia College, Chicago *Exhibitions:* Hyde Park Art Center, Chicago; P.S.I., NYC *Education:* U. of Oklahoma; U. of Colorado

Early work is influenced by her teachers Vito Acconci and James Benning who introduced her to large constructions and installations. These were suggestions of parts of buildings or rooms with a slight narrative element. In 1980 she discovered the use of Chinese ledger paper which becomes translucent with the application of heavy lacquers and orange shellac. After eight years and a sojourn in Hong Kong, her work is still Oriental-influenced. Recent works include tabletop sized, small shrines or altars; the pieces borrow from "cheap Chinese" paraphernalia. Working with various papers and scrap lumber, she always contrasts a translucent, fragile section with one that is sturdy and bright with several layers of red, orange and green.

COX, FRANCES ANDRZEJEWSKA (Painter)
c/o ARC Gallery, 356 W Huron, Chicago, IL 60610

Born: 1936 *Exhibitions:* Sioux City Biennial; Chicago Botanic Garden Biennial *Dealer:* ARC Gallery, Chicago

His first pieces are abstracted folk art dealing with floral forms. He then developed a series of plant portraits which eventually included background landscapes. In his current landscapes he deals with the theme of time. He has become interested in the creation and conclusion of time and things and has produced oil on canvas works titled *The Uncoiling of the Stars* and *The Fall of the Stars*.

COX, JEROME L. (Sculptor)
927 Marshall St. N. E., Minneapolis, MN 55413

Born: 1938 *Collections:* Vatican Museum, Rome; Bellini Collection, Florence *Exhibitions:* Strozzi Palace, Florence; Tower Gallery, Chicago *Education:* Villa Schifanoia, Florence; Illinois Institute of Technology *Dealer:* Pimblico Gallery, London

Until 1970, he was primarily involved in woodcarving in an abstract and representational style. Study and travel in Europe, primarily Florence, enabled him to master the techniques for casting in bronze, brass, silver, gold, stainless steel, and fiberglass. His work, Judeo-Christian in content, uses organic materials as inspiration for its form, which is then abstracted to symbolize movement. In many pieces, representational figures and portraits are incorporated within the resulting form, illustrating various themes. Both carved and cast, the pieces range from 1/2-inch to 8 feet and include jewelry. The artist, a Christian Brother, also maintains a studio at the Christian Brothers Provincialate in Romeoville, Illinois.

CRAGG, TONY (Sculptor)
Wuppertal, West Germany

Born: 1949 *Exhibitions:* Museum of Modern Art, NYC; Marian Goodman Gallery, NYC

With a long international record and roots in Post-Minimalism, he creates work characterized by the arrangement of discarded fragments and everyday objects. Early works are arrangements of red, yellow, blue, and green plastic shards. All of his raw material has been utilized and discarded by man previously; the "found object" is removed from its context at the junction of production and rejection and is transferred to the context of art. Working with wood, stone, metal, and synthetic materials, he produces large silhouette images of human figures and objects such as boats, bottles, and axes. Recent three-dimensional works in iron and wood are conglomerations covered with uniform patterns of scribbles, traces, and signs.

CRANE, BARBARA (Photographer)
3164 N. Hudson, Chicago, IL 60657

Born: 1928 *Awards:* NEA & Guggenheim Fellowships *Collections:* Museum of Modern Art; Art Institute of Chicago *Exhibitions:* Museum of Contemporary Photography, Columbia College, Chicago; Museum of Science and Industry, Chicago *Education:* Illinois Institute of Techology; New York U.; *Dealer:* Katheryn Edelman Gallery, Chicago

An internationally recognized photographer and renowned educator, she has explored photography as a vehicle for personal creative expression. Throughout her career, her work has been conceptually consistent even though she has varied her approach, experimented with different styles, and used almost all formats and sizes. In 1980 *Barbara Crane: 1948-1980*, a retrospective monograph, was published by the Center for Creative Photography of the University of Arizona, Tucson. In 1983 a catalog of her work, *Barbara Crane: The Evolution of a Vision*, was published by Albin O. Kuhn Library and Gallery of the University of Maryland. She is Professor of Photography at the School of the Art Institute of Chicago.

CRAWFORD, CATHIE (Printmaker, Photographer)
1119 N. Summit Blvd., Peoria, IL 61606

Born: 1949 *Awards:* Honorable Mention, Galex 14, Peoria Art Guild *Collections:* Kemper Art Collection *Exhibitions:* Brockton Art Museum, Boston, MA; Harper College, Palatine, IL *Education:* Ohio State U.; Bradley U.

Inspired by the "ever-changing hues of water, sky and land," her work draws again and again upon the elements in the landscape. While these pieces recall specific places, many times the landscape takes on the artist's particular feeling or emotion. Water, in particular, carries symbolic value for her, representing a source of replenishment, renewed energy and hope. Over time the landscape-derived images have become increasingly more abstract, even non-objective. In these later works, she strives to capture the essence of water, sky, and land, rather than its mere physicality. The monotypes and some of the woodcuts go one step further, using the qualities of water and land to speak symbolically for an inner landscape.

CROCKER, SUSAN (Photographer)
4007 Old Santa Fe Trail, Santa Fe, NM 87501

Born: 1940 *Awards:* Illinois Arts Council Fellowship Grant *Collections:* First National Bank of Chicago; Illinois State Museum, Springfield, IL *Exhibitions:* Illinois State Museum, Springfield, IL; Chicago Cultural Center *Education:* Columbia College, Chicago, IL

Chicago's architecture and city-scapes have provided the subject matter for her work. Using large, medium and small formats, she often abstracts isolated detail, juxtaposing elements of city space, such as sign posts, traffic lights and bridges. She plats with skewed scale, bringing a freshness to viewing the city. Most currently, construction and demolition are of particular interest. Beginning this work in the mid-1980s, she has documented the explosion of construction in Chicago's Loop, exploring the relationship of the newer buildings to the turn-of-the-century environment in which they are placed. She has recently completed a documentary of ironworkers on highrise construction sites. She has recently relocated to New Mexico to concentrate on landscapes and further documentary work.

CROWELL, REBECCA (Painter, Draughtsperson)
Rte. 3, Box 265B, Osseo, WI 54758

Born: 1954 *Collections:* Wisconsin State Department of Transportation; Wisconsin Art Board; U. of Wisconsin, Eau Claire *Exhibitions:* Walker Gallery, Chicago; Race

Street Gallery, Grand Rapids, MI *Education:* U. of Wisconsin, Eau Claire; Arizona State U. *Dealers:* M.C. Gallery, Minneapolis; Francine Ellman Gallery, Los Angeles

Using acrylics, oil, pastel, and charcoal, she creates abstract images from geometric shapes and organic forms. Early work consists of complex compositions with fragmented and overlapping shapes and colors. More recent, large-scale drawings in charcoal and pastel are based on simple geometric forms and divisions within those forms. The images, however, remain complex and dense, and the impact of color continues to be an important element of her approach.

CRUSING, KATHLEEN GWEN
506 S. Prairie Ave., Barrington, IL 60010

Born: 1948 *Collections:* Pillsbury, Inc., *The Chicago Tribune Dealer:* Silver Cloud, Chicago; Corporate Artwork, Palatine, IL

Departing from traditional watercolor techniques into experimental technique and collage, she has created a unique expression in art through weaving texture and color together. Through the intricacy of texture and the diversity of color, she has achieved a depth for the eye to explore. Collages are created with watercolor on over 50 kinds of hand-made paper from all over the world.

CULLEN, PEG (Painter)
12 Green Pastures Rd., Algonquin, IL 60102

Born: 1942 *Awards:* Honorable Mention, Countryside Art Center, Arlington Heights, IL *Collections:* Illinois Teachers' Retirement System, Springfield *Exhibitions:* Kemper Corp.; Artemisia Gallery, Chicago *Education:* Northern Illinois U.

First trained as an Abstract Expressionist, she displayed a method of paint application--as well as a sense of scale, shape, and form--influenced by Willem de Kooning. She felt the need to master realism and worked in oils and pencil while taking a degree in drawing. Presently concerned with the way light affects shape and color, she takes recognizable images and abstracts the qualities of shape, color, and scale. The subjects of her large prisma color and watercolor works have included abstract figures, patterned faces, blow-ups of horses, fish patterns, and shadows of palm trees on concrete. With nebulous abstract backgrounds, her work is reminiscent of Joseph Raphael.

CUNNINGHAM, SUE (Painting)
112 Manchester Dr., Decatur, IL 62526

Born: 1932 *Awards:* Award of Excellence, West Port Plaza Art Affair National Exhibit, St. Louis, MO *Collections:* Mead Johnson & Co., Evansville, IL; Quaker Oats Co., Danville, IL *Exhibitions:* Botanical Garden, Chicago; St. Louis Artists' Guild Membership Exhibition, St. Louis, MO

After a career in fashion illustrating, she turned exclusively to watercolors in 1981. Seeking the beautiful, unique, interesting and meaningful, she looks for special qualities in subject matter, things which suggest accentuated reactions of greater intensity or deeper insight. Heightened drama is expressed through light and shadow and the interaction of design elements. The landscapes of her early work developed into paintings composed of realistically depicted objects. Beginning in 1984, the ideas within the object paintings were expanded and refined, forming a new body of work, "The Field and Garden Series." These paintings, created within a framework of abstract design, are "intimate landscapes," realistically painted close-up views of vegetables, fruits and flowers.

CURMANO, BILLY (Performance Artist)
Art Works, USA, Rt. 1, Box 116, Rushford, MN 55971

Born: 1949 *Awards:* 3rd Vienna Graphikbiennale, Albertina Museum, Vienna *Collections:* Metronom, Barcelona, Spain; Milwaukee Art Museum *Exhibitions:* Contemporary, New Orleans; New York U. *Education:* Art Students League; U. of Wisconsin *Dealer:* Art Works USA, Rushford, MN

High-spirited performances emphasize the interaction of art with environment and our lives. An object may begin in the studio as a traditional painting or sculpture, then be manipulated as an element in a performance which alters its context. Two recent multileveled works, *Performance for the Dead*, in which he was buried alive for three days, and *Swimmin' the River*, explore the intermix of art and life over extended periods of time. In the *River* performance, he is attempting to wade, skip, dance, rap, mime, and swim the 2,552 miles from the headwaters of the Mississippi River to the Gulf of Mexico in three to six years. The length of time tends to shape his life as much as he shapes the performance, and the memory of the work takes on a life of its own as it becomes romanticized in people's memories.

CUSHING, THOMAS J. (Painter)
1406 N. Griffith Blvd., Griffith, IN 46319

Born: 1939 *Awards:* North Light/Hallmark Art Competition; Talman-DuSable Mural Competition *Collections:* Commonwealth Medical Association; Continental Grain Co. *Exhibitions:* Mongerson Gallery, Chicago; Palette & Chisel Academy of Art *Education:* Governors State U.; American Academy of Art

Versed in a range of media, including oil, acrylic, watercolor, stained glass, and wood, he continues in the tradition of realist, representational artists. An expert in perspective, he depicts architectural subjects--lighthouses, covered bridges, historical buildings--as well as natural subjects--dunes and flowers. Recently, he has completed a mural for the St. Joseph's Home for Girls in East Chicago, and his study at Governors State University has exposed him to etching and monoprints, techniques he looks to employ in his future works. His experience with computer graphics and video, while interesting, has yet to inspire a series of work. He hopes to write a book soon based on his experiences teaching at the American Academy of Art in Chicago for sixteen years.

CZARNOPYS, TOM (Sculptor)
Exhibitions: Museum of Contemporary Art, Chicago

As part of "OPTIONS," a series of emerging artists and new work at the Museum of Contemporary Art, eight

Crusing, *Castle in the Skies,* 30 x 23, water collage

Peg Cullen, *Craquelure,* 40 x 30, watercolor, colored
pencil

of his figures made up his first one-man show in Chicago. Beginning with live models, he makes a resin cast to which he attaches roots, branches, twigs, mosses, butterflies, birds, and other natural materials collected on expeditions in his native Michigan woods. While some of these materials are integrated to actually form anatomical features, the hands and feet are generally left "naked" and painted in a realistic manner with oils. While it can be said that the pieces provide commentary on our relationship to our environment, the effect of these startling works goes beyond a political statement. We think first of allegorical or mythical figures, of a time before modern science, where an understanding and relationship to nature lived in ritual and awe.

D'AMBRA (LITAKER), LILIANA (Painter, Sculptor)
624 Dupont Ct., Elk Grove Village, IL

Born: 1949 *Awards:* National Award of Contemporary Art; International Art Award, Catania, Italy *Collections:* State Art Institute of Catania, Italy; Gif Gallery, Catania, Italy *Exhibitions:* Orizon Gallery, Stratford, IL; Wickers Gallery, Chicago *Education:* State Art Institute, Catania, Italy *Dealer:* Michael E. Perdue, Chicago

Influenced by the Mediterranean culture in which she was brought up, and following formal training in both classic and contemporary figurative arts, she developed a personal, surrealistic style. Her subjects are romantic, full of symbolic, lyrical and mystical meaning. Some of her early pieces, such as those in "The Couple" series, were done in ink-graphics and oil. Her current almost white painted clay bas-relief figures emerge from very dark backgrounds, symbolizing a balance of opposites. In her latest works, *Flower of Creation* and *Family Group*, she eliminates the unessential to examine pre-existing esthetic concepts.

DANITS, MARCIA FELDSTEIN (Painter)
6718 N. Drake, Lincolnwood, IL 60645

Awards: Bronze Award, Wisconsin Women in the Arts *Exhibitions:* Steiner Gallery, Chicago; Artemisia, Chicago

Almost twenty years as a courtroom artist engendered her vast interest in depicting the U.S. judicial system. Her main body of figurative work concerns the defendant, the victim, and the legal workings of the courts. There is also an interest in the effects of the system on women. Over time the work gradually evolved from total figuration to a looser, more violent abstraction-- the likenesses of a John Wayne Gacy peering out from behind streaming bands of red and white. A trip to Egypt brought about a change in technique and subject matter, this recent work concerning itself with a historical presentation of Egyptian life. Here layer upon layer of paint, starting with ancient figurations and leading to images from present-day Egyptian life, captures a sense of time and enduring landscape, the heat, the dust, and the poverty.

DARLING, LAWANDA (Painter)
7740 S. Honore, Chicago, IL 60620

Born: 1951 *Collections*: Provident Hospital, Chicago; Warner Bros. *Exhibitions*: Du Sable Museum, Chicago; Special Things Gallery, Chicago *Education*: Otis Art Institute; California State U., Northridge

After leaving Chicago in 1971, she attended Otis Art Institute in Los Angeles. While there, she was influenced by the Renaissance artists and by her teacher, Charles White. Currently, children and senior citizens are the subjects of her large, figurative oil on canvas paintings. Her works tell a story that can be easily read. Her style changes according to her subject.

DAUGAVIETIS, RUTA (Draughtsperson)
3801 N. Lakewood, Chicago, IL 60613

Born: 1958 *Exhibitions:* Chicago Center for the Print; Lithuanian Museum of Art, Chicago *Education:* U. of Michigan; Northern Illinois U.

She combines elements of newspaper page layout and medieval illuminated manuscripts in work that often reflects her Latvian heritage. The newspaper motif is both vehicle for verbal content and skeleton for visual and emotional expression. At times her text is legible; in other instances it functions solely as a calligraphic or pattern element. Often the patterning in her work reflects traditional Latvian textile designs. Another characteristic of the artist's work is the superimposition of Latvian and American elements upon one another in a metaphor for the Latvian-American culture in which she lives. Although much of her past work is in printmaking, currently her primary medium is black ink.

DAVIDSON, DAVID (Painter)
9418 Harding, Evanston, IL 60203

Born: 1925 *Awards:* Illinois Arts Council Fellowship *Collections:* Library of Congress; Richard J. Daley College *Exhibitions:* Art Insititue of Chicago; Artemesia Gallery, Chicago *Education:* Indiana State U.; School of the Art Institute of Chicago

Living in France and Germany following World War II, he created work centering on wartime experiences in the manner of Kokoschka, Beckman, Kollowitz and the German Expressionists. The 1960s and 1970s brought an interest in formal portraits in both oil and charcoal, the result of training under Eric Von Cleef, a prominent German portrait artist. Recent work involves social and political satire. The dark and intense oil paintings draw from literary, historical and Biblical sources. Rembrandt's *The Anatomy Lesson of Dr. Nicholas Tulp* was the model for *The Anatomy Lesson: Chicago Style*, which is peopled with the likes of Mayors Byrne and Daley. His technique also draws from historical sources in works using heavy underpainting and the application of numerous glazes. Collage techniques and photography are also employed in these large-scale portrayals of man's folly.

DAVIES, GLEN C. (Painter, Sculptor)
108 W. Oregon, Urbana, IL 61801

Born: 1950 *Awards:* Ford Foundation Fellowship *Exhibitions:* Hyde Park Art Center, Chicago; Rockford (IL) Museum of Art *Education:* Drake U.; U. of Illinois *Dealer:* Contemporary Art Work Shop, Chicago

Stephen De Santo, *Winter,* 29 x 39, acrylic

Joseph DeJan, *L'Hermitage,* 20 x 32, pastel

Much of his color and content come from his experiences as an itinerant artist painting banners, showfronts, and signs for circuses and carnivals. His studies of Folk Art, Moral Drama, and medieval illuminated manuscripts have also been important influences. His work is a window into an imaginary world where characters live in a narrow, illusionistic "stage like" space. He uses metaphors and folk colloquialisms to illustrate a personal vision of life and morality. He makes his pieces from a combination of wooden reliefs, painted surfaces, found objects, gourds, and furniture.

DAVIS-BENAVIDES, CHRISTOPHER (Sculptor)
3254 N. Newhall St., Milwaukee, WI 53211

Born: 1955 *Awards:* Artist-in-Residency, Kohler Arts Center; National Endowment for the Arts *Exhibitions:* Esther Saks Gallery, Chicago; Charles A. Wustum Museum of Fine Arts, Racine, WI *Education:* U. of Wisconsin, Madison; U. of Wisconsin, Milwaukee *Dealer:* Esther Saks Gallery, Chicago

Seeking to start where the Russian Futurist movement ended, his work underscores the mystery and slightly skewed reality of his structures.

DE KOONING, WILLEM (Painter)
c/o Xavier Fourcade Inc., 36 E. 75th St., New York, NY 10021

Born: 1904 *Awards:* President's Medal; Andrew W. Mellon Prize *Collections:* Metropolitan Museum of Art, NYC; Museum of Modern Art, NYC *Exhibitions:* Museum of Modern Art, NYC; Whitney Museum of American Art, NYC *Education:* Academie voor Beeldende Kunsten en Technische Wetenschappen, Amsterdam, Netherlands *Dealer:* Xavier Fourcade Inc., NYC

While training in his native land of Holland for eight years, he was influenced not only by the strict academic training but also by the abstract art of the De Stijl group. Early works of the 1930s are untitled abstract works influenced by Arshile Gorky. Since the mid-1940s, he has rendered distorted figures, usually of women, in fragmented confusion. Bold brush strokes in vibrant colors, pastel tints, and black areas outlined in white typify this abstract expressionist's work. Because he has never fully rejected the earlier influences, his work shows a passionate mixture of abstract expressionistic leanings and the bold colorations of the COBRA School. Recently, he has been painting nearly abstract renderings of landscapes.

DE MARRIS, PAMELA (Photographer)
3000 Beachwood Ave. W., Muncie, IN 47304

Born: 1951 *Awards:* Top 5 New Photographers 1987, New York; 1st Place, Creative Images National Juried Exhibition *Collections:* Vincennes University Art Gallery; Kasameyer Glass, Inc. *Exhibitions:* ARC Gallery, Chicago; Burden Gallery, New York *Education:* Herron School of Art, Indianapolis

Using a technique involving underwater photography, a backyard pool, and family members as models, the artist creates surreal photographs in which a staged, absurd atmosphere distorted by water envelopes masked subjects who portray the intangible presence of their being. Fascinated by the question of what is real and what is illusion, she focuses many of her pieces on frightening aspects of life; for instance, in *Family Ties*, children's toys float colorfully around distorted, stockinged faces. The emphatic ridiculousness of her images expresses her feeling that people play roles in life that deny their true inner selves.

DE PAUW, GREG (Painter)
206 S. Davenport, Metamora, IL 61548

Born: 1955 *Awards:* National Watercolor Society 65th Annual Exhibition, L.A.; Purchase Award, Evanston Chamber of Commerce, IL *Collections:* Leeway International, Tokyo, Japan; AT&T Communications of Illinois *Exhibitions:* Butler Institute of Art, Youngstown, OH; Biennial Arkansas Exhibition, Pine Bluff, AR *Education:* Illinois State U.

Early watercolor paintings are landscapes handled as quick gestural studies of fleeting moments found in nature. During this early period Robert Delaunay influenced his approach to color, while Duchamp's theories on accidental compositions in nature freed him to use materials spontaneously. He has worked with acrylic on laminated plexiglas. Assemblies of many cubed modules, which present miniature panels of textural abstractions, are made to hang free of the wall. One work is suspended from the wall to allow the viewer a glimpse from behind--a "backstage" as some modules are transparent, others opaque. Currently, he is working with metal; a designed and texturally painted base of welded fenders, hoods, and other parts taken from cars. He attaches objects such as photos, jewelry, and other mementos to personalize each piece.

DE SANTO, STEPHEN (Painter)
1325 Kensington Blvd., Fort Wayne, IN

Born: 1951 *Awards:* John Young Hunter Memorial Award, America Watercolor Society *Collections:* Martin Z. Margulies, Coconut Grove, Fl; Wichita Art Museum, KS *Exhibitions:* Allied Artists of America, NY; Navy Pier International Art Expo, Chicago *Education:* Ball State U. *Dealer:* Jan Cicero Gallery, Chicago

Architectural close-ups from Ocean City, New Jersey have been the prime subject matter for his somewhat photorealistic acrylic painting of the last five years. Usually depicting a closely cropped corner of a house or its porch, canvas awnings create a play of sunlight and shadow that is a strong expression of the spare angular design of the work. A growing body of abstract work has resulted from his recent return to printmaking. These pieces are similar to his paintings in their attention to detail and stark graphics. Beginning with an etching as the foundation, he applies various materials such as glass, brass tubing, wood, beads and paper to the surface in order to embellish and complete the composition.

DEGRANE, LLOYD (Photographer)
11344 S. Champlain, Ave., Chicago, IL 60628

Awards: Grant, Changing Chicago Documentary Project *Collections:* Illinois State Museum *Exhibitions:* Small Works National, Rochester, NY; Art Institute of

Greg DePauw, *Jazz Dance,* 46 x 40 x 4, mixed media on metal

Grace Leslie Dickerson, *Reverie,* 20 x 16, oil

135

Chicago, Art Rental and Sales Gallery

Though he admires the work of the Surrealists and embraces dadaism, his documentary photographs and photo assemblages revolve around his reaction the suburban icons of Chicago's South Side and southern suburbs. His subjects include lawn ornaments, religious objects, truck tires that serve as flower planters, and upturned bathtubs that serve as shrines for plaster and concrete madonnas. In one surrealistic piece, a giant hamburger with eyeballs peers over a hedge of morning glories, looking at its maker, the Weber grill. In another photo, he symbolizes suburban captivity by depicting a blindfolded elderly woman surrounded by artificial flamingoes. Finally, he brings up issues of wilderness and anti-wilderness with images of cement deer, plastic flamingoes, and artificial botanical wonders.

DEJAN, JOSEPH (Painter, Textile Artist)
238 Custer Ave., Evanston, IL 60202

Born: 1929 *Exhibitions:* Grove Street Galleries, Chicago; Aurelia Gallery, Evanston *Education:* Sorbonne, Paris

Formal training in realistic, objective drawing and painting since the age of ten at "Les Beaux Arts" in Algeria and France has provided him with a solid artistic foundation that allows for the range of techniques he employs. Influenced by the classics from the museums of France (in particular the Louvre) and elsewhere in Europe, he chooses his medium according to subject: brush and/or pen and ink for North African sceneries, pastel for nudes, oil or acrylic for landscapes, tapestry for symbolic images. Most recently, he has been concentrating on mixed-media pieces (acrylic and pastel) that argue for nature and mankind existing harmoniously, and he has been designing tapestries to be woven in Aubusson.

DEL VALLE, HELEN (Painter)
P.O. Box 958, Chicago, IL 60690

Born: 1933 *Awards:* 1st Place, National League of American Pen Women; 1st Place, Water Color Painting, Idaho *Exhibitions:* Balzekas Museum, Chicago; Navy Pier, Chicago *Education:* Art Institute of Chicago; Pennsylvania Academy of Fine Arts

A realist working in oils and watercolors, she has an individual style. She once painted on small and medium-sized canvases, but now her detailed scenes of the Bible and Rocky Mountains are done on larger four by five foot pieces. She has written a book entitled *Art Quiz International* and has served on the Boards of Directors of the American Society of Artists and the Mid-America Art Association. She is an award-winning poet and hopes one day to establish a museum. "I've always tried to create art that would have aesthetic value anywhere in the world."

DELLER, HARRIS (Ceramist)
c/o Southern Illinois U., School of Art, Carbondale, IL 62901

Born: 1947 *Awards:* Fulbright-Hays Fellowship; Illinois Arts Council Artist Fellowship *Collections:* Illinois State Museum, Springfield; Evansville (IN) Museum *Exhibitions:* Esther Saks Gallery, Chicago, IL *Educa-*tion: Cranbrook Academy of Art, Bloomfield Hills, MI *Dealer:* Esther Saks, Chicago

His vessels are provocative contradictions. He sets aside traditional notions about porcelain's lightness and fragility to create boldly precise objects with an anthropomorphic stance of gesture and stride. He disregards the historical preoccupation with contained volume and instead draws attention to the external pressures of space. He supresses the third dimension to create teapots and vases on a two-dimensional plane. The spouts and handles of his pieces move linearly through space, while their edges become contours, and their milky white surfaces become grounds for richly incised graphic patterns. He continues to work within a limited visual vocabulary and to investigate the permutations of formal elements

DEMING, DAVID L. (Sculptor)
2504 Baxter Dr., Austin, TX 78745

Born: 1943 *Awards:* American Institute of Architects Award of Honor *Collections:* Southland Corporation; Ft. Worth National Bank *Exhibitions:* International Navy Pier Expo '85 & '86, Chicago; L.A. International Expo '87 *Education:* Cleveland Institute of Art; Cranbrook Academy *Dealers:* Adams Middleton Gallery, Dallas, TX

A foundation in classic figure study led him to a mechanical abstraction of the human figure along with bird and insect imagery. In the volume of work over the past fifteen years, one may witness the development of droid-like creatures. In these "guardian" figures a powerful link to an alien civilization is suggested. Works are created in metal, including stainless steel, brass, bronze, and painted steel, and are fabricated with attention to a well-crafted format that speaks to the "man in the machine age." When color is used, dark tones are contrasted to bright tones. He cites American-Japanese sculptor Isamu Maguichi and Henry Moore as his influences.

DEREMIAH (Painter)
909 W. Lakeside, Chicago, IL 60640

Born: 1960 *Awards:* Honorable Mention, Museum of Science and Industry, Chicago *Exhibitions:* Museum of Science and Industry, Chicago; North Park College, Chicago *Education:* North Park College, Chicago; American Art Academy

A self taught artist, he has been influenced by the German Renaissance. Oil is his primary medium, but he also does intense, realistic 3' x 4' drawings in a style similar to that of Ingres. Beginning in 1986 he studied signs, and his painting has progressed from earlier small street scenes to larger works depicting people in the home. He is concened with setting a mood and paints birth, life, and death in vibrant colors and strong contrasts.

DERER, CHARLES A. (Sculptor)
4831 Prospect, Downers Grove, IL 60515

Born: 1947 *Exhibitions:* College of DuPage; Fermilab, Batavia, IL *Education:* Northern Illinois U., DeKalb

His interests are in light and motion. He has combined

images from experience in various industrial jobs and as an infantryman in Vietnam into mechanical and light sculptures. In one such piece, he abstracted the nighttime helicopter tracer fire he remembered from Vietnam into a wall of red diagonal neon lights. His mile-high carbon arc light sculpture, *Parabola*, was a curve in the air visible for miles. His images appear in a number of movies filmed in Chicago. In fact, he is currently developing a conceptual work based on commercial film. Steve Waldeck, at the School of the Art Institute of Chicago, is one of the sculptor's influences.

DETWILER, LEE O. (Painter, Photographer)
P.O. Box 755, Zion, IL

Born: 1957 *Awards:* 1st Place, Zion Art Contest *Exhibitions:* Artist's Gallery, Zion; Lake County, IL Art League *Education:* Blackburn College, IL *Dealer:* Artist's Alley, Zion

He was formally trained in two-dimensional design, and in his first post-college exhibition he showed color-field works akin to those of Clyfford Still. While his work has progressed, he remains preoccupied with the tension created by the flatness of the paper. He spent three years studying philosophy, and his present work turns on the polarization of masculine and feminine forces. He has incorporated the symbolism of Eastern religions, and he uses Jackson Pollock's drip painting techniques and William de Kooning's knife painting techniques to express his subject, the female form.

DEUTCH, STEPHEN (Photographer, Sculptor)
525 Hawthorne, Chicago, IL 60657

Born: 1908 *Collections:* Art Institute of Chicago; Chicago Historical Society *Exhibitions:* Art Institute of Chicago; Chicago Cultural Center

His career has been divided between social documentary photography in the tradition of Walker Evans and sculpture employing wood carving. The photography has concentrated on urban subjects, recording the city life of people of all classes. His work is entirely in color and has included series covering life in ethnic neighborhoods seen from behind and through windows, bench sitters, and a portfolio of Nelson Algren. The figurative wood sculptures are executed primarily in fruitwoods, including avacado, walnut, and tulip. Highly abstracted, these full, rounded figures are smoothly polished. Curvatures and hollows in the sculpted wood are reminiscent of African female figures.

DEVALLANCE, BRENDAN (Performance Artist)

Exhibitions: Northern Illinois U. Gallery, Chicago; Organic Theater, Chicago *Dealer:* N.A.M.E. Gallery, Chicago

Clothes hangers, light bulbs, propane torches, bowling pins, hand grenades, safety pins, and eight track cassettes number among his "props." In such performances as *Shit for Brains* and *Cake*, he challenges the audience by cross-referencing such mundane objects and representations of them--the image of a coathanger is attached to his jacket as if it still hung in the closet--or altered versions or uses of them--for example, toasting bread with a propane torch. We become aware of these daily objects so frequently at the end of our fingers, and how much of our lives are orchestrated around them, subsumed by the commodoties of this "user-friendly" culture. As if to demonstrate this, in *Cake*, in which he wears a cake for a hat, he asks someone from the audience to come onstage and cut it. When no one is forthwith, he first cajoles, then shames, then threatens the audience into participation. He ends the piece by offering the tip that "great satisfaction can be simply found in a good game of bowling, best played when you feel like all bad things in the world are your fault."

DEVLIN, SUE (Painter)
3710 S. 117th St., Omaha, NE 68144

Born: 1947 *Awards*: Art Barter Program, Omaha Public Schools *Collections*: U. of Wisconsin, Milwaukee; Art Students League, Omaha Public Schools *Exhibitions*: Sioux City Art Center Biennial; Biennial Invitational Exhibition, Muscatine Art Center *Education:* U. of Wisconsin, Milwaukee

Influenced by the New York School in the late 1960s, her acrylics have been strong statements on the physicallity of paint and painting. Her totally abstract works are large broad areas of color with smaller nuances of contrasting brush strokes and underpainting. She contrasts the immediacy of her process with carefully thought out spatial relationships, line quality, light planes, and emotional content. Currently her works involve landforms and figures. She has been influenced by Diebenkorn and Rothenberg.

DICKERSON, GRACE LESLIE (Painter)
13326 Hardesty Rd., Fort Wayne, IN 46825

Born: 1911 *Awards:* Hoosier Salon, Indianapolis, IN; Purchase Award, Anderson Fine Arts Center Anderson, IN *Collections:* Fort Wayne Community School System; Anderson Gallery of Art *Exhibitions:* Duncan Gallery, New York and Paris; Fort Wayne Museum of Art *Education:* School of the Art Institute of Chicago; Cranbrook Institute of Art, Bloomfield, MI *Dealer:* Fort Wayne Museum of Art Sales and Rental Gallery

Concentrating on portrait and figure studies for much of her career, her earliest influence was Renoir's use of clear flesh tones against brilliantly colored backgrounds. Her work with children and dignitaries focused on play of color and aliveness of figures. Shifting to working with acrylics for their clarity of color, she has continued to strengthen her use of lighting affects to gain boldness in tone values and composition. She has expanded her subject matter from portraits to include both landscape and non-objective abstracts, remaining true to her original devotion to color as the primary vehicle of communication.

DICKSON, MICHAEL (Jeweler)
3404 N. Elaine Pl., #3, Chicago, IL 60657

Born: 1956 *Exhibitions:* Objects Gallery, Chicago; Chiaroscuro Gallery, Chicago; *Education:* Goodman School of Drama *Dealer:* Smith/Tantall Collection, Los Angeles

Without formal training, in 1987 he began experimenting and designing abstract pieces with various metals and materials. Influenced by African and Native

American art, he incorporates antique objects and ancient artifacts--including coins, arrowheads, and bullets--as well as fossilized specimens and semi-precious stones. To create additional texture and design, he treats the metals with various solutions that change the surface and color. Of late he has been moving toward larger pieces, many depicting abstract or prehistoric fantasy creatures. Working primarily with oxidized metals and found objects, he is fascinated by the transformation of everyday products of a waste-oriented society into accepted works of art.

DILWORTH, ROBERT P. (Painter)
710 N. Central Ave., Chicago, IL 60644

Born: 1951 *Awards:* Columbia College Faculty Development Grant *Collections:* Thurlow Tibbs Museum Gallery, DC; Beatrice Foods, Inc., Chicago *Exhibitions:* Tarada Loft Gallery, Tokyo; Locus Gallery, St. Louis *Education:* Rhode Island School of Design; School of the Art Institute of Chicago *Dealer:* Isobel Neal Gallery, Chicago

After a six-year study in which he was influenced by the work of Al Hold, Joseph Albers and Frank Stella, he returned to figurative and landscape motifs. Now influenced mainly by traditional Japanese and Chinese painting, Haitian painting, 19th-century American landscape painting and modern toys, he creates works that address issues that dominate our culture. A recent series, entitled "The Carnival Triad," consists of carefully rendered drawings and bright, fantastic paintings which chronicle the artist's spiritual and psychological development. Images and narratives with a surrealistic bent, lush flora, animals and humans interacting, all provide metaphors for the struggles and celebrations of daily life.

DINE, JIM (Sculptor, Painter)
c/o Pace Gallery, 32 E. 57th St., New York, NY 10022

Born: 1935 *Collections:* Centre Pompidou; Metropolitan Museum of Art *Exhibitions:* Denver Art Museum; Walker Art Center *Education:* U. of Cincinnati; Ohio U. *Dealer:* Pace Gallery, NYC

For him, the distinctions between sculpture and painting have always seemed arbitrary. His paintings have repeatedly incorporated three-dimensional objects, and his sculptures have employed painterly gesture and rich surface coloration. His recent cast bronze sculptures re-create in three-dimensional terms many of the images that have been associated with him throughout his career--hearts, tools, shells, the Crommelynck Gate. Among the new subjects in these works is a group of life-sized and smaller Venus figures, inspired by a plaster replica of the *Venus de Milo* that he found in an art store. In a group of recent paintings, the dominant image is the heart, reflecting his continuing preoccupation with personal expression and the capacity of paint to convey feeling.

DISRUD, JAMES E. (Painter)
749 W. Cornelia Ave., Chicago, IL 60657

Born: 1952 *Awards:* Illinois Artist-in-Residence; 2nd of Show, Baer Competition *Collections:* Brown and Caldwell, Walnut Creek, CA; Zebra Tech.,

Northbrook, IL *Exhibitions:* Beverly Art Center, Chicago; Corsh Gallery, Chicago *Education:* Northern Illinois U., DeKalb; U. of North Dakota, Grand Forks

In 1977 he abandoned Modernist main-stream abstraction and began painting figures in a naturalistic style. His current Post- Modernist style has been influenced by the art of the Baroque, primarily the Classicists and Caravaggesques. He fosters the play of light in his work by painting his life-size figures in a Tenebrific light and placing them against dark interiors. His oil on linen paintings are built from layers, glazes and scumbles. He begins with dark tones and forms a transparent surface suggestive of visual depth. He tends toward dark or earth-colors and his subtly neutral palette is balanced between contrasts of warm and cool tones. Since 1984 still lifes have become a more prominent element of his work.

DIXON, BOB (Ceramist, Sculptor)
3030 S. State, Springfield, IL 62704

Born: 1945 *Collections:* Illinois State Museum; Southeastern Illinois College *Exhibitions:* Springfield Seven Show, 1980; Indiana State University *Education:* Murray State U.; Illinois State U.

Raised in a carnival and formally trained in color, the artist develops his large murals and sculptured vessels with color included as an element possessing spatial properties. In an abstract expressionist manner, glazes and slips are applied to capture the implied force within each piece. The forms combine a concern for space with an emphasis on the surface and the balance between the two. Also working on a large scale in steel and in mixed media, the artist generates abstract pieces informed by his solitary lifestyle.

DIXON, KEN (Painter)
2007 31st St., Lubbock, TX 79411

Born: 1943 *Awards:* Mid-America Arts Alliance; Outstanding Emerging Artist *Collections:* Museum of Modern Art, Miami; Museum of South Texas, Corpus Christi *Exhibitions:* Maastricht International; San Antonio Art Institute *Education:* U. of Arkansas *Dealer:* Batz-Lawrence Gallery, Kansas City, KS; Campbell Gallery, Fort Worth, TX

Multi-media diptychs and triptychs juxtapose images and texts. The images are derived from photographs the artist has taken and transferred to canvas through a gum bichromate process. This process produces an aged, weathered image which is then hand painted and bordered with fragments of cursive white-writing. The result is reminiscent of postcards or personal photos scattered over the torn pages of a travel diary. But the relationship of the text to the image is indirect, eccentric, for they do not "explain" each other. Through this tension of the juxtaposition of incompatible information the viewer is made aware of the impulse to derive ordered, sensible meaning.

DIXON, SWAZEY (Painter, Sculptor)
4059 W. Roosevelt Rd., Chicago, IL 60624

Born: 1938 *Collections:* Channel 32, Chicago; Praise the Lord Club (PTL) *Exhibitions:* Mercy Seat Baptist Church; Douglas Park Library, Chicago *Education:* Art

Robert Dilworth, *Middle Passage Rites of Passage,* 69 x 54, oil on canvas. Courtesy: Isobel Neal Gallery, Ltd.

Ken Dixon, *Duck and Cover,* 40 x 75, crayon on canvas; gum bichromate

Institute of Chicago; American Academy, Chicago

His interest in such moderns as Picasso, Diego Rivera, Courbet, Lautrec, as well as the old masters, Titian, Raphael, and Caravaggio, provided inspiration for many paintings. Birds, animals, and boxers, appear in early paintings which are executed with a high degree of realism. While oil on canvas is his primary medium, he has painted murals with acrylics, and produced numerous pen and ink drawings and charcoal portraits. His illustrations include scenes from ghettos, Africa, natural settings, and urban ethnic settings. Current work focuses on religious painting, with illustrations of the parables of Christ in nineteen realistic renderings.

DOEDERLEIN, GERTRUDE L. (Painter)
3442 N. Greenview Ave., Chicago, IL 60657

Born: 1903 *Awards:* Grand Prix Humanitaire de France; Da Vinci Open Art Competition, NY *Collections:* Judd Hall, U. of Chicago *Exhibitions:* Galerie Internationale, NYC; Ligoa Duncan Galerie, NY & Paris *Education:* School of the Art Institute, Chicago; Northwestern U.

Taking influence from Oskar Kokoschka and Hans Hoffmann, her early work is primarily abstract. As she toured the world, visiting such places as Mexico, Italy and Yugoslavia, the work became more representational; her travels finding expression in her painting. Still her time spent as an abstractionist continues to influence her work. With an emphasis on color and space, the image or landscape appears to float in space, an effect that generates a feeling of the totality of the cosmic order.

DOLL, CATHERINE (Painter, Art Furniture Designer)
1917 S. Halsted, Chicago, IL 60608

Born: 1950 *Collections:* United Auto Workers Solidarity House, Detroit, MI *Exhibitions:* ARC Gallery, Chicago; Haggerty Museum of Art, Milwaukee *Dealer:* Topeka Gallery, Chicago

Drawing on her personal experiences as an autoworker, her work began as a statement reflecting the lives of laid-off workers in modern industrial situations, reflecting the tradition of Diego Rivera and WPA artists. Moving on from this specific issue, she now incorporates a more comprehensive societal experience of industry through symbols drawn from nature, exemplified by a recent series depicting wolfpacks at bay in urban landscapes. As these works have developed, three-dimensional elements have become important to their composition and their effect. Presently, tables set in front of her paintings display images extended from the canvas—for instance, a canvas of a large, headless wolf whose head is on the table in front. The use of color underscores these environments as places to examine our relationship to our own world.

DONLEY, ROBERT M. (Painter)
324 N. Harvey, Oak Park, IL 60302

Born: 1934 *Awards:* NEA Grant *Collections:* Springfield Museum, Springfield, IL; Mobil Corp. *Exhibitions:* Hokin/Kaufman Gallery, Chicago; Struve Gallery, Chicago *Education:* School of the Art Institute

of Chicago *Dealer:* Hokin/Kaufman, Chicago

Recent works continue the theme of depicting specific locales—usually aerial views of cities surrounded by wide borders filled with portraits of contemporary and historic civic leaders and citizens. Like maps, they pack as much visual information as possible into their descriptive space. Unlike maps, however, the information is not abstracted to colors, numbers, and lines; its transcription of visual information is more poetic than literal. Some buildings are invented or pirated from other locales. In earlier works the portraits of historic figures were as large as the buildings and competed with them for space. In the 70's he explored historical, mythological and literary themes, creating works crowded with tiny figures.

DORN, GORDON J. (Painter)
806 South First St., Dekalb, IL 60115

Born: 1943 *Collections:* State of Illinois; Atlantic Richfield Center for the Visual Arts, Los Angeles *Exhibitions:* Art Institute of Chicago; Rockford Art Museum *Education:* U. of Wisconsin *Dealer:* Roy Boyd Gallery, Chicago

He is a pioneer in the resurgence of encaustic painting in the Midwest, first using the medium in the early 1970s. Paintings of geometric models, grids and signs are used to describe and communicate abstract concepts of a spiritual or physical nature. Gridded networks, in two- and the illusory three-dimensional representation, are constructed from thin applications of hot wax into which is rubbed dry pigment. The architectural and engineered geometric constructions are then scored into the surface; at times several constructions float on different planes. In the tradition of Minimalists such as Kenneth Noland, the artist's gridded network frequently begins with the placement of a diamond in the center of his canvas. The similarities dissolve there, however, and the dark painterly ground is host to drawing that bridges the graffito art of Anasazi Indians and the computer-generated images of the present day.

DOUGLAS, L.J. (Painter)
1832 S. Halsted, Chicago, IL 60608

Born: 1948 *Exhibitions:* Marianne Deson Gallery, Chicago *Dealer:* Marianne Deson, Chicago

Classically trained, upon moving to Chicago she was introduced to and influenced by Magic Realism and the works of naive and visionary artists. She then experimented with ways to integrate emotional elements into her work, roughly until a trip to Europe in the early 1980s, after which she returned to the classical format of her earlier work. In her current oil paintings she explores the possibilities of narrative figuration by balancing classical illusionistic space with an understated yet abstract paint handling. She communicates a narrative in her works, not in an explicit editorial way, but through painterly devices.

DOWNIE, KEITH (Painter)
3652 N. Hermitage, Chicago, IL

Collections Howard Abrams *Exhibitions* ARC Gallery, Chicago; Central Michigan State U., Mt. Pleasant

Catherine Doll, *Sunset & Steelmill,* 120 x 72, oil.
Courtesy: Ellen & David Roth

Mohamed Drisi, *Mr. Ed O'Connor,* 45 x 36, oil on canvas

Education Michigan State U. *Dealer* Sybil Larney Gallery, Chicago

A newcomer to the Chicago art scene, he creates provocative layered works that often employ more than one surface. In so doing, he uses a wide variety of materials, often mixing acrylic and graphite with found elements and pieces appropriated from magazines and newspapers; his influences are eclectic.

DRAVES, JOHN L. (Silverpoint Draughtsperson)

4123 N. McVicker Ave., Chicago, IL

Born: 1940 *Awards:* Joseph R. Shapiro Award (Graphics); Frederick Remahl Memorial Award (Print) *Collections:* Illinois Bell Telephone, Chicago; John W. Gray Collection, Indianapolis *Exhibitions:* Adele Rosenberg Gallery, Chicago; Campanile Galleries, Chicago *Education:* School of the Art Institute of Chicago; U. of Chicago *Dealer:* Artfare Gallery, Oak Park, IL

After studying Old Master drawings and prints and developing a strong, expressive line awareness he began working with silverpoint in 1963. This has remained his primary medium and he now employs a wide space cross-hatching technique to create meticulously elegant, subtly toned portraits and scenes. He first coats the paper with a fine-toothed casein or latex and then draws with silver stylus as if using a pencil. He represents the third dimension with a buildup of cross-hatching, occasionally adding touches of colored pencil. The finished drawing undergoes a tarnishing change which may enhance the work.

DRIESBACH, DAVID F. (Printmaker)

810 Lawnwood Ave., Dekalb, IL 60115

Born: 1922 *Awards:* Ford Foundation Grant *Collections:* Portland Art Museum; State of Illinois Building *Exhibitions:* British International Print Biennial, Bradford, England; International Exhibitions of Graphic Arts, Ljubljana, Yugoslavia *Education:* State U. of Iowa *Dealer:* The Center for the Print, Chicago

The whimsical scenes of his loosely drawn color viscosity etchings often include such enigmatic objects as the moon, clocks, neckties, chandeliers, upside down people, people drinking wine, and a bespectacled man in a top hat. In *Walk On The Wild Side*, his reaction to the Lou Reed song of the same name, Little Orphan Annie is seen holding a martini and walking through a forest of cacti; her dog sports a top hat and a grin. He has studied under Mauricio Lasansky and Stanley William Hayter and has been influenced by Max Beckmann, Mark Chagall and George Grosz.

DRISI, MOHAMED (Painter)

100 W. Main St., Glenwood, IL 60425

Born: 1931 *Awards:* Best of Show, NIAA; Quincy Art Museum *Collections:* H.S.H. Princess Grace de Monaco; U.S. Treasury *Exhibitions:* Art Institute of Chicago; Pennsylvania Academy of Fine Arts *Education:* School of the Art Institute of Chicago; Royal Academy of Fine Arts, Madrid, Spain.

Prominent as a "realist with a cause," his range extends from the eloquence of the techniques of the masters to contemporary innovations. His inquiry into excellence continues to inspire scores of students and is characterized by a commitment to the refinement of intelligence, responsibility, and sincerity in fine art. Founder of the Drisi Studio Academy of Fine Art, he has been lecturing for 25 years in the areas of portrait painting, history, theory, philosophy, critique of the arts, restoration, drawing, painting, illustration, and the photographing of works of art. He teaches traditional as well as contemporary painting techniques.

DRISI, NANETTE (Painter)

100 W. Main St., Glenwood, IL 60425

Born: 1936 *Awards:* Edward M. Martin Award, 1987, Municipal Art League *Collections:* Private *Exhibitions:* Chicago Society of Artists; Beverly Art Center, Chicago *Education:* School of the Art Institute of Chicago; U. of Chicago

Subjects range from imaginative surrealism to contemporary oil portraits, in a painting style characterized by a rich use of color combined with fine attention to detail. Emphasis is placed on technical competence rather than on momentary trends in art markets, yet an ongoing personal philosophy pervades her approach to painting. This philosophy, influenced by the cultural ideals expressed by her artist/teacher husband, Mohamed Drisi, maintains that excellence is a quantifiable phenomenon linked to intelligence, responsibility, sincerity, and humanity.

DUBACK, SALLY W. (Painter)

5116 W. Cairdel Lane, Mequon, WI 53092

Born: 1946 *Collections:* DCI Corporation; Nelson Container Corporation *Exhibitions:* Milwaukee Art Museum *Dealer:* Sam Stein Gallery, Chicago; Cudahy Gallery, Milwaukee

A childhood love of the work of Van Gogh and Toulouse-Lautrec has been formative in the work of this landscape and abstract painter. Intense color and movement, as well as the sensation of forms floating off the canvas pervade the works, many of which are large-scale. Even in the abstract pieces, concerns are with earth, sky and water at the critical times of day when light is in a moment of transition, especially around dawn and dusk. Painting on the floor enables the artist to move freely as she smears, spatters, scrapes and throws the paint until the composition's ambiguity is resolved. Several pieces are worked on simultaneously, in oils and sometimes acrylics. Drawings are done in pastel and oil stick.

DWYER, MARY ELLEN (Sculptor)

2530 1/2 Dresden Rd., Zanesville, OH 43701

Born: 1946 *Awards:* Second Prize-Decorative, Clay Guild of Central Ohio, Ohio Dominican College; Fourth Place, Zanesville Art Center *Collections:* Otterbein College, Westerville, OH *Exhibitions:* Gallery Upstairs, Granville, OH; Art Phase I, Chicago *Education:* Ohio U., Athens; U. of Veracruz, Xalapa, Mexico *Dealer:* Heller-Reynolds, Granville, OH

Her work as a sculptor in clay is predicated on her interests in archaeology, geography, and geology. She

has collected shell fragments from Cozumel, and rocks and fungi from other travels, and in them she finds inspiration for her own pieces. Working with very soft clay, she is able to capture the subtle forms and textures of the geography at "land's end." Utilizing a soft, layered technique, she fashions a multiplicity of marks in an endless variety of organic forms, creating abstract sculptures as well as functional vases, some with the silver tracks left by fired pine needles, others in black or raku.

DWYER, NANCY (Sculptor, Painter)
c/o Josh Baer Gallery, New York, NY 10012

Born: 1954 *Awards:* NEA; New York State Creative Arts Public Service Grant *Exhibitions:* Semaphore Gallery, New York; Josh Baer, New York *Education*: State U. College, New Paltz, NY; State U. of New York, Buffalo *Dealer:* Josh Baer, New York

"I have always treated imagery graphically," she says of her work, "like words on a page." *Karate Club* is the result of an "analysis of line," where the line itself, cut from aluminum, is literally materialized and mounted on a carpet background like corporate signage in a bank foyer. "One is left with just enough to see the grace of the movement, and to understand that the boy is black," she points out. Working with leather, aluminum, mirror, plastic, marble, wood and Formica, she creates works that put such "commericial materials" to use in non-commercial images: a boy holding a snake, a woman holding a rat, a black boy doing karate. "It is this marriage of material and image, of meaning and object," writes one critic, "that separates Dwyer's work from graphic design *per se*..." Twenty years after Pop Art, Dwyer numbers among a second generation of artists/designers that have taken license to mine the graphic media for fine art purposes.

DYNERMAN, WALDEMAR (Painter)
4883 N. Shoreland Ave., Whitefish Bay, WI 53217

Born: 1951 *Awards:* City Council of Warsaw, Poland Award *Exhibitions:* Wisconsin Triennial, Madison; Festival of Fine Arts, Warsaw, Poland *Education:* Fine Arts Academy, Warsaw, Poland *Dealer:* Ronna Isaacs, Chiaroscuro Gallery, Chicago

The prominent Polish painter J. Perykowski influenced his figurative expressionism of the 1970s. He painted large format, primary-colored works with oils or water media, contrasting glazing to impasto paint applications. His work of the early 1980s, influenced by Monet, became more representational and realistic. After gaining skill as a realist, he brought expressionistic elements back into his work. He labels his recent Magritte-influenced work "metaphorical realism." The mood of some of these large oil works resembles the work of Balthus. The artist has most recently started to draw with pastels.

EATON, HERBERT (Sculptor)
512 E. Taylor, Box 3771, Bloomington, IL 61702

Born: 1949 *Exhibitions:* Chicago Cultural Center; Contemporary Art Workshop, Chicago *Education:* Illinois State U.

Works in a variety of media explore the tragic and the comic in the domestic relations between men and women. Carved wood and cast bronze figures confront each other in environments ranging from the barren to the theatrical. Recent tableaus incorporate the early Renaissance predella form in which drawings that comment and elaborate on the main images are added to the base of the piece. Color, usually from the darker end of the spectrum, is an integral aspect of the work. The artist also does representational figure drawings and, infrequently, paintings which also center on narrative issues.

EATON, TOM (Painter)
911 W. 100 St. Kansas City, MO 64114

Born: 1940 *Awards:* Heart of America Endowment for the Arts *Collections:* Prairie Museum, Alberta, Canada; Iowa State Gallery *Exhibitions:* Mayrath Museum of Art, Dodge City, KA; Art Institute of Chicago *Dealer:* Burnham Gallery, Kansas City, MO

After a quasi-apprenticeship with the Prairie Imagist Bors Timond-Lavell, he began portraying a functional reality through images of geometric time patterns. The artist says his reality "must become a puzzle pattern between me and the viewer." Eschewing spectral color for the fundamentalism of monotone black and white, he seeks to simplify his philosophy into abstract forms. A flat horizon and monotone sky uncluttered by the distraction of multihued forms are his primary images. He reduces depth to a scale more aligned with the rhythms of everyday life. Eroticism is not neglected, but lies beneath his primal life images.

EBERLEIN-BURMEISTER, JEANNE (Photographer)
P.O. Box 823, Portage, WI 53901

Born: 1950 *Awards:* Honorable Mention, 1987 and 1988 *Photographers' Forum* Magazine *Collections:* U. of Wisconsin, Madison; Reedsburg Teachers Association, WI *Exhibitions:* Madison Art Center Triennial; Wisconsin Women in the Arts Travelling Exhibition *Education:* U. of Wisconsin, Milwaukee; U. of Wisconsin, Madison *Dealer:* One of a Kind Gallery, Madison

Her photos are nonconfrontational, sensual poses which celebrate the human form and the reflective spirit. Close-cropped nudes make up the subjects, set off occasionally by patterns of fabric or natural objects. Working exclusively in black and white using a Mamiya 645 camera, the artist lights her figures to enhance the surface of their form, inviting the viewer to journey over a landscape of hard muscle, bone, and soft skin. Dark backgrounds contrast with the broad range of skin tones to create sensitive contours.

ECKART, CHRISTIAN (Painter)

Working with a variety of media, he achieves a wide range of effects. Of the three sets of paintings included in a recent exhibition at the Los Angeles County Museum entitled "The Spiritual in Art: Abstract Painting 1890-1985," one was made of small, smooth squares of black marble inlaid with tiny geometric figures of lighter stone in the center. Another group of paintings uses large panels of clear-lacquered wood to serve as a background for emblematic configurations of yellow

bars which themselves open to reveal small, regularly segmented chambers in an isometric perspective. Stephen Westfall of Art in America writes, "the open chambers alternatively suggest monastery or prison cells, stables, or armatures for model airplanes."

The third set in the collection contrasts the first two. Where the others "refuse the character of the artist's hand," here are large paintings which, Westfall comments, "play gesture to the romantic hilt, highlighting it in monochrome impastos of metallic paint." In perhaps his most direct religous reference, these paintings provide variations on the cross format reminiscent of Keith Milow's more compact cross-based wall sculptures or Cinabue's huge, multi-paneled collage crucifixes.

ECKERT, KURT (Painter)
312 N. Laflin, Chicago, IL 60607

Born: 1956 *Collections:* G.D. Searle, Inc., Chicago *Exhibitions:* International Contemporary Arts Fair, London; Marianne Deson Gallery, Chicago *Education:* Southern Illinois U. *Dealer:* Deson-Saunders Gallery, Chicago

His early work was influenced by Romanesque and Mayan art and architecture and by Giotto. These crudely figurative oil paintings had a cartoon-like narrative motif. He eventually dropped figuration and took the "objectness" of the painting as the primary subject of his narrative. At the same time he rediscovered the Modernist tradition of abstraction and branched into the fluid use of media such as latex, enamel, shellac, tar, wood and earth.

EDDY, HILARY (Painting)
1675 W. 275 South, Lafayette, IN 47905

Born: 1948 *Awards:* Best of Show Award, 9th Annual Sugar Creek Art Exhibition, Wabash College, Crafordsville, IN; Best of Show, Purchase Award, 13th Washington & Jefferson National Painting Show, Washington & Jefferson College, Washington, PA *Collections:* Hoyt Institute of Fine Art, Newcastle, PA; Funks Supercrost Hybrid Seeds, Kentland, IN *Exhibitions:* Olin Fine Art Gallery, Washington & Jefferson College, Washington, PA; Koehline Art Gallery, Des Plaines, IL *Education:* Normale College of Education, Bangor, North Wales; Purdue U.

Her work over the years has consistently revolved around her love and appreciation of nature. The shapes, colors and lines she finds in organic objects have inspired her to explore different ways of combining them in unusual combinations using suggestive juxtapostions, color and line exaggerations and size magnifications to emphasize the delicate subtleties. Her recent works have a more abstract quality which, she feels, comes closer to expressing the essence of the subject than do representational renditions. Characteristics reminiscent of identifiable flowers are retained while the introduction of shapes and colors enhances the overall expression of the complexity of floral forms. Colors and shapes formed by the careful manipulation and overlaying of images captures the natural entanglement and ambiguity found in the garden, greenhouse

and forest. Some canvases convey sensuous feelings, while others invite the viewer into an uncertain floating perspective achieved by layering techniques. Still other paintings express the freshness and clarity of floral forms dampened by dew and sparkling in sunlight.

EDGCOMB, JOHN O. (Sculptor)
1500 W. Kennedy Rd., Lake Forest, IL 60045

Born: 1961 *Awards:* Award of Excellence in Recent Work, C.L.C.; Angela Knott Butter Prize for Studio Art *Exhibitions:* College of Lake County, Illinois; Art Institute of Chicago Sales and Rental Gallery *Education:* Lake Forest College

Working in the tradition of Michelangelo, Rodin, and Marino Marini, he sculpts figuratively. His swiftly molded clay pieces are full of experimentation in texture and color and are either assembled after firing or fired as a single piece. Though the influence of classical and Flemish sculpture is clear he has developed his own style. His recent works have become more abstract and less formal; in some of the most recent, the figure is only hinted at through fragments of fossil-like impressions. "I want to bring out the soul of a person, the inner life in my subject matter." He is an instructor at Lake Forest Academy in Lake Forest, Illinois.

EDWARDS, STEPHEN (Painter)
RR #4 Box 119, Sheridan, IN 46069

Born: 1951 *Awards:* Hoosier Salon; Watercolor Society of Indiana *Collections:* Indiana State Museum; Eli Lilly Corporate Collection *Exhibitions:* T. C. Steel State Memorial, IN; Art in the Barn, Barrington, IL *Education:* Indiana U.

Following early training in oils, he began to explore watercolor as a sketching medium, progressing to explore its uses in expressionistic and abstract work. Influenced by contemporary British painters Robert Bolten and John Blockley, he uses emotional responses created by color as part of his search for abstract statements using realist subjects. His technique is broad and loose, yet still including a concern for realistic rendering. Bright colors layered in many washes are applied in segments and then finalized with drybrush. His work primarily concerns itself with moments and studies from everyday life, inspired by driving around and from looking at slides and photographs.

ENGELHARD, GORDON (Painter)
2039 W. Iowa, Chicago, IL 60622

Born: 1959 *Collections:* Northern Trust Bank, Chicago; DeGraaf Fine Art, Chicago *Exhibitions:* 1001 Gallery, Chicago; Prairie Avenue Gallery, Chicago *Education:* College of Wooster, Ohio *Dealer:* Swearingen Gallery, Louisville, KY

Grounding his work in the drawing techniques of Michelangelo and Leonardo da Vinci and his aesthetics in the study of optical illusion and in the physical surroundings of his upbringing in Kentucky, he concentrates the majority of his work on richly-colored symbolic landscapes of movement. These color atmospheres focus on the contrast and complements that exist between moving and stationary objects. Vivid colors and gestural lines evoke a sense of winds blowing

Nanette Drisi, *Mr. James Cooper,* 24 x 30, oil on canvas. Courtesy: Patricia & David Ankarlo

John Edgcomb, *Diving I,* 18 inches high, stoneware.

on hills or the illusion of endless walls running into the distance. Intrigued by the interplay of opposing forces, one ultimately has a sense of being a participant in the event occurring within the painting--sensing solitude, tranquility, and flux.

ENGEN, BERIT (Fiber Artist)
612 S. Cuyler, Oak Park, IL 60304

Born: 1955 *Awards:* Government Grant for Young Artist, Oslo, Norway *Collections:* National Association of Independent Insurers; N. Frank Commercial Interiors *Exhibitions:* Evanston (IL) Art Center Co-op Gallery; American Craft Council Craft Fair, Baltimore *Dealer:* Ruth Volid Gallery, Chicago

Born in Norway, she learned the craft of weaving as a child. She began making tapestries in 1978 and combines the traditions of Scandinavian textile art with Southern European and Egyptian influences. Her images, executed in Swedish linen, are either non-objective or abstracted from nature. Since moving to Chicago in 1985, her non-figurative work has been simpler, clearer and more contrastive. She is currently working on seven different series including; "Village" (inspired by Greek Village landscapes), "Misa Criolla" (her version of the Latin American church banner), "Ruins," "Just Something About Death," "Haiku," "Stargsler" (Norwegian for barriers), and "YR" (an old Norseword for both "light spring rain" and "giddy anticipation").

ENOCHS, DALE (Sculptor)
613 E. 12th, Bloomington, IN 47401

Born: 1952 *Awards:* Indiana Arts Commission Fellowship *Collections:* McDonald's Corp., Oak Brook, IL; City of Bloomington, IN *Exhibitions:* Chicago International Art Expo; Artphase 1, Chicago *Education:* Indiana U. *Dealer:* Artphase 1, Chicago

In 1979, after studying primitive and ancient cultures, he went to live in a Tibetan community in India. His yearlong stay there inspired a series of large scale ceramic steles and totem-like forms. Recently, limestone, slate, and white and black marble have been his primary media. The primitive-influenced totemic shape remains, although his pieces have become more figurative, evoking images of an unknown mythology and addressing themes of passage, duality, and transformation. He contrasts smooth polished areas with rough hewn and broken sections. The scale of his work ranges from 20 inches to 20 feet.

ERLEBACHER, MARTHA MAYER (Painter)
c/o Dart Gallery, 750 N. Orleans, Ste. 303, Chicago, IL 60610

Born: 1937 *Awards:* NEA; Merrill Foundation Grant *Collections:* Art Institute of Chicago; Philadelphia Museum of Art *Exhibitions:* Art Institute of Chicago; Dart Gallery, Chicago *Education:* Pratt Institute *Dealer:* Robert Schoelkopf Gallery, NYC; Dart Gallery, Chicago

Paintings of the 1970s are realistic depictions of fruit, eggs, and other objects in series and patterns. Since 1978 works have been figurative, in a neo-Renaissance vein, primarily portraits and studies of the female nude. The oil paintings are rendered in warm erotic color, and the graphite drawings are depicted in subtle grey. Women are often placed in ornamental interiors of checkered marble floors and walls, as in *Woman with Chaos, Time and Death*. This painting in particular presents traditional symbolic images and employs an arrangement of figures which recalls the "sacra conversazione:" a partially clad woman is surrounded by Chaos (a masked figure), Father Time, and Death (a skeleton in a cape).

ESSIG, DONNA (Painter)
1011 Ashland, Evanston, IL 60202

Born: 1956 *Awards:* Evanston and Vicinity Show *Collections:* Milliken U., Decatur, IL; Mongerson Gallery, Chicago *Exhibition:* Eleine Benson Gallery, Bridgehampton, NY; Chicago Botanic Gardens, Glencoe, IL *Education:* School of the Art Institute of Chicago; U. of Illinois *Dealer:* Zaks Gallery, Chicago

Gathering together and synthesizing an eclectic assortment of influences which range from the Italian Renaissance, Chicago Imagists, Persian Miniatures, Symbolists, Egyptian art and the work of Matisse, she began to paint large scale works of intricate detail in which abstract patterns in architectural space were surrounded by multiple borders. Images were initially based on biomorphic forms and later, when the human figure was introduced, the work became increasingly narrative. Current works employ the Mother and Child motif, rendered in a unique style of magic realism, to explore the emotional states contained within and hiding behind gesture and masks. The articulation of space, an important element in these works, is architectonic rather than natural--that is, it is a built and limiting space that is tangible and concrete.

ESTES, RICHARD (Painter)
300 Central Park West, New York, NY 10028

Born: 1936 *Collections:* Whitney Museum of American Art; Art Institute of Chicago *Exhibitions:* Venice Biennale; Whitney Museum Annual *Education:* Art Institute of Chicago *Dealer:* Freidenrich Contemporary Art, Newport Beach, CA; Graphics 1 and Graphics 2, Boston; Martina Hamilton Gallery, NYC; Fingerhut Gallery, Minneapolis

A city dweller, he paints realistic urban scenes. Early work of the 1960s featured earth tones to depict people in the generalized backgrounds of buildings. In 1967 his colors brightened, the images came into sharp focus, and the figure was abandoned entirely. He has been called a photo-realist, although his approach is painterly and does not ignore composition, color, line and form. In photographing a subject before he begins to paint, he employs several views and combines elements from each to create complex three-dimensional images. He often works in acrylic; for depth and clarity of focus, he finishes in oil. "Central Savings" (1975) and "Ansonia" (1977) are examples of the use of reflections in glass to create complex readings of depth in which

multiple imagery includes the space outside the picture.

EVANS, BOB (Painter, Printmaker)
5660 Einor Ave., Rockford, IL 61108

Born: 1944 *Awards:* One of "10 Best Shows in Chicago," David Elliot, *Chicago Sun Times Collections:* Illinois State Museum, Springfield; Lakeview Museum, Peoria, IL *Exhibitions:* Interior/Exterior, Rockford, Illinois Art Museum; Hyde Park Art Center, Chicago *Education:* Southern Illinois U.; North East Missouri State U. *Dealer:* Zaks Gallery, Chicago

His early works were paintings, but he soon moved into three-dimensional and time arts. He pushes the boundaries of conventional art, combining sound, light, motion, photography, computer based images, and video alterations to create installations that reflect the complexity of the late twentieth century. Ephemeral effects, image alteration, and the "objectness" of the act of creating are his subjects in these two- and three-dimensional works. He is concerned with the spiritual and metaphysical aspects of art and has been influenced by abstract expressionism, constructivism, and surrealism.

EVERHART, JANE (Painter)
c/o Sazama/Brauer Gallery, 356 W. Huron St., Chicago, IL 60610

Awards Fellowship, Awards in the Visual Arts; Indiana Arts Commission Grant *Collections* Arthur Anderson, Inc., Chicago; Indiana U., Bloomington *Exhibitions* Sazama/Brauer Gallery, Chicago; Swope Museum, Terre Haute, IN *Education* Indiana U.; Depauw U., Greencastle, IN *Dealer:* Sazama/Brauer Gallery

Her vibrant, rhythmic and colorful landscapes reveal the profound influence of the Chinese landscape tradition; her formal studies include Chinese language and tradition and instruction under two Chinese painters, Liang Dan-Fong and Jo Wang Hess. Her technique often combines in the same work areas of representation, calligraphy and abstraction–for example, a recognizable middle ground of crops merging at the fore with a field of calligraphic, grass-like strokes and at the back with abstracted tree or cloud shapes. This "mixing of codes" reflects her scholarly background in linguistics as well as her Chinese influences. Like Chinese landscapes, her paintings attempt to create an attitude that broadens how each person thinks about, sees, and participates in the landscape. She not only shows a great affinity for the land, but also concern over the conflict between its preservation and threats of commercial change; her intense colors alert us to the immense potential beneath her contemplative scenes.

EWART, DOUGLAS (Sculptor)
P. O. Box 7987, Chicago, IL 60680

Born: 1946 *Awards:* 1st Prize, Black Creativity, Museum of Science and Industry *Exhibitions:* Museum of Contemporary Art, Chicago; Du Sable Museum of African American History, Chicago *Education:* Apprenticeship, Master Flutemaker Aki Yakamura

As a sculptor of wind instruments, he has progressed from small bamboo flutes to large totem flutes of up to seven feet in length. He incorporates elaborately carved designs using inlaid semi-precious stones, colored epoxy, and stainless steel and brass, sometimes leaving the root stubs on the wood as a natural sculptural element. Presently, he has begun to explore the wind instruments of Australian aborigines, using black bamboo. One piece is a totem flute that uses figurative illustrations drawn from aboriginal symbols to narrate the birth of the bamboo flute. The carvings include not only figures but abstract textures contrasting with the smooth surfaces of the wood.

FABIAN, JOAN (Painter)
2845 N. Burling, #3R, Chicago, IL

Born: 1962 *Exhibitions:* Monroe Gallery, Chicago; Natalini Galleries, Chicago *Education:* School of the Art Institute of Chicago

While studying with Karl Wirsum and Richard Loving at the School of the Art Institute, she painted stylized figures and portraits of great comic characterization. Her current work, influenced by Japanese comics and foreign films, is still rich in color and line. Her human figures live in unusual spaces and patterns of fantasy color. Her subject matter's "unconsciousness in meaning" is often provocative. She paints with oils on large unstretched canvases and like many who have been influenced by the Chicago style, her work has a serious comic appeal.

FABIANO, DANIEL (Neon)
1116 Soo Marie Av., Stevens Point, WI 54481

Born: 1937 *Awards:* Wisconsin Arts Board Fellowship *Collections:* Miller Brewing Co., Milwaukee; Phillip Morris Co., Milwaukee *Exhibitions:* Milwaukee Art Museum; Joy Horwich Gallery, Chicago *Education:* U. of Wisconsin, Milwaukee *Dealer:* Joy Horwich Gallery, Chicago

Departing from his early work in stain-soaked canvases, he began a series of work that was disciplined, employing a precise, hard-edged imagery with mysterious black spaces and a sense of the deep, silent vastness of the universe, recalling Stanley Kubrick's *2001: A Space Odyssey*. In this series, he counterpoints scribbled lines symbolizing man's destructiveness with the disciplined structure of his images. From these pieces, he later developed into working in plexiglas as a medium for painting. The medium's magnifying quality underscores his recent subject matter–formally balanced pieces with complex color statements imply the rhythms of the urban scene. Most recently, works in his "Constructs" series are architecturally conceived with the metropolis in mind. He shows a concern for contemporary materials such as plastic, metal, and neon, using them to harness the energies of light to complement the existing forms.

FACH, CHARLES A. (Sculptor)
418 Spring St., Galena, IL 61036

Born: 1939 *Exhibitions:* Gillman/Gruen Gallery, Chicago *Education:* U. of Wisconsin; U. of Iowa *Dealer:* Gillman/Gruen Gallery, Chicago

Beginning as a potter in the early 1960s, he progressed to hand built clay sculptures. From these he moved to Duchamp-influenced bronze cast forms. He currently

owns and operates a foundry that specializes in lost wax molds. Some of his current works are abstract, landscape-influenced pieces. The works of Bologna, Rodin and Maillot have had an effect on the artist, but he also solicits commissions for naturalistic portrait work in either terracotta or bronze. He patinates his eighteen-inch high bronze figures in black, arranges them in compositions, and mounts them on white marble. Monoprints and thick acrylic paintings feature flat, geometric shapes.

FAIST, BARTON (Painter, Draughtsperson)
4 E. Ohio, #9, Chicago, IL 60611

Born: 1955 *Awards:* 1st Prize, New Horizons in Art; 2nd Place, American Artist Magazine Traveling *Exhibition Collections:* 1st National Bank; Jenner and Block Corporation *Exhibitions:* American Artist Magazine Traveling Exhibition; Evanston and Vicinity Juried Art Exhibition *Education:* Rosary College; School of the Art Institute of Chicago

In the early and mid-1970s the subjects of his eerie, surrealistic, ethereally romantic oil and pencil works were graveyards, dolls, portraits, and Halloween trick-or-treaters. His most significant work of the period is the judgement scene, *As A Thief In The Night.* In this piece, a doll-like battered woman who is surrounded by burning buildings comes to the realization that she is eternally lost. Since 1977, he has made classically realistic works from life. His current portraits, still lifes, and landscapes in oil and pencil show the influence of the techniques of Renaissance masters like Bellini, Van Eyck, and Vermeer. His colors are now richer as the light plays over different surface layers.

FALCONER, JAMES (Painter, Photographer)

Born: 1943 *Awards: Collections: Exhibitions:* "Hairy Who" 1966-1969, Chicago & Washington *Education:* School of the Art Institute of Chicago

While in the late 1960s he began concentrating in film and photography, he first established himself as a painter and sculptor. Of this work, Dennis Adrian writes, "Falconer's jagged and disrupted figurative images seem set in his pictorial fields like flying knives: the eye will be cut wherever we try to pick one up. His contours are full of reversals and sharp changes of direction, so much so that only a few shapes on the canvas or paper require us to spend a long time looking at them in order to apprehend their totality, and even then they are likely to turn out to be fragment-images, leaving us still anxious for the full rectification of the suggested imagery." His spatial sense is compared to early Wirsum and Nutt; his layerings are "compressed, intensifying the optical assault made by the very active contours of the component forms."

FARRELL, PATRICK (Painter)
2752 N. Summit Ave., Milwaukee, WI 53211

Born: 1947 *Awards:* Award of Excellence, Milwaukee Art Commission *Collections:* Rahr-West Art Museum; Charles A. Wustum Museum of Fine Arts *Exhibitions:* Charles Allis Art Museum, Milwaukee; Rahr-West Art Museum *Dealer:* Ruth Siegal Ltd.,NYC

In the mid-1960s he was a magic realist; using oils on

canvas board, he painted demanding still lifes. Plant clippings and their structural qualities are subjects that have fascinated him since that time. Toward the end of the 1960s he began painting the living figure with social and literary commentary. In the late 1970s he turned again to still lifes but switched his surface from canvas to both smooth and textured gessoed masonite. Contemporary subjects include Chinese lanterns, drying leaves, and fruit. He has been called a contemporary primitive or naive and his style is presently a cross between magic realism and trompe l'oeil.

FAUST, JAMES (Painter, Sculptor)
8457 Union Chapel Rd., Indianapolis, IN 46240

Born: 1949 *Awards:* Krannert Creative and Performing Arts Fellowship *Collections:* Minnesota Museum of Art; Snite Museum of Art *Exhibitions:* Indianapolis Museum of Art; Kay Garvey Gallery, Chicago *Education:* Herron School of Art; U. of Illinois

Throughout the 1970s he concentrated on surrealistic drawings; in the 1980s these gave way to experiments with color and illusion on canvas. Using two- and three-dimensional canvas covered wood constructions, he creates sculptural forms, some of which are figurative, others are architectural and environmental. The palette for these pieces is taken from the Fauvists and the psychedelic colors of the 1960s. In each a full spectrum of color is released and combined with trompt l'oeil techniques. Recently the work has become even more sculptural.

FEDER-NADOFF, MICHELE (Painter, Sculptor)
6321 N. Clark St., Chicago, IL 60660

Born: 1955 *Awards:* Edith Halkin Memorial Scholarship *Collections:* Private *Exhibitions:* Duluth Art Institute *Education:* School of the Art Institute of Chicago *Dealer:* Jan Cicero, Chicago

Trained in the Chicago School, she creates dense, intimate and patterned works inclined towards an intense sense of formal and emotional detail. Earlier relief paintings contained stitched, beaded, embroidered, painted and collaged surfaces. She has reduced the organic forms of her paintings, whether vessels, organs, hats, torsos, heads or other forms, to simple yet suggestive shapes implying a range of associations. She made her ongoing "Golems" and "Shaydim" series from beeswax, hair, handmade paper and mixed media. Her present series of bronze and cast iron sculpture is called "Mee nai Kaillim."

FEELER, CHARLENE (Painter)
208 E. 12th St., #2, New Albany, IN 47105

Born: 1943 *Exhibitions:* Jubilee Gallery, Jeffersonville, IN; Floyd County Museum, New Albany, IN *Education:* Famous Artist Schools

She learned drawing and painting techniques from the Famous Artists Schools' commercial art, illustration, and design course. Irving Shapiro, Mario Cooper, and Dale Meyers and other masters of watercolor have been significant influences. In her watercolor paintings she depicts realistic themes of still life and floral subjects. Her colors are light, bright, mostly warm tones.

Daniel Fabiano, *Holiday Inn #1,* 87 x 16 x
16, wood, plastic, chrome, neon. Courtesy:
University of Wisconsin, Stevens Point

James Faust, *Radiated Mama,* 27 x 21, acrylic on canvas

She includes just enough rich details to attract the viewer. She has studied portraiture and has successfully completed several commissions for portraits in pastel.

FERAR, ELLEN (Painter)
1441 W. Cullom, Chicago, IL 60613

Born: 1949 *Collections:* Prudential Insurance, Harris Bank *Exhibitions:* Jan Cicero Gallery, Chicago; Randolph St. Gallery, Chicago *Education:* Wayne State U. *Dealer:* Atrium Gallery, St. Louis; Rubiner Gallery, Detroit

His early, abstract expressionist-influenced landscape/colorfield works featured broad gestures, thick paint, and rich colors. In the late 1970s he painted a series of abstracted interiors that became more hard-edged, simplified structures of contrasting colors, but he has recently returned to landscape themes. His brushwork is now very loose and painterly. In these newer works, some areas are defined with drips and washes, others with linear elements and heavy build up. His palette is subdued and jutting architectural forms suggest a loosely-defined, gritty urban setting.

FERBERT, MARY LOU (Painter)
334 Parklawn Dr., Cleveland, OH

Born: 1924 *Awards:* Bronze Medal, American Watercolor Society; Certificate of Excellence, International Art Competition *Collections:* Cleveland Browns Football Club; Cleveland Museum of Natural History *Exhibitions:* Catharine Lorillard Wolfe Art Club Annual Exhibition, NYC; Butler Institute of American Art, Youngstown, OH *Dealer:* Gallery Madison 90, NY

Conditioned by the artists of the Cleveland School and influenced by the precisionist painters Demuth, Scheeler and O'Keeffe, she chose interpretive realism to express her fascination with heavy industry. In documenting the rapid changes in the industrial landscape, she combines close-up views of the elements of industry with the sturdy urban botany. *Grapevine and Old Power, House, Sunflower and Conrail Caboose* and *Thistle and Tires* juxtapose the natural and man-made environments and convey a sense of adaptation. Working in watercolor, she composes by selecting images from a unique perspective, simplifying and abstracting them, and then compressing the elements into an ambiguous plane. Recently she has increased the side of her paintings, some as wide as 10 feet, and heightened her palette, at times applying pure pigment.

FERENTZ, NICOLE (Painter, Sculptor)
1605 W. Grace, Chicago, IL 60613

Born: 1952 *Awards:* Illinois Arts Council Artist Grant and Project Completion Grant *Exhibitions:* Printed Matter, NYC; Artemisia Gallery, Chicago *Education:* School of the Art Institute of Chicago *Dealer:* Objects Gallery, Chicago

In the late 1970s she became interested in the control of language and began using cliches to express or disguise emotional content. She now takes phrases of every day live out of their narrative context and makes them political and emblematic. She recently built a 30-foot wall which she filled with a grid of 22- by 30 inch house paint-on-paper paintings. This wall served as a background for an environment of a dozen free-standing signs on which she painted slogans. She articulated these large wooden signs by a variety of means, including incising, paint layering, and collaging. The subject of the work was the language of popular culture.

FERGUSON, KENNETH (Painter)
2020 Prentiss Dr., #205, Downers Grove, IL 60516

Born: 1958 *Awards:* Merit Award, 1986 International Wildlife, Western, and American Art Show, Chicago *Collections:* Sioux Indian Museum, Rapid City, SD *Exhibitions:* International Wildlife, Western, and American Art Show, Chicago; Oak Brook Center Invitational Fine Arts Exhibition *Education:* Northern Illinois U.

After formal training in illustration, he developed a time-consuming technique of dry brush over controlled-wash water color. His historically accurate and realistic subjects are most often the American Indians who inhabited the northern Great Plains of Montana and the Dakotas. His slightly romanticized solitary figures stand in front of moody backgrounds; stormy skies may indicate a coming confrontation. His colors are vivid, realistic earth tones with highlights of red. He particularly concentrates on creating accurate flesh tones and facial features of the Native Americans.

FERRARI, VIRGINIO (Sculptor)
1147 W. Ohio, Chicago, IL 60622

Born: 1937 *Awards:* Illinois Council of the American Institute of Architects *Collections:* U. of Chicago; Collection of the City of Chicago *Exhibitions:* Zaks Gallery, Chicago; Paris Art Center *Education:* Scola d'Arte & Academi Cignaroli, Italy *Dealer:* Zaks Gallery, Chicago

Lyrical, abstract sculpture in bronze and marble is highly expressive with a minimum of means. His austere but intensely alive compositions express a search for essence, reminiscent of Brancusi's images or architectural statements by Mies van der Rohe or Aldo Rossi. More recent pieces in stainless steel vary from the monumental *Being Born* on the State Street Mall in downtown Chicago to the smaller, lyrical piece *Nine Elements,* in which the bizarre concoction of non-symmetrical cubes and planar shapes fall free and melt into the clapboard surface of a suburban house.

FERRIS, ELEANOR SPIESS (Painter)
1531 W. Birchwood, Chicago, IL 60626

Born: 1941 *Collections:* Illinois State Museum, Springfield; Portland Art Museum, Oregon *Exhibitions:* Van Straaten Gallery, Chicago; Chicago Public Library Cultural Center *Education:* U. of New Mexico; School of the Art Institute of Chicago *Dealer:* Zaks Gallery, Chicago

Her work combines the influence of Bosch, Ensor, and Delvauz in the expressive vocabulary of her New Mexican background. Drawing inspiration throughout her career from the tradition of Kachina dolls, Pueblo Indian dances, and Spanish *Penetente* sculptures, her work in the 1970s used a flattened, expressionistic style with imagined and real symbols from the Southwest's spiritual past. Growing increasingly colorful, her work began to incorporate the idea of stage settings in the

Bobbe Field, *Aries, I Am,* 4 x 3, bronze

Sheila Finnigan, *Larry's Series I: Death March,* 48 x 60, oil on masonite

early 1980s, with bodyless clothing dancing, twisting, and wandering across stages as expressions of individual personas. Recently, the figures have begun transforming into strange creatures, both human and non-human; they participate now in orderly marches and races throught space that ranges from monochromatic to very colorful within the same painting.

FETTINGIS, JOSEPH (Painter)
5942 S. Kensington, Countryside, IL 60525

Born: 1946 *Collections:* Conrad Hilton, Chicago *Exhibitions:* West Bend Gallery, West Bend, WI; Kraft Corporation *Education:* American Academy of Art

For many years he has been searching for something in his landscapes, scenes of people and of places. Through this search he developed a technical prowess, while never satisfying his desire "to say something." Teaching watercolor has provided a place for him to exchange ideas, and this has broadened his experience of art. But it is the discovery of painting pictures of old people that has provided him with a meaningful avenue of expression. Moved by their expressions, the light on their tired faces, their sadness, and their joy, he has found a subject for his art.

FIELD, BOBBE (Sculptor)
7022 Emerson St., Morton Grove, IL 60053

Born: 1940 *Exhibitions:* Water Tower, Chicago; Plazart '88, Chicago; *Education:* Del Monte Casting Foundry, Venice, CA; School of the Art Institute of Chicago

A flexible artist, she works in a variety of media, including bronze, polyclay, ceramics, plaster, and hydrocal. Her detailed sculpture is a result of the tremendous amount of time she spends with her subjects. She is in love with creating, and her first major works were called *My Son* and *My Daughter. Jack Wild--The Artful Dodger* and *A Shark at Prey* were both based on popular movies. Her latest creations, *Bobbe's Zodiac Fantasies,* are five-inch tall bronzes based on each of the zodiacal signs. Each piece has a message, and they all work together to say "Heaven on Earth, The Universe in Harmony." She has recently begun work on a whimsical horse series.

FINCH, RICHARD (Painter, Printmaker)
1301 Mt. Vernon Dr., Bloomington, IL 61704

Born: 1951 *Awards:* NEA Fellowship; Research Initiative Award, Illinois State U. *Collections:* State of Illinois Center, Chicago; Brooklyn Museum *Exhibitions:* Illinois Invitational, Illinois State Museum, Springfield; Chicago Public Library Cultural Center *Education:* Southern Illinois U., Edwardsville

After making both abstract and figurative prints and drawings during his student days, he began to explore ways of using photographic processes to make abstract images based on the figure. This work brought him new images and turned him back to prints and drawings. He presently depicts the structure and anatomy of the human figure as revealed by light. His moody works are an attempt to convey the essential reality and intrinsic character of the human form in space. His media include, oil, watercolor, intaglio and lithographic prints, and mixed media drawings. Influences include Giacometti, Matisse, Jim Dine, and Sidney Goodman.

FINE, DIANE (Printmaker)
1046 Jenifer St., Madison, WI 53703

Born: 1960 *Awards:* Artist & Display Awards, Wisconsin Artists' Biennial; Scholarship, Jewish Foundation for Education of Women *Collections:* Museum of Modern Art; Elvehjem Museum of Art, Madison, WI *Exhibitions:* Artphase 1, Chicago; Silvermine Guild Galleries, Stamford, CT *Education:* Syracuse U.; U. of Wisconsin, Madison *Dealer:* Artphase 1, Chicago

Influenced by the formalism that pervaded American universities in the 1970s she explored the variety of mark making and surfaces available in intaglio printmaking and lithography. Her current pictorial representations of interior spaces are filled with signs and symbols. Through the 1980s her interest in printmaking techniques has increased along with her political commitment to the workshop as a communal art experience. Her collaboration on artist book projects has enhanced these concerns.

FINK, MILT (Sculptor)
14852 Hauley Rd., Durand, IL 61024

Born: 1910 *Awards:* Kegan International Competition; Todas Geller Award *Collections:* Skokie Jewish Community Center, Skokie, IL; Industrial Museum, Rockford *Exhibitions:* Art Institute of Chicago; Illinois Institute of Technology *Education:* U. of Chicago *Dealer:* Grove Street Gallery, Evanston, IL

In work ranging from elongated, abstracted figures to the completely non-objective, this sculptor has completed over 25 public works throughout the Midwest. The large-scale pieces incorporate cement, bronze and aluminum casting, plastics and fiberglass into a variety of motifs, frequently revolving around Judaic themes. He also makes smaller, interior pieces, usually of cast metal. Styles range from linear arabesques in two and three dimensions to dense, modeled biomorphic abstractions to architectonic pieces composed of metal sheets with circular cutouts. He is currently working on a commission for the Union Institute in Oconomowoc, Wisconsin involving the creation of six sculptures varying in size from six feet to eleven feet. In addition, he is working on a number of pieces composed of sewer pipes.

FINNIGAN, SHEILA ELIZABETH (Painter)
999 Green Bay Road, Studio 8, Glencoe, IL 60022

Born: 1940 *Awards:* "The Last Supper: Double-cross" chosen for exhibition in Dublin, Ireland, 1989 *Collections:* Jenner & Block, Chicago; Private *Exhibitions:* State of Illinois Art Gallery, Chicago; Esther Saks Gallery, Chicago *Education:* Ohio State U.; College of Arts and Crafts, Oakland, CA *Dealer:* ARC Gallery

In the tradition of such post-impressionists as Edvard Munch and Vincent Van Gogh, her early work as a painter typically depicts angst-ridden figures. She sees herself as outside the turbulence of the situations she paints, but affected nonetheless. Her work recalls early religious painting as seen through the veil of World War II and the Holocaust; she establishes a contradic-

tory juxatposition of early religious painting and the profane figures occupying her work. She currently uses what she terms a "spectrum" palette. While thick black line against white ground outlines the figuration, the spectrum (or color theme) defuses the works' bleak philosophy, recognizing a ray of hope for the human condition. Her works on paper are in ink and tempera and consist of psychological portraits and lighter scene studies.

FINSTER, HOWARD (Painter)

Born: 1916 *Exhibitions:* Phyllis Kind Gallery, Chicago; Braunstein Gallery, San Francisco

"A second Noah predestined for this planet," the Reverend Howard Finster realized his calling as an artist in 1977 when he dipped his finger in white enamel and saw in the paint a human face. "While I was lookin' at it," he reflects, "a warm flash kind'a went all over me all the way down and it said 'paint sacred art.'" He proceeded to paste a dollar bill to a piece of plyboard and started painting the image of George Washington; he has since completed over 3,500 primitive paintings. He has exhibited widely and was one of a dozen American artists whose work was shown at the 1984 Venice Biennale. He prefers to work with tractor enamel as he can then hang his works outdoors. A preacher and one time bicycle repairman and general handyman, he built his own Garden of Paradise--a backyard environment featuring buggy hubs, bicycle parts, concrete sculpture, mirror glass, a Cadillac, junk jewelry, cat's-eye marbles, cut-outs of Hank Williams, Elvis Presley, and Henry Ford, flowers, plastic milk jugs, pumpkins, and much more.

FIRME, KEVIN (Sculptor)

P.O. Box 33, Beverly Shores, IN 46301

Born: 1953 *Awards:* 2nd Prize, Whirlpool Sculpture Exhibit *Collections:* Whirlpool Foundation; Holladay Corporation *Exhibitions:* Chicago Center for the Print; Evanston Arts Center, IL *Education:* De Paul U.; Notre Dame U. *Dealer:* Neo Persona, New York; Chicago Center for the Print

Initially interested in the work of Duchamp, his sculpture eventually evolved from a "flatness" toward the vitalist tradition, the works of which often contain more than meets the eye. In particular, the artist subverts the traditional use of a medium; for instance, by using steel--a material known for its rigidity and precision--in organic shapes, he plays with our expectations. Some of his pieces mix organic forms with structural forms, and painted areas with unpainted, the interplay speaking for his interest in exploring the commingling between the spirit of industry and that of nature.

FISCHER, GLORIA (Painter, Printmaker)

6410 Verbena Ct., Indianapolis, IN 46224

Born: 1941 *Collections:* Ontario Corporation; Radisson Corporation *Exhibitions:* Mary Bell Gallery, Chicago; Editions Ltd., Indianapolis *Education:* Herron School of Art; Valparaiso U., Indiana *Dealers:* Mary Bell Gallery, Chicago; Editions Ltd., Indianapolis, San Francisco; Miller Gallery, Cincinnati

After experimenting with a variety of printmaking tech-

niques she settled on chine colle etching, a combination of etching and collage. She prints on sheets of pieced-together hand-dyed textured lace paper and varies the color of her collage papers by layering them and/or painting them with thin acrylic washes. Since the collage papers vary from print to print, each of the prints is unique. Her early works were minimal, abstract, and monotone. Influences included Antonio Topie, Diebenkorn, de Kooning, and Bacon. Her work continues to be abstract, but now also includes more figurative and architectural lines.

FISCHER, PATTY HESTER (Painter)

708 Greenhill Way, Anderson, IN 46012

Born: 1952 *Awards:* Honorable Mention, Reno Show, West Coast Pastel Society *Exhibitions:* Silver Cloud Gallery, Chicago; Pastel Society of America Annual Show, NY *Education:* Indiana U.; Anderson College

During her years in college, she worked primarily in oils, painting a series of representational animal studies. At this point, she was greatly influenced by Remington and Frank McCarthy, and she worked to refine her subjects in a traditional manner. Her current work is still representational, although the medium is now pastel and the style contemporary. One still life features four differently colored roses in point-blank perspective. Shadows from the light create abstract shapes within the white, red, orange, pink, and powder pink petals. Recent work includes landscapes and architectural subjects, side views of houses, louvered windows, and Victorian porches. All the work is characterized by rich color and a sharp presence of light. The shapes are clear, crisp, and clean.

FISCHER, R.M. (Sculptor)

73 W. Broadway, New York, NY 10007

Born: 1947 *Awards:* NEA; Creative Artists Public Service Fellowship *Collections:* Whitney Museum of American Art, NY; Dallas Museum of Art *Exhibitions:* Chicago Sculpture International; Lafonet Museum, Tokyo *Education:* C.W. Post College, Long Island U.; San Francisco Art Institute, *Dealer:* D. Young, Chicago

"I felt that getting the work seen in non-art contexts was as essential as any studio problem I was working on at the time," he says of the presentation of his lamps in Bloomingdales in 1979. Just as the "art context" is one not traditionally reserved for art, so are the components of the works taken from non-art arenas; making lamps from articles most likely found in junk shops, he fashions them with such common items as a spaghetti colander, a spigot, or a piece of discarded scuffed brass. The resulting art-object is more than just a play on context but a functioning, highly designed lamp. Critic Dan Cameron writes, "he proudly adapts the do-it-yourself idealism of a recycled America, sometimes with a sincerity and familiarity that has been known to stymie the viewer seeking a rush of kitsch from them." And of his work in the mid-70s, "In throwaway culture he glimpsed the central truth of a critique which relies on camp for its insight: somewhere down the historical line, high culture and low culture must merge to form a composite portrait of civiliza-

tion."

FISCHL, ERIC (Painter, Printmaker)
c/o Mary Boone Gallery, 417 W. Broadway New York, NY 10012

Born: 1948 *Collections:* Metropolitan Museum of Art *Exhibitions:* Kunsthalle, Basel; Mary Boone Gallery *Education:* Phoenix Junior College, AZ; Arizona State U. *Dealer:* Mary Boone Gallery, NYC; Vivian Horan Fine Art, NYC

A leading exponent of Neo-Expressionism, he produces works in which the psychosocial self is explored through the use of taboo subject matter. Works centering around themes of sexual, racial, and social tension often capture figures in self-conscious and awkward moments. Narrative paintings, prints, and drawings depict human dramas being played out in upper-middle class suburbia or such vacation spots as Caribbean beaches; figures seem ready to take action, and the scenes suggest many possibilities. Recent works focus less on sexual themes and concentrate more on the confrontation of people of different races and cultures.

FISHBEIN, ANNE (Photographer)
12616 Mitchell Ave., #5, Los Angeles, CA 90066

Born: 1958 *Exhibitions*: Art Institute of Chicago; Printworks, Chicago *Education*: Yale U. *Dealer:* Printworks, Chicago

Influenced by Robert Frank and Garry Winogrand at Yale, she is a classic street photographer who shoots mostly in black and white in the 35 mm and medium formats. She travels around the country by foot, car, or train and searches for material by involving herself in the environment. In her nostalgic visual narrative of the old Route 66, she plays on the contrasts between the romanticized West and the real West. Using a six by seven cm Makina Ploubel and a 35 mm Leica, she documented the patchwork quilt of rustic towns' religious revival meetings and tourist stops that remain along the old highway.

FITZGERALD, KIP R. (Painter)
826 N. Winchester, Apt. 1-A, Chicago, IL 60622

Born: 1959 *Awards:* William Vonderheide Award *Collections:* Miller Gallery, Chicago, Xenon *Exhibitions:* Bates Gallery, Chicago; Feature Gallery, Chicago *Education:* School of the Associated Arts, St. Paul, MN *Dealer:* Hudson Feature Gallery, Chicago

He is interested in dissecting, exploring, and reinvestigating the meanings of pictures. His early work was positioned between a respect for romantic painting and an interest in illustrations, billboards, and pop art. He has retreated from the figure and he now first draws on images of advertisements and then selects sections for abstract functions. By repainting these fragmented sections in a crisp manner, he opposes the abstract and the photographic while at the same time becoming competitive with the popular culture he seeks to comment on. Media include oils, acrylics, spray paints, and pas-

tels.

FLAVIN, DAN (Installation Artist, Sculptor)
P.O. Box 248, Garrison, NY 10524

Born: 1933 *Awards:* William and Noma Copley Foundation Grant; National Foundation Arts and Humanities Award *Collections:* Museum of Modern Art, NYC; Whitney Museum *Exhibitions:* Art Institute of Chicago; Whitney Museum *Dealer:* Leo Castelli Gallery, NYC; Margo Leavin Gallery, L.A.

A series of minimalist structures he calls "blank, almost featureless square-fronted constructions with obvious electric lights," was begun in 1961. Later works employ fluorescent lights exclusively, without "constructions," sometimes rendering the light fixtures invisible. He now seeks to dissolve flat surfaces and restructure space. Artificial "installations" emphasize the characteristics of the rooms he works in.

FLYNN, JOSEPH FRANCIS (Painting, Portraiture)
326 E. Madison, Wheaton, IL 60187

Born: 1932 *Awards:* Best of Show/Pastel, Diamond Medal Exhibit, Palette and Chisel, Chicago; Merit Award/Pastel, Paper Chase, DuPage Art League *Collections:* Wheaton College, IL; Service Master Industries, Inc., Downers Grove, IL *Exhibitions:* Midwest Pastel Society Show, Studio in the Woods, Wauconda, IL; Palette and Chisel's Annual Exhibit, Chicago *Education:* School of the Art Institute of Chicago

A four-year scholarship student and graduate of the Art Institute of Chicago, he put aside his painting for a career as a commercial art salesman. After 20 years, he returned to his first love, portraiture. Fluent in both pastel and oil, he has been greatly influenced by John Singer Sargent, Franz Hals, Velasquez and Thomas Eakins. Work as a free-lance courtroom artist greatly enhanced his ability to quickly capture a likeness. Rich in color and style, his brushstrokes are confident, bold and assured. Over the past seven years, he has drawn or painted over 6500 faces.

FOLEY, JERRY LEE (Painter)
916 W. Washington St., Champaign, IL 61821

Born: 1953 *Awards:* U. of Illinois Fellowship in Art and Design *Collections:* Illinois State Museum, Springfield; U. of Illinois, Champaign-Urbana *Exhibitions:* Art Institute of Chicago; Indianapolis Museum of Art *Education:* Ball State U.; U. of Illinois, Champaign-Urbana

His work is about making and viewing art and in his pieces he deals with the problems of living as an artist in a world that "treats us all like dismissible and disposable parts." He has painted the word "next" on each of his new images either to goad the viewer into looking at the work for less than the average of seven seconds or to intrigue the rebellious type of gallery-goer into discovering the work's delicious colors and textural relationships. He now paints with acrylics on stretched canvas and makes polaroid and acrylic collages. "I hope this work challenges us to trust ourselves rather than

Patty Fischer, *Church with the Red Door,* 24 x 29, pastel

Elisabetta Franchini, *Capri Trio,* 18 x 24, pastel

only perceived authority."

FOLISE, JOSEPH (Sculptor)
7817 Lotus Ave., Morton Grove, IL 60053

Born: 1947 *Collections:* Muskegon Museum of Art *Exhibitions:* Muskegon Museum of Art; Campanile-Capponi Contemporary Gallery, Chicago *Education:* Chicago Academy of Fine Art

Initially inspired by an interest in archaeology and the design principles of past cultures, he sculpts timeless objects that create an aura of the past, relate to contemporary surroundings, and stir up the mystery and wonder of the future. He first casts a primal shape from a harmony of glass, metal, and stone and then experiments with surface treatments and symbols. His timeless objects are full of innocence and wisdom.

FORD, AUSBRA (Sculptor)
8215 Crandon, Chicago, IL

Born: 1935 *Awards:* National Endowment for the Humanities Fellowship *Collections:* Chicago Hilton and Towers; Dusable Museum, Chicago *Exhibitions:* Museum of Science and Industry, Chicago; Stevens Gallery, Chicago *Education:* School of the Art Institute of Chicago

The angular welded steel and laminated wood sculpture he did in the 1970s reflect his contemporary experience of African history and mythology in the town of Oskogbo in Nigeria. In these colored works of contrasting rounded bold forms he left wells to create a feeling of strength and power. In contrast to these, he draws from African-American roots and Egyptian cultures for his present works. His use of media has become broader and he now mixes welded and polished aluminum with plexiglass and carved stone with wood. Such series as "Duke Ellington," "Blues and Jazz," and "African" are stylized wall works with reflective materials.

FORTUNATO, NANCY (Painter)
249 N. Marion St., Palatine, IL 60067

Born: 1941 *Awards:* Best of Show Puchase Award, Watercolor, Illinois Table Arts Center; M. Grumbacher Award, International Society of Artists Show, Foothills Art Center, CO *Collections:* Leigh Yawkey Woodson Art Museum, Wausau, WI; Crane Foundation *Exhibitions:* Midwest Watercolor Society; East Meets West Gallery, Chicago *Education:* Zhejiang (China) Academy of Fine Art *Dealers:* Studio 15, Arlington Heights, IL; Art Gallery, Rolling Meadows, IL

Influenced by Wyeth, Hopper and the early illustrators, she uses watercolor in a transparent manner, describing close-ups of nature, old doors, windows, and artifacts, and giving special care to abstract patterns. After a period of working on oriental papers, in which she developed a delicate style of painting birds related to Chinese landscape, she was invited to attend the Zhejiang Academy of Art in 1984. There, she received instruction from Chinese landscape masters. She has been incorporating these techniques into her newer work, using the spontaneity of watercolor to describe the interaction among bird, environment, and medium.

FOUCHER, VALERIE (Painter)
5304 S. Drexel Ave., Chicago, IL 60615

Born: 1946 *Exhibitions:* Waller-Boldenweck Gallery, Chicago; Vision Quest Gallery, Chicago *Education:* Universite de Paris

Emotionally evocative oil-painted portraits and figures make up the oeuvre of this artist. Using expressive colors and a rough, primitive technique, she depicts solitary subjects who often focus their eyes just beyond the viewer, so that even the most beautiful of them reveals a sense of inquietude. Figures may be disjointed, awkwardly cropped, or overlapped with a change in scale; heads may be floating unattached in space. Inspired by the commitment of Toulouse-Lautrec, the artist also explores the psychological states of her subjects, which center on alienation and rootlessness.

FRANCHINI, ELISABETTA P. (Painter)
2115 W. Webster, Chicago, IL 60647

Born: 1960 *Awards:* Honorable Mention, Newport Art Festival, Newport RI; Honorable Mention, Evanston Lakeshore Arts Festival, Evanston, IL *Exhibitions:* Lloyd Shin Fine Art Gallery, Chicago; Beverly Art Center, Chicago *Education:* School of Visual Arts, New York; Smith College, Northampton, MA

Her early paintings are detailed, architectural landscapes of the city, reflecting her initial concentration on drawing and illustration while studying in Paris. Also fascinated by going back in time, she worked impressionistically with scenes at race tracks and yacht clubs, dressing her figures in turn-of-century costumes. These pieces communicate a sense of lost beauty and simplicity in comparison to modern society. A love for Edward Hopper inspired her to work in bold, dramatic shadows as her painting progessed to its present, hard edged style. Her most recent series, executed in the harbor of Capri, depicts the boats and their reflections at close range as part of her increasing concern with abstraction.

FRANCIS, SAM (Painter)
345 W. Channel Dr., Santa Monica Canyon, Los Angeles, CA 90402

Born: 1923 *Awards:* Tamarind Fellowship; Dunn International Prize, Tate Gallery *Collections:* Solomon R. Guggenheim Museum; Museum of Modern Art, NYC *Exhibitions:* San Francisco Museum of Art; Albright-Knox Art Gallery *Education:* U. of California, Berkeley; Atelier Fernand Leger *Dealer:* Galerie Smith-Anderson, Palo Alto, CA

After prolonged formal study, he had his first solo show in 1952 in Paris. This early work consisted of abstract paintings with large areas of color light in tone. Soon the tones became more vivid, with areas of color bleeding into each other. A trip around the world in 1957 perhaps influenced his artistic career most. Cool colors, thinly applied and arranged in asymmetrical segments on the canvas, seem to recall the Japanese tradition. During the 1960s he became increasingly occupied with lithography. Currently his Oriental tendencies continue, with the clarity and starkness of form and com-

Ney Tait Fraser, *untitled,* 11 x 14, silver gelatin print

Mark Fredenburg, *Spirit,* 24, limestone

position related to the Minimalists.

FRANCO, CHARLES VINCENT (Painter, Draughtsperson)
4453 N. Hamilton, Chicago, IL 60625

Born: 1941 *Collections:* Harris Bank, Hinsdale and Glencoe, IL; Stroud & Waller, Highland Park, IL *Exhibitions:* Jan Cicero Gallery, Chicago *Education:* St. Johns U.; School of the Art Institute of Chicago *Dealer:* Jan Cicero Gallery, Chicago

His artistic vision is an imaginative expression of nature and its works. His impressionist-influenced tree pictures of 1984 are *plein-air* studies of nature observed. Some are expressive pictures in the Romantic mode, others are revelations of form and color in atmospheric light. The arcadian mood of these pastel trees gives witness to his belief that trees are pleasing to the eye and a joy to the heart.

FRANKENSTEIN, CURT (Painter, Printmaker)
2112 Old Glenview Rd., Wilmette, IL 60091

Born: 1922 *Awards:* Municipal Art League Prize, Art Institute of Chicago *Collections:* Illinois State Museum, Springfield, IL; Union League Club, Chicago *Exhibitions:* Chicago Public Library; Art Institute of Chicago *Education:* American Academy of Art, Chicago; School of the Art Institute of Chicago *Dealer:* Chicago Center for the Print

Born in Germany, his family moved to China in the 1930s. He apprenticed with a Chinese artist and came to the U.S. after World War II. In the early 1950s he went to art school and painted realistic figurative oils and acrylics. In 1960, he began to assimilate the influences of Magritte and the Viennese School of Fantastic Realism. His fantastic paintings and prints show a gentle sense of humor and social comentary. In *Bureaucratic Landscape*, he depicts corporate men hatching from a field of giant eggs. His prints reveal a knowlege of 19th century English cartoons and show the same trenchant sense of humor.

FRANKENTHALER, HELEN (Painter)
173 E. 94th St., New York, NY 10028

Born: 1928 *Awards:* 1st Prize, Biennale de Paris; Garrett Award, Art Institute of Chicago *Collections:* Whitney Museum; Metropolitan Museum of Art, NYC *Exhibitions:* Metropolitan Museum of Art, NYC; Guggenheim Museum *Education:* Bennington College; Art Students League *Dealer:* Andre Emmerich Gallery, NYC

After formal training in Cubism she developed an individual abstract expressionistic style influenced by the work of Arshile Gorky and Vassily Kandinsky. In 1951 she became interested in Jackson Pollock and the transformation of the unconscious into concrete artistic creations. She began to explore color-field combinations and the ways in which their accidental combinations are controlled. Progressing from small areas of color in oil to large areas in acrylic, she has painted on unsized, unprimed canvas, a technique developed from Pollock's method of dripping and staining the paints onto raw canvas. Paint actually soaks into the canvas to create a purely optical image rather than a three-dimensional form.

FRANKLIN, JONATHAN (Painter)
1840 N. Rockwell, Chicago, IL 60647

Born: 1953 *Collections:* Art Institute of Chicago *Exhibitions:* Gallery Vienna, Chicago; D.E.O. Fine Arts, Chicago *Education:* U. of Mississippi *Dealer:* Masters Portfolio, Chicago

Always a figurative imagist, his early work is subdued, pensive, and introspective. Part of his training was in Indonesia and the color and expression of this early work bears the indelible reflections of the austerity he saw in the East. He also worked for a time as a printmaker in Israel. As a result of theatrical work, the content of the paintings began to open up to the viewer. His physical expression, activity, and color have become more animated while his execution is now tighter. Ultimately the paintings are about seeing one thing and becoming another: identification, manipulation, and transformation.

FRASER, JOHN S. (Mixed Media Artist)
5 North 636 Rt. 25, St. Charles, IL 60174

Born: 1952 *Collections:* Illinois State Museum, Springfield; Brunnier Museum, Ames, Iowa *Exhibitions:* Art Institute of Chicago; Klein Gallery, Chicago *Education:* Roosevelt U., Chicago; Northern Illinois U. *Dealer:* Mongerson-Wunderlich, Chicago

His initial drawings and photographs were interpretations of color and edge. He intended to capture an image of limited existence by selecting, amending, and photographing metal in a state of decay. This work was a metaphor for man as affected by nature. He currently bonds the found and manipulated in collages of paper and wood. Through a "selective/adaptive" process that combines chance and discipline, he conveys a personal and obsessive vision in which he seeks to be vulnerable and universal. With other materials such as post cards and maps, he tries to bring to his works the formal qualities of grace, eloquence, and style.

FRASER, NEY (Photographer, Printmaker)
P.O. Box 17005, Milwaukee, WI 53217

Born: 1942 *Awards:* Photograph Collection Purchase Award, Wustum Museum, Racine, WI; Arthur P. Haas Memorial Collections, Wustum Museum, Racine *Exhibitions:* The Photographer's Gallery, London; Milwaukee Art Museum, Milwaukee *Education:* Massachusetts College of Art, Boston; Pratt Institute, NYC *Dealers:* Cissie Peltz, Milwaukee; The Special Photographers Company, London

Bringing with her a broad vocabulary of technical skills from Massachusetts College of Art and Pratt Institute, her early work has progressed from straight photographs to experiments with combining negatives, solarization, and collages using hand painted xeroxes. A recent exhibition featured a number prints achieved through sandwiching of negatives, double printing, and solarization, in which nudes are depicted in the woods, at the beach, or in ultra-closeup. Perhaps the most striking was that of a man's chest and arms cradling a butterfly with wings outstretched. She has also worked on a series of four by five photographs of the West Side

of New York City and Central Park, a series of four by five street portraits done with daylight strobe, and figurative photographs. Currently she is organizing these series into handmade books while also working on a series of drawings and watercolors of a model in hats.

FRAZIER, NANCELIA (Wood Artist)
4516 S. King Dr., Chicago, IL 60653

Born: 1951 *Exhibitions:* Chicago Cultural Center; Southside Community Art Center *Education:* School of the Art Institute of Chicago

She has developed a technique which she calls "wood graphics," in which she starts by drawing on plywood, using black inks, and gradually adds colored inks. By carving into the wood, she cuts shapes. Having recently learned to work with an airbrush, the artist incorporated this technique into her wood graphic work as well as fashion illustration and editorial art.

FRAZIER, RUTH ANN (Sculptor)
1226 Ashland Ave., Wilmette, IL 60091

Born: 1928 *Collections:* Needham, Harper and Steers, Chicago; Armour and Company, Chicago *Exhibitions:* Noyes Cultural Arts Center, Evanston, IL; C. Corcoran Gallery, Muskegon, MI *Education:* School of the Art Institute of Chicago; U. of Iowa *Dealer:* Mary Bell, Chicago

Her early large outdoor pieces are in cor-ten steel, as she was attracted to its capacity to be impervious to weather. As time went on, however, she became interested in contrasting rusted surfaces with polished ones or crafted objects with found pieces for their organic and expressive qualities. She brought this interest to smaller wall-hung pieces as well. In these cases the work often begins as an abstraction of a landscape form in which the rusting surfaces suggest the changing nature of nature. Other elements in the pieces speak to change as well: the changes from hard edge to soft, from solid to fluid, from rigid to playful, from form to formless. In each case, the technique speaks not only on the thematic level but also on an emotional one. In the last few years the works of Calder and Picasso have been influential.

FREDA, JOHN (Painter)
P.O. Box 298, Evanston, IL 60204

Born: 1943 *Awards:* Leonard Goodman Award, Allentown, NY *Collections:* Cain Park Art Museum, Ohio; Illinois State Museum, Springfield *Exhibitions:* Viridian Gallery, NYC; Fountain Square Gallery, Evanston *Education:* City College of New York; City U. of New York *Dealer:* Viridian Gallery, NYC

Born in New York, he lived in Israel for a year and while there helped to found a gallery in Ein Karlem near Jerusalem. He also lived in Italy for seven years, and the influence of Mediterranean ideas and the North Italian School of metaphysical painters led him to a brightly colored symbolic style. He explores the mysteries of language, spatial relationships and story fragments with acrylic and mixed media. He is currently the visual arts coordinator for seven environmental and religious art exhibitions at the Epworth Conference Center in Indiana.

FREDENBERG, MARK (Sculptor)
1109 Greenwood-B, Waukegan, IL 60085

Born: 1955 *Awards:* 1st Place, Lincolnshire Arts Center *Collections:* Shimer College *Exhibitions:* Joseph M. Gallery, Libertyville, IL; "Best and Brightest," Scottsdale, AZ *Education:* Southern Illinois U. *Dealer:* Laura Stankovich, Chicago

Drawing his inspiration from New Age ideas, he creates bronze sculptures with spiritual overtones that are intended to provide the viewer with an uplifting experience. Previous works in direct stone carving concentrate more on emotional expression and impact, rather than on detail. His sculpture *Mother and Child* is exemplary in its use of a quiet, contemplative moment connected powerfully with larger ideas and human experience. Direct and clear, his work has been influenced by the classical form and discipline of Egyptian sculptor, Mustafa Naguib. Continuing his explorations of contemporary spiritualism within this classical structure, new works include life-size figures of St. John Neumann, St. Elizabeth Seton, and Christ.

FREED, DOUGLAS (Painter)
1100 W. Fourth St., Sedalia, MO 65301

Born: 1944 *Collections:* Stienburg Art Museum, Washington University, St. Louis; Museum of Art and Archeology, University of Missouri *Exhibitions:* Zolla Lieberman Gallery, Chicago; Vorpal Gallery, NYC *Education:* Kansas State U. *Dealer:* Vorpal Gallery, NYC

Geometrically structured canvases are embellished with richly textured surfaces built up from many thin layers of blotted oil.

Earlier work consisted of canvases, also constructed geometrically, made up of individually wrapped stretchers that joined like pieces of a puzzle. These units were sprayed with many thin layers of oil to create atmospheric surfaces. The edges of the individual unit shapes were rounded so that when assembled, the edges created incised lines that defined the structure within the painting.

FREEH, LINDA S. (Glass Artist)
2330 Pines Rd., Oregon, IL 61061

Born: 1952 *Awards:* 1st Place, Cradle Art Fair, Chicago; 2nd Place, Edgerton Art Association, WI *Education:* Dayton Art Institute; Wright State U., Dayton, OH

After formal training in design, drawing, and ceramics, she became fascinated with stained glass and the versatility of the material. In 1985, after working in a commercial studio for three years, she began her own studio, exhibiting in public art shows and executing residential commissions. She studied glass fusing with Gil Reynolds and Klaus Moje (at the Pilchuck Glass School), but she says she continues to find that her designs come from experimentation with the material itself. As a medium that can be cut, etched, painted, ground, polished, fused, slumped, blown, and cast, glass provides her with endless possibilities as material alone. She crafts both figurative and abstract pieces,

freestanding and two-dimensional.

FREEMAN, GEORGE (Sculptor)
1061 W. Balmoral, Chicago, IL 60640

Born: 1942 *Awards:* 1st Place Graphics, New Horizons in Art; Purchase Award, O.F.S. Continental Corporation *Collections*: Standard Oil of Indiana; George May International Corporation *Exhibitions:* Art Institute of Chicago; National Print Show, Bradley U., Peoria, IL *Education:* Columbia College, Chicago; School of the Art Institute of Chicago *Dealer:* Art Sales Rental Gallery, Art Institute of Chicago

Beginning as a printmaker, he became interested in the third dimension while studying at the Art Institute. His early works were monochromatic rusted planar pieces of painted or unpainted plate steel, pieces which represented the American Southwestern landscape. He was influenced by the works of Anthony Caro, Edwardo Chilada, David Smith, and Richard Hunt. Later his works evolved into a more Abstract Expressionist style, with "post-visualized constructions" in raw or polychromed steel. Currently, he sculpts volumetric wood pieces from a supply of pre-worked oak and elm parts. Similarly he welds and polychromes his more linear metal pieces from pre-existing steel.

FRITH, A. BARBARA (Painter)
1109 W. Clark St., Champaign, IL 61821

Born: 1925 *Awards:* Purchase Award, Vincennes University, CA; 2nd Prize, Illinois State Fair *Collections:* Denver Art Museum; Illinois State Art Museum *Exhibitions:* Gilman/Gruen Gallery, Chicago *Education:* Cleveland Institute of Art; Denver U. *Dealer:* Gilman/Gruen Gallery, Chicago

Her early formal training developed her imaginative and illustrative skills in which she fused abstraction with surrealism. These early pieces take influence from Frank Wilcox's abstract paintings as well as Vance Kirland's and Julio de Diago's surrealist techniques. Perhaps the greatest influences come from her studies in Korea at Ewha University where she learned calligraphy. Her early work demonstrated the formal technique of oils where the medium progress is very slow. Today, she works "fast," using watercolors (with pastel) on Japanese paper. Mounting one piece of paper on top of another, she creates a sculptured effect which she then accents with pencil and pastel. The creases become expressive components in the composition, "like brush strokes without any color other than the color of the paper," says art critic Kent Williams, "sometimes serving simply as the stems of flowers, or lending a sense of age to the compositions." The series is appropriately titled "Imaginary Landscapes."

FRYDRYCK, WALTER A. (Painter)
1434 W. Pratt Ave., Chicago, IL 60626

Born: 1941 *Awards:* NEA Grant *Collections:* Tyler Texas Art Museum; Renaissance Society, U. of Chicago *Exhibitions:* Museum of the National Art Foundation, NYC; Gilman/Gruen Gallery, Chicago *Education:* School of the Art Institute of Chicago *Dealer:* Gilman/Gruen, Chicago

Initial aesthetic investigations focused on the move-

ment of color through the incorporation of motors into works. This series was followed by works which used multiple airbrushed plexiglas planes to emphasize dimensionality. His interest in spacial concepts, such as the integration of movement, form and color, resulted in a series of acrylic fusion shadow paintings. These works utilized a process in which transparent paint is applied in an abstract manner and is fused into the plexiglass surface and placed in front of the canvas. Frontal lighting transforms the suspended pigments into a play of shadows which create unique atmospheric effects.

GADOMSKI, ROBERT (Painter)
340 Oswego, Park Forest, IL 60466

Born: 1946 *Collections:* Block Gallery, Evanston, IL; Quaker Oats Company, Philadelphia *Exhibitions:* Illinois Arts Council Gallery, Chicago; Art Institute of Chicago *Education:* Art Institute of Chicago; Western Illinois U. *Dealer:* Campanile/Capponi Art Consultants, Chicago

Gadomski's vibrant interpretations of his early Chicago environs are both reverent and pungently witty. He sees middle-class stability through his own illusionistic vision. Saints gaze out church windows, grass is supergreen, and the black framework of a shed door poses in symbolic pomp. Rural solitude, always warmed with lush greenery, is another recurring theme, and his obsessive "super-real" style is often tempered with humor or plays on the viewer's sense of perception. Bold color and carefully delineated detail interrupted occasionally with snippets of collage, intrigue and mystify the viewer while implying, if not promising, a glowing optimism. Having lived in many parts of the U.S., Canada, and Europe while working in factories, bars, and stores, as well as working as a commercial artist, lecturer, designer, and sculptor, he brings a broad yet eclectic sensibility to his work.

GALINDO, J. ALEX (Photographer)
1579 N. Milwaukee Ave., Suite 308, Chicago, IL 60622

Born: 1959 *Awards:* Weisman Scholar, Columbia College, Chicago; Logan Square Honor Prize *Exhibitions:* International Art Expo, Chicago; Limelight, Chicago *Education:* Columbia College, Chicago

As a student, his interests ranged from landscapes to stills to documentary, and for a period he shot all of these. Gradually, however, his interest began to focus on people and their environment. To this interest the work of Harry Callahan and Diane Arbus spoke powerfully. Today his photographs seek to find the commonalities in all of us, recognizing the peculiar truth that while we are each individuals, with individual qualities that we display in particular ways in our environment, we can nonetheless identify common needs—the call for dignity, self-assurance, self-respect, joy, and fulfillment. A Mestizo Indian himself, he frequently photographs Mexican-American subjects. His series *Familia Fernandez* represents two years of an intimate documentation of the life of this family and their environment, their pride, and their dignity, and is evidence of those qualities in each of us.

Barbara Frith, *Pond Water Series,* 36 x 64, watercolor pastel. Courtesy: Gilman Gallery

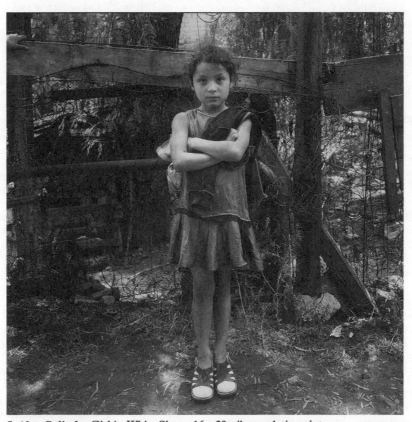

J. Alex Galindo, *Girl in White Shoes,* 16 x 20, silver gelatin print

GALL, SUSAN WRONA (Painter, Sculptor)
321 S. Sangemon St., Chicago, IL 60607

Born: 1948 *Awards:* 1st Place, Spertus Museum of Art *Collections:* Hyatt Corporation, Chicago; Peat Marwick, Inc., Chicago *Exhibitions:* Ruth Volid Gallery, Chicago; Palm Springs Art Museum, Palm Springs, CA *Education:* Beloit College, WI *Dealer:* Ruth Volid Gallery, Chicago

The spiritual and visual qualities of Frankenthaler, Turner, and Rothko provide inspiration for her landscapes. As she moves toward painted sculpture, surface and form share equal importance. A complex interrelationship of angles and curves evolves into a harmonious whole, counterpointing surfaces that are textured to define their coexistence. As each shape assumes its character, the dominant forms are patterned or drawn to emphasize their strength. Recently, the structure of her work has taken on a newer, geometric formality. These formal sculptures, done in welded steel, are primitive abstractions, exemplified by the recent mask series that explores the passive/agressive stance of human relationships, particularly that between the parent and the child.

GALLO, FRANK (Sculptor)
Dept. of Art, U. of Illinois, Urbana, IL 61801

Born: 1933 *Awards:* Prize, Interior Valley Competition, Cincinnati; Guggenheim Fellowship *Collections:* Museum of Modern Art, NYC; Whitney Museum *Exhibitions:* Whitney Museum Annual; Venice Biennale *Education:* Toledo Museum School of Art; Cranbrook Academy of Art *Dealer:* Circle Gallery, Chicago; Jack Gallery, NYC

Works of the 1950s and 1960s use polyester resin and fiberglass, giving pieces a glutinous texture. He gained recognition with elongated, often subtly erotic studies of elegant women reclining with attitudes of indifference or self-absorption. He has also composed sculptures of men. Similar figures have been made in paper relief and epoxy-resin. Recently he has also made lithographs depicting similar types of figures.

GAMUNDI, MICHEL (Painter, Sculptor)
400 N. Taylor #2, Oak Park, IL 60302

Born: 1956 *Awards:* Ohio Aid to Individual Artists *Exhibitions:* Ohio State University Raw Space; ARC Gallery *Dealer:* Corporate Art Source, Chicago; Alter Associates, Inc., Highland Park, IL

Her constructions and sculptures represent images of debris, accumulated, housed and stored by various methods of organization common to daily activities and situations. Shelves, stacks, and piles are deliberately placed in arrangements as metaphors of her personal struggle to "organize chaos." They take on the appearance of chaos while being created by the ordering of forms. The obsession to create harmony between antinomies has remained a central theme in her life and art. Her work is largely autobiographical, evolving from the personal dialogue within herself in direct reference to "past, present, and future" events and situations. It has become an allegory for the physical and psychological paradox she perceives as a notion of reality. Current work includes installations and sculptures evolving her previous interests and focusing on the quality of "still life." She is involved with reshaping fragments that are already present in the world around us, transforming them into a new existence by the placement, juxtaposition, association, and material handling of imagery.

GANNELLO, CARMELO C. (Painter, Mixed Media Artist)
621 S. Maple Ave., #306, Oak Park, IL 60304

Born: 1920 *Awards:* President's Award for Creative Endeavor, National Academy of Design; Illinois Arts Council Fellowship *Collections:* Museum of the City of New York; Chicago Historical Society *Exhibitions:* Milwaukee Art Museum; Wadsworth Atheneum *Education:* National Academy of Design

His early scenes of New York City living, parks and marine life were influenced by regionalistic and pictorial styles of painting. After suffering an eye disability in the mid-1950s he studied commercial art and worked in that field for several years. In the early 1970s, further problems with his eyes--a detached retina--caused him to see "floaters," or spots in front of his eyes. The spots themselves have become the subject of his "art of the inner eye" ever since. He paints semi-abstract to abstract works with oils, pastels, and watercolors, making black and white abstract linoleum prints. He is also active in the cause of arts for the disabled.

GARGIULO, NANCY NAINIS (Painter)
3301 Hartzell St., Evanston, IL 60201

Born: 1949 *Awards:* Merit Award, Countryside Art Center; Fritz-Smith Purchase Award *Collections:* DePauw U., Greencastle, IN; South Shore Bank, Chicago *Exhibitions:* Artemisia Gallery, Chicago; Monroe Gallery *Education:* DePauw U., Greencastle, IN

Basically a portrait painter, she has been influenced by impressionism, Degas, Pop Art, and Conceptual Art. She tries to blend both romantic and intellectual ideas. Her oil and pastel works are investigations of the systems that underlie the American middle-class way of life. Beginning with photo sketches, she combines information from the camera with what she remembers and allows unconscious thoughts and emotions to emerge. She is presently dealing with the issues of appearance and reality. In her current work she bends laminated pastel self-portraits into three-dimensional masks.

GAVIN, ALAIN (Painter)
9235 Lorel Ave., Skokie, IL 60077

Born: 1948 *Awards:* Clusman Award, Art Institute of Chicago; Best of Show, Color '86, Oak Park, IL *Collections:* Chase Manhattan Bank, NYC; Rahr West Museum, WI *Exhibitions:* Art Institute of Chicago; Jewish Museum, NYC *Education:* Brooklyn College

While his early instructors were concerned with abstract images, he preferred realism and went to study with Philip Pearstein and Leonard Anderson. The organic movement of the former and the precision of the latter helped him develop a rigorous approach to composition, which became evident in his watercolors and oils of draperies. He juggles and fusses over formal

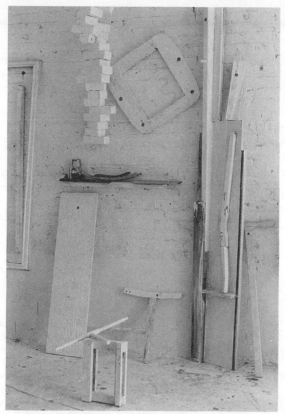

Michel Gamundi, *Still Life (Installation Segment),*
104 x 171 x 75, wood, mixed media

Ray E. George, *7/21/86,* 22 x 30, graphite, charcoal, acrylic on paper

organization, delicacy of placement and spiritual, if not religious, iconography, until the relationship is close to radiating a potential for goodness. His content now involves multiple images and his style wavers between romanticism and hyper-realism.

GEICHMAN, JUDITH (Painter)
1914 N. Milwaukee Ave. Chicago, IL 60647

Born: 1944 *Awards*: NEA Fellowship; Hyde Park Art Center, Chicago *Exhibitions*: Spertus Museum, Chicago; Hyde Park Art Center *Education*: School of the Art Institute of Chicago

Ancient cultures and their spiritual belief systems have influenced the artist. Her early large scale paintings of mandala and labyrinth images were reminiscent of rugs and tapestries; with a bright palette and thick paint application, she used elaborate rhythmic patterns, recalling Byzantine and Islamic ornamentation to refer to the dualities of life. The thought of great angel wings flapping has been the primary inspiration for her present large asymmetrical painting. Sweeping gestures, strong diagonal movements and deep dynamic spaces characterize work that is akin to that of the Willem de Kooning and the futurist painters of the early 1900s. She currently limits her palette to oranges, blacks, and whites.

GENGLER, THOMAS (Painter)
1717 W. North Shore, Chicago, IL 60626

Born: 1957 *Awards*: Merit Award, Union League Club *Collections*: 1st National Bank of Chicago *Exhibitions*: Chicago and Vicinity Exhibition, the Art Institute of Chicago; Contemporary Art Workshop, Chicago *Education*: School of the Art Institute of Chicago *Dealer*: Contemporary Art Workshop, Chicago

His early paintings, which were carefully finished small oils, grew out of classroom figure studies he transformed by substituting invented settings for the studio environment. The figure remains his primary subject; his method has been to paint from a drawing made from life, thus preserving the imprint of his initial sight. The works range from rococo-inspired, elegantly mannered odalisques languishing on beds or by the seaside to canvases of pony-tailed teenage girls posing around the open tailgate of an old red pickup truck. The scale remains small and the figures, clothed or nude, suggest narratives both mundane and mysterious.

GEORGE, DORSEY (Painter, Draughtsperson)
638 W. Arlington Pl., #55, Chicago, IL 60614

Born: 1960 *Awards*: Spectrum Award For Excellence in Drawing, Syracuse, NY; Honorable Mention, Honors Show, Syracuse U., *Exhibitions*: David Adler Cultural Center, Libertyville, IL; Evanston Art Center *Education*: Syracuse U.; School of the Art Institute of Chicago

An abstract artist, he chooses personal images that hold symbolic meaning for the viewer. He camouflages meaning through a layering technique of paint application. His colors are arbitrary and he achieves a particularly "luscious" surface by painting with a mixture of a wax solution and oil paint. There is a graphic quality to the work, and his use of wax allows him to work back into the surface as in drawing. Since the lower layers of his canvases never quite disappear, each of his paintings has a history of its own.

GEORGE, RAY E. (Draughtsperson, Printmaker)
1907 Garling Dr., Bloomington, IL 61701

Born: 1933 *Awards*: NEA Fellowship; Who's Who in American Art *Collections*: Smithsonian Museum, DC; Brooklyn Museum, NYC *Exhibitions*: Peoria Art Guild; Fred Jones Museum, U. of Oklahoma *Education*: U. of Northern Iowa *Dealer*: Printworks, Ltd., Chicago

His abstract prints and drawings are primarily concerned with the development of contradictory space (or the illusion of space), through emphasis on surface qualities. The triangular shapes have slight reference to architectural form and serve primarily as vehicles with which to manipulate pictoral space. Color is a relatively new addition and the artist has yet to determine its importance to the whole. New work is larger, four by five feet, and more involved with color. The drawings are layered, utilizing charcoal, graphite and acrylic. The basic form or structure is architectural and linear. Color works over and under this structure; surface qualities evolve from wash manipulation and are integral to the whole. Work is also done in printmaking media, especially etching and lithography.

GERBERDING, ROGER (Painter)
3925 Pleasant Ave., Minneapolis, MN 55409

Awards: 1st Prize, Municipal Art League of Chicago *Collections*: the Art Institute of Chicago *Exhibitions*: William Engle Gallery, Indianapolis; 1979 Chicago & Vicinity Show *Education*: School of the Art Institute of Chicago; Chicago Academy of Fine Art *Dealer*: Studio View Gallery, Chicago

Beginning as a photorealist, the artist has since progressed to a style incorporating influences such as American film genres of the 1950s and scene painters of the 1930s. Depictions of the lives and dreams of outwardly ordinary people serve as inspiration for the meticulously worked figurative paintings, which frequently take several years to reach completion. Often underpainting in acrylic, the artist then builds the piece layer by layer with glazes in oil. Sketches, life drawing, and copious note-taking provide additional avenues for the development of existing work and of future projects.

GIBBONS, RICHARD A. (Furniture Maker)
2800 Lake Shore Dr., #3202, Chicago, IL

Born: 1950 *Awards*: Roscoe Award; Best Piece of Cabinetry Award, NY *Exhibitions*: Art Expo, Chicago; Gallery 91, NYC *Education*: American Academy, Rome; U. of Notre Dame *Dealer*: Roy Boyd, Chicago

He is a furniture maker/architect with a background in archaeology. Combining these fields, he explores theoretical structures, erosions and excavations. For example, in his early work he has peeled back layers of simple volume, exploring inner structures. Often, he allows contrasting systems of structures to meet and clash within a single piece. His work has progressed to

more complex volumes, which he sometimes shapes like traditional furniture. Surfaces are also important to him, and he often overlays his thin shell-like volumes with sculpting appropriate to the manipulation of solid weighty masses. By locking dual and contrasting systems together the artist is able to heighten the experience of each.

GIDDINGS, ANITA (Painter)
3680 N. Delaware, Indianapolis, IN 46205

Born: 1957 *Awards:* Indianapolis Museum of Art Alliance Gallery Award *Exhibitions:* Coalition of Indianapolis Artists *Education:* Herron School of Art

Her early influences were the Abstract Expressionists and the figurative painters of the 1970s. In 1983 she began to explore the technique of stain painting and using that technique with drawing materials. She now paints in acrylic, oil, and other materials. Her concern is visual weight and form, and she repeatedly paints and draws actual or created images. Her icons are not representational in their physical reality but are rather psychological after-images.

GILBERT AND GEORGE (Photographers)
Art for All, 12 Fournier St., London E1, England

Born: 1943 (Gilbert); 1942 (George) *Collections:* Stedelijk Museum, Amsterdam; Arts Council of Great Britain, London *Exhibitions:* Sonnabend Gallery, New York; Art Institute of Chicago *Education:* Wolkenstein School of Art, Austria; St. Martin's School of Art, London (Gilbert); Oxford School of Art; St. Martin's School of Art, London (George) *Dealer:* MCA

Bringing together the four themes of sexual desire, religious feeling, class and power (each one enough to label a work ambitious) in their pieces, they continue to create challenging work. Photographic images of figures, disembodied heads, pods, and fragments of cathedrals and urban streets are arranged within a grid and connected by overlaying sections of primary colors. Power relationships are suggested through scale. In *Him* (1985), a young man in a provocative stance dominates the scene; at his feet, in miniature, Gilbert and George gaze up in a worshipful attitude. *Worlds* (1985) reverses the balance of power. In this piece, the two, their images laid atop one another, tower over two youths that sit on the sidelines along with the city scenes that are set in medallions behind the artists. As Eleanor Heartney writes of this work, "Writ large, Gilbert and George are transformed from wistful, slightly absurd spectators of the potency of youth into ominous Big Brother figures."

GILCHRIST, JAN SPIVEY (Painter, Commercial Illustrator)
304 Ingleside, Glenwood, IL 60425

Born: 1949 *Awards:* Who's Who in the Midwest; Who's Who of American Women *Collections:* Penn State U., Eastern Illinois U. *Exhibitions:* Del Bello Gallery, Toronto; Isobel Neal Gallery, Chicago *Education:* U. of Northern Iowa *Dealer:* Ward-Nasse, NYC

She has been greatly influenced by the lighting of Caravaggio and the technique of John Singer Sargent. She is concerned with genre settings and depicts family units, such as mother and child, father and child, grandparents and the like. Her work continues to move forward in the same vein, with deep chiaroscuro lighting, direct painterly strokes and narrative images. Along with a continuing interest in lighting and its effect on mood and theme, she adopts a style that is personal, unsentimental, and honest.

GILLIAM, SAM (Painter)
c/o Middendorf/Lane Gallery, 2009 Columbia Rd. N.W., Washington, DC 20010

Born: 1933 *Awards:* Guggenheim Fellowship; Norman Walt Harris Prize, Art Institute of Chicago *Collections:* Museum of African Art, DC; Corcoran Gallery *Exhibitions:* Museum of Modern Art, NYC; Walker Art Center *Education:* U. of Louisville *Dealer:* Middendorf Gallery, DC

Originally from Mississippi, he came to Washington, DC in 1962 to join the second generation of Washington Color Painters. Like the first generation, which included Morris Louis and Kenneth Noland, he has an interest in the qualities of color, applying the medium of acrylic paints onto unprimed canvas. From the mid-1960s acrylics were poured over the canvases to make abstract works. Later canvases were without frames, and by 1968 some canvases were even folded. Bold colors on draped canvases are sometimes displayed as environmental pieces, sometimes as wall pieces. For the past ten years he has made collages in addition to painting.

GILMOR, JANE (Sculptor)
119 17th St. N.E., Cedar Rapids, IA

Born: 1947 *Awards:* NEA Fellowship; Artist in Residence, School of Visual Arts, Cortona, Italy *Collections:* L.A. County Museum of Art; Museum of Contemporary Crafts, NYC *Exhibitions:* N.A.M.E. Gallery, Chicago; A.I.R. Gallery, NYC *Education:* U. of Iowa; School of the Art Institute of Chicago *Dealer:* A.I.R. Gallery, NYC

Her early work showed an interest in both the Chicago Imagists and in "outsider" artists who built Midwestern grottos in the 1930s. The experience of teaching in Greece and Italy brought her into contact with the unusual roadside shrines of the Mediterranean. Now she combines metal repousse with found objects, adding video and photographic documents of tableaux and performances she did in Greece, Italy, New York, and Iowa. In these sculptures and wall reliefs she creates a ritualistic ambience like that of a bizarre roadside shrine. Her interests lie in both the construction and deconstruction of myth as well as in the relationships between myth, experience, and culture.

GILMORE, SHARON M. (Sculptor, Painter)
2141 W. Webster, Chicago, IL 60647

Born: 1948 *Awards:* Illinois Arts Council, Artist Assistance Grant; School of the Art Institute of Chicago Fellowship *Exhibitions:* Redding (CA) Museum; Ft. Wayne (IN) Museum *Education:* Concordia U., Montreal; School of the Art Institute of Chicago

A sculptor working with fibers such as sisil, vinyl, and satin, she bases her structural technique on weaving.

The political influences of the Abakanowicz and the Jacobis and aesthetic influences of Japanese minimalism are apparent in her large-scale reliefs and three-dimensional sculptures. She addresses landscape and the human condition with brilliant colors and extreme textures. She often collaborates, as well, with dancers and performers. On moving to Chicago in 1983, she began using house and body metaphors in her sculpture. She combines found and symbolic/functional objects with wood, steel, and fiber in ways that pose unsettling questions about how one lives in the world in these pieces. She has recently taken up painting and collaging on wood.

GIORGINI, ALDO (Computer Artist)
1137 Berkley Rd., Lafayette, IN 47904

Born: 1934 *Awards:* 1st Prize, International Computer Art Show, Munich, West Germany *Collections:* Basquin Collection, Lebanon, IN; Carnegie-Mellon Art Gallery, Pittsburgh *Exhibitions:* Ukranian Institute of Modern Art, Chicago; Krannert Gallery, Puvolue U., West Lafeyette, IN *Education:* Colorado State U.; Politecnico di Torino, Italy

Having apprenticed with futurist-impressionist painter and sculptor Ambrogio Casati in Italy, his style moved toward abstract composition, using both geometric and organic forms. Working with mixtures of enamel and acrylic, he found controlling accidental occurences a particular challenge. His experience with abstract geometric representations both in black and white and in color has led to extensive experimentation with the aesthetic possibilities of ribbons and bands in black and white. In color he strives to represent abstract objects in lighting conditions that may be either natural or entirely imaginary.

GIOVANOPOULOS, PAUL
c/o Hokin Kaufman Gallery, 210 W. Superior, Chicago, IL 60610

Born: 1939 *Awards:*Chaloner Prize Foundation, NYC; Gold Medal Society of Illustrators *Collections*: Library of Congress, DC; National Museum of Athens, Greece *Exhibitions:*Hokin Gallery, FL; Louis K. Meisel Gallery, NYC *Dealer*Hokin Kaufman, Chicago

He concentrates of serial imagery in a grid format, interpreting a single image in a variety of styles from imagination, the history of art, and media sources. His works have appeared in magazines such as *Time*, *Psychology Today*, and *Fortune*, and his advertising clients include television networks and airline and car companies. In addition, he has taught at the School of Visual Arts, Parsons School of Design and Pratt Institute.

GLENN, DIXIE DOVE (Painter)
2150 N. Lincoln Pkw., Chicago, IL 60614

Born: 1923 *Awards*: 3rd Place, Kansas City, MO Museum; 1st Place, Delta Art Exhibit *Collections*: Jannes Art Publishing, Chicago; Midwest Research Institute, Kansas City, MO *Exhibitions:* National Juried Portrait Show, Natalini Gallery, Chicago; Founders

Gallery, Chicago *Education*: Washburn U., Topeka, KA; U. of Missouri, Columbia *Dealer*: Art Chicago

Because she strives to capture the essence of a subject at a particular time and place, her expressions vary from the realistic to the abstract. She began her career by exploring new watercolor combinations and technologies and by painting with Matisse-influenced colors. During her long career, her subjects have ranged from portraits of people to an abstract series of earth paintings (up to thirty by forty inches) inspired by her own garden. She now paints in subdued purples, sepias, and an ultramarine blue and her surfaces include rice paper, handmade paper, illustration board, gessoed illustration board, and 140-300 pound d'Arches paper.

GOBER, ROBERT (Sculptor)
c/o Paula Cooper, Inc., 155 Wooster St., New York, NY 10012

Born: 1954 *Collections:* Walker Art Center, Minneapolis; private *Exhibitions:* Daniel Weinberg Gallery, Los Angeles; Paula Cooper, New York *Education:* Tyler School of Art; Middlebury College

Continuing the witty and ironic dialogue begun by the Dadaists and Minimalists, for several years he has worked with the form of the sink. Since 1982 he has exhibited a series of sinks constructed from plaster, wood, steel, wire lath, and enamel paint. "The combination of the redundantly pristine shapes of the sinks and their serial arrangement," writes critic Paula Cooper of one of his exhibitions, "produced a curiously effective commentary upon the relationship between Duchamp's strategy employing the 'ready-made' and Morris' and Judd's utilizations of unitary geometricism or seriality to address questions of perception and cognition." Although the sink form is repeated, the degree of structural variation of the sinks varies enough to suggest more than the reductive analytical quality of orthodox minimalism. The forms suggest a variety of associations. To this Cooper remarks, "Having previously aestheticized the inherent qualities of the sink to produce an amalgam of Dadaist and Minimalist strategies, Gober currently seems interested in revealing the degree to which utilitarian objects are personified in our culture, often being presented as an organic counterpart to man."

GODFREY, WINIFRED (Painter)
2647 N. Orchard, Chicago, IL 60614

Born: 1944 *Awards:* 1st Prize, Artists Magazine; Award of Excellence, Chicago Botanic Gardens *Collections:* Schiff, Hardin & Waite, Chicago; Illinois State Museum, Springfield *Exhibitions:* New Horizons in Art, Chicago; Rahr-West Art Museum *Education:* U. of Wisconsin, Madison

Upon completing her formal training, she concentrated on painting the figure as a "piece of pattern" in the rectangle of the canvas. At this time, patterned fabrics and the use of patterns of light became very important in her work. This interest continued, and her most

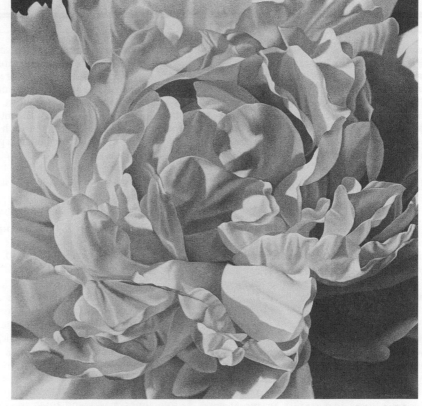

Winifred Godfrey, *White Peony,* 48 x 48, oil on canvas. Courtesy: Mr. & Mrs. Edward Byron Smith

Jeanne Goodman, *untitled,* watercolor

recent work explores patterns of light on transparent objects, with flowers as her primary subject. In *White Tulips*, her use of light creates a transparency in the petals of each flower, so that the shadows cast into the interior of the blossoms are visible through the pale white petals. In these pieces, the surface is very smooth, and the oil paint is applied in thin layers with much blending by hand, providing these photorealistic paintings with a high degree of detail but with what looks to be an airbrush soft-focus effect.

GODELLEI, RUTHANN (Printmaker, Video Artist)
P. O. Box 10225, Minneapolis, MN 55458

Born: 1958 *Awards:* Midwest Regional Film & Video Award, National Endowment for the Arts; American Film Institute and Film in the Cities *Collections:* University of Minnesota, Minneapolis *Exhibitions:* School of the Art Institute of Chicago; Museum of Contemporary Art, Chicago *Education:* U. of Minnesota

Trained in traditional print media of all types, she employs found objects in multiple media for her highly experimental work. For instance, she reuses commercial packaging and other cultural by-products for purposes of commentary; irony and humor play a large role in integrating out-of-context images and text into mass-reproducible print forms. In particular, her recent work has focused on the use of outdated commercial print technologies such as thermography, mimeography, letterpress, and open reel video. Current projects include a life-sized portrait of a motorcycle rendered expressionistically with both drawing and stencils. Her influences include Joseph Beuys and Eva Hesse.

GOLDBLATT, HILARY (Sculptor)
2424 E. Stratford Ct., Shorewood, WI 53211

Born: 1945 *Awards:* Wisconsin Women in the Arts Award *Collections:* Peck Foods Corp. *Exhibitions:* Gilman Gallery, Chicago; Rahr-West Museum, Manitowoc, WI *Education:* Milwaukee Institute of Art & Design

The influence of Henry Moore's work is evident in the early, stylized human figures done in ceramic. Building equipment for her bronze foundry led to the steel and bronze constructions that she continues to create. Reminiscent of the work of David Smith in their construction, the large-scale works are open and airy. Although the pieces have always been painted, a period spent painting on paper and studying the work of abstract painters suggested new possibilities for painting sculpture. Using the steel like a palette, she makes color into a visual element equal in power to the form.

GOLDES, DAVID (Photographer)
1900 Franklin Ave., SE, Minneapolis, MN

Born: 1947 *Awards:* National Endowment for the Arts; Bush Foundation Fellowship *Collections:* Art Institute of Chicago; Walker Art Center *Exhibitions:* Art Institute of Chicago; *Education:* Harvard U. *Dealer:* Thomas Barry Fine Arts, Minneapolis

Earlier work explored various physical phenomena, incorporating simple scientific demonstrations that counterbalanced something less analytical or more playful. He later became fascinated with the heart, creating an entire series that used real animal hearts to depict emotional subjects. These works included hearts bound with rope, confined in a box, or almost touched by an outstretched arm. His current work is a series of precariously balanced objects, such as a hammer on a block of wood supporting milk in a glass jar supporting a large tooth supporting six sheets of matzoh. The lighting is designed to enhance the fragility of the balance, and objects are chosen as a kind of shorthand.

GOLDFARB, KIM H. (Painter, Sculptor)
1514 N. Honore 1R, Chicago, IL 60622

Born: 1951 *Collections:* Deltak Corporation; James P. Productions *Exhibitions:* Neville-Sargent Gallery, Chicago; Klein Gallery, Chicago *Education:* U. of Georgia *Dealer:* Neville-Sargent, Chicago

Both the German Expressionists and English artists, such as Francis Bacon, influenced her early work, resulting in the artist generating large, boldly expressionist, figurative paintings. Later, after acquiring African art and admiring the quality of design, media, color, and freshness of approach, she began working with found wood both two- and three-dimensionally, letting the shape and texture of the object suggest the creating of what she calls "modern fetishes." The pieces, sometimes masks and totem poles or combinations thereof, incorporate hay, burlap, bones, glass, leather, tree roots, and feathers and, in places are painted with acrylics. The subject matter of her current work is tribal people and wild animals in the midst of religious acts and the "spiritual act of living."

GOLDSTEIN, JACK (Painter)
c/o Josh Baer Gallery, 270 Lafayette St., 11th floor, New York, NY 10012

Exhibitions: Josh Baer Gallery, NYC; Metro Pictures, NYC *Dealer:* Josh Baer Gallery, NYC; Karl Boorstein Gallery, Santa Monica

A former performance artist, he turned to producing photorealistic paintings of subjects from nature, such as constellations and snowflakes. Subsequent works were hyper-real compositions resembling lasers. An abstractionist, he often displays images that seem computer-generated or made with laser optics--geometric or biomorphic forms which are often Day-Glo, airbrushed acrylics with metallic paints. Such "new abstractionists," according to one critic, "do not appropriate modern abstraction so much as they simulate it."

GOLUB, LEON ALBERT (Painter)
530 LaGuardia Pl., New York, NY 10012

Born: 1922 *Awards:* Ford Foundation Grant; Guggenheim Fellowship *Collections:* Museum of Modern Art, NYC; Art Institute of Chicago *Exhibitions:* Museum of Contemporary Art, Chicago; Corcoran Gallery of Art, Washington, D.C. *Education:* U. of Chicago; School of the Art Institute of Chicago *Dealer:* Printworks Gallery, Chicago; Rhona Hoffman Gallery, Chicago

Born in Chicago, he earned degrees in art history and studio art in the 1940s, and first gained recognition in

the 1950s as a member of the Chicago "Monster School." He criticized the popular Abstract Expressionists for destroying "the individualist of the Renaissance," and over the years he moved from private images of primitive mystery to work that is factual and highly political. His recent work refers to the mercenaries and political interrogations through which power and control become manifest in the contemporary world. His reputation has grown as the art world, through its recent post-modern enthusiasms and new interest in more expressionist and political art, has caught up with him. His work, as witnessed by his prints and drawings spanning the years from 1947 to the present, traces the development of his early interest in primitive art, the subsequent use of classical art sources in existential depictions, to works that are part of the contemporary social activist scene.

GOMPF, FLOYD (Ceramist)
816 W. 19th, Chicago, IL 60608

Born: 1947 *Awards*: Illinois Arts Council Fellowship *Exhibitions*: Northern Illinois U.; Missouri Gallery, Chicago *Education*: Miami U., OH; Kansas State U.

His first non-traditional, non-functional forms were inspired by California funk. Later, he took the vessel as focus for a series of winged forms, but now his work is completely sculptural. His architectural, monolithic icons have a primitive, ceremonial feel. He makes them with a combination of ceramics, concrete, glass and aluminum.

GONZALES, ELADIO (Painter, Sculptor)
2329 W. Wilson Ave., Chicago, IL 60625

Born: 1937 *Awards:* Cintas Fellowship, NYC; National Council of Cuba Fellowship *Collections*: Institute of International Education, NYC; AT&T, NYC *Exhibitions:* Museum of Modern Art of Latin America, Washington, D.C.; Art Institute of Chicago *Education:* San Alejandro Academy of Fine Arts, Havana; School of the Art Institute of Chicago

Born and raised in Cuba, his vital works reflect the cultural mixture of his Cuban-Afro-Asian background. He celebrates life in an orgy of color, light, and movement. He often conjoins his surrealistic figures and forms in a playfully and joyous tropical sensuality. In a more somber ambience he uses them to intimate the anguish of modern cultural and racial conflicts. His media include bronze sculpture and painting in oil and acrylic. His large-scale canvases are as engaging as his bronze castings. Because of his idealization of living forms, his work has been described as "abstract eroticism."

GOODMAN, NEIL (Sculptor)
1836 S. Halsted, Chicago, IL 60608

Born: 1953 *Exhibitions:* Struve Gallery, Chicago; Art Expo *Education:* Taylor School of Art, Philadelphia *Dealer:* Struve Gallery, Chicago

His lost wax bronze sculpture contains references to still life and landscape. In his early work (1979-1982), he commented on the tension between recognizable objects and the horizontal plane, and was influenced by literature. After 1982 he began to concentrate on the

tension between figure and ground, base and object. As he made this tension more extreme, metaphorical rather than representational aspects of the sculpture began to dominate. The abstract and the representational are both present in his current architectural pieces. His sculptures stand between four and seven feet high and are richly patined in blacks, greens, and browns.

GOODNOUGH, ROBERT ARTHUR (Painter)
38 W. Ninth St., New York, NY 10011

Born: 1917 *Awards:* Garrett Award, Art Institute of Chicago; Purchase Prize, Ford Foundation *Collections:* Guggenheim Museum; Metropolitan Museum, NYC *Exhibitions:* Museum of Modern Art, NYC; Venice Biennial *Education:* Ozenfant School of Art; Hofmann School of Art *Dealer:* Andre Emmerich Gallery, NYC; Tibor de Nagy Gallery, NYC

An artist not easily categorized, he started at an early age with abstract drawings which, without their titles, were indiscernible. He did not pursue an art career seriously until after serving in World War II. Art instruction in New York under Amedee Ozenfant and Hans Hofmann influenced his abstract style. He began to make collages in 1953 and constructed dinosaurs, birds, and human figures the following year. Continuing with painting, he adopted a cubist mode in an attempt "to create a space which is neither recessive nor advancing, but just special relationships on a single plane." In the 1960s and 1970s large forms with smooth edges or small clusters of hard-edged shapes were painted on vast backgrounds of light colors.

GORDON, JUDY (Painter)
807 W. 16th St., Chicago, IL 60608

Born: 1938 *Awards*: Illinois Arts Council Grant; Yaddo Fellowship *Collections*: Kemper Collection; 1st Continental Bank, Chicago *Exhibitions*: Springfield (MO) Art Museum; Frumkin and Struve Gallery, Chicago *Education:* Northwestern U.; School of the Art Institute of Chicago *Dealer:* Struve Gallery, Chicago

In the early 1970s she began developing a series of still lifes with narrative underpinnings. She worked on large-scale paper with heavily-layered, transparent watercolor. In her intensely colored images, she shows the influence of New York still life painters such as Janet Fish and Sandia Freckleton, while maintaining a "Chicago" obsession with magic and surrealism. Her recent works show the result of the artist's fascination with a narrative impulse. Her large gouaches on paper and oil paintings of figures in a landscape show such diverse influences as Della Francesca, Balthus, and Fischel. In these paintings she explores the metaphors behind intimate human interactions.

GORDAN-LUCAS, BONNIE (Commerical Illustrator)
430 E. Kirkwood Ave., Bloomington, IN 47402

Born: 1946 *Awards:* 1st Place, Graphic Excellence, Music Publisher's Association; Winner, National Design Competition, Museum of Science and Industry, Chicago *Collections:* Museum of Science and Industry, Chicago *Education:* School of Visual Arts, New York

Lyrical lines and humorous, imaginative images are trademarks of her unique style. Her illustrations have been reproduced in numerous magazines, textbooks, and greeting cards, and have appeared as advertising art and on record album covers. When she saw that she was successful advertising a product with her paintings, she decided to "promote the individual's personality" by creating custom designs for clothing. She is now exploring the effects of color-enhancing by painting on clothing for men, women, and children of various complexions. The clothing is designed to put the wearer in the spotlight through a subtle combination of colors. Over the years her business has become nationwide; she markets clothing under the labels of "Feet First" and "My Bonnie" wearable art.

GOTO, JOSEPH (Sculptor)
17 Sixth St., Providence, RI 02906

Born: 1920 *Awards:* Guggenheim Fellowship; Palmer Prize, Art Institute of Chicago *Collections:* Art Institute of Chicago; Museum of Modern Art, NYC *Exhibitions:* Allan Frumkin Gallery, Chicago & New York; Art Institute of Chicago *Education:* School of the Art Institute of Chicago; Roosevelt U., Chicago

"Goto's small steel sculptures" writes Donald Judd, "are imitative of the effects of action upon the steel itself and, at a distance, of action upon things in general." Beginning with massive bars and pipes of steel in their crude condition, he fashions complicated and intricately balanced works. The pieces are dynamic both in their movement and surface. Block elements are contrasted with sinuous, organic shapes which seem to emerge from the solid bases; rough cut, roiled surfaces that look like layers of shale or plowed earth create a rough topography between edges and sides that are highly burnished and polished. The result is a monumental feel to a piece that may be only fifteen-inches high. In the last fifteen years, his sense for the monumental went from the suggested to the real as he has been sculpting 15-ton epics that take years to complete.

GOURHAN, PAUL (Commercial Illustrator)
912 17th St., Union City, NJ 07087

Born: 1962 *Exhibitions:* Limelight, Chicago; The Cat Club, New York *Education:* School of Visual Arts

After extensive exploration of media and techniques as a commercial artist, he adopted the "watercolor lift-off" method. After applying a wash and choosing a color to create a particular mood, he removes the paint from the board to create a positive- negative effect; he then goes back in with watercolor, gouache, and colored pencil to give the work texture and form. Current influences include Escher, Mucha, O'Keeffe, N.C. Wyeth, and Patrick Nagel. While he continues to use the watercolor lift-off method, he has incorporated the use of airbrush for certain effects to design and execute a number of illustrations--from landscapes to portraits to fantasy dreamscapes.

GRAETZ, GIDON (Sculptor)

Born: 1929 *Collections:* Ravinia Sculpture Garden, Chicago; Chamber of Commerce for Non Ferrous Metal, Moscow, U.S.S.R. *Exhibitions:* Goldman-Kraft

Gallery, Chicago; World Expo 88, Brisbane, Australia *Education:* Academy of Fine Arts, Florence, Italy; Ecole des Beaux Arts, Paris, France *Dealer:* Goldman-Kraft, Chicago

Characterized by hyper-polished surfaces and graceful hovering forms, his work, writes Amnon Barzel, director of the Museum of Contemporary Art Prato in Florence, Italy, is "attached quite fanatically to two basic concepts: (tangible) perfection and (abstract) sense of beauty." His sweeping forms suggest the movement of wind, the quiver of a wing, or the spiral of a dance--all done in a compact, opaque metal so highly polished it appears transparent. "On the one hand," writes Barzel, "bioconstructional shapes of the sculpture (their concave and convex planes) integrate landscapes or townscapes through their encircled openings into the visual aspect of the sculpture. On the other hand, the mirrored polished metal that reflects the surroundings and colors confuses the eye by a sudden 'melting' into the background." His work becomes more than an object for contemplation. "This mutual adoption of sculpture-environment," concludes Brazel, "poetizes the appearance of the art object in the process of its metamorphosis to a sensitive instrument for perception."

GRAHAME, PETER (Mask Maker)
2245 W. Belden Ave., Chicago, IL 60647

Born: 1945 *Collections:* Pegasus Theatre; American Blues Theatre *Exhibitions:* Natalini Galleries, Chicago; Cain Gallery, Saugatuck, IL

Lacking formal training, he developed his skill as a mask maker through a "knack" for the arts and crafts and through his interest in theater. He began by making masks for friends; when he returned to Chicago in 1985, he created masks for various theatrical productions and as wall sculpture. He counts his influences from every culture and period. Working with a base of plaster of paris gauze cast in a negative life-size mold, he uses acrylics, polymers, found objects, fabrics, feathers, old jewelry, and even sand and coffee grounds to fashion a broad menagerie of masks, from primitive to futuristic, Western to Oriental. His technique continues to develop as he progresses, drawing on the traditions of painting, sculpture, and collage. Seeking to capture an expression of the mystical human spirit, his masks express the dreams and hidden attributes that make up the individual personality.

GRAMS, DIANE (Painter)
1319 Belmont, Chicago, IL 60657

Born: 1957 *Awards:* Ford Foundation; Indiana U. Research Grant *Collections:* Karen Baldner, Chicago; Lee Feldman, Chicago *Exhibitions:* Contemporary Art Workshop, Chicago; Ragdale Arts Colony, Lake Forest, IL *Education:* Indiana U., Bloomington

Always a figurative painter, she cites Roger Tibbits and Robert Barnes as her earliest influences. She began painting primarily for formal concerns, concentrating on traditional subjects with lush applications of paint counterpointing broken surfaces. After a residency at Skowhegan where she worked with Jackie Winsor and

Diane Grams, *Escapes: From the Day They Bombed Libya,* 48 x 48, oil on canvas

William Harroff, *P/I/U/K/Y,* 36 x 50, artist's book

Howardena Pindel, she chose to explore mixed media, widening the content of the paintings to include feminist and conceptual concerns. During this transition, she also began to work in flat applications of color, a technique she currently uses. The surface and edges of her canvas or paper images are the containers for single or multiple human forms, shown in both a private world and sometimes in a society where size represents value to the human spirit. The images may be drawn from photos and newspaper clippings, communicating a sense of historical synthesis between both the medium of their expression and the emotional power of conflicts outside our personal experience.

GRAVES, NANCY STEVENSON (Painter, Sculptor)
69 Wooster St., New York, NY 10012

Born: 1940 *Awards:* Paris Biennale Grant; NEA Fellowship *Collections:* Museum of Modern Art, NYC; Whitney Museum *Exhibitions:* Museum of Modern Art; Venice Biennale *Education:* Vassar College; Yale U. *Dealer:* M. Knoedler, NYC

After studying art in the U.S., she moved to Florence, Italy in 1966. A few years later she moved to New York City where she made hyper-realistic sculptures of camels, camel bones, and camel skeletons. She started making films in 1969, often depicting camels, as in *Izy Boukir*, a short color film. In addition to sculptures and films, she has done many abstract paintings in acrylic and oil, some of which, like *Three by Eight*, feature sketches of camel bones as part of the composition.

GREEN, ARTHUR (Painter)
5 Elizabeth St., Stratford, ON, N5A 421, Canada

Born: 1941 *Awards:* Cassandra Foundation, Chicago; Canada Council for the Arts Bursary *Collections:* Art Institute of Chicago; New Orleans Art Museum *Exhibitions:* PA Academy of the Fine Arts; Whitney Museum *Education:* School of the Art Institute of Chicago *Dealer:* Phyllis Kind Gallery, NYC

Visual ambiguities characterize boldly-colored paintings of this Chicago Imagist. Each work depicts layer upon layer of objects, reflections, and spatial representations which do not completely connect, creating illusionistic puzzles. Work from the 1970s often represents frames, windows, and metal-looking latticework, motifs inviting a voyeuristic view into several levels of perception, as in *Difficult Decisions*. Recent work continues an interest in equivocal images and also suggests collage as he articulates the questions of vision and its interpretation.

GREEN, HARRY (Sculptor)
927 Noyes St., Evanston, IL 60201

Born: 1928 *Collections:* Klutznik Museum, Washington, D.C.; Arthur Andersen & Co. *Exhibitions:* Northwestern U.; Spertus Museum, Chicago *Education:* Kansas City Art Institute

He began his artistic career, not as a sculptor, but in photography for the U.S. Marine Corps. Currently, however, he takes authentic cultural symbols as the focal point of his work, reviving inbred emotions of a traditional Jewish heritage. With a quiet strength, he harmonizes cabalistic symbols, textured replicas of ancient synagogue friezes and stylized reliefs of biblical Jerusalem. His sand-cast sculpture is characterized by wild textures, organic shapes and natural materials. Several corporate logos and private installations feature sculpture by the artist; he is also artist-in-residence at Olin-Sang-Ruby Hebrew Union Institute.

GREENBERG, ELENA (Painter)
2120 W. Concord Pl., Chicago, IL 60647

Born: 1958 *Exhibitions:* NAB Gallery, Chicago; NNWAC, Chicago *Education:* School of the Art Institute of Chicago; U. of Wisconsin, Madison

While paint and pencil are now her chosen media, as a student she worked primarily in three dimensions and in photography. Her early paintings in oil on canvas reveal the influence of Kandinsky and the German Expressionists. During this period, she also enjoyed creating and selling fabric designs influenced by Sonia Delaney. Her interest and research into women artists in history provided inspiration and support for her work, as did her extensive travel in Europe and the Middle East. There she was greatly affected by, among other great marks of the human creative spirit, the cave paintings in France. Currently she paints on paper and masonite. Animals, bridges, boats, water, and architectural references recur as she creates a set of personal symbols in rich colorful surfaces. Facilitating communication and exploring symbolism direct her work as a practicing art psychotherapist.

GREENE, ROGER (Chemographer)
P.O. Box 4451, Chicago, IL 60680

Born: 1946 *Awards:* National Endowment for the Arts *Collections:* Fogg Museum, Harvard University; Brooklyn Museum *Exhibitions:* Neville-Sargent Gallery; Art Institute of Chicago *Education:* U. of Wisconsin *Dealer:* Eva Cohon Gallery, Chicago; Diane Rossetti Riggs, NYC

Employing a process called chemography, he creates visual images as the result of the interaction of chemical elements on a surface. Importantly, the artist does not intervene to alter the resulting image, as these works are records of fundamental process aloof from the will and in search of a universal vision. To transcend the limitations of idea and mind, the artist constructs, not a picture of nature, but a specific place from which nature is to be viewed. The resulting image is therefore untainted by man's subjective interpretations. In this way, these works speak not from the ideal of a man-centered universe but of the power, grandeur, and vision of the universe in which man conceives of himself--wherein he stands not as author or creator, but as witness.

GREGOR, HAROLD L. (Painter)
107 W. Market St., Bloomington, IL 61701

Born: 1929 *Awards:* NEA Fellowship *Collections:* Glenn Janss *Collection:* Rose Art Museum, Brandeis U., Waltham, MA *Exhibitions:* Lakeview Museum of Arts and Science, Peoria, IL *Education:* Ohio State U., Michigan State U. *Dealer:* Richard Gray, Chicago; Tibor De Nagy, NYC

In 1960 he completed his Ph.D. at Ohio State under Hoyt L. Sherman. After a decade of college teaching and painting in California, he moved to Illinois State in Normal, where he began painting realistic farm landscapes and abstract, color-patterned aerial views called "Flatscapes." At the same time, he completed a series of installations using grains and corn meal. He continues to teach at I.S.U. and to paint both farm landscapes and "Flatscapes," using both oil and acrylic. His most recent work is in an elongated panoramic format, up to eighteen feet in length.

GREINER-MEYER, SANDY (Painter, Drawing)
617 S. 23rd, Quincy, IL 62301

Born: 1945 *Collections:* Indian Hills College; Quincy College *Exhibitions:* Midwest Watercolor Society; Illinois Watercolor Society *Dealer:* Prairie House, Springfield, IL

She spent her early childhood in the country and through the 1950s and 1960s she made emotional pencil drawings of nature. After moving to an urban Michigan environment in the late 1960s she made small, tightly-painted scenes of farmlands. In 1978 she studied watercolor under Robert Lee Mejer and has since worked almost exclusively in that medium. Today her watercolors are influenced by Winslow Homer, Charles Demuth, and Andrew Wyeth. Her subject is the play of light on the old objects she finds in interiors and on landscapes. She builds up her paintings with transparent washes of color and her strong contrasts between the lights and darks of complimentary colors make the viewer look into her dark area and wonder what is there. Abstraction has become important in her recent works.

GRESL, GARY JOHN (Assemblage Sculptor)
7662 N. Sherman Blvd., Milwaukee, WI

Born: 1943 *Awards:* Cash Award, Wisconsin Artists' Biennial *Collections:* Rahr-West Museum, Manitowoc, WI; West Bend Gallery of Fine Arts *Exhibitions:* Wisconsin Triennial, Madison; Wisconsin Artists Biennial, Milwaukee *Education:* U. Wisconsin, Madison Dealer: Tera Rouge, Milwaukee

He suggests the complexity of human experience by blending the sophisticated and the naive, the advanced and the primitive, the conscious and the unconscious. In 1983 he returned to art after a long hiatus and began painting abstract and non-objective works in acrylics. In 1986 he returned to the assemblages of found objects he had experimented with in the 1960s. Currently he builds large, wall hung and free-standing sculptural assemblages of animal and modern objects. His long experience with objects as an antiques/collectible dealer helps him choose the antlers, fur and mechanical objects, often painting them with brightly colored acrylics.

GRIGSBY, JAMES (Performance Artist)

"I tip my hat to theatrical convention as a way of seducing the audience into the work," he says . While it's true that many of his works make use story-telling techniques, the narratives he presents are never the linear stories found in conventional theater. He gives us, rather, fragmented sequences with tales and characters that in their sum add up to a story of sorts. In *Mummenkleid*, for example, he presents himself first as an impassioned evangelist raving over the powers of "Rocks from God." Next we hear funny but poignant quotations from the personals in the paper, commentaries on how to maintain a happy marriage, and a recounting of a horrible dream of an open lesion. Trained in music composition and performance, dance, film, video, and sculpture, he exceeds the typically sloppy theatrical technique of most performance artists. He has written his own music, designed and produced his own sets in his exploration of eroticism, alienation, obsessive devotion, and social problems.

GROSS, MARILYN (Painter)
54 Sunset Dr., Streator, IL 61364

Born: 1937 *Awards:* Eileen Zeber Experimental Award, 4th Annual Exhibition of the North Coast Collage Society, Kennedy Gallery, Hiram, OH; Arthur & Alice Baer Competition, Beverly Art Center, Chicago *Collections:* Fort Wayne Museum of Art, Fort Wayne, IN; Shiff, Hardin & Waite, IL *Exhibitions:* Birchwood Farm Estates, Harbor Springs, MI; Engle Lane Gallery, Streator, IL *Education:* St. Louis U., St. Louis, MO; Washington School of Art, Port Washington, NY *Dealer:* Toby Falk, Tucson, AZ

Since childhood, she has been fascinated by the dynamics of color and the moods they evoke, from bold and dramatic to subtle and sensitive. Over the years, her work has become more impressionistic, tending toward abstract naturalism. Her present interests include the exploration of techniques which bring sculptural textures and dimensions to the painted surface by using materials and images that alter the viewer's perception of time and space. She works with paper and mixed media, incorporating weaving, platting, braiding, printmaking, stamping, handmade beads and papers and carved paper into her paintings. The highly textured surfaces of her work make her pieces unique in the world of watercolor painting.

GRUEN, SHIRLEY SCHANEN (Painter)
103 E. Grand Ave., Port Washington, WI

Born: 1923 *Awards:* Purchase Award, Museum of Art, St. Paul, MN *Collections:* Milwaukee Art Commission; West Publishing Company, St. Paul, MN *Exhibitions:* Museum of Art, St. Paul; Salmagundi, Chautauqua, NY *Education:* U. of Wisconsin, Madison *Dealer:* Shirley Schanen Gruen Studio & Gallery, Port Washington, WI

She is a colorist who depicts the quaint world of Port Washington, Wisconsin. The subjects of her painterly canvases include boats, trees, marina and lake scenes and early settlement scenes. In one large, five by four foot mosaic, she uses old pieces of beach glass to create an abstracted beach scene. She paints mostly in acrylic and has been influenced both by Hopper's handling of light and by American Impressionists such as Frank Benson. Currently she achieves a luminous quality by painting with white and pastel acrylics on colored crescent board.

GUNDERSON, MARLA (Fiber Artist)
1635 W. Jarvis, Chicago, IL 60626

Born: 1950 *Awards:* Illinois Arts Council Fellowship Grant, City of Chicago *Collections:* Peat, Marwick & Mitchell; Victor Cassidy Collection *Exhibitions:* Continental Crafts Gallery, Portland, OR; School of the Art Institute of Chicago Gallery *Education:* School of the Art Institute of Chicago; Mankato State U., MN *Dealer:* Ruth Volid Gallery, Chicago

Although she grew up in the wide open expanses of southern Minnesota, her sensibilities are strongly urban. For her earlier pieces she drew specific narratives directly from particular buildings and went through a long process of drawing and painting before executing a piece on the loom. Her vivid colors are inspired both by inner, personal responses and by an interest in historical textiles, specifically African strip weaves. The works are warp-faced twill weaves made predominantly of cotton with some warp painting using fabric paints and dyes. Because of her background as a painter, she sometimes relates her pieces as woven canvases.

GUNN, LORRI (Draughtsperson)
1936 W. Bradley Pl., Chicago, IL 60613

Born: 1942 *Collections:* Ruth Horwich *Exhibitions:* Artemisia Gallery, Chicago; Chicago School of Professional Psychology *Dealer:* Artemisia Gallery, Chicago

Influenced by the Imagists' use of patterns, fantasy forms, and bold color, her colored pencil on paper works of the mid-1960s ranged from cartoon-like "Grotesque Portraiture" to monochromatic symmetrical fantasy faces with optically repetitive patterns. By the early 1980s her work evolved into increasingly abstract symmetrical forms that emphasized movement and ease but at the same time focused on invention and pattern. She continues to work with colored pencil on paper, layering and blending media to create a vibrantly luminous sheen rich with intense color. Her fanciful beings dance, spin, swim, or fly through space in a harmony of line, form, color, and pattern.

GUSTAFSON, JO BARBARA (Sculptor)
9266 Pomeroy Rd., Rockton, IL 61072

Born: 1946 *Awards:* Small Works & All Media Peace Show, Countryside Art Center, Arlington Heights, IL *Collections:* Borg Warner Corporate Collection *Exhibitions:* Eleventh Annual Alice and Arthur Baer Competition & Exhibition, Chicago; Chicago International Art Exposition *Education:* School of the Art Institute of Chicago; Northern Illinois U. *Dealer:* Campanile Capponi Contemporary, Chicago; Contemporary Art Workshop, Chicago

Training in the modeling and casting of figurative works and the influence of Rodin and Henry Moore made the figure a permanent part of her sculpture. Plastic media later gave way to wood and metal, and absract organic shapes developed. At this point, color and texture were added to create surface energy. Her intense interest in the exploration of many diverse media and combinations of these media has led to an extremely broad, varied body of work. The work seeks to express innate and released energy through figurative, abstract, and organic works in wood, lead, steel, copper, marble, bark, hand-cast cardboard, and found objects.

GUTHRIE, GERALD (Sculptor, Printmaker)
207 S. Urbana Ave., Urbana, IL 61801

Born: 1951 *Collections:* Illinois State Museum; Bradley U. *Exhibitions:* Texas Woman's U.; Georgia Southern U. *Education:* U. of Illinois; U. of Wisconsin-Milwaukee *Dealer:* Deson-Saunders Gallery, Chicago

Principal influences on the artist have been the Dada and Surrealist movements as well as the scientific and mechanical ideals of the 1930s in the United States. Since the early 1970s, his work has commented on the absurd trust placed in the power of naive science, a "western magic capable of producing the utopian society." He continues to construct viewer-activated peephole boxes--dioramas--measuring fifteen inches square, housing illuminated and motorized elements which animate miniature, stereotypical interiors. Though the settings are mundane, the actions and movements created highlight suprising idiosyncracies. The artist also works in a variety of printmaking media, and is currently concentrating on a series of figurative drawings of interior spaces using colored pencil.

HAAS, RICHARD (Painter)
81 Greene St., New York, NY 10012

Born: 1936 *Awards:* Guggenheim Fellowship; NEA Grant *Collections:* Museum of Modern Art, NYC; Metropolitan Museum of Art, NYC *Exhibitions:* Whitney Museum of American Art, NYC; Brooklyn Museum *Education:* U. of Wisconsin; U. of Minnesota *Dealer:* Brooke Alexander, NYC; Young Hoffman, Chicago

Realistic murals on the outside walls of buildings in large cities such as New York, Chicago, and Boston, turn blank walls into amazing trompes l'oeil of architectural facades. The artist has also painted interior walls of offices and hotels in recent years, such as *Venetian Facade* at the Hyatt Regency Hotel, Cambridge. A printmaker as well as a muralist, he uses intaglio as his medium. Oils and watercolors also depict architectural scenes in small versions of the subjects of his murals.

HACKIN, CHARLOTTE (Painter, Video Artist)
6966 S. Main St., Rockford, IL

Born: 1919 *Awards:* 1st Place, Arizona State Fair *Exhibitions:* Daley Civic Center, Chicago; Chicago Public Library *Education:* School of the Art Institute of Chicago

Although she has painted worldwide, the beauty and mystery of the American Southwest remains closest to her heart. In 1949 she and her family moved to Arizona and her everyday contact with horses and cattle became her subject matter. She was appointed by Arizona's governor to create what became a highly successful art education program at the Phoenix Zoo. After returning to Chicago in the early 1970s she became Art Director for the Lincoln Park Zoo where she also established a city-wide art program. She continues to make and display her prints and watercolor canvases of Western

subject matter.

HAGGARD, CAROLANN (Sculptor)
P.O. Box 14521, Chicago, IL 60614

Awards: Chicago Bar Association Art Award *Collections:* Robert Wislow, U.S. Equities; Larry Levy, Levy Organization *Exhibitions:* Artemisia Gallery, Chicago; Franklin Square Gallery, Chicago *Education:* School of the Art Institute of Chicago; Accademia di Belle Arti, Carrara, Italy

Spending part of each year in Peitrasanta, Italy, she brings a particular knowledge and experience of ancient architecture, legends and myths, to bear on her sculpture. Working with marble, onyx, and bronze, the pieces are architectural in character and construction, resembling temples, shrines and tombs. Placed on pedestals, these "reconstructed ruins" are theatrical stage sets in miniature. *House of Unfulfilled Promises* encases corroded bronze figures in slabs of marble; the attic contains a burial mound beneath a marker inscribed with the words "God Bless This Happy Home." The pieces are characterized by rough texture, found tones,and hieroglyphic references suggesting ancient cultures. Critic Joyce Hansson remarks, "Although childlike and playful because of their diminutive size, they also contain an adult, grim edge."

HAID, WOODY (Performance Artist)
1420 W. Erie St., Chicago, IL 60622

Born: 1951 *Awards:* Illinois Arts Council Fellowship Grant *Exhibitions:* Mo Ming Dance Center, Chicago; N.A.M.E. Gallery, Chicago *Education:* School of the Art Institute of Chicago

Beginning as a sculptor who drew on his work and a photographer who painted on his images, he attempted a synthesis of different forms but balked at the classification "mixed-media." His need for a witness to his creativity made his categorization even more elusive. "Funny," "dark," "visual theatre," "surreal image events," and "a collection of vignettes in which the work can only be realized after absorbing the total accumulation of image, sound, and action" are all descriptions of his work. "It's an event that takes place because you're there." He is currently abstracting everyday objects into painted sculptural pieces of wood, plastic, metal and wire.

HALL, LANA CORY (Photography)
238 Ridge Ave., Winnetka, IL 60093

Born: 1941 *Exhibitions:* Monroe Gallery, Chicago; Evanston (IL) Art Center *Education:* U. of Wisconsin, Madison

Influenced by Ruth Bernhard and the early abstract painter Arthur Dove, she tries to capture the spirit of an object or situation. Her subject is the grandeur of the apparently ordinary. She transforms the accidents of wind and wave into suggestions of living presences. Her "Point Lobos Series," a group photographs of the natural rock formations occuring along the California coastline, were abstract yet graphic records of small miracles. She accents her color prints with subtle tones and splashes of drama. Her work has appeared in children's, educational, and commercial publications, as well as in numerous magazines.

HALLEY, PETER (Painter)
c/o International With Monument, 111 E. 7th St., New York, NY 10009

Born: 1953 *Exhibitions:* International With Monument, NY; Contemporary Art Center, New Orleans *Education:* Yale U.; U. of New Orleans

"Neo-Geo has become the fashionable style in Soho," writes Mark Stevens of *Time* magazine, "and Halley is one of its leading practitioners." This is an art that is as cool as a post-industrial silicon chip—indeed, Halley's imagery is made up of sharp wire-like lines, images suggestive of battery cells, conduits and computer equipment in fluorescent colors. These are not "realistically" rendered images but, rather, minimalist abstractions. What perhaps is more interesting is that these are images of components of machines (computers) whose work is reproduction, which is an abstraction of a sort. Abstracted images for an abstracted society. Or, as Stevens concludes, "Much as certain artists of the Bauhaus arranged the shapes of an industrial society into abstract art, so Halley hopes to render the electronic tone of postindustrial society....In many ways, life itself is becoming increasingly abstract, so that an "abstract" artist like Halley could almost claim—without sounding too clever by half—to be a realist."

HALLIDAY, NANCY R. (Biological Illustrator)
1003 Forest Ave., Wilmette, IL 60091

Born: 1936 *Awards:* 2nd Prize, Watercolor, National Wildlife Federation, Vienna, VA; Artist-in-Residence, Lake County Forest Preserve District, IL *Collections:* Visual Arts Gallery, Pensacola (FL) Junior College; Hunt Institute for Botanical Documentation, Pittsburgh *Exhibitions:* Smithsonian Institution, Washington, D.C.; Leigh Yawkey Woodson Art Museum, Wausau, WI *Education:* U. of Oklahoma; Art School of The Society of Arts and Crafts, Detroit

She learned Old Master techniques of oil painting under Detroit portraitist Leroy Foster, and was later influenced by internationally-known ornithologist, bird illustrator and watercolorist, Dr. George Miksch Sutton. Her biological illustrations range from detailed scientific pen and ink profiles of new species to paintings of animals and plants for popular magazines or museums. Though she avoids a harsh photographic realism, her soft and subtle works still have an appearance of three-dimensionality. She achieves a luminous quality by building her watercolor or oil colors with thin layers.

HALLMAN, HOLLY (Painter)
218 1/2 Bright St., Jersey City, NJ 07302

Born: 1959 *Awards*: NJ State Council on the Arts Fellowship; Honorable Mention, Bergen Museum of Art *Exhibitions*: Newark Museum of Art; Morris (NJ) Museum of Art *Education*: George Washington U.; U. of Wyoming *Dealer*: Sybil Larney Gallery, Chicago

Her recent canvases reflect past work in sculpture, photography, and painting. She combines the three-dimensional qualities of sculpture with the hard edges of photography and transparent-layering techniques of

painting. The result is colorful multi-media canvases. Although at first bewildering, with prolonged viewing, the weave of her illusion comes together in many different ways.

HANKE-WOODS, JOAN (Painter)
1543 Fargo, Chicago, IL 60626

Born: 1945 *Awards:* Best Amateur Artist, World Science Fiction Society's Hugo Award *Exhibitions:* Capricon VII, Chicago; Windycon XI, Chicago *Education:* North Park College

The strongest childhood influences were the masters of Impressionsism: Monet, Cezanne, and Renoir. Additionally she admired neo-Impressionists, Gaugin, Van Gogh, and Lautrec. Her interest in art carried into college, where she received a degree in fine arts in 1973. In 1976, her drawing and painting expanded as she took on the world of science fiction illustration. Images of other worlds and their denizens occupy her attention. Her efforts have earned her a nomination for the World Science Fiction Society's Hugo award for the Best Amateur Artist award every year since 1980. For the past three years, she has broadened her repertoire of techniques even further, concentrating on graphic design and computer science.

HANNAH, DUNCAN (Painter)
c/o Semaphore Gallery, 137 Green St., New York, NY 10012

Born: 1952 *Collections:* Metropolitan Museum of Art, NYC; Chase Manhattan Bank, NYC *Exhibitions:* Center Gallery, Chicago; Lockette Gallery, Chicago *Education:* Minneapolis College of Art & Design; Parsons School of Design

An artist who achieves diversity in his paintings, he provides any given exhibition with a variety of styles, from a highly rendered realism to an assumed primitivism. While the handling of paint varies, characteristic is a private, secretive quality. In *Love and Rainwater*, which portrays a couple in a wet street, the figures are inaccessible, like a scene from an old movie. *Jump* captures what we take to be the moment after a man has just landed, having committed suicide in an airshaft. The colors are delicate pastels and grays. A painter capable of "pretty" pictures as well (see *October* with its fauvist agricultural landscape), he offers viewers of his work a range of visual challenges.

HANSON, CAROL JEAN (Painter, Printmaker)
5337 N. Damen Ave., Chicago, IL 60625

Born: 1947 *Exhibitions:* Fellowship Competition, School of the Art Institute of Chicago; Standard Oil Building Exhibition *Education:* School of the Art Institute of Chicago; The American Academy of Art

Influenced by the Dutch and Flemish schools, she does portraiture and figurative works using a technique recalling Van Gogh and Vermeer that evokes strong emotional response. She also creates atmospheric watercolors and ink paintings and prints that attempt to "stand still in time" and convey a feeling of transcendence. These works also depict man's awareness of his aloneness in the universe and his disillusionment with the materialistic promises of life. The painting *Benton*

Harbor, Michigan is typical of her watercolor works.

HAOZOUS, BOB (Sculptor)
c/o Prairie Lee Gallery, 301 W. Superior St., Chicago, IL 60610

Born: 1943 *Exhibitions:* Prairie Lee Gallery, Chicago; Rettig y Martinez Gallery, Santa Fe *Education:* Utah State U., Logan, UT; California College of Arts and Crafts, Oakland, *Dealer:* Prairie Lee Gallery, Chicago

With an Indian heritage of Navajo and Apache, he considers himself an Indian artist not for the images he creates (much of what is called Indian art today, he sees as an "illustration of Indian images"), but for "philosophical reasons." It is the power of the natural world which he portrays, a power that is often portrayed as violated. Crafted in painted steel, *Black-hearted Bear* portrays a bear with a black heart ringed by automobiles. Sometimes the message is more subtle, such as his marble buffalo carved in a minimalist style with a bullet hole through it. Unadorned, the hole could be of utilitarian use (a means of carrying the piece) or it could represent the extinction of the great animal.

People, too, populate his work; many pieces speak to the plight of Indian culture. Not all of his images are harsh. In fact, most maintain an ironic humor, achieved either through an ingenious handling of materials or a poetic rendering of image as in *Heartless Woman*, in which a heart-shaped space is cut out of the steel figure's bosom.

HAPAC, DONNA (Painter)
2717 W. Nelson St., Chicago, IL 60618

Born: 1948 *Collections:* WTTW-TV, Chicago *Exhibitions:* Chicago Public Library Cultural Center, Struve Gallery *Education:* U. of Illinois; Northern Illinois U. *Dealer:* Struve Gallery, Chicago

She has produced an extended series of figurative paintings depicting inherently ambiguous situations which emphasize the faces of her subjects. Close cropping, bold compositions and a painterly technique are the artist's means of intensifying the effects of her oil and acrylic paintings and oil pastel drawings. Her objective is to confront the viewer, and to evoke an emotional response.

HARDAWAY, LYDIA (Painter, Sculptor)
2101 S. Michigan Ave., Chicago, IL 60616

Born: 1918 *Awards:* 2nd Place, Palo Alto Art Fair, Palo Alto, CA; Purchase Award, Du Sable Museum, Chicago *Collections:* Carl Hammer Art Gallery, Chicago; South Side Art Center, Chicago *Exhibitions:* Beverly Art Center, Chicago; Du Sable Art Museum, Chicago *Education:* Illinois Circle Campus; Franklin's Fine Art Center

Her early work was self-taught, and though some subjects were taken from the local environs, much of the work came strictly from her imagination. These oils also include portraits and nude figures. After placing second in a Palo Alto art fair, she enrolled in art class and began painting interiors and landscapes, exploring these subjects in bright, vibrant colors. Currently she has expanded her repertoire of technique to include

Natalia Bandura, *untitled,* 34 x 28, acrylic

Vera Berdich, *Die Frau Ohne Schaten,* oil painting & transfer
collage. Courtesy: Art Institute & Print Works

Maureen Bogle, *Indo-Pacific Group,* 20 x 36, vitreous enamel on copper. Courtesy: Mr. J. Brown

Joanne E. Bauman, *untitled #57,* 30 x 40, pencil & prismacolor pencils on prepared paper. Photographer: Michael Tropea

Maryann Bodnar Bartman,*The Red Shawl,* 20 x 12, casein

Mary Chersonsky, *Mexican Woman-Self Portrait,* 24 x 18, oil

Constance C. Bradshaw, *Morning at the Track,* 29 x 38, watercolor

Nancy Carrigan, *The Choreographer Dreams...,* one-half life size, wood, canvas, acrylic. Photographer: Kinographics

Maryrose Carroll, *Cherry & Crate,* 49 x 23 x 20, aluminum

Roy Cartwright, *Flower Form,* 14 x 25 x 13, clay. Photographer: Cal Kowal

Crusing, *Stars & Stripes,* 23 x 30, watercolor collage

Willie L. Carter, *The Magic of Moonlight,* 48 x 39, acrylic

Stephen De Santo, *Sunspot in Ocean City,* 28 x 42, acrylic

Peg Cullen, *Shadow Play,* 26 x 40, watercolor, colored pencil

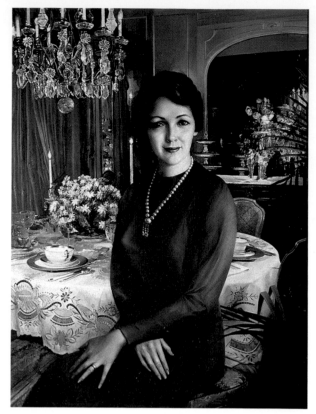

Mohamed Drisi, *Janel,* 45 x 36, oil on canvas. Courtesy: Janel
Lundahl

Grace Cole, *Classical Forms,* 48 x 36, oil. Courtesy: Galleria
Renata

Grace Leslie Dickerson, *Front Street(Hamilton, Bermuda),* 18 x 24, acrylic

J. DeJan, *Les Lavandiéres,* 57 x 43, tapestry

Ken Dixon, *The Feet of the Forest,* 40 x 78, wood, latex, acrylic on canvas

The text within the artwork reads:

once upon a time ... who was dearly loved ... she was always there ... and ... sup ... one ... day ... to ... leave ... was ... devas ... thou ... ght ... had ... gone ... Now ... they ... where ... to ... stren ... gth ... ance ... yet ... time they looked and saw ... other, part and piece ... they found so important

there was a woman ... by all her friends ... for advice, cheer, love ... port ... But ... she ... had ... Every ... one ... tated; ... they ... all ... joy ... from ... life ... had ... no ... turn ... for ... and ... quid ... after ... some ... reflected in each ... of all those things ... and wonderful in her.

Susan Crocker, *untitled,* 16 x 20, cibachrome print

John Edgcomb, *Male Torso,* 84 high, stoneware.
Photographer: Jim Horn. Courtesy: Liz Kinney

Catherine Doll, *Storm Warning,* 72 x 144, oil.

Robert P. Dilworth, *They're coming to get you, Barbara,*
69 x 54, oil on canvas. Courtesy: Isobel Neal Gallery, Ltd.

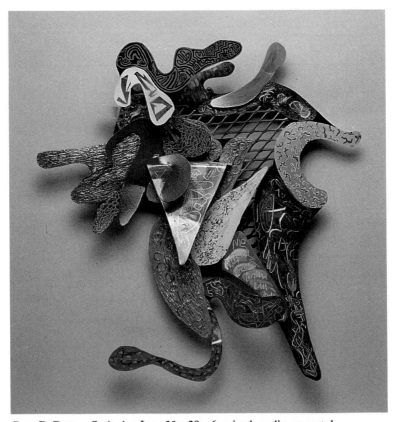

Greg DePauw, *Springing Jazz,* 30 x 28 x 6, mixed media on metal

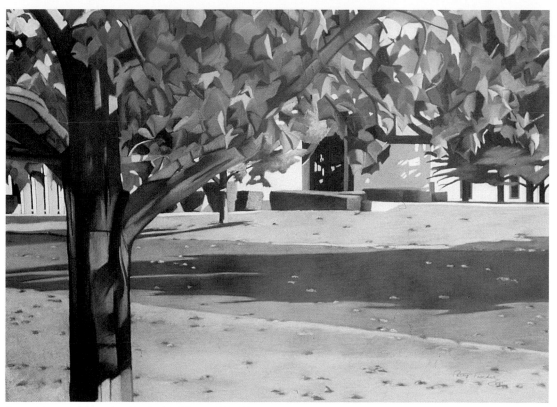

Patty Fischer, *Church with the Red Door,* 24 x 29, pastel

Elisabetta Franchini, *Portofino,* 36 x 48, oil

Bobbe Field, *Bobbe's Zodiac Fantasies,* 6 x 4 each, bronze

Daniel Fabiano, *N.C.S.F. #2,* 61 x 80 x 7(detail), wood, plastic, neon. Courtesy: University of Wisconsin-Stevens Point

Sheila Finnigan, *The Last Supper: Double-Cross,* 72 x 216, oil on masonite panels

James Faust, *The Illusionist,* 44 x 35, acrylic on canvas stretched wood construction

Michel Gamundi, *I: Mommy's Weakness,* 86 x 38 x 16, wood, mixed media

Winifred Godfrey, *Blue Delphinium,* 54 x 30, oil on canvas. Courtesy: Prince Gallery

acrylics and lithographs as she seeks to preserve important historical scenes such as Alcatraz Island and the Golden Gate Bridge. Other subject matter includes scenes of cotton pickers on a plantation, slaves, and the log cabins in which these people lived.

HARDY, CHERRYL (Painter)
710 Applewood Lane, Algonquin, IL 60102

Born: 1952 *Collections:* The Parthenon Museum, Nashville *Exhibitions:* Birmingham Museum of Art; William Engle Gallery, Indianapolis *Education:* U. of Alabama, Birmingham *Dealer:* White House Gallery, Williams Bay, WI

Acrylic paintings are layered with many glazes of different hues over heavily-textured white underpaintings. Some recent works are multiple-layered canvases that are stretched and painted, then cut on a grid, draped back, and tacked down to expose their painted undersides. The rich patinas and geometric compositions often suggest land and mineral formations as well as architectural elements. Influenced by color field and minimal art, the artist has combined sculptural techniques and media and is working on a series of shaped canvasses and abstractions of geometric figures.

HARING, KEITH (Painter)
325 Broome St., New York, NY 10014

Born: 1958 *Exhibitions:* Institute of Contemporary Art, London; Whitney Museum *Education:* School of Visual Arts, NY *Dealer:* Tony Shafrazi Gallery, NYC

A characteristic cartoon-like style creates a flexible visual language which is adaptable to a wide range of subjects and forms. Subway drawings and graffiti paintings are like automatic writings or gestural abstractions. He never plans works; images from the mind move directly to the hand, necessitating a high level of artistic performance. Expressions exist only in the moment, and a delicate balance between ritual and technology is applied as he works with codified signs of the urban fabric. A recent show included images of humans and animals, surrounded by lines of motion implying frenetic energy, drawn directly on the walls and large-scale, playful sculptures made of painted sheet metal.

HARMEL, CAROLE (Photographer)
4522 N. Artesian, Chicago, IL 60625

Born: 1945 *Awards:* Puchase Award, State of Illinois; Illinois Arts Council *Collections:* Kemper Insurance Corporate Collection; Museum of Contemporary Art *Exhibitions:* Art Institute of Chicago; Zolla/Lieberman Gallery, Chicago *Education:* School of the Art Institute of Chicago; Northwestern U.

Influenced by such surrealists as Man Ray, Magritte and Max Ernst, she creates handtoned images which are dream-like tableaux, featuring masked, nude bodies posing in a variety of surreal situations. After completing studies in film, she began doing still work which eventually became more serial in content and expression. Exploring the time element of film using five or six images, her work has begun to include references to the horror genre. The emotional content of her images is enhanced by the use of watercolors and celenium toning. The images portray a sense of high

drama in daily life taken beyond its usual parameters, as is seen in her early series of Halloween portraits and male nudes. As the work has evolved, textures and surfaces have taken on increasing importance, underscoring the eroticism of her female nudes who are devoid of glamour. The "Bird" series, showing women whose faces or bodies are obsured by large feather constructions, is an example of her concern with narrative content and formalism.

HARRIS, ARLENE (Ceramist, Painter)
1660 Old Deerfield Rd., Highland Park, IL 60035

Born: 1937 *Exhibitions:* Susan Blanchard Gallery, NYC; Artemisia Gallery, Chicago *Education:* Barat College, Lake Forest, IL *Dealer:* Mary Bell Galleries, Chicago

Her personal fantasies connect her with history, and she is deeply moved by the concerns and ideas of the men and women of the past. She uses religion and ancient cultural symbols in art that is an exploration of personal relationships. Her media are painting and ceramics. "When my work is on exhibit," she says, "I feel as if I am on stage. An art opening...is both frightening and exciting for me." Although she discovered art at the age of nineteen, shyness and parental disapproval prevented her from pursuing a formal art education until she had reached thirty-two.

HARRIS, DAVID (Painter)
1870 Ralston Av., Belmont, CA 94002

Born: 1948 *Awards:* Who's Who in American Art *Collections:* 1st National Bank of Chicago; National Bank of Detroit *Exhibitions:* Eva Cohon Gallery, Ltd., Chicago; Anderson-O'Brien Gallery, Omaha, NE *Education:* San Francisco State U. *Dealer:* Eva Cohon Gallery

Following his studies with Joan Brown, William Morehouse and Charles Farr, he developed a fluid style of realism that he used particularly in murals. In 1980, influenced by Alexander Nepote, Paul Jenkins and others, he began to work in the direction of expressive color field painters. Thick and thin applications of acrylic are used to achieve texture and transparency of color as part of his exploration of spiritual and psychic impressions of nature and movement. Structure is drawn from his long study of nature and used to support the dualism of experience and contemplation versus the excitement of discovery inherent in his paintings.

HARRISON, JAN (Painter)
3214 Bishop St., Cincinnati, OH 45220

Born: 1944 *Awards:* Ohio Arts Council Independent Artist's Fellowships & New Works Grant *Collections:* Ohio State U. Art Museum *Exhibitions:* The Contemporary Arts Center, Cincinnati; San Jose (CA) Institute of Contemporary Arts *Education:* San Jose (CA) State U.; U. of Georgia

Concerned with the correspondence between human and animal sexuality and between knowledge and innocence, her early influences were pre-Columbian Art, prehistoric cave paintings and early Renaissance painting. Her 1978 "Natural History Series" included oil on canvas paintings of the artist, her animals and her

family. In 1980 she began doing large organic charcoal and pastel paintings involving violence, sexuality, and the dark side of consciousness. "The Serpentine Wall Series" (1982-1986) were large colorful oil-on-gessoed wood paintings of people and animals in metamorphosis. Her current large pastel paintings, "The Expulsion Series," began as nude self-portraits, progressing into more massive, animal-like forms. In addition to painting, she speaks and sings in an original language she calls "Animal Tongue."

HARROFF, WILLIAM (Book Artist)
138 E. Fifth, Roxana, IL 62084

Born: 1953 *Awards:* Best of Class Award, Internationale Sommerakademie für Bildende Kunst, Salzburg, Austria *Collections:* Museum of Contemporary Art, Chicago *Exhibitions:* Center for Book Arts, New York City; Chicago Public Library Cultural Center, Chicago *Education:* Purdue U.; Indiana U. *Dealer:* Towata Gallery, Alton, IL

His early work consists of large, detailed, black & white life drawings created by placing a wide variety of marks into pattterned blocks. A turning point came in 1983 when he was invited to study (and subsequently teach the following two years) at O. Kokoschka's "School of Vision" in Salzburg, Austria. For the first time, words and images were combined together into satirical, photocollage postcard works such as *Gulliver's Travels,* inspired by the artist's research into popular culture and the Vienna Sezessionists. Currently, his work has evolved into an exploration of content and context within the "artists' book" format, asking questions of his audience and himself. Images from rubber stamps, copyright-free sources, life drawings, and words are broken down into smaller components, then recombined into a unified theme. Series such as "Biographies" and "Autobiographies" consist of row after row of human-scale, concertina-shaped postcard sets placed next to each other, fracturing the images and creating new visual associations.

HARTMAN, ARLEEN (Draughtsperson)
3033 Lorain Ave., Cleveland, OH 44113

Born: 1954 *Awards:* Ohio Arts Council Artist-in-Residence; Merit Award, Coca-Cola Bottling Co., Traveling Art Exhibit, Louisville, KY *Exhibitions:* Alleheny College, Meadville, PA; 'The Feminine Image' Traveling Exhibit, Johnstown and Blair Art Museums, PA *Education:* Cleveland State U.; U. of Cincinnati *Dealer:* Printworks, Inc., Chicago; M. Gentile Studios, Cleveland, OH

A feminist artist, she believes there is a connection between her art and her life. Her art speaks of hope for the future beyond the present political misfortune and social turmoil. She draws with graphite powder on huge sheets of paper, using an eraser to highlight images. Flying, spinning, transforming human figures whirl across the paper. She intends her drawings to move people to action. In this way she tries to use her art to restructure society. Over the last three years, she has completed a series of 400 drawings entitled "The Last Great War Between the Males and the Females: World War Four." Although she has described relationships between men and women as war, her drawings do not contain scenes of violence. Rather, they depict the inner struggle of the figures as they cope with their changing relationships. She is currently preparing a book based on this series.

HARTMAN, CAROL (Video Artist)
6478 Harbor Oaks Dr., Johnston, IA 50131

Born: 1948 *Collections:* Kirk Van Orsdale, Des Moines, IA *Exhibitions:* Soho 20, NYC; Art Institute of Chicago *Education:* California State U., Fresno; Montana State U., Bozeman

Sol LeWitt's statements placing the idea above its physical manifestation and George Kubler's discussions of context provide a springboard for her work. Stimulated by Laurie Anderson's forays into electronic and performance art, she constructs installations that utilize computers and other electronic devices to create environments in which the viewer participates in the work and actually is necessary to "complete" it. She explores relationships and the barriers involving thoughts. Viewers are confronted with combinations of images of themselves interacting with computer-generated images. Within this space, she seeks to explore underlying social issues within relationships.

HASENSTEIN, TIMOTHY (Painter)
2432 34th Ave. S., Minneapolis, MN 55406

Born: 1940 *Collections:* Bergstrom-Mahler Museum, Neenah, WI; U. of Wisconsin, Madison *Exhibitions:* Bergstrom-Mahler Museum, Neenah, WI; Ariel Gallery, Chicago *Education:* U. of Wisconsin *Dealer:* Artbanque, Minneapolis

He expresses a visual reality that is an emotional response to his environment. His abstract impressionist paintings are explorations of layered color. Accidents are crucial to him. His color is instinctive and spontaneous. He emotionally scratches and scrapes the surfaces of his large abstract canvases. He scumbles with various sized brushes and palette knives, and uses glazes of tinted stand oil to express a luminous quality or to unite passages of color. The romantic moods of the resulting non-objective works are not unlike the 19th century landscapes of the Americans, Cole, Bierstadt, and Church.

HATCH, MARY (Painting)
6917 Wilson Dr., Kalamazoo, MI 49009

Born: 1935 *Awards:* Michigan Council for the Arts Creative Artist Grant; Charles Horman Memorial Award, NAWA 96th Annual, NY *Collections:* Michigan Art in Public Places, The Upjohn Co. *Exhibitions:* CPL Cultural Center, Chicago; Gruen Gallery, Chicago *Education:* Western Michigan U. *Dealer:* Vorpal Gallery, NYC

Known for her preoccupation with the human figure, her surrealistic paintings depict the tensions of contemporary middle class life. Her early work usually features a solitary figure rendered in primary colors. Gradually, her paintings have become larger and more densely populated. Her palette has changed to deeper colors, particularly red, purple and green. Moving figures sur-

Tom Heflin, *Canadas at Dawn,* 48 x 48, acrylic on canvas. Courtesy:
Mr. & Mrs. Lawrence Gloyd

Lynn Slattery Helmuth, *Guardian Hyenas,* 96 x 72 x 60, burlap,
wood

rounded by tables, chairs, dolls, tulips, birds and other random items, are often engaged in a closed narrative, inaccessible to the casual observer. These works present symbolic relationships rather than real-world depictions of events unfolding according to some type of logic. The action occurs anyplace and anytime in what she calls "our anxious era."

HAY, DICK (Sculptor)
RR #12, Box 148, Brazil, IN 47834

Born: 1942 *Exhibitions:* Martha Schneider Gallery, Chicago *Education:* Ohio U.; New York State College of Ceramics *Dealer:* Martha Schneider Gallery, Chicago; Singature Galleries, Boston

He first gained recognition for his large clay sculptures of familiar objects in fanciful, complex combinations. Over the years, his subjects have expanded, and currently he is experimenting with the female mannequin as a form, placing it in such disparate life situations as that of a Madonna and a backpacker. These clay sculptures stand six to seven feet in height. However, not all of his work is figurative. Included is a series of circular shapes "disguised as platters." *Mega-Plate 1* makes a new addition to the tradition of art that uses the heart shape as a decorative motif. Current drawings are brilliantly colored depictions of unrelated objects--related, that is, only in their relationship to each other on the picture plane.

HAYES, BRENDA SUE (Painter)
157 E. 71st St., Indianapolis, IN 46220

Born: 1941 *Exhibitions*: Arnot Art Museum, Elmira, NY; Indianapolis Museum of Art *Education*: U. of Illinois, Champaign-Urbana; Cranbrook Academy of Art, MI *Dealers*: ArtPhase 1, Chicago; Art Source L.A., Los Angeles

Always known as a colorist, she now makes double sided sculpture-paintings by layering sewn and cut pieces of acrylic soaked canvas. Earlier experiments with acrylic pigment, woven fiber, wall sculpture and deep piled rugs pushed her toward an abstract expressionist style; other influences were Johanne Itten and Joseph and Annie Albers, as seen in the dramatic and very large color studies of space she made during this era. Her wave-shaped forms and compositions are highlighted with special lighting sources and artificial air currents. The deep dramatic existence of color is evident on all her painted surfaces.

HEINECKEN, ROBERT FRIEDLI (Photographer)
U. of California, Dept. of Art, 405 Hilgard Ave., Los Angeles, CA 90024

Born: 1931 *Awards:* NEA Grants *Collections:* Museum of Modern Art, NYC; International Museum of Photography, Rochester, NY *Exhibition*: Witkin Gallery, NYC; Light Gallery, NYC *Education:* U. of California, Los Angeles *Dealer:* Art Institute, Chicago

Founder and head of the photography department at the University of California at Los Angeles and long known for his manipulation of photographic technique, lately he has been producing images that challenge the credibility of what might be defined as "non-fiction"

commercial television. Working with images from ads, news, talk, game and exercise shows, he juxtaposes TV personalities, sometimes stacking images making composites of both male and female newscasters, to produce a commentary on the commentators. Of *Newswomen Corresponding (Faith Daniels/Barbara Walters)*, 1986, Amy Slaton of *Art in America* writes, "we see four pairs of headshots of Daniels and Walters stacked in a column, each showing the two women, who look alike to begin with, but who are here seen with matching facial expressions as well: voiceless and clonelike, they appear to be utterly artificial." Producing crude images, Heinecken functions in a parodistic role, himself a "expert pretending to lack expertise."

HEFLIN, TOM (Painter)
1162 S. Weldon Rd., Rockford, IL 61102

Born: 1934 *Awards:* 1st Prize, National Society of Painters in Casein and Acrylic; Artist Welfare Fund, New York *Collections:* Ellis Island Museum, New York; Rockford Art Museum *Exhibitions:* Art Institute of Chicago; Illinois State Museum, Springfield *Education:* Northeastern Louisiana U.; School of the Art Institute of Chicago *Dealer:* Helfin Gallery, Rockford

Deeply involved in the abstract movement of the late 1950s and 1960s, his subject matter currently is spiritual landscapes. Most work is equally divided between acrylic on canvas and acrylic on crushed paper. The works on canvas are usually large and painted thinly, then sanded with sandpaper. Smaller works involve soaking crushed and crinkled paper in stained water, then painting in diluted acrylics after the paper has been applied to a panel. In addition to exhibiting across the country, he has published the book, *Quiet Places: Paintings and Writings by Tom Helfin*.

HELLMUTH, LYNN SLATTERY (Sculptor)
914 Castle Place, Madison, WI 53703

Born: 1940 *Awards:* Wisconsin Arts Board Grant; Best Sculpture, Beloit and Vicinity Exhibit *Collections:* University of Wisconsin, Eau Claire *Exhibitions:* National Sculpture Conference, Cincinnatti; ARC Gallery *Education:* University of Wisconsin, Madison

Combining a love of nature with a quest for spiritual expression, her work metaphorically expresses a vision of reality. She has developed a technique for stiffening burlap in order to create a series of "dog" sculptures that combine branches and burlap in pieces such as *Guardian Hyenas*. Other work is totemic and/or ceremonial in nature, including *Ring of Power*, a sacred circle of burlap-draped figures that leaves a space open for the viewer to participate by completing the circle. Deepening her exploration of living sculpture, her *Sacred Circle* incorporates living trees and a seating stone to create a meditation space. Her most recent work, *Song of the Wind*, incorporates sound as its medium.

HENDERSON, PAULA (Painter)
1515 W. Howard, Studio 214, Chicago, IL 60626

Born: 1950 *Awards:* Special Assistance Grant for Chicago Public Library Cultural Center Exhibit, Illinois Arts Council *Collections:* American Telephone

Lia Herse, *Washday in Venice,* 21 x 17, watercolor

Eleanor Himmelfarb, *Totem I,* 48 x 60, acrylic

and Telegraph, Atlanta; Clark College, Atlanta *Exhibitions:* Chicago Cultural Center; Monique's, Chicago *Education:* U. of Massachusetts, Amherst

Striving to capture the spirit lying within each of her subjects, she pushes her compositions beyond the notion of portraiture. The animating force behind these works is her simplification of texture and perspective. Enhanced by a delicate palette, her images become lyrical sentiments that express both the artist's and the subject's subliminal selves. She does not seek to portray the sadness or happiness of those she paints; rather, she celebrates the moments in between, when contemplation either combines or removes both emotions. In a series entitled "The Shrine," she explores another interest of hers, landscape. The shrines are composed of objects found randomly on the shore--sticks, stones, feathers--that, when assembled as a shrine, evoke a sense of the mystical. In paintings depicting the shrines, the shrines are "desecrated, lying in ruin," and the shadows are reversed--lights become darks and darks become lights. The ordered elements in the shrine symbolize the balance in the universe, a plea for recognition of that order, and a search for guidance and illumination in creation. The desecration of the shrine symbolizes the loss of purpose and sight that leads to physical and spiritual chaos.

HERMANSON, SARAH JO (Ceramist)
445 Fairview, Elmhurst, IL 60126

Born: 1946 *Collections:* University Museum, Southern Illinois U., Carbondale; Elmhurst Art Museum *Exhibitions:* Downey Museum, CA; Lakeview Museum, Peoria, IL *Education:* Northern Illinois U. *Dealer:* Mindscape, Evanston, IL

Her recurring fascinations are clay edges, cracks, and crevices. Gardens are a recurring theme. Her willowy, swaying forms and lines resemble the subtle niceties of the land and the gentle swellings in the earth around plants. Her clay work is a union of raw edges, earthy textures, slick surfaces, sensuous edges, and often something beaded, opalescent, and even glittering with gold and shimmering with color. Her current series of playfully colorful three-dimensional ceramic wall drawings is evidence of a continuing interest in the human form. The pieces go through multiple firings at 2360 degrees Farenheit, allowing for further manipulations of the surface.

HERNANDEZ, JOHN A. (Painter, Mixed Media Artist)
2823 Live Oak, Dallas, TX 75204

Born: 1952 *Collections:* ARCO, Dallas; Groningen Museum, Groningen, Holland *Exhibitions:* New Museum, NYC; Art Exposition, Chicago *Dealer:* DW Gallery, Dallas; Moody Gallery, Houston

The simplified figures of his early acrylic on canvas paintings show the influence of Pop and Surrealism, specifically Rauschenberg, Dali, and Paschke. He placed figures in landscapes that grew to include patterns, eventually becoming three-dimensional paper collages. Influenced by the Chicago Imagists of the 1960s, he began using illustration board to explore the

third dimension. He introduced images of water, sky, insects, and advertisements and mimicked found objects in the wood of his later reliefs. In his newer wood, acrylic, enamel and mixed media work, he jams various images and objects together, forming a background which subverts his overlaid images.

HERSE, LIA ELISE (Painter)
16601 Fulton Terrace, Tinley Park, IL 60477

Born: 1936 *Awards:* Illustrator Magazine Featured Artist *Collections:* Clipper Ship Gallery, Palos Park, IL; Pine Tree Gallery, Birmingham, AL *Exhibitions:* Balzekas Museum of Art, Chicago; Tolentine Art Center, Park Forest, IL *Education:* University of Venice, Italy; American Academy of Art, Chicago *Dealer:* Clipper Ship Gallery, Palos Park, IL

Executed mostly in gouache and watercolor, her past work was realistic and semi-abstract, rendered geometrically. The human form, landscapes and still-life were her most common subjects. More recently, she has begun to explore acrylic in combination with a transparent and semi-opaque watercolor technique. Working now with botanical and nature subjects, her work is boldly rendered with spontaneous and free strokes reminiscent of John Marin's work. Intending to recreate a mood, greater importance is attached to color distribution, feeling, and contrasts than to realistic rendering.

HERSHEY, BARBARA (Photographer)
726 Lafayette Ave, Cincinnati, OH 45220

Born: 1943 *Awards:* Purchase Award, Cincinnati Bicentennial *Collections:* Cincinnati Art Museum; Cincinnati Bell Collection *Exhibitions:* Cercle Municipal, Luxembourg; Cincinnati Art Museum *Education:* U. of Cincinnati; New York U.

Her early training in art history led her to develop a strong interest in the classical figures and decaying surfaces of Renaissance frescoes and ancient statuary. In her early works she used a "cliche-verre" technique (hand painting on film) to manipulate figures, creating a haunting sense of the past and present entwined in dark surfaces and dramatic gestures. Later she used the same techniques to explore dreams and feelings with images of ethereal figures and surreal or witty juxtapositions. In these large-format works, strong colors and ambivalent spaces are used to illuminate romantic fantasies about both the natural and the man-made world.

HICKS, WILLIAM JAMES (Painter)
4727 North Malden, Chicago, IL 60640

Born: 1927 *Awards:* 1st Prize in Painting and Sculpture; Artist in Residence, 6066 N. Winthrop, Chicago *Exhibitions:* Truman College, Chicago; Artemisia Gallery, Chicago

Always a great landscape lover, he gained a much better insight into the genre while formally studying the processes of transforming nature to flat areas of linear perspective. One of his great enjoyments was to find an out of the way object and to be the first to draw it. It amused him to say "this object was never recorded by anyone but me and God." Later, he was inspired to

change media when he noticed the effect of rain water on cardboard. As the water dried it left tone values ranging from dark brown to light tan on the cardboard. The only way he could achieve this same effect at home was through a mixture of shoe polish and water which is the medium he now works in.

HIGHSTEIN, JENE (Sculptor)
c/o Michael Klein, Inc., 611 Broadway, Room 308, New York, NY 10012

Born: 1942 *Awards:* Guggenheim Fellowship; NEA Fellowship *Exhibitions:* Michael Klein, NYC; La Jolla Museum of Contemporary Art, CA *Education:* U. of Chicago; Royal Academy Schools, London *Dealer:* Michael Klein, Inc., NYC

Sculptures are based upon a minimalism which is infused with symbolism. His attempt in working with a simple, found, minimalist form is seen in *The Single Pipe Piece*, a 39-foot-long pipe suspended between two walls. His sculptures, in such materials as wood and cast bronze, are often poetic and humorous. A recent exhibition at the La Jolla museum was a mid-career retrospective of sculpted works and drawings produced within a thirteen year period.

HILD, NANCY (Painter)
1834 W. North Ave, Chicago, IL 60622

Born: 1948 *Collections:* Standard Oil of Indiana *Exhibitions:* Wutsum Museum, Racine, WI; Hyde Park Art Center, Chicago *Education:* Indiana U.

In her early ceramics, prints, and paintings she exploited the inherent humor and incongruities of the everyday world. Her subjects included metal flake car finishes, gaudy lawn sculpture, interiors of shopping malls, and the graphic perfection of Holstein cows. She has retained her sense of humor but has also moved to a style that is highly formal, richly colored, and literal. She evokes Pop Art in her current highly realistic acrylic treatments of plastic blow-up toys in their unnaturally bright colors. *Four Paws* is a study of folds and textures that recalls Photorealism.

HILL, MARVIN L. (Printmaker)
2935-A N. Weil, Milwaukee, WI 53212

Born: 1952 *Awards:* Rising Paper Co. Award *Collections:* Grinnell College, Grinnell, IA; U. of Dallas, Irving *Exhibitions:* Boston Printmakers; Bradley National, Peoria, IL *Education:* Southern Illinois U; Drake U. *Dealer:* David Barnett Gallery, Milwaukee

Influenced by a host of writers and artists including Red Grooms, Thomas Hart Benton, Henry Miller, and Gabriel Garcia Marquez, he discovered relief prints as an undergraduate and developed a three-dimensional woodcut technique as a graduate student. First, he makes a conventional woodcut or monoprint, then curving and folding it into a three-dimensional form resembling a bas relief. He cites African, Mexican and Chinese sources as inspirations and in his imagery refers to dream episodes, literary scenes, and literary concepts. He is also experimenting with ways of making free-standing sculptural prints.

HIMMELFARB, ELEANOR (Painter)
Box 474, Wheaton, IL 60189

Born: 1910 *Exhibitions:* Jan Cicero Gallery, Chicago; School of the Art Institute of Chicago *Education:* U. of Chicago; *Dealer:* Jan Cicero, Chicago

Her work has always been intimately linked with her environment. In the late 1960s, she worked in a Chicago studio, the surrounding industrial area furnishing material for a dance of flat pattern, influenced in some measure by Matisse. Later, she moved to a woodland studio, and that environment became, and remains, central. But it is her feelings about her subject, rather than its literal context, that she wishes to depict. Bold areas of color emphasize a strong sense of man's relationship to nature. In her work, influenced by Kimura, an enigmatic quality laces through and over shapes, creating a sense of shifting space. Through both her use of color and her philosophy, her work invites the viewer to participate in a poetic dialogue.

HIMMELFARB, JOHN (Painter, Printmaker)
163 N. Humphrey, Oak Park, IL

Born: 1946 *Awards:* NEA & IL Arts Council Fellowships *Exhibitions:* Brooklyn Museum; Evanston (IL) Arts Center *Education:* Harvard *Dealers:* Terry Dintenfass, NYC; Brody's, Washington, D.C.

The subject of his brush and ink on paper work is often the process of mark making itself, though his pieces have become more realistic over time. His abstract backgrounds are far from formal. Snarling dogs and menacing looking giants appear in a swirl of black and white brush strokes. In the monumental *Giants Meeting,* he depicted a giant's face and a fiercely grinning businessman's profile which was about to bite a dog whose teeth were bared for action. His surfaces are large (up to 90 x 138 inches) even in his drawings and monotypes. His monotype, *Underwater Meeting* had a calmer feel about it. The serene giant is composed of brushstrokes resembling floating seaweed.

HINKLEY, ED (Painter)
245 W. North Ave., Studio 216, Chicago, IL 60610

Born: 1946 *Awards:* 1st Prize, Countryside Art Show *Collections:* Fairmont Hotel, Chicago; McDonalds Corporation *Exhibitions:* Artemesia Gallery, Chicago; Grove Street Callery, Evanston, IL

Rooted in the traditions of American Regionalism, works explore the contemporary experience of figures in urban environments. Large format works often feature life-size figures rendered with a multi-layered transparent watercolor technique. Recent works have been darker, back-lit, and increasingly narrative.

HIRSHFIELD, PEARL (Sculptor)
1333 Ridge Ave., Evanston, IL 60201

Awards: Finalist, Alice & Arthur Baer Art Competition; Illinois Arts Council Fellowship Award *Collections:* The Peace Museum, Chicago *Exhibitions:* Klein Gallery, Chicago; Corporate Art Source, Chicago *Education:* School of the Art Institute of Chicago

A former painter, she was strongly influenced by the German Expressionists and by the early work of Leon

Golub, and was a member of his critique group in Chicago from 1953 to 1960. Her paintings gradually became three-dimensional. She has worked on sculptures and installations dealing with social issues and for the past ten years has experimented with water in motion as a sculptural form. External light sources and reflective surfaces are integral components of these works. Other large-scale work incorporates sound and programming with the painted image.

HO, RUYELL (Painter)
5412 N. Magnolia, Chicago, IL 60640

Born: 1936 *Awards:* 1st Place, Painting, Emerald City Classic VI Wichita, KS; Merit Award, ArtQuest '85 *Collections:* Illinois State Museum, Springfield, IL; Oregon State Museum, Portland, OR *Exhibitions:* River North Community Gallery, Northeastern U., Chicago; New Horizons in Art, Chicago *Education:* School of the Art Institute of Chicago *Dealer:* Ariel Gallery, NY

For the past twenty years, he has painted in self-imposed isolation, distant from the contemporary art world. His ambition as an artist goes beyond painting to a search for an original, personal and self-contained aesthetic system. After painting in oil for many years, he has switched to acrylics, primarily because of their fast-drying quality. He works on large, loose canvases, painting a single, central figure in a shallow, artifical space. The images are always well-defined, simplified and devoid of romantic or expressionistic mannerisms. He uses strong, contrasting colors and dominating forms. Seeking to create work with an intense physical presence, he values originality and visual power.

HOBBS, PAMELA (Painter, Photographer)
6165 N. Winthrop, #306, Chicago, IL 60660

Born: 1961 *Awards:* Wiesman Grant *Exhibitions:* Evanston (IL) Art Center; Artemisia Gallery, Chicago *Education:* Columbia College, Chicago; U. of Illinois

In early photographs she pursued form, to the exclusion of content. For example, she combined negatives with bright saturated colors, creating grids of new designs and textures. Later she made hand-colored photographic murals that were explorations of self-portraiture. Her interest in the surrealistic images of Rene Magritte has led her to satirize religion in a series of hand-colored photographic murals entitled, *The Seven Deadly Sins.* She is presently working on a series of watercolor florals in bright, saturated colors.

HOCKNEY, DAVID (Painter, Set Designer)
c/o Andre Emmerich Gallery, 41 E. 57th St., New York, NY 10022

Born: 1937 *Awards:* 1st Prize, International Center of Photography, NYC; Guinness Award, London *Collections:* Museum of Modern Art, NYC; Victoria and Albert Museum *Exhibitions:* Museum of Modern Art, NYC; Palais du Louvre *Education:* Bradford College of Art; Royal College of Art, London *Dealer:* Richard Gray Gallery, Chicago; Andre Emmerich Gallery, NYC

Although this British artist was first identified with late Pop Art, his stylistic tendencies came from Abstract Expressionism. Autobiographical works are known for their irony and humor, and a basic theme is the figure in designs and surroundings which explain character. Acrylic paintings are bright and naturalistic but flattened, with a strong sense of pattern. A versatile artist, he has made photographic collages in which fragments are overlapped to create one image, such as *Desk, London, July 1, 1984.* Other accomplishments include drawings, book illustrations, gouaches, lithographs, etchings, and aquatints. "Hockney Paints the Stage" is a recent showing of paintings, drawings, and displays depicting the various costume and stage designs he has executed for the theater. In 1985 he designed the cover and forty pages of the French edition of *Vogue* magazine.

HOFF, MARGO (Painter, Collage Artist)
c/o Hadler Rodriquez Galleries, 38 E. 57th, New York, NY 10022

Awards: Brower Award, Chicago Art Institute; First Prize, Magnificent Mile Art Festival, Chicago *Collections:* Art Institute of Chicago; Whitney Museum of American Art, NYC *Exhibitions:* Fairweather Hardin Gallery, Chicago; Banfer Gallery, NYC *Education:* School of the Art Institute of Chicago

Creator of paintings, collage, lithographs, sculpture, wood-blocks, theater and tapestry design, and stained glass windows, she has been artistically active for nearly half a century. Each of her works is prompted by some event or visual stimulus that, in most instances, can be discerned by the onlooker. The work is, for the most part, celebratory. Imbued with an artistic intelligence grounded in twentieth-century formal experimentation, the paintings offer a masterful use of bright, hot colors. Working most frequently in a mix of painting and collage with shapes of flat color, she takes perhaps most from Matisse, but the contribution of the Cubists and the major forms of chromatic abstraction from Mondrian to Color Field paintings are evident as well.

HOFFMAN, WILLIAM AUGUST (Sculptor)
1925 North Hudson Ave., Chicago, IL 60614

Born: 1920 *Collections:* St. Mary's College, IN; Roswell, New Mexico Art Museum *Exhibitions:* Nina Owen, Ltd., Chicago; Marmion Military Academy *Education:* School of the Art Institute of Chicago; State U. of New York, Alfred *Dealer:* Nina Owen Ltd., Chicago

Abstract ceramic sculptures evolve out of a process which focuses on the relationship of disparate parts. Gathering together an array of cast-off pieces of clay works–discarded pressed forms, coiled pots, collapsed thrown forms, rolled states and the like–he arranges and rearranges the forms until a completed work emerges. This assemblage process is deeply intuitive. The manipulation of the forms is based upon the dialectic of the relationship of their shapes, in contrast to an approach in which the artist manipulates the shape of his work in the service of a pre-existent idea.

HOFMANN, KAY (Sculptor)
1531 N. Bell, Chicago, IL 60622

Born: 1932 *Awards:* Ryerson Fellowship; 1st Place, National Society of Arts & Letters *Collections:* Borg-

John Himmelfarb, *February Meeting,* 40 x 60, brush & ink. Courtesy: Brooklyn Museum. Photographer: Ruyell Ho

William A. Hoffman, *Ancient Chinese Monument,* 25 high, glazed

Kay Hofmann, *Lake Breeze,* 25 x 15 x 12, Italian alabaster

Warner Corp.; Arthur Anderson Associates *Exhibitions:* Illinois State Museum, Springfield; Rahr-West Museum, Manitowoc, WI *Education:* School of the Art Institute of Chicago: Academia de Grand Chaumiere, Paris *Dealer:* Gilman/Gruen Gallery, Chicago

Her sculptures are always figurative, each a very personal self-portrait/statement. Female figures may emerge from the stone, appearing to be swept up in a windstorm or water current, or wrapped up in "coils of love." Taking some anatomical liberties to heighten the effect, the artist stylizes her pieces in an almost Deco-like fashion. Stone, especially marble and alabaster, is her preferred medium, although she carves in wood as well. Both the carving and polishing are done by hand using traditional methods; finished pieces reflect the artist's concern for fine craftsmanship.

HOGAN, IRMFRIEDE (Painter)
1776 W. Winnemac, Chicago, IL 60640

Born: 1943 *Awards:* Technical Assistance Award, Illinois Arts Council; 1984 M.V. Kohnstamm Prize, 80th Chicago & Vicinity Exhibit, Art Institute of Chicago *Collections:* T&S Flood; R.A. Lopez *Exhibitions:* "Mama & Herealism," Artemesia Gallery, Chicago; Art Institute of Chicago

Current works focus on the uncertainty, insecurity, and anxiety that pervades the spirit of the second half of this century. Images depict human encounters, mythical in quality, often related to the nuclear nightmares of the age. Mainly worked in oil on canvas, the images are manipulated and altered in scale and appear to be afflicted or influenced by situations and powers (superhuman and supernatural), unable to cause or control events. The images are represented literally and, not infrequently, fragmented. *Cosmic Ocean*, a six-panel work, has been an invitational at three major alternative galleries in Chicago.

HOLEN, NORMAN D. (Sculptor)
7332 12th Ave. South, Minneapolis, MN 55423

Born: 1937 *Awards:* Rachel Leah Armour Award, Allied Artists of America, NYC; Joel Meisner Award, National Sculpture Society Exhibition, NYC *Collections:* Richfield, MN; Lutheran Church of St. Philip the Deacon, Plymouth, MN *Exhibitions:* National Gallery, Washington, D.C.; Port of History Museum, Philadelphia *Education:* Concordia College, Moorhead, MN; Iowa State U.

He creates sculpture of abstract forms and realistic shapes. His media include welded steel, cast bronze, and terra cotta. His commissioned works are bas reliefs and three-dimensional metal pieces, but his personal sculptural statements are cast bronze or terra cotta figures. Though some of his figures are conventional, his fascination with the massive Venus of Willendorf and the works of Rubens, Renoir, and Gaston Lachaise is apparent in his sculptures of massive forms and greatly amplified figures.

HOLLAND, TOM (Painter, Sculptor)
227 Tunnel Rd., Berkeley, CA 94705

Born: 1936 *Awards:* NEA Fellowship; Fulbright Grant, Santiago, Chile *Collections:* Museum of Modern Art, NYC; Whitney Museum *Exhibitions:* Museum of Modern Art, NYC; Whitney Museum *Education:* U. of California *Dealer:* James Corcoran Gallery, Santa Monica, CA; Charles Cowles Gallery, NYC

Paintings and sculptures are three-dimensional, bright, geometric works, often in day-glo colors. *Helli*, in epoxy on aluminum, is one of the larger examples of what he calls a painting, even though it is two-sided and free-standing. Layer upon layer is painted and worked, each one referring to the structure of what is underneath, so that these "standup" paintings at times take on an organic quality. The substance of what exists below the surface of matter is explored through this medium. He has also worked in fiberglass.

HOLMES, DIANA DUNCAN (Photographer)
3967 Clifton Ave., Cincinnati, OH 45220

Born: 1945 *Collections:* Cincinnati Art Museum; Museum of Contemporary Art, Chicago *Exhibitions:* Spertus Museum of Judaica, Chicago; Contemporary Art Center, Cincinnati *Education:* U. of Cincinnati *Dealer:* Toni Birckhead Gallery, Cincinnati

Never a "straight" photographer, she also draws, cuts, burns, tears and uses collage to achieve a variety of effects. Using polaroids as a basis for multi-generational images, she distances her work from the viewer. For example, she represents feelings and dreams by rubbing her emulsion with a blunt pencil. In another case, she evokes romantic nostalgia for the late 19th century by making out of focus, faded, blotched sepia prints. Her work is consistently autobiographical. Since 1979 she has collaborated with writer Timothy M. Riordan in a series of limited edition artist books, in which the two address themes of time, space and travel.

HOLZER, JENNY (Mixed Media Artist)
245 Eldridge St., New York, NY 10002

Born: 1950 *Collections:* Whitney Museum; Centre Georges Pompidou, Paris *Exhibitions:* Barbara Gladstone Gallery, NYC; Documenta 7, Kassel, W. Germany *Education:* Ohio State U.; Rhode Island School of Design *Dealer:* Barbara Gladstone Gallery, NYC

Concentrating on public projects, she has made programs for electronic sign boards at Times Square and the Palladium in New York, Ceasar's Palace in Las Vegas, and Dupont Circle in Washington, DC. She writes short messages such as "Protect me from what I want" and "You are caught thinking about killing anyone you want" in order to surprise and shock passersby. Her intent is to create in the viewer a new awareness of inner thoughts. She also does installations for galleries and museums, adding new elements to create unusual spectacles in controlled environments.

HOPPOCK, KAY (Painter)
1429 Sheridan Rd., Wilmette, IL 60091

Born: 1920 *Awards:* Award of Excellence, Old Orchard Art Fest; Award of Excellence, Chicago Botanic Gardens *Collections:* Illinois State Museum, Springfield; Portland (OR) Museum of Art *Exhibitions:* Art Institute of Chicago; Chicago Botanic Gardens *Education:* Art Students League, NYC; Parsons School of

Design, NYC

Primarily a portraitist, she worked in oil and pastel for much of her career. However, after moving to Chicago in the mid-1960s she switched to watercolor and now produces vibrant images of crystal, flowers, and ceramics. Her current paintings, on d'Arches cold-pressed watercolor paper, are enormous for the medium, as large as seventy-two inches square. Beginning with photographs or slides taken from steep angles, she projects and arranges images on her large canvas and makes a first drawing with a pencil. She uses Winsor & Newton and Lefranc et Bourgeois paints.

HORN, ROBERT (Painter)
1433 Wolfram, Chicago, IL 60657

Born: 1947 *Awards:* City Arts Grant, Chicago; Illinois Arts Council Grant *Collections:* Private *Exhibitions:* Museum of Contemporary Art, Chicago; Artemisia, Chicago *Education:* Southern Illinois U., Carbondale *Dealer:* NAB Gallery, Chicago

He has been influenced by Motherwell and Kenzo Okada. While in art school in the early and mid-1960s he painted in a non-objective style. His forms were from landscape and his colors were natural. His shapes eventually developed into figures reminiscent of Nathan Olivera and Rivers. Throughout his development he has relied on traditional painting techniques. His current work was inspired by 17th century Dutch portraiture and the 19th century painters Fantin LaTour and Thomas Eakins. He only works from models. Currently he is interested in combining themes of irony and humor with the Western tradition of portraiture.

HORWICH, JUDITH EISENSTADT (Fine-Art Photographer)
101 Ravinoaks Lane, Highland Park, IL 60035

Awards: Honorable Mention, Color, Fine Art, 15th Annual East Texas International Photographic Exhibition, East Texas State U.; 3rd Place, City of Chicago Photography Award *Exhibitions:* ARC Gallery, Chicago; Art Institute of Chicago *Education:* Illinois Inst. of Technology *Dealer:* ARC Gallery, Chicago

After studying painting for several years, she became fascinated by the expressive possibilities of photography. While photographing a project at the Randolph Street food market, she learned the technical properties of light and how to use light as a creative element. With this knowledge, she moved her work into a studio, creating unconventional lighting and settings while working with food. She composes images with carefully selected backgrounds and often employs feathers, fur, lace, or metal objects to highlight the textures of fruits and vegetables and to convey more specific meanings. Using 4 by 5 and 20 by 24 color formats, variable lighting during printing, and various photographic papers, she expresses in her photographs the need and struggle for food, and the political, social, and economic consequences of variable, undependable food supplies. Her recent work is a metaphorical expression of human joys and struggles, using highly saturated, vibrant images.

HOUGH, WINSTON (Painter)
937 Echo Lane, Glenview, IL

Born: 1928 *Awards:* Huntington Hartford Fellowship *Exhibitions:* Beverly Art Center, Chicago; Gruen Gallery, Chicago *Education:* School of the Art Institute of Chicago; Northeastern Illinois U.

Rejecting most traditional instruction, he finally found support with Paul Weighardt, his teacher at SAIC, who encouraged him in his predisposition to the work of Paul Klee. Attracted to surrealism, though preferring to call it imaginative art, he works from drawings, doodles, and scribbles. His range of media includes watercolor, oil, acrylic, conte stick, and NU-pastels. He continues to experiment with various techniques and applications, such as areas of wash marked over in a fashion reminiscent of abstract expressionist Mark Tobey.

HOUSTON, JOE (Painter)
1504 W. Arthur Ave., Chicago, IL

Born: 1962 *Awards:* Illinois Arts Council Fellowship; John G. Curtis Prize *Collections:* Allen Memorial Art Museum, OH; Richard Baker Collection, NY *Exhibitions:* Contemporary Art Workshop, Chicago; Randolph Street Gallery, Chicago *Education:* School of the Art Institute of Chicago *Dealer:* P.P.O.W. Inc., New York

His paintings from the early 1980s present simple images dislocated from their usual context to provoke a reinterpretation of their meaning. Within stark, contemplative spaces, prosaic objects and anonymous figures become mysterious and metaphoric. The small scale and detailed representation in these works prompt an intimate investigation of the paintings. The technique of oil and gold leaf on panel further enhances the icon-like approach to the subject matter. His recent paintings are still fastidiously executed in oil on wooden panels but are larger in scale and scope. They depict complete views of the contemporary American landscape, revealing how man interacts with his environment. Essentially, they portray the struggle between science and nature. The paintings' romantic approach to the landscape reflects the emotional representation of late 19th-century artists such as Church and Freidrich, while their modern outlook shows a conceptual alliance with the work of contemporaries such as Neil Jenny and Mark Tansey.

HOWE, ROBERT CHARLES (Painter, Construction Artist)
#3 Cottage Ln., Midlothian, IL 60445

Born: 1953 *Exhibitions:* Natalini Gallery, Chicago

From 1972 to 1982, he illustrated human-interest stories, using turn-of-the-century techniques of staging, drawing and painting. In 1983, a diabetic retinopathy caused him to lose his vision, and for three years he ceased working. When, in 1986, he regained sight in one eye, he began addressing the subject of vision/no vision in three-dimensional constructions and oil paintings. His constructions are meant mainly as preliminary work for future paintings and drawings. In his large,

pure color "Reprieve Paintings" of single figures in an environment, he conveys a relief from the subject of blindness and suggests the isolation and waiting his loss of sight occasioned.

HUBBARD CRIBBS, MAUREEN (Painter, Printmaker)
74 Blackhawk Dr., Park Forest, IL 60466

Born: 1927 *Awards:* Community Arts Council of Park Forest Grant *Collections:* Govenors State U. *Exhibitions:* Augsburg College, MN; Northern Indiana Arts Association *Education:* Govenors State U., School of the Art Institute of Chicago *Dealer:* Prism Gallery, Evanston, IL

Early works explored the act of painting, followed by the development of the facility in portraits, landscapes, still lifes and abstraction. By the mid-1970s her work veered in two distinct directions: one representational and figurative, the other abstract. She now works primarily as a landscape painter, representing subjects of a spiritual and personal nature. Strenuously colored oil paint is layered in subtle combinations to create luminous large-scale canvases. Studies are frequently carried out in limited edition woodcuts, etchings and lithographs.

HUDSON, JON BARLOW (Sculptor)
P.O. Box 710, Yellow Springs, OH 45387

Born: 1945 *Awards:* Lush Memorial Fellowship; I.I.E., Professional Development Grant *Collections:* World Expo, Brisbane, Australia *Exhibitions:* Nina Owen Ltd., Chicago; Ruth Volid Gallery, Chicago *Education:* California Institute of the Arts, Valencia; Dayton (OH) Art Institute *Dealer:* Nina Owen Ltd., Chicago; Ruth Volid Gallery, Chicago

Experiences in other cultures are part of his inspiration, and sculpture shows the influences of Michelangelo, Moore, Chillida and Brancusi. A high degree of artistry as well as a concern for form and material characterize his works, whether small- or architectural-sized. *Paradigm*, his 100-foot tall stainless steel tower resembling a DNA molecule, was made for the World Expo in Brisbane, Australia. He based another work, *Fire in the Hole*, a 9,600 square foot mirrorlike octahedron, on his early experience of a goldmine fire. Media include bronze, marble, granite, light, and stainless steel of various treatments.

HUGHES, DOROTHY (Fiber Sculptor)
617 W. Fulton St., Chicago, IL 60606

Born: 1936 *Collections:* Art Institute of Chicago; Indiana State U. *Exhibitions:* Textile Arts Center, Chicago; Art Phase I Gallery, Chicago *Education:* U. of Illinois; Cranbrook Academy of Art *Dealer:* C. Corcoran Gallery, Muskegon, MI

Work from the late 1950s and early 1960s involved both ceramics and textiles. Influenced by her formal training, the pieces were conservative, earthy and reflected a strong Scandanavian aesthetic. Within ten years textiles became her primary focus, and her wovens left the two dimensional format as sculptural directions were explored. The low-relief pieces currently produced are frequently large-scale and influenced by natural elements in their color, shape and feel. Heavy, coarse linen is specially dyed and the many handwoven, shaped elements are interconnected using traditional floor looms.

HULL, RICHARD (Painter)
1242 W. Nelson, Chicago, IL 60657

Born: 1955 *Awards:* Logan Prize, 81st Chicago and Vicinity Show, Art Institute of Chicago *Collections:* Art Institute of Chicago; Museum of Contemporary Art, Chicago *Exhibitions:* Phyllis Kind Gallery, Chicago and New York *Education:* Kansas City Art Institute; Art Institute of Chicago *Dealer:* Phyllis Kind Gallery, Chicago and New York

After receiving his MFA degree from the School of the Art Institute of Chicago, he attracted the attention of Phyllis Kind. Employing a wax ground to serve as a base before applying the paint, he creates a rich surface for his "architectural/landscape" imagery. Impressed with both the technique and content of the paintings, Kind promptly exhibited his work in her galleries in Chicago and New York City. Numerous favorable reviews quickly followed, and his work found its way into many of the cities' most important collections. Ten years later his reputation continues to grow as his work continues to sell not only in Chicago and New York, but across the country with exhibitions in Ohio, Michigan, Wisconsin, Tennessee, California, and Washington D.C.

HUNGERFORD, RICHARD (Paper Artist)
2215 S. Union, #301, Chciago, IL 60616

Born: 1956 *Exhibitions:* Chiaroscuro Gallery, Chicago; Lill St. Studio, Chicago *Education:* U. of Illinois, Champaign-Urbana; U. of Hawaii, Manoa *Dealer:* Alter & Associates, Highland Park, IL

As a student at the University of Hawaii, he was introduced to papermaking. His exposure to the color work of de Kooning and Pollock, the sculpture of David Smith, and the muscial composition of John Cage was equally important, although it was the intensity with which each of these artists pursued their careers that influenced him most. Along with paper works, he created mixed-media installations using various materials. Since completing his degrees in art, he has concentrated on paper compositions. In these pieces, he combines a number of technical skills to create the illusion of visual depth on a flat surface. Freshly formed paper, which is soft and pliable, is his working surface. Thin layers of pigmented paper pulps are applied to the fresh papers. The surface of the paper is then manipulated with water. When dry, the illusion of texture and depth remains in the flat surface.

HUNT, RICHARD HOWARD (Sculptor)
1017 W. Lill Ave., Chicago, IL 60614

Born: 1935 *Collections:* Museum of Modern Art, NYC; Metropolitan Museum of Art *Exhibitions:* Museum of Modern Art, NYC; Art Institute of Chicago *Education:* School of the Art Institute of Chicago *Dealer:* B.C. Holland Gallery, Chicago; Dorsky Gallery, NYC

Although his medium was welded sculpture during studies in Chicago, he also made lithographs. By 1960 he included found objects and car parts and assembled

Winston Hough, *Holiday,* 18 x 24, pastel

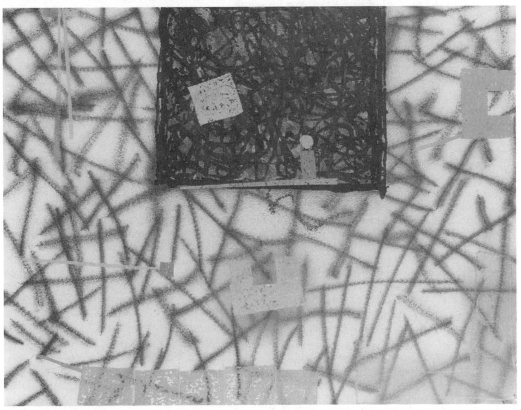

Richard Hungerford, *untitled,* 70 x 86, handmade paper. Courtesy: Alter/Associates, Inc. Photographer: Dennis Sullivan

them into plant-like and insect-like pieces with textured linear extensions. In the late 1960s he constructed "hybrid figures," combining open and closed forms. He cast sculpture in aluminum in addition to welded pieces. Since the 1970s flourishes have been added to the constructions, so that they simultaneously magnify and are magnified by space.

HUNT-WULKOWICZ, SUSAN (Printmaker)
1509 through 1513 W. Fullerton Ave., Chicago, IL 60614

Born: 1944 *Collections:* Art Institute of Chicago; Illinois State Museum, Springfield *Exhibitions:* Art Institute of Chicago; Pratt Graphics International Miniature Print Competition Biennial *Dealer:* Hunt-Wulkowicz Graphics, Chicago

As the creator of painstakingly intricate etchings and lithographs, she takes the viewer into her own imaginary world. Detailed, peaceful farmscapes, nostalgic, cozy interior spaces, and friendly barnyard animals are inspired by personal experiences. In contrast to her years growing up in Chicago, the country has always been a subject of fascination for her. "My country images are my escape to the places where I long to be," she relfects. The titles of her work likewise create this vision, *The Good Earth, The Simple Life, Summer Morning,* and *Wednesday Afternoon* among them.

HUNTER, JENNIFER R. (Painter)
2215 Elm Ridge Dr., Northbrook, IL 60062

Born: 1957 *Awards:* Award of Excellence, Arts for the Parks; Pastel Society of the West Coast *Exhibitions:* Bank of Ravenswood, Chicago; Grand Canyon South Rim Visitor Center *Education:* American Academy of Art, Chicago; Loyola U. of Chicago *Dealer:* Talisman Gallery, Bartlesville, OK; Fraser Corporate Art Programs, Chicago

After receiving a Bachelor's degree in biology in 1980, she began work in research at the University of Chicago. In 1983, the need to be creative led her to the American Academy of Art in Chicago to pursue a career as a fine artist. Her watercolors have been influenced by the works of Andrew Wyeth and Winslow Homer. Favorite subjects include window-lit interiors, fishermen, farmers and their animals, and portraits. Her oil landscape and still life paintings show the technical influence of Richard Schmid. Canvases are traditionally prepared with linen and white lead, the paint applied in alla prima transparent and opaque passages. Combining abstract pattern with a realistic subject, she captures the rugged windswept landscape of Nova Scotia, the simplicity of rural life, and rich arrangements of flowers, dolls, and assorted antiques.

IACCARINO, RALPH RANDALL (Painter)
115 McClellan Blvd., Davenport, IA 52803

Awards: Director's Award, American Artists Professional League, National Exhibition 1987; Special Mention Award, Iowa Watercolor Society *Collections:* Cedar Rapids Museum of Art; State of Iowa Art In State Buildings, Des Moines, IA *Exhibitions:* Evergreen Galleries, Bettendorf, IA; Mes Amis, Rock Island, IL *Dealer:* Ruth Volid, Chicago

His watercolors of the Costa Rican jungle form a core of his *oeuvre* and are a result of over a decade of yearly visits. Travels to Europe resulted in a series of architectural works which emphasize design and pattern. Watercolors range in size from 18 by 24 inches to works of up to six feet square. Whether depicting the encroaching shadows within an interior, the riotous colors and forms of jungle growth, or the intricate play of pattern against pattern in architectural views, all works function as aesthetic meditations that the artist hopes will elevate the human condition on physical, emotional, psychological, and spiritual levels.

INGWERSEN, MARY LOU (Painter)
1218 Cherry St., Winnetka, IL 60093

Awards: Grumbacker Award for Oil Painting; Newcomer Award, 57th St. Art Festival, Chicago *Collections:* McKinsey & Co., Chicago; Montgomery Ward Executive Office, Chicago *Exhibitions:* Art Institute of Chicago; A.R.C. Gallery, Chicago *Education:* Bennington College *Dealer:* Ruth Volid Gallery, Chicago

She creates a personal expression of land, sea and sky, using emotionally charged color, active brush strokes, and large abstract forms. Her style reflects an abstract concern for color and paint application learned from various teachers. In 1972 she went to Paris to study with Fernand Leger and André Lhôte. Then, from 1973 to 1977, she studied under Abbot Pattison at the North Shore Art League, later attending Cranbrook Art Academy in Michigan. From 1975 to 1987, she was represented by the Art Institute of Chicago's Rental and Sales Gallery. In addition, she has been on painting trips to England and France, including Dijon and Provence.

ISENSTEIN, BURTON (Sculptor)
1457 N. Wood St., Chicago, IL 60622

Born: 1955 *Awards:* Artist-in-Residence, Kohler Company, Kohler, WI *Exhibitions:* Smithsonian Institution; Art Expo, Chicago *Education:* Pitzer College; School of the Art Institute of Chicago *Dealer:* Hokin/Kaufman Gallery, Chicago

The natural world is the inspiration for his porcelain work. First concerned with the interdependent relationship of man and his environment, he made sculptures that contained both natural and man-made materials (concrete, soil, leaves). This work soon led to his brightly-colored abstractions of real and imagined creatures. These forms appeared to be part animal and part plant. He presently combines some of the more bizarre features of reptiles, fish, and mammals to create imaginary creatures that may have existed in the evolutionary past or may exist in the evolutionary future. He gives these carved porcelain forms a painterly surface which reinforces their otherworldliness.

ISSACHAR, ESTHER (Painter)
2630 E. 75th St., Chicago, IL 60649

Born: 1949 *Awards:* Merit Award, Museum of Science and Industry, Chicago *Exhibitions:* Black Creativity Exhibit, Chicago; Timbuktu African Flea Market *Education:* School of the Art Institute of Chicago

After gravitating towards expressionistic styles, the art-

ist began to explore the elements of life and passion in the glories and pitfalls of contemporary black women. Working in a variety of media and techniques—pastels on velour, collages of found objects, acrylic on canvas, and murals—she employs a bold, emotional palette and sharp, clean lines. Influenced by her environment, her children, and motherhood, she has been formulating her subjects based on her understanding of Orozco's visions of the repellent and its comments on civilization.

IWANSKI, JOHN (Painter)
7418 W. Myrtle, Chicago, IL 60631

Born: 1960 *Exhibitions:* Prism Gallery, Evanston, IL; Limelight, Chicago *Education:* Triton College, IL *Dealer:* Prism Gallery, Chicago

After being trained formally as an illustrator/designer, he spurned the world of commercial art, taking instead a tentative foray into fine art. By 1983, at any rate, he was painting abstract expressionistic pieces. He is an ardent admirer of Vincent Van Gogh but, determined to go his own way, consciously avoids any artistic influences. He now works on the largest canvases he can fit in the hatchback of his car, using acrylic paint almost exclusively. A secret, unorthodox tool he uses to apply paint to the canvas gives his work an unorthodox appearance.

JACHNA, JOSEPH D. (Photographer)
5707 W. 89th Pl., Oak Lawn, IL 60453

Born: 1935 *Awards:* NEA Fellowship, John Simon Guggenheim Fellowship *Collections:* Museum of Modern Art; Art Institute of Chicago *Exhibitions:* Art Institute of Chicago; Focus Gallery, San Francisco *Education:* Illinois Institute of Technology *Dealer:* Edwynn Houk, Chicago

At the Illinois Institute of Technology's Institute of Design he was influenced by Harry Callahan, Aaron Sikind, Edward Weston, and Frederick Sommers. In his relentless pursuit of another reality within our own, he makes landscape photos that are mysterious, enigmatic, and even chilling. He is primarily concerned with the land, and his early tightly controlled, sharp focus images of rocks, water, and landscape are often self-referential. They might contain such an image as the artist's own hand, holding a mirror. In his recent "low-fidelity photography" he uses soft edges and strange lighting effects to achieve the simplicity of marking found in his images of Michigan and Iceland.

JACKSON, FRIEDA B. (Painter, Scratchboard Artist)
4407 Brown St., Davenport, IA 52806

Born: 1914 *Collections:* Bluegrass Savings Bank *Exhibitions:* Quad Cities (IA) Regional Art Showcase; Mississippi Corridor Show

Her early oil portraits are characterized by a strong sense of design, realistic manner, and an impressionist use of color. In the 1970s she explored acrylics, pastels, and scratchboard media but, beginning in 1980, gradually shifted from oils to watercolors, although continuing to work with scratchboard. She expresses feelings about places she has been in her watercolors.

Many of them are of Mississippi bridges, architecture, and other scenery. She uses scratchboard to portray crowds, animals, and birds. She conveys the mood and action of her characters in narrative scenes.

JAFFEE, BARBARA (Painter)
1747 N. Honore St., Chicago, IL 60622

Born: 1960 *Awards:* Arts Midwest/NEA Fellowship; Illinois Arts Council Grant *Collections:* Kroger Corp. *Exhibitions:* Artemisia Gallery, Chicago; MoMing Dance and Arts Center, Chicago *Education:* School of the Art Institute of Chicago

Tracing her search for a balance between abstraction and figuration to the traditions of early modernism and cubism, she uses material and painterly issues as a vehicle for exploring the nature of representation. Her sources are organic form, architecture, technical illustration and still life. She paints in a rich blend of luminous washes and bolder opaque brush strokes, depicting common objects that solidify, only to fade, ghostlike, from view. Techniques of arrangement and collage group her sculpturally constructed, large-scale oil paintings, juxtaposing styles, techniques and ultimately, views of "physical" and "representational" reality.

JAHNKE, VIOLETTE (Painter)
W65N 727 St. John Ave., Cedarburg, WI 53012

Born: 1922 *Awards:* Purchase Award, West Publishing, St. Paul, MN *Collections:* West Publishing, Minneapolis; Miller Brewery, Milwaukee *Exhibitions:* Oklahoma Art Center; Wustum Art Museum, Racine, WI *Education:* U. of Wisconsin, Milwaukee *Dealer:* Fanny Garver Gallery, Madison, WI

In her earlier representational watercolors she explored various techniques including "wet-into-wet," and combinations of watercolor, India ink, wax resist, and litho crayon. She eventually began to tire of the watercolor medium and returned to school to earn a master's degree. While in graduate school, she moved away from the purely representational, became interested in a sense of light, and studied how the whiteness of the paper could express light. She began painting objects which she recontextualized and juxtaposed in uncommon ways. Some viewers have referred to her paintings as watercolor collages.

JAHNS, LUCY A. (Fiber Artist)
333 3rd St., Libertyville, IL 60048

Born: 1958 *Awards:* 3rd Place, Stitchery International, Pittsburgh; Honorable Mention, Fiber Directions, Rosary College, River Forest, IL *Collections:* U. of Chicago; 300 S. Wacker Dr., Chicago *Exhibitions:* David Adler Cultural Center, Libertyville, IL; Paper/Fiber, Iowa City *Education:* Northern Illinois U., Dekalb

She places traditional fiber techniques in the service of a modern sensibility. Each of her contemporary abstract tapestries is a "fabric drawing." First she dyes and manipulates the fabric. Then using her sewing machine like a drawing utencil, she builds up surfaces with lines, dots, and marks. By working with color, pattern, and surface decoration she heightens the visual

experience beyond that of the traditional craft. The effect is a surface rich in decoration and visual stimulation.

JAVANCIE, BILLIE F. (Sculptor)
21 Tophill Lane, Springfield, IL 62704

Born: 1938 *Exhibitions:* Atlas Galleries, Chicago *Education:* Sangamon State U., Springfield, IL

Influenced by Hepworth and Arp, her first pieces were poured bronze and aluminum. After studying at Sangamon State University, where she learned the lost-wax process, she became more interested in polychrome metals. This interest further expanded when she traveled throughout the world, seeing some of the great works of modern art. Her current work is most profoundly influenced by Alexander Calder and his use of bright colors, though she has not forsaken her earlier sensitivity to negative space. In her present media she is self-taught, working in polychrome aluminum, bronze, copper, and wood. The pieces are brightly colored, often featuring a ball or balls; their primary directive is Calder's desire to "make things that are fun to look at."

JAMES, TOM (Painter)
1035 Wesley, Evanston, IL 60202

Born: 1950 *Collections*: Blount Inc., Montgomery, AL; Peat, Marwick, & Mitchell *Exhibitions*: Union League Club, Chicago; New Horizons, Chicago *Education*: U. of Wisconsin

His early work, ominous but bright and hard-edged acrylic paintings incorporates allegorical streamlined trains, "night angels," and landscapes of icebergs and earth chasms. Currently, images of the industrial landscapes of Chicago dominate his paintings. Beginning with photographs of factories, boilers, transformers and the like he uses enamels and oils on metal sheets to paint metaphors for Chicago's vanishing legacy of growth. These works also serve a documentary purpose, in that many of the buildings have been razed.

JEFFERSON, DAVID (Mixed-Media Artist)
6681 N. Olympia, Chicago, IL 60631

Born: 1963 *Exhibitions:* Art Rage Galleries, Chicago; Prism Gallery, Evanston, IL *Education:* Augustana College

Influenced by the Fauves and the German painters of the early 20th century, he explored Expressionism during his undergraduate years. After leaving school, this work evolved first into a brightly-colored style of non-objective painting and then into a latex splatter style reminiscent of Jackson Pollock. His desire to do more led him to study the Dada philosophy of Marcel Duchamp and to create assemblage sculpture. Now inspired by Rauschenberg and Johns, he elevates the common object to art. His planed, wrapped, nailed, and broken windows are meant to be looked at, not looked through.

JENKINS, PAUL (Painter)
831 Broadway, New York NY 10003

Born: 1923 *Awards:* Officier des Arts et Lettres Award, France; Commandeur Arts et Lettres, France *Collec-*

tions: Museum of Modern Art; Whitney Museum of American Art *Exhibitions:* Art Institute of Chicago; Whitney Museum of American Art *Education:* Kansas City Art Institute; Art Students League *Dealer:* Gimpel and Weitzenhoffer Gallery, NYC; Karl Flinker Gallery, Paris

Work of the late 1940s and early 1950s was influenced by Yasuo Kuniyoshi. However, in 1955, he destroyed all previous work and began anew, determined not to be swayed by the Abstract Expressionists; he wanted to portray a spiritual, rather than a kinetic abstraction. An interest in mysticism and in Symbolist painters such as Gustav Moreau and Odilon Redon brought him to the understanding, as he states it: "I paint what God is to me." Acrylics, oils and other synthetic paints were poured onto the canvas in different thicknesses, laced with thin linear spills. During the 1960s work became increasingly rich in texture, affected by mood and time. Recent large canvases are moved in order to guide the flow of the pigments, leaving the paths of their ebb and flow, as in *Phenomena Track the Wind*. The addition of vivid watercolors has brought a spectrum-like quality to his work.

JEROSKI, ANTHONY J. (Sculptor)
P.O. Box 576, Muncie IN 47308

Born: 1948 *Awards:* Grand Prize, Objects and Crafts '71, Indianapolis Museum of Art; Grand Prize, 1979 Indiana Ceramics Exhibit, DePauw University *Exhibitions:* 1980 Mariette College Crafts National; Emens Auditorium, Muncie, IN *Education:* Ball State U.

Until 1981, the artist was involved in creating smaller-scale sculptural forms, incorporating materials such as clay, metal, plexigalss, wood, and neon. The pieces illustrate intricately patterned surfaces, achieved through a variety of techniques, including glaze firings, gold gilding, inlaid precious and non-precious metals, and sandblasted and inlaid plexiglass. For the past seven years, he has been working on a single, monumental piece, *Botanical Panorama*, incorporating the same materials and techniques found in his smaller pieces. The panorama, measuring 18 by 10 by 10 feet, features an ornately carved bird set in an environment of lustrous tiles, neon lighting, and filigreed tree forms.

JOHNS, JASPER (Painter)
225 E. Houston St., New York, NY 10002

Born: 1930 *Collections:* Museum of Modern Art, NYC; Whitney Museum *Exhibitions:* Museum of Modern Art, NYC; Art Institute of Chicago *Education:* U. of South Carolina *Dealer:* Leo Castelli Gallery, NYC

In a reaction against Abstract Expressionism, his first solo show in 1958 included paintings of targets, flags, numerals, and alphabets. Everyday objects were the subjects, focusing attention not on the objects themselves but on the act of painting. An encaustic painting method turned ordinary images into thought-provoking works which pointed to the ambiguity of object and image. A constant questioning of the nature of art led him to the utilization of actual objects. Cast in bronze were the likenesses of beer cans, flashlights and light bulbs; real objects were additionally affixed directly to

Jennifer R. Hunter, *Peter,* 18 x 13, watercolor

Anna Johnson, *Sky Beam,* diptych, 40 x 52, acrylic & gesso on paper. Courtesy: Deborah & Leonard Fabisiak

the paintings. Known for visual puns and contradictions, he has been compared to Marcel Duchamp. Unlike Duchamp, he has not renounced painting but has continued to question the ways of seeing.

JOHNSON, ANNA (Painter)
4518 N. Greenview 2A, Chicago, IL 60640

Awards: Best of Show, Scottsdale Artists League; Citation for Excellence, U. of Illinois *Collections:* Valley National Bank, Phoenix; Miller, Shakman, Nathan, & Hamilton, Chicago *Exhibitions:* Scottsdale, Arizona Artists League; Art Rental and Sales Gallery, Art Institute of Chicago *Education:* Kalamazoo College; U. of Illinois, Chicago

Early training included the study of color relationships as taught by Johannes Von Gumppenberg. She has also been influenced by the study of color, shape, and pattern in art and architecture throughout history and in different cultures. Her early pieces, done predominantly in oil on canvas, chose forms in nature as their subject and tend toward realism. Current paintings, executed on paper, deal with chaos and order as expressed through the clash of natural and cultural forms, the cultural forms represented by architectural details and structures. he paintings contain numerous suggestions--temples and mountains, pyramids and rooftops, columns, entryways, windows, scrollwork. Some evoke ancient vistas behind the array of structural barriers.

JOHNSON, TEDDY L. (Draughtsperson)
1515 Cedar, Galesburg, IL 61401

Born: 1958 *Exhibitions:* Cain Gallery, Oak Park, IL

As a child he loved to watch his father sketch, and until 1983 he drew only as a hobby. An electrician by trade, in 1983 he began drawing seriously during his free time. He showed his first original pieces at the local division of "The Town and County Amateur Art Show" and there won a blue ribbon. Within four years he was showing professionally. He draws in pastels because of their richness in color and velvety appearance. Impressive for his detail, his works blend colors to achieve a watercolor effect or employ dots, dashes, and line to give the impression of oils. He views his artistic ability as a gift from God, but even though many of his pictures reflect God's presence, he does not force religious imagery on the viewer.

JOLLY, MARVA LEE PITCHFORD (Ceramist)
9600 S. Merrion, Chicago, IL 60617

Born: 1937 *Awards:* Top Ten Emerging Black Artists; 1st Place, Black Creativity *Collections:* Hilton Hotel and Towers; Linda Johnson Rice *Exhibitions:* Esther Saks Gallery; Chicago Cultural Center *Dealer:* Esther Saks Gallery, Chicago

A ceramist, she was initially drawn to clay because of its immediate expressive character. Focusing on vessels, her earlier work was heavily influenced by African handbuilding techniques, the textural effects of which are underscored by her use of earth tones and blue underglazes that provide muted backgrounds for her figures. Ranging from stick figures to abstaction, her personal style communicates and depicts the energy of

the black people in the Mississippi cotton fields where she grew up. Her background as a social activist provides further exploration of the beauty and pain of the urban black experience.

JONES, BRENT (Photographer)
9121 S. Merrill Ave., Chicago, IL 60617

Born: 1946 *Awards:* Representative to World Black and African Festival of Arts and Culture *Collections:* Exchange National Bank; Columbia College, Chicago *Exhibitions:* DuSable Museum, Chicago; FESTAC, Lagos, Nigeria

He is a photojournalist who works in black and white as well as in color. His instructors included Archie Lieberman, W. Eugene Smith, Ernst Haas, and Roy DeCarava. He has written and photographed stories for the *Chicago Tribune, USA Today, Black Enterprise, Time, Newsweek,* and *Ebony.* His industrial clients include AT&T, British Airways, Illinois Bell, World Book Encyclopedia, and Hill and Knowlton. He has provided photo-illustrations for five children's books: *I Love My Grandma, The Babysitter, Basketball Basics, We Can't Afford It,* and *I Know You Cheated.*

JONES, CALVIN (Painter, Illustrator)
c/o Isobel Neal Gallery 200 W. Superior, Chicago, IL 60610

Born: 1934 *Awards:* National Conference of Artisits 1st "Aaron Douglas Award", Third World Press "Builder's Award" *Collection:* Campbell Elementary School, Detroit; Oprah Winfrey *Exhibitions:* AFAM Gallery and Cultural Center; Museum of Science and Industry, Chicago *Education:* School of the Art Institute of Chicago

His illustrative drawings, character studies, and abstract forms seem to leap from the depths of the black cultural consciousness. In his "Pan African Drawing Series," he depicted the living situations of Jamaicans, rural black Americans, and Africans themselves. Coca-Cola commissioned him to portray Black American heroes and Motorola commissioned him to paint five prominent moments in its history. In 1979 he found his eyes were severely damaged by a muscle disease. Rather than give up painting, he turned to the mural. In 1985 he underwent a cornea replacement surgery which restored eyesight. Earlier, he was a commercial artist and he been Senior Art Director for Hallmark, CNA Insurance, and Vince Cullers Advertising.

JOSEPH, RENÉ MICHELE (Painter)
719 S. 10th St., Minneapolis, MN 55404

Born: 1958 *Collections:* Brenau College; University of Minnesota Art Museum, Mr. & Mrs. Simonson *Exhibitions:* The Architecture Gallery, Chicago; David Adler Cultural Center, Libertyville, IL *Education:* U. of Minnesota; Film in the Cities, St. Paul, MN

Early paintings are large-scale oils combined with encaustic, as she took her influence from Abstract Expressionism. In the mid-1980s, she began working with shaped murals, canvas, and drawings. These images are influenced by the clothing designs of Sonia Delaunay. Over time the content and treatment of the work

Teddy L. Johnson, *The Fountain,* 18 x 10, pastel

Kaycee, *Sojourner,* 35 x 45, ink and pastel drawing

evolved further. Earlier paintings are typically abstract landscapes and portraits done in straight primary and secondary colors. Today she paints surealistic portraits of people holding something, thereby combining elements of portraiture and still life. While she still does not mix colors on the palette, she does layer them on the canvas. By doing so she calls on the viewer to optically complete the painting.

JOSEPHSON, KENNETH (Photographer)
S.I.A.C. Photography Dept., Columbus Dr. and Jackson Blvd., Chicago, IL 60603

Born: 1932 *Awards:* NEA & Guggenheim Fellowships *Collections:* Museum of Modern Art; Bibliotheque National, Paris *Exhibitions:* Museum of Contemporary Art, Chicago; Art Institute of Chicago *Education:* Rochester Institute of Technology; Institute of Design, Chicago *Dealer:* Rhona Hoffman Gallery, Chicago

After studying under Minor White and others at the Rochester Institute of Technology, he spent a year making photographs for Chrysler. The misleading surfaces and sense of unreality he found in the "real world" led him to question the photographic illusion. First gaining recognition with pictures that included the photographer as subject matter, his current humorous and deeply referential work turns on the difference between the photographic illusion and the perception of reality. His ongoing "History of Photography Series" is a series of critical and philosophic visual essays reinterpreting important 19th century photographs. He has also incorporated photographs in collage and assemblages.

JOYCE, ALICE (Sculptor)
1208 W. Newport, Chicago, IL 60657

Born: 1946 *Awards:* Illinois Arts Council Chairman's Grant; Chicago Council of Fine Arts NAP Grant *Collections:* Vernon Area Library; Private *Exhibitions:* Rockford Art Museum; IL State Museum *Education:* Avery U.; San Francisco State U.

She began her career by casting organic forms and juxtaposing them with a geometric framework of steel. After traveling to the Mayan sites in the Yucatan Peninsula, she began incorporating dwelling forms that were suggestive of archetypal structures. Her sculptures of the era seem to be relics of a personal archaeology. She presently deals with gesture on a scale refering to the figure. Her forms are often shell-like vestiges, or volumetric yet shallow constructions. Pieces of steel penetrate and pierce the work even as they support it. In a reverse archaeology of materials she builds her surfaces by layering plaster, wax, steel, oil paint, modeling paste, and fiberglass resin.

JUDD, DONALD (Sculptor)
P.O. Box 218, Marfa, TX 79843

Born: 1928 *Awards:* Brandeis University Medal for Sculpture; Skowhegan Medal for Sculpture *Collections:* Museum of Modern Art, NYC; Whitney Museum *Exhibitions:* Musee d'Art Moderne de la Ville de Paris; National Gallery of Art, DC *Education:* Art Students League, NYC; Columbia U. *Dealer:* Paula Cooper Gallery, NYC

Originally a painter in the 1950s, he turned to minimalist sculpture in 1963. Wood and metal are used to assemble unadorned symmetrical forms without bases, creating a sense of order within each piece. Implying no meaning outside of their own unified presence, large sculptures are placed on the floor and do not reach above eye-level. Opposed to the subjectivity of the Abstract Expressionists as well as to any figurative illusionism, he is concerned with achieving a spatial unity in three dimensions, usually in such solid geomtric forms as the cube. His best known works include fabricated cubes and boxes made of stainless steel or plexiglass which are painted in metallic monochromes and placed in repetitive and symmetrical arrangements.

KAHLE, GARY (Sculptor)
2670 Valley View, Arkansas City, KS 67005

Born: 1942 *Awards:* Best of Show, North Dakota Art Exhibition *Collections:* Sterling College Art Department, Sterling, KS; Gilman Gallery, Chicago *Exhibitions:* National Academy of Design, NY

A sixteen-year stint as a welder at General Electric Company taught him to manipulate stainless steel. After an industrial accident in the early 1980s, he became interested in sculpture. He represents the commonplace uncommonly and in the vernacular of the contemporary art lover. The smaller pieces, up to three feet in size, such as *The Argument*, *Spilt Milk* and *Bikini* reflect his wry and subtle sense of humor, as does *Plug*, a giant, highly polished replica of an electrical plug, projecting from a piece of Kansas limestone.

KALLENBERGER, KREG (Glass Sculptor)
c/o Habatat Galleries, 361 W. Superior, Chicago, IL 60610

Born: 1950 *Awards:* National Endowment for the Arts Fellowship Grant; Bronze Medal, International Art Competition, 1984 Olympics, Los Angeles *Collections:* Musee des Ats Decoratifs, Lausanne, Switzerland; High Museum, Atlanta, Georgia *Exhibitions:* Habatat Galleries, Chicago; Glass Art Gallery, Toronto

A reknowned craftsman, he is well-known for his unusual technique of cutting instead of blowing glass sculptures. His forms are geometric, and he attemps to create asymmetrical tension by combining different symmetrical shapes. His "Cuneiform" series consists of sets of two highly-polished pieces which do not interlock, but mimick each others' forms like puzzle pieces that don't fit together. He cites the intrinsic beauty of his medium, glass, and the difficulties it presents as fuel for his developing work. He makes the glass himself, melts it, and then cuts and polishes the material, often unsure of the form he wants until the piece is finished. He refers to this process as a "conversation with the raw material."

KANFER, LARRY (Photographer)
P.O. Box 302, Champaign, IL 61820

Born: 1956 *Awards:* Award of Excellence, Associated Professional Photographers of IL; Finalist, Ilford Cibachrome International Grant Competition *Collections:* Peat Marwick, Mitchell & Co., St. Louis; Coopers Lybrand

Drawing upon a rich background in art, design and travel, he focuses on the unique qualities of the Midwestern landscape. He exhibits an unusual sensitivity to compositions, color, texture, and light. He was influenced by Harry Callahan and the late Arthur Sinsabaugh. Some of his color photographs have a grainy appearance, lending them an almost painterly quality, while his black and white prints are sharp and distinct, resembling pencil sketches. By juxtaposing field and sky, he shows the endless horizons and changing seasons of the prairie, while at the same time setting up the canvas for such singularities as a solitary barn, a rural mailbox, or cornflower blossoms. Over the years, his style has not changed in terms of subject or composition, but rather in refinement and narrowing of focus.

KAPLAN, DAN (Sculptor)
2102 S. Wesley, Berwyn, IL 60402

Born: 1953 *Awards:* Fellowship Grant, Illinois Arts Council *Collections:* Borg-Warner *Exhibitions:* Navy Pier International Exhibit, Chicago; J. Rosenthal Gallery, Chicago *Dealer:* Dennis Rosenthal, Chicago

His early mournful, symbolic, carved wooden figures were inspired by Giacometti's tortured work. In 1974 he placed his burned, charred and mutilated figures on sprawling platforms and marched them to their individual fates in a mass requiem that concluded inconclusively in mirrors, caverns, and unnatural piles built from the excrement of the ages. Although figures have since disappeared, from his work, the tone remains the same. He juxtaposes an oversized, chainsawed anatomy with burnt resin and lightly colored sanded woods. "My work is my way of retaining hope [and] representing things and ideas that can be contemplated, judged, reconciled, and shared with others."

KAPLAN, GAIL (Photographer)
1817 N. Hudson, Chicago, IL 60614

Born: 1948 *Awards:* Illinois Artist-in-Residence; Illinois Arts Council Grant *Collections:* State of Illinois Museum *Exhibitions:* Chicago Cultural Center, Printworks, Ltd., Chicago *Education:* School of the Art Institute of Chicago; Northwestern U. *Dealer:* Printworks, Ltd., Chicago

Early photographs were of architectural environments, exploring the definition of space through light and the effects of time and habitation on the site. Later works involved the creation of dream environments, which were then photographed. The manipulation of light is integral to the work; in some instances dissolving architectural forms, in other instances becoming almost solid and delineating levels of depth. In all situations, however, light becomes the only active force in an otherwise quiet, empty place. Current works combine photography and architectural subjects.

KAPSALIS, THOMAS H. (Painter)
5204 N. Virginia Ave., Chicago, IL 60625

Born: 1925 *Awards:* Fullbright Grant; Pauline Palmer Prize, Art Institute of Chicago *Collections:* Art Institute of Chicago; Illinois State Museum, Springfield *Exhibitions:* Art Institute of Chicago; Biennial of Contem-

porary Painting, Washington, D.C. *Education:* School of the Art Institute of Chicago; Stuttgart Art School, Germany *Dealer:* Roy Boyd Gallery, Chicago

His early Rothko- and Stamos-influenced paintings are highly emotive evokations of tribal forms. In 1950, he began sculpting semi-abstract stylized figures in iron, and at the same time turned toward analytical and synthetic Cubism in painting. By the mid-1960s, he had developed a spare cubist style of painting characterized by surety of design and a shimmering, near monochromatic color scheme. Flat geometric abstractions are also characteristic of his work from this period. During the 1970s, his blueprint-like works were indebted to suprematism and constructivism. In his "Cut Glass Series," sliced tables and drinking glasses stand against a two dimensional floor-background, More recent oil paintings depict square planes which may be read as cubes, boxes, or other such configurations.

KARUZA, DAIVA V. (Painter, Fiber Artist)
6035 S. Whipple, Chicago, IL 60629

Born: 1954 *Exhibitions:* Monroe Gallery, Chicago; Balzekas Museum of Lithuanian Culture *Education:* Governors State U.

After studying traditional Lithuanian weaving techniques, she began using fiber to create her own interpretations. She first incorporated bones, shells, wood, feathers, and other natural materials into these African- and Polynesian-influenced abstract works. She subsequently used mirror elements to express her interest in paradoxes and the workings of the unconscious. Presently surrealism and psychoanalytic readings are her heaviest influence. Figures, animals, birds, and images of fire and water are the subjects of her current "unconscious" and unplanned pastel drawings and acrylic paintings.

KASEN, JUDITH ALBERTE (Sculptor)
1776 W. Winnemac, #201, Chicago, IL 60640

Born: 1949 *Awards:* Illinois Arts Council Completion Grant *Exhibitions:* U. of Illinois, Chicago Gallery; Chicago Cultural Center *Education:* Northern Illinois U.; Bradley U. *Dealer:* Walter Bischoff Gallery, Chicago

Interest in the mysterious, the obscure and the spiritual, especially as found in early Christian and Egyptian art, led this artist to her current, darkly painted assemblages. The sculptures are assembled from pieces of wood found on walks she has taken throughout the city. The varigated shapes resemble vessels and architectural structures in rested motion and lonely landscapes. Primarily wall reliefs, the works are dark, drawn and painted upon so that their lush surfaces evoke cityscapes and blackboards. One series, entitled "Stations," consists of fourteen pieces recalling personal trials and tribulations, as well as dreams, darkness and mystery.

KASPEREK, CLAUDIA L. (Painter)
1541 W. Hood Ave., Chicago, IL 60660

Born: 1948 *Exhibitions:* New Horizons in Art Grand Salon; Peat, Marwick, Mitchell & Co. Corporate Gal-

lery *Education:* U. of Illinois; U. of Chicago

Early work in the 1970s was influenced by Frankenthaler, Louis and Gilliam. Large colorful forms were expressed using acrylics, manipulated by hand, spray and gravity on unprimed canvas and silk. The paintings were then stretched or left to unfurl in the wind, tied into knots or incorporated into three-dimensional forms using wood and wire. Trees and bushes were sometimes used to exhibit the works, suggesting artificial forms juxtaposed onto natural ones. In her recent work, painting is an expression of her feminist spirituality. Incorporating abstract forms on canvas with poetry, ancient symbols and nature, her media and technique are similar to past work but the forms are no longer juxtaposed onto nature. Paint, canvas, wood, paper, bones and string become one talisman of healing power and conscious evolution.

KATZ, ALEX (Painter)
c/o Marlborough Gallery, 40 W. 57th St., New York NY 10019

Born: 1927 *Awards:* Guggenheim Fellowship; Professional Achievement Citation, NY *Collections:* Museum of Modern Art, NYC; Whitney Museum *Exhibitions:* Corcoran Gallery Biennial; Museum of Modern Art, NYC *Education:* Cooper Union; Skowhegan School of Painting and Sculpture *Dealer:* Marlborough Gallery, NYC; Susanne Hilberry Gallery, Birmingham, MI

In the 1950s large, simple figures were depicted in unspecified surroundings, as in *Ada Ada*. Figures were also cut out and mounted on plywood in order to create striking likenesses. Still isolated from their settings, figures of the 1960s became upper bodies only, as in *Red Smile*. Additional work made during this decade portrays flowers and figural groups which recall the earlier cut-outs. Clean edges and under-drawing serve to flatten and simplify the figures. Because the subjects are so large in relation to the canvas, like the face coming up out of the water in *Swimmer No. 2*, they seem to rise up towards the viewer from the picture plane.

KAUFMAN, EMILY (Sculptor)
c/o Gilman/Gruen Galleries, 226 W. Superior, Chicago, IL 60610

Born: 1950 *Awards:* Most Outstanding Sculptor Award, Boston U.; Creative Arts Fellowship, U. of Illinois *Collections:* Hirshhorn Museum and Sculpture Garden, Washington, D.C.; The Byer Museum of Art, Evanston, IL *Exhibitions:* Gilman Galleries, Chicago; Art Expo, New York *Education:* Boston U.; U. of Illinois, Champaign-Urbana *Dealer:* Gilman/Gruen Galleries, Chicago

In sizes from small table top works to wall reliefs to 4 1/2- by 3-foot free-standing pieces, she creates a sculpted world that looks as if it were stolen from the pages of a 1920s or 1930s fashion magazine. But these pieces, sculpted in epoxy resins, provide a sensuousness and eroticism that exceeds nostalgia. All the pieces are of women in various stages of undress, in robes fallen open, beads, slips and stockings, or just stockings and heels. The colors are washed out pastels, both the body and garments the same pale hue. The large work *Girl on a Fainting Couch*, in collection at the Hirshhorn Museum, depicts a young woman, roses clasped to her bare shoulder, in stockings and shoes resting on a divan—the mix of innocence and experience creates a provocative tension. The pieces are not only sensual but excel in their consummate craft and sheer beauty.

KEIDAN, BARBARA (Painter)
32071 Rosevear Dr. Birmingham, MI 48009

Born: 1928 *Awards:* Prizes, Michigan Watercolor Society *Exhibitions:* Wayne State U., Detroit *Dealer:* Rubiner Gallery, West Bloomfield, Michigan

Early watercolors were lyrical, dramatic, flowing wet impressions of landscapes and sea scapes. Bold cloud formations, vibrant sunsets, and jagged mountain forms were all protrayed with exciting color and contrasting forms. Her current paintings are non-traditional florals in mixed media. She begins a piece by drawing from life on large sheets of paper (from 40 inches to 8 feet in height) and then enlarges the most exciting portions of the flower to create a strong design statement. She highlights the pieces' sense of depth by using vibrant watercolors in the foreground and painting the background with one solid color of acrylic paint.

KELLY, DANIEL (Painter)
7225 N. Sheridan Rd., Chicago, IL 60626

Exhibition: Corsh Gallery *Education:* Ecole des Beaux Arts, Paris

A figure painter drawing his inspiration mainly from the Mannerists and the Baroque, his work takes classical, religious, and mythological themes, recasting them, often with overt homoeroticism, to reveal their occult dimension. Done in the traditional technique of glazing over a black and white underpainting, the compositions are complex, frequently combining images from different periods of history, as well as from his study of ancient and modern mysticism. Dramatic lighting and content are contrasted with an illustrative method of rendering the figures, setting up a dialogue between sophistication and naivete.

KEZYS, ALGIMANTAS (Photographer)
4317 S. Wisconsin Ave., Stickney, IL

Born: 1928 *Collections:* Metropolitan Museum of Art; Art Institute of Chicago *Exhibitions:* Art Institute of Chicago; Ciurlionis Art Gallery, Chicago *Education:* Loyola U., Chicago *Dealer:* Ruth Volid Gallery, Chicago

Born in Lithuania, he is an ordained Jesuit priest who began making photographs as a hobby. Form is his major concern; content plays a secondary role in his "design pictures." His picture stories are fragments in a very loose framework, where any points of main interest may be conspicuously absent. He is also an author whose books include: *Form and Content, Photographs, Posters, I Fled Him, Down The Nights and Down The Days* (an edition of Francis Thompson's *The Hound of Heaven* with photographic commentary), *Nature: Forms and Forces*, and *Lithuania- Through the Wall*. He recently founded the Galerija Art Gallery in Chicago and is also founder of Chicago's Lithuanian Photo Library.

Barbara Keidan, *Lilies,* 34 x 48, watercolor, acrylic ground

Daniel Kelly, *A Christian's Satori,* 52 x 34, oil

KIEFER, ANSELM (Painter)
Hornback/Odenwald, West Germany

Born: 1945 *Collections:* Neue Galerie/Sammlung Ludwig, Aachen, West Germany; Stedelijk Van Abbemuseum, Eindoven, Netherlands *Exhibitions:* Art Institute of Chicago; Mariam Goodman Gallery, NYC *Education:* Staatliche Kunstakademie, Dusseldorf

In the 1970s his paintings and books on the architecture of the Third Reich brought him attention, much of it fearful and full of accusation. "The buildings I painted," he says of the work then, "were connected with crime, with power. I'm not interested in painting innocent things like Matisse." Today, while his art has moved away from the specific references to Germany's violent recent history found in *Heroic Allegories* (a book of collected self-portraits of him raising his arm in the Nazi salute), it is lauded for its depth and vision, for its moral conscience.

KIEFER-BELL, JULIE (Painter)
107 Mattek Ave., DeKalb, IL 60115

Born: 1946 *Awards:* Juror's Cash Awards, Norris Gallery, St. Charles, IL; Juror's Third Place Cash Award, 11th Annual Alice & Arthur Baer Juried Exhibition, Beverly Art Center, Chicago *Collections:* State of Illinois; Blue Cross of Chicago *Exhibitions:* Beverly Art Center, Chicago; Chicago Botanic Garden *Education:* U. of Wisconsin, Madison; St. Cloud State U., MN *Dealer:* Broden Gallery, Madison, WI; Harleen & Allen Fine Art, San Francisco, CA

Her oil paintings and drawings of the 1960s and early 1970s were figurative. Still lifes of the mid-1970s evolved into symbolic narrations of negative experiences and memories through mixed media drawings and oils. Foliage first appeared in these works in 1976 and the first large-scale painting of her "Foliar" series was completed in 1977. The "Foliar" works, smooth-surfaced interpretations of various plants, continued concurrently with the narrative images. In 1984, she explored transparency, luminosity, color, and form in a series of bottle paintings and drawings which were placed in a setting of light reflected from colored foil paper. She then returned to the "Foliar" works, bringing new translucent and luminous properties to the pieces, including backlighting the works completed since 1985.

KIESEL, POLLY (Painter)
c/o 1771 Girard Ave. South, Minneapolis, MN 55403

Born: 1961 *Awards:* Visual Fellowship, Fine Arts Work Center, Provincetown, MA; Sudden Opportunity Grant, Minnesota State Arts Board *Collections:* Walker Art Center; First Bank Systems *Exhibitions:* Walker Art Center; Contemporary Art Workshop, Chicago *Education:* Rhode Island School of Design; Minneapolis Institute of Art *Dealer:* Thomas Barry Fine Arts, Minneapolis

She has created a hybrid mythology of the public and private by combining mass images with personal symbols. In canvases and works on paper, she strips slickness from mass media images and exposes issues of sex, race, cultural morality and learned desire that lie behind marketing tactics. Her customized, mixed-media frames comment on the work and reinforce its inherent humor. She also includes non-specific, abstract, and biomorphic forms in paintings that currently tend to resemble bas-relief. These layered canvases function like hyper-surreal stage sets, their theatricality and emphasized depth drawing the viewer in.

KILAND, LANCE (Painter, Printmaker)
3153 Bloomington Ave. South, Minneapolis, MN 55407

Born: 1947 *Awards:* NEA & Bush Foundation Fellowships *Collections:* Walker Art Center; General Mills Collection *Exhibitions:* Whitney Museum; Block Gallery, Chicago *Education:* Moorhead State U.; Southern Illinois U. *Dealer:* Thomson Gallery, Minneapolis

A male human figure with an unidentifiable monolithic object were the subjects of his Neo-Expressionist paintings of the early 1980s. Although he posed these realistically rendered subjects in confrontation, their relationship was obscure. In 1984, Cubist and Futurist influences became important, and his figures became less realistic, more machine-like. Since 1985, his paintings have been Cubist, or they have recalled the early efforts of Abstract Expressionist artists such as Gorky or Pollock. Although the paint application remains expressive, the surface is thinner, the stroke is broader, and the hues are less muddy and more colorful.

KIMLER, WESLEY (Painter)
c/o Struve Gallery, 309 W. Superior St., Chicago, IL 60610

Born: 1953 *Collections:* Capitol Development Board, State of Illinois *Exhibitions:* Frumkin and Struve Gallery, Chicago; Ivory/Kimpton Gallery, San Francisco *Education:* Minneapolis College of Art and Design; Laguna-Gloria School of Art, Austin, TX *Dealer:* Struve Gallery, Chicago; Ivory/Kimpton Gallery, San Francisco

Early figurative paintings emulate such California pop-style artists as Roy De Forest. Since 1983 works have been expressionistic. Large-scale action paintings recall Jackson Pollock in exploring the nature of paint and color and in the pure act of painting. He refers to himself as an Abstract Expressionist but insists that his art is representational. "Abstract Expressionism is the only true realism," he says. Attempting to reveal the subconscious, he combines the purely abstract with faint suggestions of figuration.

KINKLE, CHARLES A. (Sculptor)
7420 S. King Dr., Chicago, IL 60619

Born: 1946 *Awards:* Honorable Mention for Outstanding Achievement in Ornamental Frames *Exhibitions:* Museum of Science and Industry, Chicago; Loyola Country Fair *Dealer:* Lissay Frame Company, Chicago

With no formal training, he began using his engineering background to develop frames for pictures. One design led to another--bouquet elements became mounted flowers, balconies, bricks, daisies, and many other forms. 1400 pieces, hand-cut on a mitre-box, make up a bonsai tree. Wood pieces are fit together as place mats and trophy trees. *Oriental Flowering Tree* contains 1,790 white, oriental red, black, meadow green, and gold leaf pieces and is based on Far East design.

Julie Kiefer-Bell, *Foliar SS-1,* 52x66, oil

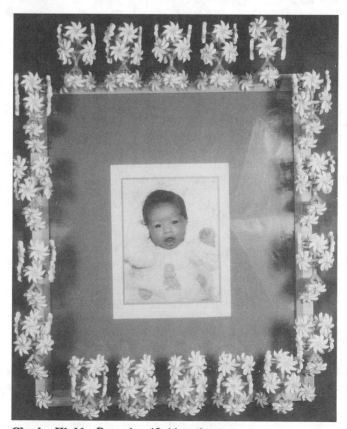

Charles Kinkle, *Dreaming,* 19x14, sculpture

Presently, he is studying photgraphs from India for structural forms that he can put into frame design.

KINSELL, ROBERT P. (Painter)
2026 W. Waveland Ave., Chicago, IL 60618

Born: 1951 *Awards:* Purchase Award, A.R.T.S. Resource, San Francisco *Collections:* Citizens Fidelity Bank, Louisville, KY *Exhibitions:* Rahr-West Museum, Manitowoc, WI; Dobrick Gallery, Chicago *Education:* U. of Wisconsin, Madison

After serving an apprenticeship with Philip Pearlstein in 1971 he moved to Chicago and continued to work in a strict representational style, producing still lifes and figurative works throughout the 1970s. In 1978, Dobrick Gallery held an exhibition of his figurative work. This led him to re-examine his methods and to search for a new style. After returning to school to earn his MFA degree in 1985, he has worked more conceptually. His settings for single figures and arrangements of multiple figures have an enigmatic quality to them. Presently he has increased the intensity of his work by greatly reducing the scales of both his oil on panel paintings and his silverpoint drawings.

KIRULIS, KARIN (Sculptor)
1201 E. 60th St., #2, Chicago, IL 60637

Born: 1950 *Collections:* United Airlines, Manufacturers Hanover Corporation *Exhibitions:* David Adler Cultural Center, Libertyville, IL; Contemporary Art Workshop, Chicago *Education:* Ohio U.; School of the Art Institute of Chicago *Dealer:* Lyman/Heizer Assoc., Northfield, IL

Influenced by David Smith's early pieces, and the more linear works of Giacometti, she cast her early figurative bronze work directly without going through a mold-making process. She made the forms for these one-of-a-kind pieces from combustible materials such as cloth, sheet wax, wood, and metal wire. She now continues to cast directly, feeling that this method insures vitality. She believes that art has the potential to change the way we view the world and ourselves. Her animal forms are a metaphor for statements about reality and the broader conditions of life. Her works are explorations of paradoxes--like strength and fragility, inside and outside, animal forms and debris.

KISSANE, SHARON FLORENCE (Painter)
15 Turning Shores, S. Barrington, IL 60010

Born: 1940 *Awards:* Prix de New York, Ligoa Duncan; Honorable Mention, Chicago Sketch Club Exhibition *Collections:* Tweed Museum, University of Minnesota; Art Institute of Chicago Library *Exhibitions:* Ligoa Duncan, NYC; Rayonde Duncan, Paris *Education:* De Paul U., Chicago; Northwestern U.*Dealer:* International Society of Cooper Artists, NYC

She has devoted the last ten years to post card art. In one piece, *Anarchistic Male Evening*, she places the word "cool" over her picture of pop star George Michael holding a symbolically erotic guitar. Her drawings are extremely detailed and precise, and she describes them as "serious mail art." Her doctoral training in linguistics has made her aware of the worldwide agreement in verbal and non-verbal symbols, and in her current work she uses the copier to create collages that merge verbal and visual art forms. She is contributing editor to the Buenes Aires arts magazine, *El Tiempo*, and in 1989 she will curate a "Women In World Peace" exhibit at Chicago's Jane Addams Center.

KITZEROW, SCOTT (Painter)
550 W. Brompton, Chicago, IL 60657

Born: 1955 *Exhibitions:* School of the Art Institute of Chicago; Northwestern U. *Education:* School of the Art Institute of Chicago

Interested in the visionary work of surrealist Max Ernst, his early paintings, drawings, and photo collages were series of objects which he reduced to the minimal structures of form and color. His current depictions of sacred places are related to his interest in the colors of Matisse and the structure of architectural forms. These principally acrylic, large abstract paintings are investigations of light and color. His recent influences include the concept of sacred geometry and the works of Josef Albers and Charles Sheeler. Many of his most recent paintings have a curiously symmetrical balance of form and color.

KLAMEN, DAVID (Painter)
c/o Deson-Saunders Gallery, 750 N. Orleans, Chicago, IL 60610

Born: 1961 *Exhibitions:* Marianne Deson Gallery, Chicago; Art Institute of Chicago *Collections:* Krannert Art Museum, Champaign, IL; Illinois State Museum, Champaign *Education:* U. of Illinois; School of the Art Institute of Chicago *Dealer:* Deson-Saunders Gallery, Chicago

A deeply romantic imagery is used in his works to impart feelings of both loneliness and foreboding. These feelings are further heightened by his use of highly varnished surfaces, creating an eerie tension and stillness. Such a quality is particularly apparent in *Untitled*, in which two gazelles are drinking at a small waterhole. Of his work one curator has commented, "Klamen exhibits a coincidence of representational skill and the sort of meditative, almost mystical sensibility, rarely seen in today's rationalistic technologically-oriented world."

KLAVEN, MARVIN (Painter)
406 S. Westdale, Decatur, IL 62522

Born: 1931 *Awards:* Tiffany Foundation Grant *Collections:* Mack Gilman, Chicago; Millikin U. *Exhibitions:* Millikin U.; Illinois Wesleyan U. *Education:* U. of Iowa *Dealer:* Gilman Gallery, Chicago

He painted his earlier earth-toned still lifes and figures with a glazing technique of oil painting. In the 1970s he changed to acrylic and concentrated on landscape. His work moved from dark earth tones and glazing techniques to a combination of flat and organic shapes of color. The figure, landscape, and later the photograph remained his sources of ideas. He has recently moved to monotypes.

Diana Kleidon, *Detroit City,* 20x16, photograph

Alexandra D. Kochman, *Linear Construction,* 35x25x3, raku fired clay. Courtesy: Ms. Adrienne N. Kochman. Photograph: Jerry Kobylecky

KLEIDON, DIANA (Photographer)
20 Brookside Pl., Springfield, IL 62704

Born: 1952 *Collections:* Illinois State Museum, Springfield; Freeport Art Museum, IL *Exhibitions:* Olive Tree Gallery, Daley College, Chicago; Koehnline Art Gallery, Oakton College, Des Plaines, IL *Education:* Southern Illinois U.; Sangamon State U. *Dealer:* Prism Gallery, Evanston, IL; Blackbourn Art Consultants

Abstract cityscapes have been an ongoing study of hers since 1978. They are graphic, bold images created around design principles and, as such, strike the viewer on an intellectual rather than emotional level. The subjects are usually parts of architecture, sculpture, or some kind of structure. Her intent, however, is not to photograph these structures per se, but rather to create new graphic images. The components of buildings, sky and sculpture generate a composition that is a world unto itself.

KLEIN, SHERI R. (Sculptor)
P209 Rogers Rd., Athens, Georgia

Born: 1956 *Awards:* Artist-in-Residence, Glassell School of Art, Museum of Fine Arts, Houston; Artist-in-Residence, Ragdale Foundation, Lake Forest, IL *Exhibitions:* Western New York Exhibition; Randolph Street Gallery, Chicago *Education:* School of the Art Institute of Chicago

A sculptor with formal training in painting and drawing, her first works were inspired by nature, geometry, and architecture. She built these simple shapes by hand and purposefully left evidence of her workmanship. She is now inspired by the fleeting moments of nature such as the opening of a flower bud, the passing of a cloud, or the turning of a leaf. Now working abstractly and symbolically, she begins with investigatory drawings in charcoal and ink and eventually combines simple, abstract cast bronze forms with marble, hydrocal, and clay. Through her arrangement of shapes in these small wall pieces and floor-based works she creates a dialogue of ideas and form.

KLEINMAN, ART (Painter)
1441 W. Cullom, Chicago, IL 60613

Born: 1949 *Awards:* 1st Prize, Elgin Community College Drawing Competition *Collections:* Continental Corporation, Chicago; Peat Marwick & Mitchell, St. Louis *Exhibitions:* Randolph St. Gallery; Contemporary Arts Center, Cincinatti *Education:* Kansas U. *Dealer:* Jan Cicero Gallery, Chicago; Atrium Gallery, St. Louis

His colorful non-representational work shows an abiding interest in geometric abstraction. In the late 1970s, he painted minimalist, reductive forms on shaped canvas over wood. The early 1980s saw him introduce the grid into relief paintings he made on wood. At the time, his primary interest was in dealing with the physical reality of the "painting as object." In the mid-1980s he returned to the stretched rectangular canvas, and while the grid remained his underlying structure, he increased the sense of place and movement within the plane of the picture. His palette is broad and garishly artificial oils. He uses a wide variety of textures, sheens, opacities, and brush stroke directions to achieve his effects.

KLEMENT, VERA (Painter)
727 S. Dearborn, Chicago, IL 60605

Born: 1929 *Awards:* Fellowship, John Simon Guggenheim Memorial Foundation; NEA Grant *Collections:* Museum of Modern Art, NYC; Illinois State Museum *Exhibitions:* Art Institute of Chicago; Marianne Deson Gallery, Chicago *Education:* Cooper Union *Dealer:* Roy Boyd Gallery, Chicago

For three decades she has worked in the tradition of Abstract Expressionism. Her new paintings use the technique of encaustic to enhance the clarity of her colors. In these works, she continues a previous exploration of what she calls a "two-part connection." The total picture plane is one "part," the other a plane made from a square or rectangle of canvas that is affixed to the canvas ground.

KNUTSEN, ELAINE (Ceramist)
37 W. Timberline Dr., Blue Grass, IA 52726

Born: 1930 *Awards:* 1st Place, Oconomowoc Festival of Arts, WI; 1st Place, Naperville Art Fair, IL *Exhibitions:* Quad Cities Arts Council, Rock Island, IL; Artists in Action, Muscatine, IA

Middle-aged and seeking to rejuvinate her life, she struck out to find an avenue of self-expression. In discovering the clayworks of Pompeii she found such a road. She further studied North American Indian pottery and began working with clay herself. In exploring the boundaries of form in clay, she has crafted finely decorated quarter-inch vases, six foot totems, wall reliefs, jewelry, and figurative and abstract sculpture. This versatility affords a wide latitude of work, yet each exhibit almost invariably leads on a secret pathway back to nature. Initially, the viewer is struck by the grace of the pieces, but on second and third examinations other facets are revealed in the intricately woven surfaces. Her "addiction" to minutely executed detail has become the signature of her work.

KOCAR, GEORGE F. (Painter)
24213 Lake Road, Bay Village, OH 44140

Born: 1948 *Awards:* Butler Midyear Juror's Award, Butler Institute of Art, Youngstown, OH; Gold Medal, Metro Art Competition, NY *Collections:* Sandusky Cultural Center, OH; Central Missouri University *Exhibitions:* Edinboro University, PA *Education:* Syracuse U.; Cleveland State U. *Dealer:* Ariel Gallery, New York

A painter and freelance illustrator, he paints from the storehouse of ideas and images in his mind. His paintings, which blend his interests in cartoons, illustration, and abstract art, takes umbrage with the social and political platforms of the day. The figures in his paintings are absurd and frequently grossly deformed. *Adam and Eve* juxtaposes the Biblical beginning of mankind with images of what could be mankind's ending. Adam's upraised finger is a reference to Michelangelo's finger of God. Silhouettes of reptiles and missiles cut the painting diagonally in half; the reptiles represent

Gilda Kolkey, *Family Portrait*, 28x20, oil on canvas

221

extinction, the missiles possible extinction. A wire snake represents technology, and an apple core skewered on a sword stands for war. Such an array of images and symbols is a trademark of his work.

KOCHMAN, ALEXANDRA D. (Ceramist)
5453 N. Virginia Ave., Chicago, IL 60625

Born: 1936 *Awards:* Governor's Purchase Award, Springfield, IL; First Award, Oakbrook Center Invitational Fine Arts Exhibition *Collections:* State of Illinois Art Collection, Chicago; Illinois State Museum, Springfield *Exhibitions:* Artemisia Gallery, Chicago; Evanston Art Center, Evanston, IL *Education:* Univ. of Illinois, Chicago; Art Institute of Chicago *Dealer:* Judith Racht Gallery, Lakeside, MI

Blending her skills in painting and ceramics, her works demonstrate the possibilities of clay for sculptural expression. In these pieces she strives to undermine the symbolic meaning that people give to familiar objects. To do this she works with abstract forms that leave the viewer interpreting the object in terms of form, shape, line, and texture. The vessels she creates are designed primarily to emphasize the beauty of unglazed clay. However, she also contrasts glazed surfaces with unglazed ones to give them an antiquated look or to suggest erosion. Although she uses many different firing processes, raku firing is her favorite. Included in the range of pieces are vessels, trestled structures, wall-hung sculptural forms, and tile tapestries.

KOGA, MARY (Photographer)
1254 Elmdale Ave., Chicago, IL 60660

Born: 1920 *Awards:* NEA & Illinois Arts Council Fellowships *Collections:* Art Institute of Chicago; San Francisco Museum of Modern Art *Exhibitions:* Truman College, Chicago; Art Institute of Chicago *Education:* School of the Art Institute of Chicago; U. of Chicago *Dealer:* Illinois Artisans Shop, Rental Purchase Gallery, Chicago; J.B. Speed Art Museum, Louisville, KY

She is known for her documentary photographs of people and for the subtle, close-up abstractions of floral and natural forms she photographs in natural light. She shot her first photographs in black and white and in the late 1970s she spent three summers photographing the Hutterite religious community in Alberta, Canada. She revealed the Hutterite way of life in a series of direct and simple photographs of simple homes, covered heads, giggling children, women in long dresses, and emotionless faces. Her soft and translucent color photographs of flowers resemble watercolors while her black and white photos of the same subject strive for a graphic effect.

KOHN, BILL (Painter)
6100 Kingsbury, St. Louis, MO

Born: 1931 *Awards:* Fullbright; Missouri State Art Council *Collections:* St. Louis Art Museum; Chase Manhattan Bank *Exhibitions:* St Louis Art Museum; Alcazar Palace, Seville, Spain *Education:* Washington U., St. Louis; Mills College, Oakland *Dealer:* Jan Cicero, Chicago

In the 1970s the subjects of his still lifes were styrofoam, wood and metal which, seen and lit from above, took on the appearance of deserted cities. He subsequently replaced the styrofoam with above views of real cities. In Chicago, the Sears Tower became his vantage point. In his current large acrylic work he has made an about-face, shifting his vantage point to the ground looking upward. Chicago remains his subject, however. Whether from the top down or ground up, his strong use of light and shadow reveals severely simplified volumes liberated from their human contents.

KOLKEY, GILDA (Painter)
1100 N. Lake Shore Drive, #21 B, Chicago, IL 60611

Awards: North Shore Art League Award of Excellence; New Horizons Painting Award *Collections:* Dr. and Mrs. I. S. Belgrade; Mr. & Mrs. Weiner, Highland Park, IL *Exhibitions:* Art Institute of Chicago; Chicago Cultural Center *Education:* U. of Illinois *Dealer:* Galleria De Swan, Chicago

She conveys emotions more than technique in an attempt to work in both an imaginative and personal way. Early work reflects the influence of her background in drawing, architecture, and sculpture. She has recently shifted from using ombres to bright colors, including high reds, emphasizing the play of light and shadow. Labelled "mystical," the paintings are mysterious and richly ornamented figurative studies. An unconcious sense of conflict and elusive push and pull between the compositional elements create a gentle, bittersweet irony. Often extremeiy whimsical, her "vignettes" may be drawn from such everyday occurrences as movies, heightened by her deeply personal use of color into stories that are both sincere and direct.

KOMAR (VITALY) AND MELAMID (ALEXANDER) (Conceptual Artists)
181 Canal St., 5th Fl., New York, NY 10013

Born: 1943 *Collections:* Tel Aviv Museum, Israel; Guggenheim Museum, New York *Exhibitions:* Museum of Modern Art, Oxford, Enland; Museum of Decorative Art, Paris, France *Education:* Stroganov Institute of Art & Design, Moscow, U.S.S.R.

Coming to America from the Soviet Union, and bringing with them a history of another culture, the world view described by their work is broader than what most current art deals with. Using as a central motif the Yalta Conference--an image that brings with it a remembrance of world war as well as a new world geopolitical order--they synthesize their experiences both in the Soviet Union and the United States. Stalin, once erased from history by Kruschchev's directive, is resurrected to appear in images that span civilization. One finds him amidst the iconography of imperial Rome, shaking the hand of George Washington, hoisting a Churchill-headed lion over his shoulders. Splicing together cultural decors in their multi-imaged assemblages, they address a range of issues simultaneously--among them, personal history, heterosexuality, political mythology, the history of iconography, power and hope, death. And while a sense of humor informs the work, it is, comments critic Gary Indiana, "usually

the melancholy, deep-cutting humor of displaced persons, wit sharpened by catastrophe."

KOONS, JEFF (Sculptor)

c/o Sonnabend, 420 West Broadway, New York, NY 10012

Born: 1955 *Exhibitions:* International With Monument Gallery, NYC; Daniel Weinberg Gallery, Los Angeles *Education:* Maryland Institute College of Art; School of the Art Institute of Chicago *Dealer:* Sonnabend, NYC

He reproduces or represents consumer goods as symbols which confront moral social issues. In 1980 he started encasing vacuum cleaners under plexiglass boxes to represent the new and to explore self-containment, display, and preservation. He turned to the idea of submersion in 1985 in a show that featured tanks in which basketballs floated in suspension, bronzes of scuba snorkels, and Nike posters of sports figures. In 1986 he created an edition of stainless steel, decorative Jim Beam decanters which were sent to the factory in Kentucky to be filled with liquor and officially sealed. Recent works are reproductions of kitsch gift items cast in steel and an inflated rabbit made in Taiwan.

KOPER, PIP (Painter, Sculptor)

736 W. Beach Ave., Chicago, IL 60622

Born: 1946 *Exhibitions:* Cliffdwellers Club, Chicago *Education:* Shimer College

In the late 1970s, he worked in ceramic sculpture and printmaking. Since 1980, he has concentrated on paintings in oil and acrylic and multi-media collages. A two year sojourn in a remote hamlet in Finland instilled an interest in primitive and folk art images. Currently, subject matter ranges from real and imaginary cityscapes peopled by cavorting creatures to interior spaces which dissolve into multidimensional contrapositions of interactive spaces. A recent series, "Saints of Chicago," explores the darker side of the artist and the city. Utilizing plastic, wire, broken glass, razor blades and other objects with grim, hazardous connotations, works such as *St. Loop* and *St. O'Hare* characterize the messy and dangerous aspects of life in the big city.

KOSS, JIM (Book Artist)

411 Yale Ave., N., Seattle, WA 98109

Born: 1952 *Awards:* NEA Fellowship *Collections:* Mills College Library, CA; U. of Washington Library *Exhibitions:* Printworks, Ltd., Chicago *Education:* School of the Art Institute of Chicago; Mills College, CA *Dealer:* Printworks, Ltd., Chicago

He combines painting, printmaking, collage and letterpress printing to create one-of-a-kind books and small editions. His primary subjects are the land and journeys of various characters through several environments. These journeys often involve heroic figures, legendary or otherwise, who perform as characters on a discreet stage. His narratives serve as metaphors for contemplation and discovery. Currently his work involves collage, drawing, watercolor, suminagashi, woodblock printing, and hand set type.

KOSTABI, MARK (Painter)

361 W. 36th St., #3-A, New York, NY 10018

Born: 1960 *Awards:* Proliferation Prize, East Village Eye *Collections:* Museum of Modern Art, NYC; Seibu Museum, Japan *Exhibitions:* Ronald Feldman Gallery, NYC; Seed Hall Tokyo, Seibu Museum *Education:* California State U., Fullerton *Dealer:* Ronald Feldman Gallery, NYC

Working primarily in oil, and sometimes spray paint and mixed media, his paintings are landscapes, portraits, still lifes and abstracts, often incorporating the figure. His sculptures, in bronze, are usually two to three feet high, but can get as large as ten to twelve feet. The figures present in both the paintings and sculptures are faceless or headless. Rather than resisting the commercial world his approach seeks to integrate art with the mass media. He employs an ever extending staff, which he hires for concepts as well as construction, has had over 600 group shows, and designed the 1986 Bloomingdales Bag.

KOUNELLIS, JANNIS (Sculptor)

Via del Banco de Santo Spirito 21, 00186 Rome, Italy

Born: 1936 *Collections:* Galleria Nazionale d'Arte Moderna, Rome *Exhibitions:* Museum of Contemporary Art, Chicago; Musee d'art contemporain, Montreal

His recent exhibition at the Museum of Contemporary Art in Chicago, which included works distributed among various warehouses around the city, represented two main orientations in his development: one explicating the structure/sensibility dichotomy, the second that of cultural fragmentation. Of the first, heavy steel-plate pedestals or armaments combined with organic materials, such as spun wool, baskets of ground coffee, an egg, a pile of coal, even fire, create engaging studies of textural contrasts. With regard to the second, since the late 1960s he has been developing a vocabulary that expresses the cultural indentity crisis that has gripped postwar Europe. This is perhaps most poignantly captured in a small, pedestaled classical plaster bust from 1975 toppled on its side with a flame spewing from its ear. Since the mid-1970s fragments of plaster figures have appeared in his work, usually set among common stones gathered from the countryside. But his work also appropriates the tools and icons of the industrial age, creating a stage where they become artifacts of a culture since demised.

KOWALSKI, DENNIS (Sculptor)

4401 N. Ravenswood, Chicago, IL 60640

Born: 1938 *Awards:* Fellowship Grant, NEA; Artists Fellowship, Illinois Arts Council *Collections:* Art Institute of Chicago; Museum of Contemporary Art, Chicago *Exhibitions:* "Space Probe (4)," Hyde Park Art Center; Cleveland Center for Contemporary Art *Education:* School of the Art Institute of Chicago

Two diverse influences are evident in his work: the works of Brancusi and Moore and his concern with contemporary social and political issues. He uses both

found and artist-manufactured objects, often incorporating paintings into his sculptural installations. Using his minimalist style to give full range to an emotional and political point of view, he has created works including a satirical comment on the Strategic Defense Initiative, as well as the more gentle *Universe by the Seat of Your Pants*. The latter features a black stool pierced with hundreds of tiny holes which, suspended from the ceiling and flooded with light, is transformed into a twinkling, star-filled microcosm of the night sky.

KOZMON, GEORGE (Painter)
3602 Severn Rd., Cleveland Hts., OH 44118

Born: 1960 *Awards:* Fellowship, NEA; Individual Artists Fellowship, Ohio Arts Council *Collections:* Cleveland Museum of Art; Chicago Title and Trust Company *Exhibitions:* Mary Bell Galleries, Chicago; Robert L. Kidd Gallery, Detroit *Education:* Cleveland Art Institute

His earlier work, motivated by the desire to capture his immediate response to his environment, is more experimental and figurative and less refined than today. After experimenting with a variety of media (including conte crayon, inks, and acrylics), he started to create stark, dramatic, black and white renditions of building and architectural fragments. Current work incorporates architectural and other artificial structures and spaces with natural settings. His subject matter is drawn primarily from numerous trips to Europe and from photographs and sketches. He works by layering three to four coats of gesso on unstretched canvas, followed by multiple applications of acrylic washes. He creates images by using a razor to scratch back the layers of acrylic to the underlying gesso.

KRALL, VITA (Painter)
18 Atwater St., Milford, CT 06460

Born: 1923 *Exhibitions:* Chicago Community Art Show; Rockport Amateur Art Show *Education:* Washburn U., KS

Primarily a colorist who has been influenced by French and American Impressionism, she began painting in Kansas after studying life drawing with Hunt. She incorporated better composition and design concepts into her work while taking workshops at Rockport, Massachusetts. Her subjects are landscapes and occasionally florals, and she pays special attention to color balance and light-value contrasts. At present she continues to render small sketches, first into larger watercolor sketches, and from these into oil paintings. Present subject matter is taken from a painting trip to Aspen, Colorado and from Chicago's Michael Reese Hospital.

KRAMER, LINDA L. (Photographer, Sculptor)
370 Glendale Ave., Winnetka, IL 60093

Born: 1937 *Awards:* Illinois Arts Council Fellowship; Dorland Fellowship, Temecula, CA *Collections:* Museum of Contemporary Art, Chicago; Purdue U., IN *Exhibitions:* Art Institute of Chicago; Museum of Contemporary Art, Chicago *Education:* Scripps College, Claremont, CA; School of the Art Institute of Chicago

From 1973 until 1980, her sculptures were small-scale porcelain chairs, painted in soft matte colors. Representing the human in chair form, these pieces are actually self portraits. In 1980, she created the large-scale installation, *Graffiti Artifacts*, using pots and burnished terracotta shards incised with graffiti. Continuing in this vein, she has come to include natural and cultural concerns on a global scale. *Three Cultures, Red, Yellow, Blue* and *World Energy* use large ceramic vessels to represent real and imagined cultures.

KRANTZ, CLAIRE WOLF (Painter)
903 W. Roscoe, Chicago, IL 60657

Born: 1938 *Collections:* Museum of Contemporary Art, Chicago; Franklin Furnace Archive, NY *Exhibitions:* ARC Gallery, Chicago; National Gallery of Women in the Arts, Washington, D.C. *Education:* U. of Illinos; School of the Art Institute of Chicago

Her work combines products of modern technology with an artist's sense of how the mind strives to bring order from disorder. While at the Art Institute, she was greatly influenced by the Generative Systems Department which emphasizes technological approaches to image-making. She refined her ideas at Stanford, guided by Nathan Oliviera's work with monoprints. These, along with her critical studies, prompted her to explore the ways combined images evoke meaning. Currently, she creates collages and monoprints, machine-made, oil-painted, and drawn, assembled into wall hangings and books. The abstract images are derived from experiences at home and travels abroad, natural scenes and manufactured objects. She considers her works to be metaphors for how images create and mediate experience.

KRAUSE, CHARLES A. (Sculptor)
3374 N. 55th St., Milwaukee, WI 53216

Born: 1944 *Awards:* Research Grant, U. of Wisconsin, Milwaukee; Artist-in-Residence Grant, Peninsula School of the Arts, Fish Creek, WI *Exhibitions:* International Sculpture Competition and Maquette Show, Mercer College, Trenton, NJ; Concordia College Fine Arts Gallery, Mequon, WI *Education:* Southern Illinois U. *Dealer:* R. Volid Galleries, Chicago

Between 1964 and 1967, after formal training in figurative realism, he developed a personal style of organic, biomorphic astraction influenced by Moore and Giacometti. In graduate school he became interested in the works and philosophies of David Smith and Thomas Walsh, and began casting richly textured plant-like forms in bronze. From 1970 onward he looked to the works of Julius Schmidt and Arnoldo Pomodoro for inspiration. In the early 1970s he began making richly textured cast bronze and aluminum wall reliefs. These were followed by streamlined chrome and brass plated steel pieces. He is currently sculpting abstract landscapes using bronze, aluminum, and cast iron.

KRAUT, SUSAN (Painter)
1415 Ashland Ave., Evanston, IL 60201

Born: 1945 *Awards:* Purchase Award, Illinois State Museum *Collections:* Art Institute of Chicago; Illinois State Museum *Exhibitions:* "Point of Contact," River

Viita Krall, *Lanesville, Mass.,* 16x20, oil

North Gallery, Northeastern University; Museum of Contemporary Art, Chicago *Education:* U. of Michigan; School of th Art Institute of Chicago *Dealer:* Deson-Saunders, Chicago

Influenced by an exhibition of photorealist work in the early 1970s, she began creating small, monochromatic, interior still lifes. As this style developed, she looked to the works of Giorgio Morandi, Vuillard, and especially Seurat for inspiration and instruction. By the early 1980s, she was working in acrylic on textured paper, moving away somewhat from the photorealist style to a quiet yet expressive idiom. She has been creating soft interiors set against a glowing light and landscapes visible through the ever-expanding windows which characterize her current style. In *Oxbow Windowsill,* for example, a small ceramic bowl sits in the lower corner of the painting while the line of trees and dappled sunlight draws the eye out of the interior and into the world beyond. Her use of paint has become progressively looser and rougher, and she has recently been concentrating on observational studies of local landscapes.

KRETZMANN, MARK (Painter)
3305 W. Belle Plaine, Chicago, IL 60616

Born: 1955 *Awards:* Rickert-Ziebold Trust Award Winner *Collections:* Southern Illinois University Museum *Exhibitions:* Rickert-Ziebold Exhibition; "Recent Works," College of Lake County, Illinois *Education:* Atelier Neo Medici; Verneville-sur-Seine, France *Dealer:* J. Rosenthal Fine Arts, Chicago

His studies in France included the techniques of classical and photorealist oil painting. Influenced further by realist painters Hopper, Hockney and Balthus, he developed a quiet yet bold and figurative style. Works are created through stages of drawing, underpainting, glazing, and *alla prima* painting on primed canvas or linen. He describes his style as a balance of cool photorealism and warm romanticism.

KRONICK, STANLEY (Painter)
731 Henn Ave., P.O. Box 3693, Minneapolis, MN 55403

Born: 1909 *Awards:* Award of Excellence, North Star Water Color Society Miniature Show, St. Paul, MN; 1st Place in pastel, 2nd Annual Edina Art Center, MN *Exhibitions:* Edina Art Center, Edina, MN; Robin Gallery, Minneapolis, MN *Education:* U. of Minnesota; Minneapolis School of Art

As a boy of ten, he liked to draw cartoons and through a mail order course in cartooning became skilled enough to later work for an independent studio in California making animated films. In addition to cartoons, he had an opportunity to design and paint large scenic backgrounds for 20th Century Fox. But before his professional cartooning days, he spent several years in college studying art. There his skill in realism was developed, as well as his interest in the French Impressionists, an influence that would show in later works. Though he can work in a variety of media, watercolor is his favorite. Noted for his seascapes, he also generates collages with colored matte board, some which are abstract, some figurative.

KRUGER, BARBARA (Conceptual Artist, Film Critic)
55 Leonard St., New York, NY 10013

Born: 1945 *Award:* NEA Fellowship *Exhibitions:* L.A. County Museum of Art; Whitney Museum *Education:* Syracuse U.; Parsons School of Design, NY *Dealer:* Mary Boone Gallery, NYC

At one time she worked for *Conde Nast* as a magazine designer and picture editor and acknowledges this background as an influence in her work. Her varied activities include large photographs, posters, artists' books, and films. She is best known for "her searing juxtapositions of simple appropriated images and blunt text," explains critic John Sturman. Recent text/image works include the addition of color; some works, such as *What me worry?* contain only texts. She has also begun to explore the lenticular photograph, which presents two distinct images as the viewer shifts position, allowing her to produce complex juxtapositions in her images.

KURTZ, JOHN A. (Painter, Sculptor)
825 W. Lill, Chicago, IL 60614

Born: 1942 *Exhibitions:* Artemisia, Chicago *Dealer:* Zaks Gallery, Chicago

He started painting with acrylics in 1968. His first works recalled tintype photographs and the Jazz Age, and two years later he began adding such surrealistic elements as rag dolls and giant frogs to his somewhat subdued paintings. Eventually, this imagery became the focus of an imaginary, often humorous world of figures and animals. His current paintings, sculptures, and papier-mache masks have been likened to the works of the Chicago Imagists, but are perhaps more closely related to magic realism. Reaching backward in evolutionary time and forward to a landscape of robots and computers, he includes even the smallest forms of life in the cosmic framework of his all-encompassing view of the universe.

KUZNITSKY, SUSAN (Painter)
3450 Dempster, Skokie, IL 60076

Born: 1955 *Awards:* Best Portrait, Pastel Society of America, New York; Juror's Award, Kansas Pastel Society *Collections:* Blue Cross/Blue Shield Building *Exhibitions:* Gallery 100, Chicago; Hoorn-Ashley Gallery, Nantucket, MA *Education:* American Academy of Art, Chicago *Dealer:* Prestige Gallery, Skokie, IL

Influenced by the work of Albert Handall, she concentrates her work in the medium of pastel. Other influences include Degas and Mary Cassatt, as well as John Singer Sargent's use of light. Her subject matter is personal, exploring the romantic subtleties of everyday events, as in her "Hat" series. These images portray women in various settings, with a motif of hats repeated in each. Other current series include one on mothers with children and another on landscapes. Her work is on sandpaper, and she has recently begun to explore painting in oils. Creating a contemporary feeling in the people in her pieces, the moods of the surrounding backgrounds are often period, further underscoring the traditional properties of her technique and materials.

Linda Kramer, *Clear Energy,* 120x96(base), ceramic, wood

Adrienne Kyros, Crucifixion,
30x12, woodcut print

KVAALEN, ARNE (Painter)
1721 Fernleaf Dr., W. Lafayete, IN

Born: 1923 *Awards:* Merit Award and Purchase Award, Sheldon Swope Museum of Art, Terre Haute, IN *Collections:* Sheldon Swope Museum of Art, Terre Haute, IN; Davenport, IA Museum of Art *Exhibitions:* Evanston Museum of Art, Evanston, IL; Fort Wayne Museum of Art *Education:* Walker Art School; U. of Iowa *Dealer:* Jan Cicero Gallery, Chicago

While he was a graduate student at the University of Iowa in the early 1960s, his style was primarily abstract expressionism, alluding to landscape motifs and characterized by prominent brush strokes and palette knife application of paint. After a sabbatical in Montana and Wyoming in the late 1970s, his work experienced a definite shift toward realism. Many drawings and watercolor studies were done on site; paintings in oil and acrylic were done in his studio. Since 1984 his works have used the Midwest, chiefly Indiana, as a theme. His most recent works are done on paper with dry pigment and pastels and portray complex foregrounds of deep grass, weeds, and wild flowers along roadsides with fields and woodlots beyond. Another recurring theme is the broad sweep of the Midwest horizon showing a quiet land beneath an active sky.

KYROS, ADRIENNE MARIETTA HUDKINS (Printmaker, Painter)
2520 Wellington, Westchester, IL 60154

Awards: Printmakers Award 1985 *Exhibitions:* Clipper Ship Gallery, Palos Park, IL; Jem Alexander Gallery, Westchester, IL *Education:* School of the Art Institute of Chicago

Recent watercolors and woodcuts are characterized by an emphasis on creating an illusion of three dimensional "real space" expressed in an expressionistic style. The elements of design, motif, and color are integrated in floral, landscape and still life works as well as in works which depict human and mythical figures. Early training at the School of the Art Institute was in still life and figure painting. After leaving school she developed a semi-abstract expressionistic style with an emphasis on design and motif rather than color in woodcuts. Matisse's influence is evident in the concern with color harmony and relationship of parts of a work.

LADD, WILLIAM (Mixed Media Artist, Painter)
1728 W. Balmoral, Chicago, IL 60640

Born: 1952 *Awards:* Award of Excellence, Illinois Regional Print Exhibition; 3rd Place, New York International Exhibition; *Collections:* Carnegie Print Collection *Exhibitions:* Art Institute of Chicago; Fay Gold Gallery, Atlanta, Ga.; Norris Gallery, St. Charles, IL. *Education:* School of the Art Institute of Chicago.

His initial interests were in the Northern Renaissance as seen in the work of Albrecht Dürer, poetry and German philosophy. The study of Dürer subsequently led to an interest in printmaking and then to art school, where he discovered photography. The years between 1975 and 1983 were characterized by the incorporation of drawing and photography with lithography, screenprinting, and etching. It was at this time that he began concentrating on developing new printmaking techniques. His later work as a commercial artist led to his incorporating commercial art techniques with printmaking and photography. He currently works in large format mixed media incorporating photography, oil and enamel on masonite. Complex, rich pieces take up to six months to complete. His subjects are inspired by myth, poetry, and history, particularly those of Northern and Western Europe. Narrative and figurative, each work is built around one or more images, reflecting a synthesis of materials.

LADEWIG-GOODMAN, JEANNE (Painter)
C/O Contemporary Art Workshop, 542 W. Grant Pl., Chicago, IL 60614

Awards: 1st Place, 1980 Watercolor Show, Chicago Artists Guild *Collections:* Park Ridge Schools; Quinlan Gallery *Exhibitions:* Ferguson Gallery, Concordia College, River Forest, IL; Chicago Hild Cultural Center *Education:* Institute of Design, Illinois Institute of Technology; School of the Art Institute of Chicago

The German Expressionists' emphasis on color and feeling and the vigorous use of primary color in the artwork of children are noted influences. Paintings, which the artist says result from thoughts, memories, music, colors, sounds, feelings, and moods, are built up from layer upon layer of color, so as to leave actual recognition to the viewer. This limitation to the suggestion and feel of an environment is a relatively recent development. Earlier works used figures, buildings, and realistic landscapes.

LAMANTIA, JOE (Commercial Illustrator)
820 W. Howe St., Bloomington, IN 47401

Born: 1947 *Awards:* Print Advertising Annual Merit Award *Exhibitions:* Natalini Gallery, Chicago; Campus/Community Arts Center, Bloomington, IN *Education:* U. of Illinois

The covers of the literary magazine *Indiana Review* have been his exhibition space since 1985. An interest in the Bauhaus, the Dadaists and Surrealists, especially in their "assemblage" technique of collage, as well as knowledge gained from a variety of creative disciplines, including dance and theater, have led to a format of three-dimensional collages which are photographed for reproduction. Photos, photocopies, and real objects are combined into bright, upbeat images which frequently have some aspect of Indiana as the theme. Among several images which have been generated are *Indiana Power*, which set a neon sign and a paper model of a power plant in a landscape of coke and coal pieces; and *American Gothic*, complete with corn kernel typography, corn sprouts in topsoil and an updated photo of the famous couple.

LAMB, MATT (Painter)
1550 N. State Parkway, Chicago, IL 60610

Born: 1932 *Collection:* National Treasury, Washington,

Wm. Ladd, *Shadows,* 60x40, photograph

Alan Larkin, *Wedding Dance,* 50x40, oil. Courtesy:
Printworks Gallery

D.C.; Native Illinoisian's Collection, State of Illinois Building, Chicago *Exhibitions:* Spertus Museum of Judaica, Chicago; Galleria Renata, Chicago *Dealer:* Carl Hammer, Chicago

A funeral home director by trade, he is a self-taught Abstract Expressionist who began to work with a brush and palette knife in 1982. *Dachau* and *North and South*, his initial, very large oils, were vibrant emotional paintings depicting the human condition. He has moved on to watercolor, pen and ink, acrylics and mixed media, and his current compositions are dominated by flat forms, bold textures, and vivid colors. Inspired by children's books and the Old and New Testaments, he is a prolific painter whose joyful work is characterized by a special appreciation of life.

LAMIS, LEROY (Sculptor, Computer Artist)
3101 Oak St., Terre Haute, IN 47803

Born: 1925 *Awards:* Artist in Residence, Dartmouth College Collections: Des Moines Art Center *Exhibitions:* Museum of Modern Art; Whitney Museum *Education:* New Mexico Highlands; Columbia U.

In the 1960s he explored the potential and flexibility of sheet plastics in his tectonic structures. He based his work on constructivist principles, addressing three modes of plane construction: vertical and horizontal complementaries; twisted planes; and radiating compounded cubes. These luminous structures became shimmering cubes which receded into a symmetrical progression. His animated kinetic visual display, *EIGHT5'S* is a computer program designed to be seen on a color monitor as well as a work to be displayed on the wall. Like his other constructivist pieces, it is an interpretation of society, in this case, directed toward the tremendous potential for the use of computers in the art world.

LANGE, RICHARD (Painter)
3538 Pine Grove, Chicago, IL 60657

Born: 1943 *Awards:* Beatrice Grant *Exhibitions:* Sybil Larney Gallery, Chicago; Beacon Street Gallery, Chicago *Education:* U. of Illinois, Chicago; Columbia College, Chicago *Dealer:* Sybil Larney Gallery, Chicago

Recent paintings and charcoal drawings offer raw glimpses of scenes of hunters and their prey. Like the historical permutations of man's unsolved conflict with nature (to co-exist or to control, to live in harmony or exploit) the depiction of an apparent victory such as a man with a landed fish, reads as easily as a man fallen prey to his instinct to plunder, to a base impulse to destroy for trophy. These works are painted, not expressionistically but in haste, as if there were not the luxury of time to indulge in the mixing of color, or the careful preparation of canvas. On the contrary, paint is so hurriedly applied that it drips from the images and off the work, leaving splotches of exposed canvas and nerve.

LANTERMAN, MARGARET (Sculptor, Draughtsperson)
1934 W. Bradley, Chicago, IL 60613

Born: 1950 *Awards:* Illinois Arts Council; Illinois State Museum Purchase Award *Collections:* IBM; Quaker Oats *Exhibitions:* University of Illinois Gallery; Roy Boyd Gallery, Chicago *Education:* U. of Illinois,; Miami U., Ohio *Dealer:* Roy Boyd Gallery, Chicago

Abstract pastel landscapes depict a nature where man's presence is evident but does not impose upon the locale. Favored scenes include ancient Neolithic and pre-Columbian sites such as those she has visited in the Midwest and Southwest. Her impressions of these sites are transformed into luminous colors and symbolist forms inspired by such turn-of-the-century abstractionists as Arthur Dove and Georgia O'Keeffe. Sculptural works also convey the mythic and spiritual qualities of these sites. Commonly, she will modify and arrange actual stones, but she will also frequently tint concrete and cast iron along with wood to create large- and small-scale fragments of rooms or ritual spaces that the viewer can enter mentally but not physically.

LANYON, ELLEN (Painter, Printmaker)
412 N. Clark St., Chicago, IL 60610

Born: 1926 *Awards:* NEA Fellowship; Yadoo Fellowship *Collections:* Metropolitan Museum of Modern Art, NYC; Art Institute of Chicago *Exhibitions:* Metropolitan Museum of Modern Art, NYC; Museum of Modern Art, NYC *Education:* School of the Art Institute of Chicago; Iowa State U. *Dealer:* Richard Gray, Chicago; Susan Caldwell, NYC

Early depictions of her native Chicago landscapes are rendered in egg tempera. In 1951 she painted a series of monochromatic interiors from old photographs of relatives. Ten years later an interest in magic led to a series of fantastic paintings dealing with table magic. She is known for her many surrealistic works of the 1970s, such as *Spoolbox-Thread Web Construction* or *Super Die-Box*. These are primarily acrylic paintings on canvas which depict boxes opening like Pandora's to reveal insects, lizards, snakes and other creatures. Recent paintings and drawings do not feature boxes, but are rather delicate and sensitive depictions of birds, flowers, and fans in magic realist style.

LARKIN, ALAN (Painter)
1016 Washington, South Bend, IN 46601

Born: 1953 *Awards:* Merit Award, Boston Printmakers; 3rd Place, Hudson River Museum *Exhibitions:* Printworks Gallery, Chicago; Contemporary Art Gallery, New Harmony, IN; *Education:* Penn State U.; Carleton College *Dealer:* Printworks Gallery, Chicago

His early works, derived from his fascination with Albrecht Dürer, were highly complex black and white crayon lithographs dealing with an imaginary world, *The Garden of Delights*. In 1980, his work shifted to a multi-colored series, "Death Comes to South Bend." His previous concern with complex surface texture has shifted to a pursuit of refined surface, mimicking real material and influenced by the technique of 19th-century artists Le Page and Millais. Alternating now between oil painting and printmaking, the work is figurative, narrative and in large scale, seeking to create

Dennis Laszuk, *Neighbor Mexico,* 99x86, acrylic, nylon, plastic pipe and net

Bob Lee, *untitled,* oil on canvas

a sense of mystery while using bright "spotlights" to reveal the subject.

LARSON, STEVE (Painter)

P.O. Box 692, North Liberty, IN 46554

Born: 1950 *Awards:* National Watercolor Society Award; Best of Show, Elkhart (IN) Art League *Collections:* Midwest Museum of American Art; McDonald's Corporation *Exhibitions:* The Loadstone Gallery of Contemporary Art, South Bend, IN; Bicentennial Art Center and Museum, Paris, IL *Education:* Indiana U., Bloomington

His work reflects the conservative tastes of his Indiana customers. His media include both oils and watercolors, although he is better known for the latter because he travels with them. The vivid and deep tones of his watercolors make them appear to be acrylics, as he has developed a technique of applying many transparent layers of color. He has taught painting at the Fernwood Nature Center and at the Division of Continuing Education of Indiana University at South Bend.

LASZUK, DENNIS (Painter, Sculptor)

3359 N. Seminary, Chicago, IL 60657

Born: 1952 *Awards:* NEA Fellowship; Illinois Arts Council Fellowship *Exhibitions:* Contemporary Art Workshop, Chicago; The Renaissance Society, Chicago *Education:* Northeastern U.; School of the Art Institute of Chicago

Early three-dimensional paintings, which might very well be viewed as painted sculpture, represent his response to the frontiers of our century-space, the undersea environment and the microscopic. Curious about how a painting might relate to the expanded perception one might develop as a result of exploration in these frontiers, he chooses man-made materials such as plastic pipe, nylon, and acrylic because they too seem to represent exploration and invention. Currently, he is involved with a figurative series of work entitled "Corporate Logos," in which various social concerns are examined with respect to his earlier themes.

LAWRENCE, DIANE L. (Painter)

3426 S.E. Crestwater Dr., Topeka, KS 66605

Born: 1949 *Awards:* Technical Assistanceship Grant, Kansas Art Commission for Lithography; Honorable Mention, Watercolors, Topeka Art Guild Exhibition *Collections:* First National Bank of Illinois, Chicago; Anderson Accounting, Chicago *Exhibitions:* "Flower Visions," Wichita Art Museum, KS; "Art in Bloom," Merrill Gallery, Kansas City, MS *Education:* Kansas City Art Institute *Dealer:* Van Straaten Gallery, Chicago

Her training in studio art eventually led to floral still lifes in oil. As her work progressed, she became more interested in rendering the translucence of floral color and shifted into watercolor. She was drawn to floral subjects because of the artistic and expressive possiblities in color, form, and vitality of the image. Using a bright and varied palette, she depicts the processes of life and growth intrinsic to floral forms. She paints from life, preferring to render the flowers in larger- than-life,

close-up perspective, often without any container or vase in view. Her specialties are irises, water lilies, poppies, orchids, violets, and tulip-tree flowers. Her style is characterized by the deft manipulation of tonal contrasts and the handling of color, both in pools and within strict compositional limits. More recently, she has been interested in works which combine floral themes with images of the female body.

LAWTON, JAMES LEONARD (Sculptor)

3485 Zimmer Rd., Rt. 1, Williamston, MI 48895

Born: 1944 *Collections:* City of Detroit, Cass Park *Exhibitions:* Centennial Art Exhibition of the National Association of State, University and Land Grant Colleges, Federal Reserve Board Art Gallery, Washington, D.C. *Education:* Murray State U.; Kent State U.

His sculpture centers around three-dimensional compositions drawn from both naturalistic and imaginary sources. These include forms derived from urban and rural landscape, and formal structures that challenge traditional aesthetics through the displacement of readily comprehensible components. Not satisfied with formal innovation, he has also worked to achieve a "sculptural skin" with a painterly surface. The resulting structures evoke the humanistic experience of change.

LEAVITT, FRED (Photographer)

916 Carmen, Chicago, IL 60640

Born: 1941 *Awards:* Percent for Art, Chicago *Collections:* Norton Galleries, Palm Beach, FL; Vatican Collection, Rome *Exhibitions:* Rinaline Museum of Art; Santa Barbara (CA) Museum of Art *Dealer:* Printworks, Ltd., Chicago

Influenced by the geometry of Cartier-Bresson's work, the realism of Robert Frank and the humor of Elliot Brewitt, he bears the torch of "straight" 35 mm photography. His early photos were high-contrast studies of nature; in his later, urban images he reduced the size of the frame's subsection to the point where his principle subject became the relationship of subject and frame. The strong light he has used in recent black and white wild animal photographs results in graphic depictions and abstracts. Body language is one of his principle concerns in these images, which he printed on white seamless paper.

LEE, ROBERT (Painter)

4030 N. Kildare, Chicago, IL 60632

Exhibitions: R.H. Love Gallery, Chicago; Butler Museum, Youngstown, OH *Education:* Parsons School of design, NYC *Dealers:* Wiggins & Childers, Esq., Santa Fe, NM; T. Summers, Oklahoma City, OK

Through disproportionality he achieves a beauty unusual in the representation of the female form. His exhibit at the R.H. Love Gallery in Chicago was called "Femivision" and there, with a pointillist mastery of oil on canvas, he depicted fat women with small heads, delicate slender girls with elongated necks and fragile hands stretching out from elegant robes. Through pointillism he is able to mask the unusual blend of colors that brings about a rhythmic harmony to his work. While blues and purples have come to dominate his canvasses, he still introduces an abundance of various

D. Lenehan, *untitled,* 41 x 26, oil crayon on paper

colors in the same painting.

LEIS, MARIETTA PATRICIA (Painter)
2901 Euclid Ave., N.E. #21D, Albuquerque, NM 87106

Born: 1938 *Awards:* Honorary Distinction Award, International Art Biennial, Capranica, Italy; 4th Annual Faber Birren Color Award Show, Stamford Art Association, CT *Collections:* Sunrise Development Corp., Palm Springs, CA; First Interstate Bank, Albuquerque, NM *Exhibitions:* Chabot College Art Gallery, Hayward, CA; ASA Gallery, University of New Mexico *Education:* U. of New Mexico *Dealer:* Darmouth Gallery, Albuquerque

Obsessed with doors as both a literal and metaphorical form, she returns again and again to explore its possibilities. She constructs and paints doors, thus transforming them into art. Employing a wide range of materials, acrylic and oil paints, house paints, charcoal, plaster, straw, grouting and glass, the finished "door" confronts the viewer on a primal level, though its complex treatment also invites intellectual pursuit. While the surface is highly varied, the colors are closely modulated earth tones. As the form of a door, window, arch, invites one in, so does the subtle and highly layered surface of these pieces provide not a solution but an invitation to investigate.

LEMIEUX, ANNETTE (Mixed Media Artist)

Assembling objects evoking war, death, mourning and abandonment, she moves between various media such as sculpture, painting, photo-montage and readymades. Her works are laced with sarcastic irony. In *Party Hat*, she uses German helmets dotted with festive oil colors arranged vertically on the wall. In *Vancancy*, a large monochrome field holds a tiny red memorial star and smaller, oval frames contain convex bubbles of solid color, standing in for missing portraits. Unnecessary loss is powerfully felt in her work as she makes powerful substitutions for the missing.

LENEHAN, DANIEL (Painter, Draughtperson)
9958 S. Winchester, Chicago, IL 60643

Born: 1964 *Collections:* Beloit College Art Department *Exhibitions:* Beloit and Vicinity Exhibit *Education:* Beloit College

His earliest figurative work was influenced by Paul Klee, though the generalized postures, black-line characterizations and fragmented head shapes were his own. His subjects were usually solitary figures rendered with oil crayon on paper and projected from small to larger size. While he continues to use the same black line in his newer work, he has developed a more detailed treatment of the figure. His newer work has a lush stained-glass look, and though he still projects his initial drawings to full size, the stark surreality of his early work has given way to ironic physical impossibilities of a subtler kind. "I still work to make these images readable, and meaning-plural, although I still find dark or pessimistic topics most interesting."

LENTING, JOHN (Painter)
P.O. Box 325, Park Forest, IL 60466

Born: 1946 *Awards:* McDonald's Corp. 4th Purchase Prize *Collections:* McDonald's Corp.; University Park YWCA *Exhibitions:* R.D. Beard & Co.; Prairie State College *Education:* U. of Illinois, Chicago *Dealer:* Deborah Lovely Gallery, Oakbrook, IL

He has been working abstractly, using nature as a reference, since 1970. Inspired by de Kooning, Joop Sanders, Anton Heyboer and recently, Clyfford Still, his expressionistic figurative abstractions deal with superstitious, mystical, and subconsciously sexual imagery. Exploring multiple media, including unorthodox materials such as shoe polish and dental wax, he seeks spontanaiety in his work over an underlying structure. His technique involves rapid brushwork with large, thick strokes and incorporates an earthy palette with bright red and yellow highlights.

LERNER, ARTHUR (Painter)
368 W. Huron, Chicago, IL 60610

Born: 1929 *Awards:* Fulbright Fellowship; NEA Fellowship *Collections:* Art Institute of Chicago; Continental Bank of Illinois *Exhibitions:* The Art Insitute of Boston; University of Michigan Museum of Art *Education:* School of the Art Institute of Chicago *Dealer:* Jan Cicero Gallery, Chicago

Early work deals with symbolic and mythological subject matter, influenced by painters such as Soutine and Hyman Bloom. Following this are figurative works influenced by Giacometti and Bacon, which are concerned with the "existential condition." In more recent years, he has directly confronted natural objects and landscapes; first through the exploration of the abstract elements found in objects such as shells, stones and flowers scattered on his studio floor and later through direct observation of the Maine coastline. Most interested in describing the tentative balance between the abstract and the real, the configurations of rock, debris, light and shadow enable this painter of large scale oils to work both representationally and abstractly.

LEVIN, PAMELA GILFORD (Painter)
1666 Cloverdale Ave., Highland Park, IL 60035

Born: 1951 *Awards:* McDonald's Corp. Purchase Prize; Affiliated Bank Group Purchase Prize *Collections:* Schiff, Hardin & Waite; Cole Taylor Financial Group *Exhibitions:* Two Illinois Center, Chicago; Jack Gallery, New York *Education:* U. of Iowa; Harvard U. *Dealer:* Sybil Larney Gallery, Chicago

The current spiritual nature of her work has grown out of an initial focus on fantasy. The hard and soft geometric elements found in previous works are now present in readily identifiable architectural images, such as pools, columns, and stairs that float within diffuse substructures. A recent series, "Someone Else's House," marks her expansion technically from exclusively two-dimensional to occasional three-dimensional works, which include sculpture and incorporate elements such as glass, stone, and light. Through a consistent process orientation and the use of universal rather than personal shapes, the artist endeavors to manifest a transcendant equilibrium.

LEVINE, SHERRIE (Painter, Mixed Media Artist)

Elizabeth Collins Lewis, *Boneyard,* 44x30, pastels on paper. Courtesy: Zaks Gallery

c/o Mary Boone Gallery, 417 West Broadway, New York, NY 10012

Born: 1947 *Exhibitions:* Baskerville and Watson Gallery, NYC; Wadsworth Atheneum, Hartford, CT *Education:* U. of Wisconsin, Madison *Dealer:* Mary Boone Gallery, NYC

Around 1976 she began a series of silhouettes called "Sons and Lovers," portraits of Washington, Lincoln and Kennedy taken from coins, and subsequently cut silhouettes out of photographs found in magazines. Ideas regarding appropriation led to work which clearly exposed its origins in past art: she re-photographed work of the famous photographers Edward Weston and Eliot Porter and her new copy prints were shown at Metro Pictures. She also copied paintings by Miro, Mondrian and Malevich, among others; says Gerald Marzorati, "she made it clear that piracy, with its overtones of infringement and lack of authorization, was the point." Recent works move in another direction: the "Gold Knot" series employs bare plywood panels in which only knots in the wood are painted gold; "Broad Stripes" are mahogany panels with vertical stripes painted in casein. In some instances, stripes have been applied to prefabricated wooden chair seats.

LEVINSON, BETTO (Painter)
1040 Lake Shore Dr., Chicago, IL 60611

Born: 1910 *Exhibitions:* Spertus Museum, Chicago; Evanston Art Center *Education:* Silvermine Art Guild, Norwalk, CT; School of the Art Institute of Chicago *Dealer:* Prism Gallery, Evanston

From the late 1960s until recently, her efforts were in etching, collography, and mixed media printmaking. Her method involved random application of asphaltum and soft grounds from which she would discover form, working directly from predetermined non-objective forms or objects. Currently her concentration is on painting in oil, acrylic, and mixed media. Abstractions based on a mother-and-child motif are done with bright colors, notably pink, grey, blue, and orange. The style is derivative of the abstract expressionists and cubists, special influences being Kandinsky and de Kooning.

LEWIS, ELIZABETH COLLINS (Painter)
1121 Oak Ave., Evanston, IL 60202

Born: 1941 *Awards:* Illinois Arts Council 1987 Special Assistance Grant; McDonalds Corp. Purchase Prize *Collections:* McDonalds Corp. *Exhibitions:* Artemisia Gallery, Chicago; Northern Illinois University *Education:* Art Students League of New York; Wayne State U. *Dealer:* Zaks Gallery, Chicago; Chicago Consultants for Contemporary Art

In monumental studies of women and men portrayed with empty garments, mannequins, and isolated environments, the artist addresses issues such as aging, solitude, love, and death. Elements of nature such as animal skulls, tree limbs, prairie grass, and light and shadow from the rising or setting sun play dramatic roles in these combined interior/exterior views, reflecting the influences of such artists as Bacon and De Chirico. Primarily working in oil on canvas until the early 1980s, the artist now creates densely built surfaces of pastel in cool colors for her realist/surrealist diptychs and triptychs.

LEWITT, SOL (Sculptor, Conceptual Artist)
c/o John Weber Gallery, 1452 Greene St., New York, NY 10012

Born: 1928 *Collections:* Museum of Modern Art; Albright-Knox Gallery *Exhibitions:* Josef Albers Museum, West Germany; ARC, Paris *Education:* Syracuse U. *Dealer:* John Weber Gallery, NYC

After working for architect I.M. Pei in the mid-1950s, he began making wall reliefs and then three-dimensional sculptures. With the open, modular, cubical structures of 1964 he was recognized as a Minimalist. Wall drawings three years later were deliberately painted over after their exhibition, emphasizing their impermanence. A spokesman for Conceptual Art, he published several articles in the late 1960s describing the artist's concept and formulation of an idea as more important than its execution. Wood or metal open cubes in various arrangements are painted white in order to draw attention away from the display itself. The titles are significant because they bring meaning to the work by describing its premise, clarifying the abstractions of mathematics, philosophy and linguistics.

LICHTENSTEIN, ROY (Painter)
P.O. Box 1369, Southampton, NY 11968

Born: 1923 *Collections:* Whitney Museum of American Art, NYC; Museum of Modern Art, NYC *Exhibitions:* Solomon R. Guggenheim Museum, NYC; Whitney Museum Annual, NYC *Education:* Ohio State U.; Art Students League *Dealer:* Leo Castelli Gallery, NYC

As a young painter his style was abstract expressionist, but in 1957 cartoon images from bubble-gum wrappers were his motifs, and during the early 1960s he became increasingly concerned with making art from mass-produced merchandise. Huge reproductions of single frames from comic-strips using Ben Day dots (a simulation of the typographic technique) were contributions to the Pop movement.

In later years media included sculpture reliefs which were representations of images borrowed from comic-strips and art deco. Reproductions of advertising fragments, travel posters, romance characters or stylized landscapes make insipid what is already trite. He avoids definition by continuing to make derivatives. Using an anonymous language, the sources are transformed, presenting new terms for understanding art.

LIPSKI, DONALD (Sculptor)

A combination of raw materials found on city streets inhabit Donald Lipski's art. On the surface, a playful superficiality pervades the assemblies, involving such elements as a steel conveyor belt, a shovel, baby shoes, pennies or maps. Each work combines two or three elements. There is an obsession with roundness; coils, wheels, cones, and dials. Lipski adheres to a literalism which treats all objects the same way. Hierarchy is absent. For example, money loses its symbolic value by representing metalic discs which stamp the rubber of car fan belting. Maps become simple surfaces. This

Connie Livingston-Dunn, *Three Phases of Eve, 15x23*, watercoler. Courtesy: Bergren Gallery

Joan Lycardi, *Bee, Fern & Barb, 19x26*, pen and ink

literalism has become an important modern technique. As it liberates the objects from human or humanist meaning, the humor seems to be enjoyed not by the viewer, but by the objects themselves.

LIU, YAO ZEN (Painter)
2317 W. Taylor St., Chicago, IL 60612

Born: 1945 *Collections:* Luwen U., Belgium; China National Art Gallery *Exhibitions:* East West Contemporary Art Gallery, Chicago; Shanghai Art Gallery, Shanghai *Education:* Shanghai Fine Art College; U. of Iowa

Influenced by the great European Masters, he developed a realistic style of oil painting. His subject matter included the distinguishing characteristics of people from different walks of life and different professions. Drawing his motifs from Chinese historical figures and events in modern society, he transferred emotions to the canvas by arranging people's activities artistically. In 1983, he came to the U.S. to study painting. While here he did study work from nature, developed sketch skills and techniques of using both brush and palette knife to build up oil paint, explored the use of color combinations, and began using imagination and memory as a source of creative energy.

LIVINGSTONE, BIGANESS (Painter)
Art Dept., University of Wisconsin, Fox Valley, Midway Rd., Menasha, WI 54952

Born: 1936 *Awards:* Bunting Institute for Independent Study, Radcliffe College *Collections:* Chase Manhattan Bank, New York; Shiff, Hardin & Waite, Chicago *Exhibitions:* Zolla/Lieberman Gallery, Chicago; Limelight, Chicago *Education:* Massachusetts College of Art; U. of Wisconsin, Madison *Dealers:* Cudahy Gallery, Milwaukee Art Museum, WI

Her early works were figurative and expressionistic, and were followed by a series of conceptual, cut-out canvases. In 1980, she returned to her previous figurative, gestural style. These works were characterized by their large scale, fauve palette, energetic brushwork and emotional energy. In 1986 while on sabbatical, she began to acquaint herself with the opportunities of computer-generated images. These works feature renditions of heads on rag paper and canvas. She creates the image using a stylus on a pad attached to the computer keyboard. As she draws, the image appears on the computer monitor. Her software mimics the appearance and texture of a variety of conventional art tools and materials. She stores the images on a diskette and produces the final image using a color inkjet printer attached to the disk drive. She is currently at work on large, 5 foot canvasses generated with the aid of a computer.

LIVINGSTON-DUNN, CONNIE (Painter)
107 E. Oregon, Polo, IL 61064

Born: 1940 *Awards:* 3rd Place Illinois State Fair Professional Art Exhibition *Collections:* Sauk Valley College; Mersey Side County Museum *Exhibitions:* St. Lukes Medical Center, Chicago; 5th Annual Art Education Show, Chicago *Education:* Northern Illinois U. *Dealer:* Donna Moore Studio, Dixon, IL; Bergner Gallery,

Rockford, IL

Her passion for painting exotic scenes in oils began during her residence in Hawaii in the early 1960s and was influenced by oriental art as well as the impressionists and post-impressionists. As a registered art therapist, the influences of the expressionists became prominent in the 1970s when she also began painting in watercolor. The rainbow and other feminine symbols of heightened awareness are found in these works. During this period she was greatly influenced by Prendergast, Gaugin, Mattise and O'Keeffe. Currently her oils are painted left-handed due to permanent damage to the muscle and nerve of her right arm. These are aerial views of landscapes and cityscapes. Her watercolors contain mystical symbols of vibrant colors and sensations in tropical scenes which have been influenced by the philosophy of Kandinsky and other visionary artists.

LLOYD, TIMOTHY L. (Metalsmith)
22 Fareway Drive, Northfield, MN 55057

Born: 1937 *Collections:* Smithsonian Museum, Washington, DC; C.M. Russell Museum *Exhibitions:* Museum of Contemporary Crafts, New York; Clark Gallery, Boston *Education:* School for American Craftsmen, Rochester Institute of Technology *Dealer:* Esther Saks Gallery, Chicago

Historically, his work includes one-of-a-kind pieces of jewelry typified by use of color and texture. Recurring themes include the use of smooth, circular shapes contrasted with irregular and repetitive constructed elements, using reflections to attain depth in the relatively flat pieces. His influences include formal study with Hans Christiansen and informal study in Europe over a period of five years. Similar themes are apparent in commissioned work, including raised vessels, church artifacts, and medallions. Materials used currently are silver and gold, contrasted with colored niobium, tantalum, or titanium. Many pieces use landscape, high-altitude images of Earth, and geologic forms as subject matter.

LOGSDON, WOODY (Photoweaver)
P.O. Box 72, Versailles, IL 62378

Born: 1948 *Awards:* Member, Royal Photographic Society of Great Britain *Exhibitions:* Art Institute of Dayton, OH; Illinois Artisans Shop, State of Illinois Building, Chicago *Dealer:* Illinois Artisans Shop, Chicago

His interest in cutting up photographs goes back at least twenty years. He has always wanted to extend the photographic image beyond two-dimensional. Although he has produced an extensive body of traditional photography, he has no compunction about cutting up a photograph to reassemble it into another composition. By treating the image in this open manner, he believes he can contribute to photography's maturation as an art form. Photoweaving melds photography with weavng to create a new type of art form. The process involves cutting or tearing photographs into various width strips and reassembling them using weaving techniques. The resulting pieces display a type of

deconstructed, extremely tactile surface wholly unlike other types of photographic treatment.

LONG, LOIS A. (Photographer)
2836 W. Leland, Chicago, IL 60625

Born: 1940 *Awards:* IL Arts Council, Grant & Fellowship *Collections:* Standard Oil, Borg-Warner *Exhibitions:* Chicago Cultural Center; Kodak Show, School of the Art Institute of Chicago *Education:* Mudelein College; School of the Art Institute of Chicago

She came to photography after formal training in the ideas of the Cubists and the Bauhaus School and after several years experience in painting and printmaking. In 1978 she began documenting the paintings she found on the walls of urban buildings and the manufacturer's castaways such as metal scraps and glass shards she saw as found sculptures. The works of both Ray Metzker and Aaron Siskind were very important to her at this time. By 1983 she was using glass shards and mirrors for their reflective capabilities. She has made studies of light, shadow, glare, and reflection and is concerned with layering and fragmenting forms. Her color photographs both challenge and delight the viewer, playing with his sense of space and his understanding of the real and abstract.

LONG, RICHARD (Sculptor)
121 York, Bristol, BSG 5QG, England

Born: 1945 *Collections:* Museum of Modern Art, NYC; Art Institute of Chicago *Exhibitions:* Anthony d'Offay Gallery, London; Gallerie Konrad Fischer, Zurich *Education:* West of England College of Art, Bristol; St. Martin's School of Art, London *Dealer:* Donald Young Gallery, Chicago

Concerned with ideas of time, movement and places, Richard Long uses stones, sticks, seaweed and other materials to re-create fundamental shapes familiar to all of mankind. In one piece, Long selected rocks from a quarry and arranged them in two simple circles around an open ring. His simple geometric drawings on papers and walls are created with river mud. He is a classical artist using economy of image and congruity in materials. Long speaks to human memory with works resonating calm.

LOPEZ, JOYCE P. (Painter, Sculptor)
1147 W. Ohio St., Chicago, IL 60622

Born: 1941 *Awards:* Illinois Arts Council *Collections:* Bank of America; Burroughs Corp. *Exhibitions:* Ukranian Museum of Modern Art; Klein Gallery, Chicago *Education:* School of the Art Institute of Chicago

The artist works with many contrasts. She attempts to make opposites visually and emotionally compatible, though not necessarily harmonious. In the 1970s, she addressed these concerns along with the life and death issues of the Phoenix Fable in a series of non-literal, abstract acrylic paintings on unstretched canvases. Currently she evokes both architectural plans and the art deco movement by superimposing geometric black and white shapes over quiet, watercolor-like pastel areas in acrylic on gessoed stretched canvas paintings. In this work, stark unpainted areas contrast sharply with painted ones, as in a contrast between noise and silence.

LOSTUTTER, ROBERT (Painter)
c/o Dart Gallery, 750 N. Orleans #303, Chicago IL 60610

Born: 1939 *Collections:* Art Institute of Chicago; Museum of Contemporary Art, Chicago *Exhibitions:* Renaissance Society, U. of Chicago; Dart Gallery, Chicago *Education:* School of the Art Institute of Chicago *Dealer:* Monique Knowlton Gallery, NYC; Dart Gallery, Chicago

In the late 1950s he was influenced not by Abstract Expressionism but by John Rogers Cox, an academic painter who spoke of the importance of preliminary drawings and glazing methods. Richard Lindner also influenced his development of a personal iconography. Unlike many of his fellow Chicago Imagists he is very concerned with technique, and spends many hours working on preparatory sketches and watercolors before painstakingly painting, glazing and repainting. Early imagery centers upon masked figures in some type of bondage with ropes. During the mid-1970s bird-like heads or masks were added to the figures, and more recently flowers were tied to a figure's chest or head, as in *Hummingbird and Two Orchids*. These quasi-erotic paintings also seem to express the pleasure and pain of man's co-existence with nature.

LOVE, ED (Sculptor)
PO Box 530745, Miami, FL 33138

Born: 1936 *Awards:* Guggenheim Fellow; Individual Award in the Arts, Washington, D.C. Commission on the Arts *Exhibitions:* "Constructs," Montpeliar Arts Center, Laurel, MD; "Soundings," Howard University, Washington, D.C. *Education:* California State U., Los Angeles

A distinguished sculptor, he is best known for his expressive pieces executed in welded steel and chrome. His abstracted figures vividly depict the various themes which recur throughout his work: social oppression and justice, music, sexuality, mythology, and African ritual. His totem series, for example, celebrates the connection he feels to great jazz musicians such as Charlie Parker, John Coltrane, and Thelonious Monk. Other works depict the dominant characters in the Egyptian Book of the Dead, Isis, Osiris, Set and Horus. Although these ideas span many times and cultures, the metal scraps and car bumpers he uses speak to a pan-cultural contemporary audience of the industrial age. A professor of art at Washington, D.C.'s Howard University for over twenty years, he has recently been named founding Dean of Visual Arts at Miami's New World School of the Arts.

LOVE, RICHARD (Painter)
600 N. McClurg Ct., Chicago, IL 60611

Born: 1939 *Collections:* Post Collection, Switzerland; Vagnino Collection, St. Louis, MO *Education:* Northwestern U., Evanston, IL; U. of Illinois, Chicago *Dealer:* DiLaurenti Gallery, New York

For the past seven years, his work has centered on figurative studies in a quasi-surrealistic manner. Using many iconographic elements, the work is an amalgam of imagism and surrealism. Always employing strong

contrasts, the work explores good/bad, ugly/beautiful as part of his view of a future pluralistic society. Contemporary American life provides much of his imagery for commentary on the Middle Eastern War and other historical reference points.

LOVING, RICHARD (Painter)

1857 W. Armitage, Chicago, IL 60622

Born: 1924 *Collections:* Art Institute of Chicago, Museum of Contemporary Art *Exhibitions:* Lerner/Heller Gallery, NYC; Roy Boyd Gallery, Chicago *Education:* New School for Social Research, NYC *Dealer:* Roy Boyd Gallery, Chicago

In the 1960s he gained national recognition by painting figurative surrealistic imagery with vitreous enamel. This work evolved through a series of large scale drawings to his recent abstract symbolic oils on canvas and wood panels. He layers technique and meaning in a metaphor for consciousness. Intense dots, dashes, and small brush loads of paint, suggest complex fields of energy. While he presents a veiled metaphysical language through symbolic elements such as flowers, crystal, flames, falling water, and curtains, he nonetheless makes abstract relationships an important component of his works. His flat shape and illusionary depth reflect the dichotomies of stressed relationships.

LOWITZ, TED (Painter)

1776 W. Winnemac Ave., Chicago, IL 60640

Born: 1956 *Exhibitions:* Randolph Street Gallery, Chicago; University Club, Chicago *Education:* Brown U.; U. of Illinois, Chicago

He is best known for his simple conceptual installations that invite viewers to turn their thoughts inward and savor a moment of introspection. Other conceptual works include modest hand-held assemblages of everyday objects which, when combined, remind us of the presence of the sublime in everyday life. All of this early work is characterized by a straightforward handling of materials. In 1986, he returned to abstract painting in an effort to address the sublime more sensually. He is currently involved in a long-term investigation of the formal, psychological, and other constituents that play a part in our endeavor to touch the sublime.

LUECKING, STEPHEN (Sculptor)

1934 W. Bradley, Chicago, IL 60613

Born: 1948 *Awards:* Clussman Prize, Art Institute of Chicago; Illinois Arts Council Fellowship *Collections:* ARCO; Quaker Oats *Exhibitions:* Chicago Cultural Center; Purdue U., Indiana *Education:* Quincy College; Miami U. *Dealer:* Roy Boyd, Chicago, Los Angeles

His spare, industrially crafted steel and cast iron abstractions betray the reductive and theoretical influences of minimal and conceptual art. In suggesting ancient scientific and astronomical instruments, his sculptures also reflect both a stint the artist had as a surveyor during 1975 and a long-held interest in astronomy of the past. Cosmographs, highly schematic scientific and religious diagrams of the universe, from

diverse cultures and periods, are currently his major inspirations. The paintings he derives from these sources are more embellished, intimate and radiantly colored than his sculptures. Executed in oil and alkyd on paper, wood, or fresco, they strike a more markedly religious chord as well.

DIERDRE, LUZWICK (Draughtsperson)

W9442 Golfside., Cambridge, WI 53523

Born: 1945 *Exhibitions:* Madison Art Center; Artemisia Gallery, Chicago *Education:* Ripon College *Dealers:* Cudahy Gallery, Cudahy, WI; Milwaukee Museum of Art

She is a self-taught graphic artist who specializes in charcoal. Since 1973 she has transformed biblical imagery into a space-age vernacular. In her extremely detailed 18- by 24-inches charcoal on paper pieces she combines a realistic, Dürer-like narrative imagery with a subliminal symbolism reminiscent of Dali. In 1976, sixty of her drawings were published under the title "The Surrealists' Bible." In her latest collection of one hundred forty drawings, "Christ-Kin," she interprets the life and teachings of Christ. She is presently dealing with themes of depersonalization in a super-technological age in a book to be called, *The People.*

LYCARDI, JOAN (Draughtsperson)

5229 W. 64th St., Chicago, IL 60638

Born: 1946 *Awards:* 2nd Place, National Society of Artists, Santa Fe, TX; 2nd Place, Koshare Kiva, La Junta, CO *Exhibitions:* Amos Eno Gallery, NYC; Fort Wayne Museum of Art *Education:* American Academy of Art

Her early watercolor paintings of children are innocent unblemished views of life. After working with watercolors for a period of years, she began to find it too soft and limiting a medium. She moved to pen and ink and there found a hospitable environment for her cast of characters of all ages. The medium allowed her to stimulate a more uniform response while casting shadows on the darker side of human nature. While realism has dominated her past works, she is currently making surrealist war shields and masks depicting emotional facades. The works are executed in molded paper, acrylic, and found objects.

LYNCH, TOM (Painter)

605 N. Chestnut, Arlington Heights, IL

Born: 1950 *Collections:* Neville Public Museum; Burber Art Museum, Rockford, IL *Exhibitions:* Paris Preview, Arlington Heights, IL *Education:* American Academy of Art; U. of Illinois *Dealer:* Merrill Chase Galleries, Chicago; Richard Thompson Galleries, San Francisco

While three years spent working as a commerical illustrator reinforced his technical skills, it was his private study with American masters in watercolor that provided the ground for him to develop his current impressionistic style. Though he loves to paint cityscapes and rural woods, he does so not so much to capture the details but rather the mood. Painting lightly with vivid colors and contrasting dark and light passages has become his hallmark, one that secured him a job teaching painting for the television series, "The

Ray E. George, *4/3/87,* 45 x 59, drawing

Barbara Frith, *Birds,* 30 x 57, watercolor, pastel. Courtesy: Hodgeman Collection

J. Alex Galindo, *R. C. Gorman,* 15 x 15, cibachrome print

Tom Heflin, *A World at Peace,* 48 x 60, oil on canvas. Courtesy: Mr. & Mrs. John McDonough

Diane Grams, *Escape I: Return to the Womb, Escape II,* 48 x 30 each, oil on canvas

Jeanne Goodman, *Purple Sound,* 24 x 36, oil

Lynn Slattery Hellmuth, *Ring of Power,* 120 circle, stiffened burlap

Winston Hough, *The Magician,* 45 x 50, oil, acrylic

William A. Hoffman, *The Mad Hatter's Teapot,* 18 high,
glazed ceramic

Kay Hofmann, *Pulling Away, 18 x 14 x 9,*
pink alabaster

Eleanor Himmelfarb, *Act III,* 40 x 40, acrylic

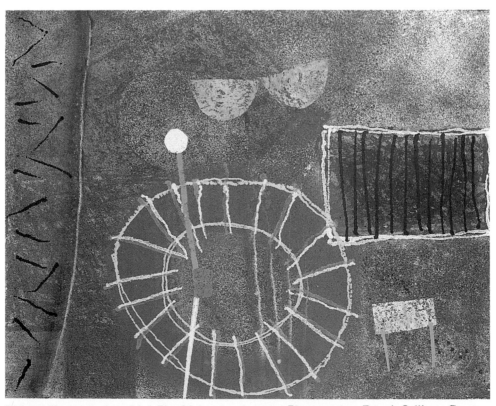

Richard Hungerford, *untitled,* 70 x 86, handmade paper. Photographer: Dennis Sullivan. Courtesy: Alter/Associates, Inc.

Teddy L. Johnson, *The Flock,* 18 x 24, pastel

Jennifer R. Hunter, *Acadian Coast,* 18 x 24, oil on linen

John Himmelfarb, *Listening In,* 40 x 72, oil on canvas. Courtesy: Terry Dintenfass, New York. Photographer: Ruyell Ho

Anna Johnson, *Earth/Sky Parallels,* diptych, 52 x 40, acrylic & gesso on 100 percent rag paper

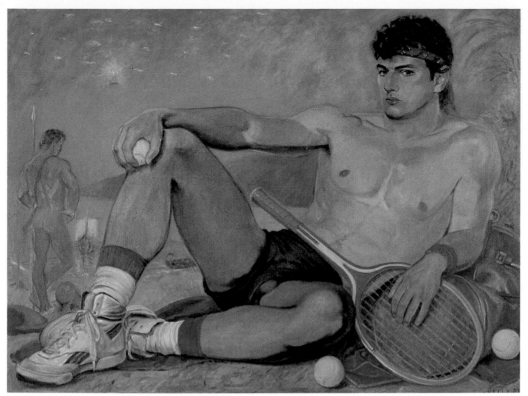

Daniel Kelly, *Portrait of David Bussy (with Reverberations from the Bronze Age),* 36 x 48, oil

Julie Kiefer-Bell *Foliar BR-1,* 36 x 49, oil

Kaycee, *European Odyssey,* 72 x 72, oil

Vita Krall, *Waterfall,* 9 x 12, watercolor

D. Lenehan, *untitled,* 26 x 41, oil crayon, oil paint on paper

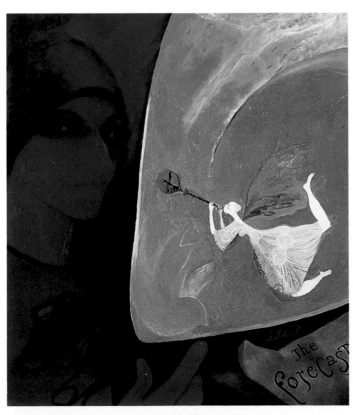

Gilda Kolkey, *The Forecast,* 28 x 24, oil on canvas

Adrienne Kyros, *Vision of Color,* 23 x 30, watercolor

Connie Livingston-Dunn, *Castle Rock Goddess,* 20 x 16, water-
color. Courtesy: Bergren Gallery

Linda Kramer, *World Energy,* 72 x 96 x 168, ceramic, wood, paint

Bob Lee, *Les Femmes De La Nuit,* oil on canvas

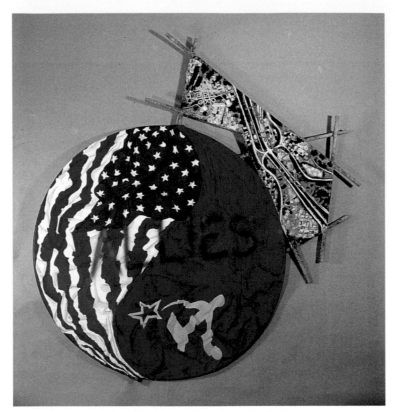

Dennis Laszuk, *Allies,* 82 x 86, acrylic, nylon, plastic pipe

Alexandra D. Kochman, *Into the Sky,* 54 x 102, raku fired clay tiles. Photographer: Jerry Kobylecky. Courtesy: Judith Racht Gallery

Wm. Ladd, *Cinematic Shoes,* 50 x 60, mixed media

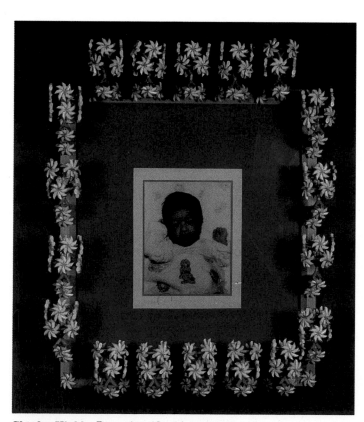

Charles Kinkle, *Dreaming,* 19 x 14, sculpture

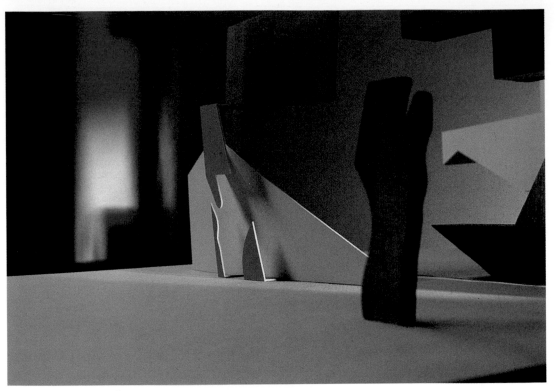

David Miletto, *Waco Continued,* 12 x 25 x 23, mixed media

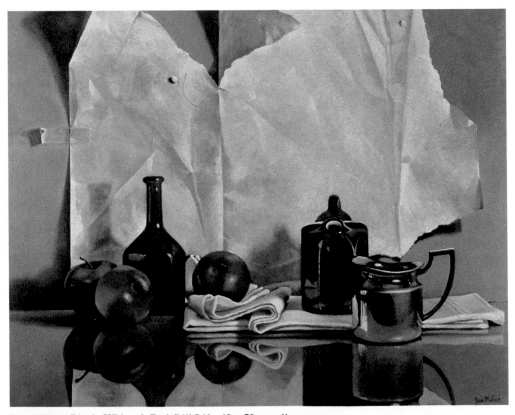

Jan Miller, *Black, White, & Red Still Life,* 40 x 50, acrylic on canvas

Magic of Watercolor."

MACAULAY, THOMAS (Sculptor)
5510 S. Scarff Rd., New Carlisle, OH 45344

Born: 1946 *Awards:* Guggenheim Fellowship; Asian Cultural Council Fellowship *Exhibitions:* O.K. Harris Gallery, NYC; Artemesia Gallery, Chicago *Education:* Saint Olaf College; U. of Iowa *Dealer:* Twining Gallery, NYC

An exploration of the process of perception has been the subject of the site-specific installations of this environmental artist. Audience interaction is the focus of the work, with the act of questioning being the content. Installations alter existing architecture by introducing information which conflicts with the designed spatial order of the site, presenting two competing perceptual sets simultaneously. Initial disorientation, a moment of resolution and final inability to visually control the environment is accomplished by weaving into the space known and unknown, ordered and chaotic, real and mimetic and two and three-dimensional spatial information. Materials used to transform the space include tape and metallic reflective paper; basic forms such as circles are the formal touchstones in the intellectually and conceptually playful vertigo-inducing installations.

MACHIN, ROGER (Sculptor)
1436 W. Randolph, Chicago, IL 60607

Born: 1955 *Awards:* National Endowment of the Arts Grant; Illinois Art Council Grant *Collections:* De Paul U., Chicago; Niagara U. *Exhibitions:* Art Park, NY; Chicago Sculpture International Mile 4, Chicago *Education:* Brighton Polytechnic, Sussex, England; School of the Art Institute of Chicago

Raised in England, he arrived in Chicago in 1978 to study sculpture. Working as an ironworker to get his "green card," he began generating large-scale pieces. The early pieces are "half improvised, half manufactured," using principally steel plus a wide variety of other materials. After ten years, he is building what he calls "three-dimensional allegories." These pieces often appear scientific with an apparent function; however, upon closer inspection, it is discovered they are not. A British satirical sensibility is operative here, where parts that appear to be capable of precise, mechanical movement are in fact wholly nonfunctional. Currently he is working on a smaller scale and watching for the influences of his recent travels in East Central Africa. of a trip to Africa.

MACQUEEN, JOHN (Photomontage Artist)
1858 W. Iowa, Chicago, IL 60622

Born: 1950 *Awards:* Illinois Artist Fellowship *Exhibitions:* Evanston Art Center, IL; Illinois Regional Print Show *Education:* School of the Art Institute of Chicago

Taking direction and inspiration from his lifetime interest in Egyptian hieroglyphics and an encounter with Diego Rivera murals in Mexico, his work has been oriented to mass media for presentation to the general public. Using contemporary symbols, the images reflect the timeless and essential elements basic to all societies: male and female energy, deterioration and destruction, birth and creation. Currently, images are high contrast black and white photomontages. Transferring the montage to the hoto silkscreen process, he produces large prints that are displayed on the advertising spaces of the Chicago Mass Transit system. Six sets of prints have been installed since 1983. In 1985, he expanded his project to include a billboard in the heart of the Chicago Art Gallery district.

MADEJCZYK, JANE (Painter)
6456 N. Lakewood, Chicago 60626

Born: 1946 *Exhibitions:* State National Bank of Evanston, IL; Midwestern Realists *Education:* School of the Art Institute of Chicago; U of Pennsylvania

Moderately sized oil paintings depict intimate nocturnal scenes. Figures in domestic environments and household objects reflected in moonlit mirrors are predominant themes. Her involvement is with the power of color and the relationship of color to convey the recognizable forms of the visible world and to express the inner spirit of a place, an object or a person. The moderately sized works reflect the influence of Charles Burchfield, Arthur Dove, Fairfield Porter and Alice Neel. Her particular style of painterly realism was influenced by her study with Neil Welliver.

MADSON, JERRY (Painter, Mixed Media Artist)
P.O. Box 891, Bemidji, MN 56601

Born: 1948 *Exhibitions:* Lyn Kottler Gallery, NYC; Duluth Billboard Project, MN *Education:* Bemidji State College, MN

In the late 1960s he abandoned art school to investigate expressionism and suprematism. He accomplished his artistic statements of the era through dripping paint, hard-edge line, Dada, and the colorist techniques of Albers and Reinhardt. Today he creates "alla" or art language. The work takes place at "the point where the curves of expressionism and minimalism meet." The degree to which each of his landscapes contains language extends from one word to a total abstraction devoid of symbols. In 1984, his work was the subject of a program presented by Universidade de Mato Grosso in Brazil. He is also a poet.

MAHMOUD, BEN (Painter)
School of Art, Northern Illinois University, DeKalb, IL 60115

Born: 1935 *Awards:* Fellowship, Painting, NEA *Collections:* Art Institute of Chicago; Brooklyn Museum, NY *Exhibitions:* Illinois State Museum; Northern Illinois University Gallery, Chicago *Education:* Ohio U. *Dealer:* Zaks Gallery, Chicago

From the 1960s until the mid-1970s, he worked in a photorealist style, painting from photographs. Since then, he has developed a more personal iconography as a result of a growing interest in psychology. He works on a rather large scale, usually 40 inches by 60 inches, with acrylics and mixed media. His palette tends toward darker hues, with a predominance of deep blues, maroons, and aquamarines. His most recent work, on the theme of bathers, seems to be evocative of a post-modernist attitude. The imagery is drawn from his dreams, and the narrative tension apparent in his paint-

ings derives from struggle between cynicism and innocence.

MAHONEY, BARBARA BAYNES (Painter)
2740 Blackhawk Rd., Wilmette, IL 60091

Born: 1931 *Collections:* Mrs. Richard M. Nixon *Exhibitions:* American Watercolor Society, NYC; Butler Institute of American Art, PA *Education:* Mundelein College, Chicago; School of the Art Institute of Chicago *Dealer:* Joy Horwich Gallery, Chicago

Freely painted yet realistic renderings of architectural subjects in watercolor and pen and ink are her speciality. Transforming a fascination with new conceptions of cities and a nostalgia for the classical building types, the large-scale works combine the softness of historical edifices with the starkness of skyscrapers in a joyous, whimsical fashion. The influence of Raoul Dufy and Mark Tobey is apparent in many works, which are done in a palette comprised mainly of pastels and "off colors." Much of her work is done on commission for corporate collections.

MALAGRINO, SILVIA A. (Photographer)
4421 N. Paulina, Chicago, IL 60640

Born: 1950 *Awards:* 1988 Illinois Arts Council Fellowship; 1987 Community Arts Grant, Chicago Office of Fine Arts *Collections:* Latin American Museum, OAS, Washington, DC; Museum of Contemporary Photography, Columbia College, Chicago *Exhibitions:* Museum of Mexican Art, Chicago; Centuro Cultural General, San Martin, Buenos Aires, Argentina; *Education:* Philadelphia College of Art; U. of Illinois

She was trained in French and Spanish literature and influenced by Mallarme, Cortazar, and Garcia Marquez. The year following the 1976 coup d'etat in her native country of Argentina, she began to take pictures when the university was closed. Initially a means to resist and to elude censorship, her involvement in photography became a principal mode of artistic expression. Photocollages combine media images with personal photos, drawings, and written messages. Recent series explore the relationship between inner life and the exterior world, with themes such as the tension between the effects of coercion and the drive for personal autonomy, the relationship of past to present, and time as a both a personal and a collective experience.

MALLINSON, JOHN-LUKE MICHAEL (Painter)
1322 W. Thorndale, Chicago, IL 60660

Born: 1958 *Exhibitions:* The Prism Gallery, Evanston Beginning as a self-styled naive Christian mystic, he gathered imagery from contemplative meditation. He spent five years in volunteer social service, which helped to shape his spiritual and social world view, and he then began applying his experiences to visual art. At first, these endeavors were limited to moderately-sized, expressionist oil paintings. To enhance his ability to communicate in the post-modern world, he recently began educating himself in art theory. He sees two forces directing his work--one being what he considers the constraining need to use currently accepted symbols and methodologies in order to communicate; the other is the desire to remove as much subjectivity from his spiritual "samplings" as possible. The result is a collection of such stylistically diverse work that style itself becomes the medium. The effect is a cross-referencing of imagery that breaks boundaries and offers a universal communication.

MALONEY, IRENE (Painter)
736 Stonegate Rd., Libertyville, IL 60048

Born: 1946 *Awards:* 1st Place, L.A. County *Collections:* Mural Harbor General Hospital, Harbor City, CA *Exhibitions:* U. of Chicago; North River Community Gallery, Chicago *Education:* U. of Chicago

Paintings, drawings and sculpture dominate her early works. Find here still life painting influenced by Cezanne and drawings reminiscent of Kollwitz or Pearlstein, as well as a mixed work in anti-war posters made in the 1960s. Currently she works in collage with paper and acrylic, charcoal, watercolor, crayons and graphite. Influenced by Nancy Spero, her content now focuses on contemporary women. In some of her work, actual garments are incorporated into the canvas with paste, complementing the female figures. The color of the work is subdued, with many neutral grays, black and white.

MANDEL, RENEE (Bookbinder)
1051 W. North Shore, Chicago, IL 60626

Born: 1945 *Collections:* Newberry Library, Chicago *Exhibitions:* Artists Book Works, Chicago; *Education:* School of the Art Institute of Chicago

Creating books as one-of-a-kind, decorative objects, she employs a combination of traditional and non-traditional approaches in her works. Books may be covered with marbled papers and commercial bookcloth, fabric that is hand-printed with her own designs, or cloth on which photographic images have been printed. Blueprinting and brownprinting are among the techniques used. Currently the artist is doing bindings using handmade Japanese papers as cover material.

MANGOLD, ROBERT PETER (Painter)
90 Eldridge St., New York, NY 10002

Born: 1937 *Awards:* National Council on the Arts Award; Guggenheim Fellowship *Collections:* Museum of Modern Art, NYC; Whitney Museum *Exhibitions:* Whitney Museum; Guggenheim Museum *Education:* Cleveland Institute of Art; Yale U. School of Art *Dealer:* Paula Cooper Gallery, NYC; Donald Young Gallery, Chicago

Early minimalist works are matte-surfaced pastel wall pieces such as *Pink Area*, oil on masonite. Later geometric shapes on plain backgrounds are minimalist paintings which encourage controversial discussions on

Roger Machin, *Wheelchair,* 36x23x29, aluminum chair frame and steel. Photograph: Matt Dinerstein

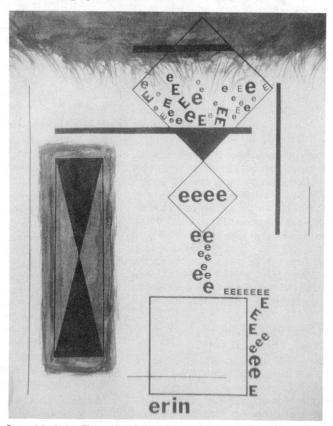

Jerry Madson, *Erin,* 17x14, ink on paper

the nature of art, as in *Incomplete Circle No. 2.* Recent work continues an interest in formal problems and their self-referential answers. Color-suffused shaped canvases, sometimes in several panels, emanate tension geometrically controlled by line.

MANGOLD, SYLVIA PLIMACK (Painter)
c/o Brooke Alexander, 59 Wooster St., New York, NY 10012

Born: 1938 *Collections:* Museum of Modern Art, NYC; Whitney Museum *Exhibitions:* Fuller Goldeen Gallery, San Francisco; Brooke Alexander, NYC *Education:* Cooper Union, NY; Yale U. *Dealer:* Brooke Alexander, NYC

Lush landscapes are painted and glazed in a manner similar to that of the Romantic Hudson River School painters and framed with trompe-l'oeil borders of masking tape. Like the bits of tape, the subject of these works is not what it seems. Of this subject, she says, "These are works about the perimeter and about a series of decisions." These pieces are further about the historical relationship between the artist and the observable world, about reality and illusion. In 1965 she painted restricted and technically demanding views of the wooden floors and walls of her studio, depicting light which entered from an unseen window. In 1973 mirrors were included in the studio views. The earliest use of the masking tape device occurs in 1975 in works in which the "taped" areas are eitther blank or suggestive of graph paper. This device calls attention to the act, procedures, decisions, and artifice of painting and highlights the fact that the realistically-rendered scene is artifice.

MAPPLETHORPE, ROBERT (Photographer)
24 Bond St., New York, NY 10012

Born: 1946 *Awards:* CAPS Grant; NEA Fellowship *Collections:* Metropolitan Museum of Art; Museum of Modern Art, NYC *Exhibitions:* Whitney Museum Biennial; Museum of Modern Art, NYC *Education:* Pratt Institute *Dealer:* Robert Miller Gallery, NYC

His work explores the erotic by creating what some consider to be pornographic images and photographic pieces. Pictures of flowers and portraits contain undertones of sensuality. Sadistic and violent images are also used to create disturbing compositions. A well-known and notable example is "Portrait of Frank Diaz," which shows a muscular man holding a dagger above his head ready to strike; a mirror hangs beside the photograph, so that the viewer becomes the man's potential victim. Recent subjects have been derived from sensationalized or staged scenes of New York City's homosexual community. Mapplethorpe died while this book was in progress.

MARC, STEPHEN (Photographer)
5401 Hyde Park Blvd., Chicago, IL 60615

Born: 1954 *Awards:* 1987 Illinois Arts Council Artists Fellowship; 1983 Eli Weingart Chicago Grant *Collections:* Museum of Contemporary Photography, Chicago; California Museum of Photography, Riverside *Exhibitions:* Evanston Art Center; Midwest Photography Invitational IV Travelling Exhibition

Education: Tyler School of Art; Pomona College

Previous photographic work includes black and white urban landscapes at night, exaggerated color fragments of people and their environments, and a series of self-portraits in black and white and color, some of which were multiple image/three-dimensional and were exhibited in stereoscopic viewers. Recent areas of interest have involved documentation of Chicago's South Side African-American community, which resulted in a recently published monograph, *Urban Notations,* and a second body of work which explores the graphic light and shadow found in environmental details. In these pieces, images alternate freely between existing and fabricated situations, with surrealistic overtones.

MARDEN, BRICE (Painter)
54 Bond St., New York, NY 10012

Born: 1938 *Collections:* Museum of Modern Art, NYC; Whitney Museum *Exhibitions:* Whitney Museum; Guggenheim Museum *Education:* Boston U.; Yale U. School of Art *Dealer:* Mary Boone Gallery, NYC; Steven Leiber, San Francisco

During the 1960s he painted monochromatic panels using encaustic as a medium, leaving bare, thin margins along lower edges which reveal paint drips. Subsequent works are multi-paneled works joined horizontally, each panel covered entirely with paint. Vertical joinings, such as in "Red, Yellow, Blue," characterized series of the 1970s. In 1981 a series of oil paintings were executed on marble fragments and horizontal and vertical lines emphasizing surface qualities. Recent works include prints, drawings, and a series of post-and-lintel paintings utilizing a capital-T configuration; they are organized in symmetrical patterns and arrangements of interlocking color. Current paintings are oils on canvas which unify the concerns of painting, drawing, and surface.

MARINI, MARINO (Sculptor)

Born: 1901 *Exhibitions:* Philadelphia Museum; Weintraub Gallery, NYC *Education:* Academie Belle Arti, Florence, Italy *Dealer:* Samuel Stein Gallery, Chicago

In order to value Marino Marini fully, we must see that he is a sculptor and a painter at the same time. He unites both color and form in his sculpture. Further, the colors do not simply cover the forms, they have an independent life of their own. Keeping these elements in harmony is one of the mysteries of Marini's art. First, he interprets his emotions in a series of sketches, pen drawings, gouaches, and oil-paintings all hinging on the same theme. After many variations of color and design, a third dimension develops. Then he begins to hew the plaster, wood or bronze and finally, he carves the delicate surface and adds color. For Marino, the artistry is never finished. He often changes the surface of previous works. Although Marino is primarily and sculptor, he is a remarkable painter as well.

MARKS, JANINA (Printmaker, Fiber Artist)
5490 S. Shore Dr., Chicago, IL 60615

Born: 1923 *Awards:* Kappa Kappa Award, Dunes Art

Barbara Baynes Mahoney, *Where the Action Is,* 30x22, watercolor

Silvia A. Malagrino, *The Damned,* 40x30, photograph

Foundation; 1st Prize, Motorola Show *Collections:* Balzekas Museum of Lithuanian Culture, Chicago; National Museum, Vilnius, Lithuania; *Exhibitions:* North Shore Art League, Winnetka; Balzekas Museum, Chicago

Influenced by the rich folk art tradition of her native Lithuania, she portrayed a nostalgic attachment for her former home in a series of huge oil-on-canvas paintings in bright primary colors. In 1975 she returned to an earlier interest in tapestry weaving. Working with Persian knots or flat weaving, she began manipulating texture, tone, and varying effects of light and dark in work that relied less on folk images and became more direct, personal, and abstract. The subject of her detailed, spontaneous, hand-colored prints, which also use the media of woodblock and linoleum, remains the Lithuanian folk and storytelling images of her youth.

MART, SUSAN (Painter, Draughtsperson)
1842 N. Burling, Chicago, IL 60614

Born: 1941 *Awards:* Women's Board Museum Purchase Award, Burpee Art Museum, Rockford, IL *Collections:* State of Illinois Center, Chicago; Ball State U., Muncie, IN *Exhibitions:* A.R.C. Gallery, Chicago; U. of Wisconsin *Education:* School of the Art Institute of Chicago

Her doorways in space remain, creating a quiet unreal world. Never having used graphite pencil for anything but quick sketches, she began to use it exclusively for finished pieces. Working in black and white she drew real forms, which she enlarged and manipulated into unreal situations. She sketched movement on her paper by combining architectural elements with foliage and ribbons. Today she continues to use graphite pencil but has now incorporated color oil washes into the work. Surface quality is very important and she builds up color with many layers.

MARTIN, EMILY (Painting)
742 7th Av., Iowa City, IA 52240

Born: 1953 *Awards:* Iowa Arts Council; NEA Fellowship *Collections:* Project Arts, U. of Iowa *Exhibitions:* Koehnline Gallery, Des Plaines, IL; Contemporary Art Workshop, Chicago *Education:* U. of Iowa *Dealer:* Bedyk Gallery, Kansas City, MO

Her formal training in life drawing reflects the influence of Paul Klee and Joan Miro. She works on rice paper with watercolor, gouache, acrylic and colored pencils, concentrating on humor. Her compositions are derived from social situations that are sometimes funny, sometimes horrible scenes of people both alone and together. Truly mixed-media, the pictures are a combination drawing and painting. Recently, the humor of her work has begun to take on an ironic edge. Less specific or linear than cartoons, her simple figures create a social commentary through exaggeration and satire. As work has increased in size, she has begun to increase the complexity of the compositions, with several scenes interacting off one another. She is currently doing installations that are room-size drawings of an entire town or location.

MARTIN, RAY (Multi-Media Artist)
307 N. Cuyler, Oak Park, IL 60302

Born: 1930 *Awards:* NEA Fellowship; Fulbright Fellowship *Collections:* Museum of Contemporary Art, Art Institute of Chicago; *Exhibitions:* Cultural Center Chicago *Education:* Institute of Design, Chicago *Dealer:* Printworks Ltd., Chicago

He started his career as a painter-printmaker, taking influence from the Dadaists and surrealists on the one hand and the Abstract Expressionists on the other. (At this time too he had an interest in book making which was to emerge again in the 1970s and become an important part of his current output.) His early paintings are abstract, while the prints and drawings contain pictorial and word imagery. Currently, his prints, books and videos contain words and visual images in sequences. The paintings and drawings contain pictorial elements along with symbols and words. Some symbols, such as commercial logos and pop icons, retain their specific meanings, while others, invented by the artist, have broader, less specific meaning. He also makes use of ancient art and folk art imagery. The artist's books are major works, some involving two or more parallel narratives told within 48 to 80 pages.

MASCHIETTO, ROMANO (Painter, Muralist)
2346 W. Palmer St., Chicago, IL 60647

Born: 1944 *Awards:* Neighborhrood Arts Grant, Chicago Office of Fine Arts; Project Completion Grant, Illinois Arts Council *Collections:* DuSable Museum, Chicago; Joseph Cardinal Bernadin *Exhibitions:* Elixir Gallery, Chicago; Limelight, Chicago *Education:* School of the Art Institute of Chicago

Realistic indoor and outdoor murals painted in high intensity colors express the richness of life in action. Indoor works are more diverse in style, ranging from art deco, folk/primitive, expressionism and impressionism to strict realism, depending upon the desired atmosphere. Private work until recently was abstract; however, the artist now feels that the combination of several historically established styles in a single work produces a contemporary statement using existing language. Among the many commissions completed to date are the series of twenty-five 45 foot Clipper Express semi trailers on which the artist has painted a menagerie, and a 2,640 square foot mural, *Happy 150 Chicago* on the Grant View Apartments on the city's South side.

MATTOCKS, ELIZABETH (Painter, Photographer)
P. O. Box 223, Middlebury, IN 46540

Born: 1921 *Awards:* Indiana Arts Commission *Collections:* Gerald Ford Museum, Grand Rapids *Exhibitions:* Fort Wayne Art Museum; South Bend Museum

Works in a variety of media, including textiles, draw on American culture for inspiration. A series of portrait paintings centers on former American presidents including John F. Kennedy and Jimmy Carter. *Three Dead, Three Alive* depicts three prominent statesmen and their wives: John and Jackie Kennedy, Martin Luther and Coretta Scott King, and Robert and Ethel Kennedy. Other works focusing on Americana are commissions for such cities as Chicago, Ft. Wayne, and

John-Luke Mallinson, *Justice of the Americas,* 41x54, oil on canvas

Emily Martin, *A Dinner Party Which Honors No One,* 12x14, waterbased mixed media on rice paper.
Courtesy: University of Iowa Hospitals and Clinics

Indianapolis, as well as a large acrylic mural titled *Indians and Pilgrims*, which comemmorates the first Thanksgiving. Her work in watercolor has included *Whisper in My Ear*, showing two ears of corn touching at the silks. Concentrating on using natural subjects, she utilizes moonflowers as symbols in *Male and Female*.

MAXWELL, TERRY (Painter)
1003 Weaver, Emporia, KS 66801

Born: 1946 *Awards:* Purchase Award, Kansas Watercolor Society *Exhibition:* Kansas Postcard Artist Series *Collections:* Hallmark Cards, Kansas City, MO; Frito-Lay Inc., Topeka, KS *Exhibitions:* Wichita Art Museum; American Watercolor Society, New York, NY *Education:* Wichita State U.; Emporia State U., Kansas

After several years painting primarily landscapes, he began to paint intensely colored still lifes with strong contrasting patterns and color forms. In these pieces he combines organic shapes with geometric patterns and experiments with images of paintings within paintings and still lifes within landscapes. In *Red Checkered Cloth* find teapots set out on several red checkered cloths while against the wall is a painting featuring the same cloth only with assorted fruits arranged upon it. Currently, his works are very large (30 inches by 40 inches) florals and still lifes with very brilliant color. He utilizes different viewer perspectives which elongate and distort objects and shadows. To this he adds strongly-designed patterns and shapes arranged in contrasting colors, all to the effect of changing what might be a visually benign image into a challenging one.

McCANN, SUE (Photographer)
2522 N. Burling St., Chicago, IL 60614

Born: 1941 *Awards:* Design award for Catalog, Beckley Cardy *Exhibitions:* Northwestern Atrium Center

She is intrigued by man's attempts to control the environment and most of her subjects are landscape and natural phenomena. She has photographed culturally pure architecture including the temples of Japan. She has recorded natural phenomena in Hawaii, where volcanic eruptions, rain forests, and atmospheric and ocean effects have created powerful, mysterious, mystical, and dramatic effects. Among her influences are the works of Buckminster Fuller and by the African/primitive art she saw while traveling and collecting art on that continent. She has taught photography at Oak Park and River Forest High Schools in Illinois.

McCAULEY, ROBERT N. (Sculptor)
2130 Oxford St., Rockford, IL 61103

Born: 1946 *Awards:* NEA Grant, Drawing; IAC Fellowship, Sculpture *Collections:* Security Pacific National Bank; Illinois State Museum *Exhibitions:* Roy Boyd Gallery, Chicago; Sonoma State University, CA *Education:* Washington State U.; Western Washington U. *Dealer:* Roy Boyd Gallery, Chicago; Ivory Kimpton Gallery, San Francisco, CA

The conflict of nature vs. culture is explored in drawings that depict walls of towers in exaggerated angular configurations, the placement of eye-like windows suggesting an anthropomorphic watchful presence. Early large-sized drawings portrayed the city as metaphor for the revised American Romantic vision. Translated into sculpted works, space, literally divided and defined, is articulated through the contrasting and opposing sides of the organic and the technological. In current works, this theme is explored through the use of sculpted animals juxtaposed with architectural constructions and cultural artifacts.

McCLAIN, WARDELL (Painter)
11820 S. Harvard, Chicago, IL 60628

Born: 1951 *Awards:* 1975 Malcolm X College Award *Collections:* Chicago South Side Community Art Center *Exhibitions:* Chicago Public Library; Isobel Neal Gallery, Chicago

The artist is a realist, working in oils as well as pen and ink and graphite. Influenced by the perfection he finds in the works of Rembrandt and W. H. Hunt, he specializes in portraits of famous people with particular backgrounds. Subjects also include still lifes and nature scenes. He is currently painting on a larger scale than in previous years and putting imagination in the forefront.

McCLIMENT-HORVATH, CATHERINE & SILVER, CHARLES (Painter, Photographer)
PO Box 1473, Bloomington, IN 47402

Born: 1957/1951 *Awards:* Winners, Readers Opinion Citation Award, Collector's Photography Magazine, Los Angeles *Collections:* Louisville Photographic Archives, U. of Louisville *Exhibitions:* Jacques Baruch Gallery, Chicago *Education:* Indiana U.

They met at Indiana University, where she was studying linguistics and art and he photography with Henry Holmes Smith. Their artistic collaboration began in 1983, and the couple are best known for delicately colored, hand-painted black and white photographs. Employing a pure painterly technique, she works with artists' oils and a photochemically reactive turpentine substitute to prevent fading. Photographs are printed on matte finish paper, a surface which readily absorbs the paint. Subject matter includes portraiture, still lifes, and figurative studies, and often features nudes and partial nudes in erotic poses with pieces of clothing and jewelry. Besides extensive commercial work in cosmetics, fashion, and greting cards, their fine arts work has been widely exhibited throughout the country.

McCOMBS, JACK (Sculptor)
P.O. Box 13, Shirley, IL 61772

Born: 1951 *Exhibitions:* 76th Exhibition by Artists of Chicago and Vicinity, Art Institute of Chicago; 28th Annual Drawing and Small Sculpture Show, Ball State U., Muncie, IN *Education:* Kansas City Art Institute; Illinois State U., Normal IL

His work is linked with time and change via the sculptural possibilities of the solar cycle. These possibilities are defined by four interacting components: the latitude and topography of the selected site, the composition of the sculptural structure, the sun and its cycle and the involvement of the viewer. The physical

Elizabeth Mattocks, *Whisper in My Ear,* 26x22, watercolor

Pennington McGee, *3 Graces,* 24 x 36, charcoal on paper

placement of the sculpture's elements are determined by the same geometrics as those used to calculate sundials and navigational aids. Works are composed of an arch or arcade, which contains a device oriented to the changing angles of the sun's rays, and markers that denote trigonometrically determined points on the earth's surface. The arch and pylons are sited so that they form a narrow corridor facing directly east and west. The light beam this produces crosses the ground and pylons at a steady and noticeable rate. The sun's movement and its reflected light energize the sculpture, creating a distorted sense of time in the viewer.

McEACHRON, MARCIA (Sculptor)
420 N. 5th St., Ford Centre 58, Minneapolis, MN 55401

Born: 1947 Awards: Public Sculpture Award, 1985; Minnesota Museum of Art Exhibition Grant Collections: Minnesota Museum of Art; University of Wisconsin Alumni Collection Exhibitions: Evanston Art Center, Evanston, IL; Bradley Gallery, Milwaukee Education: U. of Wisconsin, Milwaukee

Ancient themes of human and animal mythology are the basis of the welded steel and bronze sculptures created by the artist since 1979. Found objects, industrial materials, and architectural ironwork are joined and transformed into horses and other animals, mythical warriors, and other figures. Her material and linear form influenced by David Smith, the artist has developed ironworking techniques in her sculptural statements and has produced several large-scale pieces in stainless steel and bronze for public and private commissions. Additional color is used sparingly to better define the forms.

McGEE, PENNINGTON (Painter)
1218 W. Huron, Chicago, IL 60622

Born: 1950 Collections: Amoco Oil Exhibitions: Limelight, Chicago; Chicago Art Institute Rental Gallery

After fours years of formal training in anatomical illustration and wood engraving under the tutelage of Adrian Troy, he began painting in oil. Taking ideas and images from his dreams, he first produced woodblocks and later brought these images to the canvas. These "fanta-realist" paintings show the artist's admiration for the strength, energy, and vitality in the works of Cimabue, Van Gogh, and Chaim Soutine. Furthermore, it was these artists' influence that led him to his present direction. In 1986, after many years of creating controlled, representational pieces, he put away his paints and returned to the basic drawing tools. Following the European visionaries--such as Picasso, Brancusi, Gauguin, and Modigliani--who embraced African art, he began working with a "primitive" approach to both drawing and ideas. His main focus has become the direct interpretation of ideas with charcoal, soft pastels, and oil pastels on heavy water color paper in large size. In many pieces, the crucifix appears as a central theme.

McMAHON, MARGOT A. (Sculptor)
921 N. LaSalle, #17, Chicago, IL 60610

Born: 1957 Awards: Aliza A. Drew Award; Yale University Scholarship Collections: Mr. and Mrs. David Ruttenberg, Chicago; Mr. and Mrs. William Rentschler, Lake Forest, IL Exhibitions: Neville-Sargent Gallery, Chicago; Aerie Gallery, Chicago Education: Yale U.; Hamline U., St. Paul, MN Dealer: Neville-Sargent Gallery, Chicago

A student of both anatomy and sculpture, she interprets the human form through an individual expression and an invented anatomy of planes and angles. Influenced by Degas, Giacometti, Matisse, and Rodin, she captures a moment of life and a shadow of memory in full figures, portraits, and groups of figures in cast bronze, resin, and lightweight cement. Her first community portrayal was of eight people of the Yale-New Haven community. These Hands Have Done A Lot was a series sculpted in the mid-1980s portraying Italian immigrants of Homewood, Illinois with life like heads and hands. Her most recent series of ten portrait sculptures, Just Plain Hard Working, depicts ten people of ten different Chicago neighborhoods who have significantly contributed to their communities and the city. Each figurative sculpture reflects the importance of the individual, whether in a group or in a solitary composition.

McNISH, DIANA (Sculptor)
132 S. Bennett, Geneva, IL 60134

Born: 1930 Exhibitions: Gilman/Gruen Gallery, Chicago; Clay & Caboodle Gallery, Geneva, IL Dealer: Clay & Caboodle Gallery, Geneva, IL

Whimsical concoctions of social commentary are constructed in fiberglass over a steel armature. The life-size pieces often begin with a found object or driftwood that suggests a particular character. Using fiberglass, ciment fondu, and acrylics, she then creates characters, either contemporary--feminist activists, flower children, and aerobic dancers or classical heroes of Greek mythology and American history. In addition to the elongated figurative works, the artist also makes assemblages of found objects housed in "boxes" such as guitar cases, window frames, and radiator moldings.

McQUILKEN, ROBERT (Photographer)
728 Hill Ave., Glen Ellyn, IL 60137

Born: 1952 Awards: 2 New York Art Directors Club Awards; Washington International Salon Collections: Kodak Film Corporation, American Society of Magazine Photographers Exhibitions: ASMP Exhibit, Rosemont Horizon, Rosemont, IL; Professional Photographers Showcase, Epcot Center, Disney World, FL Education: Wheaton College Dealer: Black Star, NYC

After studying with former Life and Look magazines picture editor Douglas Gilbert, his early work focused on the stark landscapes of northern Canada, Norway, Scotland, and Alaska. In these photographs, he pictured timeless, enduring inhabitants--a soaring eagle, a 90-year-old gold miner, a Highland chieftain's crumbling castle--against the vastness of tundra and taiga. He developed a black and white film processing technique yielding extremely fine grain prints from 35mm negatives, a technique which became his trademark. He has authored numerous books on both the artistic

Jane Meredith, *Lone Woman,* 9x6, gouache

J.M. Mesplé, *Creation,* 48x36, oil on linen with handmade frame. Courtesy: Hokin/Kaufman Gallery. Photograph: Tom Van Eynde

practice and the business opportunities of photography, as well as books and magazine articles based on his frequent and expert action photography. He also commonly made use of cameras taped to airplane wings, sleds, boats, and participants, or remote control shutter equipment. He died on location while photographing an underwater subject during the production of this volume.

MEEKER, BARBARA M. (Painter)
8314 Greenwood Ave., Munster, IN 46321

Born: 1930 *Awards:* National Watercolor Oklahoma; Hoosier Salon, Indianapolis *Collections:* Indiana Bell Telephone; Purdue U. *Exhibitions:* Oklahoma Watercolor Society; Aqueous, Owensboro, KY *Education:* DePauw U.

A Professor Emerita, her career as a teacher has provided her a forum for a constant interchange of ideas. She has taught at all levels, public and private, serving the last twenty-one years at Purdue University, Calumet as a teacher of drawing and color theory in the department of architectural technology. All of this experience, combined with study with peers, has led her through various media, from drawing to collage, from mixed-media to acrylic and watercolor, and now back to mixed water media and drawing. Her subject matter varies from representational to non-objective compositions. In each, color is extremely important to the dynamic of the painting.

MENZER, TONY (Ceramist)
P. O. Box 156, Amherst, WI 54406

Born: 1951 *Collections:* Vice-President Walter Mondale *Exhibitions:* Lill Street Gallery, Chicago; Visions Gallery, Marshfield, WI *Education:* U. of Wisconsin

Influenced by the precision and the experience of working at the Kohler Company in Wisconsin, he presently concentrates on wheel-thrown porcelain. His glazes, reminiscent of the surface of blown glass, incorporate zinc crystals grown during the cooling process. His work is exclusively decorative and classic in shape and form. He uses a constant variety of hues; the current series is primarily in blues, yellows, greens, browns, and whites. David Huchhauser, Marc Hanson, and Herbert Sanders are his inspirations.

MEREDITH, JANE (Painter, Illustrator)
333 E. Ontario St. #4010B, Chicago, IL 60611

Born: 1944 *Exhibitions:* Natalini Galleries, Chicago; Crain's Chicago Business Illustration Show *Education:* Illinois State U.

Though taken with the work of Munch, Kokoschka and Art Brut, she spent the latter half of the 1960s photographing demonstrations and recycling that passionate reality through graphite drawings. While teaching throughout the 1970s, she continued to adapt her photographs by juxtaposing expressive faces with late Gothic/cemetery sculpture or patterned backgrounds in prismacolor renderings. Encountering the work of Morandi, she paralleled his flower studies, substituting grasses and choosing gouache as her medium. More recently, she adopted a Renaissance style in her painting, and applied the techniques to graphic design and illustration. Continuing with gouache, she pursues portraits of strong, expressive personalities or studies of sculptural fragments and intimate locales.

MERTZ, SARAH BURNHAM (Painter, Printmaker)
820 S. Langley Ave. #206, Tucson, AZ 85710

Born: 1939 *Exhibitions:* Imagery Gallery, Glen Ellyn, IL; Jung Institute, Evanston, IL; Artemesia Gallery, Chicago *Education:* U. of Arizona; U. of California, Berkeley *Dealer:* Linda Gilbert, Imagery Gallery, Glen Ellyn

As a co-founder of OMAVA, an organization formed in 1975 to encourage Chicago artists to work together for mutual objectives, she decided to re-explore her largely abstract expressionist training. Beginning with automatic drawing, she did a series of spontaneously drawn pastels, adding "automatic destruction" via erasing. The results from this period are works with new amalgams of forms unlike any of her previous work. By 1976, she was using solvents to cut through the layered glazes of her paintings. Out of this came two large paintings, *Love God* and *Love Goddess*--two statements about gender and its meaning in the biological world, with an effort to separate real differences from mythological and social interpretations. A current project called *Love Pantheon Gardens* springs from the earlier work. The "Beings" featured in this series appear in dreams and meditations and are realized through spontaneous drawings and brush paintings, which are then developed in oils and intaglios.

MESPLÉ, JAMES (Painter)
3714 N. Fremont, Chicago, IL 60613

Born: 1948 *Collections:* Ruth Horwich, Chicago; Dana and Michael Treister, Chicago *Exhibitions:* Hokin/Kaufman, Chicago; Evanston Art Center, Evanston, IL *Education:* U. of Missouri; School of the Art Institute of Chicago *Dealer:* Hokin/Kaufman Gallery, Chicago

Surreal, brilliantly colored figures with rubberband arms cavort with demons, angels, and other mythological creatures against the backdrop of the Chicago skyline. Although he borrows from the Chicago Imagist vocabulary in meticulous draftsmanship, brilliant coloration, and distortion of figures, he uses it as a means to link the past to the present rather than to expose the dark aspects of modern life. Postmodern references are made to late Medieval and early Renaissance painting, Near Eastern textile designs, and European and Midwestern American architectural classicism. Works are painted with a mixture of oils and egg tempera and are sometimes set in elaborately carved, painted wooden frames. He has designed the sets for the Chicago City Ballet, Fall, 1987 premier of *Chicago!*. His work was also included in an exhibition at the Queens Museum titled "On Classical Myths in Contemporary Art in 1988."

METCALF, BRUCE (Sculptor)
132 Crain Ave., Kent, OH 44240

Born: 1949 *Awards:* NEA Fellowship; Ohio Arts Council Fellowship *Collections:* Philadelphia Museum of

Jill Meyerhoff, *Bar Scene,* 18x22x7, mixed media

Robert Middaugh, *Merlin's Skywatch,* 52x44, acrylic on canvas.
Courtesy: Rockford Art Museum

Art; Cranbrook Academy of Art *Exhibitions:* Dayton Art Institute; Perimeter Gallery, Chicago *Education:* Syracuse U.; Tyler School of Art *Dealer:* Perimeter Gallery, Chicago

Trained as a jeweler/metalsmith and briefly as an architect, he now produces sculpture, jewelry, and drawings. In all these formats, he combines elements of narration and symbolism with meticulous craftsmanship. Most works are never larger than the human form, inviting close inspection and imaginative engagement. Sculptures like *He Killed Himself, She Mentioned Proudly* and *Worry Boy* depict tragicomic situations that ordinary people occasionally confront. Ongoing themes are negativity, the difficulty of establishing meaningful human contact, and the struggle to extricate oneself from pain. Although the artist rejects both nihilism and despair, he recognizes that finding a healthy optimism can be a difficult process. His works all document this internal psychological battle.

METCOFF, DONALD (Photographer)
1560 Sandburg Terr., Chicago, IL 60610

Born: 1944 *Awards:* 3rd Pl., Sister Kenny International Art Show, Minneapolis *Exhibitions:* Beatrice Education Center Galleries, Chicago; Sultzer Public Library, Chicago *Education:* Governor's State U., Park Forest

Placing emphasis on design and environmental settings, his work in architectural photography has been directed toward modern and historical buildings in the context of their current environments. He uses his technique to highlight the qualities of the buildings he photographs, such as a series of structural storefronts which seem almost to be falling over each other. Often, a single section of a building is used to communicate an entire structure. His current project concentrates on ethnic churches in Chicago neighborhoods. He creates, with the individual buildings, a metaphor for spiritual existence in urban settings by photographing their exteriors and interiors and by emphasizing the contrast in color.

MEYER-BERNSTEIN, GERDA (Painter, Sculptor, Photographer)
954 W. Washington St., Chicago, IL 60607

Collections: Karl Ernst Osthaus Museum, West Germany *Exhibitions:* Museum Bochum, Bochum, West Germany; Neuer Berliner Kunstverein, Berlin *Education:* School of the Art Institute of Chicago *Dealer:* A.I.R. Gallery, NY

As a native of Germany, she witnessed severe violence and social upheaval; consequently, she says, her work is shaped by a political conscience. Greatly touched and influenced by Hieronymus Bosch, Matthias Grunewald, Ensor, and Beuys, she says the content of her pieces is directed to the historical, political, and social environment. She works with a vocabulary of intense personal forms, and the visual and psychological aspects of the pieces reflect a continuity of content and theme over a period of many years, though the material and the means of expression have shifted to a variety of media. She uses obsolete objects, such as parachutes, old army helmets, rusted bolts and the like,

in such a way that they break their connection with their original function. Taking pride in her womanhood and expressing a solidarity with women of the past, she reflects a feminine point of view in all of her themes.

MEYERHOFF, JILL (Sculptor, Installation Artist)
1963 W. Cullom, Chicago, IL 60613

Born: 1962 *Awards:* John Merlow Award; Award of Excellence, Ravenswood Art Festival *Collections:* Pomodoro Ristorante, Dallas *Exhibitions:* Art Phase 1, Chicago, "Small Works;" Chiaroscuro, Chicago, "Off the Wall" *Education:* Indiana U., Bloomington *Dealers:* ArtPhase 1, Chicago; Chiaroscuro, Chicago

Her work has focussed on the "diorama" as sculpture. Each piece is set in a familiar scene, such as a bar, restaurant or street corner. Her figures, five to six inches high are detailed, but have no facial features; she relies on their animated poses and implied activity in their dynamic grouping to communicate human emotions. A recent series includes dancing figures who carry colorful, beaded Mardi-gras masks. With exaggerated poses and uninhibited colors this new series attempts to explore movement and color. The diorama is a means of presenting reality in a scale more acceptable to her: "I've always had a need to transform the world into something I could hold in my hand," she writes.

MEYERS, MICHAEL (Performance Artist)

Exhibitions: Organic Theatre, Chicago; *Education:* Art Institute of Chicago

Michael Meyers works with a series of scenic impressions in performances. For example, *Reconstructing* is an episodic, non-linear narrative about remembering and forgetting. Many variations of the concept are presented. A woman repeats a story about her dress, dialog is repeated among men in the background, dancers repeat a dance over and over. A song strings the scenes together and sophisticated lighting creates a dreamlike state. Michael Meyers has been working in the unstructured area of performance art for twelve years. His work stimulates audiences seeking new, theatrical possibilities.

MICHOD, SUSAN (Painter)
2242 N. Dayton St., Chicago, IL 60614

Born: 1945 *Awards:* Artist's Grant, Illinois Arts Council *Collections:* Museum of Contemporary Art, Chicago; Indianapolis Museum of Art *Exhibitions:* Susan Caldwell, NY; Gwenda Jay Gallery, Chicago *Education:* Pratt Institute, NY; U. of Michigan, Ann Arbor *Dealer:* Gwenda Jay Gallery, Chicago

Her involvement in the 1970s with Pattern Painting and her love of three-dimensional decor have found a meeting place in her most recent work. Where pieces were once "environmental paintings," with surprising ensembles of color-coordinated chairs and toys accompanying the painted canvas, find here a more immediate marriage of the two. Most of the work includes window shutters, door frames, or pieces of wood attached directly to the canvas. In other cases, the

Ruth Aizuss Migdal, *Goddess #3,* 41x22x14, clay-epoxy & mixed media.
Photographer: A. Urbu

Laura E. Migliorino, *On the River Banks We Touched Each Other,* 22x30, oil crayon, oil, pencil on paper.
Courtesy: Rifle Sport Alternative Art Gallery, Minneapolis

canvas itself has been cut or stretched up over a piece of wood. The painted areas are often abstract, though not entirely non-referential. In this way, she unites the literal and the metaphoric. The titles (*Matisse for Now, de Kooning Meets the Lotus Eaters*), also establish a poetic context for the work.

MIDDAUGH, ROBERT (Painter)
1316 Cornelia, Chicago, IL 60657

Born: 1935 *Awards:* Purchase Prize, American Academy of Arts & Letters *Collections:* Art Institute of Chicago; Illinois State Museum, Springfield *Exhibitions:* Rockford Art Museum, IL; Loyola University, Chicago *Education:* School of the Art Institute of Chicago

As a child, he loved finding places where people were absent; as an adult, he creates such places in his paintings. In his paintings, he finds worlds of architectural fantasy. *Mutes' Theatre* depicts a futuristic fortress containing what looks like a Shakespearian stage. Lined up in neat rows before the stage, as if waiting for the show, are a series of small, green, wicket-like arches. *Solitary Confinement* gives a view of a corridor lined by six cells. Between the doors are blank TV monitors, and from each doorway a hose-like tube slithers toward a mysterious red-louvered machine sitting in the center of the corridor. In much of the new work, activity of some sort appears to be taking place, for instance on the tops of buildings, yet a certain menace remains, the viewer still being the only person present.

MIGDAL, RUTH AIZUSS (Sculptor)
2238 N. Geneva Terr., Chicago, IL 60614

Born: 1932 *Awards:* Pauline Palmer Prize, Art Institute of Chicago; Illinois Arts Council *Exhibitions:* Rockford Art Museum, Rockford, IL; Elaine Starkman Gallery, NYC *Education:* School of the Art Institute of Chicago; U. of Illinois *Dealer:* Elaine Starkman, NYC

She uses the female torso as an archetype, making it serve as a reference for the continuum of human experience. Trained as a painter and printmaker, she began working in the third dimension in order to fully express the sensuality, eroticism and formal issues that inspired her work. Starting in raku, she accidently discovered her current technique of epoxying fragments together. Free to expand the scale of her pieces and work with an additive approach, she created forms which began to explore the cubist influences of her experiences as a painter. Often with multiple buttocks and breasts, the torsos evoke the continual breakdown and recreation of life through the reorganization of space and time. Expressing the unconscious and physical knowing of the body, her figures develop female sexuality with a spirit drawn from the sacred and celebratory figures of Hindu and Hellenic goddesses. Present work has taken on a concern with color. Her use of pigments in wax, oil stick and pastels further underscores cubist sensibility toward shape, as well as negative and positive space.

MIGLIORINO, LAURA E. (Painter)
2449 Harriet Ave. S., Minneapolis, MN 55405

Born: 1959 *Awards:* 1st Prize, Bloomington Art Center

Annual Exhibition; Jerome Purchase Award, University of Minnesota Art Museum *Collections:* University of Minnesota Art Museum *Exhibitions:* The 79th Chicago and Vicinity Show, Prints and Drawings; Rifle-Sport Alternative Art Gallery, Minneapolis *Education:* School of the Art Institute of Chicago; U. of Minnesota *Dealer:* Margaret Stenger, Studio 13 Gallery, Minneapolis

Working in a narrative/imagist style which enables her to express personal feelings about various episodes in her life, the artist counts influences ranging from Degas to Hollis Sigler. A high-key palette, utilizing oil pastel, paint, collage, graphite, and found objects, is layered to a thick texture and scraped back until the desired image is achieved. Images vary from extremely abstract to written narratives involving objects and landscapes. The images are depicted in a naive yet intense manner that invites the viewer to participate in the events.

MILETTO, DAVID (Space-Light Artist)
167 Briarwood, Palatine, IL 60067

Born: 1949 *Exhibitions:* Sioux City Art Center Biennial; Colorado North American Sculpture Exhibition *Education:* School of the Art Institute of Chicago

Influenced by his studies of perception, relativity, and quantum mechanics, he has created an experimental work that has been described as "Architectural-Drawing-Environmental-Sculptural-Design." In the untitled work, he uses photographs of a highway overpass, photographs of a friend walking through the Piazza della Signorina in Florence, and the *Waco Tribune-Herald* newspaper as points of origin for a multi-dimensional installation of slides, objects, and drawings. The evolving work is a world unto itself, and the artist gives each piece a coordinate as it is completed. His recent abstractly figurative bronze sculptures are an emotional and mental play, similar to a stream of consciousness in writing.

MILLER, CONSTANCE (Handmade Paper Maker)
511 Chapman, Edwardsville, IL 62025

Born: 1947 *Collections:* Indianapolis Museum of Art; Mitchell Museum, Mt. Vernon, IL *Exhibitions:* Sheldon Swope Museum, Terre Haute, IN; Cheney Cowles Museum, Spokane, WA *Education:* Southern Illinois U. *Dealer:* Mindscape Gallery, Evanston, IL

After formal training in painting and fiber, she began combining both disciplines into a form of "paper paintings." Her present paper works are large-scale explosions of lyrical color. She makes these abstract pastels by overlaying pieces of torn paper to look like brushstrokes, onto a ground of puzzle-like, "patty-cake" style handmade paper. She works mainly on commission, and some of her larger clients include AT&T, Upjohn, IBM and McDonnell Douglas Automation.

MILLER, JAN (Painter)
R.R. 1, Box 101A, Monee, IL 60449

Born: 1939 *Awards:* 1st Place, Illinois State Fair Professional Exhibit *Collections:* Fort Lauderdale Museum of Art; Illinois Fine Arts Museum *Exhibitions:* 75th

Beverly Moor, *Structural Excavations II*, 36 x 52 x 4, mixed media. Photographer: Jack Grossman

Jan Miller, *Foil Paper & Wood,* 40 x 30, acrylic on canvas

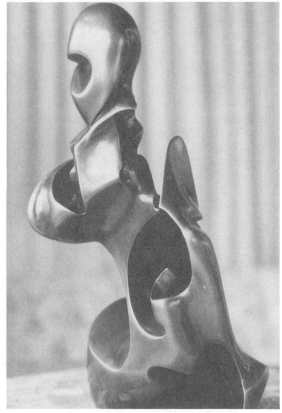

David Miletto, *Self Portrait II,* 9 x 5 x 4, bronze

Chicago & Vicinity Exhibition; One Illinois Center, Chicago *Education:* St. Xavier College *Dealer:* Joyce Petter Gallery, Saugatuck

Done in a personal, quiet, and contemplative style, the artist's still life paintings place familiar domestic objects in deceptively simple and rigorously formal settings. Drawing on the work of Morandi and Chardin, she became intensely preoccupied with creating balances and harmonies utilizing the geometry, textures, and colors of her subjects. Painting in acrylic with layers of glazing, she imbues the objects with an extreme three-dimensionality. Changes in scale and angle transform the ordinary into an extraordinary experience, forcing the viewer to look anew at the everyday world.

MILLS, DAN (Sculptor)
2012 Welwyn Ave., Des Plaines, IL 60018

Born: 1956 *Collections:* First National Bank of Chicago; McDonald's Corporation *Exhibitions:* Chicago Public Library Cultural Center; Hyde Park Art Center, Chicago *Education:* Northern Illinois U.; Rochester Institute of Technology *Dealer:* Sybil Larney Gallery

Throughout the 1980s he has collected materials from Chicago's gutted or demolished buildings. Seeking to portray the common ground and universal histories embedded in urban and rural vernacular architecture, he uses these materials as a basis for constructions. Charcoal, graphite and acrylic glazes are sometimes applied to the already weathered wood and paint-encrusted materials, resulting in a palette of rich purples, reds, yellows, greens, blues, and oranges. His recurrent subject is the house. Some sculptures are readings of existing structures and are made with materials from the buildings they depict. Others are constructed as markers, reminding us of the personal histories of the generations who inhabited these anonymous buildings.

MITCHELL, DENNIS LEE (Ceramist)
2144 McDaniel Rd., Evanston, IL 60202

Born: 1946 *Awards:* National Endowment for the Arts Craftsman Fellowship; National Endowment for the Arts Crafts Critic Fellowship *Collections:* Boymans Van Boinegan Museum, Rotterdam, Netherlands *Exhibitions:* Exhibit A Gallery, Chicago *Education:* Hayes U., Ft. Hayes, Kansas; Arizona State U. *Dealer:* Exhibit A Gallery, Chicago

Having used the circular form from early in his career, he creates pieces that are directed at a primary wholeness of organic structures. In the early 1980s, the form of the vessels took on increasing significance, connecting human inspiration and innovation with natural shapes. Departing from the convex, wall-mounted shapes of the past several years, his work has begun to emphasize a bowl form, intensifying the relationship with the viewer's own archetypal history. This series, entitled "Firmament," has as its subject matter the mystery and wonder of the Space Age and the questions it raises regarding actual space.

MITCHELL, RODGER (Painter)
921 Pontiac, Wilmette, IL 60091

Born: 1935 *Collections:* Murlas Collections; Kleinmuntz Collection *Exhibitions:* Spartus Museum, Chicago; Beverly Art Center, Chicago *Education:* American Academy of Art

Trained in landscape and portraiture at the American Academy of Art, he early on began using thin glazes, rubbing them on with a palette knife and allowing the texture of the canvas to play an important role. Currently he is working with highly liquid oils that are poured onto wood panels and then scraped to a glaze-like finish, leaving the texture of the wood emergent. This controlled blending of liquids of various viscosities produces unusual translucent effects reminiscent of glass sculpture. While this technique maintains elements of abstraction, the overall result in these pieces is representational. The images can be said to be realistic, though not photorealistic. In one piece, a highly stylized flower symbolizes first life. The image lies against a monochrome background in four sections done in shades of purple and violet that can be viewed as petals. Recent works representing volcanic action have been inspired by a trip to Hawaii.

MOGENSEN, LOIS (Printmaker, Draughtsperson)
7606 36th Ave., Kenosha, WI 53142

Born: 1934 *Awards:* Alice & Arthur Baer Art Competition, Beverly Art Center, Chicago; Parkside Award, Parkside National Small Print Exhibition *Collections:* Harris Bank, Chicago; Southeast Banking Corporation, Miami *Exhibitions:* Boston Printmakers; Print Exhibition, Miami International *Dealer:* Jan Cicero, Chicago

While in graduate school she found similarities in the ways Edward Hopper and Giorgio de Chirico used light and space. Like the work of these two influential masters, her earlier etchings and drawings have a lonely, mysterious quality. After becoming interested in, and influenced by, such contemporary artists as David Hockney, Jim Dine, and Wayne Thiebaud, she became concerned with the object. Recently, she has been drawing and etching deck chairs.

MOLENDA, DON (Painter)
112 Carriage Way, Hinsdale, IL 60521

Born: 1958 *Exhibitions:* School of the Art Institute of Chicago; Meadowclub Art Exhibit, Rolling Meadows, IL *Education:* School of the Art Institute of Chicago

By day, as a commercial artist, he renders realistic drawings for his clients; by night, in his paintings, he distorts and abstracts his subject matter, which he bases upon a psychological, creative, imaginary world of images, most often images taken from the interactions of the events of everyday life. With the advent of the computer in the work environment, he has been trying to combine the technology of computer image-making with his paintings. He draws parallels between the technique of George Seurat at the turn of the century and his idea of breaking down painting to indivudual tiny dots of color which are blended by the eye of the viewer and the theories of color photography and the

Sylvia E. Mullen, *Inevitable for Boys, Detail #3,* 22 x 44, acrylic paint

Stephanie Nadolski, *High Passage,* 30 x 22, acrylic, watercolor on paper

electromagnetic spectrum.

MOMINEE, JULES (Stained Glass Artist)
5001 Lincoln Ave., Evansville, IN 47715

Born: 1954 *Exhibitions:* Zion Lutheran Church, Beecher, IL; Roselle United Methodist Church, Roselle, IL

After formal art training, he started a full-time stained glass studio in 1979, working primarily on commissioned pieces. He frequently uses realistic figures and traditional symbols against an abstract background. The color combinations blend subtle shades with contrasting colors. Currently he is exploring ways of beveling glass in a non-traditional manner, incorporating three-dimensional pieces to create an unusual sense of depth and texture in his panels.

MOOR, BEVERLY B. (Painter, Paper Artist)
530 Ravine Dr., Highland Park, IL 60035

Born: 1944 *Awards:* North Shore Art League Award of Excellence, Chicago *Collections:* Standard Oil of Indiana; IBM Corporation *Exhibitions:* Gallery 500, Philadelphia; Judy Youens, Houston *Education:* U. of Texas; Rhode Island School of Design *Dealers:* Alter Association, Highland Park, IL; Lyman/Heizer, Northbrook, IL; Sorenson Moy, Chicago

Family ancestry and the search for a missing quality led her from the traditional medium of painting to the three-dimensional world of textiles and fibers. Inspired by a fraternal grandfather who was a well-known textile designer during the "art deco" 1920s, at age 21 she went to school to study design and graphics. Starting as a painter, then exploring collage and construction, she finally discovered her medium of choice in papermaking. Her work is best described as handmade paper that is first painted, then torn, sewn, woven, and rolled to develop a three-dimensional surface. The final pieces suggest archaeological landscapes. The handmade paper she uses comes from all over the world.

MORONI, ALDO JR. (Sculptor)
310 2nd St. N., Minneapolis, MN 55401

Born: 1953 *Awards:* McKnight Fellowship, 1982 and 1987 *Collections:* Walker Art Center, Minneapolis; Chicago Tribune *Exhibitions:* Chicago Art International; Artpark, Lewiston, NY *Education:* Minneapolis College of Art & Design *Dealer:* Thompson Gallery, Minneapolis

Miniature cities and urban settings that mimic history have been the mainstay of his body of work since 1976. Originally working in wax, the pieces are now done in concrete and fired white and red stoneware, utilizing the coloration inherent in the material. Short stories describing the histories of these imaginary cities often accompany the pieces. Inspired by Western civilization from 850 B.C. to the present, the artist is currently at work on a large-scale imaginary city, which will tour nationally between 1990 and 1993.

MORRIS, DENNIS (Papermaker)
1116 N. Milton, Springfield, IL 62702

Born: 1943 *Awards:* Mayor's Award, Illinois Art Week, Springfield *Collections:* Corporate and Private Collections *Exhibitions:* American Craft Expo; Oak Brook Invitational *Education:* Arrowmont School of Arts and Crafts, Tennessee *Dealer:* Contemporary Art Services, Chicago

Torn sheets and cast pieces of handmade paper are assembled in three-dimensional wall panels that emphasize texture and pattern. The pieces are inspired by the structure of crystals and geological formations. Compositions, which previously focused on the "whiteness" of white, now suggest movement through subtle color changes. Trained at the Arrowmont School of Arts and Crafts in Tennessee, he studied under noted fiber artists Joan Michaels Paque and Richard Daehnert. He created images using both loom and off-loom techniques, exploring surface decoration and embellishment with fiber. He then began to use paper as a primary medium. Sheets of homemade paper are torn or cut into small units of various textures and thicknesses, which are placed flat and on edge. Changing light conditions create a play of light and shadow to enhance the illusion of movement created by the structural pattern.

MOSES, RICHARD H. (Painter)
707 W. Healey, Champaign, IL 61820

Born: 1937 *Awards:* U. of Illinois Research Board; Artist of the Year, Kansas Federation of Art *Collections:* St. Paul Art Center; Tony Curtis *Exhibitions:* Fairweather-Hardin Gallery, Chicago; Sheldon Museum, U. of Nebrasa *Education:* U. of Nebraska; Wichita State U.

His past influences include Kurt Schwitters, Joseph Cornell, Eva Hesse, Bruce Conner, and Robert Nickle. His special interest in Dada inspired his earlier collage and mixed-media constructions. Currently, influences such as Hesse have moved him toward the mathematical repetitive themes of his purist-oriented, handmade paper collage. Ilya Bolotowsky, Ben Nicholson, Mondrian, and a number of Bauhaus artists have all become important to him.

MOTHERWELL, ROBERT (Painter)
909 North St., Greenwich, CT 06830

Born: 1915 *Awards:* Belgian Art Critics Prize, Brussels; Gold Medal, Pennsylvania Academy of the Fine Arts *Collections:* Museum of Modern Art; Metropolitan Museum of Art *Exhibitions:* Museum of Modern Art; Whitney Museum of American Art *Education:* Stanford University; Columbia University *Dealer:* M. Knoedler, NYC

Combining interests in art, philosophy and psychoanalysis while doing graduate work in the 1930s, he traveled to Europe and became fascinated with the exiled Surrealists and with French Symbolist poetry. He

exhibited with the Surrealists in New York in 1942, but shortly afterward helped form the New York Abstract Expressionist movement. He has always made paintings along with collages, and in the last two decades has made several hundred prints. Committed to an abstract vocabulary, he conveyed meaning from the artist's unconscious mind, guided by instinct modified by reason. He is known for paintings which cover entire walls such as *Elegy for the Spanish Republic, No. 3.*

MULLEN, SYLVIA (Painter)
195 Sunnyside Ave., Elmhurst, IL 60126

*Born:*1945 *Awards:* 1st Place President's Award, Cunningham Memorial Museum, Bakersfield, CA *Exhibitions:* Artemisia Gallery; DeKalb Illinois U. *Education:* School of the Art Institute of Chicago; Northern Illinois U.

Influenced by the color theory of Joseph Albers, she carried her natural ability to render realism into a curriculum heavily directed towards abstract elements. This juxtaposition of styles is evident in pieces such as *Dicotomy and Colorspace* in which color is used within figures to symbolize inner conflicts. Primarily a painter of human figures, she graduated from the portrayal of social statements into a close examination of emotional upheaval and human interaction. Environment, body language and the vivid clothing her figures wear all express inner human emotion. In one piece, *Rainbow Shirt,* a brightly clad young man looms in the canvas, most of which is composed of his elbow and sleeve. The painting's unusual composition and the teenager's severe expression are landmarks of the emotional power the artist attempts to achieve.

MUTH, MARCIA (Painter)
c/o Yolanda Gallery of Naive/Folk Art, 300 W. Superior St., Chicago, IL 60610

Collections: Museum of Fine Arts, Santa Fe, New Mexico; Museum of Naive Art, Paris, France *Exhibitions:* Midwest Museum of American Art, Elkhart, Indiana; Wright Museum of Art, Beloit, Wisconsin *Education:* U. of Michgan *Dealer:* Yolanda Gallery of Naive/Folk Art, Chicago

Self-taught as a painter with a degree in Library Science, she sees her work as part of an obligation "to preserve in paintings those days of the first third of our 20th century." She is not concerned, however, with the major historical events, but rather with the ways in which people of the 1920s and 1930s lived and worked. Factories of the period are the focus of her interest, as they represent the heart of the industrial economy that made the United States the world power that it is today. In these paintings of factories and other businesses, her bold colors, sense of space and composition lead the viewer into and through the paintings. All of her characters are real (though "naively" rendered), their facial expressions and body postures giving each character individuality. "I am trying not to just present a frozen moment in time," she says, "but an interpretation of those elements that came together to make those years so special."

MUTTER, SCOTT (Photographer)

410 Cumberland, Park Ridge, IL 60068

Born: 1944 *Awards:* NY Society of Publication Designers Award of Merit; NY Art Directors Club Award for Editorial Photography *Collections:* International Center of Photography, NYC; Chase Manhattan Bank, NYC *Exhibitions:* Indianapolis Museum of Art; McDonald's Corporate Headquarters, Oak Brook, IL *Education:* U. of Illinois, Champaign *Dealer:* Printworks, Ltd., Chicago

Through the use of montage techniques, disparate images are joined seamlessly together in a logic-defying whole: the outstretched wings of a bird dissolve into a cavernous cathedral interior, which in turn seamlessly fades into a rocky gorge. Or, in another print, a swan floats in a marble courtyard which has melted into water. Inspired by the visual evolution of Chinese language, in which abstract concepts were articulated through the superimposition of visual symbols, these works function according to an analogous grammatology.

NACHMAN, ROGER (Glass Artist)
1473 Elliott Ave. W., Seattle, WA 98119

Born: 1953 *Awards:* Pilchuck Scholarship, 1984 & 1986 *Exhibitions:* Boulder Arts & Crafts, Boulder, CO; Contemporary Crafts Gallery, Portland, OR *Education:* U. of Colorado *Dealer:* Mindscape, Evanston

Abstract wall pieces of fused glass that make references to archeological finds are part of this artist's "Mesopotamia Series." Muted tones and the use of gold and other metallic leaf have become signatures of his work, which blends a complex of emotions and ideas with a primitive sense of refinement. Inspired by Japanese brush painting and calligraphy, he designs the irregularly shaped pieces so that their presence is achieved through simplicity and quiet strength. Through the interplay of the optical qualities of the glass and the surface textures and designs, the pieces are imbued with a life of their own.

NADOLSKI, STEPHANIE (Painter)
25287 Barsumian Dr., Tower Lakes, IL 60010

Born: 1945 *Awards:* Best of Show, Adler Cultural Center, Libertyville, IL *Collections:* Museum of Art of the American West, Houston; U. of Mississippi, Oxford, MS *Exhibitions:* Museum of Art of the American West, Houston; Prairie Center for the Arts, Schaumburg, IL *Education:* San Jose State College *Dealer:* Barr Gallery, Houston; Deerpath Gallery, Lake Forest, IL

Her early works are primarily representational oil and watercolor landscapes. Experimenting with a wide variety of media, including handmade paper, found objects, collographs, watercolor and acrylic, her most recent work has been mixed media. During the past year, she has concentrated primarily on monoprints pulled on handmade paper, enhanced by the addition of watercolor, ink, and metallics. Use of color and sensitivity to line, motion, and texture allow her to define her abstract subjects. Her new works are intuitive and meditative, evoking the "inarticulate speech of the heart" and following avenues of expression that pursue the unpredictable.

NARDI, DANN (Sculptor)
1701 E. Taylor, Bloomington, IL 61701

Born: 1950 *Awards:* NEA; IL Arts Council Fellowship *Collections:* State of IL; Coca-Cola Corp. *Exhibitions:* Roy Boyd Gallery, Chicago; Fay Gold Gallery, Atlanta *Education:* Illinois State U. *Dealer:* Roy Boyd Gallery, Chicago

Formally trained in painting, his early works were painted constructions. These soon led to free-standing sculptures. In 1982 he began working with cast concrete. He created timeless subjective fragments using color-pigmented concrete. A concern with permanency and sight specificity was evident in these works as was a painterly and architectonic sensibility. His forms are still architectonic, but he has now begun to suggest such functional objects as basins, masks, and tables. His scale has grown and the pieces are increasingly centered on the relationship between his materials (concrete, wood, bronze) and the pieces' implied functions.

NATKIN, ROBERT (Painter)
24 Mark Twain Lane, West Redding, CT 06896

Born: 1930 *Collections:* Museum of Modern Art, NY; Whitney Museum *Exhibitions:* Whitney Museum; San Francisco Museum of Modern Art *Education:* School of the Art Institute, Chicago *Dealer:* Gimpel and Weitzenhoffer Gallery, NYC; Douglas Drake Gallery, NYC

During the 1950s he was an Abstract Expressionist and early influences included not only Willem de Kooning but also Mark Rothko, Henri Matissse and Paul Klee. Later the "Apollo" series presented translucent bands of color which seemed to hover over the canvases. The surface of the canvas is emphasized in most of his paintings, in which multi-colored compositions are rendered in a pointillist and crosshatch style, while at the same time an illusion of depth is created, the images seeming to float in undefined planes--as in the "Intimate Lighting" series. Biomorphic and anthropomorphic shapes are evident in the recent "Bern Series"--large, colorful works in translucent acrylics on paper.

NAUMAN, BRUCE (Sculptor)
c/o Leo Castelli Gallery, 420 W. Broadway, New York, NY 10012

Born: 1941 *Awards:* NEA Fellowship; Aspen Institute for Humanistic Studies Grant *Collections:* Whitney Museum; Los Angeles County Museum of Art *Exhibitions:* Museum of Modern Art, NY; Whitney Museum *Education:* U. of Wisconsin; U. of California, Davis *Dealer:* Leo Castelli Gallery, NYC; Gemini G.E.L., Los Angeles

In the late 1960s he gained recognition with multimedia presentations in such media as neon, rubber, fiberglass, sound, video, and even holography. Slogans in neon played with language and mocked advertising gimmicks. Pieces made of rubber and fiberglass were bent, folded and hung, emphasizing the objects' properties rather than the objects themselves. He has made casts of his own body in fiberglass, clay and neon, during taped or live performances in an attempt to probe self-awareness. At times the audience members were asked to participate in video performances in order to expand their own self-awareness. Language, inner meaning and experience continue to be important in the sculptures and various other presentations.

NEGLEY, JAMES S. (Painter)
179 Cranston Ct., Glen Ellyn, IL 60137

Born: 1967 *Exhibitions:* Galesburg Civic Art Center, Galesburg, IL *Education:* Iowa State U.

Influenced by Hopper, Cezanne and Van Gogh, his early work shows a concern with balancing the expressive qualities of painting with formal discipline. He took up print making and mixed-media ceramics to explore the relationship of a figure to the space it inhabits. Working with intaglio printing techniques and various sculpting materials (e.g., wood, steel, ceramics), he created flimsy-legged figures. Although whimsical, these creatures stand precariously in brooding landscapes or quiet interior spaces. In another one of his works, a small panel with a painted landscape on it is suspended by cables in front of a figure painting. The simple displacement of the landscape to the foreground works against the accepted conventions of figure and landscape. Lu Bro has called his work "truly outstanding" and hails him as one of the major young artists of our time.

NELSON, LISA (Fabric Construction Artist)
6978 N. Greenview, Chicago, IL 60626

Born: 1956 *Awards:* 1st Prize, Woven Design, J.P. Stevens Competition, Philadelphia *Collections:* Floor Plan Ltd., Northbrook, IL *Exhibitions:* Muse Gallery, San Antonio; Natalini Gallery, Chicago *Education:* Philadelphia Textile; School of the Art Institute of Chicago *Dealer:* Ruth Volid, Chicago

She first studied textile design at Philadelphia Textile, where she specialized in multi-harness weaving. She became interested in cloth's tactile, sculptural nature while studying with Francis Piatek at the Art Institute of Chicago. Her first group of tapestries showed the influence of African Textiles, Hans Hoffman, and Navaho designs. Today she wraps canvas strips with threads and mounts them like canvas on stretchers. She adds woven cloth beads and acrylic paint to this background, forming boldly colorful "x"s and diamond forms. Her aim is to inspire a meditative state, reflective of the nature of weaving itself.

NELSON, WILLIAM (Painter)
100 W. Kenilworth Dr., Prospect Heights, IL 60070

Born: 1942 *Awards:* 4th Place, Oil Painting, Watercolor, and Printmaking, International Art Competition, Mussavi Gallery, NY *Collections:* National Museum of Natural History; Smithsonian Institution *Exhibitions:* Chicago Botanical Garden; Senate Caucus Room, Russell Senate Office Building, Washington, D.C. *Educa-*

James S. Negley, *Within a Defined Space*, 12 x 4, intaglio

Richard A. Nichols, *Golden Bridge*, 40 x 31, watercolor

tion: School of the Art Institute of Chicago *Dealer:* Jean Paul Loup

He began classes at the Art Institute of Chicago and was later awarded a full scholarship. He was most influenced by the Impressionists' use of color and by the ideas of Salvador Dali. After leaving the Art Institute, his technique became more realistic, and rural settings replaced images of urban life. Working by day as an illustrator for the Chicago Tribune, he painted by night and held his first major exhibition in 1973. A year earlier, he had been invited to the Pine Ridge South Dakota Indian Reservation to paint the Ogalala Sioux sundance ceremony. Deeply impressed by what he recorded, he began to explore Native American motifs and images in his work. In 1975, the U.S. Olympic Committee commissioned him to record the 1976 Summer and Winter Olympic Games. In the 1980s, his canvases have become larger, usually measuring 50" by 70." Earlier impressionist and surrealistic influences have reappeared in his work as he paints more from his imagination. One recent painting, for example, features a giraffe surrounded by scarlet flowers and foregrounded against ancient Egyptian wall paintings and architecture.

NETTLES, BEA (Photographer)
406 W. Iowa, Urbana, IL 61801

Born: 1946 *Awards:* NEA Fellowship; Illinois Arts Council Fellowship *Collections:* Museum of Modern Art, NYC; International Museum of Photography at Eastman House, Rochester, NY *Exhibitions:* Museum of Contemporary Photography, Columbia College, Chicago; American Cultural Center, Paris *Education:* U. of Illinois; U. of Florida *Dealer:* Catherine Edelman Gallery, Chicago; Illinois Photographer's Project, Chicago

Her work has always involved the use of alternative photographic processes due to her initial training in painting and printmaking. As a result, the pieces, including hand-colored photographs, non-silver prints, photographs on fabric, limited edition books, and photo-etching, are hard to classify. Regardless of the processes explored, the content of her images has remained consistent. The images, both autobiographical and archetypal, are suffused with allegorical dreamlike subject matter. Many pieces have multiple overlays of images and color as well as handwork, drawing, and stitching. The content of her recent work draws on the experience of parenting, the pieces incorporate portraits and writing done by her children.

NICHOLS, RICHARD A. (Painter)
1020 Cedar Ave., Suite 2T, St. Charles, IL 60174

Born: 1963 *Awards:* Louisiana Watercolor Award *Collections:* Century Engraving & Embossing, Chicago; National Bank of Brookfield *Exhibitions:* Louisiana Watercolor Society, New Orleans; Adirondacks Watercolor Society *Education:* American Academy of Art, Chicago *Dealer:* Nichols Fine Art Studio, St. Charles, IL

A graduate of the American Academy of Art in Chicago, he gained exposure to a wealth of watercolor styles and techniques. Choosing a strong, bold palette,

he works in an impressionist vein to paint scenes from throughout the country. He works on saturated paper and seeks to emulate the color values of Monet and Sargent in these paintings of nature.

NICKOLSON, RICHARD EMERY (Painter)
5020 N. Illinois St., Indianapolis, IN 46208

Born: 1946 *Awards:* Artist in Residence, Vermont Studio School; Artist in Residence, Virginia Center for the Creative Arts *Collections:* Rose and Company, Chicago; Chase Manhattan Bank, New York *Exhibitions:* Contemporary Art Workshop, Chicago; Indiana University Art Museum, Bloomington *Education:* Maryland Institute of Art; Indiana U. *Dealer:* Patrick King Contemporary Art, Indianapolis

His works provocatively combine figuration and abstraction to communicate the sense of wonder one experiences when first confronting the landscape of the Midwest. The artist sets icons such as water towers and grain elevators against expansive blue skys in his small-scale, sometimes shaped canvases. On top of these monumental forms, he applies playful abstract elements, such as bands of a primary color, intended to integrate formal elements with pictorial concepts. Working in oil, his technique involves loose brushwork that is structurally deliberate, and an intense, naturalistic palette with blue overtones.

NIFFENEGGER, AUDREY (Printmaker)
813 Washington St. #2N, Chicago, IL 60202

Born: 1963 *Awards:* George D. and Isabella A. Brown Traveling Fellowship, School of the Art Institute of Chicago; Award of Excellence, Evanston and Vicinity Show, Evanston Art Center *Collections:* Rudnick & Wolfe, Chicago; Temple University Rare Book Collection, Philadelphia *Exhibitions:* "Urgent Messages," Chicago Cultural Center; "Third Annual Artists' Books and Recordings Exhibition," Museum of Contemporary Art, Chicago *Education:* School of the Art Institute of Chicago *Dealers:* Printworks, Chicago; Tony Zwicker, New York

She is known for her handmade books, for which she does her own binding, printing, typesetting, writing, and artwork. The books vary, but usually contain full-page aquatint prints with accompanying text on the opposite page. She begins her work on a book with a written idea from which she goes on to create the illustrations. Her craftworking skills, such as etching, bookbinding, and letterpressing, are derived from techniques which date back hundreds of years. Her books include "The Adventuress," "The Spinster," "The Murder: A Detective Story," and "Aberrant Abecedarium," the only non-narrative work. Her drawing style is naive and stylized, midway between expressive book illustration and cartooning. Among the artists and writers who have influenced her unusual, accessible, provocative, and beautiful art are Aubrey Beardsley, May Klinger, Max Ernst, H.G. Wells, Colette, and many writers of mysteries.

NIKOLIC, TOMISLAV (Painter)
6007 Sheridan Rd., Chicago, IL 60660

Born: 1937 *Awards:* Gold Medal, International Grand Prix, Antibes, France; Lutetia Second Prize, City of

Tomislav Nikolic, *Stock Market,* 22 x 28, drawing

David Norstad, *Wetting the Daffodils,* 23 x 18, fiber collage.
Courtesy: Gallery 4, Moorhead, MN

Paris *Exhibitions:* Galeries d'Art International, Chicago and Paris *Education:* School of Decorative Arts, Yugoslavia *Dealer:* Galeries d'Art International, Paris and Chicago

Born in Yugoslavia and trained as a restorer of old paintings, he moved to Paris in 1963 where he began to paint seriously. In 1969, he came to the United States, settling in Chicago. Fascinated by the frantic energy and competition he found in the States, he produced a series of quasi-abstract paintings based on contact sports. Their source derived primarily from televised football, the paintings usually feature two colliding figures with the point of contact dissolving in an expressionistic swirl of primary colors blurred into a ground of thick white. This entire biomorphic mass floats on a flat, frequently split field of dark, muted purples, green, and grays. More recent works place his athletes against a background of newspaper and magazine clippings. In his paintings of the late 1980s, he has begun to deal with political and social events of everyday life. The colors he now uses are transparent.

NILSSON, GLADYS (Painter)
1035 Greenwood Ave., Wilmette IL 60091

Born: 1940 *Collections:* Museum of Modern Art, NYC; Whitney Museum of American Art *Exhibitions:* Museum of Contemporary Art, Chicago; Whitney Museum of American Art *Education:* School of the Art Institute of Chicago *Dealer:* Phyllis Kind Gallery, Chicago & NYC

This Chicago Imagist first gained recognition as part of the Hairy Who group in the late 1960s. Her colorful watercolors depict often innumerable fanciful figures in complex arrangements, overlapping and twisting with activity across the canvas. Crowded, elongated figures engage in odd encounters, providing something of a puzzle for the viewer. Because the main concern is the transformation of form, these lyrical images are made to be observed again and again, each sequence of vision lending a new interpretation to the intertwined shapes. Most works are on a small scale, but some large-scale canvases have been made as well. Although her primary medium is watercolor, she has also employed acrylic.

NOGUCHI, ISAMU (Sculptor, Designer)
32-37 Tenth, Long Island City NY 11106

Born: 1904 *Awards:* Fellowship, John Simon Guggenheim Memorial Foundation; Bollingen Fellowship *Collections:* Metropolitan Museum of Art; Museum of Modern Art *Exhibitions:* Whitney Museum of American Art; Museum of Modern Art *Education:* Columbia U. *Dealer:* Pace Gallery, NYC

An apprentice to Constantin Brancusi from 1927 to 1929 in Paris, he then studied brush drawing in Peking and pottery in Japan. In 1935 he created set designs for Martha Graham's dance company, as well as a high-relief mural in Mexico City, Mexico. In 1942 he made one of the first illuminated sculptures, and three years later a series of *Gunas* consisted of marble slabs placed on tripods. Experiments with media continued, including the employment of stainless steel, stone, ceramics, aluminum and bronze. Designs for lamps, furniture,

gardens, and playgrounds aimed at a Western commercial market also retained an Oriental flavor with forms like three-dimensional equivalents of calligraphy. In the 1960s simple sculptural pieces with roughened surfaces of bronze or marble were often placed in gardens in order to emphasize relationships between the object and the environment. During the next decade stainless steel sculptures explored the properties of surface density and reflected light. Recent works in stone bring a sensual and spiritual refinement to the medium. (Isamu Noguchi died while this book was in production.)

NOLAND, MICHAEL (Painter)
5416 N. Glenwood #2, Chicago, IL 60640

Born: 1958 *Collections:* Ohio State U.; Illinois State U., Normal *Exhibitions:* Contemporary Art Center, Cincinnati; Columbus Museum of Art *Education:* Cameron U.; Ohio State U., Columbus *Dealer:* Zaks Gallery, Chicago

His childhood experiences in rural Oklahoma have strongly influenced his art. His early expressionistic acrylic-on-canvas paintings were depictions of human figures and animals, reminiscent of Francis Bacon. Since 1982 he has painted intense personal translations of farm scenes, farm equipment, farm animals, and natural disasters such as tornadoes, floods, and soil erosions. Although many of his preliminary drawings are from life, his paintings are about transforming the landscapes into a personal vision. Among his influences are Thomas Hart Benton, Grant Wood, John Stuart Curry, and Charles Birchfield. His medium is oil on canvas.

NOLET, DIDIER (Painter)
c/o Struve Gallery, 309 W. Superior, Chicago, IL 60610

Born: 1953 *Awards:* Robert Rice Jenkins Memorial Prize, Art Institute of Chicago; Artists Fellowship, Illinois Art Council *Collections:* Museum of Fine Arts, Pau, France; Springfield Art Museum, Missouri *Exhibitions:* University of Chicago; Art Institute of Chicago *Education:* Ecole des Beaux-Arts, France *Dealer:* Struve Gallery, Chicago

He is best known for his glowing, mysterious landscapes and figurative paintings executed in a poetic-realist style reminiscent of Balthus. The techniques of the Old Masters, as well as Chardin, Courbet, Seurat, and Cremonini greatly influenced his early work, which consisted of still lifes from nature with an emphasis on composition. During the late 1970s he developed a fascination with the play of light, an element he included in imaginary interior scenes and a long series of still lifes of objects and clutter commonly found in an artist's studio. When he moved to Chicago from Paris in 1979 he had greatly increased the distance between the spectator and the painted subject. Recent work in pastel and oil features dream-like images from his imagination and from childhood memories. These works are characterized by large, flat areas of color and swift, short brushstrokes for figure definition.

NORSTAD, DAVID (Painter, Fiber Artist)
HC.9, Box 498, Island Lk., Detroit Lakes, MN 56501

Born: 1947 *Awards:* 1st Place, Fargo Regional; Cash Award, Bismarck Art and Galleries Show *Collections:*

North Dakota Museum of Art, Grand Forks; Bismarck Art & Galleries Assoc. *Exhibitions:* North Dakota Museum of Art, Grand Forks; E'Lan Gallery, Bismark *Education:* North Dakota State U., Fargo; McNay Art Institute, San Antonio

Painting in watermedia and acrylics, with an emphasis on landscapes, especially woods and panoramic views of farms and fields, he developed an Expressionist style based on Impressionist influences. He continues to paint, but has also progressed into collage and soft sculpture. He hand-dyes fabrics, fibers, and found objects and uses ragged appliqués in work that wittily expresses nostalgic human emotions. His colors are monochromatic or complementary. Roses, pinks, violets, and reds characterize his scenes of people eating at a smorgasbord, ladies mowing a lawn, elderly people with children, and strawberry-picking excursions.

NOVAK, JOYCE (Painter)
1306 E. Clarendon, Arlington Heights, IL 60004

Born: 1929 *Awards:* Cultural Exchange Artist, selected to exhibit, teach, and paint, U. of Beijing, Peoples' Republic of China; Purchase Award, McDonald's Fine Art Competition *Collections:* Continental Bank, Chicago; Stone Container Corporation, Chicago *Exhibitions:* University of Illinois, Champaign-Urbana; Sgraffito Gallery, Williwaw Studios, Chicago *Education:* U. of Michigan *Dealer:* East West Gallery, Chicago

She began to pursue art seriously in the early 1970s after a lifetime of creating art on a rather small scale. Her first teacher, George Buehr, influenced her early work by introducing her to the urban and industrial landscapes which form the basis of her work. By the early 1980s she had moved on to experiment with many media, including gouache, airbrush, pastels, charcoal, and acrylics, and to express her own feelings about the cosmological and geological origins and processes of creation. Her current "Alpha and Omega" series is composed of acrylic paint on flat areas contrasted with raised areas of textured acrylic compound. Influenced by spirituality, alchemy and nature, she has created a series of savage, primordial landscapes representing perpetual life through elemental change and supernatural means. These works glow in otherworldly colors, creating an alien yet familiar atmosphere bathed in mystic overtones.

NOVOSELAC, TONI (Painter, Drafter)
400 W. Reader St., Elburn, IL 60119

Born: 1952 *Awards:* Warrnga Art Prize, Australia *Exhibitions:* Royal Easter Show, Sydney, Australia; Aurora University, Aurora, IL *Education:* Seaforth Technical Institute, Sydney, Australia

Early work was influenced by the French Impressionists and the Heidelberg school of early Australian colonial art, as well as by the geometric abstraction of Piet Mondrian. Subsequently, the artist was drawn to the imagery of Australian Aboriginal bark and cave paintings; pieces were done on untreated burlap. Her interest in working on unprimed supports has con-

tinued; current paintings, primarily still lifes and figuration, are done on raw canvas. Mixed media drawings make up an important aspect of her work and are executed in an impressionistic style using a bright and full palette.

NUTT, JAMES TUREMAN (Painter)
1035 Greenwood Ave., Wilmette IL 60091

Born: 1938 *Collections:* Museum of Contemporary Art, Chicago; Whitney Museum of American Art, NYC *Exhibitions:* Art Institute of Chicago; Venice Biennale *Education:* School of the Art Institute of Chicago *Dealer:* Phyllis Kind Gallery, Chicago

This Chicago Imagist first gained recognition in the late 1960s as part of The Hairy Who group of painters. Meticulously executed drawings and paintings depict fantastic characters engaged in ironic dramatic scenes. Distorted figures recall those of Cubism in that they often possess several faces at once, perhaps representing different states of feeling. The dramas are erotic and mysteriously threatening, and although (or perhaps because) Nutt adds oddly placed captions and gives the works cryptic titles, the situations remain inexplicable, and therefore engaging.

ODOM, LADDIE SCOTT (Commerical Illustrator, Kite Maker)
114 W. Grand, Chicago, IL 60610

Born: 1955 *Exhibitions:* Prism Gallery, Evanston, IL; Objects Gallery, Chicago *Education:* Wayne State U., Detroit; Sheridan College, Ontario *Dealer:* Prism Gallery, Evanston, IL

A freelance commercial artist, he specializes in computer-generated illustration and animation. He also makes kites. His work is inspired by "fractals"--mathematically generated geometric structures and patterns that resemble organic forms; crinkled paper can reveal fractals, as can the way in which pigment is applied, revealing their similarity to other natural forms. As for his kites, though he thinks of them as flying sculptures, they are first and foremost meant to be flown. The kites are made of natural materials--bamboo, kinwashi paper, silk, natural twines--though he is considering moving into more contemporary materials. He uses traditional Chinese, Indian, and Japanese kite designs, but he has begun to include more modern structural elements. The motif in in both his commercial design and his kites remains the exploration of underlying structures in materials, emphasizing the fractal forms and the "chaos" found within them.

OLAH, JOE (Painter)
56 E. 56th Ave., Merrillville, IN 46410

Born: 1959 *Exhibitions:* Midwest Museum of American Art, Elkhart, IN; Atrium Gallery, Gary, IN *Education:* Indiana U. Northwest; Ball State U. *Dealer:* Horizon Gallery, Merrillville, IN

Surrealistic themes, often involving fish, dolphins, hieroglyphics, and Aztec mythology, are the subjects of the brightly colored, graphic works of this artist. Differing types of surfaces, such as canvas, paper, and pebbleboard, serve as the foundations for paintings which employ thick layers of gel medium and pris-

macolor pencil. The artist favors the unusual in order to encourage controversy in his paintings; he has completed a series of crucifixions, emphasizing the ugliness of the event.

OLDENBURG, CLAES THURE (Sculptor)
556 Broome St., New York NY 10013

Born: 1929 *Collections:* Museum of Modern Art, NYC; Whitney Museum of American Art, NYC *Exhibitions:* Metropolitan Museum of Art, NYC; Museum of Modern Art *Education:* Yale U. School of Art; School of the Art Institute of Chicago

Born in Sweden, his early life was spent shuttling between America and Scandinavia. By the time he moved to New York in 1956, his figurative works were rendered with a loose brush stroke. Four years later he was involved with a group of artists including Jim Dine, which started a new kind of participatory art called "happenings." During the next decade numerous happenings, with crude costumes, cardboard props, all kinds of objects and crowds of people made up his media. Later he imitated Pop Art by painting and selling plaster replicas of food and other merchandise. His monumental stitched pieces in soft vinyl or canvas and stuffed with kapok--*Soft Toilet*, for example--are collapsible objects that rely on gravity and chance for their ultimate shape. The similarity of these pieces to human forms serves to lessen their potential irony, for this artist's main goal is to delight the senses.

OLENDORF, BILL (Painter, Printmaker)
9 E. Ontario, Chicago, IL 60610

Born: 1924 *Awards:* Grant, Rockefeller Foundation *Collections:* Tiffany & Co.; First National Bank of Chicago *Exhibitions:* Art Institute of Chicago; Galerie Bernhgim, Paris *Education:* Harvard; School of the Art Institute of Chicago

Oil paintings and prints of European and American urban landscapes make up the majority of the subject matter of his work. Paris rooftops, Spanish villages, and urban America are all depicted in his medium- to large-scale oil on canvas paintings and in both his color and black and white prints. These representational landscapes are executed in a painterly impressionism--realism without being naturalistic. His prints of LaSalle Street in Chicago and Wall Street in New York have been distributed among the financial community with great success.

OLKINETZKY, SAM (Collage and Construction Artist)
Rt.1, Box 151-A, Norman, OK 73072

Born: 1919 *Awards:* Tulsa & Oklahoma City Purchase Awards; Governor's Award *Collections:* Philbrook Art Center, Tulsa; Oklahoma Art Center, Oklahoma City *Exhibitions:* Museum of Modern Art; Guggenheim Museum

His earliest influences were Picasso, Gris, and Piero Della Francesca. He subsumed the influences of Pollack, Kline, and Motherwell and made geometric abstractions in the late 1940s and 1950s. By the 1960s, Zen influences had led him to make his slate-based collage constructions and paper cardboard and found object painted reliefs. The Zen quality remains in his leather collage diptychs, triptychs, and polyptychs of the 1980s. Most recently, he has restricted his serial geometric collages to three color lines on either black or white smooth acrylic surfaces. He continues his leather series and ink drawings.

OLSON, J. WAYNE (Photographer)
P.O. Box 6215, Chicago, IL 60680

Born: 1952 *Awards:* Illinois Arts Council Artist Fellowship; Arizona Historical Society *Exhibitions:* Prairie State College; N.A.B. Gallery *Education:* U. of Arizona, Tucson

Through photography, he explores the relationship between language and image. Joseph Beuys, Marcel Duchamp, Steve Reich, and the conceptual artists of the the early 1970s all influenced him during his formal training. In his early work, he deconstructed images of urban graffiti by cutting the surfaces of photographs and reconstructing them into a new representation of the image. He currently creates mythical constructions of nature, memory, and history. He deconstructs these small polaroids by applying gold leaf, pigment, decal, paint, and other materials to their surfaces.

OLSON, PATRICIA SHAFFER (Painter)
1955 W. Morse Ave., Chicago, IL 60626

Born: 1927 *Awards:* Kansas Pastel Society National Award *Collections:* Northeastern Illinois U. *Exhibitions:* Art Institute of Chicago; Society Des Pastelistes de France *Education:* Northeastern Illinois U.; Loyola U. *Dealer:* Carol Hendrickson, Arlington Heights, IL

Strongly influenced by Expressionists and Fauves, she initially did large, emotional oil paintings using rich, complementary colors for optical edges in order to create form. Distorted to stress movement and excitement, the figures later began to inhabit a world of shadows and dissolving walls and barriers. In recent work, her palette has cooled and matured, but continues to stress emotionality through the strong use of evocative purples and other hues. Reflecting the influence of her life in the city, the figures are never alone, but are seen reacting to the stimulus of an urban environment. She uses both oils and pastels, interchanging techniques so that pastels have a painterly texture and brush work in oil is similar to drawing. More allegorical in nature, her most current series, "Woman as Hero," casts modern women in the role of ancient goddesses.

O'MALLEY, ANNE M. (Sculptor)
2453 N. Janssen, Chicago, IL 60614

Born: 1953 *Awards:* Recognition Award for Professional Contributions in the Field of Education, Sculpture, Oakton Community College *Exhibitions:* U. of Illinois Medical Center, Chicago; Illinois Institute of Technology, Chicago *Education:* DePaul U.; U. of Illinois, Chicago

She works with a diverse range of materials from African hardwoods to pen and ink drawing. Her work is both abstract and representational, often in combination. One example of this is *Linear Transformation*, in which a drawn, two-dimensional building is seen

Laddie Scott Odom, *Lunar/Dairy Delta,* 48 x56, kinwashi, ink, dowel

Onli, *Cosmopolitan Daydream,* 12 x 18, graphite

through a three-dimensional, geometric abstract form. She takes pleasure in creating both types of works and from combining them in ways that express the duality of human nature and that of the man-made and natural worlds.

ONLI, TURTEL (Painter)
5121 S. Ellis, Chicago, IL 60615

Born: 1952 *Awards:* Award of Excellence, Artist Guild of Chicago; American Artists of Reknown *Collections:* Columbia College, Chicago *Exhibitions:* Limelight Club, Chicago *Education:* School of the Art Institute of Chicago; Port Royal Atelier Studios, Paris, France

Influenced and inspired by the innovations witnessed in jazz, he has devoted himself to creating a similar approach in visual art, which he calls Rhythmism. His goal is to accomplish the melody, composition and rhythmic line of music in two dimensions. His body of work contains acrylic, oil and airbrush paintings that are both abstract and figurative. One collection is a painted and drawn interpretation of the late Jimi Hendrix. Since 1971 his rhythmistic idiom has met with critical acclaim in both fine and commercial art circles. More important to the artist is its future impact on the international contemporary art scene. In addition to his work on canvas, he has developed his own line of wearable art.

ORR, LEAH (Fiber Sculptor)
925 N. Alabama St., Indianapolis, IN

Born: 1937 *Awards:* Best in Fiber, Indiana Craft Market *Collections:* Lincoln Hotel, Indianapolis; Park Fletcher Business Center, Indianapolis *Exhibitions:* Indianapolis Museum of Art; Kentuckiana Fiber 1988 *Education:* Indiana University; St. Mary-of-the-Woods College, IN *Dealer:* Corporate Art Source, Inc., Chicago

Original wool tapestries were textural, painterly, and of medium scale. A desire to break from flat color and shape led her to work in larger sculptural forms. Experimenting with new materials resulted in the art form of wireworks. Drawing upon the "optical games" in the work of Paul Klee, the pieces in her series of *Wireworks* are minimal statements using copper-coated pvc wire in a netted form. Their complementary colors and loose weave allow for visual mixing, as one shape transforms into another, undulating the structural gridwork. The tapestries fold and twist onto themselves and are also minimalist, sequential studies. The artist works primarily on a commission basis.

ORTH, DAVID (Woodworker)
1107 Chicago Ave., Oak Park, IL 60302

Born: 1953 *Exhibitions:* Esther Saks Gallery, Chicago; Evanston Art Center, IL *Education:* Northwestern U.

The artist designs and builds art furniture. Exposure to Costa Rican and Guatemalan folk art during the 1960s grounded his woodworking technique and artistic direction. Although his work in the 1970s fell under the discipline of the Arts and Crafts movement and Architectural Modernism, his current work is a more dynamic metaphor--at once moving and still, primitive and cosmopolitan, ethereal and material. Native and exotic wood, metal, and glass components appear to hover, span, grasp, and invisibly connect. These relationships are further articulated in a variety of materials and color. Although realizing that furniture as art has significant limitations, he believes that it has a unique repertoire of meanings precisely because of its inherent necessity, utility, and archetypal role.

OSTERHUBER, MAGDA (Painter)
1837 N. Cleveland, Chicago, IL 60614

Born: 1934 *Awards:* U. of Iowa; Countryside Art Center *Collections:* Roger Ebert; U. of Iowa *Exhibitions:* Beverly Art Center, Beverly, IL; U. of Illinois, Chicago; *Education:* U. of Iowa; U. of Illinois, Chicago

The artist wants her work to become a presence, an equivalent to her experience of the real. In her recent paintings, her preoccupation has been with the time-worn fragments and remains of matter that are witness to the human hand. In a series titled *Veronica's Veil*, this preoccupation has been with permanence and the Divine in the human face and the presence of Christ in the human condition. Her method is to apply washes of acrylic paint to the canvas tacked on a wall. She then paints colors and shapes on bits of newspaper, and rubs or imprints images from them onto the canvas, attempting to evoke the passage of time and to permit the unpredictable. "Ultimately," she says, "this process of art is as complex and as simple as the placing of a line upon a blank surface."

OSTERLE, DALE (Printmaker, Mixed-Media Artist)
903 Sunnymeade, DeKalb, IL

Born: 1939 *Awards:* Illinois Arts Council, Special Assistance Grant *Collections:* I.B.M.; McDonald's *Exhibitions:* Chicago Center for the Print; Countryside Gallery, Chicago *Education:* Rhode Island School of Design; Northern Illinois U. *Dealer:* Chicago Center for the Print

She grew up in New England and has a special affinity for winding paths, trees, and woods. Her first intaglio landscape, was entitled . . . *miles to go*, and she feels that she has traveled the path of Frost's poem. The two directions of her work are romantic and expressionist landscapes and expressionist portraits. The landscapes are traditional etchings, while the portraits are expressions and impressions in mixed media. In her painterly series of post-modern portraits, "New Faces," she began with simple printed forms and embellished the surface with glitter, jewels, feathers, and other unorthodox treatments. Now also using metallic paint, she has arrived at a form midway between print and painting.

OTT, MICHAEL (Painter)
1520 Crescent, Lawrence, KS 66044

Born: 1945 *Award:* Governor's Award, Artist for the State of Kansas *Collections:* Hallmark Art Collection; Hughes Corporation *Exhibitions:* Wichita Art Museum, KS; Spencer Museum of Art, Lawrence, KS *Education:* U. of Colorado; U. of California, Berkeley *Dealer:* Joy Horwich, Chicago

Leah Orr, *Life Goes On: Frances Farmer(detail),* 60 x 72, tapestry-wool. Photograph: Garry Chilluffo. Courtesy: Indiana Bell, An Ameritech Company

David Orth, *Dining Table,* 84 x 30 x 29, walnut, maple, glass

He has had a longstanding interest in social art in both its political and personal manifestations. His artwork has taken two primary directions. On one hand, he has created a number of humorous paintings which deal with vacationing and the absurdity of many vacation locales and situations. In one such painting, for example, he presents a lovely Western vista, with a dead dog in the middle of the road. His other main artistic endeavor has been a series of painted T-shirts and another series of paintings of clothing. This work derives from two interests: first, as a continuation of the pop art movement, which made extensive use of screenprinting, and further as a visual representation of his view of the social function of clothing. He believes that by wearing certain kinds of clothes people make statements concerning their feelings about themselves, both physically and intellectually. Images are both figurative and geometric in type, and both the paintings and the T-shirt paintings are executed in a bright watercolor palette.

OYADUN (Lillian Roberts) (Illustrator, Printmaker, Painter)
6144 N. Winthrop, Chicago, IL 60660

Born: 1958 *Awards:* International Ladies Garment Workers Union "America's Next Great Designer" Award; Mid-America Award for Creative Fashion Sketches *Collections:* Jeff Designs, Copenhagen, Denmark *Exhibitions:* Special Things Gallery, Evanston, IL; South Side Community Art Center *Education:* School of the Art Institute of Chicago; Parsons School of Design, NYC

An early focus on fashion design and illustration led to an interest in clothing as art. Illustrations, which at first functioned solely as visual records of clothing, gradually shifted in focus to express a deepening fine-art interest in form, movement, and the human figure for its own sake. Current drawings, paintings, and prints reflect this fine-art focus. Previous activity includes the creation of a sportswear collection for Jeff Designs, Copenhagen, Denmark, an Artist-In-Residence post at the District 88 Public School in Homewood, Illinois, lectures, workshops and demonstrations, research, exhibits, fashion shows, and consulting work.

PACE, JOEL M. (Painter, Draughtsperson)
7001 W. Wolfram St., Chicago, IL 60634

Born: 1951 *Awards:* 1st Place, Harrisburg Annual Juried Exhibition *Exhibitions:* Union League Club, Chicago; Sazama/Brauer Galleries, Chicago *Education:* Carnegie Mellon U., U. of Illinois, Champaign *Dealer:* Sazama/Brauer, Chicago

As an undergraduate, he was influenced by Thiebaud, Pearlstein, Rosenquist, and the other New Realists. By the early 1980s, he had become interested in the work of Caravaggio and the Pre-Raphaelites. He then found that the Symbolists, particularly Khnopf and Klinger, had reconciled these disparate strains of imagery and technique. His current imagery involves a disconcerting juxtaposition of conflicting and related objects. He paints on gessoed panels and employs glazing and underpainting techniques. He also makes very detailed graphite drawings.

PADRON, FRANCIS (Painter)
1907 S. 48th Ct., Cicero, IL 60650

Born: 1960 *Awards:* Illinois Arts Council Grant; Smiths Scholarship *Collections:* Loyola University, Chicago *Exhibitions:* Mexican Museum of Chicago; Instituto Nacional Potosino de Bellas Artes, Mexico *Education:* School of the Art Institute of Chicago; Loyola University, Chicago

Incorporating "the simplicity of Chagall and the complexity of Dali" with the formal and social concerns of the Mexican Social Realists, the artist creates both easel- and mural-sized works. Inspiration is drawn from Biblical parables as well as the writings of philosophers such as Descartes, St. Augustine, Jung and Paul Mosier. Works include a mural on Chicago's Southwest side, *We the People*, which was executed with the assistance of gang members. Working in a variety of media including ink, acrylic and tile mosaics, he intends his realistic, primarily figurative pieces to serve as philosophical messages.

PALADINO, MIMMO (Painter)
Largo La Foppa 5, 20121 Milan, Italy

Born: 1948 *Exhibitions:* Royal Academy of Arts, London; Marian Goodman Gallery, NYC *Dealer:* Richard Gray Gallery, Chicago

Mythic imagery of primitive cultures are key to the unseen world in Mimmo Paladino's paintings. In *Gocce nella Valle*, swirls of aquatint and sugarlift beleaguer a crouching figure and animal forms loom among smaller figures, allusive to birth and mortality. Often repeated in Paladino's work is the concept of transparency. Threadlike lines create planes acting as screens, through which layers beneath emerge. Figures are seen within, performing mysterious activities. Skeletons, masks, animals and Christian symbols often populate his canvases. Paladino perceives the artist as spiritual vehicle.

PALAZZOLO, TOM (Filmmaker, Graphic Artist)
808 N. Elmwood, Oak Park, IL 60302

Born: 1937 *Awards:* Grant, American Film Institute; Grant, Illinois Arts Council *Collections:* Museum of Modern Art; Film Center, Art Institute of Chicago *Exhibitions:* Facets MultiMedia, Chicago; Whitney Museum of American Art *Education:* School of the Art Institute of Chicago *Dealer:* Chicago Center for the Print

Although an accomplished graphic artist and photographer, he is best known as an independent filmmaker. His interests run to the eccentric and grotesque, perhaps as a result of spending his childhood in close proximity to a circus ground. His droll, dead-pan documentary films chronicle all that is weird in the Midwest, from backyard barbecues to compilations of images found and manufactured. His films have been widely exhibited both here and abroad and he has won many awards at film festivals all over the world. His most famous works include *Venus and Adonis* and a rare narrative film, *Caligari's Cure,* an expressionist celebration in a deft and unpremeditated off-hand idiom.

PALUZZI-KELSEY, CLAUDINE (Painter, Sculptor)
4525 Carrollton Ave., Indianapolis, IN 46205

Born: 1931 *Awards:* N.E.A. Grant; Scholarship, John Herron Art School *Collections:* Indiana Central College; Evansville Museum of Arts and Science *Exhibitions:* Purdue University; Indianapolis Museum of Art *Education:* John Herron Art School; Indiana U.

Earliest influences were Michelangelo's sculptures, Ingres' drawings, and Kathy Kolowitz's children. She lived in Rome twice and there fell in love with the Italian fountains, sculpture, and way of life. She has a sense of humor about her work and once created a baloney sculpture that was used in a commercial for a well-known meat company. On another occasion, she sculpted a four-foot papier maché piggy bank. She works on commission and tries to retain her own style and artistic integrity while satisfying her customers' needs. "I feel that art is a series of problem-solving situations, in which the artist seeks the best possible solution," she says.

PAQUETTE, THOMAS (Painter)
303 Jefferson Rd., Edwardsville, IL 62025

Born: 1958 *Awards:* Purchase Award, Illinois Small Painting Exhibition, Western Illinois U., Macomb; Fellowship, Southern Illinois State U., Edwardsville *Collections:* Minnesota Pollution Control Agency; Southern Illinois U.; *Exhibitions:* Rifle Sport Alternative Art Gallery, Minneapolis; St. Louis Design Center *Education:* Bemidji State U., MN; Southern Illinois State U., Edwardsville Dealer E.S. Galt Gallery, St. Louis

Influenced by Dada and Surrealism, his early surrealistic canvases were explorations of the basic tenets of individual reality. His philosophical approach is now more subtle, but he has placed average people in bizarre settings to show the horror, humor, and fantasy that lies beneath the surface. Working in a variety of media, including collage and oil on canvas, he has taken cues from painters as diverse as Morandi, Hopper, and Magritte. In some pieces he uses the "textureless" surfaces of gessoed panel and paper as a basis for an exploration of texture. Also interested in tonal relationships and color value, his work is also typified by high-key colors.

PARETI, MARYBETH (Ceramist)
Rt. 1 Box 133, Soldiers Grove, WI 54655

Born: 1955 *Exhibitions:* Gickory Street Gallery, St. Louis; Danko Gallery, Chicago *Education:* Kent State U.; New York U.

While attending a master's program in Italy (1979/1980) she was exposed to Venetian designer Frederica Marangoni, glass master Livio Seguso, and printmaker Riccardo Licata. While there, she made a series of abstract, mixed-media drawings in which she combined geometric forms with water pylon images. After teaching college ceramics in Chicago for three years, she moved to southwestern Wisconsin where she now works as a ceramic artist. In her recent work with asymmetrical porcelain tiles, she used a wide range of slips and stains to focus on issues of color and texture.

She has recently introduced metal, plastic, and handmade paper into the architectural designs of her small- and large-scale wall relief tiles.

PARKS, CARRIE ANNE (Ceramist, Draughtsperson)
824 Pine Ave., Alma, MI 48801

Born: 1955 *Awards:* Purchase Award, Rutgers National; Purchase Award, Auburn Works on Paper Exhibition *Collections:* Clemson U., Austin Peay State U. *Exhibitions:* Lill St. Gallery, Chicago; Objects Gallery, Chicago *Education:* Wesleyan U., Virginia Commonwealth U. *Dealer:* Objects Gallery, Chicago

Her earlier pieces of sculpture functioned as elements of larger environments. Her doorways, floors, and domestic objects were parts of places where something might happen. Her drawings of bare façades and interiors also resembled stage sets waiting for the play to begin. More recently, her settings have become less inviting. The figures inhabiting them do so uneasily, exhibiting tensions between each other and with their environments and circumstances. She is aware of, and influenced by the ancient potters of Japan and China and she admires the combination of realistic specificity and magical symbolism they saw in their work. She hopes her work will function in the same way.

PASCHKE, EDWARD F. (Painter)
1927 E. Estes, Chicago IL 60626

Born: 1939 *Awards:* Logan Medal, Art Institute of Chicago; Cassandra Grant, Cassandra Foundation *Collections:* Art Insitute of Chicago; Museum of Contemporary Art, Chicago *Exhibitions:* Art Institute of Chicago; Whitney Museum Annuals, NYC *Education:* School of the Art Institute of Chicago *Dealer:* Phyllis Kind Gallery, Chicago

In a biting style aided by acid colors, this Chicago Imagist presents disturbing events and enigmatic people from real life in order to provoke "emotive responses" from the viewer. He began as part of the Pop movement, and is well-known for his sometimes grotesque figures which question sexual identity such as *Nueva Yorka* and *Tropicale*. Current work includes figures which look as if they have been electronically produced in a "high-tech" surrealism of neon colors. A recent collaboration with Lyn Blumenthal and Carole Ann Klonarides resulted in the video *Arcade*.

PATTISON, ABBOTT (Sculptor)
334 Woodland Ave., Winnetka, IL 60093

Born: 1916 *Awards:* Logan and Eisendrath Prizes, Art Institute of Chicago; Contemporary American Sculpture Award, Metropolitan Museum *Collections:* Whitney Museum, NYC; Art Institute of Chicago *Exhibitions:* Metropolitan Museum, NYC; Whitney Museum, NYC *Education:* Yale U. *Dealer:* Fairweather-Hardin Gallery, Chicago

A magnetic attraction to the great works of Michelangelo and Rodin gave early direction and inspiration to this prolific sculptor. Figuration, landscape and abstraction have all been explored in the primarily cast bronze or welded metal works of a career which spans almost 50 years. A blending of Greek, Chinese and

primitive art forms can be found in the welded steel, brass, bronze and other metals as well as carved marble and stone and ceramic pieces that are represented in major collections across the country. Many pieces are outdoor, large-scale works, including groups of larger-than-life figures, such as a commissioned piece for the Chicago State University. The artist divides his time between Winnetka and a summerhouse in Lincolnville, Maine.

PATTISON, BILL (Painter)
2025 E. 80th St., Indianapolis, IN 46240

Born: 1950 *Awards:* National League of Pen Women, Indianapolis *Exhibitions:* Scared Arts Exhibit, Billy Graham Museum of Art, Wheaton, IL; Lafayette, Indiana Museum of Art *Education:* Washington School of Art; LaSalle Institute *Dealer:* Artistic Expressions: Indianapolis

Influenced by the luminosity of Van Meer, the chiaroscuro of Rembrandt, and the Americana of Rockwell, he has progressed into a style that is distinctively fresh and original, specializing in figurative depictions of early- to mid-Americana. He is also a portraitist and is currently illustrating the cover of the magazine *The Good Old Days.*

PAUL, JOYCE (Painter)
2640 W. Mequon Rd., Mequon, WI 53092

Born: 1946 *Awards:* First Place, Visual Arts Fellowship Grant, Wisconsin Arts Board *Exhibitions:* Hyde Park Art Center, Chicago; West Bend Gallery of Fine Arts, West Bend, WI *Education:* U. of Wisconsin, Milwaukee *Dealers:* Edgewood Orchard Galleries, Fish Creek, WI; Dillard Gallery, Minneapolis, MN

The Old Masters and other figurative artists are strong influences on her. Working in watercolor, acrylic, and mixed media, she has researched a range of media and surfaces, trying to find the optimal materials for rendering the tension of human relationships and the whimsical fantasy of lived experience. Her works are large and richly colored. The figures feature exaggerated physical and facial elements, as though seen through a magnifying glass. Current work is exclusively oil on linen and canvas. She has been working on a series of "portraits," large heads which are approximately four times life-size, exploring the landscape qualities and patterns in the human face.

PAWLAN, ANDREW H. (Wood Crafter)
3719 N. Fremont St., Chicago, IL

Born: 1946 *Awards:* Fellowship Grant, Illinois Arts Council; Fellowship Grant, Art Park, NY *Exhibitions:* "Made in Chicago," Merchandise Mart, Chicago; On the Wall Gallery, NY *Education:* U. of Illinois *Dealer:* Hoken Kaufman Gallery, Chicago

He is best known for his elegant wooden furniture executed in a minimalist style. Originally trained as an architect, he began woodworking in 1970, making the transition to furniture in the early 1980s. A designer as well as an artisan, he uses the principles of mathematics and geometry as the basis for his designs. He works with hardwood, fiberboard, plywood, lacquer, laminate, and veneer, and this year has incorporated marble, glass, and upholstery in his furniture. He cites the principles

of Italian futurism, the Bauhaus, the Prairie School, and the art of ancient Greece and Rome as major influences on his style and approach. His goal is to use his understanding of materials and structure to create functional furniture that is both graceful and lavish.

PAYNE, JOHN (Sculptor)
25645 Western, Park Forest, IL 60466

Born: 1934 *Awards:* Danforth Fellowship *Collections:* Hilton Towers and Hotel, Chicago; Governors State University *Exhibitions:* Navy Pier International, Chicago; Gruen Gallery, Chicago *Education:* U. of Wisconsin, Madison; Beloit College

Developing a style as a result of looking with a deep curiosity at the developments of the civilized world, he claims influence not from other artists but, rather, from nature and technological design. His work often follows his early interests in flight, space, and change. A large series produced in the 1960s reflects this interest, with such titles as "Imagine Me an Astronaut" and "Moon Walker." Though the titles are narrative, the pieces themselves are abstract. His recent work makes particular use of light and motion. One work investigates these interests and themes in a mix of media, using wood, stone, and metal. Currently, he is producing both large and small pieces combining casting with carving and fabrication.

PEART, JERRY LINN (Sculptor)
1544 North Sedgwick St., Chicago, IL 60610

Born: 1948 *Awards:* Jeanette Sacks Art Achievement Medal, Arizona State U.; Award, Chicago Art Association *Collections:* Museum of Contemporary Art, Chicago; Nathan Manilow Sculpture Park *Exhibitions:* Illinois Collection for the State of Illinois Center; E. B. Crocker Art Gallery, Sacramento *Education:* Southern Illinois U.; Arizona State U. *Dealer:* Con Struct, Chicago

Working in a constructivist manner, he fabricates large-scale sculpture by welding together aluminum or steel components. Organic forms are often assembled onto more strictly geometric forms, giving the finished piece a sense of animation and life. Volumes and space are manipulated and balanced to build a formal harmony within the piece. Applied color is a distinctive feature in his work; some works are monochrome with a single surface color, while others are polychrome, the multiple surface colors vitalizing the metal volumes. He has executed a variety of large public sculptures across the United States.

PELTZ, LORRAINE (Painter)
5475 S. Everett, Chicago, IL

Born: 1959 *Awards:* Short Term Artist in Residence, (STAR) Illinois Arts Council; Honorarium, School of the Art Institute of Chicago *Exhibitions:* "Masks: Artists Make Masks for the Chicago Opera Theatre," Klein Gallery, Chicago; "Paintings," 101 N. Wacker, Chicago *Education:* State U. of New York, New Paltz; U. of Chicago *Dealer:* Marianne Deson Gallery, Chicago

When she moved to Chicago from New York in the early 1980's her paintings were abstractions of simple

Magda Osterhuber, *Veronica's Veil No. 4,* 50 x 39, acrylics on canvas

Bill Pattison, *The Critics,* 22 x 30, graphite

phenomena of daily life. Gradually, more recognizable elements entered the compositions, and a need to paint from real life arose for her. These paintings were lush still lifes situated in an austere interior. Placed in such settings, the objects, most of which were vessels or containers of some kind, took on anthropomorphic qualities. Initially, the paintings were contained interiors, but over time, more doorways and windows appeared, through which light from a distant room or some far-off landscape could be seen. Presently, the paintings are concerned as much with the landscape as with the still life. The vessels are often paired on a table and juxtaposed against an evocative landscape, many of which are from photographs and memories of the artist's travels. She paints with oils, using lush, seductive color and definitive and dramatic light. The works reflect the continuity of nature contrasted with transience of manufactured objects and situations.

PENN, IRVING (Photographer)
Irving Penn Studios, 89 Fifth Ave., New York NY 10002

Born: 1917 *Collections:* George Eastman House, International Museum of Photography; Museum of Modern Art *Exhibitions:* Metropolitan Museum of Art; Museum of Modern Art *Education:* Philadelphia Museum School of Industrial Art *Dealer:* Marlborough Gallery, NY

He first studied with revolutionary fashion photographer Alexey Brodovitch at the famed "design laboratories" in Philadelphia in the late 1930s; he then worked as a graphic designer in New York. He painted for a year in Mexico before returning to New York City in 1943 to accept a job as cover designer for *Vogue* magazine. He gained recognition when he photographed the covers himself, and for over forty years he has remained an editorial contributor to the magazine. His clients are in industry and advertising throughout America, Europe and Asia.

PEPPERS, ROBERT EDWIN (Painter, Printmaker)
1217 Main St., Lafayette, IN 47901

Born: 1949 *Awards:* 1st Place, Painting, Atlanta Life Insurance National Art Competition *Collections:* U.S. Embassies; Atlanta Life Insurance Co. *Exhibitions:* High Museum; Donnelly Gallery, Lake Forest (IL) College *Education:* Ohio U.

Influenced by the New Humanists, his early work contrasts the innocence of childhood and the trials of modern man in his large oil paintings and relief prints. Adults are portrayed as awkward intruders in a world filled with dolls and carousels; His garish colors are reminiscent of those in an amusement park. His recent paintings are explorations of art and animation related to Italian futurism and visual phenomena. He deals with modern concerns while remaining true to his African-American heritage. His realism has become a departure point for the jazz-like, improvised abstraction he plays out as extended or blurred edges and multiple images.

PERKINS, DONNA C. (Painter)
1128 W.Staver St., Freeport, IL 61032

Born: 1920 *Awards:* Purchase Prize, Wisconsin Salon of Art; 1st Prize, Beloit and Vicinity *Collections:* U. of Wisconsin; Rehabilitation Hospital of Chicago *Exhibitions:* Annual National Exhibition, Sarasota, FL; Art U.S.A.; Old Orchard Invitational

Drawn to Stieglitz's haunting photographs and to Aaron Bohrod's early moody street scenes, she began painting with oil and casein on Masonite. Her first exhibition was in 1953. Beginning with sketches that often bore no relation to the final work she sat on her knees with the Masonite on the floor, painting and scraping and painting again until she had built up layers of paint. Her current figurative works are characterized by scenes of dark stormy snowy days or blacktop streets sparkling in the rain. Painting with acrylic on Masonite, she contrasts dark and light or saturates the work with color in the manner of an Edward Betts watercolor.

PERLOW, SANDRA J. (Photographer, Drafter)
802 Westwood, Wilmette, IL 60091

Born: 1940 *Awards:* Honorarium, Paper Press, Chicago *Collections:* Kemper Insurance Co.; Peat, Marwick *Exhibitions:* Chicago Cultural Center; Hyde Park Art Center *Education:* Illinois Inst. of Design; School of the Art Institute of Chicago

Inspired by the pathos and exhilaration in the work of such Italian artists as Giotto, Francesco Clemente, and Enzo Cucchi, the artist creates pastel and charcoal drawings with an expressionistic and surrealistic sensibility. Figures may be intertwined with a mysterious landscape of mountains, trees, or buildings all askew, or they may stand alone in highly charged settings. Involving concepts such as resurrection, fragmentation, and activity, each work signifies a single message, while the overall body of work is a series of loosely connected episodes. Current pieces are done in earthtones that emerge from dense backgrounds.

PERNOTTO, JAMES (Painter, Sculptor)
27 1/2 Federal Plaza West, Youngstown, OH 44503

Born: 1950 *Awards:* Ohio Arts Council Fellowship; National Studio Program, Institute for Art and Urban Resources, NY *Collections:* Art Institute of Chicago; Madison Art Center, WI *Exhibitions:* Perimeter Gallery, Chicago; Art Expo Chicago *Education:* Ohio State U.; U. of Wisconsin *Dealer:* Perimeter Gallery, Chicago

A native of Youngstown, Ohio, he brings the smoke and flames of the steel mills, the clangs and whistles of amusement parks, and the aura of the city's shrines, Catholic churches, and schools to the world of his paintings. Drawing on his background in architectural illustration and design and in sculpture, he creates environmental installations and paintings with architectural elements. The environments are often intense, the artist inhabiting them with ancient and medieval symbols and imagery set against the conflicts of modern times. *The Passion*, a depiction of Christ's crucifixion, draws on the artist's recollections of his childhood in a devoutly Roman Catholic home within the industrial environment of his home town--the scene set against a background not of Golgotha, but of steel

John Payne, *Mock I "V" Form,* 48 x 240 x 84, corten steel

Jean Poklop, *Oracle,* 40 x 30, oil on paper

mills and other industrial plants.also typified by high key colors.

PERRET, MARGUERITE (Painter, Installation Artist)
1470 W. Warner, #2, Chicago, IL 60613

Born: 1958 *Collections:* J.B. Speed Museum Purchase Gallery, Louisville *Exhibitions:* Prairie Ave. Gallery, Chicago; Midwest Works on Paper, Grand Rapids *Education:* Southern Illinois U.; Montclair College

Her paintings, constructions, and installations display a heightened sense of the dramatic and recall a state of intellectual senselessness particular to dreams and states of emotional intensity. Over the years, her themes have evolved into a disturbing yet engaging vision of a philosophical paradise caught in a violent state of flux. While her two-dimensional works continue to evoke images of storms and landscapes, she has found her strongest resolution in three-dimensional work. She builds her smaller sculptures and installations from scenic drops and heavily painted cut-out planes. Through scale and intensity, she demands viewer participation.

PERRI, CHRISTINE (Painter)
1123 W. Columbia Ave., Chicago, IL 60626

Born: 1953 *Awards:* Evanston (IL) and Vicinity: Paintings *Exhibitions:* Printworks, Chicago; Noyes Cultural Center, Chicago *Education:* U. of Illinois, Chicago; U. of California, Los Angeles *Dealer:* Sazama/Brauer Gallery, Chicago

Her paintings and mixed-media drawings have their origins in the time arts, specifically literature. Most of her works contain more than one scene, and because there are sometimes hints that the scenes are different versions of one event, there is a suggestion that one occurred before the other. The viewer may perceive the relationship between the scenes as casual, accidental, as happening at the same time, or as commenting on each other. In any case, the viewer "travels" from one scene to another and there is a perceived back and forth movement in space which creates an illusion of time passing.

PETACQUE, JUDY MORRIS (Textile Artist)
309 W. Eugenie St., Chicago, IL 60614

Exhibitions: Art Institute of Chicago Print Show; Bendel of New York *Education:* School of the Art Institute of Chicago; Loyola U., Chicago

Artist, designer, and teacher, she takes her inspiration both from the elements in nature and found objects and those in primitive art. Of nature she is drawn to the colors, shapes, and textures found in feathers, pebbles, wood, shells--even shadows. In primitive art she finds power and purity in masks, sculptures, pottery, basketry, and textiles. She assimilates her appreciation for both of these worlds through a collage technique which weaves forms, colors, and textural contrasts. She creates a wide variety of work, including wall hangings, rugs, clothing, wallcoverings, and other assorted textiles.

PETERSEN, WILL (Painter, Printmaker)
1604 Greenleaf, Evanston, IL 60202

Born: 1928 *Awards:* "Best of the Year," Kyoto-Osaka Mainichi Newspapers, Japan; "Provost's Purchase" 1987 Bradley National Print Annual *Exhibitions:* Taipei International, Taiwan; Art Institute of Chicago Chicago & Vicinity Drawing; *Collections:* Philadelphia Museum of Art; San Francisco Palace of the Legion of Honor *Education:* Michigan State; California College of Arts & Crafts *Dealer:* Lyman-Heizer, Chicago

He began exhibiting at New York's Meltzer Galleries in 1951; showed the painting *Philosopher's Wagon* at Momentum Mid-Continental Chicago in 1952; and founded Bay Printmakers Society in California in 1955. He first went to Japan when he was stationed there during the Korean War, remaining to live there through 1965. While in Japan, he learned the language, practiced calligraphy, and studied the ancient Noh dance drama. Upon his return to the U.S., he taught at Ohio State University and West Virginia University and established Plucked Chicken Press in Chicago. Current works include monoprints, and since 1985, he has resumed exhibiting his oil paintings. Works evince influences of oriental aesthetic and subject matter and are expressionistic, with strong structural concerns. His heroes are Zeami, Hunt, Balthus, all of ancient Egypt, and drunken Chinese poets.

PETTIT, JIM (Ceramist)
21709 94th Ave. N., Port Byron, IL 61275

Born: 1955 *Awards:* 1981 Rickert-Ziebold Trust Award, Southern Illinois University *Collections:* Black Hawk College; Southern Illinois University *Exhibitions:* Creative Claythings Gallery, Chicago; Riverside Galleries, Galena, IL *Education:* Southern Illinois U.

Specializing in the rare and difficult *nerikomi* technique, the artist creates classically shaped, nonfunctional vessels. Dating back to 4th-century China, the process involves the use of a mixture of colored clays that yield spontaneous patterns reminiscent of stone and earth formations. The unglazed pieces present a mixture of natural tones and hues such as brown, green, blue, and white that swirl around the structure, revealing the path of their construction.

PFEIFFER, WERNER (Sculptor, Painter)
Flat Rock Road, Cornwall Bridge, CT 06754

Born: 1937 *Awards:* Commission, Federal Government, West Germany *Collections:* Museum of Modern Art, NYC; National Museum, Stockholm *Exhibitions:* City Museum and Gallery, Stuttgart; Shippee Gallery, NYC *Education:* Akademie of Fine Arts, Stuttgart *Dealer:* Neville Sargent Gallery, Chicago; Shippee Gallery, NYC

He puts the enormous energy of controlled chaos to work. His soaring, expanding images are free of narrative gesture. The dynamic of contradiction rules his constructions and he brings a seeming logic to randomness and order. His work is a mixture of painting, sculpture, collage, and construction. He builds visual mosaics by placing painted or printed fragments against settings of color and form. His work often projects a

seeming playfulness but closer examination reveals a tight control and structured organization.

PHELAN, MARY (Painter)
2120 W. Pensacola, Chicago, IL 60618

Born: 1953 *Awards:* Greenshields Foundation Grant *Collections:* Library of Congress; Nashville Symphony Orchestra *Exhibitions:* Palette & Chisel Gallery, Chicago; David Adler Cultural Center, Libertyville, IL *Education:* The School of the Art Institute of Chicago; American Academy of Art, Chicago

Beginning her career as a portraitist, she turned to Cezanne, seeking to develop a more unified way of seeing. Inspired by his planes of color, the work expanded to landscape and still life. Incorporating the elements of other Post-Impressionists, she developed a series of decorative works in oils and pastel which combined the effects of flat areas of color and repeated patterns of reflected light. A recent series, inspired by travels to Ireland, consists of a group of landscapes which focuses on the texturally diverse, "hard and soft" elements she observed. Working from ink sketches done on location, color and composition are further developed through watercolor and colored pencil studies until their final rendition in oil on canvas. She is currently working on portraits and book illustrations.

PHILLIPS, MARGARET KLIMEK (Painter)
1456 W. Irving Park Rd., Chicago, IL 60613

Born: 1926 *Collections:* Willard Ice Revenue Center Collection; Nuveen *Exhibitions:* NY State Exposition; School of the Art Institute of Chicago *Education:* School of the Art Institute of Chicago; Columbia U. *Dealer:* Kathleen Lombardo, Chicago

Using legible images such as pillows, windows, and television sets, she shifts focus from the obvious configurations of portraiture to the bypassed information the genre holds about a human being; for instance, the imprint of a body on pillows or the reflection of a figure in a window. Her images throw the viewer off balance and force a re-examining of position. Though she sometimes paints poetically in pastels, her work is not serene. What seems readily identifiable loses some of its literalness. Her current simplified houseplant paintings and large sky paintings continue her concern with still life situations.

PIATEK, FRANCIS JOHN (Painter)
3925 N. Troy, Chicago, IL 60618

Born: 1944 *Awards:* 1985 NEA Grant; Illinois Arts Council Grant *Collections:* Art Institute of Chicago; Smart Gallery, U. of Chicago *Exhibitions:* 1967 Whitney Annual, New York City; Terra Museum, Chicago *Education:* The School of the Art Institute of Chicago *Dealer:* Roy Boyd Gallery, Chicago

Luminescent oil paintings of knotted tubular forms referring to a wide variety of experiences, spaces, and states of matter have been the primary focus of this artist. Neither purely nor reductively abstract, the works employ illusionistic space illuminated by a variety of kinds of light. More than ten years of research into the materials and techniques of artists throughout the centuries, notably Monet, Carravaggio and

Rembrandt, has enabled the artist to use his signature forms as a screen for painterly performance. Drawing is also essential to his work, and he has recently become involved in collage. A recent exhibition included the series *Mythology of the Studio*, collage-assemblages of photographs, transparencies, and found materials that relate the private space of his studio to mythical places such as Troy.

PICEK, LOUIS (Painter)
Box 340, West Branch, Iowa 52358

Born: 1947 *Awards:* Purchase Award, Sioux City Art Center; Purchase Award, State of Iowa Collectons: U. of Arkansas; Sioux City Art Center *Exhibitions:* Susanne Feldman Gallery, NYC; Marianne Deson Gallery, Chicago *Education:* U. of Iowa *Dealer:* Outside In Gallery, Los Angeles

Early in his career his work moved from expressionism to a narrative and figurative style which was highly influenced by primitive and folk art. In bright flat colors, patterns and decorative design are done with acrylic on both canvas and masonite. Recent work has become three-dimensional, including the use of shaped-surfaces often made up of layers of wood and the construction of wooden boxes on which are added carved elements. These are then painted with an all-over narrative. Themes are drawn from the contemporary world, to which certain elements of fantasy are added.

PICK, EIJA (Performance Artist)
630 W. Surf St., Chicago, IL 60657

Born: 1949 *Awards:* Winner, Competition for the Development of Experimental Works; Fellow, Yellow Springs Institute, Chester Springs, PA *Exhibitions:* Ceres Gallery, NYC; A.R.C. Gallery, Chicago *Education:* Columbia College, Chicago; Helsinki School of Economics and Business Administration

She creates surreal, dream-like images by juxtaposing text, visual imagery, choreography, and voice and sound elements. She approaches her subjects with humor and her staged collages often contain an absurd and cartoon-like imagery which she conveys with a physical comedy. The work functions on several levels simultaneously, resembling an abstract or geometric design where lines from different directions overlap and intersect. Her subjects include attitudes toward money, a woman's experiences in the world of work, fairytales from childhood, transitions, and relationships between myth and reality.

PINKEL, SHEILA (Photographer)
126 Hart Ave., Santa Monica, CA 90405

Born: 1941 *Awards:* NEA Grants, 1979, 1982 *Collections:* Los Angeles County Museum of Art; Seattle Museum of Art *Exhibitions:* "Critical Comment," U. of Illinois, Circle Campus, Chicago; "Photographic Explorations," Columbia College, Chicago *Education:* U. of California, Berkeley; U. of California, Los Angeles

After formal training in painting and sculpture, she continued to expand her technical ability into the area of graphics, exploring themes of surrealism, visual paradox, and illusion. She studied photography as part

of this exploration, experimenting with other light-related technologies as well. The artist's current work is about her love for nature and her concern with growth of the military in the US and abroad. To date, she has installed ten "Thermonuclear Gardens," information artworks detailing the extent to which the military has embedded itself in our economy. She has been using the media of xeroxography, both with conventional machinery and xeroradiography, as well as laser scanning and digitalizing technology. She cites Joseph Beuys, Hans Haacke, Esther Parada, Robert Heinecken, and Helen and Newton Harrison as important influences.

PINKOWSKI, EMILY (Painter)
3085 Blackthorn Rd., Riverwoods, IL 60015

Born: 1924 *Collections:* Illinois State Museum, Springfield; Schiff, Hardin & Waite *Exhibitions:* Indianapolis Museum of Art; Gallery Genesis, Chicago *Education:* U. of Chicago; Mundelein College

Influenced by Picasso, Leger, and Beckman, her work reflects a reaction to the onslaught of technological advances. Past series have revolved around crushed cars, auto parts, truck segments, heavy-duty machinery, metal objects and electronic components. Presently she emphasizes the interrelation of humans and technology. Images of people are automated, mechanized, and programmed. Her work has progressed in two major directions: two-dimensional paintings include ambient details, while the sculptural paintings of canvas on wood are cut-out and hinged diptychs, triptychs and environments.

PINSKY, JOANNA (Painter)
1223 Grant St., Evanston, IL 60201

Born: 1942 *Awards:* Illinois State Museum Purchase Award; Evanston Civic Center Award of Excellence *Collections:* Illinois State Museum; Honeywell Corp. *Exhibitions:* Millikin University, Decatur, IL; State of Illinois Gallery *Education:* Cornell U. *Dealer:* Perimeter Gallery, Chicago

Initially interested in creating architectural forms with systematic but emotional color, the artist began working with shaped canvases. In an effort to contrast the constructed form with organic substance, she developed a process of mixing various sands, sawdust, and gravel with a polymer medium. Current work may be viewed as landscapes from an aerial perspective, in which lines incised into the textured areas are to be read as rivers or roads. Synthesizing abstraction and representation, the vividly expressive acrylics explore the arbitrary nature of boundaries, both internal and external to the work, which seem to be held in a temporary balance that could be upset at any moment.

PIZZINI, MARY (Painter)
214 W. Lake Dr., Edwardsville, IL 62025

Born: 1935 *Awards:* 3rd Best of Show, Southern Illinois Open Competition; Edgar Orchard Prize for Painting, St. Louis Artist Guild Painting Exhibition *Collections:* Mark Twain Banks, St. Louis; Mitchell Museum, Mt. Vernon, IL *Exhibitions:* Mid-America Biennial, Owensboro, KY; Wabash Valley Exhibition, Mt. Ver-

non *Education:* Washington U., St. Louis *Dealers:* Art Selection Service, Chicago; E.S. Galt Gallery, Chicago

Using sponges, papers, and sprays in intuitive ways, she first applied paint to hard surfaces such as paper and masonite. She then began painting on both sides of clear plastic, designating shapes through blockout techniques. Since 1982, she has been attempting to free her images from the confining borders of a traditional frame. She begins by cutting the most interesting areas from her completed paintings on masonite or plastic. After achieving a satisfactory arrangement of these images on a work surface, she fixes the pieces with glue or a binder post. Finally, she affixes the image to hot plastic, achieving a three-dimensional sculptural effect where color comes from the back of a picture plane.

PLOCHMANN, CAROLYN (Painter)
Rt. 9, Box 104, Carbondale, IL 62901

Born: 1926 *Awards:* New York Graphic Society Award; Norton Award, Chautauqua *Collections:* Evansville Museum of Arts and Science; Butler Institute of American Art *Exhibitions:* Kennedy Galleries, NYC; Toledo Museum of Art *Education:* U. of Toledo, State U. of Indiana

Always a figure painter, she underplays conventional three-dimensionality and early in her career ignored the surface blandishments and familiar charms that painters introduce at the expense of strong form. Though the rarely literal figures of her early paintings are rooted in life, they were intended as equivalents to the spirits informing them. Her recent works suggest the rich textures of medieval tapestries and illuminated manuscripts, evoking a subdued and reflective atmosphere. The figures in these works, executed in oils, gouaches, watercolors, and ink on masonite, seem increasingly in touch with contemporary life. Nevertheless, they bear characteristics that mark them as outsiders.

PLOTKIN, NANCY (Painter, Sculptor)
113 E. Bellevue, Chicago, IL 60611

Born: 1931 *Awards:* Paper Press of Chicago; Fellowship, School of the Art Institute of Chicago *Collections:* Continental Illinois Bank of Chicago; Paper Press of Chicago *Exhibitions:* Museum of Contemporary Art, Chicago; Artemisia Gallery, Chicago *Education:* School of the Art Institute of Chicago

Often inspired by literature, she makes narrative installations. For her early poetic pieces she drew and painted on abstract, geometric wood shapes. Occasionally, she combined these forms with realistic drawings and sculptures of human beings and animals. The subject matter of her recent color pencil work is disturbing and sometimes violent. In these small sequential drawings, figures interact in intense and mysterious ways. Most recently, she is again combining drawing, painting, and sculpture. She now incorporates sculptured elements and found objects into these essentially geometric wall pieces.

POKLOP, JEAN (Painter)
520 N. Parkwood Ave., Park Ridge, IL 60068
Born: 1934 *Awards:* Illinois Arts Council Completion

Vincent K. Pollard, *Reflections,* 8 x 10, collage

Ann Ponce, *El Amor de Flores,* 66 x 46, oil

Grant; Scholarship, Columbia College *Collections:* Illinois State Museum; Illinois Bell Telephone Co. *Exhibitions:* Eastern Illinois U.; U. of Illinois-Urbana *Education:* U. of Illinois; Columbia College, Chicago *Dealer:* Diane Donohue, Chicago

Influenced by macro-lens photography, she initially did work which was executed in acrylic and concentrated on complicated patterns. It developed in series form from close-up nature studies to a historical view of the art of women in domestic settings, culminating with a detailed study of the interior of a computer detailing chips, circuitry and binary language as imagery. Later work, done in oils, became a combination of metaphoric still life objects and appropriated art historical figures placed in a landscape. Current pieces are done with oil on paper, using glazes and oil sticks. Draped figures and chairs evolved into draped landscapes, finally transforming form, nature and object into one mass of energy. Color is subtle and emotionally involving, while texture and gesture vie with luminous passages within an overall surface pattern. Influenced by Gauguin and the Symbolists, the artist continues to concentrate on allegorical themes concerning the nature of existence.

POLLARD, VINCENT K. (Performance Artist)
8001 S. Exchange Ave., Chicago, IL 60617

Born: 1944 *Awards:* Certificate of Achievement, International Black Writers Conference; Golden Poet Awards, World Press of Poetry *Exhibitions:* 1st United Auto Workers Local 551 Arts, Crafts and Talent Show *Education:* Maryknoll College; U. of Chicago

His involvement in art began with writing and performing his own poetry. Wishing to stretch his own imagination and that of his audiences, he sought methods of incorporating colored light, live or audiotaped instrumental music, and the spoken word into an interactive and reinforcing whole, while simultaneously respecting the elements he was combining. His images are often street scenes, landscapes, and seascapes set to match, anticipate, or reflect the spoken narrative. Multiple processing of images enhances the effect or mood. For example, prints from two color transparencies are combined into a single image, rephotographed, transferred to black-and-white, xeroxed, and then recolored with acrylic and/or marker pens. Black/African-American and Philippine history and culture often influence the themes of his work.

PONCE, ANN (Painter)
209 Woodbine, Wilmette, IL 60091

Born: 1950 *Collections:* Blue Cross Blue Shield, Chicago; Earlham College, Richmond, IN *Exhibitions:* Steiner Gallery, Chicago; ARC Gallery, Chicago *Education:* Indiana University *Dealer:* William Engle Gallery, Indianapolis, IN; De Graaf Fine Art, Inc., Chicago

During the 1970s her interest in neo-impressionist figural painting inspired her early work in charcoal, oil, and casein. Initially many of the pieces were figurative and drawn from live models. Eventually she began using imagery from antique photographs. Specific influences at this time include contemporaries Nick Ab-

dalla of New Mexico, Keith Lindberg of California, and Duane Hanson. In the 1980s she has worked primarily in oil and her fascination with the figure continues. The paintings are often large, featuring anonymous individuals in unposed settings, often at the beach where the surroundings are elemental--air, sunlight, horizon, earth and water. A recent painting, *The Wave,* speaks to this directly. In it a little girl stands, her back to the viewer, gazing out over an expanse of water. Far out at the horizon, the dark green water meets the sky; just ahead, it curls into a small wave; directly in front of her, another wave breaks into foam; and just where she stands, the most recent wash of water retreats around her ankles.

POND, CLAYTON (Painter)
130 Greene St., New York, NY 10012

Born: 1941 *Awards:* N.E.A.; American Specialists State Department Grant *Collections:* Boston Museum of Fine Arts; Museum of Modern Art, NYC; Art Institue of Chicago *Exhibitions:* Martha Jackson Gallery, NYC; Linden Gallery, NYC; Van Straaten Gallery, Chicago *Education:* Pratt Inst.; Carnegie Inst. of Technology *Dealer:* The Jack Gallery, NYC; DeGraaf Fine Arts, NYC

Paintings and prints glorify simple subjects of his immediate environment by isolating objects in monumental grandeur. He utilizes high intensity colors to create a dramatic and intriguing overall composition; seeking respect for otherwise obscure themes: sails, radiators, bathtubs and toilet paper. His fascination with the interplay of color relationships reflects his cheerful optimism and semi-satirical sense of humor. He spent earlier years expanding the silk screen medium through the use of a high gloss varnish over the images, printed in thick layers of bright, contrasting colors.

POPE, CARL ROBERT JR. (Fine Art & Commercial Photographer)
3722 Riley, Indianapolis, IN 46218

Born: 1961 *Awards:* Best of Show, Museum of Science and Industry, Chicago; Portfolio Finalist (Central Indiana), Kodak Medallion of Excellence *Collections:* Southern Illinois Student Art Works; Indiana Historical Society *Exhibitions:* Indianapolis Art League's Downtown Gallery, Indianapolis, IN; Eleyes Designs, Indianapolis, IN *Education:* Southern Illinois U.

The principles of fashion photography, album cover art and classic photojournalism informed his earliest work. While at school, he explored a range of style and techniques. Thematically, the focus of his work was environmental portraiture, that is, the relation between a subject and his/her surroundings. Presently, his work concerns the struggles and disasters of human relationships. The works of Diane Arbus, Eugene Smith, Cindy Sherman and Ralph Gibson are particularly strong influences. Daily life, the cinema, and intense new wave music are the sources of his inspiration. He is currently engaged in two major projects. The first is a series of dark, dramatic images of people in conflict. The second are "diary photographs" that deal with his own experiences rendered in a variety of techniques including handcoloring, duotoning, toy camera images and found

Carl Pope, *untitled,* 16 x 20, black and white photograph

Faith Posey, *Image-Twice Removed,* 16 x 24, pencil

imagery. The writing on these images is related objectively and thematically to the subjects.

POSEY, FAITH (Painter)
4051 S. Montgomery, Chicago, IL 60632

Born: 1944 *Awards:* Juror's Award, 59th Rockford & Vicinity Show; Honorable Mention, "Galex 19" *Collections:* Byer Museum of the Arts, Evanston, IL *Exhibitions:* NAB Gallery, Chicago; Van Buren, Chicago *Education:* School of the Art Institute of Chicago

During his formal training as a sculptor, he worked with both modeled figurative form and carved abstract form, while maintaining a keen interest in representational figure drawing. In the early 1970s, his focus turned to painting, first in acrylic and later in oil as his interest in using the cropped figure as a means of dividing space within the composition progressed. The paintings are realistic, as the artist sticks to a natural palette. His drawings, also of the figure, are done in charcoal and charcoal pencil. Most recent works step back from the figure to include symbolic surroundings. They have become more personal, at times autobiographical, and often deal with the artist-model relationship.

POSKA, ROLAND (Printmaker, Painter)
411 Lincoln Ave., Rockford, IL 61102

Born: 1938 *Collections:* Milwaukee Art Museum; Scottsdale Center for the Arts *Exhibitions:* Milwaukee Art Museum; Gilman/Gruen Galleries, Chicago *Education:* Rockford College; Cranbrook Academy of Art *Dealer:* Mack Gilman, Chicago

In his early work he was concerned with the synthesis of hard edge and soft edge, which he called deckle edge. In 1967 he purchased a paper-making machine and began "sculpting" paper into shape. Nature is the subject of his heroic-sized handmade cast paper pieces. He grinds pigment into fiber and allows the fiber to carry color through his work. He compresses forms and colors within expanding fields, and he is fascinated by visual textures and the manipulation of surfaces. In 1984 he unveiled *From Blue to Blue*, a 270-foot abstract cast pulp and pigment work depicting the course of four seasons in one day.

POTTER, VERONICA S. (Painter, Printmaker)
714 N. Lake Shore Dr., Tower Lakes, Barrington, IL 60010

Awards: Best of Show, Ars Graphis IV, Oak Park, IL; Best of Show, Mt. Prospect Art League, Mt. Prospect, IL *Collections:* Art Institute of Chicago; Art Museum, Rockford, IL *Exhibitions:* Barrington Area Arts Council, Barrington, IL; David Adler Center, Libertyville, IL *Education:* Carnegie-Mellon U. *Dealers:* Kaleidescope, Barrington, IL; Art & Frame Gallery, Lake Zurich, IL

While she teaches oil painting and drawing, most of her current work is in printmaking, primarily etching. Her prints are figurative and emotional, often featuring dancers or nudes. She is now working on an extended series entitled "Night People," which explores the essential loneliness of the human psyche from a woman's point of view. The images depict a basic, elemental relationship between female and male, employing imaginative symbolism and subtle monochromatic values to elicit an emotional response from both sexes. Many of her works comment on the isolation of women in today's society and their association with men.

POWER, CYRILLAP (Mixed-Media Artist)
ARC Gallery, 356 W. Huron, Chicago, IL 60610

Awards: Edward L. Reyerson Traveling Fellowship *Exhibitions:* Hyde Park Art Center, Chicago; Countryside Art Center, Arlington Heights, IL *Education:* School of the Art Institute of Chicago

Artists Edward Kienholz and Joseph Beuys inspired her to explore personal and surreal situations in less traditional media. These early pieces are large constructions made of plywood, roofing paper, linoleum, and other building materials. The content of her recent work explores issues of escape and freedom for women. These pieces are more directly influenced by the work of Daumier and the philosophy of the German Expressionists. They are smaller, made of masonite, papier maché, copper, aluminum, and wire and are painted with muted colors punctuated by splashes of color. "The humble materials I use," she says, "speak of everyday life and also of the endurance of the human spirit."

PRESCOTT, FRED (Sculptor)
c/o Prairie Lee Gallery, 301 W. Superior St., Chicago, IL 60610

Born: 1949 *Collections:* Bulova Corporation Center, NYC *Exhibitions:* Lakota Gallery, Santa Monica; Arthur Meisnere, Washington D.C. *Dealer:* Prairie Lee Gallery, Chicago

His fascination with making things with steel began at an early age while he "played" in his father's machine shop. Using band saws, punch presses, grinders, mills, lathes, he built everything from boats to abstract sculpture. As a teenager he painted, producing large abstract paintings in acrylics. His true passion, however, was steel sculpture, in particular, pieces that involved movement. Today, with 20 years experience sculpting steel, he produces large, colorful, kinetic sculpture. The work takes for its inspiration the outside world, and although he often returns to the "Cowboy and Indian" imagery of the Southwest where he lives, he also has a cosmopolitan vision. In *Wall Street Boogie*, a yellow and blue helicopter roars back and forth over the buildings on Wall Street as stockbrokers wearing suits and ties ride bulls and bears down the street while a bright yellow taxi joins the fray with the resigned driver looking on. His Southwest pieces feature cowboys, Indians, vultures, and the ubiquitous cactus. While his skill and scope has developed over the years, a sense of humor and play continues to pervade his work.

PRICE, RITA F. (Painter, Printmaker)
1665 Dartmouth Ln., Deerfield, IL 60015

Awards: Award of Excellence, Spertus Museum, Chicago; Award of Excellence, American Jewish Arts Club *Collections:* Carter Presidential Library and Museum, Atlanta; International Mineral and Chemical Bank, Northbrook, IL *Exhibitions:* Art Institute of Chicago; Chicago Center for the Print *Education:* School of the Art Institute of Chicago *Dealer:* Center for the Print, Chicago

Veronica S. Potter, *Night People I,* 16 x 20, etching, aquatint

Cheryl Quick, *Rick's Farm-Interior,* 8 x 10, black and white photograph and rubber stamps

While pursuing a professional career as a painter, she returned to an intense interest in printmaking during the 1970s. The challenge of evolving images from inert metal surfaces led her into subjects reflecting her fascination with nature. Organic shapes and forms drawn from this influence combined increasingly with experiences from her travels abroad in the 1980s to create an entirely new vocabulary of images for her. Recently, the spontaneity of monotypes has allowed her to explore the poetic effects of painting combined with printmaking, working impressionistically with muted colors and continuing the theme of plant forms.

PRINDLE, WARREN B. (Painter)
3839 W. Lawrence Ave., Chicago, IL

Born: 1959 Awards: Lynn Borst Memorial Award; Union League Civic and Arts Foundation Award Collections: Gallery Sternberg; Surovek Fine Arts, Palm Beach Exhibitions: James H. Barker Gallery, Nantucket, MA; NAB Gallery, Chicago Education: American Academy of Art; Eastern Illinois U. Dealer: Lyn Heizer, Northbrook, IL; Alice Lovell, Sharon, CT

Early academic training based on the format of the 19th-century Belgian Academy led him to investigate perspective and anatomy. This led to charcoal drawings on toned mat-board of interiors populated with many highly rendered nudes. He also produced a number of pleine-aire works in the tradition of Pissaro and the Barbizon School. These landcsapes are on highly textured, striated grounds of white lead and pumice. Current work reflects a variety of influences: Jean Francois Millet in its still, quiet, timeless attitude; 1940s and 1950s American film noir in its dark, inky shadows and straightforward narrative; and the social realists and Ash Can school, particulary John Sloan, in its gritty yet humane depiction of the poor, inner-city proletariat. The artist has a predilection for a somber palette, leaning to grayed blues and violets. In overall mood, the work is pensive and melancholy.

PULLEY, ROBERT (Sculptor)
8670 W. 450 S., Columbus, IN 47201

Born: 1948 Awards: A.R.T. Gallery; U. of Indianapolis Collections: McDonald's Corporation; Dickens Design Group Exhibitions: Martha Schneider Gallery, Highland Park, IL; A.R.C. Gallery, Chicago Education: Ball State U. Dealer: Shirley Downs, Chesterton, IN

Figural works are human-scaled, yet possess a monumental presence. The vessel theme is explored in an earlier series. These works are characterized by a stony quality which is often mixed with contrasting elements such as wood, metal, fiber, or water, which fills basins. In the early 1970s he produced utilitarian pottery and raku ware, beginning sculpted works in 1977.

PURYEAR, MARTIN (Sculptor, Printmaker)
c/o Donald Young Gallery, 212 W. Superior St., Chicago, IL 60610

Born: 1941 Collections: Solomon R. Guggenheim Museum, NYC; Corcoran Gallery of Art Exhibitions: Whitney Museum Biennial; Solomon R. Guggenheim Museum Education: Royal Academy of Art, Stockholm, Sweden; Yale U. School of Art Dealer: Mc-Intosh/Drysdale Gallery, Houston; Donald Young Gallery, Chicago; Landfall Press, Chicago

Although his work does not follow a single style, he has always shown a great interest in the surface qualities of his medium, wood. Many kinds of unusual woods such as hemlock or African blackwood are used, along with other exotic materials, as in M. Bastion Bouleverse, an installation made of hickory, Alaskan cedar and deerskin. Branch-like shapes often emerge from the wood's natural state as well as from careful workings of the materials, creating a sort of "natural artificiality," in simplified gestural pieces. Linear forms are often suggestive of functional objects such as tools and farm implements, as in the installation entitled Some Tales, Bask, Self. Wall pieces, architectural presentations and outdoor projects are also linear but have also featured geometrical solids such as cones and cubes. Recently he has added printmaking to his repertoire.

QUICK, CHERYL (Photographer, Printmaker)
5002 Illinois St., Lisle, IL

Awards: Honorable Mention, ARC Gallery, Chicago Collections: Wright Jr. College, Chicago; Illinois Benedictine College, Lisle, IL Exhibitions: Prism Gallery, Evanston, IL; Artemesia Gallery, Chicago Education: School of the Art Institute of Chicago

Influenced in the 1970s by Rauschenberg and the reemergence of etching and drawing, she produced embossings of antique lace gloves and other old fabrics. Hand colored, doillies and clothes were used to combine a feminine concern with her passion for printmaking. Recent interest in Tai Chi has had an overwhelming influence on her work. Using the shape of the Chinese meditation symbol Pi, in both monoprints and photographs she has begun to explore movement, balance and flux. Her color photos in this body of work have a printmaking sensibility to them, while her monotypes are large and printed from antique mirror shapes. Most recently, she has begun to add rubber stamps to her prints and new black and white photos.

QUINN, ANN C. (Fiber Sculptor)
7246 W. Everell, Chicago, IL 60631

Born: 1957 Exhibitions: Northeastern U.; Lincolnwood Library Education: Northeastern U.; School of the Art Insititute of Chicago

After exploring fiber sculptures for years, she has devised an original multi-dimensional technique which enables her to create moods and trigger emotions using subtle color combinations. Inspired by such artists as Claire Zisler, Margaret Wharton and Peter Voulkas, she weaves free-flowing abstract forms on a larger-than-life scale.

QUINN, WILLIAM (Painter)
Sazama/Brauer Gallery, 361 W. Superior, Chicago, IL 60610

Born: 1929 Awards: M-AAA/NEA Fellowship Collections: High Museum of Art, Atlanta; Butler Institute of American Art, Youngstown, OH Exhibitions: Sazama/Brauer Gallery, Chicago; Elliot Smith Gallery

Ann C. Quinn, *untitled(detail),* fiber sculpture. Courtesy: Rita Quinn

James S. Rousonelos, *At 27 Turned 35,* 16 x 12, oil on canvas

M. R. Reid, *The Stranger,* 30 x 40, charcoal on paper. Partially funded by a grant from the Illinois Arts Council

Education: U. of Illinois, Urbana *Dealer:* Sazama/Brauer Gallery, Chicago

For 25 years after studying with Paul Burden and Carl Halty, he explored the world of abstract images. The work of Matisse, and later the work of Richard Diebenkorn--for its balance struck between the subject of the painting and painting as the subject--provided him a huge area of investigation. By 1982, however, he took leave of his previous route, teaching, and moved to Paris to "start over." Now he paints by "looking rather than thinking," availing himself of more traditional forms, those of people and animals and other such "emotional" works.

RABELL, ARNALDO ROCHE (Painter)

c/o Struve Gallery, 309 W. Superior, Chicago, IL 60610

Born: 1955 *Exhibitions:* Cultural Center, Chicago; Art Institute of Chicago *Education:* School of the Art Institute of Chicago; School of Architecture, U. of Puerto Rico *Dealer:* Struve Gallery, Chicago

Paintings combine images from his Puerto Rican heritage with contemporary expressionism. Using the technique of frottage, a gessoed paper or canvas is covered with etching ink and placed over the nude model. An impression is taken by scraping the paper to reveal the contours of the model's body. Another technique he uses is the rubbing of paint on a canvas wrapped around the model, resulting in broadened monumental images of the figure which sometimes give the illusion of having been flayed or unfolded. These figures are often depicted in interiors surrounded with still-life objects and tend to evoke symbolic or mythological dramas.

RAUSCHENBERG, ROBERT (Painter)

c/o Leo Castelli Gallery, 420 W. Broadway, New York, NY 10012

Born: 1925 *Awards:* Grand Prix D'Honneur, Thirteenth International Exhibtion of Graphic Art, Ljubljana, Yugoslavia; Venice Biennale *Collections:* Whitney Museum, NYC; Museum of Modern Art, NYC *Exhibitions:* Whitney Museum, NYC; Museum of Modern Art, NYC *Education:* Kansas City Art Institute; Art Students League *Dealer:* Leo Castelli Gallery, NYC

After working with de Kooning, in 1955 he exhibited his "mixed media" paintings that combined painted elements with found objects in an effort to breack down the boundaries between art and life. He also participated at Black Mountain College with composer John Cage and dancer Merce Cunningham in some of the first performances that later came to be called "happenings." His new methods opened the way for Pop Art. Combinations of disparate images through photo-transfer, silkscreen, incorporation of found objects, and painted forms resulted in striking juxtapositions. Since 1966 he has experimented with disks, motors, plexiglass, sound, and variations in technique such as the transfer of photographs to silk-screen in the manner of Andy Warhol. Recent work includes a silk-screen-like collage of photographic images on the surface of Talking Heads' plastic record album, *Speaking in Tongues.*

REBECHINI, FERDINAND (Sculptor)

1390 Howard St., Elk Grove, IL 60007

Born: 1923 *Collections:* Standard Oil Co.; Brunswick *Exhibitions:* Art Institute of Chicago; Pennsylvania Academy of Fine Art *Education:* School of the Art Institute of Chicago

Coming from a family of sculptors, he began his training at an early age, working as an apprentice carver and caster. He works in a variety of metals, as well as in wood, stone, clay, and fiberglass. Many of his works have been inspired by organic forms that he has seen on his travels through the West and Southwest. Recently, some of his works have been executed in a nonobjective style. These sensual forms, which display a clear understanding of the material at hand, express feeling and imagination.

REGINATO, PETER (Sculptor)

60 Green St., New York, NY 10021

Born: 1945 *Awards:* Guggenheim & NEA Fellowships *Collections:* Metropolitan Museum; Hirshhorn Museum, Washington, D.C. *Exhibitions:* 57th St. West, NY; River North Concourse Building, Chicago *Education:* San Francisco Art Institute *Dealer:* Patricia Hamilton, NYC

Influenced by Julio Gonzales and David Smith, he is a master of classic welded steel sculpture who acknowledges a debt to Picasso, Matisse, and Miró. In the mid-1960s he made painted fiberglass sculpture. He began teaching himself welding in 1970 and was concerned during that decade with lattice structures. Currently, he builds tough yet exuberantly elegant cut out steel pieces. Their success depends on combination and balance. He begins by arranging his cutouts in a two dimensional space. He then balances them through trial and error. Sunwashed pastels are set off by deep colors and high contrast. His circular forms and lines belie a vertical impression.

REHFELD, JAMIE GARDNER (Commercial Illustrator)

514 E. Oak St., Sioux Falls, SD

Born: 1950 *Awards:* 1st Place, Santa Monica Blvd. Art Show; Best Overall, Burnsville Center *Collections:* Senator Tom Daschle *Exhibitions:* The Odeum, Villa Park, IL; Kent Galleries *Education:* NSC *Dealer:* Rehfeld Galleries, Sioux Falls, SD

Her formal art training, with its emphasis on the abstract and spontaneous, left her to master controlled illustration on her own. She pursued this task by executing a series of studies with colored pencil. Where previously she worked on white backgrounds, she consequently began to explore the influence of mid-tone and neutral backgrounds on the application of soft color pencil, and has continued in this medium with a diversity of subject matter. With their muted earth tones and soft edges, her works, be they portraits, wildlife, still lifes, or landscapes, present an endearing world.

REID, M. R. (formerly Michael Reid Rubenstein) (Painter)

1003 W. Armitage, Chicago, IL 60614

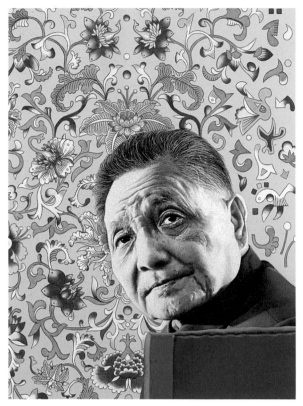

Jane Meredith, *Deng Xiaoping,* 10 x 8, gouache

Pennington McGee, *Waiting,* 42 x 56, oil pastel on heavy watercolor paper

Barbara Baynes Mahoney, *Charm and Majesty,* 25 x 40, watercolor

Jerry Madson, *Erin Camelot O'Connor,* 72 x 52, acrylic, ink on canvas

John-Luke Mallinson, *Waterwalker,* 36 x 48, oil on canvas

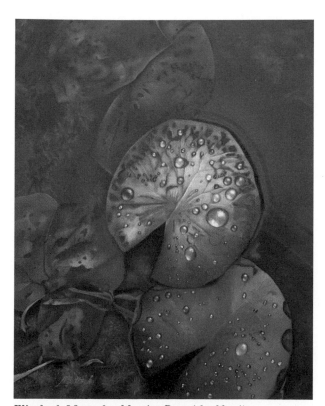

Elizabeth Mattocks, *Morning Dew,* 16 x 20, oils

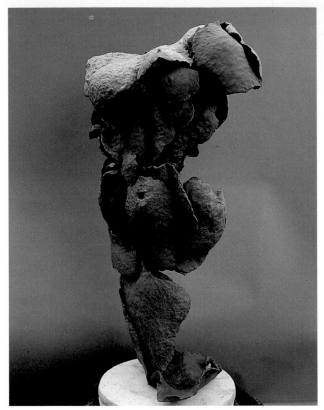

Ruth Aizuss Migdal, *Venus #1,* 45 x 30 x 20, clay, epoxy, mixed media. Photographer: Shirle Jenssen

Beverly Moor, *African Excavations,* 36 x 40 x 4, mixed media. Photographer: Jack Grossman

Tomislav Nikolic, *Master of Art (L. Castelli),* 48 x 42, oil on canvas, collage

Stephanie Nadolski, *Lands Beyond,* 33 x 45, acrylic and watercolor on paper

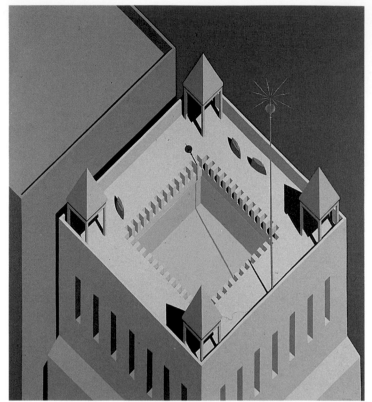

Robert Middaugh, *Transmission Pool,* 60 x 54, acrylic on canvas. Courtesy: Rockford Art Museum

Emily Martin, *Separate Rooms,* 38 x 22, water-based mixed media on rice paper. Courtesy: University of Iowa Hospitals & Clinics

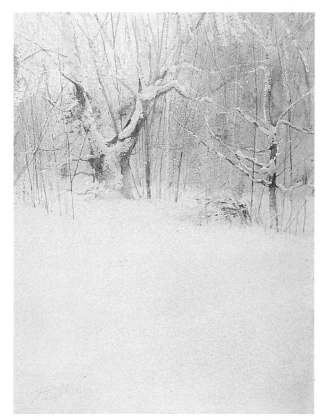

Richard A. Nichols, *Dusk's Whisper,* 40 x 31, watercolor

Bill Pattison, *Childhood Memories,* 24 x 18, oil

Sylvia E. Mullen, *Rainbow Shirt,* 12 x 26, acrylic paint

John Payne, *Sarcophagus Series: Jewel in the Crown,* 60 x 60 x 26, shaped granite, cast aluminum, oak base

David Norstad, *She Has Her Daddy's Nose,* 14 x 21, fiber collage. Courtesy: Gallery 4, Moorhead, MN

Jean Poklop, *Legacy,* 40 x 30, oil on paper

Leah Orr, *Transparent Form,* 144 x 96, copper, pvc. Photographer: Gary Chilluffo. Courtesy: Indiana Bell, An Ameritech Company

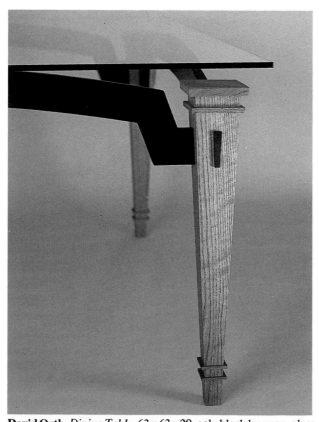

David Orth, *Dining Table,* 63 x 63 x 29, oak, black lacquar, glass

Onli, *Femme Chat,* 18 x 12, prismacolors

Veronica S. Potter, *Night People III,* 16 x 20, etching, aquatint

Cheryl Quick, *PI One,* 10 x 12, color photo

Ann Ponce, *Girl with Graffiti,* 42 x 54, oil

Laddie Scott Odom, *W(2) Form,* 50 x 48, kinwashi, enamel, dowel. Courtesy: Prism Gallery

Faith Posey, *The Grey Area,* 36 x 48, oil

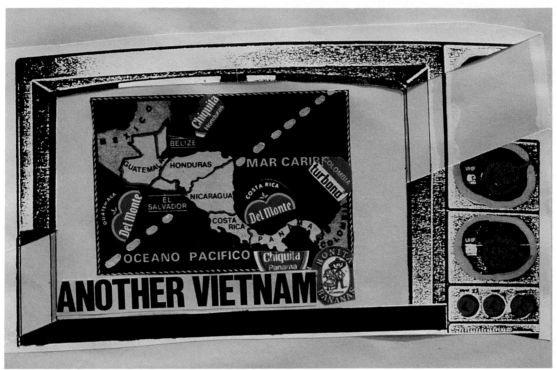

Vincent K. Pollard, *T.V. War,* 8 x 10, collage

Ulli Rooney, *About To...,* 68 x 150, enamel on canvas. Courtesy: Sybil Larney Gallery

Ann C. Quinn, *untitled,* 72 x 36, fiber sculpture

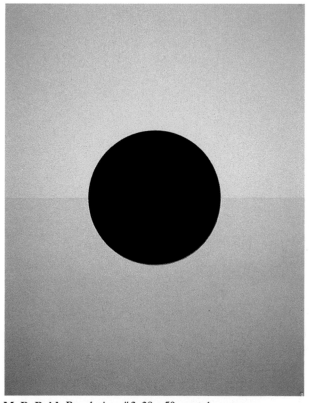

M. R. Reid, *Resolution #3,* 38 x 50, pastel on paper

Tom Roberts, *Clown,* 14 x 11, crayon and colored pencil

Janet Simpson, *Salamanders from Hell,* 44 x58, oil on canvas

Born: 1949 *Awards:* Illinois Arts Council Fellowship Grant *Exhibitions:* J. Rosenthal Fine Arts, Chicago; Name Gallery, Chicago *Education:* School of the Art Institute of Chicago; Art School of U. of Hartford

Switching from canvas to paper, which was less formal and cheaper, allowed him a period of freedom, even recklessness, with his work. With sheets of paper pinned to every wall, he drew with charcoal, striking, scratching, smudging, and erasing--excavating figures from the surfaces. Turning 39, however, evoked a need to do something different. Much of the previous period, while successful, was also desperate. He went back to school and began reading the writing of artists Donald Judd, Joseph Albers, Robert Smithson, and others. The new work is about discovering a new self, a circle in a rectangle. A series of drawings explores the relationship between a circle and a rectangle. After making twelve or so variations of these drawings with pastel or graphite, he decided to "make a deeper commitment, that of canvas and paint." While the core of the early work was seduction, spirituality is the force now.

REILLY, JEANNE (Sculptor)
1522 W. Hood Ave., Chicago, IL 60660

Born: 1948 *Awards:* 1st Place, Hyde Park Art Show *Exhibitions:* ARC Gallery, Chicago; Chicago Cultural Center *Education:* School of the Art Institute of Chicago

Her earlier abstract sculptures are ambiguous shapes that exist as parts of larger participatory environments. One installation forms a kind of storage room or library of found objects and constructed forms; another is a series of carnival-like booths; another leads the viewer through a maze. Her current wall-sized assemblages are also made from numerous individual pieces. She groups these together to form, for instance, a forest of pedestals, each crowned with a piece. Her materials harken back to historical methods. She casts in bronze and plaster and even carves in stone. Then she treats her materials to reveal their inherent beauty. While her forms remain abstract, her biggest influence is now the art of prehistoric and ancient civilizations.

REYNOLDS, JOHN D. (Ceramist)
R1 Box 73, Mt. Vernon, IN 47620

Born: 1949 *Awards:* Blaffer Trust Memorial Fellowship; Best of Show, Kentucky Guild of Artists and Craftsmen *Collections:* Humble Oil; Evansville, Indiana Arts and Education Council *Exhibitions:* Mid-States Craft Exhibit; Clay and Fiber National *Education:* Southern Illinois U. *Dealer:* New Harmony, Indiana Gallery of Contemporary Art; Guild Gallery, Lexington, KY

Trained as a functional potter, he developed an individual figurative style based on the anthropomorphic qualities of the 16th-century Japanese Haniwa terra cotta tomb figures. This style is used to create a non-gender-based commentary on how the contemporary male sees the contemporary female through the medium of his feelings. Beginning with cut slabs of stoneware, 32- to 36-inch high representational figures are pieced together. These figures are then fired with blue and black salt glazes, creating a look similar to

bronze casting. Their raw edges showing, the works are decorated with modern looking hair and clothes and embossed with as many details as possible.

REZAC, RICHARD (Sculptor)
c/o Feature Gallery, 340 W. Huron, Chicago, IL 60610

Born: 1952 *Awards:* Grant, NEA; Grant, Oregon Arts Commission *Collections:* Museum of Contemporary Art, Chicago *Exhibitions:* N.A.M.E. Gallery, Chicago; Feature Gallery, Chicago *Education:* Pacific Northwest College of Art; Maryland Institute College of Art *Dealers:* Feature Gallery, Chicago; Susanne Hilberry, Birmingham, MI

Originally a painter and draughtsperson, he began sculpting in 1980. He was a student during the rise of minimalism, and its influences are apparent in his work today. Small-scale and simple in appearance, his pieces exhibit warm, genuine meanings which belie the precise geometry of their construction. His works refer to natural forms and often embody specific political or social comment. He works with a variety of materials, which include cast metal and concrete, constructed and carved wood, and plaster, often creating surprising combinations of opposing materials, such as metal and silk, that bring out the unusual qualities of each.

RICH, DAVID (Painter)
1661 Laurel Ave., St. Paul, MN 55104

Born: 1952 *Collections:* IDS Corporation, Helmut Schaal, West Germany *Exhibitions:* Grayson Gallery, Chicago; Minneapolis Institute of Art *Education:* U. of Oregon; Kansas City Art Institute *Dealer:* Dolly Fiterman Gallery, Minneapolis; Franz Bader, Washington D.C.

His early abstract paintings evoke urban landscapes. Broadly painted, these oil-on-canvas works reveal a process of compositional changes where planes interlock to create a structural rhythm in which things seem to shift into place. Recent paintings maintain this sense of immediacy and are clearly rooted in everyday life, depicting figures and their surroundings. The focus is on the connections, the spatial intervals, and the light that moves through and around the scene. His paintings bring a suggestion of monumental significance to a seemingly ordinary moment. Recent large paintings explore interactions between figures, while smaller works are semi-abstract landscapes.

RICHERSON, JIM (Sculptor)
2526 W. Eastwood, Chicago, IL 60625

Born: 1956 *Awards:* Whirlpool National Sculpture Competition; Illinois Center Exhibition *Collections:* Boy Scouts of America; Coe College *Exhibitions:* Metropolitan Museum, Coral Gables, FL; Fort Smith Art Center *Education:* Coe College, IA; U. of Chicago *Dealer:* Sonia Zaks, Chicago

Based on the human figure, sculptures are dynamic assemblages of maze-like enclosures with rich polychromed surfaces. A state of flux, a sense that the figural and spatial relationships continually form and reform, results from a deliberate confusion of the distinction between positive and negative space. The human figure is explored with the use of such diverse

materials as wood, paint, paper, metal, charcoal and other mark-making tools. A work may begin with simply tracing body parts and forming a composition through repetition of this element. The use of the figure arises out of wide-ranging and diverse traditions in the history of art; however, these works in their material and conceptual emphasis are sourced most clearly in constructionist and futurist works.

RICHTER, GERHARD (Painter)

Born: 1932 *Awards:* Arnold Bode Prize, Kassel; Oskar Kokoschka Prize, Vienna *Exhibitions:* Galerie Reinhard Onnash, NYC; Marian Goodman Gellery, NYC *Education:* Kunstakademie, Dresden, Germany

One of the most important West German painters of the postwar period he practises widely diverse styles. Predominantly working in oil on canvas, he composed fascinating, complicated abstract painting while simultaneously producing realistic still lifes and landscapes. He usually exhibits them side by side. His subject matter can be descriptive, literal or abstract, yet he insists, "The paintings do not differ from one another, I change my method of approach..." The viewer can sense in his work a desire to push the representational toward the abstract and the abstract toward the representational. From his early grisaille technique with newspaper images, to his recent abstractions of vibrant, unmixed hues, plus his gray monochrome studies in between, he is considered to be a painter somewhere between modern and post-modern, although many concur that he is in a category of his own.

RICHTER, RON (Painter)
22 W. 551, Tamarack, Glen Ellyn, IL 60137

Born: 1958 *Exhibitions:* Chronicide Gallery, NYC; Troy-Hayner Cultural Center, Troy, OH *Education:* Southern Illinois U. *Dealer:* The Edge Gallery, Villa Park, IL

In his early work, he dealt exclusively with the figure. By the early 1980s he was using appliances, automobiles, and bulldozers as subjects. Through these canvases of suburban icons he implies the inevitability of constant change, while at the same time displaying his concern with the rapid development of Chicago's suburbs. In some of his large paintings of bulldozers, he features a massive idealized subject alone. In others, more portrait-like figures stand in the foreground while large bulldozers loom in the rear. Painters as diverse as Grant Wood, Max Beckmann, and Roy Lichtenstein and have influenced him, and his style alternates between expressionism and a painterly realism.

RICKEY, GEORGE (Sculptor)
Rd. 2 Box 235, East Chatham, NY 12060

Born: 1907 *Awards:* National Fine Arts Honor Award, American Institute of Architects; Brandeis University Creative Arts Award *Collections:* Museum of Modern Art, NYC; Hirshhorn Museum & Sculpture Garden *Exhibitions:* Guggenheim Museum; Albright-Knox Art Gallery *Education:* Trinity College; Oxford University

For the past three decades he has offered movement as the major element in his sculpture. He studied painting in Paris with André L'hôte, Leger, and Ozen-

fant in the 1930s; after World War II he began to explore kinetic sculpture. First works were inspired by natural shapes; soon thereafter he began to employ the simple geometric shapes fashioned out of steel and other metals that have become the characteristic aspect of his work. Slender blade-like forms balanced on knife edges and tipped by the wind and rain to fall and move in parallel rhythms were succeeded by rectangular planes that rotated upon on a conical base. Recent sculpture, fabricated in stainless steel and designed for outdoor installation, continues his progression from moving planes to moving volumes.

RILEY, BRENT (Painter)
3519 Middleton Ave., Cincinnati, OH 45220

Born: 1950 *Awards:* Ohio Arts Council Grant *Collections:* Cincinnati Art Museum; Indiana U. *Exhibitions:* Contemporary Arts Center, Cincinnati; Zolla Lieberman, Chicago *Dealer:* Dart Gallery, Chicago

He is a self-taught artist who has been equally influenced by contemporary art, art of other periods, and the painting and sculpture of Bali and India. He paints his small scale color or grisaille works with acrylic on masonite boards that rarely exceed fifteen inches square. His first step is to make a line drawing on tracing paper. Then he paints from background to foreground, initially leaving out the figures. Once he completes the background and foreground, he paints the smaller details such as figures and trees over them. His technique is like that of an egg tempera painter.

RILEY, BRUCE (Painter)
630 S. Governor, #5, Iowa City, IA 52240

Born: 1954 *Awards:* Grant, Ludwig Vogelstein Foundation *Exhibitions:* Contemporary Art Workshop, Chicago; Perimeter Gallery, Chicago *Education:* Art Academy of Cincinnati; U. of Cincinnati *Dealers:* Perimeter Gallery, Chicago; Contemporary Art Workshop, Chicago

Influenced by the Symbolists and Surrealists, he painted his early representational landscapes and figures with oils on acrylic primed canvas or acrylic primed panels. He continues to look at the work of other artists but now tends to develop in directions of his own. He still works with oils and he applies them to the canvas in a traditional way. He starts with a lean paint and develops toward a last application of a fat paint. His subjects remain the figure and landscapes.

RIORDON, KEVIN (Collage Artist)
1480 W. Webster, Chicago, IL 60614

Born: 1950 *Collections:* Museum of Modern Art; Museum of Contemporary Art, Chicago *Exhibitions:* Museum of Contemporary Art, Chicago; W. Hubbard Gallery, Chicago

In the 1970s he studied a variety of techniques while working as a printer. He then focused on offset printing and began publishing *Stare Magazine.* In the magazine's nine published issues between 1976 and 1983, he featured over one hundred artists. This work led to a number of self-organized exhibits and a collaboration with poet Jerome Sala on three books. In his collages, he tries to emulate the sublime sureness of Jean Arp

Onray, *Brave New World,* 48 x 36, acrylic on canvas

Tom Roberts, *excerpt from Map is Not the Territory,* 12 x 9, pen & ink

and Andre Masson. These pieces are either representational photo montages or free-form shapes cut from graphic arts materials. His appoach is post-conceptual with "just the minimum daily requirement of irony."

RIS, THERON CALDWELL (Painter)
5542 Riverview Drive, Waunakee, WI 53597

Born: 1931 *Awards:* "Madison Review" Invitational Cover; Artist in Residence, Wisconsin Art Board *Exhibitions:* Chicago Cultural Center; Museum of Fine Arts, Oak Ridge, TN *Education:* U. of Wisconsin, Madison; Stanford U. *Dealer:* Spaightwood Galleries, Madison, WI; Signature Gallery, Stoughton, WI

Originally working expressionistically in oil and influenced by the work of Karel Appel and Sandro Chia, she now concentrates on collage incorporating mixed media and watercolor. Using a full, bright palette and found objects, she creates pieces that are both abstract and figurative, frequently depicting strolling romantic couples in a playfully frenzied style with a surrealist bent. Her work is an ongoing exploration of the human condition, concentrating on relationships. Recent work has been more joyful and less angst-ridden.

ROBERTS, TOM (Animator, Filmmaker)
333 S. East Ave., Oak Park, IL 60302

Born: 1959 *Awards:* Grand Prize, Animated Short, Festival of Illinois Filmmakers *Exhibitions:* Chicago Filmmakers *Education:* Columbia College, Chicago

Working in Chicago, he began studying film and animation. In 1982 his interest shifted to comics as a means of making personal and sometimes political and social statements. Influenced by the comic art of Jack Kirby and Chuck Jones as well as the pictorial essays of Robert Osbourn, he continued to combine experimental animation with his drawing. Presently, his work is in pen and ink, colored with pencil. A sense of anarchy and spontaneity, as was found in the animated shorts of the 1940s, is combined with the harsh realities and paranoias of current events. He experiments continually with ink, recently adding graphic patters to produce subliminal subtexts to the story he conveys.

ROBINSON, TOM (Multi-Media Artist)
742 Buena, Chicago, IL 60613

Born: 1945 *Awards:* Designer/Creator of the IANU Award; First Place, Woodworld Design, *Exhibitions:* New Art Forms Exposition, Chicago; Judy Racht Gallery, Chicago *Dealer:* Ruth Volid Gallery, Chicago

Over the past fifteen years, he has been developing several types of artworks: painting executed on plexiglass, furniture design and construction, and photorealist wood mosaics. His most recent work combines all of these into free-standing sculptural stands which house translucent paintings, wood mosaics, and carved items. Pieces stand approximately five feet tall and appear similar to tall, slim window frames with artwork placed near the top of the frame. He cites the assemblage works of Joseph Cornell as a major influence.

ROCCA, SUELLEN (Painter)

Her adventurous imagist paintings are teeming with formal events, high color and organic forms. Her autobiographical collection contains imagery reminiscent of late adolescent fantasies, such as plants, rings and dancing figures. These images are repeated and varied obsessively until their original identity is transformed, then lost. The extremely animated forms are realized through a harmonious balance of vibrant and muted colors.

RODGERS, DAVID L. (Sculptor)
900 E. First St., Bloomington, IN 47401

Born: 1943 *Collections:* Stanford University Museum of Art; Indianapolis Museum of Art *Exhibitions:* Museum of Science of Industry, Chicago; New Harmony Gallery of Contemporary Art, New Harmony, IN *Education:* Indiana U., Bloomington

Beginning with drawing and painting from the nude in the mid-960s, he shifted his attention to sculpture. He began to create a personal style of abstract, visual metaphors for the human figure. In 1967, he started handcarving small Indiana limestone sculptures. In 1975, his explorations brought him to consider innovative applications of architectural stone fabrication techniques to produce monolithic carvings and multi-stone constructions. In the late 1970s, he extended his designing to include environments for his large installations. *Sunform,* an accurate equatorial sundial of limestone set in a circular, exposed, aggregate plaza, represents his first large Chicago site-specific sculpture and environment design.

RODWAN, SUSAN C. (Painter)
2018 W. Chicago Ave., Chicago, IL 60622

Born: 1953 *Collections:* private and corporate *Exhibitions:* Evanston Art Center; Lakeview Museum, Peoria *Education:* Michigan State U; U.of Michigan *Dealer:* Bodinet Gallery, Flossmoor, IL

Working in oil on canvas and handmade paper, she combines bold imagery with hard-edged black outlines in her abstracted landscapes of the city of Chicago. Inspiration is sought from both the run-down and dilapidated sections of town and the scenic Lakeshore area. Elements of expressionism are utilized to produce a harmony of color, shape, texture and form.

ROGALA, MIROSLAW (Video Artist)
1524 S. Peoria, Chicago, IL 60608

Born: 1954 *Awards:* Nominee, Rockefeller Intercultural Fellowship; Fellowship Grant, Illinois Arts Council *Collections:* Video Data Bank, Art Institute of Chicago; Museum of Modern Art *Exhibitions:* Museum of Contemporary Art, Chicago; "A Unique Experiment in Video Theatre by Miroslaw Rogala," Briar Street Theatre, Chicago *Education:* Krakow Academy of Fine Arts, Poland; School of the Art Institute of Chicago *Dealer:* Video Data Bank, Art Institute of Chicago

Although he grew up on a farm without electricity, and didn't see a television set until he was fifteen, he is now considered to be one of the country's pioneering video artists. His installations feature multi-monitor video with multi-channel sound, all in a carefully designed and constructed installation-type setting. With a background in music and painting, he presents images and sounds which refer to his life in Poland, his experience

of urban life in America, and situations artwork and emotions that transcend national boundaries. Since the costs of his work are so high, he often works in collaboration with other artists, associations, and organizations. In addition to his fine arts work for exhibition, he has also created works for live theatrical presentation, such as the Goodman Theatre's production of *A Sunday in the Park with George* after Georges Seurat's famous work. He uses a Sony camera, a Z-Grass UV-1 computer image processor, a Synclavier II sound computer, and an Amiga computer.

ROHALL, RED (Painter)
6332 N. Guilford Ave., Indianapolis, IN 46220

Born: 1957 *Awards:* Wurlizter Foundation Fellowship; Indiana Arts Commission Fellowship *Exhibitions:* Ruschman Gallery, Wilmette, IL Editions Limited Gallery, San Francisco *Education:* Rochester Institute of Technology *Dealer:* Editions Limited Gallery, Indianapolis

In his abstract gouache on paper paintings, he explores the myths and legends of the desert landscape. The subtle interplay of light and color on the desert floor provide inspiration for a modern, urban "deco" vision of ancient and austere cultures. Taking geometric shapes out of their original context, he develops a tension between memory and expressively colored conceptual forms.

ROLLINS, TIM (Mixed Media Artist)

He unites art-making with activism. He has taught at some of the poorest schools in New York City. The Art and Knowledge workshop he developed has become so successful, it is entering its sixth year. Some twenty students; K.O.S., or Kids of Survival, collaborate on projects shown internationally and are represented in several major American museums. These paintings by Rollins + K.O.S are derived from literary works, among them Lewis Carroll's Alice's *Adventures in Wonderland*, Nathaniel Hawthorne's *The Scarlett Letter*, and Franz Kafka's *Amerika*. Book pages or whole chapters cover the canvases, contributing a shadowy background, often rendered illegible by the imagery painted over it. One message builds upon another, interacting in such a way to "...relate the themes of the novels to the history we are making today," in Rollins' own words. The aesthetic value of the work is as successful for viewers as its educational value is for young artists who are discovering the world in which they live.

RONEY, JANET (Painter)
Rural Route #2, Box 39, Lovington, IL 61937

Born: 1942 *Awards:* "Watercolor Illinois", Wabash Valley Exhibition *Collections:* Southern Illinois University *Exhibitions:* Sheldon Swope Gallery, Terre Haute, Indiana; Chicago Botanical Gardens *Education:* U. of Illinois *Dealer:* Illinois Artisan Shop, Chicago

Trained as a history teacher, this Illinois artist/farmwife has always had a consuming passion for painting the Illinois prairie and chronicling the way civilization has made its mark upon it. Her early works in watercolor and oil call her public's attention to the fastvanishing native prairie. Surprisingly, her distinctive realistic watercolor style, one in which she avoids somber colors, was developed without formal instruction. One recent subject, the Illinois Amish community, borders her husband's farm. Respecting her Amish friends' taboo of being photographed or painted, each of her Amish paintings becomes a challenge to show the human presence without showing the human form. Whether painting the native prairie or the Amish culture, the artist paints to capture aspects of life before they disappear entirely.

ROONEY, JOHN (Painter)
124 W. Ottawa St., Sycamore, IL 60178

Born: 1931 *Awards:* 2nd Prize, Other Media, 60th Annual International Juried Exhibition, Harrisburg, PA; Purchase Award, 15th Annual Anderson Winter Show, IN *Collections:* Chase Manhattan Bank, NY; Anderson Fine Arts Center, IN *Exhibitions:* Walter Bischoff Gallery, Munich, Germany; Northern Illinois U. Art Gallery, Chicago *Education:* Sryacuse U.; Akademie der bildenden Kuenste Munich, West Germany *Dealer:* Walter Bischoff Gallery, Chicago and San Jose, CA

Oil paintings, charcoal, pastel, and pencil drawings done in the 1960s during, and immediately following, a ten year period of travel and study in Europe strove for a synthesis between abstraction and representation in their treatment of figure and landscape subjects. Franz Nagel, the prominent German muralist with whom he studied, and such artists as Picasso, Beckmann, and Leger, clearly influenced these early works. This phase culminated in the mural, *Loungers*, a 6 1/2 x 24 foot work in pastel and acrylic. Paintings and silk screen prints of the 1970s feature a highly polished hard-edged precision. Employing an elaborate and painstaking execution involving preliminary studies, tracings and various stencilling and masking techniques, these works are characterized by their strong, solid colors, crisp cleanly rendered forms and a treatment of the figure that combines a highly reductive geometric stylization with dramatic monumental power. In the 1980s a new, more directly expressive figurative style has emerged, exploring themes involving dramatic groupings of figures and a willful, spontaneous treatment of image, medium, and form.

ROONEY, ULLI (Painter)
124 W. Ottawa St., Sycamore, IL 60178

Awards: German Academic Exchange Service Fellowship to Paris; Illinois Arts Council Artists Fellowship Award *Exhibitions:* Goethe Institute, Chicago; Walter Bischoff Gallery, Chicago *Education:* Akademie der bildenden Kuenste, Munich, West Germany *Dealer:* Walter Bischoff, Chicago & San Jose, CA

Early work shown in America consisted of marker and pen and ink drawings. Lines arranged in different groupings and patterns according to different principles--exploring these processes and what they do to a given surface characterizes her work in the 1970s. Recent pieces show a return to the canvas. In 1986 she discovered in the fast drying oil enamels a medium ideally suited to her need for frequent, spontaneous overpainting in the development of an image. By this time shapes had become recognizeable objects--heads

or figures surrounded by an almost landscape-like space, with the movement of the brushstroke creating a dark, mysterious background and atmosphere for her figures. These are silent, brooding paintings, which seem to relect her roots and the Illinois landscape with its everchanging skies and limitless expansion into the horizon.

ROSENBERGER, CAROLYN (Painter)
Box 203 Highway G., Iola, WI 54945

Born: 1945 *Awards:* Best of Show, Scandinavia Art Show; Purchase Award, New London Art Fair *Collections:* Green Tree Studio *Exhibitions:* Vernae's, Waupaca, WI; Stephen's Point, WI *Education:* U. of Wisconsin, Oshkosh

Even though most of her formal training was in Realism, she was influenced by the Impressionist work of Monet and the textural quality of Van Gogh. This led her to choose oils for her textural realistic paintings. She then studied under Karlyn Holman and became intrigued with watercolors. For the past two years she has devoted herself to that medium exclusively, developing a technique which incorporates her love of nature and texture. She now produces realistically textured landscapes and abstract compositions by combining watercolors with salt, denatured alcohol, and plastic wrap.

ROSENQUIST, JAMES (Painter)
Box 4, 420 W. Broadway, Aripeka, FL 33502

Born: 1933 *Awards:* Torcuato de Tella International Prize, Buenos Aires *Collections:* Metropolitan Museum of Art, NYC; Museum of Modern Art, NYC *Exhibitions:* Museum of Modern Art, NYC; Solomon R. Guggenheim Museum, NYC *Education:* Art Students League *Dealer:* Leo Castelli Gallery, NYC

Early work was abstract, but emloyment as a Times Square billboard painter in the late 1950s led to the application of commercial art imagery, producing paintings in day-glo colors that resembled randomly arranged advertising fragments like the different layers of a billboard. These Pop works were made by splicing blow-ups of commercial motifs and then creating for them a new context, sometimes readable and other times elusive to the viewer. An interest in depicting "visual inflation" continued in montages incorporating such modern materials as neon, plexigalss, plastic and Mylar in free-standing constuctions, murals and picture-asssemblages.

ROSSER, STEPHEN J. (Painter, Sculptor)
c/o Prairie Lee Gallery, 301 W. Superior St., Chicago, IL 60610

Born: 1954 *Exhibitions:* Prairie Lee Gallery, Chicago; C. G. Rein Gallery, Santa Fe *Education:* U. of Tulsa; Southwestern Oklahoma State U. *Dealer:* Prairie Lee Gallery, Chicago

Working as a cowboy on the family ranch, in 1980 he began painting subjects related to the rural environment--chaps, boots, hats and such. He also became interested in the architecture of religious structures and was making installations incorporating the rural paintings with typical ranch objects and sculptural pieces

into the basic floor plan of these "holy places." For a period, influenced by the writings of Carl G. Jung, he began paintings of archetypal images. Dissatisfied with images from Egyptian, Babylonian, and other ancient art, he began mining esoteric societies for archetypal forms. Out of this came "The Masked Shaman Series." Eventually, however, he returned to the imagery of the rural southwest in a group of paintings entitled "The Cowboy and Indian Wild West Series." Most of these paintings, *The Cowboy with Satellite Dish* and *Cowboy Duck*, for example, contrast the heavy seriousness of the Shaman works.

ROSSI, BARBARA (Painter)
139 Spring St., New York, NY 10012

Born: 1940 *Collections:* Art Institute of Chicago; Museum of Contemporary Art, Chicago *Exhibitions:* Museum of Contemporary Art, Chicago; Whitney Museum, NYC *Education:* Art Institute of Chicago *Dealer:* Who Chicago

Early works consist of paintings on colored plexiglass, with changing shadows cast according to the surrounding light. Highly abstract figures are skillfully crafted by thin lines, small dots and broad strokes of color. Rossi, a nun, often evokes the eternal in her work, but also refers to the contemporary environment. *Flower Returning to the H2O* conveys the symbol of a fresh outlook, but also brings with it a reference to ancient Irish monks. In recent works, Rossi uses wood surfaces, painting and sanding them as many as seventeen times. Her technology is extraordinarily precise without sacrificing a mystical radiance.

ROUSONELOS, JAMES S. (Painter)
3010 West Addison, #2E, Chicago, IL 60618

Born: 1952 *Collections:* McDonald's Corporation; Wolfe-Lipson Metals, Inc. *Exhibitions:* Galleria Renata, Chicago; Limelight, Chicago *Education:* Southern Illinois U. *Dealer:* Galleria Renata, Chicago

Diverse artistic influences, the work of Ingres, David and the photo realist painters of the 1970s, are brought together in his social-realist paintings documenting and critiquing man's existence and plight in contemporary society. Current works increasingly incorporate the religious dimension of man's experience. Works are painted in oil on canvas, masonite or wood panel. The Old Master technique of glasing is often used in contrast with acrylic backgrounds of abstract elements.

ROYER, CATHERINE MILLS (Painter)
5336 Graceland Ave, Indianapolis, IN 46208

Born: 1954 *Awards:* 2nd Place, Indiana Artists Show, Indianapolis Museum of Art; Galex 20, Galesburg, IL *Collections:* Evansville (IN) Museum of Arts and Sciences; Center for Mental Health, Anderson, IN *Exhibitions:* Showcase Invitational, Water Tower Art Association, Louisville, KY; St. Mary of the Woods College *Education:* Ball State U.; Butler U. *Dealer:* Rolla Gladstein, Louisville, KY

Feeling a kinship to the surreal, mysterious, and fantastic imagist works of Magritte, de Chirico, Hopper, and Kahlo, she began painting empty but evocative interiors in oil. Her colors were rich and subtle, and she

John Rooney, *Dance Like a Wave of the Sea,* 96 x 162, acrylic on canvas. Courtesy: Walter Bischoff Gallery

Ulli Rooney, *Self Image,* 54 x 48, enamel on canvas

often explored complementary and neutral tones. Eventually she began to people these canvases with groups of anonymous figures draped in fabric. In her most recent oil series she depicts often immense and threatening flowers. Her paint application is still exacting and smooth, although it is thicker than in many realist works. The believable depth and solid three-dimensionality contrast with the outlandish subject matter. The large scale of the works and the intensity of their colors make the images confrontational.

RUSCHA, EDWARD JOSEPH (Painter, Conceptual Artist)
1024 3/4 N. Western Ave., Hollywood, CA 90029

Born: 1937 *Collections:* Museum of Modern Art, NYC; Whitney Museum, NYC *Exhibitions:* Whitney Museum, NYC; San Francisco Museum of Modern Art *Education:* Chouinard Art Institute *Dealer:* Leo Castelli Gallery, NYC

Early Pop paintings are hyper-realistic depictions of garages--some on fire--and other buildings. A humorous series describes proper word and name usage. *Every Building on the Sunset Strip* was just that, in a montage showing both sides of the street. He is known for book of photographs of ordinary things, such as *Twenty-six Gasoline Stations* and *Real Estate Opportunities,* in which typography and pictures are combined to make a cohesive whole. Text is eliminated. They are simply reproduced snapshots; the books do not "house a collection of art photographs--they are technical data-like industrial photography."

RUSH, JOHN (Commercial Illustrator)
123 Kedzie St., Evanston, IL 60202

Born: 1948 *Awards:* Gold Medal, Society of Illustrators, New York *Exhibitions:* R. H. Love Galleries, Chicago; Natalini Gallery, Chicago *Education:* Art Center College of Design *Dealer:* Pema Browne Ltd., New York

His experience as an industrial designer produced a photorealist precision and polish in his early work. The subjects for these works were frequently machines made into the form of people, or people who are wholly or partially made out of machinery. In recent years, he has chosen a new challenge for himself, that of the human figure, depicting personalities from history and mythology. Working with gouache on heavily gessoed board, his surfaces, once air-brush flat, are now sandpapered and scraped. He is influenced in pictorial narrative by Michelangelo, Velazquez, and Winslow Homer.

RUTHERFORD, KAREN JENSON (Weaving, Multi-Media)
513 S. 21 St., Terre Haute, IN 47803

Born: 1939 *Awards:* Illinois Arts Council Exhibition Grant; Purchase Award, Northbrook Craft Exhibition, North Shore Art League, Northbrook, IL *Collections:* Illinois State U., Milner ibrary, Normal, IL; Center for the Visual Arts, Gallery Permanent Collection, Illinois State U., Normal, IL *Exhibitions:* Illinois Arts Council, Chicago; Gayle Wilson Gallery, NY *Education:* U. of Wisconsin; Illinois State U.

In 1969, she began weaving functional items on a four-harness loom. Twenty years later, she creates complex, minimalist pieces which illustrate the tension between reality and illusion. She is most interested in working with line as a design element. The structure of her works are open in form, lacking a strict outline. She works with linen fibers, colored by India ink washes rather than dye. These washes, combined with the intricate, moving structures, result in woven, draped arrangements pressed behind plexiglass, creating the illusion of frozen movement.

RUTSCHMANN, NANCY ANDER (Painter, Graphic Designer)
111 Lakenheath Way, Logansport, IN 46947

Born: 1947 *Exhibitions:* Hoosier Salon, Indianapolis; Fehsenfeld Gallery, Indianapolis *Education:* U. of Illinois

Her early graphics influence works were primarily oil on canvas. In order to reinforce her overall concept and to insist on viewer involvement she used strong color, eliminated detail, and employed a single subject on the front plane with no middle and little background. Recent mixed media works involve pen and ink, colored pencils, acrylic washes, collage, and hand-made paper. Though the graphics influence is still obvious, she now uses humor, personification, and Surrealistic devices to challenge the viewer to look at the human spirit. Using the image of woman, she symbolically weaves past and present, dream and reality. Her hand images beckon the viewer to travel into the landscapes of the human mind, explore the nature of human suffering and aspirations or to consider the meaning of still moments.

RYAN, MICHAEL (Painter)
1510 N. Fairfield Ave., Chicago, IL 60622

Born: 1956 *Exhibitions:* "Art for Young Collectors Sale--A 39 Year Tradition," The Renaissance Society, U. of Chicago; "Formal Abstraction," N.A.M.E. Gallery, Chicago *Education:* Tyler School of Art, Philadelphia *Dealer:* Robbin Lockett Gallery, Chicago

For the last several years, he has created paintings and drawings of mulberry and catalpa trees. These works, the result of painstaking efforts, are exercises in the study of structure. They have proceeded in two venues. In one, he has used a router saw as a drawing implement on plywood. The skeletal renditions of a single tree from four perspectives are painted with tiny brushstrokes of bright color so that, even from a short distance, they appear as a soft mass of natural color. Secondly, he works with graphite on vellum paper. For these pieces, a single drawing is presented in its various stages of development on many sheets of paper. His use of trees as his only subjects borders on the obsessive; it is an obsession that concerns itself with the gray area between the structure of the world as it is and as it is perceived.

RYDING, JEAN COUPE (Printmaker)
1147 W. Ohio, Chicago, IL 60622

Born: 1948 *Awards:* Award of Excellence, North Shore Print Exhibition, Evanston, IL *Collections:* 3M Company, Minnesota; Northern Trust, Chicago *Exhibitions:*

Nancy Ander Rutschmann, *Shelter,* 18 x 24, oil on canvas

Don St. Cyr Toups, *La Principessa dei Uccelli,* 23 x 15,
pen & ink

S.A.G.A., New York; Chicago Center for the Print *Education:* U. of Iowa, Iowa City; Hochschule der Kunste, West Berlin, Germany *Dealer:* vanStraaten Gallery, Chicago

Her Midwestern upbringing formed an early visual perspective that a six-year residence in West Berlin drastically altered. While she lived in Europe, the European Expressionists became the primary influence for her wood and metal sculptures. She turned to woodcut prints upon returning to the United States in 1977. The woodcut allowed her to combine the colors of painting with the sculptural techniques involved in carving the woodcut. The New York Abstract Expressionists, particularly de Kooning and Kline, influenced the work she produced in this country. Her interest now lies in textures, particularly the layering of color and form for its expressive qualities. Recent influences have been the Japanese printmakers of the Ukiyo-e period for the balance and quality of line in their work. Her woodcuts have become larger and more abstract, exchanging her earlier landscapes, figures, and flowers for patterns and shapes with spare, expressive qualities. Her inspiration, however, continues to be human emotions, those of fear and loss.

RYMAN, ROBERT (Painter)
17 W. Sixteenth St., New York, NY 10011

Born: 1930 *Collections:* Museum of Modern Art, NYC; Whitney Museum, NYC *Exhibitions:* Guggenheim Museum, NYC; Kunsthalle, Basel, Switzerland *Education:* Tennessee Polytechnical Institute; George Peabody College *Dealer:* Blumhelman Gallery, NYC; Galerie Lelong, NYC

Since the early 1960s he has applied white pigment to square surfaces of aluminum, plywood, canvas, steel, paper, or fiberglass, exploring the process of painting. Each kind of white pigment produces its own distinctive effect, and variations in brushstroke and paint application modify the overall composition. Over the years his style has remained unchanged. Small- and large-scale square white paintings challenge the viewer's expectations, forcing one to discover the essence of the painting process: the look of paint next to bare surfaces, the texture of a short stroke, the difference between enamel and oil--each painting is a new configuration and a unique lesson in perception.

RZEZOTARSKI, DARLENE WESENBERG (Ceramics Artist)
2019 N. Newhall St., Milwaukee, WI 53202

Born: 1943 *Exhibitions:* Milwaukee Art Museum; Chicago Center for Ceramic Art *Education:* U. of Wisconsin, Milwaukee *Dealer:* Objects Gallery, Chicago

After completing a Master of Arts in Comparative Literature in 1969, she became interested in puppetry as a mode of dramatic and artistic expression. At Theatre X, she learned plastic and wood puppetmaking techniques, after which followed an intensive period of exploration in sculptural methods and media. She began working with clay in 1982, investigating the interrelationship of poetic and sculptural modes of expression. Influenced by German Expressionism and

Greco-Roman and Teutonic myth, as well as themes from other mythologies and folklores, she set about interpreting these archetypical situations in a contemporary context. Technically, she continues to explore the potentials of clay and glazes, using a multi-layered approach involving a wide variety of underglazes, glazes, lustres, and metallics. She creates small, figurative sculptural pieces, often with structural allusions to functional origins and thematic allusions to mythical origins and contemporary situations.

SADLON, A. KIMBEL (Draughtsperson)
12 Farmington Close, Rockford, IL 61111

Born: 1937 *Awards:* Fogelson National Fine Arts Award; Midwest Watercolor Society Award *Collections:* United Airlines, LaGuardia Terminal; Montgomery Ward *Exhibitions:* Burpee Art Museum, Rockford, IL; ARC Gallery, Chicago; *Education:* U. of Wisconsin, Madison; Northern Illinois U. *Dealer:* Van Straaten Gallery, Chicago

Since the late 1950s she has used abstraction to explore both media and form. Her drawings are a record of a visual search for the essence of an image. Her monotypes and paintings on canvas, aluminum, and plexiglass are examples of the personal visual language she has developed through mark-making. She creates an immediacy for herself and for the viewer by combining oil sticks, acrylic, and graphite. Landscape influences may emerge in her serial work but, as her series progresses, her forms become self-referential.

SADOWSKI, HELENA (Sculptor)
647 Randall Dr., Troy, MI 48098

Born: 1945 *Collections:* Private *Exhibitions:* Somerset Mall, Troy, MI; Detroit Artists Market *Education:* Cranbrook Academy of Art

Coming from a tradition of figuration, with extensive exposure to the works of Michelangelo and Rubens, her first works were explorations of the formal and emotive aspects of the figure and the expressive possibilities of the partial figure. After studying minimalist abstraction and the works of Robert Smithson, Magdalena Abakanowicz, and Louise Nevelson, she began to use anatomical references as parts of larger abstract forms. She now expresses wonder at the natural world and its inhabitants. Working in both two and three dimensions, she evokes the universality of human experience while at the same time capturing the uniqueness of a particular person, place, moment, or feeling.

ST. CYR TOUPS, DON (Painter, Textile Artist)
401 E. 32nd St., Chicago, IL 60616

Born: 1933 *Exhibitions:* Hyde Park Art Center, Chicago; Pan American University Art Gallery, Edinburg, TX *Education:* School of the Art Institute of Chicago

Both his paintings and his Batik textiles express a fluid, decorative interpretation of natural forms as well as organic and geometric figurations. A rich spectrum of colors and textures enhances the highly-detailed patterns, while a transparent effect is maintained throughout. The paintings and drawings are usually mixed media. Transparent inks, oil-based crayon,

acrylics, transparent colored tissue overlays, metallic paint, and silk cords make up some of the materials. An opulence characterizes these often dreamlike, mystical works.

ST. GERMAIN, PATRICK (Painter)
P.O. Box 336, Marquette, MI

Born: 1947 *Awards:* Grant, Michigan Council for the Arts *Collections:* Smithsonian Institution Air and Space Museum; Madison, WI Art Center *Exhibitions:* Detroit Institute of the Arts; Robert Kidd Gallery, Birmingham, MI *Education:* U. of Wisconsin, Madison *Dealer:* Robert Kidd Gallery, Birmingham, MI

In 1978, after working for several years in environmental sculpture and "energy field" painting, he tried to escape the art world by moving to Michigan's Upper Peninsula. Free of art trends and other pressures, he became interested in folk and children's art. His paintings are a mixture of abstraction, realism, and fantasy. The rich tapestry of life in the Upper Peninsula serves as a backdrop for a humorous social commentary that is a mixture of nature's magic and of contemporary culture. He has a passion for pigments: he paints with acrylic, fabric dye, house paint, or watercolor on canvas, wood, paper, or papier maché.

SAKAOKA, YASUE (Sculptor)
c/o Leukart, 330 S. Stanwood, Columbus, OH 43209

Born: 1933 *Awards:* Pollock-Krasner Foundation Award; 1986 Ohio Arts Council Development Grant *Collections:* Arnot Museum, Elmira, NY; Schumacher Gallery, Columbus, OH *Exhibitions:* Carnegie Center, Covington, KY; Arts Consortium, Cincinnati *Education:* U. of Oregon; Reed College *Dealer:* Nancy Johnson, Columbus, OH

Modular-oriented installations of Origami-inspired shapes are the result of influences ranging from Stella and Tony Smith to Buckminster Fuller. Working models of paper and wood dowels are adapted to life-size or larger works that combine a variety of materials for a rich visual experience. The abstract assemblages may incorporate stone, fiber, iron, cast bronze, and paper in a configuration reminiscent of architectural forms, folded paper units, and expandable modular design. An experimentalist, the artist is little interested in trends.

SALIMBENE, MICHAEL (Painter)
3359 Oak Park Ave., Chicago, IL 60634

Born: 1945 *Awards:* Ragdale Foundation *Exhibitions:* Special Things Gallery, Evanston, IL

Landscapes in craypas, pastel, and water color draw upon the historical concerns of landscape painters for intent and imagery. The artist is trained in Chinese painting techniques on rice paper in water color. A primary focus is the articulation of mood and feeling through rhythmical strokes of color. As important as the scene depicted is the sense of pleasure--in working with particular materials and in the act of painting--that infuses these works.

SALLE, DAVID (Painter)
c/o Mary Boone Gallery, 417 W. Broadway, New York, NY 10012

Born: 1952 *Awards:* CAPS Grant *Collections:* Whitney Museum; Kunstmuseum, Basel, Switzerland *Exhibitions:* Art Institute of Chicago; Leo Castelli Gallery, NYC *Education:* California Institute of the Arts *Dealer:* Mary Boone Gallery, NYC; Martina Hamilton Gallery, NYC

Part of the European and American conceptual painting movement, which ranges from the totally abstract to a combination of abstraction and figuration, he operates in a figurative vein. Images are taken from high and low culture, many of them appropriated. Mixed-media diptychs and triptychs combine drawing, painting, sculpture, and photography to present strong figures, often nudes who appear to be viewing interacting figures. Women are are usually depicted on their backs or kneeling, often without clothes – their faces are seldom seen. The works suggest endlessly shifting perspectives with ambiguous messages. He has deliberately incorporated the rhetoric and art conventions of the 1980s to make ironic commentaries and has said he would like to think of his work as "totally promiscuous and omnivorous."

SAMARAS, LUCAS (Assemblage Artist)
c/o Pace Gallery, 32 E. 57th St., New York, NY 10023

Born: 1936 *Awards:* Woodrow Wilson Fellowship, Columbia School of Art *Collections:* Museum of Modern Art, NY; Whitney Museum *Exhibitions:* Museum of Modern Art, NY; Museum of Contemporary Art, Chicago *Education:* Rutgers U.; Columbia U. *Dealer:* Pace Gallery, NYC

Born in Greece, he moved to America in 1948 and later studied with Alan Kaprow and Meyer Schapiro. In the late 1950s and early 1960s sculptures were made of plaster-dipped rags or tin foil, and pastels featured images related to both Pop and Surrealism. "Boxes" of the 1960s were small-scale assemblages which incorporated knives, pins, tacks, scissors and razor blades. Other fetish-like assemblages and constructions incorporated yarn, string, sand, plastic, nuts, bolts, mirrors, nails, pencils, and kitchen utensils. An interest in theater led him to participate in "happenings," and more recently in performance and body art. This self-exploration is evident in several series of Polaroid photographs of himself, notably "Phototransformations," and sometimes of others, often nude, in which the emulsion pigments were altered. Recent works include miniature anthropomorphic beings in bronze as well as pastel drawings and ink washes.

SANTLOFER, JONATHAN (Painter)
151 W. 28th St., New York, NY 10001

Born: 1946 *Awards:* NEA Grant; Painting Scholarship, Skowhegan School of Painting & Sculpture *Collections:* Chase Manhattan Bank; Grand Rapids Museum of Art, MI *Exhibitions:* Heckscher Museum, Huntington, NY; Institute of Contemporary Art, Tokyo *Education:* Pratt Inst.; Boston U. *Dealer:* Graham Modern, NYC

A combination of abstraction and figuration, shaped

canvases often resemble flowers or human organs, rendered in brilliant colors. The paint is encrusted upon the surface, creating rich textures and rhythmic movement. The canvas is cut in various shapes and altered so that it recedes and protrudes, creating a relief. Along with actual shadows, illusionistic space is also created with color and shading. He once called his paintings, "organisms." His goal is to make the abstract palpable. With evocative titles like "The Arrival" or "Scenes of Heroism," he encourages viewers to make their own associations.

SARGEN-SIMON, RITA (Sculptor)
606 Florence Ave., Evanston, IL 60202

Born: 1924 *Awards:* Honorable Mention, Whirlpool Foundation Sculpture Competition; Finalist, National Exhibition Women Artists, Springfield, IL *Collections:* Amoco Corporation, Chicago; Englehard Minerals, NJ *Exhibitions:* Illinois State Museum, Springfield; Art Institute of Chicago Rental Gallery *Education:* Alfred U.; Art Students League, NYC *Dealer:* Nina Owen Ltd., Chicago

Inspired by nature, her early surrealist stoneware pieces show human figures transforming into earth and mountain configurations. She then moved toward the abstract figurative sculpture, which she cast by the lost wax process into bronze and aluminum. This work led to the introduction of new materials, and her lyrical metal and plexiglas forms move through space with an elegant assurance. Now influenced by nature and contemporary architecture, she uses sheet metal to create strongly defined abstract spatial constructions. Her pieces are three- to six-foot free standing sculptures, wall reliefs up to twelve feet in length, and maquettes for large-scale commissions.

SAVAGE, KAREN (Photographer)
307 N. Cuyler, Oak Park, IL 60302

Born: 1948 *Awards:* Illinois Arts Council Grant in Photography *Collections:* Art Institute of Chicago; Visual Studies Workshop, Rochester, NY *Exhibitions:* Printworks, Ltd., Chicago; Art Institute of Chicago *Education:* School of the Art Institute of Chicago *Dealer:* Printworks, Ltd., Chicago

Her early work in photography, collage and printmaking, influenced by Duchamp, Man Ray, Warhol and Rauschenberg, draws upon media imagery and other forms of popular culture. Combining vernacular imagery with images from advertising and other found sources, including reproductions from 19th Century painting, her current work deals with serial attitudes. This amounts to a reprocessing of found imagery toward the construction of a personal narrative. She also creates arrangements in the studio and photographs them to complete a narrative. The actual presentation usually takes the form of a series of single, framed "pictures" grouped in a specific configuration. One recent installation, *Just Dancing,* contained more than twenty individual units.

SAVASTIO, JOHN (Painter, Draughtsperson)
1606 Greenwood Dr., Mt. Prospect, IL 60056

Born: 1959 *Collections:* General Mills Corporation, Minneapolis; Dayton Hudson Corporation, Min-

neapolis *Exhibitions:* Thomas Barry Fine Arts, Minneapolis; Country Side Art Gallery, Arlington Heights, IL *Education:* Minneapolis College of Art and Design *Dealer:* Studio Fifteen, Arlington Heights, IL

Influenced by the mural-painting tradition, his wall-sized drawings return to a 1930s style of bulbous geometry. Outside reality is twisted by the pressures of the modern world into dreamlike encounters where the organic is geometricized, the human roboticized. His high contrast tonality dissolves differences between interior and exterior, night and day, natural and man-made. By 1981 he had begun working toward a three-dimensional treatment of objects and space. The size of his drawings has steadily decreased and, in his current intimately-sized pieces, he uses a wide angle format to depict an imaginary space reflecting the urban and suburban environments.

SCHAAL-MORICOLI, SHARON (Painter, Draughtsperson)
603 Central, Wilmette, IL 60091

Born: 1946 *Exhibitions:* Art Institute of Chicago; Kirchen Fine Art, Chicago *Education:* Kansas City Art Institute; School of the Art Institute of Chicago

At an early age she became interested in Flemish painting and sought the expertise of Robert White in Washington, DC. Later she studied in private studios, learning the Flemish technique which she now modifies for her own work. Also attracted to the work of the mannerists and Pre-Raphaelites, she works strictly figuratively. Meticulously rendered graphite drawings are done on the finely grounded linen canvases, which are then painted with up to 30 layers of transparent oils in hues of reds, violets, and greenish umbers. Work reaches completion at different stages; at times the pencil remains part of the finished piece, other times it is completely covered. Works are primarily nudes and details of figures in interior settings, and her aim is to portray subconscious suggestion in the pose of the model.

SCHATZ, LINCOLN (Sculptor)
247 E. Ontario, Chicago, IL 60611

Born: 1963 *Awards:* Fellowship, Museum of Fine Arts, Houston *Exhibitions:* Sculpture Park, Chicago; International Art Expo, Chicago *Education:* Bennington College, VT

Influenced by David Smith and Anthony Caro, his first sculptures used found steel objects and fabricated steel shapes in large, gestural constructions placing object against object. This developed into a more intense and symbolic exploration of the relationship between self and others. More recently, his work has concentrated on distinct, individual objects and symbols, emphasizing their disjointed yet ritualistic identities and their relationships to each other as a "rite of passage." Increasing evidence of handwork on the steel includes chiseling and applied colors. Current works are large constructions in which the viewer can walk through the sculptures, experiencing the space created. This viewer participation also serves to underscore the ritualized quality of his linear and object shapes.

Sharon Schaal-Moricoli, *A Play on Words,* 28 x 48, pencil

Douglas E. Schmidt, *Pyramid I(side A & B),* 29 x 65, painted handmade paper

SCHIFF, MOLLY J. (Painter)
1245 W. Jarvis Ave., Chicago, IL 60626

Born: 1927 *Awards:* Illinois State Museum, Springfield; Borg Warner Collection *Exhibitions:* Illinois Arts Council; Freeport Art Museum *Education:* School of the Art Institute of Chicago *Dealers:* Campanile Gallery, Chicago; Joy Horwich, Chicago

Shortly after beginning her art studies in 1958, she acquired skills in varied painting, drawing, and print media. Subjects have ranged from portraiture and landscape to still life, and figures. She considers all colors as "color" whether black, white, or primary. During the 1970s she used various media to execute a large body of work based on studio objects. She selected twenty of these boldly designed multicolor works for an exhibition titled "Drawn Paintings." In the 1980s she has used oil stick on canvas for a series of aquatics and still lifes. She is currently painting strong figurative forms with watercolor, pen, pencil, and pure oil sticks.

SCHILLER, ROBERT M., Jr. (Photographer, Painter)
2456 W. 38th St., Chicago, IL 60632

Born: 1925 *Collections:* Museum of Modern Art, NYC; Bell Telephone Co., Chicago *Exhibitions:* Hyde Park Art Center, Chicago; On Chicago Gallery *Education:* Institute of Design

After serving an apprenticeship in commerical photography, he studied visual design under the Russian Constructivist Laszlo Moholy-Nagy before entering the world of fine art and commercial photography on his own. Figurative and abstract works are manipulated in the darkroom in order to achieve surrealistic effects. During the 1960s in particular, he actively exhibited his black and white works in such places as the Eastman House and the Museum of Modern Art. Although still involved in photography, he does most of his recent work using an abstract brush in ink drawings portrayed in an organic and surrealistic manner. Primarily black and white, the palette is sometimes extended through the use of colored ink and oil stick.

SCHMIDT, DOUGLAS E. (Painter)
3403 S. Wozniak, LaPorte, IN 46530

Born: 1959 *Exhibitions:* Prism Gallery, Evanston, IL; Campanile Gallery, Chicago *Education:* Miami U., Ohio; Indiana U. *Dealer:* Prints Unlimited Gallery, Chicago

Works are created using cast or poured paper techniques. In casting paper, the image is formed by paper pulp placed into a mold made from a clay original. Through this process, the artist creates a limited edition of signed and numbered pieces. Various dyes, pigments, and materials, such as twine, foil, and lace, are incorporated directly into or attached to the paper to create color, texture, and pattern. He also uses hand-carved woodblocks to print images into the surface. His subject matter is culturally eclectic--he sees art as a part of a continuous link to man's past, and therefore he picks themes and motifs from a range of cultures and periods, incorporating them into a 20th-century context. The cultures he draws on include those of ancient Egypt and China, and the Mayans, American Indians, and aboriginal Australians.

SCHNEIDER, JANINA (Creative Artist)
Art Resource Studio, 2828 N. Clark St., Chicago, IL 60657

Born: 1957 *Awards:* Neighborhood Arts Award, Chicago Council of Fine Arts; Citizen of the Month, Lerner Newspapers *Exhibitions:* Broadway Art Fair, Chicago; Mayor Byrne's Summertime Festivals, Chicago *Education:* Grahm Junior College, Boston

With degrees in child development and art, she opened the Art Resource Studio, out of which she holds classes for both adults and children in drawing, painting, and crafts. She also has developed workshops for teachers, camp counselors, and scout leaders. Her own painting, while abstract, is influenced primarily by Greek Art, which she studied in the fourth grade. Also greatly influencing her is the work of her grandmother, Evelyn Russo, especially the specific style and intricacy with which she depicts floral scapes and architecture. Currently she is working mostly with acrylic, though at times works are done in pencil.

SCHOCH, SALLY (Fiber Artist, Painter)
1427 Gregory, Wilmette, IL 60091

Born: 1934 *Collections:* Marshall Field's; Bally Corp. *Exhibitions:* Pickwick Galleries, Wilmette; Art Rental & Sales, Art Institute Chicago *Education:* School of the Art Institute of Chicago; U. of Miami, Coral Gables, FL.

She interprets urban landscapes in her oil paintings and works of fiber assemblage. She is challenged by the city of Chicago and is striving to make a statement which incorporates the city's character and complexity. The changing skyline over the years has been a particular source of inspiration in works which emphasize the relationships of buildings through the interplay of positive and negative space. Using Scandinavian weaving techniques, the artist evokes parallels between the different architectural elements of a city and the individual fibers woven together to form a single fabric. She is currently creating a "Skyline" series handwoven in blue wools, silks, and cottons.

SCHWARTZ, CARL (Painter)
13872 Pine Villa Ln. S.E., Ft. Myers, FL 33912

Born: 1935 *Awards:* Logan Medal, Art Institute of Chicago; Purchase Prize, Illinois State Museum *Collections:* Britsih Museum, London; Smithsonian Institute, Washington, D.C. *Exhibitions:* Art Institute of Chicago; Cultural Center, Chicago *Education:* School of the Art Institute of Chicago *Dealer:* Campanile/Capponi Art Consultants, Chicago

While he taught figure drawing and painting for some 27 years--painting figurative as well as landscape pieces--today he works exclusively with landscapes. His current work continues to reflect his long time interest in the effects of light on his subjects. While he considers himself a "realist" painter, he nonetheless works within the Impressionist tradition; indeed, he cites Cezanne and Monet as his major influences. He works full-time in his Florida studio, painting from sketches and

photographs of the lilly ponds and foliage in the nearby lagoons and surrounding woods and glades. Time and again, he is attracted to water imagery, an interest exemplified in painting *Wet Woodland* and *Bubbling Stream*. In addition to his acrylic paintings (occasionally he works in watercolor, rarely in oil), he also produces hand-pulled limited edition stone lithographs.

SCULLY, SEAN (Painter)
New York

Born: 1945 *Awards:* Guggenheim Fellowship; NEA Fellowship *Collections:* Tate Gallery, London; The Metropolitan Museum of Art, NYC *Exhibitions:* Rowan Gallery, London; The Clocktower, NYC *Education:* Croyden College of Art, London; Harvard U. *Dealer:* Art Institute, Chicago

"Humanized abstraction" accurately describes the work of this artist. Stripes of surface color in differing widths allow the ground beneath to emerge, creating uncharacteristic, subtle hues. Through shifts in weight, color and brushwork, through unbalanced compositions and wavering edges of color, each piece possesses an imperfect personality. These works are at once forceful and genuinely human. Scully's rugged individuality is evidenced in early use of tape as texture in finished pieces, when other artists used tape only to attain hard-edged precision. He later eliminated the tape, allowing the edges of his colored stripes to undulate. In the early 1980s he began to misalign painted panels of different sizes with stripes of differing widths. He adopted the use of oil paint in favor of acrylic. He added a gel medium to the oils, producing a creamier, more translucent quality. Formalist art has long used the stripe motif, yet his stripes have unique, personalized power.

SEGAL, CHARLOTTE (Painter)
3150 N. Lakeshore Dr., Chicago, IL 60657

Born: 1931 *Collections:* Borg Warner Corp.; Security Pacific Bank, Los Angeles *Exhibitions:* Illinois State Museum, Springfield; Chicago and Vicinity Show, Art Institute of Chicago *Education:* Barat College *Dealer:* ARC Cooperative, Chicago

The contours and crisp edges of her early plant forms undulate with the colors she applied in thin glazes of oil and watercolor. She was influenced by O'Keeffe's references to nature and Turner's mystical use of color and movement. Her current large oils have close figure-to-ground relationships. The ghost-like figures that inhabit her canvases appear to be caught in space. These figures are headless and faceless, since she is only interested in their spiritual nature and not their identities. She still uses flora as a tool for expressing form and color and her painting has become thicker, with brush strokes suggesting forms as the work evolves.

SELLERS, GAIL (Sculptor)
89 E. Quincy, Riverside, IL 60546

Born: 1952 *Awards:* Fellowship, Illinois Arts Council *Exhibitions:* Illinois State Museum, Springfield; Indiana U., NW, Gary *Education:* School of the Art Institute of Chicago; Northern Illinois U., De Kalb

Influenced by the works of Paul Klee, Jean Arp, Gaston Lachaise, and Georgia O'Keeffe, her biomorphic forms are metaphors for growth. Using clay, cement, and paper pulp as raw materials for mixed media earth-toned sculpture, she juxtaposes anthropomorphic references as a means of indicating the relationship between growth and mankind. Her interest in growth stems from an understanding of nature's cycles, a respect and love for its ordered development, and a concern for man's relationship to nature's domain. She is currently a member of the Art Faculty at North Central College in Naperville, IL.

SENSEMANN, SUSAN (Painter)
3818 N. Kenmore, Chicago, IL 60613

Born: 1949 *Awards:* Grant, Illinois Arts Council; Grant, Ford Foundation *Collections:* Illinois State Museum; Lakeview Museum, Peoria, IL *Exhibitions:* Art Institute of Chicago; U.S.Information Service, Ankara, Turkey *Education:* Tyler School of Art, Philadelphia; Syracuse U. *Dealers:* Locus Gallery, St. Louis, MO; Roy Boyd Gallery, Chicago

Hieronymous Bosch and Pieter Brueghel influenced the artist's realistic depictions of objects associated with Christian iconography in the early 1970s. Later, after moving to Chicago, the work gradually moved toward abstraction. Although she still employed painstaking glaze techniques in oil, her use of imagery shifted to a personal response to complex architectonic structures. A series of large paintings in 1983 were intensely colored and expressive in their use of thickly layered paint. Recent oils, as well as drawings in pastel and oil pastel, are her response to the pre-Renaissance works of Italian painters such as Giotto and Fra Angelico. Heavily encrusted "compartments" of color surrounded by energized lines and coils represent spatial configurations that are both highly structured and evocative of a sense of mystery, movement, and spirituality.

SETH, RICHARD P. (Painter)
619 Cornell St., Ottawa, IL 61350

Born: 1940 *Awards:* Merit Award, Southside Art League Show, Greenwood, IN *Collections:* Continental Bank, Chicago; Continental Grain, Chicago *Exhibitions:* McCormick Place, Chicago; Lynn Kottler Gallery, NYC *Education:* Sherwood College, Naini Tal, India *Dealer:* Lakeview Museum, Peoria, IL; Tarble Art Center, Charleston, IL

After his art training at Sherwood College in India he was most influenced by American artists such as Rauschenberg, Wyeth, and Hopper. He now uses acrylics and mixed media to paint representational landscapes of the American Midwest. Although this work is representational, its implications are abstract. He applies the acrylics with layers of paint and glazes in an egg tempera style. His mixed media work is a series of barns, recognizable but filled with movement. These numbered works show the influence of the Cornell Boxes he found intriguing. Throughout his career he has also been concerned with Native American themes.

SHADUR, BETH (Painter)
1617 Dobson, Evanston, IL 60202

Born: 1954 *Awards:* Grant, Chicago Artists Abroad; Samuel T. Arnold Fellowhip, Brown U. *Collections:* Bergman Collection; Kemper Collection *Exhibitions:* Hudson River Museum; ARC Gallery, Chicago *Education:* U. of Illinois, Chicago; Brown U. *Dealers:* J. Rosenthal Gallery, Chicago; Joanne Carson Gallery, Denver

In her early autobiographical watercolors, she created narratives of personal history by depicting objects and memorabilia placed on maps and diagrams. The works appear to be collages or montages of images in bright, saturated colors whose intensity enhanced their inherent humor. She composes her most recent work from narrative images. As in a stage set, she arranges figures, objects, and architectural forms in ways that allow them to act as media for interaction between painted elements. She uses scale, unusual color combinations, and real and imagined forms to give her work a surreal quality.

SHAPIRO, IRVING (Painter)
1335 N. Astor St., Chicago, IL 60610

Born: 1927 *Awards:* Ranger Award; North Winds Medal *Collections:* American Medical Association; Borg-Warner *Exhibitions:* Union League Club of Chicago; Neville-Sargent Galleries, Chicago *Education:* School of the Art Institute of Chicago; American Academy of Art *Dealer:* Ruth Volid Galleries, Chicago

His style, influenced by Burchfield, Hopper, O'Keeffe, and Homer, is best described as classic/contemporary impressionism. Eschewing modern movements and trends, he has continued to explore the possibilities of classical technique. Through the years, he has pursued a thorough and understanding attitude toward watercolor, despite its reputation as a preliminary or fleeting medium.

SHAW, THOM (Painter)
1015 Hempstead Dr., Cincinnati, OH 45231

Born: 1947 *Awards:* Fellowship Award, Ohio Arts Council; 38th National Convention of the Visual Arts Award *Collections:* Chase Manhattan Bank; Cincinnati Art Museum *Exhibitions:* High Museum, Atlanta; Mary Bell Gallery, Chicago *Education:* Cincinnati Art Academy; U. of Cincinnati *Dealer:* Malton Gallery

At the Cincinnati Art Academy, Professors Stanszeck, Collins, and Douglas impressed upon him the expressive and symbolic powers of colors as they relate to one another and to an entire piece. This he demonstrates in his textual (and textural) mixed media paintings and drawings. These influences, and the importance of "what's happening at the edges as compared to what's happening elsewhere," are evident in all of his works, regardless of their shape or size. The artist's current works are vibrant oils on stretched canvas, some of which depart from the traditional square or rectangle. He is inspired by music and sees himself emulating the rhythms of jazz and reggae in the passages of color and the series of pulsating patterns and marks.

SHAW-CLEMONS, GAIL (Printmaker, Draughtsperson)
3012 P. St. S.E., Washington, D.C. 20020

Born: 1953 *Awards:* 1st Place Drawing, Miller Brewing Co., 2nd Place Drawing, Atlanta Life Insurance Co. *Collections:* Milwaukee Art Commission; Corn Row & Co., Washington, D.C. *Exhibitions:* Museum of Science and Industry, Chicago; Caribe Art Center, Chicago *Education:* U. of Maryland *Dealer:* Alex Gallery, Washington, D.C.

The works in her thesis show were inspired by dreams. In both prints and pastel drawings, surrealist-influenced images and forms hovered above the Earth, often interacting with reality. Her present work, often figurative and always symbolic of life, deals in the organic forms and colors of nature. Continuing to use both prints and pastels, she blends vibrant and soft fields of color around bold organic forms creating a magnified view of life's origins.

SHAY, ED (Painter, Sculptor)
1312 W. North Ave., Chicago, IL 60622

Born: 1947 *Awards:* NEA Fellowship; IAC Artist's Grant *Collections:* De Cordova Museum, Lincoln, MA; Minnesota Museum of Art, St. Paul *Exhibitions:* Roy Boyd Gallery, Chicago; Chicago Public Library Cultural Center, Chicago *Education:* U. of Illinois *Dealer:* Roy Boyd Gallery, Chicago

From 1971 to 1976 he worked on a series of large, representational aquatic paintings in collaboration with Charlotte Rollman. In 1977 he moved from New York City back to the Midwest, where he worked almost exclusively in watercolor. Installing a number of theatrical sets in his backyard and studio, he photographed them and made paintings from the resulting photographs. This series of watercolors is characterized by intense primary colors and scenes which appear as metaphors for psychological distress. By 1985 he realized that his primary involvement was often in the creation of the theatrical sets in his backyard. He began making sculpture, almost on a whim. The stick forms he often used in his sets became primary elements as he moved to the process of casting bronze leaves, and sticks.

SHELTON, EDWIN P. (Sculptor)
4411 N. Beacon St., Chicago, IL

Born: 1956 *Collections:* Private *Exhibitions:* 314 Market St. Gallery, Rockford, IL; Lill St. Gallery, Chicago *Education:* U. of Wisconsin, Madison

Contemporary American Folk artists had a strong influence on his earlier work. He built and painted temporary objects from materials he scavenged from dumpsters and the streets. Later these sculptures were destroyed, leaving only his drawings from this era. His present drawings and wall sculptures are depictions of imaginary characters. His fragmented figures suggest a personal mythology. Building with a range of materials, he paints the textured earthenware surfaces of his wall-hung flat wood cut-outs. Sometimes he includes glass and fibers in his wall reliefs.

Richard P. Seth, *We Promised Them Many Things,* 13 x 27, acrylic

Gail Shaw-Clemons, *Welcome Stranger,* 17 x 21, color pencil.
Courtesy: Atlanta Life Insurance

SHEN, IGNATIUS (Painter)
5420 N. Sheridan Rd., #408, Chicago, IL 60640

Born: 1936 *Awards:* National Dean's List Award *Collections:* Peking Museum; Shanghai Museum *Exhibitions:* Art Institute of Chicago; Northwestern University Art Gallery *Education:* Washington U., St. Louis; Shanghai U.

Employing exotic colors and daring to reshape nature, he works vigorously in a variety of styles. There is a tremendous momentum in his painting. His lifelike horses glow with health and radiate strength. At the same time, he is admired for his harmonious state of mind, his conscientiousness, and his sensitivity of feeling. His work is alike in both appearance and spirit to that of Xu Bea-Hung, president of the Peking Art Institute, under whom he studied.

SHERMAN, CINDY (Photographer)
c/o Metro Pictures, 150 Greene St., New York, NY 10012

Born: 1954 *Collections:* Museum of Modern Art; Metropolitan Museum of Art *Exhibitions:* St. Louis Art Museum; Rhona Hoffman Gallery *Education:* SUNY, Buffalo *Dealer:* Larry Gagosian Gallery, Los Angeles; Metro Pictures, NYC

Early black and white 8 by 10 inch prints were similar to film stills in which images from middle-class popular culture, popular films, horror flicks and television programs were exploited. She photographed herself in various roles as model, director and photographer. Cibachrome prints featured her in mini-melodramas, complete with theatrical settings and props. Recent works continue the role-playing as she poses as various glamourless models in very large color prints that parody designer-clothes fashion photography. These women are portrayed with a new sense of power and a sardonic sense of humor.

SHERMAN, MARY (Painter)
2470 N. Clybourn Ave., Chicago, IL 60614

Born: 1957 *Awards:* Alison R. MacComber Award *Exhibitions:* National Portrait Gallery, Smithsonian Institute; Gallery Vienna, Chicago *Education:* Academie der Angewandte Kunste, Vienna; Boston College *Dealer:* Victoria Espy, Chicago

Following an apprenticeship and extensive training as a portrait artist, she began working abstractly, later returning to the figure in an allegorical setting. Inspired by Alban Berg's opera *Wozzeck*, she recently created a series portraying the doomed lovers Wozzeck and Marie and their illegitimate child in thickly painted, overwhelming yet empty spaces. Gold leaf, enamel, pastel and casein are interspersed in grounds of subtly colored, almost monochromatic textured oils to portray the tension found in figures dwarfed within large spaces. The artist reveals a sensibility shared with painters such as Klimt and Schiele, endeavoring to express mood and emotion with the fewest and most essential items necessary. Current work explores a triptych format and religious iconography, such as the Madonna and Child.

SHERWOOD, ELLEN (Ceramist)
1504 Ashland Ave., Evanston, IL 60201

Born: 1946 *Awards:* Robert Rice Jenkins Memorial Prize, Chicago And Vicinity Show, Art Institute of Chicago; Purchase Prize, New Horizons Show *Collections:* Kohler Collections, Kohler, WI *Exhibitions:* Chicago and Vicinity, Art Institute of Chicago; David Adler Cultural Center, Libertyville, IL

Initially inspired by the humor of Claes Oldenburg's sculptures, she created small-scale ceramic interiors that celebrated the common object in a proscenium-like format. These developed into intimate, dreamlike spaces with increasingly pale, grayed colors. In the late 1970s she did a temple series inspired by her fascination with unconscious levels, featuring recessed spaces with some elements partially visible behind broken walls. Her later works have been more detailed and precise—sometimes portraying actual rooms, all white in color—and of a pristine, jewel-like quality. Currently her work is more abstract, focusing on small areas of architectural space, and emphasizing composition, color, and relationship of objects.

SHILSON, WAYNE STUART (Painter)
19017 Euclid Path, Farmington, MN 55024

Born: 1943 *Awards:* First Place, STC '84; Merit Award, Art Center of Minnesota *Collections:* Honeywell Corp.; Pillsbury Co. *Exhibitions:* Minneapolis Institute of Arts; Normandale College Center Gallery, Bloomington *Education:* U. of Minnesota *Dealer:* Parks Fine Arts, Elmhurst, IL

Although a painter of serene landscapes that evoke solitude and a place where mankind can live in a harmonious atmosphere, he does not like to paint from nature. Rather, his compositions are conceived and executed in his studio. Extremely influenced by studies of art history, especially by the pointillists and impressionists, his works employ the stippling technique of the latter and use a palette of bright colors—no blacks or earth tones. The vibrating effect of the juxtaposed colors is countered by the harmonization of tints and the underpainting. Acrylic and gloss enamel paints are used in his works, which are of medium scale.

SHORE, REBECCA (Quiltmaker)
2038 N. Oakley, Chicago, IL 60647

Born: 1956 *Awards:* Chairman's Grant, Illinois Arts Council; Artists Fellowship, Illinois Arts Council *Collections:* U. of Chicago Hospitals *Exhibitions:* "Quilt Invitational," Textile Arts Center; "Quilts," Carl Hammer Gallery, Chicago *Education:* School of the Art Institute of Chicago *Dealer:* Carl Hammer, Chicago

Trained originally as a painter, she began making quilts in 1980 as a result of interests in textiles, particularly Japanese kimonos and traditional Amish, American, and African-American quilts. Typically her works are based on a geometrical scheme or some system of spatial depiction. Many of her recent quilts explore the illusion of three-dimensionality. Using many different types of materials, these works present solidly built geometric shapes in a highly structured scheme. Within her self-imposed rules, she feels free to invent or improvise, as quiltmakers have done for centuries. Other recent influences include American gameboards,

Jo Siddens, *Earthtide: Fallout,* 96 x 72 x 48, cast flax paper

Julie Lutz Simmons, *White Orchid,* 26 x 42, watercolor collage. Courtesy: Alice Bingham Gallery, Memphis, TN

Suriname patchwork, garden design, Kuba raffia cloth, and Japanese family crests.

SIDDENS, JO (Painter)
111 Hillside Ave., Waterloo, Iowa 50701

Born: 1929 *Awards:* Special Award, National Small Print and Drawing Exhibition, Cobleskill, NY; Purchase Award, University of South Dakota *Collections:* Museum of Contemporary Art, Bahia, Brazil; Bureau of Exhibitions, Lodz, Poland *Exhibitions:* Tokyo Metropolitan Museum of Art, Japan; Pratt Graphic Center, NY *Education:* U. of Iowa; Pratt Graphic Center, NY

Painter, printmaker, and sculptor, she constantly explores the extension of illusionistic space on a two-dimensional surface into actual three-dimensional space. Her early paintings are influenced by the California painters Diebenkorn, Bischoff and Olivefira, who brought the figure (after de Kooning) back to abstract expressionism. Work of the 70s includes a number of "environments" which combine sound, dance and visual images. In 1980, she produced a series of twelve large lithographs, as a traveling exhibition entitled *Fossil Images,* which generated experimentation in cast paper. Current work utilizes the broad number of techniques she has developed; she works in collagraphs and monoprints that approach mural size, sculptural reliefs, and sculptural installations. Throughout her work, focus is on the human figure as a metaphor for human experience. Her latest pieces employ life-size figures, mostly flat silhouettes like Matisse cut-outs, that are captured leaping, falling, marching, cowering, rejoicing and agonizing, against a flat background, patinaed to suggest the disintegration of time.

SIERRA, PAUL (Painter)
1712 N. Halsted, Chicago, IL 60614

Born: 1944 *Awards:* Purchase Award, 35th Illinois Invitational, Illinois State Museum; Best of Show, New Horizons in Art, 1982, Chicago Public Library Cultural Center *Collections:* Illinois State Museum; Rolli Foundation Museum, Montevideo, Uruguay *Exhibitions:* "Mira!" Traveling Exhibition of Hispanic Art, Chicago; Artemisia Gallery, Chicago *Education:* School of the Art Institute of Chicago; American Academy of Art, Chicago *Dealer:* Gwenda Jay Gallery, Chicago

Influenced by Goya and visions of the Caribbean, the artist is known for intense, tropical colors and surrealistic imagery. Current works explore juxtapositions of different domains of reality using the dialectic of opposites: interiors and exteriors, man-made vs. natural landscapes, etc. Other works explore the struggle to dominate or the uneasy equilibrium of detente. A 1984 series explored a single idea from several visual perspectives based upon the theme of personal familial loss. Drawing upon the rituals and iconography of Cuban Santeria, he explored the impulse to seek answers to life's impenetrable mysteries. Another series consisted of a group of landscapes devoid of human presence yet acknowledging human existence. A series of interiors followed in which everyday symbols of domesticity became characters in a drama thrown off balance by otherworldly forces.

SIGLER, HOLLIS (Painter)
22663 N. Prairie Rd., Prairie View, IL 60069

Born: 1948 *Awards:* NEA Visual Fellowship; Awards in the Visual Arts, Southeastern Center for Contemporary Arts, Winston-Salem *Collections:* Museum of Contemporary Art, Chicago *Exhibitions:* The Corcoran Gallery of Art Biennial; Whitney Biennial *Education:* The School of the Art Institute of Chicago *Dealer:* Dart Gallery, Chicago; Barbara Gladstone Gallery, NYC

Inspired by outsider art, she abandoned illusionistic, figurative painting and turned to a faux naive style in the mid-1970s. Her figureless, richly colored canvases suggest the aftermaths of pains, frustrations, domestic traumas, and lush pleasures. Her protagonists seem to have just left the scene. Intriguing scrawled captions, such as "I Just Want It To Stop" or "Why is Guilt Part of Temptation," suggest messages to friends and lovers, and work as part of her close-to-the-bone observations of human relations. She sometimes uses fertile landscapes to suggest a healthy independence, but even in these more upbeat works she retains a wary sense of having to pay for happiness.

SILBERMAN, ELLIOT (Painter, Photographer, Printmaker)
1201 N. 7th Ave. E., Duluth, MN 55805

Born: 1943 *Awards:* Annual Young Quinlan Best Print of Show Award, 1965 *Exhibitions:* 5th and 8th Annual Minnesota Biennial; 1967 Pennsylvannia Academy of Fine Arts Print Show *Education:* Minneapolis School of Art *Dealer:* Gallery 323, Duluth, MN

Specializing in lithography until the mid-1960s, the artist cites a variety of influences which led him to his current mode of spontaneous art-making. These include abstract expressionism, Kandinsky's visual studies of musical rhythms, and primitive art. Paintings are small, done in oil on masonite, and executed quickly so that conscious thought enters only in the selection of colors. Portraits, landscapes and seascapes, and abstractions are painted in the colors of the season; emotion and rhythm always permeate the finished product. The artist is also involved in mail art, postcards, and collaborative projects.

SIMMONS, JULIE LUTZ (Painter)
P.O. Box 305, Charleston, MO 63834

Born: 1942 *Awards:* Award of Excellence, St. Louis *Collections:* Embassy Suites, La Jolla, CA; Marriott Hotels, Atlanta, GA *Exhibitions:* Anderson-Rippee Interiors, Memphis; Watercolor '87, Invitational, St. Charles, IL *Education:* Murray State U., KY; Southeast Missouri State U., MO

Exploring different aspects and media of art since early childhood, she began to pursue painting in earnest upon graduation from college. As an adult she began in oils, painting realistic still lifes and landscapes, and for a short period she ventured into sculpture. She began to miss working with color, and therefore she returned to the easel, only this time with watercolor and collage as her primary media. These paintings include a broad range of subjects, from flowers to architecture, portraits to abstract landscapes. The collage works

incorporate pieces cut from her own paintings, put back together and placed on another background, with ink or pieces of rice paper often added to them. Her most recent work is done on gessoed masonite. Many of these paintings are of very large swans, with the texture of the gesso providing a contrasting surface for the medium gloss acrylic finish.

SIMPSON, JANET (Painter)
735 Osage Ave, Kansas City, KS 66105

Born: 1954 *Exhibitions:* William Engle Gallery, Indianapolis; New Art Examined '88 *Education:* Ohio U.; U. of Kansas

Early influences include Cezanne, Picasso, and Kupka, as well as Abstract Expressionist Clifford Still. Work of the late 70s and early 80s suggests an abstract, silent terrain. Done in oil, the paintings explore the concept of space in regard to abstract painting, merging tangible space into an illusionistic space. Recent work continues to deal with abstract forms in figurative space. *Conversation Piece,* an early 1986 painting, contains three large interlocking shapes that suggest an enormous jigsaw puzzle. Continuing to use oil, the works have a painterly quality with an active surface developed from the interaction of shape, color and space.

SIMPSON, JO RANDOLPH (Painter)
3422 Clark St. #1, Des Moines, IA 50311

Born: 1928 *Awards:* Best of Show, 1st, 2nd, 3rd and Artist's Choice Awards, Watercolor Art Society, Houston; Juror's Merit Award, Art League of Houston *Exhibitions:* Iowa Watercolor Society; Des Moines Art Center Museum Shop, Iowa *Education:* American Academy of Art, Illinois; Chicago Academy of Fine Art *Dealer:* Des Moines Art Center, Iowa; Huston's Inspiration Book Shop, Des Moines

After several years of working as a commercial artist, she became interested in watercolor as a fine art. At this time she also began working in acrylics, initially painting portraits which were characteristically "loose and free," then leading to pastel portraits and landscapes most often inspired by actual places. Gradually her repertoire expanded to include abstraction using a palette heavy in mauves and blues, reds and yellows. In the first stages of the work, paint is applied in broad masses with drips and splashes; later, detail and calligraphy is added. "The landscapes and seascapes are sometimes begun on untouched paper, letting them emerge much like sculpting a stone," states the artist. Bright, clear colors give a luminosity and transparency to the pieces.

SINGH, KANWAL PRAKASH (Draughtsperson)
7832 Susan Dr. South, Indianapolis, IN 46250

Born: 1939 *Awards:* Daverman Merit Award in Architecture, U. of Michigan; 1st Prize & Best Drawing, Hoosier Salon, Indianapolis *Collections:* Ronald W. Reagan, Indiana U. *Exhibitions:* Jefferson National Life Gallery, IN; Presidents Gallery, Columbia Club, Indianapolis *Education:* U. of Michigan

Surrounded by ancient architecture and artistic creativity while growing up in India, he conceived a desire to capture the architectural legacy of man in pen and ink drawings. His style has been influenced by the Old Masters. He presents his subjects in close-up, highlighting detail and splendor, challenging the viewer to explore the spirit of buildings' original creators. His first drawings were linear, somewhat flat and sparse, but he has now added sensuality, texture, landscape details, spatial arrangement, and an intensity of line and form. He now occasionally adds color with pencils, crayons, or pentels, highlighting a segment of the drawing or an entire piece.

SISTO, GUS (Ceramist)
822 W. 19th St., Chicago, IL 60608

Born: 1954 *Collections:* McDonald Corporation, Chicago; Craft Alliance Gallery, St. Louis *Exhibitions:* Esther Saks Gallery, Chicago; Norris Cultural Center, St. Charles *Dealer:* Mindscape Gallery, Evanston, IL

His abstract expressionistic compositions utilize functional formats as a vehicle for aesthetics, particularly floor compositions and platter compositions. Using layered color patterns punctuated by both negative and positive line drawings, his images are derived from the seemingly chaotic, yet ordered phenomena of nature, and its daily interaction with man-made phenomena. He creates deep metallic texture in combination with glossy, colorful areas. The surfaces of these platters are rich and tactile, incorporating a response to light as part of the piece. Among the techniques he uses are airbrush, stippling and other handbrush work. Intense contrasts of colors, such as black and turquoise, are typical of his current work and highlight the tension of his subject matter.

SKJERVOLD, GERALDINE REID (Mixed Media Artist)
1258 W. Winona #1A, Chicago, IL 60640

Born: 1944 *Exhibitions:* Neville-Sargent Gallery, Chicago; Artphase I Group, Chicago *Education:* California State U., Sacramento

Her training, under the guidance of Joseph Raphael, Jim Nutt, and Mel Ramos, nurtured her experimental, personal approach to creating art. She believes it is essential to make art from within, mediating personal experiences and observations for others. Among her works are a series of cedar boxes filled with modern urban archeological artifacts and a set of large paintings layered with textile-like patterns and surrealist scenes combined with postcard-like landscapes. She feels any medium or technique is appropriate for creating art.

SKOMSKI, THOMAS (Sculptor)
7009 N. Glenwood Ave., Chicago, IL 60626

Born: 1948 *Awards:* Illinois Arts Council; Fellowship, Art Institute of Chicago *Exhibitions:* State of Illinois Art Gallery; Hyde Park Art Center, Chicago; *Education:* School of the Art Institute of Chicago

His early wood carvings were influenced by Native American artistic and spiritual traditions. The study of Jungian psychology and Zen Buddhism provided the basis for a shift toward the use of light as subject matter in more sculptural constructions. Light refracted

through water and glass, creating moire patterns in the environment, is one of the events that transform static objects into kinetic sculpture. Using materials from common experience, such as peg board, generic glass gallons, and expanded steel, he creates compositions that integrate the look of Japanese gardens with the sensibility of Northwest Coast Indian carving. The formal content of the sculptures centers on an interplay of opposites, reality and illusion, both in substance and in the effect created on the environment.

SKUDERA, GAIL (Painter, Textile Artist)
2012 Welwyn Ave., Des Plaines, IL 60018

Born: 1952 *Awards:* Purchase Award, Illinois State Museum, Springfield *Collections:* Baird & Warner Corp., Chicago; Illinois State Museum, Springfield *Exhibitions:* Hyde Park Art Center, Chicago; Columbia College, Chicago *Education:* Northern Illinois U., DeKalb *Dealer:* Sybil Larney Gallery, Chicago

Having studied both the Gobelin Tapestry weavers and the color theory of the Impressionists, she developed a technique of combining the physical components of painted color and representational form with the woven surface. In her work she blends two or more images into a single entity. First she paints canvas or paper, then she slices it into the long strips which she reconstructs through weaving. Though she abstracts her portraits, plant forms, and flowers through this deconstruction-reconstruction process, their forms remain apparent in the gestalt of the final work. She presently dissects her canvases according to painted shapes and contours, creating a convoluted warp.

SLEPIAN, MARIAN (Cloisonne Artist)
5 Overlook Dr., Bridgewater, NJ 08807

Born: 1934 *Awards:* Best of Show, Raritan Valley Art Association; 1st Place, Craft Concepts *Collections:* AT&T, NJ; American Standard, NJ *Exhibitions:* State Museum of New Jersey; Morristown Museum, NJ *Education:* Fashion Institute, NYC *Dealer:* Mindscape, Evanston, IL

Applying her skill as a painter to the challenging medium of cloisonne enamel, she fashions contemporary concepts in an ancient art. Heavily influenced by the abstractions of the 1950s, she works to achieve images that challenge our interpretive skills as well as evoke strong emotions. Using a medium traditionally reserved for jewelry-making, her pieces are large-scale and more than simply decorative. She takes advantage of the bold and exciting colors available in cloisonne, and her images are panoramic, capturing the essence of a place and its people--be it a Biblical theme or a fairy-tale image. In each case her goal is to involve the viewer in aesthetically pleasing "environments" whose subtle complexities provoke continually renewed emotional and intellectual responses.

SMILLIE, ROSEMARY (Painting)
1351 Prairie, Aurora, IL 60506

Born: 1927 *Collections:* Panhandle of Eastern Pipeline, Houston, TX; S & C Electric, Chicago *Exhibitions:* House of Representatives, Washington, D.C.; State of Illinois Building, Chicago

She began her career as a commercial artist, but ten years ago decided to devote herself to fine art. She paints in oil, watercolor and pastels and creates collages from free-form brass spills. The medium she uses on any given work results from her choice of subject and the mood she wishes to convey. Changing from oil to watercolors has freed up her style, lending an impressionistic cast to her work. Shapes and images develop as bold colors are added and layered. As the painting develops from the abstract to the representational, subjects emerge from her past and her subconscious.

SMITH, JOEL (Painter)
321 S. Lafayette, Macomb, IL 61455

Born: 1929 *Awards:* Purchase Award, Oakland Museum; Award, Columbus Museum *Collections:* Museum of Modern Art; Tate Gallery, London *Exhibitions:* Museum of Fine Arts, Budapest; Kyoto Art Museum *Education:* U. of California, Berkeley *Dealer:* Campanile-Campponi, Chicago

While at Berkeley, he switched from realism to abstraction. In these works, he used cubist and classical art theory to abstract the forms and shapes of figure and landscape painting. He filled these painterly canvases with personal symbolism. In his current work he starts with a brush stroke and allows the painting to develop through a series of interlocking relationships between unity and contradiction, between theory and action. He may complete several related paintings on the same canvas before achieving his final concept. He covers these underpaintings in a nihilistic act, leaving exposed sections to combine fluidly with the overpainting and making a powerful assertion of dynamic human complexity.

SMITH, RICHARD (Painter)
c/o Gimpel Fils, 30 Davies St., London, W1R 1LG, England

Born: 1931 *Awards:* Scull Prize; Harkness Traveling Fellowship *Collections:* Smithsonian Institution, Washington, D.C.; Tate Gallery, London *Exhibitions:* Knoedler Gallery, London; Young Hoffman Gallery, Chicago *Dealer:* Feigen, Chicago

Smith's early abstract work dealt with Pop subjects, inspired by American advertising imagery. Brash, exuberant canvases referred directly to commercial products with package-like shapes. Smith's deepest interests though, involved the formal properties of painting: color, structure and form. He moved to a minimalist series having to do with time and sequence. Often one color was used, with a second acting as an accent. Later he began references to nature: woods, fields and rivers. Further developments brought sequences of kite-like forms, suspended by string, rods or rope. Canvas is formed into squares, rectangles or polygons, in sequence along the wall, fanned out like a deck of cards. Smith's work has evolved from noisy aggressiveness to almost placid subtlety, using beautiful colors.

SMITH, RICK EDWARD (Painter, Assemblage Sculptor)
432 N. Austin Blvd., Oak Park, IL 60302

Janet Simpson, *Gathering,* 42 x 58, oil on canvas

Eleanor Spiess-Ferris, *Waterfowl,* 22 x 33, gouache. Courtesy: van Straaten Gallery, Chicago

Born: 1959 *Awards:* Honorable Mention, Halifax National Art Festival, Ormand Beach, FL *Collections:* Muskegon Art Museum, MI; CBS Records, Los Angeles *Exhibitions:* Natalini Gallery, Chicago; DeGraaf Fine Art Gallery, Chicago *Education:* Western Michigan U.; Kendall School of Design, Grand Rapids, MI

After formal training as an illustrator, he finished his fine art education as a painter with an emphasis in realism. After experimenting with abstract expressionism and other techniques, he began working with a much more fluid technique. Drawings done with erasers and fingers took the place of airbrush and templates. Color was added as he explored a variety of media from 1983-1985. His move to Chicago confirmed another direction he had taken in his work. The work of Joseph Cornell (a construction and assemblage artist) was exhibited at the Art Institute; seeing it confirmed in him the inspiration to work in the three-dimensional medium, in which he had been experimenting for two years. For the past five years, he has worked with found objects, various appropriated materials, boxes and doors. The newest series consists of found objects placed inside of hollow, glass, human-size heads which are placed on found object stands or bases.

SNYDER, SHERWOOD III (Sculptor)
1960 N. Lincoln Park West, Chicago, IL 60614

Born: 1928 *Collections:* Standard Oil, IN *Exhibitions:* Union League 3-D Show, Chicago; Elizabeth Ferguson Gallery, IL *Education:* Western Michigan U.; U. of Oregon

Early work combined painting with artifacts, found objects, and architectural remnants. Influenced by the paintings of Georgia O'Keeffe and the later works of Louise Nevelson, the artist experimented with juxtaposing found and altered objects. As his personal experiences broadened with trips to Europe, Australia and the Orient, so did his range of materials. Brass pulls, push pins, springs, chessmen and wooden spools, fabric and styrofoam, plastic and aluminum, metal and wood may all be found in his work. Contrasting the multiplicity of materials is the simplicity of color: the works are either all black or all white.

SOESEMANN, PETRA (Sculptor, Quiltmaker)
1755 N. Wilmot, Chicago, IL 60647

Born: 1953 *Awards:* 1986 Fulbright Fellowship; 1984 & '85 Illinois Arts Council Grant *Collections:* Private *Exhibitions:* "Sculpture Chicago '85" Symposium; State of Illinois Gallery *Education:* School of the Art Institute of Chicago; Cleveland Institute of Art *Dealer:* Ruth Volid Gallery

An on-going fascination with the personal and sometimes eccentric visions expressed in "outsider" and folk art has influenced her approach to materials and images. Wood constructions of the last ten years often refer to furniture or clothing forms. *Drawing Table* is inlaid with curiously animated colored pencils, altered to curve and twist beyond the table surface; an architecturally-rendered shirt of plywood and linoleum becomes an *Old Flame*, singed with a branding iron. In her quilts, she departs from established patterns and techniques, yet pays homage to the history of the craft by incorporating unique interpretations of traditional designs. Using one of her quilts as a source, she transformed a design idea into an outdoor maze-like walkway with tile and glass embedded in cement echoing the patchwork. She remains involved with landscape-oriented sculpture.

SPECTOR, BUZZ (Installation Artist)
7002 N. Clark St., Chicago, IL 60626

Born: 1948 *Awards:* NEA & IL Arts Council Fellowships *Collections:* Art Institute of Chicago; Museum of Contemporary Art, Chicago *Exhibitions:* Art Institute of Chicago; Franklin Furnace, NYC *Education:* Southern Illinois U., Carbondale; U. of Chicago *Dealer:* Roy Boyd Gallery, Chicago

He is a conceptual artist who shuffles form and meaning. In *Double Readings*, his installation at Chicago's Randolph Street Gallery, he opposed a stairway made of over 4,500 books and a set of simple bookshelves containing every book in his personal library to a small book documenting the same exhibit. This book was also called *Double Readings*. In *History Lessons*, his collection of mixed-media collage, he illustrated the Modernist debt to Dutch genre painting by superimposing a series of rectangular color cue chips over a group of crudely rendered landscapes. Similarly he set common color postcards of the Dutch landscape into Mondrian-like color fields.

SPERO, NANCY (Painter)
530 La Guardia Place, New York, NY 10012

Born: 1926 *Exhibitions:* A.I.R Gallery, NYC; Institute of Contemporary Arts, London *Education:* Art Institute of Chicago; Ecoles des Beaux-Arts, Paris *Dealer:* MCA Gallery, Chicago

Through extended paper scroll-like bands running horizontally, across the wall, Spero explores rape, murder and political atrocities; victims and the tools of victimization. Early work includes over 100 harrowing war paintings created during the Viet Nam War. They contain graphic images; for example, phallic heads spitting blood or fire. The work *Codex Artau*, a staccato placement of images and quotations, is a compassionate tribute to Antonin Artaud and his spiritual anguish, from which Spero drew a parallel to the suffering of women in history. Since 1974, Spero's work has depicted the struggle of women in a male-dominated world. Figural and verbal fragments from media and other texts are compressed to form powerful montages exploring themes of patriarchy and sado-sexual oppression, childbirth, divorce, racism, rape, as well as women's grace and power.

SPINNER, RICHARD (Graphic Artist)
111 E. Chestnut, Chicago, IL 60611

Born: 1952 *Collections:* Aurter Wurtz, Time Life *Exhibitions:* Marshall Fields, Chicago; WGN-TV, Chicago *Education:* Chicago Academy of Fine Arts, Art Institute of Chicago

An exuberant graphic artist, Richard Spinner has developed his own technique using Letraset graphic

tapes and has published instructions for the technique which is designed particularly for work on illustration boards. In addition to his geometric tape designs, he sculpts and crafts designs for stained glass windows, the stained glass further demonstrating his interest in geometric composition. He continues to work as a graphic artist though he recently has produced a line of scarves.

SPONBERG, LARS-BIRGER (Painter)
1340 Berkley Ct., Deerfield, IL 60015

Born: 1919 *Collections:* Armour Company, Chicago; Hollister Corporation, Libertyville, IL *Exhibitions:* "Summer Place," North Park College, Chicago; Deerpath Gallery, Lake Forest, IL *Education:* School of the Art Institute of Chicago

He paints realistic landscapes in acrylic and oil on linen. Influenced by Richard Diebenkorn and Fairfield Porter, he works in a simple, direct style, rendering what he sees in a conceptual framework. His current series of paintings, "Summer Place," consists of strongly composed visions of landscapes on a summer evening. The works deal with solitude and longing, and they evoke a wistful, nostalgic feeling. His limited palette includes only nine colors: white and two each of blue, red, yellow, and earth tones. Work on the "Summer Place" series, the major paintings of his career, has occupied the last six years.

SPRAGUE, MARY (Painter)
6351 Pershing Ave., St. Louis, MO 63130

Born: 1934 *Awards:* Missouri Visual Arts Biennial Award; National Endowment for the Arts *Collections:* St. Louis Art Museum; Las Vegas Art Museum *Exhibitions:* Klein Gallery, Chicago; American Academy of Arts and Letters *Education:* Stanford U. *Dealer:* Eliot Smith Gallery, St. Louis

Her work consists of partially formed and sometimes abstracted images on paper, usually dealing with aspects of daily life in interior spaces. Although color is seductive and rich, it is used to elaborate on a foundation of light and dark values as the primary compositional concern. The drawings are washed, scraped, and rubbed to modify and temper light, which is employed to alter spaces and moods. Underscoring her use of light and value is a bold technique that emphasizes spiritedness of gesture and line. Bruce Guenther, curator of Contemporary Art at the Seattle Art Museum has said of her work, "...a rhapsody of bravado drawing...Sprague celebrates the act of making art drawing, painting and seeing--with her bold composition and dramatic extremes of light and dark."

STABILITO, JOE (Painter)
Joe Stabilito abandoned the abstract painting style in favor of highly individual renderings of medieval imagery. Crosses, rings, sinister towers and volcanoes often emerge in the background and surround Dali-like elements such as disembodied eyeballs or blood vessels. Stabilito isolates each item, rendering it tightly, ignoring scale. The paintings are scored and pitted to affect age and to enhance the antique, medieval religious quality.

STANLEY, ROBERT (Painter)
312 E. Golf Road, Des Plaines, IL 60016

Born: 1942 *Awards:* Award of Merit, International All Paper *Collections:* Art in Embassies, U.S. State Department; Penn Johnson, Minneapolis; *Exhibitions:* Joy Horwich Gallery, Chicago; Germanow Gallery, Rochester, NY *Education:* Pratt Institute, New York *Dealer:* Joy Horwich Gallery, Chicago

His early works in the 1960s were dark and figurative, with an oriental overtone suggestive of the work of Al Reinhart. He now works both on canvas and with computers, exhibiting cibachrome prints of his computer art. The relationships between images are repeated in borders and connected by geometric forms. Recently, he has used high-key, intense color, glazed and brushed in, to create simplicity and richness--the inspiration for which work derives from the music of Philip Glass. The forms are related in an attempt to discover the unities of existence, expressed in full harmony. Main fields represent the edge of perception. Borders within the edges set off realities beyond usual perception, separating the physical from the personal world.

STAPLES, CYNTHIA K. (Painter)
2922 W. Palmer, Chicago, IL 60647

Born: 1944 *Collections:* Kemper Collection, Chicago *Exhibitions:* Joseph Gross Gallery, Tucson; ARC Gallery, Chicago *Education:* Pratt Institute, Brooklyn *Dealer:* Suzanne Brown, Chicago

Combining the real with the imaginary, her paintings deal with how we construct meaning from our perceptions and expectations. She has been influenced by the Surrealists and by the principles of theatrical set and scene design. These paintings are executed in oil using traditional underpainting and glazing techniques. She also creates realistic still lifes in pastels.

STARN TWINS (Mixed Media Artists)
Exhibitions: Museum of Contemporary Art, Chicago

These artists are twin brothers who use pieces of photographs in collaborative works that relate closely to sculpture and painting. Photographic conventions are broken by creased and scarred prints, push-pinned or taped into place. The images are often out of focus. Surrounding them are incomplete frames and glass-like fragments serving neither a decorative nor a protective purpose. Although broken conventions are not new to the photography world, the Starns' unique pieces have become hot commodities to art collectors who make little profit from duplicative contemporary photographs.

STARZL, DEBORAH (Painter)
5019 Lawn Ave., Western Springs, IL 60558

Born: 1951 *Awards:* Cash Award, New Horizons in Art, Chicago Cultural Center; Cash Award, Chicago Botanic Gardens, Glencoe, IL *Exhibitions:* Springfield (IL) Art Museum; New Horizons in Art, Chicago Cultural Center *Education:* School of the Art Institute of Chicago; U. of Indiana

During her academic training, she felt a natural affinity for the works of Francis Bacon and for color theory in

general, especially that of Larry Poon. In 1981 she became interested in Roman bust portraiture. Her renderings of heads and busts are convincing portrayals coaxed from a visible substructure of tangled lines and shifting planes. Her current large oil paintings and small gouache works exhibit her ruthless emphasis on intense color juxtaposition. In the final amalgam of this work, she depicts the inmates of the common psyche being blown, along with their residue and accoutrements, across a modulated color field.

STEELE, JEFF (Sculptor)
P.O. Box 1104, Libertyville, IL

Born: 1954 *Collections:* Northbrook, IL; *Exhibitions:* Art Institute of Chicago; C.D. Peacock Jewelers, Chicago *Dealer:* It's A Small World, Winnetka, IL

Since childhood, he has created one-of-a-kind "Lilliputian-styled existences." He has also painted surreal watercolors. He now merges both interests to create three-dimensional realistic watercolor interiors. Using paper, paint, wood, fabric, and any other useful items, he painstakingly hand-details the ceilings, floors, walls, and personalized furnishings and accessories. Subjects have included 18th-century tobacco shops, a dollhouse workshop, a marionette studio, and a bookshop with 300 tiny handmade books. He has been interested in the work of Eugene Kupjack and in the Thorne Rooms of the Art Institute of Chicago, and inspired by Walt Disney, Norman Rockwell, David Bower, and Erte.

STEINBACH, HAIM (Sculptor)

Born: 1944 *Awards:* McDowell Fellowship; Yaddo Fellowship *Exhibitions:* Concord Gallery, NYC; Lamagna Gallery, NYC *Education:* Pratt Institute, NYC; Yale U. *Dealer:* R.Hoffman Gallery, Chicago

Haim Steinbach's sculpture deals with consumerist American culture. He has shown himself to be poetic and daring in his presentation of cultural clichés. One of Steinbach's pieces displays pre-Christian clay pots on wedge-shaped ledges juxtaposed with three modern cups--one shaped like a breast, two others with silly slogans written on them. The piece is an effective allusion to the evolution from hand-crafted beauty to machine-made kitsch. Steinbach also collects towels, pots, tea kettles, trash receptacles and corn flakes, placing these banal, modern items next to high-kitsch blue lava lamps and horror masks. Steinbach is becoming known as an intelligent experimenter within modern consumerist art.

STEINBERG, RUBIN (Painter)
3127 Jerome, Chicago, IL 60645

Born: 1934 *Awards:* Municipal Art League Award, Chicago; 1st Place, Hyde Park Art Center, Chicago *Collections:* Southern OH Museum, Portsmouth; IL State Museum, Springfield *Exhibitions:* Museum of Science and Industry, Chicago; Art Institute of Chicago *Education:* School of the Art Institute of Chicago; Illinois Institute of Technology, Chicago

Straddling the line between painting and sculpture, he creates three-dimensional work reminiscent of Dada, Max Ernst, and Jackson Pollock by pulling leather and rope through his canvas, printing on it with a variety of

techniques, and gluing found objects to its surface. His textures, complexity of composition, and richness of surface evoke the magical contours of distant unexplored planets. Painted metal bits from old machines collide with toys and glue embossings to create a repetitive rhythm that constantly articulates and rearticulates the surface of his work. In recent years a growing use of color has added an evocative mood-provoking quality to his work.

STELLA, FRANK (Painter)
17 Jones St., New York NY 10013

Born: 1936 *Awards:* First Prize, International Biennial Exhibition of Paintings, Tokyo *Collections:* Albright-Knox Gallery, Buffalo; Art Institute of Chicago *Exhibitions:* Museum of Modern Art; Whitney Museum *Education:* Phillips Academy, Andover, MA; Princeton U. *Dealer:* M. Knoedler & Co., NYC; Lever/Meyerson Galleries, LTD., NYC

Work of the late 1950s was characterized by a series of black stripe paintings in which painted bands alternated with unprimed canvas. To eliminate three-dimensional references, the stripes were extended from the flat picture surface to the edge of the canvas. He then moved to metallic aluminum paints and shaped canvases to avoid illusionistic spatial effects. These massive canvases were followed by similar series, using stripes of color outlined in white, and later, zigzags, arcs and other shapes in fluorescent polychrome. In the 1970s he still employed flat, synthetic hues on large canvases, but the idea of structure had become more complex. Colors change value as one's eyes move across the paintings, the shapes and colors interacting in a constant state of flux. His work changed dramatically in the late 1970s. Becoming more expressionistic in style, he applied himself to three-dimensional relief constructions.

STERLING, JOSEPH (Photographer)
2216 N. Cleveland Ave., Chicago, IL 60614

Born: 1936 *Collections:* Museum of Modern Art, NYC; Art Institute of Chicago *Exhibitions:* International Museum of Photography at George Eastman House, Rochester, NY; Hallmark Collection, Kansas City *Education:* Institute of Design, Illinois Institute of Technology *Dealer:* Houk Gallery, Chicago

He studied documentary photography with Harry Callahan, Aaron Siskind, and Frederick Sommer at The Illinois Institute of Technology's Institute of Design. He then became interested in the distortion of images through multiple-motion techniques which involved both camera and lens. In his recent work he has explored negative images, panoramic views looking straight down, the combinations of various forms and images, and the use of unphotographic negatives.

STEVENS, PEGGY (Photographer)
5739 S. Maryland, Chicago, IL 60637

Born: 1939 *Awards:* Associate of the Photographic Society of America; Gold Medal, Best General Nature Print, C.A.C.C.A. International Salon *Collections:* Chicago Historical Society; Adler Planetarium, Chicago *Education:* U. of Chicago; Art Institute of Chicago *Dealer:* Artisans 21 Gallery, Chicago

Lars-Birger Sponberg, *Wicker Chair in Corner,* 40 x 44, oil. Courtesy: Art Schaefer

Robert Stanley, *Chaos. Cosmos,* 8 x10, computer (cibachrome print)

She developed her photographic skills in camera club competitions. In 1965 she began making slides, but it wasn't until 1976 that she began printing seriously in both color and monochrome. She uses experimental techniques of posterization, solarization, and black light to create striking images. As a member of Artisans 21 Gallery in Chicago, she exhibits both abstract photographs with strong patterns and vivid color, and pictorial series such as "America the Beautiful" and "Wildflowers of the Chicago Area." She has lectured extensively on photographic topics, has been president of the Chicago Area Camera Clubs Association (1987-1988), and is currently teaching Wildflower Photography at DePaul University, Chicago.

STEVENS, SUE (Painter)
1344 W. Lunt, Chicago, IL 60626

Awards: Renaissance Society, Bergman Gallery, Chicago; *Collections:* Dave's Italian Kitchen *Exhibitions:* Dittmar Memorial Gallery, Northwestern U.; Nicholas Korkantzis Sculpture Studio, NY *Education:* American Academy of Art; Northwestern U.

Influenced by the Impressionists as well as by the German expressionists, she initially did portrait sculpture before moving on to life drawings and portrait paintings. Her work is characterized by a lavish use of paint and the combination of abstract backgrounds with realistic subjects. In addition to her work in sculpture and painting, she created the set for the Chicago Opera Repertory Theater's production of Cimarosa's *The Secret Marriage.* Minimal in style, the set consisted of a single room painted in a manner similar to that of Matisse.

STEVIC, VLADAN (Painter)
2270 N. Lincoln Ave., Chicago, IL 60614

Born: 1949 *Exhibitions:* Cabaret Metro, Chicago; Paradise Club, Chicago; Ascot Realty, Chicago; *Education:* Architectural U. of Belgrade

His influences include Victor Vasarely, Symbolic art work, Surrealist philosophy, the Far East, and Devotional Buddhism. He works with acrylic and airbrush on canvas, and his thoroughly contemporary paintings have a slightly mystical feel to them. He mixes futuristic design and religious imagery in order to make the connection between outer space and Earth. One of his themes is the sophistication man acquires by looking outward and attempting to make progress inward. He has been commissioned to paint Chicago's skyline.

STOCKWELL, CONSTANCE (Painter)
2926 California St. NE, Minneapolis, MN 55418

Born: 1952 *Awards:* Mentor/Protege Honorarium, W.A.R.M. Gallery, Minneapolis *Collections:* Ternes Corporation; Isika & Associates International *Exhibitions:* Augsburg College, Minneapolis; Museum of Church History and Art, Salt Lake City, UT *Education:* Minneapolis College of Art & Design; Minnesota Museum of Art

Claiming as her two major influences Paul Cezanne and Joaquin Sorolla for their exceptional use of warm and cool color, the artist began painting in both oil on canvas and acrylic/mixed media on paper. Landscapes of austere subtlety are derived from the vistas of Utah's canyons and Redrock country. The spiritualization of nature is explored through a painterly-realist style encompassing strife, opposition, and balanced harmony of forms. Figures and animals frequently populate the landscapes, situated beneath apocalyptic skies. Shapes and planes of reflected light and color are interwoven in the layered brushwork of the dramatic narratives.

STONE, MICHELLE (Painter)
1354 W. Touhy, Chicago, IL 60626

Born: 1951 *Exhibitions:* Struve Gallery, Chicago; L'aire Du Verseau, Paris *Education:* School of the Art Institute of Chicago *Dealer:* Struve Gallery, Chicago

Figurative works are cut up and reformed into relief constructions that function as visual analogs and as commentary on the fragmentary quality of human experience. Early abstract expressionist influences were followed by an interest in the human figure. The relief constructions progressed from wall reliefs to works with an increased emphasis on sculptural form, and thematically, to an emphasis on relationships.

STONEHOUSE, FRED (Painter)
3347 N. 38th St., Milwaukee, WI 53216

Born: 1960 *Collections:* Milwaukee Art Museum; Lubar Collection *Exhibitions:* Alternative Museum, NYC; Milwaukee Art Museum *Education:* U. of Wisconsin, Milwaukee *Dealers:* Center for Contemporary Art, Chicago; Michael Lord Gallery, Milwaukee

After leaving the University of Wisconsin at Madison, he began discovering new influences. He looked at old cartoons, primitive and Outsider Art, Mexican and American folk art, and the works of Frida Kahlo, Bosch, Ensor, Giotto, Phillip Guston, and others. Eventually he began synthesizing different parts of all of these into a personal style, developing his current images of strange, silent, highly emotional figures who make the best of their limited situations.

STRADFORD-GRANT, LESLEE (Painter)
5436 S. Ingleside, Chicago, IL 60615

Born: 1950 *Collections:* City of Chicago Permanent Collection; Hampton Institute *Exhibitions:* American Language Center, Casablanca; Museum of Modern Art, Bahia, Brazil *Education:* School of the Art Institute of Chicago; Illinois State U.

Influenced by the Impressionists, African art, and textile design, she began creating stain paintings with natural dyes using squeeze bottles, sponges, rollers, and found implements. After living in North Africa, she started incorporating object patterns as well as calligraphy. Painting on unstretched, unprimed canvas, she has developed a lyric, abstract expressionist style. She embellishes her paintings with appliquéd designs of Early American clothing patterns and tool designs. Her acrylic palette often consists of muted browns, greens, and blues, with only sporadic moments of bright color. Using string, sequins, and found objects to add texture to the surface of the canvas, she has been able to create the illusion of depth, as well as the appearance of space.

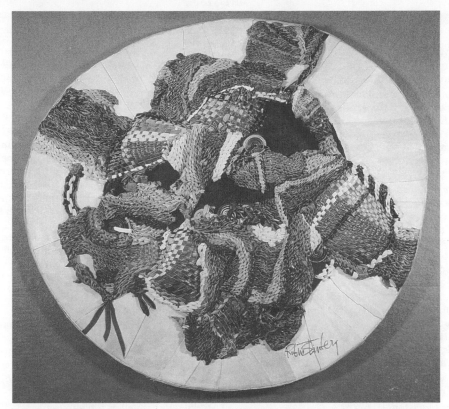

Rubin Steinberg, *untitled,* 24 x 36, leather and suede collage

Vladan Stevic, *In a Search for Devotion,* 36 x 48, acrylic, airbrush

STRATHMAN-BECKER, RANDY
(Printmaker)
Box 504, Struble, IA 51057

Born: 1953 *Awards:* 1st Place in Printmaking, Art Quest; Yaddo Fellow *Collections:* Yaddo Corporate Collection *Exhibitions:* Peace Museum; Chicago Center for the Print *Education:* Southern Illinois U., Carbondale *Dealer:* Chicago, Center for the Print

Influenced by the narrative forms of Northern European Renaissance paintings and illuminated manuscripts, he has been developing a pictorial form that incorporates both image and text. Early prints, both from color woodcuts and intaglio etchings, are narrative in nature, though their expressionistic qualities make them more than mere illustrations of events. He continues to consult Northern Renaissance painting and is currently concentrating in woodcuts; however, the content has become affected by the satire of Warrington Colescott, and by the early 20th-century German publication *Simplicissimus* and the contributions to that magazine by expressionist artists Kathe Kollwitz, Otto Dix, and Bruno Paul. Consequently, the recent work, though narrative, is more humorous. He has also created a series of historically-based prints, in addition to his satiric work.

STRUVE, GAIL REINHOLTZEN (Sculptor)
1210 Forest, Evanston, IL 60202

Born: 1935 *Exhibitions:* Evanston Art Center, IL; Evanston City Hall *Education:* Cleveland Institute of Art; Northwestern U.

Though she has studied at a number of institutions, her training has not been highly formal. From the 1950s and through the 1960s, she painted in oil on canvas. Gradually she switched to sculpture, with Picasso and the Primitive influencing her most. Of late, she has been working in clay and casting in concrete. She also spends time drawing, creating strong-lined abstract figures (her sculpture also abstracts the figure). At this point, she says that everything she does and sees influences her work, which includes teaching sculpture.

STUART, CAROLYN (Painter, Jeweler)
J.W. McCormack Station, Box 4537, Boston, MA 02101

Born: 1960 *Exhibitions:* Art Institute of Chicago; Quadrum Gallery, Chestnut Hill, MA *Education:* Massachusetts College of Art, Boston

She has studied art since the age of nine, her early influences including a broad range of artists and time periods, from Rembrandt to Van Gogh, Michelangelo to Pollack, Egyptian and primitive cave painting to color field and other abstract painting. Her own work is abstract and is known for its visionary content. Whether done with oil on wood or charcoal or with pastel on paper, her works are marked by their brilliant colors. The jewelry as well presents mystical, abstract images rich in color. In both media, the raw subject matter of her work often comes to her in "vision form" or in geometric symbols, to which she adds familiar forms to create a point of reference.

SULLIVAN, BRIAN J. (Sculptor)
1418 W. Division, Chicago, IL 60622

Born: 1958 *Collections:* Admiral Tool Company, Chicago; Wax Museum, Nashville *Exhibitions:* Beverly Art Center, Chicago; Michael Karolyi Memorial Foundation, Vence, France *Education:* U. of Wisconsin, Milwaukee; U. of Illinois, Urbana

The works of artists Louise Nevelson, David Smith, Julio Gonzales, Joseph Cornell, John Chamberlain, and Nancy Graves have had the greatest impact on this sculptor. Trained as a metalsmith/designer, he quickly moved into mixed media and steel, where he found a greater freedom of expression. His desire is not to make pretty objects but statements that provoke and challenge. In particular, he is concerned with the issues of stewardship of the world. Using found steel parts, weapons, and assorted bits of hardware, he creates "objects of war." Often painted with a bright, somewhat whimsical palette, his works often reveal an explicit irony between what one sees and what is meant.

SULLIVAN, JACK (Printmaker)
202 S. Paint St., Chillicothe, OH 45601

Born: 1935 *Collections:* Cincinnati Insurance Company; Eastway Corporation *Exhibitions:* Cumming Gallery, Erie, PA; Water Tower Art Show, Chicago *Education:* U. of Chicago; Wright State U. *Dealers:* Spirit Gallery, Columbus, OH; Catherine Starr, Philadelphia

Originally trained as a photographer, he incorporates photographic images into his serigraphs. His principal subjects have been the human figure and nature. His interest in juxtaposing the figure and nature, as well as his interests in Classical mythology and Renaissance and Baroque art have led to his "Mythological Series," an open-ended series of multicolored serigraphs in which he uses figures and fantasy landscapes to create personal visual interpretations of Classical Greek and Roman myths in a twentieth-century context. He uses as few as one or as many as sixty screens for each of his multicolored, hand-pulled images.

SULLIVAN, JACKIE (Painter)
#5, The Landmark, Northfield, IL 60093

Born: 1920 *Collections:* Borg-Warner; McDonald's *Exhibitions:* Illinois Invitational, Illinois State Museum, Springfield; Bernal Gallery, Chicago *Education:* De Pauw U.; School of the Art Institute of Chicago *Dealer:* Neville-Sargent Gallery, Chicago

Always influenced by Monet's colors and Turner's sense of atmosphere, she has more recently been interested in Rothko, Olivera, and the Luminists. Her first oils came directly from models or sites. Gradually she shifted to watercolors and began painting from memory, abstracting and distilling her personal experiences. Her "Hiatus" series evolved from a memory of sea walls in England and of similar structures in the south of France. She builds a tactile, shifting, abstract sense of place and time by layering paint on the canvas. She dissolves form with light and color to express an "essence" or "abstraction of memory." She currently paints with oil on large canvases or paper.

SULLIVAN, JANET (Painter)
695 N. 400 E., Valparaiso, IN 46383

Constance Stockwell, *Heaven's Tryst,* 54 x 40, oils

Bruce Thayer, *Sight-Unscene,* 45 x 44, mixed media on paper. Courtesy:
Zaks Gallery of Chicago

Born: 1921 *Awards:* Salon Show, Northern Indiana Art Association; Southern Shores Show *Exhibitions:* Purdue University North Central *Education:* U. of Illinois; Illinois Institute of Technology Institute of Design *Dealer:* The Art Barn Gallery, Valparaiso, IN

Influenced by the Impressionists, especially the works of Monet, she specializes in floral and landscape painting. Her work is also marked by the frequent use of windows and period furniture as part of the composition. Currently she is working on large flowers in oil, having just returned from California where she did watercolors of the coast, mountains, and water. Influenced by German Expressionist Oscar Kokoschka, she often does away with local color, using color instead as a means of expressing emotion. Her colors compete by acting and reacting with one another, and in this sense her paintings are given energy through contradiction.

SULLIVAN, JANICE (Fiber Artist)
4166 S. 20th St., San Francisco, CA 94114

Born: 1952 *Awards:* City of Hayward Award, Forum for the Arts *Collections:* Clark Metals, Hayward, CA; Hanson and Norris Law Firm, San Mateo, CA *Exhibitions:* Downey Museum of Art, Downey, CA; Del Mano Gallery, Los Angeles, CA *Education:* Massachusetts College of Arts; Boston U.

Combining formal training and non-traditional experimentation in her education, she has carried these themes into spatial orientation of the tapestry. Ambiguous in historical context, the fabrics are vehicles that transport the viewer through time as artifacts of an ancient age or remnants of a future generation not yet discovered.

SULTAN, DONALD (Painter)

Born: 1951 *Collections:* Art Institute of Chicago; The Metropolitan Art Museum, NYC *Exhibitions:* Blum Helman Gallery, NYC; Name Gallery, Chicago *Education:* University of N. Carolina; School of the Art Institute, Chicago *Dealer:* Samuel Stein Fine Arts, Chicago

Two groups of paintings stand out in Donald Sultan's collection. In one group, simple geometric shapes are abstracted from complex real-world objects and emboldened by pulsating color. The images often take on more than one meaning. A large lemon becomes an eyesocket or a female breast and nipple. Smokestacks with tubular chimneys emitting colored smoke become *Industrial Flowers*. Another group of paintings, inspired by industrial catastrophes, rely less on color and more on rhythmic arrangements of light and dark patches or lines, reminiscent of Jackson Pollack. For many of Sultan's pieces, four-foot square units made of stretcher bars, plywood, masonite and vinyl tiles form the backing upon which butyl rubber is applied to form a distinctive, matte black surface. When color is applied, a rich mixture of opposing forces results.

SUMMERS, CAROL (Printmaker)
133 Prospect Ct., Santa Cruz, CA 95065

Born: 1925 *Awards:* Louis C. Tiffany Foundation Fellowships; Fellowship, John Simon Guggenheim Memorial Foundation *Collections:* Metropolitan Museum of Art, NYC; Corcoran Gallery of Art *Exhibitions:* Museum of Modern Art, NYC; Brooklyn Museum *Education:* Bard College *Dealer:* Fendrick Gallery, Washington, DC; Associated American Artists, NYC & Philadelphia

Early woodcuts feature abstract biomorphic shapes. After 1958, preliminary rough sketches in ink and brayer were applied to paper before the final print was made. During the 1960s images of domestic life in cubist space were more recognizable such as in the piece *Bon Appetit*. The artist is known for simplified landscapes and mountainscapes, often each peak a different color. Sometimes color is printed on the back of the paper for the desired coloristic effect. Recent large and simple landscapes are multi-colored, each element saturated with color. Some of these woodcuts are executed in a technique similar to rubbings.

SUNDBY, MEL R. (Sculptor)
19675 Forest Blvd., Forest Lake, MN 55025

Born: 1940 *Awards:* Best of Show Awards, Bayfield, Oshkosh, Duluth *Collections:* Circus World Museum *Exhibitions:* Unicorn Gallery, Minneapolis; Vorpal Gallery, Chicago

After formal training with Belgian sculptor Oliver Stebelle, he taught at the college level and opened his own casting studio, where he has developed a unique portrait sculpture and glazing method using the Raku firing technique. Starting with a clay slab, he sculpts either lyrical or historical portraits. The Raku glazing then produces a variety of coppers, greens, and grays in the piece. Influenced by the romantic classicists, he chooses the human figure as subject, seeking always to render the poetic nature of the self and to convey the inside of a person by depicting the outside.

SUNWARD, JUSTIN HUGO (Painter)
6054 N. Hermitage, Chicago, IL 60660

Born: 1939 *Awards:* Nepenthe Mundi Society *Collections:* Private *Exhibitions:* Gilman/Gruen Gallery, Chicago; Guild Gallery, Baton Rouge, LA *Education:* School of the Art Institute of Chicago

In his early work he specialized in large figurative murals for public and private clients. After extensive study and exploration of color, he conceived the idea that color, removed from all its preconceived meanings, could convey a metaphysical meaning. His "Color Symphonies" were at first highly meditative, but now represent both the inner and outer universe. These thickly painted oils on canvas are characterized by scores of shades and jewel-like colors in fine, complex patterns which never repeat. "When finally viewed up close, an entire universe in miniature opens up and the surface of the canvas can be scanned and almost read."

SURDO, BRUNO (Painter)
101 Ambleside, Des Plaines, IL 60016

Born: 1963 *Collections:* Northrop Art Museum, Minneapolis *Exhibitions:* Palette and Chisel Academy *Education:* American Academy of Art, Chicago; Atelier Lack, Minneapolis

Using a strong background in traditional techniques, his work applies the approach of Old Masters to contemporary subject matter. Exploring compositions within these techniques, the work is naturalistic and formal, with strong emotional colors. Figures--including a recently begun series of nudes on subways--and still lifes make up his primary subject matter. He has developed a technique that includes strong underpainting while utilizing layers of oil paint to create illusionary optical color effects within a strong preliminary drawing. Of key importance in the work is a sense of space within the painting, reaching out toward the viewer and including him. This is achieved through his handling of line, value, and color.

SWAN, NANCY B. (Painter)
37714 Valley Rd., Oconomowoc, WI

Born: 1930 *Awards:* 1st in Watercolor, 2nd in Graphics Wisconsin Regional Art Show; 3rd in Oil, Tri-County Art Association Fair, Waukesha, WI *Exhibitions:* The Fredricks Gallery, Wauwatosa, WI; The Theatre, Delafield, WI *Education:* U. of Wisconsin, Milwaukee

Largely self-taught, and influenced by Picasso's early work, she began by painting non-objective, coloristic abstractions. Severe personal setbacks have inhibited her progress, but a personal catharsis has led her to a "mystic/impressionistic" representational style. Although she has experimented with many different media and styles, including palette knife, etching, ink, ink wash, block print, and oil painting on masonite, she mainly paints with watercolors on large pieces of illustration board (up to 4 x 6 feet). She has adopted a spartan simplicity and is presently painting in a spare, hard-edged, light-filled impressionistic style.

TAAFFE, PHILIP (Painter)

Philip Taaffe's paintings are reconstructions of other abstract paintings, as well as originals which pretend to be copies. He questions old concepts and adds new meaning in the process. His major gift lies in his ability to reinterpret Op art. Bridget Riley's *Mangrov,* for example, is transformed from wavy patterns to an exotic, rippling gold surface. Taaffe uses dizzying parallel waves and interconnected triangles, but he softens Op and breathes new life into it. He also establishes a sense of art-historical connectedness with his paintings that Op art never accomplished. A mixture of printmaking, collage and painting produce his effects.

TAGLIENTI, JOSIE (Painter)
2145 N. Dayton, Chicago, IL 60614

Born: 1943 *Collections:* Collins, Miller, Hutchins; Raymond Kujanen *Exhibitions:* Lithow's, Chicago; Natalini Gallery, Chicago *Education:* U. of Guanatjuato *Dealer:* Natalini, Chicago

While her academic training in drawing provides a basis for her thought processes, over the years her work has continued to explore the bounds of abstract expressionism, including experiments with dye on fabric. Study in Mexico introduced her to issues of mythology and spirituality which brought her to begin to experiment with the human form in her intensely colored paintings. Recent years have found her obsessed with images of wings and flight as a way to the subject of

death and what lies beyond it. She has developed her own technique, rubbing chalk dust into mulberry paper, polishing the surface with her palms, then introducing more colored dust, adding water and turpentine and beginning again, before introducing the figurative. The series *Flight,* rich in orange, pink, yellow and magenta, considers flying from the bird's point of view as a way to capture the sense of movement, though she considers the pieces "metaphysical abstractions."

TASHJIAN, BERJ (Architectural Drawer)
1245 Briarwood Ln., Northbrook, IL 60062

Born: 1910 *Awards:* Freehand Life Drawing, MIT; Design Award, St. Vartan's Church of the Armenian Diocese, NYC *Exhibitions:* Figurative Art League, Evanston, IL; North Shore Art League, Winnetka, IL *Education:* Massachusetts Inst. of Tech.; Harvard U.

Employed as an architect throughout his career, he is the recipient of numerous design awards. His other activities in a broad range of the arts include poetry, opera singing, and figurative painting. His portraits have been described as being highly original in execution: arresting facial expressions are articulated in unusual colors. In the 1980s, he formed the Muzart Christmas card design company.

THATCHER, GREG (Painter, Papermaker)
c/o I.C.A., 607 W. Broadway, Fairfield, IA 52556

Born: 1949 *Awards:* Canadian Ministry of Youth Culture and Athletics Grant *Collections:* Fidelity, Boston *Exhibitions:* San Francisco Museum of Modern Art; Van Straaten Gallery, Chicago *Dealer:* Prism Gallery, Evanston, IL; Van Straaten Gallery, Chicago

In graduate school, he built up large abstract landscape images through thick expressive acrylic underpainting, then refined a deep pictorial space through spray, squeegee, and brush work. Throughout his career he has continued to explore pictorial space, now also working in three dimensions. In a series of large-scale handmade paper pieces, he dealt with the underwater themes of his snorkeling expedition to Mexico. In these works, cast paper fish, seaweed, collage areas, and paper elements extend up to 1 1/2 feet from the wall. In his current tropical garden series of mixed media paintings and monotypes, he uses exotic rice papers, gold leaf, and intense colors to create luminous, richly textured images of pools, palm trees, and gardens.

THAYER, BRUCE (Painter)
1515 Kelly Rd., Mason MI 48854

Born: 1952 *Awards:* 1988 Michigan Council for the Arts Grant *Collections:* Rutgers State U. of New Jersey; Northern Illinois U. *Exhibitions:* Urgent Messages, Chicago Cultural Center; *Signs, Times, Writings from the Wall,* Detroit Institute of Art *Education:* School of the Art Institute of Chicago; Central Michigan U. *Dealer:* Zaks Gallery, Chicago

Cartoon-like cutouts reflecting the influence of Balinese puppets populate the watercolor and mixed media collages of this satirical artist. Modern day heiroglyphs incorporate words and images in a series depicting *Disasters of Industry,* which is based on historical and current events and myths. Combining

humor, child-like writing, and obsessive detail with biting social commentary, the pieces are intended to mirror the insanity of present day society. Originally working with single images and titles in oil on burlap, current work combines brightly-colored watercolor collages and drawings with industrial themes in multi-level panoramas.

THOMAS, LARRY (Painter, Printmaker)
528 Lincoln Ave., Lincoln, IL 62656

Born: 1950 *Awards:* Selected by Illinois Consortium for International Studies to teach in London, England; Chairman's Grant, Illinois Arts Council *Collections:* Chicago Title and Trust Company, Chicago; R.G.Ray Corporation, Chicago *Exhibitions:* Millikin University, Decatur, IL; Lincoln College, Lincoln, IL *Education:* Southwest Missouri State U.; U. of Iowa *Dealer:* Mary Bell Gallery, Chicago; Harleen and Allen, San Francisco

He trained as a printmaker with Maurice Lasansky and Keith Achepol, and as a painter with Byron Burford. Kandinsky, Gorky and de Kooning have all influenced him. In recent years he has continued to work in abstraction, using his immediate surroundings and the Midwestern landscape as subjects. Rather than viewing the trees, clouds, barns, houses, and people as mere objects, he uses them symbolically to represent fertility, masculinity, femininity, struggle, serenity and other themes. In these works he combines jagged edges with hard edges, rough scrubbed textures with smooth airbrushed textures, and biomorphic forms with geometric shapes. Such combinations are an attempt to bring opposites together in one cohesive design.

THORN, BRUCE (Painter)
1579 N. Milwaukee Ave., #316, Chicago, IL 60622

Born: 1952 *Education:* School of the Art Institute of Chicago; U. of Illinois, Chicago *Dealer:* Zaks Gallery, Chicago

Before his formal education, the artist worked for two years in the Ivory Coast, where he became influenced by West African, Egyptian, and Tantric art. These influences and a lasting interest in Sufi philosophy combine to produce paintings simultaneously mystic, creative, playful, and serious. Employing traditional methods of glazing in oil on canvas, wood, and glass, the pieces mix reality and fantasy in a bright and full spectrum of colors. The narration generally involves figures and landscapes and is intended to inspire, heal, and spiritually uplift the viewer.

THORNTON, SUE (Painter, Collagist)
3414 E. 2nd St. #3, Tucson, AZ 85716

Born: 1959 *Exhibitions:* Missouri Gallery, Chicago; Contemporary Art Workshop, Chicago *Education:* School of the Art Institute of Chicago *Dealer:* Missouri Gallery, Chicago

With a background in printmaking and photography, she reveals her processes, and manipulates readily understood imagery until it becomes ambiguous. She layers obscure, recognizable forms, abstract images and marks, while allowing her early drawings beneath the surface to remain visible. Sometimes she incorporates

photos and found objects. The clarity and suggestiveness of her colors are vital to her, as she wants them to convey as much meaning as her imagery does. She paints these 20 x 30-inch works with a translucent wax medium. Her subjects have included "Chicago Urban Landscapes" and "Arizona Landscapes."

THREADGILL, LINDA (Sculptor, Jeweler)
1913 Beulah Lane, East Troy, WI 53120

Born: 1947 *Awards:* NEA Fellowship; Outstanding Research Award, U. of Wisconsin, Whitewater *Collections:* American Craft Museum, NYC; Lannan Foundation, Palm Beach, FL *Exhibitions:* Esther Saks Gallery, Chicago; American Craft Museum *Education:* Tyler School of Art, Philadelphia; U. of Georgia, Athens *Dealer:* Esther Saks Gallery

Displaying a fascination with both pattern and texture, her sculpture and jewelery are highly crafted--the nonferrous and precious metals textured through a photoetching process prior to fabrication. The images are both representational and abstract, signifying things precious and cherished, treasured and prized. Her interest in jewelry lies in its personal involvement with the wearer, the intimate scale, and the challenge of the considerations of wearability. In *Pairs*, two bronze pears are held in a footed silver vessel. The linear, etched surface of the bowl contributes to the impression of great depth. Although at first glance the piece appears unwearable, it is actually not very deep and quite wearable. Both her jewelry and her freestanding sculpture are characterized by faultless surfaces and meticulous construction.

TORLUEMKE, THOMAS J. (Painter)
1801 W. Erie, Chicago, IL 60622

Born: 1959 *Awards:* Certificate of Excellence, North Coast College Society, OH; Certificate of Excellence, Metro Art International, NY *Collections:* State of Illinois Building, Governors Office; Amoco Corporation *Exhibitions:* Metro Art International, NY; Steiner Gallery, Chicago *Education:* American Academy of Art *Dealer:* R.H. Love Galleries, Chicago

In 1986, he departed from the traditional methods of painting to begin a series of abstract watercolors based on ultrasound film. The pieces use crayon and watercolors to produce a lucid overlay and create a mix of boldly-colored abstract and representational forms. From this series, he began to explore pattern--working with oil and using ordinary subjects, but paying more attention to the detailing pattern. A body of miniature watercolors represents the pinnacle of his ideas concerning pattern, detail, and color. With that series completed, he began grappling with moral and religious issues in his work. These latter pieces, done on paper of various sizes and shapes with tempera paint, are less figurative and are based on an overlay of pattern, using a number of repeated symbols to address his new concerns.

TORN, JERRY (Draughtsperson)
1318 W. Cornelia, Chicago, IL 60657

Born: 1933 *Collections:* Art Institute of Chicago; Virginia Museum of Fine Arts, Richmond *Exhibitions:* Fairweather Hardin Gallery, Chicago; Cafe Jasper,

Bruce Thorn, *What a Myth,* 14 x 65, oil and enamel on wood

Tom Torluemke, *Ashes to Ashes,* 22 x 30, tempera with acrylic emulsion. Courtesy: Naldo Coelho-American Academy of Art

Chicago *Education:* U. of Iowa *Dealer:* Space 900, Chicago

Inspired by the pleasure that dance gives people as well as expressive possibilities found in dancers both in motion and at rest, the artist has, for several years, chosen male dancers as the subjects of his finely detailed, reductive drawings. Done in graphite and colored pencils on a variety of toned papers, the drawings typically focus on a particular gesture or movement found during observation of rehearsals and informal posing of Chicago-based professional dancers. First interested in figurative and portrait work while studying with Maurico Lasansky, the artist has, since 1982, loosened his drawing style, now contrasting detailed elements such as heads and shoulders with more suggestive indications of the rest of the body.

TOWNER, NAOMI WHITING (Fiber Artist)
610 E. Taylor St., Bloomington, IL 61701

Born: 1940 *Awards:* Textron Fellowship 1962-3 *Collections:* Illinois State Museum; Eureka College *Exhibitions:* Museum of Contemporary Crafts, New York; Northern Illinois University Gallery, Chicago *Education:* Rochester Inst. of Technology; Rhode Island School of Design *Dealer:* Ellen Sorenson, Chicago

Greatly influenced by post-World War II artists who explored the essence of landscape, the artist's wall hangings become rich and varied planes with constantly shifting illusions of light, surface, texture, and reflections. The loom-controlled pieces employ a wide variety of weave structures and materials, including refractive and low-luster threads, ribbons, and tapes. Often, many thin threads are intertwined to achieve subtle changes through the juxtaposition of colors and textures within the group. The landscape motifs of the imagery are influenced by memories of trips and by concepts of time and space.

TOWNSEND, PALA (Painter)
2033 N. Fremont St., Chicago, IL 60614

Born: 1942 *Awards:* Fellowship, Massachusetts Council on the Arts and Humanities *Exhibitions:* Rose Art Museum, MA; The Cliff Dwellers Club, Chicago *Education:* Tufts University; School of the Museum of Fine Arts, Boston; U. of New Mexico *Dealer:* Stavaridis Gallery, Boston

The American landscape paintings of Hartley and Dove and the mythic tendencies of Pollock and Pousett-Dart form points of departure for her paintings, which seek to reformulate an abstract imagery for the present. The art and literature of ancient Amerindian cultures have also been a major source of inspiration for her work, particularly in the use of elemental signs, primordial surfaces, and words used as images. Her canvases are large--from 76 x 108 inches to double that size--and consist of simple geometries composed of a complex oil and encaustic surface. The resulting effect is a palimpsest of color, marks, and words organized around the formal devices of rectangles and circles that suggest elements of landscape or rudimentary architecture.

TROVA, ERNEST (Painter, Sculptor)

c/o Trova Foundation, 8112 Maryland Ave., Suite 200, St. Louis, MO 63105

Born: 1927 *Awards:* "National Humanitarian Award of 1979," National Recreation and Park Association; Utsukushi-ga-hara Open Air Museum Award, Tokyo, Japan *Collections:* Museum of Modern Art, NY; Whitney Museum of American Art, NY *Exhibitions:* Pace Gallery, NY; Tate Gallery, London *Education:* U. of Missouri, St. Louis *Dealer:* Philip Samuels Fine Art, St. Louis

From his self-taught beginnings in 1946, to his present status as a sculptor of originality and force, his art has demonstrated an unquestionable continuity. While his early efforts were influenced by Dubuffet and de Kooning, he found his own artistic identity in the early 60s in the series *Study/Falling Man,* which he developed in paintings, graphics, assemblage and sculpture for more than ten years. In the early 70s, he shifted his primary focus to a new direction--large-scale, geometric constructions in steel. The decade was dominated by three series of monumental sculptures. In the 80s, he has once again returned, with an enriched vision, to the theme of the Falling Man by undertaking the synthesis of figuration and construction into a singular sculptural concept. He has also expanded his interest in "collectibles" and the processes of design and fabrication through his creation of edition artwork.

TRUCKENBROD, JOAN (Computer Artist)
14 Cari Ct., DeKalb, IL 60115

Born: 1945 *Collections:* South Dakota State University; Allan Friedman & Associates *Exhibitions:* IBM Gallery, New York; Artemisia Gallery, Chicago *Education:* The School of the Art Institute of Chicago

Studying with Sonia Sheridan, she created images using a variety of energy sources. Following this study, she began to express the sensations of phenomena in the natural world that are invisible to the human eye. Using a computer graphics system, she created a visualization of the distortion of reality that occurs when figures are reflected on irregular surfaces. Works in a series of large 7 x 10-feet printed canvases typically feature integrated fluid patterns over a range of dynamic color fields. In her current work, she explores the multiplicity of human behaviors. In these pieces, a computer synthesizes personal experiences into multidimensional images; these images are "digital portraits" of given behavioral roles, woven together to highlight the complexities and conflicts of the human psyche.

TUCKMAN, LARRY S. (Photographer)
3418 N. Wolcott, Chicago, IL 60657

Born: 1959 *Awards:* Albert P. Weisman Scholarships; Honorable Mention, East Texas International Photography Show; *Collections:* Chicago Historical Society; Private *Exhibitions:* Ukrainian Institute of Modern Art, Chicago; Prairie Avenue Gallery, Chicago *Education:* Columbia College, Chicago

Having been influenced by such photographers as Diane Arbus, Bruce Davidson, and Lewis Hines, his early concerns were in documentary photography. He spent many years photographing graffiti, abandoned buildings, and close friends. More recently interested

Jerry Torn, *Dan Duell,* 24 x 17, graphite drawing

Naomi Whiting Towner, *Night Walk: Edge of Normal,* 48 x 46, weaving with surface embellishments

in the black and white photographs of Larry Clark and Danny Lyons, he spent four years photographing young people (ages ten to twenty) in Uptown, one of Chicago's most ethnic, racially mixed and depressed areas. In the stark, ugly, and grim imagery of this work, he documented the racism, rituals and uncertainties involved in growing up in such a neighborhood. He is currently a Staff Photographer for Pettersen Associates in Chicago.

TURK, BETH (Sculptor, Installation Artist)
100 Broadway, Wilmette, IL 60091

Born: 1940 *Awards:* IL Arts Council Program Completion Grant & Purchase Award *Collections:* Exxon; Standard Oil *Exhibitions:* ARC Gallery, Chicago; Organic Theatre, Chicago *Education:* School of the Art Institute of Chicago *Dealer:* ARC Gallery, Chicago

Though she was formally trained in sculpture and photography at the School of the Art Institute of Chicago, her primary medium has been the installation. Kienholtz and Eva Hesse were the first people to influence her in that direction. It was through looking to them that she developed an interest in formal invention and installation art. Her early pieces such as "The Hindenberg" and "The Red Library" were characterized by a devious sense of social commentary. In her last installation, "Art Play," figures played an important role. Her upcoming installation, "Spider Art," will involve the relationship of art, spiders and life.

UIHLEIN, KAYCEE (KATHRYN) (Painter)
P.O. Box 3604, Oak Brook, IL 60522

Born: 1944 *Exhibitions:* Vanderpoel Art Gallery, Chicago; Artemisia Gallery, Chicago *Education:* Southern Illinois U.; School of the Art Institute of Chicago

Comfortable working with a variety of media including watercolor, ink, pastel, acrylic, oil, and screen prints, she explores the theme of women and their journeys through life. Abstract figuration is the core of the work, characterized by dynamic coloration and bold lines. While the brush technique may be categorized as primitive, it is complemented by a sophisticated overall design. As she works with a wide range of media, so also is there a wide range of formats. Her collection includes 18 x 40-inch pastel and ink works of male and female figures and 40 x 55-foot drawings of rock n' roll and religious figures. Her primary influences are Picasso and de Kooning, and while some of her pieces are political, they are not polemical.

UMLAUF, KARL (Sculptor)
105 Royal La., Commerce, TX 75428

Born: 1939 *Awards:* Grand Prize, Texas Arts Celebration, Houston; 1st Prize in Sculpture, Midwest Biennial, Joslyn Museum, Omaha, NE *Collections:* Joslyn Museum; New Orleans Museum of Art *Exhibitions:* Amarillo Competition; Miriam Perlman Gallery, Chicago *Dealer:* Mac Gilman Gallery, Chicago

His original two-dimensional paintings were influenced by structural Abstract Expressionists like Kline and Chamberlain. He then began making reliefs, using imagery that featured geological studies, geo-physics,

archeology, mythological symbols, and studies in comparative anatomy. At first these pieces were made from vacu-formed buterate. Then he experimented with fiberglass, until he reached his present medium, which is the casting of paper over clay to create bas reliefs. In a spontaneous way, he works dry powder and liquid acrylic emulsions into the cast paper, creating pieces whose final effect is one of an iconography both ancient and contemporary.

USHENKO, AUDREY A. (Painter)
1615 Sheridan Rd., Champaign, IL 61821

Born: 1945 *Awards:* Critics' Choice, NYC *Collections:* Everson Museum, Syracuse, NY; Private *Exhibitions:* Minnesota Museum Traveling Exhibition; Gilman/Gruen Gallery, Chicago *Education:* Northwestern U., Evanston, IL *Dealer:* Gilman/Gruen, Chicago

Her paintings are complex, multi-figure narratives that dramatize the human experience. She often uses the narrative shorthand of the Greek Myth as a revisionary tool and also depicts contemporary people gathering in conversation, one of the guests often being death, a skeleton wrapped in a shroud, whose presence is recognized only by a few. Notable for her draughtsmanship, strong design, and naturalistic groupings of people, she paints with oil on white or colored ground areas regrounded with lead. Her technique is a combination of the paint application methods of the Old Masters, and the color and light theory of the Impressionists.

VAGNIERES, DOROTHY (Sculptor)
161 E. Chicago Ave., #39E, Chicago, IL 60611

Born: 1934 *Exhibitions:* Del Bello Gallery, Toronto; Amos Eno Gallery, New York City *Education:* School of the Art Institute of Chicago

After spending some eight years investigating various media, including drawing, painting, and sculpting, she began developing an individual "microcosmic" assemblage style. Her works are small sculptural assemblages of rusted found objects inhabited by tiny acrylic human forms, made habitable by pieces of dried acrylic paint, fur, wire, ribbon, string, beads, and other comfortable embellishments which are painted onto the assembled armature of rust.

VALENTINE, KEVIN (Painter, Printmaker)
1508 Greenwood St., Evanston, IL 60201

Born: 1957 *Awards:* Honorable Mention, Chicago Artist's Guild Watercolor Show *Exhibitions:* Ditmar Gallery, Evanston, IL; Pinnacle Gallery, Rochester, NY *Education:* Principia College, Elsah, IL *Dealer:* Wenniger Graphics

Always intrigued by the figure, he continues to work with it as the subject of his paintings and prints. In college while he received training first in landscape painting, metal smithing, and abstract design, he returned to his true inspiration on the example of introspective figure artists Raphael Soyer and Egon Schiele. Employing a broad range of materials and techniques—etching figures from photos, mapping color and abstract designs onto the print to create variations, applying rice paper, scraping into the

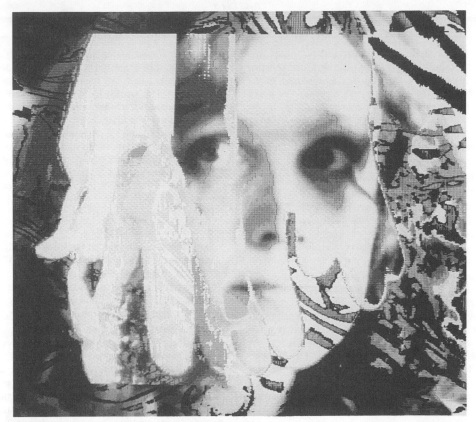

Joan Truckenbrod, *Free Radical,* 24 x 26, photograph

Willa Bowen Van Brunt, *Cityscape,* 8 x 10, watercolor

variously inked section--his prints and paintings are noted for their multi-layered appearance. Currently the artist's treatment of the figure has become more abstract. More often than not, only close-ups of parts of the figure are found or arrangements of many figures. In both the prints and paintings, a balance between a drawing-like quality and an abstract application of color is achieved.

VALONIS, EDMUND J. (Painter)
18540 Dundee Ave., Homewood, IL 60430

Born: 1922 *Awards:* Outstanding Artistic Merit, Eleventh Juried Annual, Miller Art Center, Sturgeon Bay, WI *Exhibitions:* Natalini Gallery, Chicago; Wickline's *Education:* Governor's State U., IL; Illinois Institute of Technology *Dealer:* Natalini Gallery, Chicago

His classes with artist Carol Boyajian were the single most important influence on his style and approach. His early work comprises floral still lifes--in particular, enlarged views of single blossoms, with an emphasis on detail and the careful blending of color. He went on to landscapes featuring quiet, calm, distant vistas with an occasional excursion into ancient ruins. He became interested in the works of the Hudson River School, especially those of Kensett and Gifford. However, in his most recent work he has turned to the fractured rock surfaces of the American southwest.

VAN BRUNT, WILLA BOWEN (Painter, Photographer)
9156 N. Central Ave., Indianapolis, IN 46240

Awards: Merit Award, North Coast Collage Society; 1st Place, National League of American Pen Women Miniature Exhibition, 1987, 1988 *Collections:* Private *Exhibitions:* Brown County Art Gallery, Nashville, IN; 1988 N.L.A.P.W. National Biennial, Washington, DC *Education:* U. of Illinois; Butler U.

Her work shows interest in a variety of media, including watercolor, collage, line drawing, acrylic, and photography, and recent work has been abstract or non-objective. Color and texture are important in the works, and she employs numerous experimental techniques to depict emotions, movement, action, and spatial relationships. Cityscapes and landscapes are favorite subjects of the paintings. She also does calligraphy and is an active member in a number of professional artists' guilds and organizations. For the last eight years, she has been an art teacher in the Indianapolis public school system.

VAN DEURZEN, JAMES (Sculptor)
10250 Mathewson Rd., Mazomanie, WI 53560

Born: 1952 *Awards:* Fellowship, Creative Glass Center of America *Collections:* Corning Museum of Glass; New Orleans Museum of Art *Exhibitions:* Great American Gallery, Atlanta; Mindscape, Evanston, IL *Education:* U. of Wisconsin, Madison *Dealer:* Mindscape, Evanston

Before working in art, he took degrees in Art History and Ancient History. His studies focused on the work of the Cycladic peoples, Minoans, Egyptians, Greeks, and Native peoples of North, Central, and South America. Inspired by the richness and depth of expression, and by the creation of ceremony and beauty in these cultures, he seeks to achieve something of the same in his glass works. He works with molten glass--both blown and fused--and a palette of intense, highly saturated hues. His images are often derived from the anthropomorphizing of creatures--dogs, cats, fish--or from the abstraction of human physiognomy. The resulting work consists of two parts: a base and the fused glass image, and it has a gestural and lyrical quality that enhances its intended humorous, "poke-fun-at-us," nature.

VAN LAAR, TIMOTHY (Painter)
505 W. William, Champaign, IL 61820

Born: 1951 *Awards:* Yaddo Fellowship; Illinois Arts Council Artist's Fellowship *Collections:* Detroit Institute of Art; Illinois State Museum *Exhibitions:* Chinese National Fine Art Museum, Beijing; Museum of Fine Arts, Houston *Education:* Wayne State U.; Calvin College *Dealer:* Gwenda Jay Gallery, Chicago

His work in the late 1970s was primarily geometric abstraction. By 1981 the paintings had evolved into simple diagrammatic representations, partly from interest in the work of artists such as Magritte and Philip Guston. The paintings are infused with a sense of the theatrical, and many of the images of the mid-80s are set in a theater environment of spotlights, curtains, and stages. His interest in surreal tableaux has extended to a series of diptychs and still life paintings that use obvious symbols drawn from science and art in ironic and jarring combinations, often evoking a nervous humor.

VAN VLECK, SHERYL A. (Painter)
1311 Highway 330, Griffith, IN 46319

Born: 1948 *Awards:* National Council of Artists Art Classic Award; Shipstad Best of Show, St. Paul *Collections:* Winnebago Public Indian Museum; American Indian Culture Research Center *Exhibitions:* Horizon Gallery, Bloomingdale, IL; Springville Museum of Art, UT *Education:* U. of Illinois; Govert Art Academy

She uses her formal training in portraiture and anatomy to express her love of and commitment to Native American society and to her own Native American heritage--Chirichuas Apache and Nocona Comanche--producing a new documentation in paintings. Early photorealist oils have evolved into pieces that use oil, soft pastel, and Prismacolor pencils in a style that blends realism and impressionism. Borrowing the technique of 17th-century Dutch painter Jan Vermeer, she lays down a foundation of primary colors and then layers glazes to establish flesh tones without obscuring the vibrant undercoating. The level of detail, however, is uneven throughout the painting; she chooses instead to present certain areas of the painting with high detail resolution while leaving others merely suggested. In one painting, that of an Indian boy at a drinking fountain, the boy, spigot, and water pop out from the blurred background. The vibrant colors that enliven these ordinary scenes have become the artist's hallmark.

Rose Van Vranken, *Shell Form #1,* 20 high, bronze

Marya Veeck, *Death of a Dark Horse,* 4 x 5, oil. Courtesy: Mr. and Mrs. Blake DeBoest, Chicago

VAN VRANKEN, ROSE (Sculptor)
435 Tallowood, Houston, TX 77024

Born: 1919 *Awards:* Medal of Honor, Academic Artists Association, Springfield, MA; 1st Prize for Sculpture, 1982, 1985, 1988, Salmungundi Club, New York *Collections:* Coventry Cathedral, England; University of Iowa Museum of Fine Art, Iowa City; *Exhibitions:* Purdue University; U.S. State Department; *Education:* New York Art Students League; U. of Iowa *Dealers:* Gilman/Gruen Gallery, Chicago; Genesis Gallery, Chicago

Her sculptural forms are primarily based on nature, including plants, sea forms, animals, rocks and figures. Designing semi-abstract forms to capture the spirit of the subject, she counts among her influences Greek, Chinese, and Egyptian art. The fundamental technique is direct carving in wood or stone, followed by bronze castings made from the carvings. This direct approach emphasizes mass and rhythms within mass. These rhythms are further underscored by her use of variegated areas of highly polished bronze contrasted against dark patina. Recent figures have increased in size, and she has begun to explore large, abstract plant forms in urethane covered in resin.

VARJ, SHANOOR (Painter, Photographer)
1960 N. Lincoln Park W., Apt. 403, Chicago, IL

Born: 1949 *Awards:* 1st Prize, Polaroid Professional Chrome *Exhibitions:* Cafe Jasper, Chicago; Shanoor Studio

During the mid-1970s, after formal training in photography and advertising design in London, he came to Chicago and began working for advertising agencies like Leo Burnett and BBDO. His large, unstretched canvases of that period were influenced by prehistoric cave art, Abstract Expressionism, maps, and aerial photography. In the early 1980s, he returned to photography and began drawing on 8 x 10-inch negative self-portraits. His oil paintings on photographic prints distort the facial image and underscore patterns already existing in the negative image. He is influenced by electronic communication, TV, and the atomic threat, and his photographs reflect an era of speed and fear.

VEECK, MARYA (Painter)
2223 W. Melrose, Chicago, IL 60618

Born: 1954 *Collections:* Schiff, Hardin & Waite, Chicago *Exhibitions:* Natalini Galleries, Chicago; Ariel Gallery, New York City *Education:* Drake U.; Byram Shaw School of Painting and Drawing Ltd., London *Dealers:* Erie Street Galleries, Chicago; Partners Gallery, Bethesda, MD

Always interested in painting as a narrative, she has developed a series of visual symbols in constructed and actual interiors that explore the seductiveness and menace of a materialistic urban society. The works are fairly large, with areas of flat, intense color intended to move the eye of the viewer around the surface. In a language comprised of a variety of provocatively kitschy collected objects, the paintings describe situations and subjects from "portraits" of an elderly couple to the world as seen from the eyes of an abused child.

At times almost claustrophobic, the works explore the themes of duality, materialism, and isolation in an unsettling manner.

VIEUX, MARIAN J. (Sculptor)
2963 N. Summit Ave., Milwaukee, WI 53211

Born: 1950 *Awards:* Wisconsin Arts Board Sculpture Fellowship Grant *Collections:* Madison Art Center, Madison, WI; Citicorp *Exhibitions:* Addison Gallery of American Art, Phillips Academy, Andover, MA *Education:* U. of Kansas; Emporia State U. *Dealer:* Lyman-Heizer Associates, Northbrook, IL; Joy Horwich Gallery, Chicago

Synthesizing her study in sculpture and her experience in the landscape, she created a form of nomadic art that incorporates the landscape of the West Coast, Gulf of Mexico and the Midwest-Great Lakes area. Her view of trees as mystical matrices and as monuments to primordial life emerged in sculptural form in 1978. Out of the structure and form of the artist's wrapped tree and the surrounding forest life come the compositional rhythms of primordial life: movement in the forest and the awareness of a personal presence in a mysterious habitat. Her compositions became more complex with the residence- and site-specific wrapped tree sculptures at Ossabaw Island, Georgia and MacDowell Colony, exemplified by the construction of *Forest Panorama* (50 x 100 x 9 feet). Trees wrapped in vibrant, multicolored bands of fibers, leather and vinyl, some crisscrossed, others spiraling, and others covering the entire trunk, create an intensified, almost spiritual perception of place. Recently she has extended her work to include miniature wrapped tree landscapes, using branches and sticks.

VOLAY, PETER (Painter, Sculptor)
3532 W. 83rd St., Chicago, IL 60652

Born: 1915 *Awards:* John Hancock Art Award, Chicago; Best of Show Cash Award, Hyde Park Art Center *Collections:* Household Finance Corporation *Exhibitions:* Hyde Park Art Center, Chicago; Beverly Art Center, Chicago *Dealer:* Joy Horwich Gallery, Chicago

He laced his first paintings of Chicago-area Victorian-style homes with a sardonic, sometimes biting, art-historical wit. For example, he would paint a house and put an image of Whistler's Mother on the front porch, or of Mona Lisa in an upstairs window. In this work, he used a combination of modeling paste and acrylic gel to create a bas relief effect. He now paints distorted subjects with oils. His humorous, convoluted paintings of classically-styled buildings and well known people (including Ronald Reagan) resemble funhouse mirror reflections. He also makes sculptural pieces with found objects.

VOLPE, DORIS (Painter)
1505 N. Willow St., Lake Forest, IL 60045

Born: 1930 *Awards:* Deer Path (IL) Art League; North Shore Art League *Collections:* LA State Gas Co., New Orleans *Exhibitions:* IL State Fair, Spingfield; New Horizons, Chicago *Education:* Lake Forest (IL) College *Dealer:* Renata Buehler, Chicago

Steven Waldeck, *Bedroom,* 40 x 40 x 4, opaque plastic painted relief with electric lights

Steven Waldeck, *East Room,* 90 x 42 x 14, assemblage with electric light

The beauty of things, exotic and mundane, has exerted a strong pull on her emotions and is the primary subject of her still lifes. Her current "White Room" paintings involve a paring down and an uncluttering of thoughts and surroundings. In these works she renders such objects as tables and fruit realistically but places them in an imaginary space that need not be specific or real. The work is a type of conceptual realism that enhances what the eye can see with what the mind can imagine. She is known for her sharp-edged, highly-controlled presentations of everyday objects. She has studied with Hubert Ropp, Abbott Pattison, and Ed Paschke.

WAHLGREN, WILLIAM R. (Painter, Printmaker)

15 Indian Hill Rd., Winnetka, IL 60093

Born: 1959 *Awards:* Artists' Roster, IL Arts Council Arts in Education Program *Collections:* First Bank of Evanston; Sandoz Corp *Exhibitions:* The Kemper Group; School of the Art Institute of Chicago *Education:* School of the Art Institute of Chicago

Originally influenced by the rural landscape of his native Midwest, his first paintings were highly realistic Midwestern landscapes and mundane yet realistic still lifes. After studying art formally at the School of the Art Institute of Chicago, he began to take an interest in paint, surface, and the act of painting. His current work is a series of monochromatic canvases or studies. On close observation each of these rectangular abstract pieces reveals a minutely worked surface texture which the artist has built from successive layers of color. He continues to work monochromatically with the same formal concerns.

WALDECK, STEVEN (Kinetic Artist)

28812 W. Golfview Dr., Spring Grove, IL 60081

Born: 1943 *Awards:* Eisner Prize, University of California, Berkeley *Collections:* McDonald's Corporation; Exploratorium, San Francisco *Exhibitions:* AES Gallery, Chicago; College of Lake County, IL *Education:* Ohio U.; U. of California, Berkeley

What at first appears to be a photorealist painting (in rendering and in quality of light) is a work illuminated from behind with real light penetrating the translucent "canvas" and causing elements such as leaves or shadows to play across the surface and within the depicted scene. Other works employ trompe l'oeil painting techniques to give the illusion of a room beyond the "real" but "nonfunctional" architectural components. Other more "traditional" assemblages and kinetic machines incorporate found objects and sound. In 1969, he established an area of experimental media called Kinetics and Electronics which eventually led to the development of the Time Arts Department at the School of the Art Institute of Chicago.

WALKER, DARREN (Painter)

R.R. 1, Box 58, Summitville, IN 46070

Born: 1960 *Awards:* Best of Show, 1986 Indiana State Fair; 1982 Society of Illustrators Student Competition *Exhibitions:* Anderson Fine Arts Center, Anderson, IN; St. Francis College, Fort Wayne *Education:* St. Francis College

Combining watercolor, airbrush, and graphite in a style of surrealistic realism, the artist's subject matter includes animals and man-made objects. The technically sophisticated pictures impart a dreamlike quality through their slick, super-realistic juxtaposition of incongruent elements. A recent piece, *Out from the Inner City*, looks through a car windshield at an underwater scene of tropical fish into which an erotic beach scene has been inserted.

WALKER, MARY (Sculptor)

2761 Dean Pkwy., Minneapolis, MN 55416

Born: 1939 *Awards:* Bush Foundation Fellowship; McKnight Foundation Fellowship *Collections:* First Bank System, Minneapolis; Southeastern Banking Corporation, Miami *Exhibitions:* Evanston Art Center, Evanston, IL; Minneapolis Institute of Arts, *Education:* Purdue U. *Dealers:* Perimeter Gallery, Chicago; MC Gallery, Minneapolis

She began to work with scuplture in the mid-1970s after early work in painting. The images were geometric, totemic forms on painted wood, reflecting an interest in combining minimalism's reductive forms with sensual handmade surfaces and evocative color. In the early 1980s she began a series of armor-like masked figure forms of laminated painted paper. These pieces, exhibited in groups, seem theatrical and ritualistic, with an essential protected privacy or mystery. The works, *Ceremonial Quartet*, and *Evening Situation*, are multi-part pieces from this period. Her current sculptures--architectural forms of arches and gateways--are constructed from twisted, compressed paper combined with found wood. Through these forms she comments on the idea of passage, both as movement and as initiation. The pieces are painted with enamel in layers of color to produce a patinated surface. Among recent works are *Memory's Boundary*, and *Songline*. She has also designed works for live theater, such as masks for the Guthrie Theatre's 1987 production of "The Bacchae."

WALKER, STEVE (Painter)

1255 W. Columbia, Chicago, IL 60626

Born: 1957 *Collections:* Private *Exhibitions:* Art Institute of Chicago Rental Gallery; *Education:* Northern Illinois U.

After initially working in a stiff, geometric style, he became influenced by the looser work and primary palette of Alexander Calder. He has developed a tight, free, and powerful style in hopes of finding gestural essence in the life surrounding him. Bold and slashing strokes, exemplifying the purity of an action, are combined with gestural drawings that are overlapped and repeated onto a graduated ground. The large scale works, done in oil, draw from observation of the figure, but become abstractions of movement rather than representations.

WALSH, THOMAS (Sculptor)

Art Dept., SIU-C, Carbondale, IL 62901

Born: 1937 *Awards:* Prix de Rome; Tiffany Foundation Grant *Collections:* Speed Museum, Louisville; Mint Museum, Charlotte, NC *Exhibitions:* Toledo Museum

Darren Walker, *Out from the Inner City,* 34 x 42, acrylic, watercolor

Valerie Warshauer, *Galaxy,* 42 x 60, oil on canvas

of Art; ARC Gallery, Chicago *Education:* U. of Michigan *Dealer:* Fairweather-Hardin, Chicago

During the past eight years, he has attempted in his work to condense and distill sculptural metaphors related to basic themes that have been gestating since 1965: the sacred and the profane, life and death, and transformation. His choice of medium--cast bronz--speaks powerfully to these themes through its enormous flexibility, its carrying power and permanence, and its affirmation of the past. His sources are wide-ranging and encompass artists as seemingly disparate as Giselbertus, St. John of the Cross, Pascal, Baudelaire, Manzu, and Eliade. He is also continually fascinated by the symbology of such structures as the Arch of Titus, the Portals of Chartres, the Gateway Arch in St. Louis, and the *axis-mundi* of the Indian tepee.

WALTER, JUDY ANNE (Fiber Artist)
1446 Chase St., Chicago, IL 60626

Born: 1951 *Awards:* Judge's Choice Quilt, San Diego; Judge's Special Merit Award, American Quilt Society; *Collections:* Loyola University Medical Center, Maywood, IL *Exhibitions:* Textile Art Centre, Chicago; University of Illinios *Education:* Lake Forest College; U. of Illinois *Dealer:* Illinois Artisan Shop, Chicago; American Gallery of Quilt & Textile Art, Gig Harbor, WA

"The colors are letters, used to spell new words; the groupings of shapes are sentences expressing my conceptions of events and people in my life and the world around me." So comments this primarily self-taught fiber artist. Interested in extending the boundaries of traditional patchwork quilting, her early work explores the geometric concepts of composition found in Islamic art. Out of this work she developed new ways of generating patterns. These fabric constructions express her concerns with rhythmn, symmetry, movement, and pattern. Her current work takes inspiration from the watercolors of Paul Klee and the work of Arthur Dove. Here the artist is concerned with color and light as means of capturing temporal change and movement. This concern is reflected in her fabric constructions which are composed of fabrics that respond to light in a variety of ways. To this she adds stitchery which gently sculpts the surface.

WANDERSEE, REBECCA J. (Painter)
1467 W. Winona, 3rd Floor, Chicago, IL 60640

Born: 1960 *Exhibitions:* Chicago Public Library Cultural Center; Beverly Art Center, Chicago *Education:* Minneapolis College of Art and Design *Dealer:* Phyllis Kind Gallery, Chicago

As a student she painted in a non-objective style and used photographs of cemetery monuments both as a trigger for ideas and as a direct visual source. At first she looked at the way the monuments' abstract architectural elements carried meaning. Next she explored the humanlike form of the urn, and finally became interested in the statues of women. Her current paintings are oils with intense colors and beautiful surfaces. Her images of statues of women interact with elements of nature such as branches, leaves, and waves.

She places these matriarchal symbols in paintings where the coexistence of opposites acts as a source of energy.

WARSHAUER, VALERIE (Painter)
545 Stratford Place, Chicago, IL 60657

Collections: Columbia Broadcasting System, NYC; Boulevard Bank, Chicago *Exhibitions:* Cafe Jasper, Chicago; Chicago Public Library *Education:* Northwestern U., Evanston, IL; School of the Art Institute of Chicago

She prefers the freedom of abstraction and makes paintings that are far removed from established traditions. Sometimes her abstractions are inspired by nature, but others of her paintings are completely non-objective and bear no relation to nature. She concentrates on expressions of color and likes the fact that her work can be misread. She has a series called "Artist's Secret--These are not what you think they are." "I like my work to generate different kinds of stylistic and color variations," she says, "and in so doing create something no one has seen before."

WASHINGTON, JENNIE S. (Painter)
11439 S. Racine Ave., Chicago, IL 60643

Born: 1931 *Awards:* Dusable High School Hall of Fame; Grant, Chicago Office of Fine Arts *Exhibitions:* Seaway Bank, Chicago; Institute of Jamaica, Kingston *Education:* School of the Art Institute of Chicago; American Academy of Art, Chicago

Influenced by her artistic mother and inspired by her instructor, Dr. Margaret Burroughs, she is known for her historical and contemporary portraits of figures such as Jean Baptiste Pointe DuSable and Cardinal Joseph Bernadin. Blending just the right shades of color she is able to capture a realistic and radiant quality in her clients. Further influenced by muralist Bill Walker, she has painted large (up to 9 x 32-foot) murals on scenic canvas and masonite. She is currently begining a series of realistic acrylic paintings of Chicago church exteriors and has recently completed a series of acrylic human interest paintings on primed wood blocks.

WATERBURY, JONATHAN (Photographer, Painter)
c/o Deson-Saunders Gallery, 750 N. Orleans, Chicago, IL 60610

Exhibitions: Deson-Saunders Gallery, Chicago; Museum of Contemporary Art, Chicago; State of Illinois Gallery, Chicago; Feature Gallery *Education:* School of the Art Institute of Chicago *Dealer:* Deson-Saunders Gallery

Advertising and media strategies are used in creating photographs and large-scale wall paintings. These works explore the vast power that cultural edifices, such as the media, large corporations and increasingly the art world itself, have in the modern world.

WATERHOUSE, MONA (Papermaker, Painter)
N7753 Sundown Court, Menasha, WI 54952

Born: 1942 *Awards:* Marquette Haggerty Museum; National Art Exhibition, Roanoke, Virginia *Collections:* GUAD/Graphics, Inc.; Westvaco Corporation *Exhibi-*

Mona Waterhouse, *Mandala IV,* 42 x 42, hand made paper and mixed media. Courtesy: David and Nancy Warner

Emil Weddige, *Pilgrims,* 22x30, Colorstone lithography. Courtesy: Mike Mitchell

tions: Mindscapes, Evanston; Paper/Fiber IX, The Iowa City Arts Center *Education:* U. of Massachusetts, Amherst

Using paper as ameans of self-expression, her work is about energy and moments of stillness and clarity. Using pure cotton fiber in forming the sheets, dyes and pigments are added with an airbrush. Mysterious objects and personal symbols are created by stencilling and the application of collage materials and paint. Often there is an opening in the center of the pieces where strange, otherworldly landscapes exist. A recent series, "Gossamer Spirit," reflects the influence of Japanese paper scrolls, creating a window onto the extraordinary that lies beyond the walls of the ordinary.

WATERMAN, CLARK (Stained Glass Artist)
W1554 Mortensen Rd., Brooklyn, WI 53521

Born: 1938 *Awards:* Grant for Atrium Windows, Badger Prairie Health Care Center *Collections:* Highsmith Company *Education:* Cranbrook Academy of Art; Pilchuck School of Glass

After a formal training in traditional metalsmithing, he began to make minimalist-influenced metal sculpture and large three-dimensional multi-canvas paintings. He then left the field of art and studied Eastern religious thought for six years. In 1979 he returned to art and began making his current unique stained glass works. These custom-designed pieces, often depicting elements of landscape, are bold yet simple, colorful yet subdued. While his style is contemporary, it is grounded in both tradition and design. He works both through direct involvement with the customer and in collaboration with interior designers and architects.

WEBER, JOHN PITMAN (Painter)
4839 N. Springfield, Chicago, IL 60625

Born: 1942 *Awards:* Fulbright Fellowship, France *Collections:* City College, NYC; Harvard U.*Exhibitions:* "Days of Rage," Randolph Street Gallery, Chicago; "Friday Diego," Artemisia Gallery, Chicago *Education:* Harvard U.; School of the Art Institute of Chicago

The artist's work has mainly been in the area of murals. He brought a Legeresque flavor to mural painting in the 1970s, wrote a book on murals, helped to reinvent the methods of collective composition, and did some work in free-form cement relief sculpture. A dozen of his collaborative public works survive in the Chicago area (on the southwest corner of North Avenue and Springfield, for example). At present he works in acrylic on unstretched, grommeted canvas, juxtaposing large figures and plant forms in painterly hot colors. Often evoking Third World news photos and scenes of his own family life, he plays with tense visual relationships between personal emotion and public acts.

WEDDIGE, EMIL (Printmaker)
870 Stein Road, Ann Arbor, MI 48105

Born: 1907 *Awards:* Library of Congress Award, 1951 *Collections:* Metropolitan Museum of Art, NYC; National Gallery of Art, D.C. *Exhibitions:* Farnsworth Museum, ME; Besser Museum, Alpena, MI *Education:* U. of Michigan; atelier of the master lithographer

Edmund Desjoubert *Dealers:* Teri Mari, Ann Arbor; Mike Mitchel, NYC

A pioneer in the revival of stone-based lithography in the United States, he creates works which are painterly, in contrast to the hard-edge, linear works associated with the lithographic process. His technical virtuosity is such that a work was once unhung from a print exhibition because it was thought that watercolor had been used. After examination, however, it was rehung and given an award. To produce such prints, from eight and twelve colors must be laid in successive, accurately registered tusche washes. He turned to printmaking in the 1920s out of a desire to bring art closer to people--to create an "everyperson kind of art." Vibrant, animated colors and forms express the manifold aspects of human experience--as he says, "the big religious theme, the ruggedness of the land, sky and water, mythology and the world of make believe that goes into the circus."

WEGMAN, WILLIAM (Video Artist, Photographer)
431 E. 6th St., New York, NY

Born: 1943 *Awards:* Guggenheim Fellowship; NEA Fellowship *Collections:* Museum of Modern Art, NYC; Whitney Museum *Exhibitions:* Museum of Modern Art, NYC; Whitney Museum Biennial *Education:* MA College of Art, Boston; U. of IL *Dealer:* Holly Solomon Gallery, NYC

Video tapes, drawings, and photographs are humorous, often parodic works, characterized by informality and deliberate artlessness. *Madam I'm Adam*, for example, is a "visual palindrome"--that is, two identical photographs, one printed backwards. In 1975, he began a four-year series of over-exposed and under-exposed black and white photos with comments written directly onto the prints. He is known for photographs and video tapes which feature his dog, Man Ray, whom some consider his alter ego, in comical costumes and situations. Large-scale color Polaroid prints of the dog were published in the book *Man's Best Friend* in 1982, the year of the dog's death.

WEITZMAN, LEE (Furniture Maker)
1524 S. Peoria, Chicago, IL 60608

Exhibitions: Hokin Kaufman Gallery, Chicago; Renwick Gallery, Smithsonian Institution, Washington D.C. *Dealer:* Hokin Kaufman Gallery, Chicago

"Wood picked me and I picked furniture," he says by way of introduction. Starting with wood bought from an old lumber yard, eleven years ago he began working with wood. Soon afterward he chose furniture as the mode to continue to explore the possibilities of the medium. Today he incorporates a range of exotic materials in his pieces, including special stones, shells, rare woods, plastics and concretes. Although he is open to all fabrication processes, he comes from, and usually designs out of, the tradition of woodworking. While the visual aspect of design is one of the most potent in his work, his pieces always include integrity in their functional and structural elements. Shapes, textures, colors, and porportions are united in a harmonious fashion. Pieces exhibit an original contemporary style that he hopes, he says, "will some day be considered classic."

John Rooney, *Queen of the Night,* 108 x 144, acrylic on canvas. Courtesy: Walter Bischoff Gallery

Richard P. Seth, *Farmscape Along Rt. 18,* 24 x 36, acrylic

Julie Lutz Simmons, *Union Station Window,* 40 x 30, watercolor. Courtesy: Abstein Gallery, Atlanta, Georgia

James S. Rousonelos, *Changes (Mannikin Stop),* 37 x 25, oil on canvas

Douglas E. Schmidt, *Ancient Rug #5,* 27 x 48, handmade paper with wood block

Nancy Ander Rutschmann, *Lunar Phases & Mythical Grecian Faces,* 26 x 18, mixed media

Don St. Cyr Toups, *Metamorphosis,* 15 x 23, ink painting & mixed media

Jo Siddens, *Earth Temple: Astarte,* 102 x 42 x 48, cast
flax paper

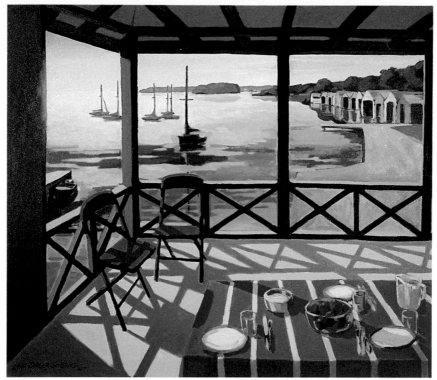

Lars-Birger Sponberg, *Striped Table Cloth,* 40 x 46, oil, Courtesy: Art Schaefer

Gus Sisto, *Swimming Pool Mural,* 60 x 144, ceramics

Sharon Schaal-Moricoli, *Nina,* 44 x 28, oil

Robert Stanley, *Fossil of an End,* 36 x 48, acrylic on canvas

Rubin Steinberg, *Bark of the Dog,* 30 x 40, acrylic sculptweaving assemblage

Jerry Torn, *Forgive Me,* 23 x 33, lithograph

Bruce Thorn, *Painting the West,* 8 x 9, oil & gold leaf on wood

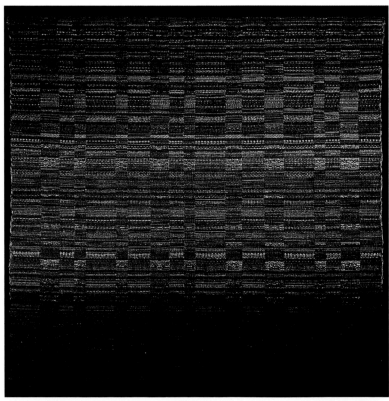

Naomi Whiting Towner, *Fuji Flashback,* 48 x 46, weaving with surface embellishments

V. Stevic, *Two Wishes,* 36 x 48, acrylic, air brush

Tom Torluemke, *Carnevale,* 50 x 168, tempera with acrylic emulsion. Courtesy: Naldo Coelho-American Academy of Art

Rose Van Vranken, *Shell Form #2,* 29 x 15, bronze

Joan Truckenbrod, *on becoming,* 24 x 26, cibachrome print

Willa Bowen Van Brunt, *Mountain Area,* 16 x 20, mixed media collage

Antoni Zamora, *Sun Over the River,* 18 x 14, oil on canvas

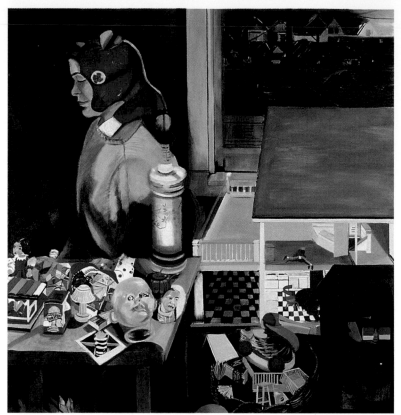

Marya Veeck, *Julie Guarding the House of Games,* 46 x 48, oil

Willow Winston, *Heather-Café Commercial,* 34 x 48, oil on canvas

Darren Walker, *Duesenberg,* 28 x 44, acrylic, watercolor

Philip White, *Woman in Doorway,* 24 x 36, oil

Victoria Yau, *Passion,* 16 x 21, mixed media

Kathy Newell Worby, *Miss Demeanor,* 30 x 22, oil

Cecilia Wood, *Linda,* 22 x 10, slip painting
with luster of porcelain

Valerie Warshauer, *Secrets of the Sea,* 25 x 32, acrylic on paper

Emil Weddige, *Princess and the Model,* 22 x 30, lithograph in color. Courtesy: Lou Basso Collection

Hollis Sigler, *She Wants to Belong to the Sky Again,* 43 x 61, oil on canvas. Courtesy: Museum of Contemporary Art, Chicago. Illinois Arts Council Purchase Grant from Matching Funds

WELCH, PATSY (Painter)
2020 W. Shakespeare, Chicago, IL 60647

Born: 1951 *Awards:* First Prize, International Painting Exhibition, Nice, France; Guy Brown Wiser Memorial Award, South Bend Indian Art Museum *Exhibitions:* Imagery Art Gallery, Glen Ellyn, IL; Art Institute of Chicago, Sales and Rental Gallery *Education:* U. of Tennessee; L'Ecole des Beaux Arts, Paris

Influenced by local Tennessee watercolorists and by anatomy studies in Paris, she paints small-scale figurative and landscape works in oil and watercolor. Subjects include her acquaintances and various phenomena relating to that American landmark, Wrigley Field. Her technique involves underpainting and glazing in oil; in watercolor, she is experimenting with the addition of pastels.

WELTON, ALICE (Painter, Mixed Media Artist)
38732 Brindlewood Ln., Elgin, IL 60123

Born: 1948 *Awards:* Best of Show, Skokie Art Guild; Best of Show, Palatine Art Guild *Collections:* Chicago Title and Trust; Prudential Insurance of Chicago *Exhibitions:* "Art in Paper," Swen Parson Gallery, Northern Illinois University; Illinois Institute of Technology *Education:* Northern Illinois U. *Dealers:* Mary Bell Galleries, Chicago; Judith Posner Gallery, Milwaukee

Her early watercolors were realistic, moving into an exploration of color combined with negative space. These works achieved a unique minimalist-expressionist style influenced by the design elements, philosophy, architecture, and gardens of the Oriental Masters. Her process of creation is based on intense concentration on the technical aspects of transparent watercolor, printmaking, and paper-making. Recent works include watercolor and acrylic paintings, hand-colored monotype collage, and painterly, three-dimensional constructions fabricated of handmade paper. These pieces juxtapose delicate pastels with brilliant movements of bright color.

WESLEY, ED (Holographer)
5331 N. Kenmore Ave., Chicago, IL 60640

Born: 1952 *Awards:* Artist-in-Residence Direct Grant, Museum of Holography *Collections:* Global Images, New York; Museum of Holography, New York *Exhibitions:* "Images in Time and Space," Montreal, Canada; Benny's CASINO, Chicago *Education:* U. of Illinois, Urbana

"Ed 'Big Daddy' Roth gave me my basic credo on art at the ripe old age of fourteen when I asked him at a custom car show why he put the word 'Coors' on a tee-shirt. His reply was 'because it looks good!'" So Ed Wesley cites beatnik Ed Roth as one of his early influences. Other influences include Andy Warhol, in particular the Brillo and Campbell's pieces. While his influences quote images from mass media, Wesley's work is primarily abstract though some images appear. He says his holograms are rather uninteresting when viewed with a lazer, as the subjects are just wrinkled pieces of shower glass. But when they are showered with white light, they become explosions of color floating in space. Several works are collaged holographic film, the compositions based on his "doodles."

WESSELMANN, TOM (Painter, Sculptor)
231 Bowery, New York, NY 10002

Born: 1931 *Collections:* Museum of Modern Art, NYC; Whitney Museum *Exhibitions:* Queens Museum; Sidney Janis Gallery *Education:* Cincinnati Art Academy; Cooper Union *Dealer:* Sidney Janis Gallery, NYC

Anticipating Pop Art, early work combines painting and collage. The "Great American Nudes" are female figures depicted in solid, bright, unmodelled areas of color, juxtaposed with advertisement clippings or mass-market products. Multi-media tableaux, such as *Bathtub Collage No. 3*, are oil on canvas works with objects attached. Later paintings often reduce nudes to breasts, lips, or genitals, as in *Bedroom Tit Box*. These nudes are often accompanied by depictions of modern still-life objects such as ashtrays, televisions, and kitchen gadgets. In 1984 his work underwent a dramatic change. Current work is constructed from shaped aluminum with interior cut-outs; they resemble large painted drawings. He is also creating "drawings" from laser-cut steel.

WESTERMANN, H.C. (Sculptor)
Brookfield Centre, CT

Born: 1922 *Exhibitions:* Art Institute of Chicago; Whitney Museum of American Art, NYC *Education:* School of the Art Institute of Chicago *Dealer:* Who Chicago

It is evident that H.C. Westermann's imagery is rooted in deep inner experiences. The enormous range of materials employed by Westermann places him in high esteem in modern sculpture. There is also keen interest in his drawings, watercolors and prints. His wartime experience gave birth to powerful works such as Death Ships. There are equally powerful works dealing with the absurdity of contemporary American materialism as well as the West's existential plight. Westermann is a consummate artist whose voice is universal and authentic.

WEXLER, CAROLE (Painter, Jeweler)
260 E. Chestnut, #1102, Chicago, IL 60611

Born: 1929 *Awards:* Honorable Mention, Artist Guild Show, 1981 *Exhibitions:* Joy Horwich Gallery, Chicago; Museum of Contemporary Art, Chicago *Education:* School of the Art Institute of Chicago; American Academy of Art

For many years she studied figure painting on a formal level. Midway through her career, she began abstracting her forms and working with color and texture, her initial influences coming from Van Gogh and Modigliani. After a number of years, she developed her own elongated portrait style of multi-media collage, using materials such as cloth, paint, pens, thread and canvas. From collage, she progressed to painting designs on wooden beads and making unique necklaces, bracelets, pens, and earrings. She has continued with a multi-media approach; her current painting is done exclusively on jewelry and greeting cards.

WHARTON, MARGARET (Sculptor)

Born: 1945 Education: University of Maryland; School of the Art Institute of Chicago

Involved in the women's movement in the 1970s, Margaret Wharton helped to found Artemisia, Chicago's first cooperative gallery for women. Her early works included box-like enclosures with various textures and moods. She is interested in common objects as art, a concept which began with the Dada movement. Wharton began to use the chair as a medium, finding images and ideas through the restructuring of chairs. She systematically dissects each chair through careful cutting and numbering of the parts. She recreates what exists as opposed to adding to or subtracting from it. This gives her work its mystical element. The sculptures carry a sense of history and past experience with them, which Wharton equates with the genetic powers of memory that women seem to possess; memory beyond biological years. In one experiment, Wharton joined chair parts to glass, which created the impression of a specimen examined on a slide. In another, she separated as many chairs as possible out of a single chair; the resulting chairs were close in size. This concept of death and reincarnation gives her art its special power.

WHITE, BRUCE (Sculptor)

453 Somonauk St., Sycamore, IL 60178

Born: 1933 Collections: Indianapolis Museum of Art Exhibitions: Appalachian Summer Festival, Boone, NC; Chicago International Art Exposition Education: U. of Maryland; Columbia U. Dealer: Roy Boyd Gallery, Chicago and Santa Monica, CA

For the past 16 years, his work has been concerned with the creation of monumental and public sculpture. He brings to the work the extensive knowledge he gained in his doctoral program, experimenting with metals, metal fusion, and chemical and electro-chemical protective surfaces. While he anticipates certain characteristics of form, he usually conceives of the idea for the sculpture through the direct manipulation of the material, typically sheet and plate metal. During the initial process, he says he looks for unique events of compound stress formations that are structurally viable and exciting. While he sometimes combines or assembles very large units into one piece, the works are generally conceived as monolithic forms. The pieces not only engage the viewer in their restrained yet dynamic form, but also in their fresh choice of color, examples of which are Hot Springs, an orange-pink, jagged arch, and Precipice, a pineapple-colored work that resembles a space-age Christmas tree.

WHIPPLE, JEFF (Painter)

2040 W. Le Moyne, Chicago, IL

Born: 1957 Awards: Florida Artist Fellowship; Illinois Arts Council Fellowship Exhibitions: Sybil Larney Gallery, Chicago; Florida St. U., Tallahassee Education: U. of S. Florida Dealer: Sybil Larney Gallery, Chicago; Barbara Gillman Gallery, Miami

He presents realistically rendered figures and objects in vignettes that seem to float on a surface of colors and markings. Works with titles such as Ambition and What Are Friends For are attempts to make the viewer contemplate the relationships of the images presented on the canvas. Though he works in all two-dimensional media, he primarily paints in oil. Since the mid-1980s he has also been writing plays and doing performance pieces. Seven of these works have been produced in Chicago.

WHITE, PHILIP B. (Painter)

710 Clinton Pl., River Forest, IL 60305

Born: 1935 Awards: National Academy of Design Award of Merit; Union League Club Collections: Union League Club, Chicago; Borg Warner Corp., Chicago Exhibitions: Oeschlaeger Gallery, Chicago; Campanile Gallery, Chicago Education: U. of Southern California

His realistic paintings combine precise detail, a soft quality of light, and a careful study of the fleeting moment to create uniquely personal statements about his vision of life and the people around him. Working in egg tempera, he uses colors that are rich yet transparent, evoking a visceral feeling of life in the subjects of his paintings. Traditional subject matter, particularly portraits and figure studies, are treated with an eye toward clarity and simplicity of communication, allowing emotional and sensory impressions to be created for the viewer. His use of light is particularly luminous, underscoring a sense of time and place through its almost tangible presence. Reminiscent in feeling to the work of Dutch Masters, his images are drawn from the Midwest, capturing the qualities of life there.

WILDE, JOHN (Painter, Draftsperson)

RFD 1, Box 429, Evansville, WI 53536

Born: 1919 Awards: Childe Hassam Purchase Award, National Academy of Arts & Letters; Lambert Prize, Pennsylvania Academy of the Fine Arts Collections: Whitney Museum of American Art, NYC; Art Institute of Chicago Exhibitions: Metropolitan Museum of Art, NYC; Museum of Modern Art, NYC Education: U. of Wisconsin, Madison Dealer: Perimeter Gallery, Chicago

The artist meticulously crafts intimate, introspective paintings and drawings that combine reality with elements of the fantastic. Influenced by the work of the 15th-and 16th-century Northern Europeans and the 14th-and 15th-century Italians, as well as by surrealists such as Max Ernst, he works from images which come to mind spontaneously. Paintings are done in oil on gessoed wood panels using many layers of glazes and, lately, a slightly greater impasto. Drawings are executed in silverpoint, pencil, or wash. The intimacy and small scale of his work are a conscious reaction to the overly expressive nature of much contemporary art.

WILEY, WILLIAM T. (Painter, Assemblage Artist)

615 Main St., Sausalito, CA 94965

Born: 1937 Awards: Purchase Prize, Whitney Museum; William H. Bartels Prize, Art Institute of Chicago Collections: Museum of Modern Art, NYC; L.A. County Museum of Art Exhibitions: Museum of Modern Art, NYC; Art Institute of Chicago Education: San

Philip White, *January Thaw,* 24 x 36, oil

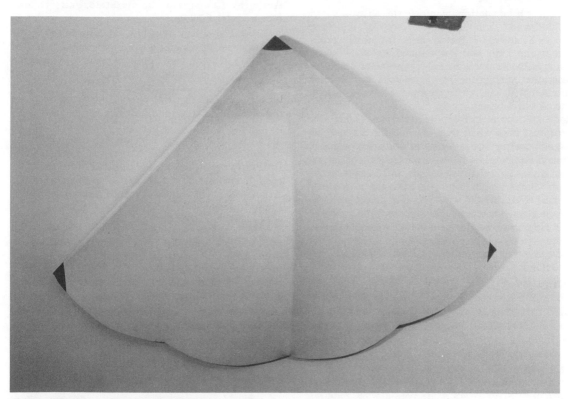

Hodges Williams, *White Shape,* 40 x 56 x 6, acrylic

Francisco Art Institute *Dealers:* Hansen Fuller Goldeen Gallery, San Francisco; Allan Frumkin Gallery, NYC

Early paintings are expressionistic and full of mysterious symbols. He gained recognition in the mid-1960s as a California Funk artist, painting images of minutiae related to Surrealism and Dadaism. Comic-strip figures and children's book illustrations are combined with mystical landscapes in off-beat works related to Pop. Verbal puns accompany fragments of letters, logs, and notebooks in collages and constructions. Objects such as feathers, string, rope, and branches--suggesting American Indian artifacts--and children's games of cowboys-and-Indians are incorporated into three-dimensional works which show a love for the American West. Imaginative drawings, such as *The Balance is Not So Far Away From the Good Old Daze*, are meticulously drawn and show infinite spatial planes, imaginary charts, and metaphysical objects.

WILHELMI, WILLIAM (Ceramist)
1129 Ocean Dr., Corpus Christi, TX 78404

Born: 1939 *Awards:* Texas Art Award; First Place, CC Arts Foundation Award *Collections:* Long Beach Museum of Art, CA; Everson Museum of Art, NY *Exhibitions:* Lean Albano Contemporary Art, Chicago; Lester Lampert, Chicago *Education:* UCLA; San Diego State U. *Dealer:* Holland/Wilhelmi Gallery, Corpus Christi, TX

Art critics have admiringly referred to the artist's work as "odd-mod," "unashamedly decorative," and "consciously beautiful." Wilhelmi admits to pushing decoration to the limit and has dubbed his work "awake fantasies." Most pieces are richly ornamental and highly decorative, taking cues from Luca della Robbia, Peter Max, Art Nouveau, Art Deco, and the Near and Middle East. A wheel-oriented potter trained in the traditional mode, his departures from the useful vessel seem to be functional even when they are not--for example, his ceramic cowboy boots, a pair of which are owned by Ronald Reagan. His repertoire includes such diverse creations as light fixtures, murals, and ceramic medallions. Glazes range from rich earth tones to glossy, tropical colors of soft, subtle pastels; pieces are richly ornamented with appendages of roccoco coils and carvings. He draws repeatedly upon the prominent flora of South Texas, adorning his pieces with images of palm trees, cactuses, banana leaves, birds of paradise, and calla lillies.

WILLERS, BILL (Sculptor)
c/o U. of Wisconsin, Oshkosh, Oshkosh, WI 54901

Born: 1938 *Collections:* C. Upjohn; Ray-O-Vac Corporation *Exhibitions:* Madison Art Center, WI; Zaks Gallery, Chicago *Education:* Colorado State U. *Dealers:* Zaks Gallery, Chicago; Henri, Wash., D.C.

He is best known for his carved architectural miniatures, or human events stages. Using an artistic language of halls, doorways, stairs, passageways, windows, and furniture, he carves simple yet profound limestone representations of the interior locations of our lives. The forms, recognizable, yet abstracted, refer to universal human concerns for connection, communication, refuge, and community. The greatest influence on his art is his childhood, spent in Europe, the Middle East, and Japan, whose various ancient buildings deeply impressed him with their ability to unite disparate times and places. His most recent work includes shallow reliefs with abstract forms combined with architectural fragments.

WILLIAMS, HODGES A. (Painter)
5338 N. Kenmore, Chicago, IL 60640

Born: 1954 *Awards:* Hyde Park Art Center *Collections:* Christian Loppe Peyrin, Inc., Chicago *Exhibitions:* Hyde Park Art Center, Chicago; Corsh Gallery, Chicago *Education:* Columbia College, Chicago *Dealer:* Corporate Art Source, Chicago

The minimum constituents of physical phenomena and objects, such as light, air, a floor, and a wall, are the starting point from which their abstracted correlates, shape, dimension and color, are explored. The resultant works are not reductionistic analyses however, but are reconstructions which strive to harmonize energy and movement, the intellect and the emotional/sensual. In such work, color and shape are languages independent of images, and they are expressed in three-dimensional shaped canvases.

WILLIAMS, STEVEN A. (Painter)
4448 S. Michigan Ave., Chicago, IL

Born: 1949 *Awards:* First Prize, Chicago Housing Authority *Exhibitions:* Illinois State Fair; Palmer House Hotel, Chicago

A native Chicagoan, Williams has contributed to his hometown with his mural work, painting a mural of Chicago's founder, Jean Baptiste DuSable, in the heart of downtown, as well as a mural of *The Last Supper* in St. Mary of the Lake Catholic Church. Working in acrylics, oils, chalk, and pencils, his work includes thousands of paintings and drawings. He counts Picasso as a primary early influence, but he has concentrated mainly on creating his own images. His recent portraits in oil, however, are photorealistic, with emergent surrealistic qualities. Included in his list of portraits is that of Malcom X, which now hangs in one of Sammy Davis, Jr.'s hotels; his most famous portrait is perhaps that of former Illinois Governor Richard B. Ogilvie.

WIMBERLEY, JOHN (Photographer)
2298 Cornell, Palo Alto, CA 94306

Born: 1945 *Collections:* Chevron U.S.A.; Syntex Corporation *Exhibitions:* Gallerie Zur Stockeregt, Zurich; Museum of Contemporary Arts, Houston *Dealer:* J.J. Brookings & Co., San Jose

Though he began making photographs in 1966, it was not until after a 1969 mystical experience in Del Puerto, CA, that he found his style. He works solely in black and white and looks for intensity of meaning in his figures and animistic nature images. In his late 1970s Mt. Diablo landscape series, "Spinning Trees," he saw sky and earth as metaphors for spirit and matter. This work led to his underwater photographs of the early 1980s where spirits of women seem to be floating mid-air in a magical environment of fire and water. He

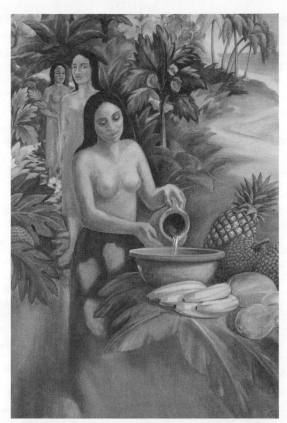

Willow Winston, *Tahiti Paradise (detail),* 99 x 48 , oil
on canvas. Courtesy: Oyster Marine Ltd., Ipswich

Cecilia Wood, *untitled,* 14 diameter, unglazed slip painting, plate clay

has been influenced by Ansel Adams. His camera is a Sinar 5x7 and his film is Kodak T-Max 180.

WINSLOW, ROBERT (Sculptor)
2352 North Clybourn, Chicago, IL 60614

Born: 1949 *Collections:* Arizona State U.; L.A. County Art Museum *Exhibitions:* AES Gallery; Art Expo '88 *Education:* Arizona State U.; U. of California *Dealer:* AES Gallery, Chicago

Prolific in several media, he is most noted for his work as a sculptor, specifically as a stone carver. Among his secondary pursuits are painting, etching and drawing. A strong elemental feeling is present in his early work of the 1970s, associated with his formative years in Arizona. His sculpture from that time is abstract, showing heavy influences from primitive art and tending to be geometric with harder edges. His move to Chicago in the early 1980s marked a turning point in his work. Overall, his forms softened and became more organic. In the mid 1980's his biomorphic forms have become cleaner, streamlined and refined. He sculpts delicate, fabric-like forms that appear to ripple in waves of melodic movements.

WINSTON, WILLOW (Painter, Printmaker)
42 Tall Oaks Dr., East Brunswick, NJ 08816

Born: 1943 *Awards:* Stowells Trophy Centenary Prize for Printmaking, Royal Academy, London *Collections:* Muffield College, Oxford, England; Oyster Marine Ltd., Ipswich, England *Exhibitions:* Janice S. Hunt Gallery, Chicago; Scott McKennis Gallery, Richmond, VA *Education:* Central School of Art, London *Dealer:* Janice S. Hunt Galleries, Inc., Chicago

Initially influenced by Rembrandt and William Blake, her early detailed mezzotints and finely cut wood engravings were poetic and visionary illustrations for the ancient Chinese philosophical work, *Tao te Ching,* and for the work of American writer Kim Chernin. Influenced by Poussin's composition and Georgia O'Keeffe's clarity, she eventually turned to oils. The themes of nature's underlying rhythms and of man's ability to live in harmony with them are evident in her landscapes, figures, and interiors. In *Heather--Cafe Comercial, Madrid* she connected the infinity of wall mirrors with a concentrating figure. *Chicago Wedding* is an homage to that city's diverse architecture.

WINTERS, TERRY (Painter)
c/o Sonnabend Gallery, 420 West Broadway, New York, NY 10012

Born: 1949 *Exhibitions:* Museum of Fine Arts, Boston; The St. Louis Art Museum, MO *Education:* Pratt Institute *Dealer:* Sonnabend, NYC

Subjects are derived from scientific diagrams of the structure of natural objects. These primary forms, a synthesis of organic and geometric form, are repeated and varied. In recent works the structural units are depicted within an ambiguous space that suggests the microscopic and the cosmic. Images evolve from inscriptions within the substantive "space" of the paint itself to enlarged and reduced variations which overlap in varying densities and degrees of focus. This treatment gives rise to associations with concepts such as the materialization of thought and the constant revision of its systems in its quest to know that which exists beyond appearances.

WIRSUM, KARL (Painter)
1936 Bradley, Chicago, IL 60613

Born: 1939 *Collections:* Whitney Museum, NYC; Museum of Contemporary Art, Chicago *Exhibitions:* Museum of Contemporary Art, Chicago; Krannert Museum of Art, Champaign, IL *Education:* School of the Art Institute of Chicago *Dealer:* Phyllis Kind Gallery, Chicago

Working in a variety of media, including painting, sculpture, and assemblage, he creates compositions characterized by a tongue-in-cheek humor, quirkiness, the use of puns and bafflement. In *Spitting Image*, a boxer, reflecting the pun in the title, is both spitting mad and spitting through two gaps in his teeth. Many works have a childlike and carnival-like quality about them, utilizing recognizable, popular images and bits of American icons. One canvas serves as an advertising bill portraying freak shows. Works reflect his life experiences and his unique visual associations. He has created a number of works using kites, one of which depicts Christ outstretched on the kite's cross-bars as if on a crucifix. Other work includes dolls made from macramé and doll-like sculptures. *Chest Peter* has movable arms and a penis with a metal hook to keep it erect.

WISE, FRANK R. (Painter)
1366 Terrace Dr., El Dorado, KS 67042

Born; 1949 *Collections:* Hank Cochran *Exhibitions:* Nelson-Atkins Museum of Art, Kansas City, MO; Mulvane Art Center, Topeka *Education:* Emporia State U. *Dealer:* Union Hill Arts, Kansas City

Influenced by Sheeler of the Precisionists and by Cottingham of the Photorealists, he conveys a simplified atmosphere of physical reality in acrylic-on-canvas paintings. Using a camera, he begins with formal abstracted compositional studies, finding common forms, often mechanical, and cropping them into uncommon compositions. A recent graduate exhibition included eight medium-sized (up to 3 x 3-foot) close-ups of the valves and curves of musical instruments. The closer views of his subjects open visual and emotional possibilities for him.

WISS, CHAR (Fiber Artist)
2864 Sheridan Place, Evanston, IL 60201

Born: 1930 *Awards:* Merit Award, 5th Evanston Juried Arts Exhibition *Collections:* State of Illinois Center Collection *Exhibitions:* Neville Sargent Gallery, Chicago; On Sight Art, Evanston, IL *Education:* American Academy of Art, Chicago

Originally a graphic artist and "Sunday painter," she experimented with a number of media until, in 1975, she took a weaving class, wherein she discovered the arts of tapestry and basketry and other three-dimensional work in fiber. Attracted to the simplicity of coiling and its limited materials (waxed linen available in ten colors wrapped over a wire or fiber core), she set about exploring the possibilities of fiber art. Much of her art consists of variations on the basket. Her baskets,

Kathy Newell Worby, *Breaking Free,* 19 x 25, mixed media. Courtesy: Collection of Gail Simpkins

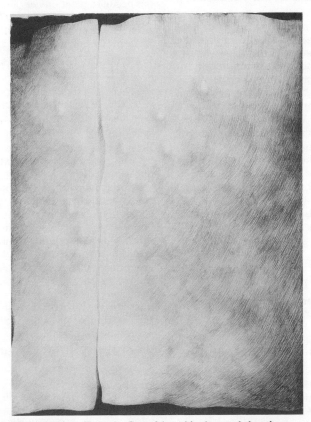

Victoria Yau, *Tears in Cast,* 34 x 44, charcoal drawing

sometimes triangular, sometimes oval, lack handles and are made with bumps and other irregularities that are both visually and tactually exciting. Patterns played out in the colors complement and contrast with the shapes and forms. Rather than lament the limited choice of colors, she enjoys the challenge it gives her design skills.

WITTENBERG, JET (Painter)
P.O. Box 534, Ogden Dunes, IN

Born: 1936 *Awards:* People's Choice Award, Indianapolis Art Museum *Exhibitions:* Fort Wayne Museum of Art; Art Institute of Chicago *Education:* St. Joseph's Academy *Dealers:* Thornhardt Berger Co.; De Bauer Fine Arts, Chicago

Her oil and watercolor paintings reflect an intimate familiarity with nature, flowers, and children. She lives in the Indiana Dunes along the edge of Lake Michigan and has studied the area's wildflowers, as well as the changing moods and colors of its sand, skies, and water. Using both brush and palette knife, she paints serene still lifes, florals, and primitive snow scenes. She has traveled to Africa, and the subjects she painted there include the water lilies of Tanzania and the elephants of Kenya.

WOHL, LAURIE (Painter)
1030 E. 50th St., Chicago, IL 60615

Born: 1942 *Exhibitions:* ARC Gallery, Chicago; Galerie Taub, Philadelphia *Education:* Columbia Law School, NY; Sarah Lawrence College *Dealer:* ARC Gallery, Chicago

Influenced particularly by modern artists Klee, Kandinsky, and Mondrian, she continues to explore the ritualistic, unspoken, but powerful religious elements in the psyche that form the spiritual content of art. Early pieces are strictly geometric and include a large body of "Desert Mandalas," which are ceremonial in nature, drawing on Egyptian, Coptic, Aztec, and American Indian symbols. While acrylic remains her medium of choice, the paintings have increasingly become highly textural; in some, areas are built up with modeling paste, while in others, paint is used primarily as a stain. The current body of work, "Ancient Messages," is envisioned as "found" tablets, scrolls, and artifacts unearthed from hidden places or desert sites. The symbols appear as raised figures reminiscent of hieroglyphics; the messages allude to the mysteries of birth, suffering, journeying, guardianship, and redemption.

WOLF (Ceramist)
1928 S. Jefferson, Chicago, IL 60616

Awards: Ragdale Foundation Scholarship; Community Arts Assistance Grant, Chicago *Collections:* Baltimore City Hall; Osaka City Hall, Japan *Exhibitions:* Northside Gallery, Chicago; Theater Project, Baltimore *Education:* School of the Art Institute of Chicago; Towson State U.

Ceramic jewelry, known as "Wolf Wear," and porcelains for the home, such as tiles, murals and mirrors, are created and distributed nationally by this artist. Drawing on her extensive travels, notably to Italy and Mexico, as well as on her interests in various historical and cultural movements, she fashions faces and miniature animal and human bodies to be worn as jewelry or simply displayed. Images vary from pixies to Renaissance grande dames, and frequently incorporate precious stones and metal lustres. She finds artists such as Bronzino, Carpaccio and Mantegna particularly inspirational. A new emphasis is the creation of postcard-sized bas relief tiles, in which ideas and techniques are drawn from religious and mystical stories from the 13th-16th centuries. These concepts are combined with modern technologies to create precious, whimsical and unique objects.

WOOD, CECILIA (Ceramist)
1320 W. Columbia #406, Chicago, IL 60626

Born: 1943 *Awards:* Michigan Council for the Arts *Exhibitions:* Detroit Institute of the Arts; Lill Street Gallery, Chicago *Education:* Eastern Michigan U. *Dealer:* Lill Street Gallery, Chicago; Selo-Shevel, Ann Arbor, MI

Beginning her career in painting, she worked in that medium from 1969 until 1975, when she began exploring ceramics, using inlaid copper for symbolic female figures depicting transformation. Studying in Japan and Korea, she has concentrated on sculpture and thrown forms in raku and oxidation-fired, metallic glazed porcelain. Developing large black surfaces as backgrounds for colorful and powerful human images, she employs a very painterly technique in creating the figures. She has begun to paint on her pottery recently as though it were a canvas. Simple, elegant forms in black glaze with silver specks on porcelain reflect the inner growth she has experienced in the eighties.

WOODLEY, JAMES E. (Photographer)
4510 S. Leamington, Chicago, IL 60638

Born: 1945 *Exhibitions:* J.B. Speed Art Museum, Louisville, KY; Museum of Science and Industry, Chicago *Education:* Columbia College, Chicago; Chicago Academy of Fine Arts

Beginning at age fifteen with a box camera given to him by his godmother, he continued to "paint with photographs" through school and college, and thereafter professionally. In 1985, he opened his own photo studio and gallery and, with grants from the City of Chicago, he taught photography classes to the neighborhood youth. Drawn to human dramas, he has captured a broad range of human expression, from climactic street scenes in Paris to quiet moments between mother and child at home in Chicago. Titles include *Peeping Tom*, *Men in White*, *A Long Walk*, *Imitation of Life*, and *Mother's Love*. All of the photographs present a brilliant coloration and a perspective that gives the viewer a feeling of being a part of the photograph.

WOODROW, BILL (Sculptor)

Alleyways, streets and junkyards are Bill Woodrow's archives. He collects raw materials for his art there, mostly mechanical and electrical appliances that are transformed into sculpture. Basic sheet metal is formed into accurately proportioned shapes, such as a fish, a human arm, a lobster, leaves, a chair or a hummingbird.

With a pair of tin snips and a hammer or drill, he cuts these images and bends them outward, while still attached to the original piece. For example, the metal on a car door is carved, bent and extended in leaf-like fans in *Trivial Pursuits*. It appears a car door has given birth to tree branches. Woodrow's sculpture focuses on the abusive impact man-made elements have upon natural elements. These crude objects with jagged shapes are often delicate and always beautiful.

WORBY, KATHY NEWELL (Painter)
909 Gamon, Wheaton, IL 60187

Born: 1956 *Collections:* Tatem Gallery, Fort Lauderdale, FL; Lakeview Museum of Arts and Science, Peoria, IL *Exhibitions:* Portfolio 4, Linlithgow, Scotland; Oakbrook Fine Art Promenade, Chicago; *Education:* Northern Illinois U.

A mixed-media artist comfortable with ink, watercolor, acrylic, and airbrush, she combines the influences of a number of "isms" to arrive at uniquely-fashioned work. Borrowing elements from expressionism, surrealism, and realism, she works with the images of animals--most recently with horses. Her series *Breaking Away et. al.* is strongly influenced by G.H. Rothe for the spiritual quality she gives her animals and Michael Parks for his use of realism in combination with dreamlike qualities. Here, horses breaking away from the confines of the carousel serve as a metaphor for breaking away to higher spiritual levels.

YAU, VICTORIA (Painter)
2609 Noyes, Evanston, IL 60201

Born: 1939 *Awards:* Chairman's Grant, Illinois Arts Council *Collections:* Dr. Y. Mizuno, Japan; Dr. K. Fugino, Japan *Exhibitions:* Kamakura Gallery, Tokyo, Dorothy Rosenthal Gallery, Chicago *Education:* U. of Puget Sound *Dealer:* Fairweather Hardin Gallery, Chicago

As an art critic for the *Mainichi Daily News* wrote, "her medium, watercolor collage, is an exquisite blend of finely crafted papers and delicately blended overlays of soft but colorful applied hues." Although best known for her sensuous, poetic watercolor collages, her more recent paintings include large, abstract oil landscapes that like her collages continue to explore a varied range of colors and forms--from the subtle to the vibrant, from the earthy to the whimsical. Whether in oil, pastel, or watercolor collage, all of her works are visual expressions reflecting her long personal interest in Chinese Imagery poetry. The artist derives her inspiration from Oriental philosophy, which has played an dominant role in her art. This aspect can be seen in works such as *Pause*, where she craes an atmosphere in which a piece of mineral is frozen to a standstill in the cosmos.

YOES, AMY (Installation Artist)
1820 W. Cortland, Chicago, IL 60622

Born: 1959 *Awards:* Luso-American Foundation Grant, Portugal; Raymond Nelson Fellowship, School of the Art Institute of Chicago *Collections:* Bell and Howell *Exhibitions:* Dart Gallery, Chicago; Randolph Street Gallery, Chicago *Education:* School of the Art Institute, Chicago, U. of Arizona, Tuscon

Large scale installations utilizing rear projected animations, constructivist furniture, and kinetic elements in various theatrical settings have been her major area of interest since 1984. One installation, *Still Life,* creates an eerie green carnival world with flickering lights and cartoonish three- dimensional props set within a contemporary cubistic framework. To this add three small projectors rattling out animated films made by the artist. Her latest installations involve the use of marble for its specific historical significance. The projects incorporate elements such as water, heat, and fire; one piece consisting of eleven black marble urns that constantly pour water. She is currently working on collage relief paintings that make use of the refuse of the consumer culture. She sees these pieces as germinations for future installations.

YOO, DEBRA (Painter)
1355 W. Greenleaf, #1J, Chicago, IL 60626

Born: 1955 *Awards:* Honorable Mention, Rockford (IL) International Print and Drawing Exhibit *Collections:* Kemper Group, Long Grove, IL; State of Illinois Revenue Center, Springfield *Exhibitions:* Pain Art Center, Oshkosh, WI; Chicago Botanic Society, Glencoe, IL *Education:* U. of Chicago *Dealer:* Jan Cicero Gallery, Chicago

As a student with Vera Klement at The University of Chicago, she painted abstract geometric forms in color fields. After graduation she began working on realistic still lifes and was interested in reconciling the essentially abstract, formal qualities of her initial painting style with the very specific reality of her subjects. She is currently painting realistic still lifes, interiors, and landscapes with oil on canvas and casein or acrylic on paper. In these painterly works she displays intense colors and a strong sense of light. She suggests depth by creating a strong tension between the plane of the canvas and a diagonal composition. Her most recent work includes landscapes of Alpine scenes from a 1987 painting trip to Switzerland.

YOSHIDA, RAY KAKUO (Painter)
1944 N. Wood, Chicago IL 60622

Born: 1930 *Awards:* Frank G. Logan Medal, Art Institute of Chicago; Walter M. Campana Prize, Art Institute of Chicago *Collections:* Art Institute of Chicago; Museum of the Twentieth Century, Vienna *Exhibitions:* Art Institute of Chicago; Museum of Contemporary Art, Chicago *Education:* U. of Hawaii; School of the Art Institute of Chicago; Syracuse U. *Dealer:* Phyllis Kind Gallery, Chicago

Born in Hawaii, he was first recognized as a Chicago Imagist. *Comic Book Specimens* is a series of collages consisting of picture fragments and balloon captions from super-hero comic books arranged into strange narratives. Figural and object fragments are included in many of the paintings, as in *Partial Evidences*. Wavy stripes often cover an entire composition, modulating the images, giving the figures striped faces and striped clothing. This interest in the gradual metamorphosis of form, and in the subtle modulation of color are prevalent themes throughout his work. Later work contains geometrical forms articulated in intricate

patterns of dots and shapes and placed on backgrounds of the same minute patterning.

ZACK, MARILYN L. (Painter)
560 Linden Rd., Frankfort, IL 60423

Born: 1947 *Exhibitions:* Northern Indiana Arts Association; Part Forest Art Center, IL

Having developed an individual impressionistic style with an emphasis on the use of color, the artist has proceded to paint landscapes of her local area: figures caught in the midst of an activity and portraits which capture the "inner person" of the sitter. Currently she is at work on a series of bathers and beach scenes as well as pictures reminiscent of old family album photographs. In all her work, the layering progression from wash to impasto, with traces of each step remaining in the finished piece, is an important aspect of their style, giving the pieces life, freshness and vibrancy. The oils display the influence of artists such as Sargeant, Monet, Degas and Burt Silverman.

ZAMORA, ANTHONI (Painter)
5540 N. Lotus Ave., Chicago, IL 60630

Born: 1909 *Awards:* Monetary Award, Polish Art Club of Chicago *Collections:* Estergom, Hungary, Private *Exhibitions:* Osnabruck, Germany; Fisher Galleries, Chicago *Education:* School of the Art Institute of Chicago

While growing up in Poland he drew the Polish kings, literary, and political figures with pencil. In college he studied under J. Palme, using nature and still lifes as his subject matter. With great freedom he painted with oil and watercolor, and drew with pencils and crayons. In 1939 he became a German prisoner of war and in 1944 he was forced into a Nazi slave labor camp. He returned to painting in 1945 and in 1950 he joined the faculty of the Art Institute of Chicago. He was acclaimed for his use of color and his work has been compared to that of the great Polish painters Podkowinski, Gierymski, and Ziomek. Zamora died while this book was in production.

ZEBRUM, CAMERON (Painter)
1642 W. Edgewater, Chicago, IL 60660

Born: 1955 *Awards:* Illinois Arts Council Artist Fellowship *Collections:* Private *Exhibitions:* Museum of Contemporary Art, Chicago; Chicago Cultural Center *Education:* Cleveland Institute of Art; Cranbrook Academy of Art *Dealer:* Gwenda Jay Gallery, Chicago

Having grown disinterested in the process-orientation of printmaking, he began to work in wood and paint for a more direct, organic effect. Using shaped constructions of wood slats to reinforce the painted image, as well as collage elements such as bark, beads, and map fragments, he creates pieces that function as both "borderline representational" observations of nature and resonant abstractions. The effect of the intensely hued brushwork, suggesting landscapes or garden scenes, over the familiar rhythmic geometry of the architectural slats evokes the complex experiences and shifting moods of everyday life, and reflects the influence of the spirituality and crafstmanship found in old boats and homes, as well as in American Indian artifacts.

ZEISLER, CLAIRE (Sculptor)
c/o Rhona Hoffman Gallery, 215 W. Superior, Chicago, IL 60610

Born: 1903 *Collection:* Art Institute of Chicago; Stedelijk Museum, Amsterdam *Exhibitions:* Whitney Museum; Art Institute of Chicago *Education:* Institute of Design, Chicago *Dealer:* Rhona Hoffman Gallery, Chicago

Small fiber works employ a double weave and are stuffed to form pillows. These are suspended in a filigree of web-like spiders' packets. Later work is monumental in scale and employs macramé and wrapping to create suspended forms with dramatic contrasts of hard, tightly-controlled wrapping and free-flowing ropes. In the more recent "Coil Series," she uses natural hemp, wool, and polyester in bright primary colors wrapped over steel coil to give the works a new dimension and liveliness.

ZIEMBO, DANIEL L. (Painter, Printmaker)
P. O. Box #16, 248 Grand Av., Lake Villa, IL 60046

Born: 1941 *Collections:* IBM; State of Illinois *Exhibitions:* Roy Boyd Gallery, Chicago; B. Z. Wagman, St. Louis *Education:* U. of Illinois *Dealer:* Roy Boyd Gallery, Chicago

His early work reflected an interest in the Midwest landscape, farming, and farm-family histories, both in painting and printmaking. Tightly realistic, the work was influenced by Diebenkorn and David Park. Later he moved toward a more lyrical and abstract style, and his current images are drawn from world-wide travel and natural subjects. He has begun to develop a printmaking technique in which the work is drawn directly onto mylar to make transparencies for the color separations. Using landscape as a bridge between abstraction and realism, he seeks to push his images as far as possible by distending and extending perspective while still maintaining an image that is recognizable. Present influences are Hockney and Joseph Raphael.

ZIMMERMAN, WILLIAM (Painter)
311 Dotson Dr., Ames. IA 50010

Born: 1920 *Awards:* First Prize, Breckenridge, Colorado *Collections:* Art Institute of Chicago *Exhibitions:* Breckenridge Gallery, CO; College of Design, Iowa State U. *Education:* School of the Art Institute of Chicago; Iowa U.

Finding that his formal training restricted his natural inclinations, he set out to retrain himself. The training began with trips into the wilderness where he could reconnect with the "great scheme of the cosmos" as well as his human historical roots. The paintings that followed have included oil and watercolor portraits and landscapes, some realistic, some abstract. In the work, he attempts to synthesize forms derived from that which is common to humanity. He is drawn historically to the great Western traditions of Greek classical art and to the romanticism of the 18th and 19th centuries--the Greek for its intellectual content, the romantic for its service to the sublime and the picturesque. Currently

he splits his time between painting portraits and writing a book on the history of Greek art.

ZOST, JOSLYN (Draughtsperson, Printmaker)
432 N. Austin Blvd., Oak Park, IL 60302

Born: 1960 *Collections:* Alma College permanent collection *Exhibitions:* Artemesia Gallery, Chicago; Expressions Gallery, Oak Park, IL *Education:* Albion College, Albion, MI, Grand Valley State College, Grand Rapids, MI

Influenced by her studies in anthropology, her first drawings, prints, and paintings have a primitive quality and subject matter, though progressively they demonstrate the artist's own style. Some of her present drawings are sincere portraits of "people out of her head." The starkness in which the plain white background plays against the graphite, charcoal, and warm pastel skin tones gives the work a unique quality. Her drawing has a childlike honesty that varies in degress of sophistication and technique from piece to piece. The present works are large scale (7 feet square and larger) drawings in charcoal, which are dream-like scenes of figures, shadows, and lines.

ZWICK, ROSEMARY (Sculptor, Painter, Printmaker)
1720 Washington St., Evanston, IL 60202

Born: 1925 *Collections:* Standard Oil Co., Chicago; United States Post Office, San Francisco *Exhibitions:* Chicago & Vicinity Exhibitions, 1947-56; Indianapolis Museum of Art *Education:* Iowa State U.; School of the Art Institute of Chicago *Dealer:* Nina Owen, Ltd., Chicago

Working throughout her career in a variety of media and in modes of expression ranging from social realism to complete abstraction, she is currently dividing her time between abstract landscape paintings and prints based on personal experience and large sculptures of wood, metal, and clay. A recent series involved variations on the circle, symbolizing the philosophical continuity of life. Constructed of laminated plywood and polished brass, the circles are broken and recombined with the addition of a variety of materials.

Antoni Zamora, *Portrait of My Wife,* 16 x 20, oil on canvas

Rosemary Zwick, *Duality,* 24 x 22 x 10, Stoneware and
Brass Rod

ADVERTISING PHOTOGRAPHERS OF AMERICA/CHICAGO CHAPTER
1725 W. North Ave., Chicago, IL 60622 (312) 342-1717

Chairman: Jeff Schewe *Director:* Linda Tuke *Annual Dues:* $300 *Members:* 150 *Eligibility:* Must receive half of total annual income from photography

Programs/Activities: Organizes seminars, lectures and educational programs geared towards advertising photographers. Lobbies for important issues. *Exhibitions:* Annual Black-Tie Formal Ball; Traveling Show comprised of members' work.

ART ENCOUNTER
927 Noyes, Evanston, IL 60201 (312) 328-9222

Co-Directors: Joanna Pinsky, Ellen Kamerling *Annual Dues:* $25 *Members:* 250

Programs/Activities: Organizes tours of art galleries, studios, museums and private collections and related events for corporations and private organizations. Offers workshops and classes in schools and senior citizen centers.

ART ON THE MOVE
1171 Linden Ave., Highland Park, IL 60035 (312) 432-6265

Director: Joan Arenberg

Programs/Activities: Organizes tours in Chicago area, nationally and abroad.

ART RESOURCES IN TEACHING (A.R.T.)
18 S. Michigan Ave., Suite 1004, Chicago, IL 60603 (312) 332-0355

Director: Amy Greenwood

Programs/Activities: Non-profit organization bringing visual art education to Chicago public elementary school children. Activities include hands-on workshops, museum tours, slide presentations and discussions.

ARTS MIDWEST
528 Hennepin Ave., Suite 310, Minneapolis, MN 55403 (612) 341-0755

Chairman: Wayne Lawson *Director:* David Fraher *Annual Dues:* None *Members:* Membership from nine Midwestern states *Eligibility:* Professional visual artist and non-profit exhibition spaces from nine-state region.

Programs/Activities: Arts Midwest/NEA Regional Visual Arts Fellowship Program; performing arts touring program; Meet the Composer/Midwest Program; Midwest Acquisitions Program.

BEVERLY ART CENTER
2153 W. 111th St., Chicago, IL 60643 (312) 445-3838

President: Jean Barclay *Manager:* Pat McGrail *Fee:* $25 (family) *Members:* 850 *Hours:* M-F 8-6 (evenings until 8 when classes in session), Sat 10-2, Sun 1-4

Programs/Activities: This community art center supports two art galleries, presents performing arts series and exhibitions of visual arts, and offers classes in art, music, drama, dance and crafts for children and adults. *Exhibitions:* The Pillsbury Concourse gallery presents monthly exhibitions of contemporary art; the Vanderpoel Gallery holds a permanent collection of late 19th- and early 20th-century art, part of which it displays at the Ridge Park Field House on the South Side, and also has periodic exhibits of contemporary artists. The Beverly Art Center's fair is held in June.

CENTER FOR ARTS CRITICISM
Market House 205, 289 E. 5th St., St. Paul, MN 55101 (612) 224-7849

President: Roy Close *Director* Patricia Clark Koelsch *Annual Dues:* None

Programs/Activities: Center provides public forums, lectures, workshops, roundtable discussions, conferences, and internships in art criticism. Center's grant programs contribute to development of critics and dissemination of art criticism. The organization works with print and broadcast media to develop new venues for art criticism.

CHICAGO ART DEALERS ASSOC.
107A W. Delaware Place, Chicago, IL 60610 (312) 649-0064

President: Roberta Lieberman *Executive Director:* Natalie van Straaten *Annual Dues:* None *Members:* 35 *Eligibility:* Membership is by invitation. Member galleries must have been in business for two years.

Programs/Activities: Not-for-profit organization recognizing the importance of integrity and responsibility in working with artists, collectors and museums. Provides programs for the public to cultivate a greater appreciation of fine arts, and promotes a greater awareness of Chicago as a major international art center.

CHICAGO ARTISTS' COALITION
5 W. Grand Ave., Chicago, IL 60610 (312) 670-2060

Director: Arlene Rakoncay *Annual Dues:* $25 *Members:* 2500

Programs/Activities: Offers various benefits and services to its members including: job referral service, slide registry, resource center, group health insurance and the monthly publication *Chicago Artists' Coalition News*.

CHICAGO COALITION FOR ARTS IN EDUCATION
1225 W. Belmont, Chicago, IL 60657 (312) 929-7287

Chairman: Eunice Joffe *Director:* Tammy Steele *Annual Dues:* $20 individual, $50 organization *Members:* 100

Programs/Activities: Coalition advocates increased and higher quality of arts educational programs in Chicago public and parochial schools. Produces *Chicago Art Resources: Growing Up With Art*, a directory listing more than 200 art organizations in Chicago and their art educational programs. Promotes annual "Arts in Education Week," as well as poetry, poster and performance events.

CONTEMPORARY ART WORKSHOP

542 W. Grand, Chicago, IL 60610 (312) 472-4004

Executive Director: John Kearney *Director:* Lynn Kearney

Programs/Activities: This not-for-profit organization was founded more than thirty years ago and is still operated by one of the original founders, John Kearney. Two gallery spaces are dedicated to group and solo shows of emerging Chicago artists, who submit portfolios and slides in anticipation of selection. The workshop has studio spaces available to renters, who are also selecting according to their portfolios. The organization works with the Threshold psychiatric rehabilitation center and has an apprentice program with the Art Institute.

NORTHERN INDIANA ARTS ASSOC.

1040 Ridge Rd., Munster, IN 46321 (219) 836-1839

President of the Bd. of Dir.: Jerome M. Gardberg *Director:* Marcia Carle *Annual Dues:* $25 individual, $35 family *Members:* 1,200

Programs/Activities: Organizes workshops, classes, fundraising events, lectures, performances, and exhibitions, etc. *Exhibitions:* "Curator's Choice, Indiana"; "New Directions: The New Media"; "Pride in Our Heritage"; "Salon Show." Artists: Benini, Vagnieres, Kleidon, Opel, Aller, Colombik, Feyrer and Shadur.

LATINO ARTS COALITION

850 N. Milwaukee Ave., Chicago, IL 60622 (312) 243-3777

Executive Director: Deanna Bertoncini *President:* Elba Rodriguez *Annual Dues:* $10 Students; $20 Individuals; $25 Families *Members:* 100

Programs/Activities: Sponsors the Latino Arts Coalition Gallery and promotes the work of Latino artists doing contemporary, cutting-edge work; works with artists on grantsmanship and sponsors lecture series coordinated with the subject matter of the gallery exhibitions. *Exhibitions:* "We the People," a 20 x 690-foot mosaic at the Cook County Correctional Facility featuring the work of 30 of the nation's leading Latino artists.

MARWEN FOUNDATION

325 W. Huron, #215, Chicago, IL 60610 (312) 944-2418

Chairman: Steve Berkowitz *Director:* Diane M. Fitzgerald

Programs/Activities: Not-for-profit art education organization devoted to the creation, appreciation and criticism of art among Chicago school children through community outreach programs and studio courses. Provides financial support for exceptional students from the Studio Program.

MICHIGAN COUNCIL FOR THE ARTS

1200 6th St., Detroit, MI 48226 (313) 256-3731

Chairman: Leon S. Cohan*Director:* Barbara K. Goldman *Annual Dues:* None *Members:* 15 *Eligibility:* Funded programs must take place in Michigan; creative artist grants assist Michigan artists

Programs/Activities: State agency that supports the arts through grants, technical assistance, publications, workshops and other exhibition and assistant programs.

MIDWEST PASTEL SOCIETY

P.O. Box 1698, Palatine, IL 60078-1698 (312) 991-3860

President: Priscilla Rae Whippo*Annual Dues:* $15 *Members:* 215 *Eligibility:* Only pure pastel, no oil

Programs/Activities: Sponsors seminars, demonstrations and exhibitions. Publishes a quarterly newsletter, *Strokes*. *Exhibitions:* "2nd Annual Members' Exhibition"; "Midwest Pastel '89: Fourth Annual National Juried Exhibition."

MI RAZA ARTS CONSORTIUM

1900 S. Carpenter, Chicago, IL 60608 (312) 829-1620

Executive Director: Jose Gonzalez *Membership Dues:* $15.00 for individuals; $25.00 for community organizations; $35.00 for institutions

Programs/Activities Promotes Latino artists and their work; Publishes MIRARTE, a newsletter offering news of Latino artists, exhibits, funding sources, and arts issues *Exhibitions* "Day of the Dead"; "Frida y Diego: Una Pareja"; "Cinco de Mayo."

N.A.M.E. GALLERY

700 N. Carpenter, Chicago, IL 60622 (312) 226-0671

President: Sharon Connelly-Conklin *Director:* Christine Montgomery

Programs/Activities: Non-profit gallery exhibiting experimental performance, installation and site-specific work in addition to artists exploring painting, sculpture, and photography. Organizes panel discussions, lectures and gallery tours. *Exhibi-*

tions: Valentine's Benefit; "Performorama"; children's exhibition.

NOYES CULTURAL ARTS CENTER GALLERY

927 Noyes St., Evanston, IL 60201 (312) 491-0266

Chairman: Steven Fiffer *Director:* Joseph Zendell *Annual Dues:* None *Members:* 9 *Eligibility:* Members of Evanston Arts Council, appointed by Evanston Mayor.

Programs/Activities: "Landscape of the Mind" with Margaret Lanterman, Jacqueline Moses, Didier Nolet, and Sandra Perlow.

NEAR NORTHWEST ARTS COUNCIL

1579 N. Milwaukee Ave., Chicago, IL 60622 (312) 278-2900

Chairman: Laura Weathered *Director:* Eileen Ryan *Annual Dues:* $10 *Members:* 900 *Eligibility:* Artist or friend of the Arts

Programs/Activities: Organizes artist studio and gallery tours; produces newsletter, calendar, and exhibition opportunities; curates "Face the Street," a presentation of non-traditional art forms. *Exhibitions:* "My Country is Winter," Jill Armstrong, David Nash; "Recent Paintings," Lisa Lockhart; "Experimental Sound Studio," Perry Venson, Lou Mallozi; "North Light/South Light," Brazilian and Chicago artists; and "Day of the Dead."

OLD TOWN TRIANGLE ASSOCIATION

1763 N. North Park, Chicago, IL 60614 (312) 337-1938

President: Monika Betts (1989) *Administrator:* Marion Olson *Dues:* $15 individual, $25 family *Membership* 450 families

Programs/Activities: This organization is dedicated to the betterment of the historic Old Town community. Its artistic enterprises include an art school that offers classes in a wide range of visual arts; a gallery with new openings and shows monthly; and the Old Town Art Fair, one of the best known fairs of its kind the country.

SCULPTURE CHICAGO

840 N. Michigan Ave., Suite 600, Chicago, IL 60611 (312) 951-0094

Chairmen: Robert A. Wislow, Suzanne Clarke McDonough *Director:* Robin Franklin Nigh *Annual Fees:* None

Programs/Activities: Not-for-profit organization dedicated to the creation and presentation of monumental sculpture to the public. *Exhibitions:* "Invitational" including Vito Acconci, Richard Deacon, Judith Shea, Richard Serra; "Art-In-Progress Symposium" featuring emerging artists.

TEXTILE ARTS CENTRE

916 W. Diversey Pkwy., Chicago, IL 60614 (312) 929-5655

Chairman: David L. Johnson *Director:* Donna Hapac *Annual Dues:* Variable

Programs/Activities: Sponsors lectures, classes, workshops and films on textile arts including: weaving, knitting, spinning, basketry, dyeing, fabric painting/printing, quilting, etc. *Exhibitions:* "Wearable Art"; "Guatemalan Textiles"; "Quilt Show"; "Annual Faculty Show"; and "Architectural Tapestries."

WALKER'S POINT CENTER FOR THE ARTS

438 W. National Ave., Milwaukee, WI 53204 (414) 672-2787

Chairman: Richard J. Kendro *Directors:* Jane Brite, Phyllis Chicorel *Annual Dues:* $26 Individuals, $13 Artists *Members:* 160 *Eligibility:* Proven exhibition/performance record (for artist membership only)

Programs/Activities: Not-for-profit organization that promotes interdisciplinary collaborations including music, video, film, site installations and performance art. Organizes student workshops, tours and local activities. *Exhibitions:* "A Venture Into Installation"; "Poetry Reading/Poetry Book Exhibit"; "Lost Knowledge"; "Employment/Unemployment" performance art; various site-specific and participatory installations.

WOMEN IN THE DIRECTOR'S CHAIR

3435 S. Sheffield Ave., #3, Chicago, IL 60657 (312) 281-4988

President: Linda Leifer *Office Coordinator:* Karen Carlson *Annual Dues:* $25 *Members:* 300 *Eligibility:* Interest in female film/video artists

Programs/Activities: "Works-In-Progress" screening and discussion of unfinished film/video projects, "Members-Only-Salon" screening held in member's homes. *Exhibitions:* "1989 Women in the Director's Chair 8th Film & Video Festival."

WOMEN IN DESIGN

400 W. Madison, Suite 2400, Chicago, IL 60606 (312) 648-1874

President: Sherry Trojniar Russo *Annual Dues:* $35 new member, $30 renewal *Members:* 200 *Eligibility:* Individuals interested in graphic, textile and interior design.

Programs/Activities: Monthly and special programs with subject matter as determined by annual membership surveys.

GALLERIES CROSS-REFERENCED BY SPECIALTIES

The following list represents concentrations and not necessarily the exclusive focus of the gallery; because of the multiplicity of styles they represent, many galleries have more than one listing. For complete gallery descriptions, consult the Gallery section beginning on page 37.

ANCIENT
DOUGLAS DAWSON GALLERY
THE GRAYSON GALLERY

AFRICAN
NICOLE GALLERY, THE ART OF HAITI
DOUGLAS DAWSON GALLERY
GILMAN/GRUEN GALLERIES
MICHAEL WYMAN GALLERY

ALTERNATIVE SPACE
ARC GALLERY
BEACON STREET GALLERY & PERFORMANCE CO.
CONTEMPORARY ART WORKSHOP
CRANE GALLERY
MO MING GALLERY
MORE BY FAR
N.A.M.E. GALLERY
PAPER PRESS GALLERY & STUDIO
RANDOLPH STREET GALLERY
SCHOOL OF THE ART INSTITUTE OF CHICAGO, GALLERY II

AMERICANA
W. GRAHAM ARADER III GALLERY
CARL HAMMER GALLERY

APPLIED ART
FLY BY NIGHT

ART FURNITURE
CHIAROSCURO
HOAKIN KAUFMAN GALLERY
B.C. HOLLAND
OBJECTS GALLERY
PARENTEAU STUDIOS ANTIQUES GALLERY

ASIAN/PACIFIC
GILMAN/GRUEN GALLERIES
LLOYD SHIN GALLERY
MICHAEL WYMAN GALLERY
YOLANDA GALLERY OF NAIVE ART

CONTEMPORARY
AES FINE ART GALLERIES
AMERICAN WEST
ARTPHASE I
MARY BELL GALLERIES
BEACON STREET GALLERY & PERFORMANCE COMPANY
CAIN GALLERY
CENTER FOR CONTEMPORARY ART
CHIAROSCURO
JAN CICERO
EVA COHON GALLERY
COMPASS ROSE GALLERY
CORPORATE ART SOURCE, INC.
DART GALLERY
DE GRAAF FINE ART, INC.
DESON-SAUNDERS GALLERY
CATHERINE EDELMAN GALLERY
FAIRWEATHER HARDIN
WALLY FINDLAY GALLERIES
GILMAN/GRUEN GALLERIES
GOLDMAN/KRAFT GALLERY, LTD.
RICHARD GRAY GALLERY
THE GRAYSON GALLERY
GROVE ST. GALLERY
HABATAT GALLERIES
HOFFMAN GALLERY
HOKIN KAUFMAN GALLERY
BILLY HORK GALLERIES
JOY HORWICH GALLERY
JANICE S. HUNT GALLERIES
GWENDA JAY GALLERY
R.S. JOHNSON INTERNATIONAL
KASS/MERIDIAN
PHYLLIS KIND GALLERY
KLEIN GALLERY
SYBIL LARNEY GALLERY
LATINO ARTS COALITION GALLERY
LAREW'S GALLERY
ROBIN LOCKETT GALLERY
R.H. LOVE GALLERIES, INC.
MERCALDO GALLERY
MERRILL CHASE GALLERIES
PETER MILLER GALLERY
MINDSCAPE GALLERY
ISOBEL NEAL GALLERY, LTD.
NEVILLE-SARGENT GALLERY
O'GRADY GALLERIES, INC.
PERIMETER GALLERY
PRESTIGE GALLERIES
RAMSAY GALLERY
RIZZOLI GALLERY
BETSY ROSENFIELD GALLERY
J. ROSENTHAL FINE ARTS, LTD.
SAZAMA/BRAUER GALLERY
SCHOOL OF THE ART INSTITUTE OF CHICAGO, COLUMBUS DR. GALLERY
SCHOOL OF THE ART INSTITUTE OF CHICAGO, GALLERY II
LLOYD SHIN GALLERY
SKOKIE PUBLIC LIBRARY GALLERY
STATE OF ILLINOIS ART GALLERY, CHICAGO
SAMUEL STEIN FINE ARTS
STRUVE GALLERY
TOWER PARK GALLERY
UPSTART GALLERY
VAN STRAATEN GALLERY
RUTH VOLID GALLERY
WALTON STREET GALLERY
DONALD YOUNG GALLERY
THE ZAKS GALLERY
ZOLLA\LIEBERMAN GALLERY

CRAFTS/DECORATIVE ART
CHIAROSCURO
FABRILE GALLERY, LTD.
FLY BY NIGHT
JOY HORWICH GALLERY
ILLINOIS ARTISAN SHOP
MERRILL CHASE GALLERIES
MINDSCAPE GALLERY
PARENTEAU STUDIOS ANTIQUES GALLERY
REZAC GALLERY
ESTHER SAKS GALLERY

EASTERN EUROPEAN
JACQUES BARUCH GALLERY, LTD.

EUROPEAN
DESON-SAUNDERS GALLERY
WALLY FINDLAY GALLERIES
FLY BY NIGHT
B.C. HOLLAND
EDWYNN HOUK GALLERY
PARENTEAU STUDIOS ANTIQUES GALLERY
PRINCE GALLERY
RAMSAY GALLERY
GALLERIES MAURICE STERNBERG
VAHLKAMP & PROBST GALLERY, INC.
VAN STRAATEN GALLERY
WORTHINGTON GALLERY

FIBER ART
JACQUES BARUCH GALLERY, LTD.
DOUGLAS DAWSON GALLERY

FILM/VIDEO/PERFORMANCE
ARC GALLERY
BEACON STREET GALLERY
CRANE GALLERY
MO MING GALLERY
RANDOLPH STREET GALLERY
SCHOOL OF THE ART INSTITUTE OF CHICAGO, GALLERY II

FOLK
BEACON STREET GALLERY & PERFORMANCE COMPANY

GALLERIES CROSS-REFERENCED BY SPECIALTIES

HAITIAN
NICOLE GALLERY, THE ART OF HAITI
GILMAN/GRUEN GALLERIES

HISTORICAL PERIODS
CAMPANILE GALLERIES, INC.
WALLY FINDLAY GALLERIES
FLY BY NIGHT
B.C. HOLLAND
EDWYNN HOUK GALLERY
R.S. JOHNSON INTERNATIONAL
R.H. LOVE GALLERIES, INC.
MERRILL CHASE GALLERIES
MONGERSON-WUNDERLICH GALLERIES
PARENTEAU STUDIOS ANTIQUES GALLERY
PRESTIGE GALLERIES
PRINCE GALLERY
SAMUEL STEIN FINE ARTS
GALLERIES MAURICE STERNBERG
VAHLKAMP & PROBST GALLERY, INC.
WORTHINGTON GALLERY

ISRAELI
GOLDMAN-KRAFT GALLERY, INC.

JAPANESE
AIKO'S
KLEIN GALLERY

JEWELRY
ARTIFACTS
CHIAROSCURO
FLY BY NIGHT
REZAC GALLERY

LATINO
LATINO ARTS COALITION GALLERY
NEEDLMAN GALLERY

MAPS
W. GRAHAM ARADER III GALLERY

MIDWESTERN/REGIONAL
CAMPANILE-CAPPONI ART CONSULTANTS
LAREW'S GALLERY
RIZZOLI GALLERY

NAIVE
CARL HAMMER GALLERY
PHYLLIS KIND GALLERY
YOLANDA GALLERY OF NAIVE ART

NATIVE AMERICAN
AMERICAN WEST
PRAIRIE LEE GALLERY

NON-EUROPEAN
DOUGLAS DAWSON GALLERY

PHILIPPINE
AD-INFINITUM

PHOTOGRAPHY
EHLERS CAUDILL GALLERY, INC.
EDWYNN HOUK GALLERY
RIZZOLI GALLERY
BETSY ROSENTHAL GALLERY

PRIMITIVE
THE GRAYSON GALLERY
MICHAEL WYMAN GALLERY

PRINTS
AIKO'S

W. GRAHAM ARADER III GALLERY
CAMPONILE-CAPPONI ART CONSULTANTS
CHICAGO CENTER FOR THE PRINT/HUNT-WULKOWICZ GRAPHICS
EVA COHON GALLERY
R.S. JOHNSON INTERNATIONAL
KASS/MERIDIAN
LANDFALL PRESS, INC.
MERCALDO GALLERY
MERRILL CHASE GALLERIES
PRINTWORKS GALLERY
J. ROSENTHAL FINE ARTS, LTD.
VAN STRAATEN GALLERY
SAMUEL STEIN FINE ARTS

PUBLIC SPACES
FERMILAB GALLERY

SCULPTURE
HABATAT GALLERIES
OBJECTS GALLERY
NINA OWEN
SKOKIE PUBLIC LIBRARY GALLERY

SOVIET
STRUVE GALLERY

TAPESTRY
DEGRAAF FINE ARTS

WESTERN AND SOUTH-WESTERN
AMERICAN WEST
PRAIRIE LEE GALLERY

WOMEN'S ART
ARC GALLERY
ARTEMISIA GALLERY

THE ART INSTITUTE OF CHICAGO

Director: James N. Wood

President: Laurence Chalmers Jr.

Vice President of Development and Public Affairs: Larry Ter Molen

Executive Director of Public Affairs: Eileen Harakel

Director of Publications: Susan F. Rossen

President of The School of The Art Institute: Anthony Jones

Africa, Oceania, and the Americas *Curator:* Richard F. Townsend

American Arts *Field-McCormick Curator of American Arts:* Milo M. Naeve

Architecture *Curator:* John R. Zukowsky

European Decorative Arts and Sculpture Eloise W. Martin *Curator:* Lynn S. Roberts

European Painting *Curator of European Painting Before 1750, Acting Departmental Head:* Martha A. Wolff

Oriental and Classical Art *Curator, Departmental Head:* Jack Sewell

Photography *Curator:* David B. Travis

Prints and Drawings *Prince Trust Curator of Prints and Drawings, Department Head:* Douglas W. Druick

Curator, Earlier Prints and Drawings: Suzanne F. McCullagh

Textiles *Curator:* Christa C. Thurman

Twentieth-Century Painting and Sculpture *Curator, Departmental Head:* Charles F. Stuckey

Curator: Neal D. Benezra

Conservation *Executive Director:* William R. Leisher

Museum Education *Executive Director:* John K. Lydecker

Ryerson and Burnham Libraries *Executive Director:* Jack P. Brown

BALZEKAS MUSEUM OF LITHUANIAN CULTURE

Chairman of the Board/President: Stanley Balzekas Jr.

Executive Director: Val Ramonis

Children's Museum/Education *Director:* Pat Bakunas

Performing Arts *Head:* Nijole Martinaitis

MARY AND LEIGH BLOCK GALLERY

Director: David Mickenberg

Asst. Dir. of Collections: James Riggs-Bonamici

CHICAGO HISTORICAL SOCIETY

President/Director: Ellsworth Brown

Director of Curatorial Affairs: Susan Tillett

Conservators: Carol Turchan, Anna Kolata

Architecture *Curator:* Wim de Wit

Archives/Manuscripts *Curator:* Archie Motley

Costumes *Curator:* Elizabeth Jachimowicz

Decorative/Industrial Arts *Curator:* Robert Goler

Painting and Sculpture *Curator:* Wendy Greenhouse

Prints and Photographs *Curator:* Larry Biskochil

THE CHICAGO PUBLIC LIBRARY CULTURAL CENTER GALLERIES

Department of Cultural Affairs *Commissioner:* Joan W. Harris

Chicago Office of Fine Arts *Executive Director:* Madeline Murphy Rabb

Director of Visual Arts/Chief Curator: Gregory G. Knight

Curator of Exhibitions: Kenneth C. Burkhart

THE MARTIN D'ARCY GALLERY OF ART

Founder/Director: Rev. Donald F. Rowe

THE DU SABLE MUSEUM OF AFRICAN AMERICAN HISTORY

President Emeritus/Founder: Margaret Burroughs

President: Amina Dickerson

Chairman of the Board: Odel Hicks

Chief Financial Officer: Hezekiah Baker

Registrar: Theresa Christopher

Education Coordinator: Angela Rivers

Assistant Archivist: Toni Castoni

THE EVANSTON ART CENTER

President, Board of Trustees: Thurman Jordan

Executive Director: Martha Winans Slaughter

FIELD MUSEUM OF NATURAL HISTORY

Chairman of the Board: Robert A. Pritzker

President: Willard L. Boyd

Vice President/Collections & Research: Harold K. Voris

Anthropology *Curator:* Bennet Bronson

Botany *Curator:* John J. Engel

Geology *Curator:* John R. Bolt

Zoology *Curator:* Robert F. Inger

THE FREEPORT ART MUSEUM AND CULTURAL CENTER

Chairman of the Board: Dr. Wilma McNess

Director: Dane F. Pollei
Emeritus Director & Curator: Philip Dedrick

THE HYDE PARK ART CENTER

Chairman of the Board/President: Ruth Horwich
Director: Barbara Saniie

THE LIZZADRO MUSEUM OF LAPIDARY ART

Chairman of the Board: Russell M. Kemp
Director: John S. Lizzadro
Curator: Diana Nicholas

THE MEXICAN FINE ARTS CENTER MUSEUM

Chairperson, Board of Directors: Antonio V. Garcia
President: Helen Valdez
Executive Director: Carlos Tortolero

MITCHELL INDIAN MUSEUM AT KENDALL COLLEGE

Director/Curator: Jane T. Edwards

MUSEUM OF CONTEMPORARY ART

Chairman: Paul Oliver-Hoffmann
Immediate Past President: John D. Cartland
Deputy Chairman: Jerome Stone
Chief Curator: Bruce Guenther
Associate Director: Mary E. Ittelson
Public Relations Director: Maureen King
Education *Director:* Alice Piron

THE MUSEUM OF CONTEMPORARY PHOTOGRAPHY

Director: Denise Miller Clark

THE MUSEUM OF SCIENCE AND INDUSTRY

President/Director: James S. Kahn
Building Department *Acting Director:* Robert Stanton
Education *Director:* Barry VanDeman
Exhibits *Director:* Paul Huffer
Science *Acting Director:* Barry VanDeman

THE MUSEUM OF THE FINE ARTS RESEARCH AND HOLOGRAPHIC CENTER

Chairman of the Board: Leonard Rubin

Executive Director: Loren Billings
Curator: John Hoffmann
Education *Chairperson:* Jan Pels

THE ORIENTAL INSTITUTE MUSEUM OF THE UNIVERSITY OF CHICAGO

Director: Janet Johnson
Curator: Karen Wilson
Conservator: Laura D'Alessandro

THE PEACE MUSEUM

Chairman of the Board: Paul Gray
Director: Marianne Philbin
Curator: Lee Ann Schray

THE RENAISSANCE SOCIETY AT THE UNIVERSITY OF CHICAGO

President: Thomas C. Heagy
Director: Susanne Ghez

THE DAVID AND ALFRED SMART GALLERY

Acting Director: Jeffrey Abt
Curator: Richard Born
Visting Assoc. Curator: Sue Taylor

SPERTUS MUSEUM OF JUDAICA

Chairman of the Board: William Gofen
President: Howard Sulkin
Director: Dr. Morris Fred
Curator: Olga Weiss
Vice Pres. of Academic Affairs: Dr. Byron Sherwin

THE STATE OF ILLINOIS ART GALLERY

Director: Debora Donato

THE TERRA MUSEUM OF AMERICAN ART

Chairman/Founder: Daniel J. Terra
Director: Harold T. O'Connell
Curator: D. Scott Atkinson
Education *Head:* Roberta Gray Katz

UKRAINIAN INSTITUTE OF MODERN ART

President: Oleh Kowerko

INDEX

How to use this index: Museums, galleries and artists are listed below alphabetically. In the gallery section of the book, galleries are listed alphabetically with corresponding gallery numbers (in numerical order) next to their titles. Artists affiliated with or showing at a gallery are also indexed by gallery number, followed by the gallery's page number. For example, Keith Downie, indexed G# 58, 66, is found by locating gallery number 58 in the gallery section, which is the Sybil Larney Gallery on page 66. Artists whose names are in bold have reproductions which appear on the page number in bold.

A

Abakanowicz, Magdalena, 26
Abayta, Tony, G# 5, 36
Abbie, Lynn, 82
Abboreno, Anthony, 82
Abbott, Berenice, G# 83, 73
Abercrombie, Gertrude, 22
Abeshaus, Yevgeni, G# 37, 44
Acconci, Vito, G# 56, 65, 82
Ace, Zoa, G# 17, 40
Ad-Infinitum, 36
Adami, Valerio, G#28, 42; G# 37, 44
Adams, Hank Murta, G# 88, 74
Adams, Roger, 57, 82, 83
Addison, G# 63, 68
Adell, Carrie, G# 65, 68
Adler, Iris, G# 7, 37
AES Fine Art Galleries, 36
Africano, Nicholas, G# 25, 41; 82
Afshar, Ani, 57, 82, 83
Agam, G# 105, 79
Agnew, Therese, 84
Agostinellis, Dawn, G# 101, 78
Ahlstrom, Ronald, 84
Ahn, MiSook, G# 7, 37
Ahrendt, G# 28, 42
Aiko's, 36
Albert, Herman, G# 83, 73
Albrecht, B., 84
Albright, Bill, G# 90, 75
Allan, William, G# 56, 65
Allegretti, Marge, G# 72, 70, 84
Allen, Leslie, 84
Allen, Page, G# 51, 48
Allen, Terry, G# 56, 65
Altea, Lloyd, G# 68, 69
Alter, Amy, G# 17, 40
Altman, Edith, G# 69, 69; 84
Altman, Harold, G# 46, 47; G# 63, 68; G# 81, 72; G# 100, 78
Alvar, G# 81, 72
Alvarez, G# 81, 72
Amato, Cheselyn, 86
Amenoff, Gregory, G# 88, 74
American West, 36
Amft, Robert, 61, 85, 86
Ami, Karen, G# 2, 36
Amm, Sophia, 86
Amos, Emma, G# 70, 69
Anderle, Jiri, G# 10, 37
Anderson, Craig, G# 58, 66; 63, 85, 86
Anderson, Joy, 86
Anderson, Lorraine, 86
Anderson, Othello, 88
Andoe, Joe, G# 25, 42
Andre, Carl, 88
Andreu, Jose, 58, 87, 88

Angel, Dennis, G# 22, 41
Apgar, Jean, 88
Appel, Karel, G# 37, 44; 88
Arakawa, Shusaku, 89
Arbabi, Shahla, G# 72, 70
Arbus, Diane, 26
Arc Gallery, 36
Archer, Cynthia, 89
Ardell, Jack, 89
Ardissone, G# 34, 43
Armato, Mildred, 60, 87, 89
Armato, Patricia, 89
Armin, Emil, 22
Armleder, John, G# 25, 42
Arndt, Thomas, 89
Arneson, Robert, G# 56, 65; G# 99, 78
Arning, Eddie, G# 42, 46
Arnoldi, Charles Arthur, G# 53, 65; G# 55, 65; G# 56, 65; 90
Arseneau, Gary, 90
Art Institute of Chicago,, 10, 23
Artemisia Gallery, 37
Artifacts, 37
Artner, Alan, G# 2, 36
Artphase I, 37
Artschwager, Richard Ernst, G# 43, 46; 90
Atget, Eugene, G# 30, 42
Atkinson, Elizabeth Ann, 90
Aubin, Barbara, G# 32, 43
Audubon, John James, G# 6, 37
Auer, Hildegard, G# 106, 79
Augustin, Pierre, G# 73, 70
Ausman, Caroline, G# 2, 36
Avison, David, 90

B

Bacon, Francis, 26
Baehmann, Susan, 90
Bagenal, Caroline, G# 101, 78
Bahauddeen, Muneer, G# 70, 69
Baird, Andrew, G# 80, 72
Baj, Fontana, G# 28, 42
Bajuk, Erika, G# 36, 44
Baker, Gloria, 92
Baker, Joe, G# 5, 36
Bakker, Gabrielle, 92
Bala, Paul, 92
Balbo, Tom, G# 36, 44
Balcar, Jiri, G# 10, 37
Baldessari, John Anthony, G# 28, 42; 92
Balet, Jan, G# 105, 79
Balma, Mark, G# 104, 79
Balthus, G# 45, 47
Balzekas Museum of Lithuanian Culture, 18
Bamber, Judie, G# 16, 40

Bandris, Ruth, 88
Bandura, Natalia, 91, 92, 177
Bandy, Ron, 92
Bannard, Walter Darby, G# 61, 66; 93
Banys, Nyole, 93
Baptiste, Gene, G# 82, 72
Barazani, Morris, G# 36, 44; 93
Barbier, Annette, 93
Barlow, Michael, G# 70, 69
Barnard, Jamey, 93
Barnes, Kathy Chan, G# 101, 78
Barnum, Robert, G#40, 46,60, 91, 93
Baron, Hannelore, G# 84, 73
Barrett, Bill, G# 27, 42; G# 76, 70; 94
Barron, William, 94
Bartel, Marvin, 94
Barth, Charles, 94
Barth, Frances, G# 19, 40
Bartman, Maryann, 94, 95, 179
Baruch Gallery, Jacques, 37
Bastian, Linda, G# 19, 40
Bates, David, G# 88, 74
Bauer, Arik, G# 37, 44
Bauer, Marlene, G# 7, 37
Bauer, Ruth, G# 44, 47
Baum, Don, 94
Bauman, Joanne, 95, 96, 178
Baur, Mike, G# 110, 80
Bayalis, John, G# 91, 75; 96
Bayer, Robert, 96
Baynard, Ed, G# 97, 76
Beacon Street Gallery & Performance Company, 38
Beall, Nina, 96
Bean Bennett, G# 90, 75
Bearden, Romare, G# 70, 69
Becker, Arlene, 96
Beckmann, Max, G# 52, 48; G# 106, 79
Beeby, Thomas, 12
Beekman, Jan, 96
Beerman, John, G# 16, 40; G# 25, 42
Behrens, Susan, 98
Bejar, Felicino, G# 71, 69; 28
Belcher, Alan, G# 60, 66
Bell Galleries, Mary, 38
Bell, Jay Paul, G# 72, 70
Bell, Leslie, 97, 98
Bellevance, Leslie, 98
Belleza, Norma, G# 3, 36
Bellows, George, G# 15, 38
Beman, Roff, 24
Benda, Ric, G# 13, 38, 62, 97, 98
Bender, Janet Pines, G# 2, 36; 98
Benesh, Tom, G# 31, 43
Bengen, Berit, 100
Benglis, Lynda, G# 25, 42; G# 56, 65
Beninati, Carlo, 100

Benivedes, Christopher Davis, G# 90, 75

Benoit, Rigaud, G# 73, 70

Benson, Valerie, 100

Bent, Geoffrey, 100

Benton, Thomas Hart, G# 6, 37

Bercaw, Ruth Bowles, 100

Berdich, Vera, G# 83, 73, **99,** 100, **177**

Berggren, Ulla-May, 62, 99, 102

Berkowitz, Steven, 61, 101, 102

Berman, Zeke, 102

Bernard, Cindy, G# 86, 74

Bernstein, Rick, G# 41, 46; **67**

Berringer, Jennifer, G# 90, 75

Berti, Chris, G# 75, 70

Bertoia, Harry, G# 32, 43

Besler, Basil, G# 6, 37

Beyer, John, 102

Bezalel, Aharon, G# 37, 44

Biadholm, Sharon, 102

Bianchi, G# 28, 42

Bick, G. Elyane, G# 27, 42

Bigaud, Wilson, G# 73, 70

Bigbear, Frank Jr., G# 80, 72; 103

Bing, Ilse, G# 48, 48

Bingham, George, 35

Binkley, Joan, G# 21, 41

Bird, Damian, G# 51, 48

Bird, Jim, G# 90, 75

Birmelin, Robert, G# 89, 74

Bishop, Leon, 103

Blades, Barbara, 103

Blakely, Roger, G# 76, 70

Blank, Sandi, 64, 101, 103

Blatchford, Jaqui, 103

Bledsoe, Judith, G# 105, 79

Bloch, Susan, G# 7, 37

Block Gallery, Mary and Leigh, 20

Block, Carol, G# 7, 37; 103

Blosser, Nicholas, G# 22, 41

Blue, Robert, 104

Bobbe, Judith, 104

Bodmer, Karl, G# 6, 37

Boesche, John, 104

Bogle, Maureen, 104, 105, 178

Bohrod, Aaron, G# 91, 75; **53,** 104

Boileau, Lowell, G# 36, 44

Bolande, Jennifer, G# 60, 66

Bolle, Alan, 63, 104, **105**

Boltanski, Christian, G# 25, 42; 26, 106

Bonner, Jonathan, G# 44, 47

Bonoan, Istella, G# 3, 36

Book, Lynn, G#66, 68

Booth, George Warren, 106

Borby, Harry, G# 27, 42

Borniak, Lesia, 35

Borstein, Elena, 106

Borysewicz, Alphonse, G# 88, 74

Boschulte, Richard, 106

Bosman, Richard, G# 25, 42

Bosslet, Eberhard, G# 25, 42

Botero, Fernando, # 97, 76

Botti, Italo, G# 40, 46

Bourdon, Robert, G# 84, 73

Bourke, Mary, G# 58, 66

Bovard, Ronald, 64, 106, **107**

Bowen, Kenneth, 108

Boxer, Stanley, G# 44, 47

Boyle Family, The, 108

Bradley, David, G# 5, 36; G# 80, 72

Bradshaw, Constance, 107, 108, **180**

Bradshaw, Glenn, G# 72, 70; 108

Brakke, Michael, G# 28, 42

Brams, Krimmer, 108

Bramson, Phyllis, G# 25, 41; G# 56, 65; 32, 108

Branberg, Christina, 110

Braque, Georges, G# 34, 43; 22, 26

Brauer, Arik, 110

Brennan, Deborah A., 110

Brenner-Pullman, Esther, G# 12, 38

Breton, Jules, 16

Brevier, Evans R., 102

Brewer, Kathleen, 110

Brewer, Willam, 110

Briggs, Lamar, G# 72, 70

Britko, Steve, G# 80, 72

Broer, Roger, G# 80, 72

Brooks, Edward, 59, 109, 111

Brouwer, Charlie, G# 27, 42

Brown, Charlotte, G# 47, 47

Brown, Deborah, G# 19, 40

Brown, Frederick J., G# 44, 47; 111

Brown, John Gary, G# 23, 41

Brown, John George, G# 98, 76

Brown, Laura, 111

Brown, Matt, G# 16, 40

Brown, Nancy, G# 17, 40

Brown, Roger, G# 54, 65; G# 56, 65; **58,** 111

Brown-Wagner, Alice, 111

Browne, Byron, G# 99, 78

Brubaker, Jack, 112

Brueghel, Pieter, 18

Brugioni, David, 109, 112

Brulc, Lillian, 112

Brummel, Heinz, G# 65, 68

Bruskin, Grisha, G# 56, 65; G# 99, 78

Bucher, Suzanne M., 112

Buck, John, G# 56, 65

Budd, Erik, 112

Buehr, George, G# 32, 43

Buhot, Felix, G# 52, 48

Bujnowski, Joel, 112

Bunn, Kenneth, G# 74, 70

Bunster, Carmen, 114

Burden's, Chris, 26

Burkhart, Kenneth, 114

Burns, Sharon, 114

Burroughs, Sidney O., G# 7, 37

Burroughs, William S., G# 55, 65; 114

Burton, Sigrid, G# 44, 47

Bushman, David, 114

Buth-Furness, Christine, 115

Butler, Catherine, G# 65, 68

Butler, James P., G# 15, 38; G# 99, 78

Butler, Karen, G# 36, 44

Butterfield, Deborah, G# 111, 80, 115

Buttram Sr., David, 59, 113, 115

Byrne, Francis, 115

Bywaters, Diane, 115

C

Cady, Sam, G# 51, 48

Caillebotte, Gustave, 16

Cain Gallery, 38

Calder, Alexander, G# 20, 41; G# 38, 44; 26, 28

Callahan, Dennis, 115

Callow, George, G# 82, 72

Calvin, Jane, G# 83, 73; 116

Cameron, Brooke, 116

Cameron, Julia Margaret, 12

Campanile Galleries, Inc., 38

Campanile- Capponi Art Consultants, 38

Campoli, Cosmo, G# 22, 41

Campotosts, Harry, G# 81, 72

Canneto, Stephen, 116

Cannon, Catherine, 116

Canogar, G# 28, 42

Card, Susan B., 116

Carlson, Clair, 116

Carlson, George, G# 74, 70

Carlson, Lynn, 118

Carlson, William, G# 88, 74

Caro, Anthony, 118

Carpenter, Jane, G# 8, 37

Carrie, Edouard Duval, G# 73, 70

Carrigan, Nancy, 113, 118, **180**

Carroll, Maryrose, 117, 118, **181**

Carroll, Patty, G# 30, 43, 118

Carswell, Rodney, 120

Carter, Richard, G# 12, 38

Carter, Willie L., G# 70, 69, **117,** 120, **182**

Cartwright, Roy, 119, 120, **181**

Cass, Bill, G# 28, 42

Cassatt, Mary, G# 52, 48; G# 63, 68; 16, 35

Castel, Moshe, G# 37, 44

Castellani, G# 28, 42

Caster, John, G# 97, 76

Caster, Paul, G# 79, 72

Castle, Wendell, G# 44, 47; 120

Castner, Patty, G# 7, 37

Catlin, George, G# 6, 37

Ceccobelli, G# 28, 42; 39

Cedrins, Inara, 120

Cemin, Saint Clair, 120

Center for Contemporary Art, 40

Cezanne, Paul, 16

Chadwick, Lynn, G# 37, 44; 121

Chaet, Bernard, G# 89, 74

INDEX

Chagall, Marc, G# 37, 44; G# 63, 68; G# 97, 76; **13, 22**

Channer, Martha, G# 66, 68

Chapin, Francis, G# 32, 43

Charlesworth, Bruce, 45, 121

Che, Chuang, G# 27, 42

Cheatle, Esther, 121

Cheronsky, Mary, 119, 179

Cherry, Herman, 121

Chersonsky, Mary, 119, 121, 179

Chevillon, Vivian, 122

Chia, G# 28, 42

Chiaroscuro, 40

Chicago Center for the Print/Hunt-Wulkowicz Graphics, 40

Chicago Historical Society, 20

Chicago Public Library Cultural Center Galleries, 20

Chicago, Judy, 122

Chihuly, Dale, G# 88, 74; 122

Childs, Lucinda, G# 66, 68

Chinn, Michael, 122

Chlopecki, Jim, G# 51, 48; G# 95, 76

Chong, Ping, G# 66, 68

Christenen, Dan, G# 56, 65

Christenson, Nicole, G# 80, 72

Christo, G# 56, 65; G# 94, 75; 26, 122

Christopher, Jan, 122

Cicero, Jan, 40

Ciol, Elio, G# 83, 73

Citrin, Judith, 124

Ciurej, Barbara, 124

Clark, Edward, G# 70, 69

Clark, James, 124

Clark, John, 124

Clearly, Manon, G# 89, 74

Clemente, Francesco, G# 28, 42; 124

Close, Chuck, 32, 124

Cobo, Chema, G# 111, 80

Coffaro, Patrick, G# 80, 72

Coffey, Susanna, G# 91, 75

Cohen, B. J., G# 101, 78

Cohen, Connie, G# 19, 40

Cohen, Lynne, G# 83, 73; **71**

Cohon Gallery, Eva, 40

Cole, Grace, 123, 125, 184

Coleman, George, 125

Coleman, James, 32

Colescott, Robert, 125

Colescott, Warrington, G# 79, 72

Collier, William, G# 40, 46

Collings, Betty, 125

Collins, Austin, 125

Collins, Raymonde W., 126

Columbik, Roger, G# 22, 41; G# 58, 66

Compass Rose Gallery, 41

Conger, William, 126

Connan, Gloria, 126

Contemporary Art Workshop, 41

Contro, Antonia, G# 16, 40

Contro, Mary Ann, G# 101, 78

Conway, Rose Marie, 126

Cook, Beryl, G# 46, 47; G# 105, 79

Cook, Edward, 126

Cooper, Barbara, 126

Cooper, C.E., 126

Cooper, Don, G# 89, 74

Coplans, John, G# 25, 42

Copley, William, G# 54, 65

Coran, Scott, 128

Corazzo, Michelle, 127, 128

Coren, Lois, G# 101, 78; 128

Cornelius, Philip, G# 90, 75

Corot, J.B.C., 15

Corporate Art Source, Inc., 41

Corrado, Alba, G# 36, 44

Cortes, Edouard, G# 98, 76

Cortez, Carlos, 128

Costan, Chris, G# 64, 68

Cottingham, Robert, G# 56, 65; G# 84, 73

Coulter, Cynthia, 128

Courbet, Gustave, 15

Cox, Diane, G# 51, 48

Cox, Frances, G# 2, 36; 128

Cox, Jerome, 129

Cragg, Tony, 129

Cranach, Lucas, 15

Crane Gallery, 41

Crane, Barbara, G# 29, 42; 129

Crawford, Cathie, 129

Cribbs, KeKe, G# 41, 46

Crocker, Susan, 127, 129, 186

Crowell, Rebecca, 129

Crusing, Kathleen, 130, 131, 182

Cucchis, G# 28, 42

Cullen, Peg, 130, 131, 183

Cunningham, Sue, 130

Currie, Steve, G# 16, 40

Currier and Ives, G# 6, 37

Currier, Mary Ann, G# 44, 47

Cushing, Thomas, 130

Cvijanovic, Adam, G# 88, 74

Czarnopys, Tom, G# 111, 80; 130

D

D'Ambra, Liliana, 132

D'Arcy Gallery of Art, The Martin, 21

Dahlgren, Leslie, G# 83, 73

Dailey, Dan, G# 88, 74

Dali, G# 63, 68

Daniel, Mary Reed, G# 70, G# 101, 69, 78

Danits, Marcia, 132

Danzig, Elaine, G# 91, 75

Darger, Henry, G# 42, 46; 24

Darling, Lawanda, 132

Dart Gallery, 41

Daub, Matthew, G# 19, 40

Daugavietis, Ruta, 132

Daumier, Honore, G# 52, 48; 32

Davidek, Stefan, G# 27, 42

Davidson, Bruce, 29

Davidson, David, 132

Davidson, Herbert, G# 82, 72

Davies, Glen C., 132

Davila, Jim, G# 80, 72

Davis, Alonzo, G# 70, 69

Davis, Mary Anne, G# 51, 48

Davis-Benavides, Christopher, 134

Davy, Woods, G# 58, 66

Dawson, William, 24

De Breanski, Gustave, G# 82, 72

De Chirico, Giorgio, G# 52, 48

De Forest, Roy, G# 99, 78

De Kooning, Willem, G# 38, G# 45,44, 47, 134

De la Paz, Neraldo, G# 88, 74

De Maria, Merz, G# 28, 42

De Marris, Pamela, 134

De Pauw, Greg, 134

De Santo, Stephen, 133, 134, 183

De Taos, Muebles, G# 17, 40

Dean, Laury, G# 66, 68

Dean, Peter, G# 56, 65

DeBlasi, Tony, G# 44, 47

Degas, 32

DeGenevieve, Barbara, G# 29, 42

DeGraaf Fine Art, Inc., 42

Degrane, Lloyd, 134

Deihl, Randall, G# 44, 47

DeJan, Joseph, 133, 136, 185

Del Valle, Helen, 136

Delaunay, Robert, G# 106, 79

Deller, Harris, G# 90, 75; 136

Delvaux, Paul, G# 37, 44

Deming, David, 136

Deom, John, G# 89, 74

DePauw, Greg, 134, 135, 188

Deremiah, 136

Derer, Charles, 136

Deson Gallery, Marianne, 42

Dessi, G# 28, 42

Detwiler, Lee, 137

Deutch, Stephen, 137

Devallance, Brendan, 137

Devlin, Sue, 137

Diamond, Martha, G# 88, 74

Dickens, Lu, G# 36, 44; G# 72, 70

Dickerson, Grace Leslie, 135, 137, 185

Dickson, Jane, G# 88, 74

Dickson, Mark, G# 12, 38

Dickson, Michael, 137

Dill, Laddie John, G# 56, 65; G# 111, 80

Diller, Burgoyne, G# 99, 78

Dilworth, Robert, G# 70, 69; **138, 139, 188**

Dine, Jim, G# 38, 44; G# 53, 65; G# 94, 75; G# 103, 78; 138

Disrud, James E., 138

Dix, G# 106, 79

Dixon, Bob, 138

Dixon, Ken, 138, 139, 186

INDEX

Dixon, Swazey, 138
Doederlein, Gertrude, 140
Doherty, Karon, G# 75, 70
Doll, Catherine, 140, **141, 187**
Donaldson, Jeff, G# 70, 69
Donley, Robert, G# 44, 47; 140
Doremus, Susan, G# 21, 41
Dorn, Gordon, 140
Douglas Dawson Gallery, 42
Douglas, L.J., 140
Downie, Keith, G# 58, 66; **71,** 140
Doyle, Tom, G# 76, 70
Drasler, Greg, G# 16, 40
Draves, John, 142
Drew, Nancy, G# 47, 47
Driesbach, David, 142
Drisi, Mohamed, 141, 142, **184**
Drisi, Nanette, 142, **145**
Duback, Sally, 142
Dubina, Michael, G# 64, 68
Dubuffet, Jean, G# 37, 44; G# 38, 44; G# 45, 47; G# 53, 65; 26, 34
Duchamp, Marcel, 26
Dudley, Randy, G# 84, 73
Duffaut, Prefete, G# 73, 70
Dunshee, Susan, G# 72, 70
Durand-Brager, Henri, G# 82, 72
Duranton, Andre, G# 108, 79
Dürer, Albrecht, 12
Du Sable Museum of African-American History, 21
Dusenbury, Phillip, G# 36, 44
Dwyer, Mary, 142
Dwyer, Nancy, G# 43, 46; 143
Dyck, Paul, G# 74, 70
Dynerman, Waldemar, 143
Dziuba, Gabriele, G# 86, 74

E

Earl, Jack, G# 79, 72
Eaton, Herbert, 143
Eaton, Tom, 143
Eberlein-Burmeister, Jeànne, 143
Ebner, Tim, G# 60, 66
Eckart, Christian, 143
Eckert, John, G# 57, 65
Eckert, Kurt, 144
Eddy, Hilary, 144
Edelman Gallery, Catherine, 42
Edelstein, Phyllis, G# 101, 78
Edgcomb, John, 144, **145, 187**
Edwards, JonMarc, G# 16, 40
Edwards, Stephen, 144
Effort, Noble, G# 17, 40
Ehlers Caudill Gallery, 42
Eickholt, Robert, G# 31, 43
Eight, The, G# 15, 38
Eisemann, Michael, G# 37, 44
El Greco, 15
Engelhard, Gordon, 144
Engen, Berit, G# 104, 79; 146
English, Mark, G# 74, 70

Enochs, Dale, 146
Erlebacher, Martha, G# 56, 65; G# 89, 74; 146
Erte, G# 63, G#81, 68, 72
Escher, M.C., 28
Essig, Donna, G# 110, 80, 146
Estes, Richard, G# 16, 40, 146
Evans, Bob, 147
Evans, Edward, G# 12, 38
Evans, Jil, G# 91, 75
Evans, Sharon, G# 66, 68
Everhart, Jane, G# 91, 75; **77,** 147
Ewart, Douglas, 147
Exhibit Hall, 33

F

Faber, David, G# 72, 70
Fabian, Joan, 147
Fabiano, Daniel, 147, **149, 190**
Fabien, G# 34, 43
Fabrille Gallery Ltd., 43
Fach, Charles, 147
Fairweather Hardin, 43
Faist, Barton, 148
Falconer, James, 148
Falkman, Susan, G# 27, 42
Farmer, Josephus, G# 108, 79
Farrell, Patrick, 148
Farrington, Reed, G# 49, 48
Faust, James, 148, **149, 191**
Feder-Nadoff, Michele, 148
Federighi, Christine, G# 90, 75
Feeler, Charlene, 148
Feinberg, Elen, G# 84, 73
Ferar, Ellen, 150
Ferbert, Mary Lou, 150
Ferentz, Nicole, 150
Ferguson, Kenneth, G# 90, 75; 150
Fermilab Gallery, 43
Ferrari, Virginio, 150
Ferrella, Andre, G# 64, 68
Ferris, John, G# 42, 46
Fettingis, Joseph, 152
Field Museum of Natural History, 22, 23
Field, Bobbe, 151, 152, **190**
Fielding, Wayne, G# 24, 41
Finch, Richard , 152
Findlay Galleries, Wally, 43
Fine, Diane, 152
Fink, Milt, 152
Fink, Ray, G# 22, 41
Finkel, Shirley, G# 40, 46
Finnigan, Sheila, G# 2, 36; **151,** 152, **191**
Finster, Howard, G# 54, 65; 153
Firme, Kevin, 153
Firmin- Girard, G# 98, 76
Fischer, Gloria, G# 12, 38; 153
Fischer, Patty Hester, 153, **155, 189**
Fischer, R. M., 153
Fischl, Eric, G# 16, 40; 26, 154

Fish, Julia, G# 60, 66
Fishbein, Anne, G# 83, 73, 154
Fisher, Vernon, G# 56, 65
Fitzgerald, Kip, 154
Fitzpatrick, Gayle, G# 2, 36
Flavin, Dan, G# 109, 80; 26, 154
Flemens, Suzanne, G# 2, 36
Fleming, Alex, G# 59, 66
Fligny, P., G# 81, 72
Florsheim, Lillian, G# 32, 43
Fly by Nite, 43
Flynn, Joseph Francis, 154
Foley, Jerry Lee, 154
Folise, Joseph, 156
Folise, Joseph, G# 101, 78
Folwell, Jody, G# 80, 72
Folwell, Polly Rose, G# 80, 72
Fontaine, Pierre, 13
Fontaine, Paul, G# 106, 79
Foosaner, Judy, G# 90, 75
Ford, Ausbra, G# 70, 69; 156
Fortunato, Nancy, 156
Foucher, Valerie, 156
Franchini, Elisabetta P., 155, 156, **189**
Francis, Sam, G# 38, 44; G# 53, 65; 156
Franco, Charles, 156
Frank, Ellen, G# 51, 48
Frank, Robert, 12, 28
Frankenstein, Curt, 158
Frankenthaler, Helen, G# 53, 65; G# 106, 78; 158
Franklin, Jonathan, 158
Fraser, John S., 158
Fraser, Ney Tait, 157, 158
Frazier, Nancelia, 159
Frazier, Ruth Ann, 159
Freda, John, 159
Fredenburg, Mark, 157, 159
Fredericks, Sarah, G# 17, 40
Freed, Douglas, 159
Freedman, Katie, G# 17, 40
Freeh, Linda, 159
Freeman, George, 160
Freeport Art Museum and Cultural Center, The, 22
Freleng, Friz, G# 105, 79
French, David, G# 60, 66
Frets, Barbara, G# 47, 47
Freund, Art, 27
Fricano, Tom, G# 32, 43
Friedeberg, Pedro, G# 71, 69
Friefeke, F. C., G# 15, 38
Frith, A. Barbara, G# 36, 44, 160, **161, 241**
Frydryck, Walter, 160
Fuchs, Bernie, G# 74, 70
Fuentes, Leo, G# 22, 41
Fydryck, Walter, G# 36, 44

G

Gadiel, Deborah, G# 101, 78
Gadomski, Robert, G# 14, 38; 160

INDEX

Gaines, Anne Farley, G# 58, 66
Gaines, Charles, G# 56, 65
Galindo, J. Alex, 160, **160, 242**
Gall, Susan, 160
Gallo, Frank, G# 36, 44; G# 28, 42; 162
Gamundi, Michel, 162, **163, 192**
Gannello,Carmelo, 162
Gantz, Mitchell, G# 17, 40
Garcia, Effie, G# 80, 72
Gargiulo, Nancy, 162
Gasca, Gilberto Lopez, G# 14, 38
Gascard, Cilly, G# 108, 79
Gauguin, Paul, 18
Gavin, Alain, 162
Gehry, Frank, G# 109, 80
Geichman, Judith, 164
Geiser, David, G# 89, 74
Gengler, Thomas, G# 22, 41; 164
Genoves, G# 28, 42
George, Dorsey, 164
George, Ray E., G# 83, 73, **163,** 164, **241**
George, Richard, G# 91, 75
George, G# 28, 42
Gerber, Gaylen, G# 60, 66
Gerberding, Roger, 164
Gibbons, Richard A., 164
Gibbs, Tom, G# 110, 80
Gibson, David, G# 12, 38
Giddings, Anita, 165
Gilbert and George, 165
Gilbert, Jack, G# 88, 74
Gilbert, Victor, G# 98, 76
Gilbert, G# 28, 42
Gilchrist, Jan, 165
Giliberto, Tony, G# 58, 66
Gill, Madge, 81,
Gilliam, Sam, G# 55, 65; 165
Gilman/Gruen Galleries, 44
Gilmor, Jane, 165
Gilmore, Sharon, 165
Gilmore, Shawn, G# 66, 68
Giovanopoulos, Paul, G# 44, 47; **49,** 166
Glazer, Karen, G# 29, 42
Glenn, Dixie Dove, 166
Gober, Robert, 166
Godellei, Ruthann, 168
Godfrey, Winiford, G# 82, 72, 166, **167, 192**
Godie, Lee, G# 42, 46; 24
Goldbeck, O. E., G# 87, 74
Goldberg, Glenn, G# 25, 42
Goldblatt, Hilary, 168
Golden, Pamela, G# 60, 66
Goldes, David, 168
Goldfarb, Kim, G# 72, 70; 168
Goldman-Kraft Gallery, Ltd., 44
Goldstein, Daniel, G# 72, 70
Goldstein, Jack, G# 25, 42; 168
Golub, Leon, G# 22, 41; G# 43, 46; G# 83, 73; **51,** 168

Gompf, Floyd, G# 64, 68; G# 101, 78; 169
Gonzales, Eladio, 169
Goodman, Jeanne, 167, 228, **243**
Goodman, Neil, 169
Goodman, Sidney, G# 89, 74
Goodnough, Robert, G# 61, 66; 169
Gorchov, Ron, G# 56, 65
Gordan-Lucas, Bonnie, 169
Gordon, Judy, 169
Gordon, Russell, G# 51, 48
Gorman, R. C., G# 5, 36; G# 46, 47
Goto, Joseph, 170
Gould, John, G# 6, 37
Gourfain, Peter, G# 75, 70
Gourhan, Paul, 170
Goya, 12
Graetz, Gidon, G# 37, 44; 170
Graham, Allan, G# 55, 65
Grahame, Peter, 170
Grams, Diane, G# 101, 78; 170, **171,** 243
Grantham, Lee, G# 36, 44
Graves, Nancy, G# 38, 44; 172
Gray Gallery, Richard, 44
Grayson Gallery, The, 44
Green, Arthur, 172
Green, Denise, G# 56, 65
Green, George, G# 44, 47
Green, Greg, G# 25, 41
Green, Harry, 172
Greenberg, Elena, 172
Greene, Robert, G# 88, 74
Greene, Roger, 172
Greenwood, David, G# 72, 70
Gregor, Harold, 172
Greiner-Meyer, Sandy, 173
Gresl, Gary, 173
Grigsby, James, G# 66, 68; 173
Grimes, Emily, G# 87, 74
Grimmer, Mineko, G# 55, 65
Grodner, Alexa, G# 27, 42
Groover, Jan, G# 88, 74
Gross, Cheryl, G# 17, 40
Gross, Marilyn, 173
Gross, Michael, G# 75, 70
Grove St. Gallery, 46
Gruen, Shirley Schanen, 173
Gunderman, Karen, G# 90, 75
Gunderson, Marla, 173
Gunn, Lorri, G# 7, 37; 174
Gustafson, Jo Barbara, 174
Gustin, Chris, G# 75, 70
Gustin, Dan, G# 89, 74
Guthrie, Gerald, 174

H
Haas, Richard, G# 43, 46; G# 56, 65; 174
Habatat Galleries, 46
Hackin, Charlotte, 174
Haddon, Arthur Trevor, G# 81, 72

Haggard, Carolann, 175
Haid, Woody, G# 66, 68; 175
Halbrooks, Darryl, G# 47, 47
Halkin, Ted, G# 19, 40
Hall, Lana Cory, 175
Halley, Peter, G# 43, 46; 175
Halliday, Nancy R., 175
Hallman, Holly, 175
Halstead, Cathy, G# 37, 44
Hamady, Walter, G# 79, 72
Hambourg, Andrew, G# 34, 43
Hamilton, Russel, G# 80, 72
Hammer Gallery, Carl, 46
Hanke-Woods, 176
Hanna, Kevin, G# 75, 70
Hannah, Duncan, 176
Hansen, Steven, G# 36, 44
Hanson, Carol, 176
Haozous, Bob, G# 80, 72; 176
Hapac, Donna, 176
Hara, Keiko, G# 79, 72
Hardaway, Lydia, 176
Hardesty, Michael, G# 16, 40
Hardimon, Ghita, G# 101, 78
Hardy, Cherryl, 193
Haring, Keith, G# 53, 65; 193
Harles, Graham, G# 51, 48
Harmel, Carole, 193
Harney, Rick, G# 36, 44
Harrington, Bryan, G# 19, 40
Harris, Arlene, G# 12, 38; 193
Harris, David, 193
Harrison, Jan, 193
Harroff, William, 171, 194
Hart, Frederick, G# 63, 68
Hartenstein, Bonnie, G# 19, 40
Hartman, Arleen, 194
Hartman, Carol, 194
Harvey, Don, G# 25, 41
Hasenstein, Timothy, 194
Hassam, Childe, G# 61, 66
Hatch, Doug, G# 97, 76
Hatch, Mary, 194
Hattendorf, Bill, G# 101, 78
Hawk, William, G# 90, 75
Hawkins, William, G# 42, 46
Hawthorne, Chris, G# 65, 68
Hay, Dick, 196
Hayes, Brenda, 196
Hayes, David, G# 72, 70
Heers, Wendall, G# 27, 42
Heflin, Tom, 195,, 196, 242
Heidacker, Staphanus, G# 83, 73
Heinecken, Robert, G# 83, 73; 196
Helfman, Sheldon, G# 91, 75
Hellmuth, Lynn Slattery, 195, 196, **244**
Hemmingway-Jones, Catherine, G# 11, 38
Hemsoth, Michele, G# 22, 41
Henderson, Edward, G# 16, 40
Henderson, Paula, 196

Hendon, Cham, G# 54, 65
Henri, Robert, G# 15, 38
Henry, John, G# 64, 68; G# 97, 76
Henselmann, Casper, G# 76, 70
Hepworth, Barbara, G# 38, 44; 20
Hermanson, Sarah Jo, 198
Hernandez, John, 198
Herndon, Charles, G# 36, 44
Herse, Lia Elise, 197, 198
Hersh, Howard, G# 80, 72
Hershey, Barbara, 198
Hesse, Eva, 32
Hester, Patty, 189
Heyman, Steven, G# 111, 80
Hibel, Edna, G# 81, 72
Hicks, William James, 198
Hidson, Pat, G# 36, 44
Higdon, Randall, G# 100, 78
Highstein, Jene, G# 43, 46; 199
Hild, Nancy, 199
Hill, Marvin, 199
Himmelfarb, Eleanor, 197, 199, **246**
Himmelfarb, John, 199, **201, 248**
Hinkley, Ed, 199
Hirshfield, Pearl, 199
Hladic, Judy, G# 57, 65
Hlavacek, Nancy, G# 17, 40
Ho, Ruyell, 200
Hobbs, Pamela, 200
Hockney, David, G# 38, 44; G# 53, 65;
G# 89, 74; G# 103, 78; 26, 200
Hodgkin, Howard, G# 16, 40
Hoeksma, Ron, G# 13, 38
Hoff, Margo, 200
Hoffman Gallery, 46
Hoffman, William, 200, **201, 245**
Hofmann, Hans, G# 38, 44; G# 61, 66
Hofmann, Kay, G# 36, 44, 200, **201,
245**
Hogan, Irmfriede, 202
Hokin Kaufman Gallery, 47
Holder, Kathy, G# 79, 72
Holen, Norman, 202
Holland, B. C., 47
Holland, Tom, G# 53, 65; 202
Holley, Lonnie, G# 42, 46
Holmes, David, G# 34, 43
Holmes, Diana, 202
Holzer, Jenny, G# 43, 46; 26, 202
Homer, Winslow, 16
Hopkins, Budd, G# 19, 40
Hopper, Peggy, G# 74, 70
Hoppock, Kay, 202
Hork Galleries, Billy, 47
Horn, Robert, 203
Horwich Gallery, Joy, 47
Horwich, Judith, 203
Hough, Winston, 203, **205, 244**
Houk Gallery, Edwynn, 47
Houlberg, Klint, G# 71, 69
House, Herbert, G# 70, 69

Houston, Joe, G# 22, 41; 203
Howe, Robert, 203
Howes, Royce, G# 16, 40
Hubbard Cribbs, Maureen, 204
Huchthausen, David, G# 41, 46
Hudson, Jon Barlow, G# 104, 79; 204
Hughes, Dorothy, G# 27, 42; 204
Hull, Richard, 204
Hunenko, Alexander, 35
Hungerford, Richard, 204, **205, 246**
Hunt Galleries, Ltd., Janice, 48
Hunt, Richard, G# 27, 42; 204
Hunt-Wulkowicz, Susan, G# 62, 40;
G# 100, 78; 206
Hunter, Jennifer, 206, **209, 247**
Huston, Doug, G# 83, 73
Hyde Park Art Center, The, 22

I

Iaccarino, Ralph, 206
Illinois Artisan Shop, 48
Ingwersen, Mary, 206
Ipousteguy, Jean, 20
Isenstein, Burton, G# 44, 47; 206
Issachar, Esther, 206
Issacs, Ron, G# 91, 75
Itatani, Michiko, G# 28, 42
Ito, Myoko, G# 54, 65
Itter, William, G# 110, 80
Iwanski, John, 207

J

Jablonsky, Carol, G# 105, 79
Jachna, Joseph, 207
Jackson, Frieda, 207
Jackson, Nancy, G# 71, 69
Jackson, Preston, G# 14, 38; G# 70, 69
Jacobs, Agnes, G# 20, 41
Jacobs, Pam, G# 17, 40
Jacobshagen, Keith, G# 84, 73
Jaecks, Joel, G# 19, 40
Jaffee, Barbara, G# 91, 75; 207
Jahnke, Violette, 207
Jahns, Lucy A., 207
James, Tom, 208
Janssen, Horst, G# 106, 79
Javancie, Billie, 208
Jay Gallery, Gwenda, 48
Jefferson, David, 208
Jellerson, Darine, G# 74, 70
Jenkins, Paul, G# 97, 76; 208
Jensen, Jens, 21
Jeroski, Anthony, 208
Jimenez, Luis, G# 54, 65; G# 56, 65
Johns, Jasper, G# 45, 47; G# 103, 78;
26, 208
Johnson International, R. S., 48
Johnson, Anna, 209, 210, **248**
Johnson, Bruce, G# 76, 70
Johnson, Freitas, G# 90, 75
Johnson, Indira, G# 90, 75
Johnson, Lester, G# 37, 44

Johnson, Martin, G# 54, 65
Johnson, Teddy, 210, **211, 247**
Johnston, Ynez, G# 106, 79
Jokinen, David, G# 39, 44
Jolly, Marva Lee, 210
Jones, Brent, 210
Jones, Calvin, G# 70, 69; **50,** 210
Jones, Chuck, G# 105, 79
Jones, Frank, G# 42, 46
Jones, S. L., G# 42, 46
Joseph, Nathan Slate, G# 39, 44
Joseph, René, 210
Josephson, Kenneth, G# 43, 46; 212
Joyce, Alice, 212
Juarez, Roberto, G# 88, 74
Judd, Donald, G# 43, 46; G# 109, 80;
212
Julian, Peter, G# 56, 65
Justis, Gary, G# 21, 41
Juszczyk, James, G# 19, 40; G# 56, 65

K

K'Onofrio, Bernard, G# 88, 74
Kabak, Robert, G# 49, 48
Kadishman, Manashe, G# 37, 44
Kahle, Gary, 212
Kallenberger, Kreg, G# 41, 46; **50,** 212
Kandinsky, Wassily, G# 106, 79; 18
Kane, Cindy, G# 89, 74
Kane, Mitchell, G# 60, 66
Kaneko, Jun, G# 55, 65
Kanfer, Larry, 212
Kanner, Chiam, G# 95, 76
Kapheim, Tho, G# 100, 78
Kaplan, Dan, 213
Kaplan, Gail, G# 83, 73; 213
Kapsalis, Thomas, 213
Karpowicz, Terrence, G# 58, 66
Karuza, Daiva, 213
Kasen, Judy, G# 90, 75; 213
Kasperek, Claudia, 213
Kass/Meridian, 65
Katz, Alex, 214
Kaufman, Betsy, G# 16, 40
Kaufman, Emily, G# 36, 44; 214
Kaycee, 211, 250, 358
Kearney, John, G# 22, 41
Kedzior, Beverly, G# 2, 36
Keidan, Barbara, 214, **215**
Keigher, Charles, G# 40, 46
Kelley, Mike, 32
Kelly, Daniel, 214, **215, 249**
Kent, Melanie Taylor, G# 46, 47
Kertesz, Andre, G# 48, 48
Kezys, Algimantas, 214
Kiefer, Ansel, 216
Kiefer, Anslem, G# 25, 42
Kiefer-Bell, Julie, 216, **217, 249**
Kiesel, Polly, 216
Kiland, Lance, 216
Killips, Terry, G# 22, 41

INDEX

Kim, Po, G# 32, 43
Kimler, Wesley, 216
Kind Gallery, Phyllis, 65
King, Jaye, G# 87, 74
King, Kathleen, G# 19, 40
King, William, G# 44, 47
Kinkle, Charles, 216, 217, 255
Kinsell, Robert, 218
Kipniss, Robert, G# 63, 68; G# 100, 78
Kirchner, Ernst, G# 52, 48; G# 106, 79
Kirkeby, Per, G# 84, 73
Kirtlow, G. Sherman, G# 27, 42
Kirulis, Karin, 218
Kissane, Sharon, 218
Kitzerow, Scott, 218
Klamen, David, G# 28, 42; 52, 218
Klauba, George, G# 110, 80
Klaven, Marvin, 218
Klee, Paul, G# 106, 79; 32
Kleidon, Diana, 219, 220
Klein Gallery, 65
Klein, Margeaux, G# 51, 48
Klein, Sheila, G# 86, 74
Klein, Sheri, 220
Kleinman, Art, 220
Klement, Vera, 32, 220
Kline, Franz, G# 38, 44; G# 45, 47; 19
Kluge, Constantin, G# 34, 43
Klunk, Robert, G# 101, 78
Knight, Karla, G# 25, 42
Knowles, James, G# 12, 38
Knutsen, Elaine, 220
Kocar, George, 220
Koch, Lewis, G# 30, 43
Kochman, Alexandra, 219, 222, 254
Koga, Mary, 222
Kohlmeyer, Ida, G# 44, 47
Kohn, Bill, G# 19, 40; 222
Kolisnyk, Peter, 35
Kolkey, Gilda, 221, 222, 251
Koller, Alphons, G# 24, 41
Komar and Melamid, 222
Komar, G# 103, 78
Kooi, Hans, G# 72, 70
Koons, Jeff, G# 109, 80; 223
Kooyman, Richard, G# 75, 70
Koper, 223
Koss, Jim, G# 83, 73; 223
Kostabi, Mark, 223
Kosuth, Joseph, G# 43, 46
Kounellis, Jannis, G# 28, 42; G# 43, 46; G# 109, 80; 26, 223
Kowalski, Dennis, 223
Kozar, Steven, G# 97, 76
Kozmon, George, G# 12, 38; 224
Krall, Vita, 224, 225, 250
Kramer, Linda, 224, 227, 253
Krantz, Claire, 224
Kraus, Neil, G# 17, 40
Krause, Charles, 224
Kraut, Susan, 224

Kretzmann, Mark, 226
Krochmaluk, Yuri, G# 42, 46
Kronick, Stanley, 226
Kruger, Barbara, G# 43, 46; 226
Kruger, Daniel, G# 86, 74
Kubin, Alfred, G# 106, 79
Kudla, Frank, G# 65, 68
Kunc, Karen, G# 19, 40
Kunzli, Otto, G# 86, 74
Kuo, Yih-Wen, G# 90, 75
Kurtz, John, 226
Kuznitsky, Susan, 226
Kvaalen, Arne, 228
Kwan, Nam, G# 94, 75
Kwitz, Al, G# 22, 41
Kyros, Adrienne, 227, 228, 252

L

Lachman, Mildred, G# 2, 36
Ladd, William, 228, 229, 255
Ladewig-Goodman, Jeanne, 228
LaLande, Jacques, G# 81, 72
Laloue, Eugene Galien, G# 98, 76
LaMantia, Joe, 228
LaMantia, Paul, G# 110, 80
Lamb, Matt, G# 42, 46; 228
Lamis, Leroy, 230
Landfall Press, Inc., 65
Landfield, Ronnie, G# 44, 47
Lange, Dorothea, G# 48, 48
Lange, Richard, 230
Lange, Rick, G# 58, 66
Langsdorf, Martyl, G# 33, 43
LaNoue, Terence, G# 111, 80
Lanterman, Margaret, 230
Lanyon, Ellen, G# 56, 65; G# 83, 73; 230
Larew's Gallery, 65
Larkin, Alan, G# 83, 53; 73, 229, 230
Larney Gallery, Sybil, 66
Larsen, Edward, G# 111, 80
Larsen, Fran, G# 5, 36
Larsen, Hal, G# 5, 36
Larson, Ed, G# 56, 65
Larson, Steve, 232
Lass-Gardiner, Margaret, G# 7, 37
Laszuk, Dennis, 231, 232, 254
Latino Arts Coalition Gallery, 66
Laufer, Susan, G# 16, 40
Laurenceau, Lionel, G# 73, 70
Lawrence, Diane, 232
Lawrence, Jacob, G# 70, 69
Lawrence, Sir Thomas, 15
Lawrence, G# 81, 72
Lawton, James, 232
Lazzari, Margaret, G# 51, 48
Lazzo, Chris, G# 17, 40
Le Sidaner, Henri, G# 98, 76
Leaf, June, G# 22, 41; G# 56, 65
Leary, Dan, G# 83, 73
Leavitt, Fred, 232

Lebe, David, G# 29, 42
Lebenski, Stanislav, G# 41, 46
Ledgerwood, Judy, G# 60, 66
Lee, Robert, 231, 232, 253
Leger, Fernand, G# 38, 44; G# 52, 48; 32
Leis, Marietta, 234
Lembeck, Jack, G# 44, 47
Lemieux, Annette, 234
Lencioni, Daniel, G# 46, 47
Lenehan, Daniel, 233, 234, 251
Lennon, John, 32
Lenting, John, 234
Lerner, Nathan, 27
Lerner, Arthur, G# 19, 40; 234
Lerner, Leslie, G# 84, 73
Leslie, Alfred, G# 56, 65
Levesque, Diane, G# 7, 37
Levin, Pamela Gilford, G# 58, 66; 234
Levine, Sherrie, G# 109, 80; 234
Levinson, Betto, 236
Lewan, Dennis, G# 81, 72
Lewis, Elizabeth Collins, 54, 235, 236
Lewis, William A., G# 27, 42
LeWitt, Sol, G# 43, 46; G# 56, 65; 236
Lhermitte, G# 98, 76
Lichtenberg, Julie, G# 51, 48
Lichtenstein, Roy, G# 38, 44; G# 53, 65; 26, 236
Liepins, Inese, G# 101, 78
Ligare, David, G# 56, 65
Likan, G# 63, 68
Lindner, Frank, G# 49, 48
Linn, Steve, G# 41, 46
Lipshitz, Jacques, 20
Lipski, Donald, 236
Livingston-Dunn, Connie, 237, 238, 252
Livingstone, Biganess, 238
Livingstone, Joan, G# 7, 37
Lizzardo Museum of Lapidary Art, The, 24
Lldebrando, G# 86, 74
Lloyd, Timothy, 238
Lockett Gallery, Robin, 66
Loeb, Lex, G# 17, 40
Loeb, Neil, G# 46, 47
Loeber, Ken, G# 79, 72
Logsdon, Woody, 238
Long, Lois, 239
Long, Richard, 239
Look, Dona, G# 79, 72
Lopez, Joyce, 239
Lostutter, Robert, G# 25, 41; G# 28, 42; 239
Louissaint, Franck, G# 73, 70
Love Galleries, Inc., R. H., 66
Love, Ed, 239
Love, Richard, 239
Loving, Richard, 240
Lowe, Marvin, G# 83, 73
Lowitz, Ted, 240

Lowly, Tim, G# 22, 41

Luccario, Rebecca, G# 80, 72

Luecking, Stephen, 240

Lui, Yao, 238

Luks, George, G# 15, 38

Lum, Ken, G# 60, 66

Lutes, Jim, G# 25, 41

Luzwick, Dierdre, 240

Lycardi, Joan, 237, 240

Lyn, Joyce, G# 8, 37

Lynch, Rhett, G# 80, 72

Lyon, Joan, G# 2, 36

M

Macaulay, Thomas, 257

MacCauley, Robert, G# 22, 41

Machin, Roger, 259, 257

Mack, Bill, G# 63, 68

Macke, August, G# 106, 79

Macnamara, Peggy, G# 84, 73

MacQueen, John, 257

Madejczyk, Jane, 257

Madsen, Loren, G# 111, 80

Madson, Jerry, 257,259, 306

Mageri, Beverly, G# 90, 75

Maginnis, Kevin, G# 86, 74

Magritte, Rene, G# 37, 44; G# 97, 76; 26

Mahmoud, Ben, G# 110, 80; 257

Mahoney, Barbara Baynes,258, **261,**306

Mail, Barbara, G# 8, 37

Malagrino, Silvia,258, 261,

Maldonado, Alex, G# 42, 46

Mallinson, John-Luke Michael, 258, **263, 307**

Maloney, Irene, 258

Man Ray, G# 30, 42; G# 48, 48

Mandel, John, G# 16, 40

Mandel, Renee, 258

Manet, Edouard, 15

Mangold, Robert, G# 43, 46, 258

Mangold, Sylvia Plimack, G# 43, 46, 260

Mann, Jay, G# 17, 40

Mann, Thomas, G# 65, 68

Mann, Toni, G# 17, 40

Mapplethorpe, Robert, G# 88, 74, 260

Marc, Franz, G# 106, 79

Marc, Stephen, 260

Marden, Brice, 260

Marini, Marino, G# 53, 65; G# 97, 76; 66, 261

Marks, Janina, 261

Marquis, Richard, G# 65, 68

Marraccini, Lee, G# 8, 37

Marsh, Reginald, G# 98, 76

Mart, Susan, G# 2, 36, 262

Martin, Emily, 263, 262, **310**

Martin, Henri, G# 98, 76

Martin, Ray, G# 83, 73, 262

Martinazzi, Bruno, G# 86, 74

Martinez, Paula Pia, G# 22, 41; G# 59, 66

Maschietto, Romano, 262

Maslach, Steve, G# 65, 68

Matiosian, Pamela, G# 58, 66

Matisse, Henri, G# 34, 43; 18, 32

Matta-Clark, Gordon, G# 43, 46; 26

Matta, G# 37, 44

Mattocks, Elizabeth, 262, **265, 307**

Max, Peter, G# 63, 68

Maxwell, Terry, 264

McGee, Pennington, 265, 266, **305**

McCann, Sue, 264

McCauley, Robert, 264

McClain, Wardell, 264

McCliment-Horvath, Catherine, 264

McCombs, Bruce, G# 13, 38

McCombs, Jack, 264

McCormick, Rod, G# 8, 37; G# 63, 68

McCullough, Geraldine, G# 70, 69; **39**

McCullough, Ed, G# 76, 70

McEachron, Marcia, 266

McElhinney, James, G# 89, 74

McFarlane, Bryan, G# 70, 69

McFayden, Donald, G# 25, 41

McGee, Pennington, 263, 266, **307**

McHugh, Owen, G# 19, 40

McKelvey, James, G# 17, 40

McKnight, Thomas, G# 81, 72

McLaughlin, Donald, G# 16, 40

McMahan, Margot, 266

McNaughton, John, G# 44, 47

McQuilken, Robert, 266

Meeker, Barbara, 268

Melamid, G# 103, 78

Melton, DeAnn, G# 19, 40

Melton, Diane Meyer, G# 19, 40

Mendenhall, Kim, G# 89, 74

Mendoa, Tony, G# 29, 42

Menzer, Tony, 268

Mercaldo Gallery, 66

Meredith, Jane, 267, 268, **305**

Merisio, Pepi, G# 83, 73

Merrill Chase Galleries, 68

Merrill, Hugh, G# 83, 73

Mertz, Sarah, 268

Mesplé, James, G# 44, 47; **56, 267,** 268

Metcalf, Bruce, G# 79, 72; 268

Metcoff, Donald, 270

Metzler, Kurt, G# 27, 42

Mexican Fine Arts Center Museum, The, 24, 25

Meyer-Bernstein, Gerda, 270

Meyerhoff, Jill, 269,270

Meyerowitz, Joel, 12

Meyers, Michael, 270

Mezricky, Dagmar, G# 14, 38

Michals, Duane, G# 29, 42

Michod, Susan, G# 51, 48; 270

Middaugh, Robert, 269, 272, **310**

Mies van der Rohe, Ludwig, 32

Migdal, Ruth Aizuss, 271, 272, 308

Migliorino, Laura E., 271, 272

Milan, Henrietta, G# 40, 46

Miletto, David, 256, 272, 273

Miller Gallery, Peter, 68

Miller, Constance, 272

Miller, Howard Seth, G# 66, 68

Miller, Jan, G# 47, 47; **256,** 272, 273

Miller, Maureen, G# 2, 36

Millet, Jean-Francois, 16

Millikan, Jeff, G# 29, 42

Mills, Dan, G# 58, 66; **51,** 274

Milonadis, Konstantin, 35

Mindscape Gallery, 68

Miretsky, David, G# 27, 42

Miro, Joan, G# 20, 41; G# 37, 44; G# 53, 65; G# 63, 68; G# 94, 75; G# 97, 76; 20, 22

Mitchell Indian Museum at Kendall College, 24

Mitchell, Dennis, 274

Mitchell, Rodger, 274

Mogi, Teruko, G# 4, 36

Moholy-Nagy, Laszlo, G# 30, 42

Molenda, Don, 274

Mominee, Jules, 276

Moming Gallery, 68

Monaghan, Brian, G# 75, 70

Monany, Peter, G# 82, 72

Mondrian, Piet, 18

Monet, Claude, G# 34, 43; **15, 17**

Mongerson- Wunderlich Galleries, 68

Monk, Meridith, G# 66, 68

Montgomery, David, G# 42, 46

Moor, Beverly, 273, 276, **308**

Moore, Henry, G# 37, 44; G# 53, 65; G# 94, 75; 20, 32

Moore, Jeff, G# 101, 78

Moore, G# 97, 76

Moran, Mike, G# 90, 75

More by Far, 69

Morgensen, Lois, 274

Moroni, Aldo, 276

Morris, Dennis, 276

Morris, William, G# 88, 74

Morse, Samuel F.B., 31, 34

Moses, Richard, 276

Moss, Joan, G# 29, 42

Mosset, Olivier, G# 25, 42

Motherwell, Robert, G# 53, 65; G# 97, 76; G# 103, 78; 276

Moty, Eleanor, G# 79, 72

Moulins, Master of, 15

Moyet, Claus, G# 41, 46

Mr. Imagination, G# 42, 46

Mullen, Philip, G# 20, 40

Mullen, Sylvia, 275,277, **312**

Muller, Josef Felix, G# 16, 40

Munter, Gabriele, G# 106, 79

Murphy, Cathryn, G# 89, 74

Murphy, Stephanie, G# 17, 40

Museum of Contemporary Art, The, 26

Museum of Contemporary Photography, The, 28
Museum of Science and Industry, 25
Museum of the Fine Arts Research and Holographic Center, The, 30 Mussoff, Jody, G# 16, 40
Muth, Marcia, G# 108, 79; **49, 277**
Mutter, Scott, G# 83, 73; 277
Myers, Joel Philip, G# 88, 74
Myers, Michael, G# 66, 68
Myers, Walt, G# 64, 68

N

N.A.M.E. Gallery, 69
Nachman, Roger, 277
Nadolski, Stephanie, 275, 277, 309
Nagler, Monte, G# 87, 74
Nagy, Moholy, 32
Nakoneczny, Michael, G# 111, 80
Nanao, Kenjito, G# 20, 40
Naponic, Tony, G# 56, 65
Nardi, Dann, 278
Natkin, Robert, 278
Nauman, Bruce, 278
Nauman, Bruce, G# 109, 80
Nauman, G# 28, 42
Neal Gallery, Ltd., Isobel, 69
Neckvatal, Dennis, G# 111, 80
Needlman Gallery, 69
Negley, James, 278, 279
Neiman, LeRoy, G# 63, 68
Nelson, Lisa, 278
Nelson, William, G# 49, 48; 278
Nessi, G# 34, 43
Nettles, Bea, G# 29, 42; 280
Neuhaus, Corky, G# 87, 74
Neuhaus, Max, 26
Nevelson, Louise, G# 53, 65
Neville, Judith, G# 108, 79
Neville-Sargent Gallery, 69
Newbury, Sandra, G# 95, 76
Newman, Elizabeth, G# 21, 41
Nice, Don, G# 56, 65
Nichols, Richard A., 279, 280, 311
Nickolson, Richard, 280
Nicole Gallery, The Art of Haiti, 70
Nicosia, Nic, G# 25, 42
Nieman, Leroy, G# 81, 72
Nierman, Leonardo, G# 63, 68
Niffenegger, Audrey, G# 83, 73; 280
Nikolic, Tomislav, 280, 281, 309
Nilsson, Gladys, G# 54, 65; 282
Nina Owen, 70
Noggle, Anne, 29
Noguchi, Isamu, 32
Noland, Kenneth, G# 20, 40; G# 61, 66
Noland, Micheal, 282
Nolde, Emil, G# 52, 48
Nolet, Didier, G# 22, 41; 282
Norstad, David, 281, 282, 313
Notkin, Richard, G# 90, 75
Novak, Bob, G# 36, 44

Novak, Breteslar, G# 41, 46
Novak, Joyce, 283
Novoselac, Toni, 283
Nunley, Vivian, G# 58, 66
Nussbaum, Tom, G# 54, 65
Nutt, James, G# 54, 65; 283
Nyambi, Obaji, G# 24, 41

O

O'Brien, Kevin, G# 27, 42
O'Connor, Christine, G# 7, 37
O'Donnell, Hugh, G# 20, 40
O'Grady Galleries, Inc., 70
O'Keeffe, Georgia, 10, 35
O'Kelly, Low, G# 108, 79
O'Malley, Anne, 284
Objects Gallery, 70
Obuck, John, G# 25, 42
Ochocki, Greg, G# 46, 47
Odom, Laddie, 283, 285, 317
Olah, Joe, 283
Oldenburg, Claes, G# 56, 65; G# 89, 74; G# 103, 78; 10, 26, 284
Olendorf, Bill, 284
Olivero, Raymond:G:# 49, 47
Olkinetzky, Sam, 284
Olson, J. Wayne, 284
Olson, Patricia Shaffer, 284
Onli, Turtel, 285, 286, 315
Onray, (see Richter, Ron)
Ontani, G# 28, 42
Oppenheim, G# 28, 42
Oriental Institute Museum of the University of Chicago, The, 30
Orkin, Ruth, G# 87, 74
Orr, Leah, 286, 287, 314
Orth, David, 286, 287, 314
Oshita, Kazuma, G# 44, 47
Osterhuber, Magda, 286, 291
Osterle, Dale, 286
Ott, Jacqueline, G# 86, 74
Ott, Michael, 286
Overvoorde, Chris Stoffel, G# 27, 42
Oyadun, 288

P

Pace, Joel, G# 91, 75; 288
Padron, Francis, 288
Paladino, Mimmo, G# 28, 42; G# 38, 44; G# 94, 75; 288
Palazzolo, Tom, 288
Palchick, Bernard, G# 19, 40
Paluzzi-Kelsey, Claudine, 289
Panayotis, G# 24, 41
Papas, Bill, G# 74, 70
Paper Press Gallery and Studio, 70
Paquette, Thomas, 289
Parada, Esther, G# 69, 69
Parada, Julian, G# 108, 79
Parcher, Joan, G# 86, 73
Parenteau Studios Antiques Gallery, 70

Pareti, Marybeth, 289

Parish, Tom, G# 36, 44
Parks, Carrie Anne, 289
Paschke, Ed, G# 28, 42; G# 54, 65; G# 56, 65; 26, 32, 289
Pattison, Abbott, 289
Pattison, Bill, 290, 291, 311
Paul, Joyce, 290
Pavlik, Michael, G# 88, 74
Pawlan, Andrew, 290
Pawlan, Andrew, G# 44, 47; 290
Payan, C., G# 81, 72
Payne, John, 290, 293, 312
Peace Museum, The, 32
Pearlstein, Philip, G# 56, 65; G# 83, 73; G# 100, 78
Pearson, Lou, G# 72, 70
Peart, Jerry Lynn, 290
Peck, Adair, G# 36, 44
Peck, Fay, G# 36, 44
Peiser, Mark, G# 65, 68
Peltz, Lorraine, 290
Pena, Amado, G# 5, 36
Penck, A. R., G# 94, 75
Pendergast, Maurice, G# 15, 38
Penn, Irving, 292
Peppers, Robert Edwin, 292
Pera, Isabella, G# 36, 44
Percier, Charles, 13
Perehudoff, Catherine, G# 36, 44
Perimeter Gallery, 72
Perkins, Danny, G# 41, 46
Perkins, Donna, 292
Perlman, Hirsch, 32
Perlow, Sandra, G# 91, 75; 292
Pernotto, James, 292
Perret, Marguerite, 294
Perri, Christine, G# 91, 75; 294
Petacque, Judy, 294
Petersen, Will, 294
Petran, James, G# 101, 78
Pettit, Jim, 294
Pfeiffer, Werner, 294
Phelan, Mary, 295
Phillips, Margaret, 295
Piacenza, Aldo, 24
Piatek, Francis, 295
Picasso, Pablo, G# 25, 42; G# 38, 44; G# 45, 47; G# 52, 48; G# 53, 65; G# 63, 68; G# 97, 76; G# 108, 79; 16
Piccillo, Joseph, G# 56, 65; G# 88, 74
Picek, Louis, 295
Pick, Eija, 295
Pierce, Amanda, G# 90, 75
Pierre, Andre, G# 73, 70
Pijuan, G# 28, 42
Pilat, Kathy, G# 24, 41
Pinkel, Sheila, 295
Pinkowski, Emily, 296
Pinney, Melissa, G# 7, 37
Pinsky, Joanna, 296
Pittman, John, G# 84, 73

Pizzini, Mary, 296
Plagena, Peter, G# 19, 40
Plattner, Phyllis, G# 90, 75
Plochmann, Carolyn, 296
Ploof, John, G# 66, 68
Plotkin, Nancy, G# 7, 37; 296
Poklop, Jean, 293, 296, **313**
Pollack, Don, G# 75, 70
Pollard, Vincent, 297, 298, **318**
Pomodoro, Arnaldo, 20
Ponce, Ann, 297, 298, **316**
Pond, Clayton, G# 27, 42; 298
Poole, Leslie, G# 36, 44
Pope, Carl, 298, 299
Porret, Jean-Jacques, G# 23, 41
Porter, Elliott, G# 33, 43
Posey, Faith, 299, **300**, **317**
Poska, Roland, G# 36, 44; 300
Post, Howard, G# 80, 72
Postiglione, Corey, G# 19, 40
Potter, Veronica, 300, 301, 315
Potthaste, Edward, G# 98, 76
Power, Cyrilla, G# 2, 36; 300
Prairie Lee Gallery, 72
Prekop, Martin, G# 19, 40
Prescott, Frederick, G# 80, 72; 300
Prestige Galleries, 72
Price, Rita, 300
Prida, Fernando Ramos, G# 27, 42
Prigov, Dimitri, G# 99, 78
Prill, Margaret, G# 64, 68
Prina, Stephen, G# 60, 66
Prince Gallery, 72
Prince, G# 28, 42
Prindle, Warren, 302
Printworks Gallery, 73
Propp, Marilyn, G# 91, 75
Prussian, Claire, G# 44, 47
Puett, Garnett, G# 25, 42
Pulley, Robert, 302
Punke, Paul, G# 87, 74
Puryear, Martin, G# 56, 65; G# 109, 80; 302

Q

Quick, Cheryl, 301, 302, 316
Quinn, Ann, 302, 303, 319
Quinn, William, 52, 77, 302

R

Rabel, Arnaldo Roche, G# 22, 41; 304
Radis, Jackie, G# 66, 68
Rainey, Clifford, G# 41, 46
Ramberg, Christina, 31, 32
Ramirez, Martin, G# 28, 42; G# 54, 65
Ramsay Gallery, 73
Randolph Street Gallery, 73
Rauschenberg, Robert, G# 89, 74; G# 103, 78; 26, 304
Raymond, Zizi, G# 16, 40
Rebechini, Ferdinand, 304
Reboli, Joseph, G# 44, 47

Recchia, Lousi, G# 17, 40
Redon, Odilon, G# 52, 48
Redoute, Pierre-Joseph, G# 6, 37
Reginato, Peter, 20, 304
Reheis, Craig, G# 46, 47
Rehfeld, Jamie, 304
Reid, James, G# 67, 68
Reid, M.R., 303, 304, 319
Reilly, Jeane, 321
Rembrandt, G# 63, 68; 10
Renaissance Society at the University of Chicago, 32
Renoir, Pierre August, G# 34, 43; G# 63, 68; G# 97, 76; 10, 16
Reuter, John, G# 29, 42
Reynolds, John, 321
Rezac Gallery, 73
Rezac, Richard, 321
Rhodes, Daniel, G# 90, 75
Rice, Nancy Newman, G# 91, 75
Rich, David, 321
Richards, Dave, G# 21, 41
Richardson, Jean, G# 46, 47
Richardson, Sam, G# 51, 48
Richerson, Jim, 321
Richman, Estelle, G# 2, 36
Richter, Gerhard, 26, 322
Richter, Ron, 322, 323
Rickey, George, 322
Riley, Brent, 322
Riley, Bruce, G# 22, 41; 322
Rimsa, Petras, 19
Riordon, Kevin, 322
Rippon, Tom, G# 88, 74
Ris, Theron, 324
Rivers, Larry, G# 45, 47; G# 89, 74
Rizzoli Gallery, 74
Robbe, G# 63, 68
Robert Barnum, 60
Robert, Francois, G# 88, 74
Roberts, Lillian see Oyadun, 288
Roberts, Tom, 320, 323, 324
Robinson, Theodore, G# 61, 66
Robinson, Tom, 324
Rocca, Suellen, 324
Rockwell, Norman, G# 81, 72
Rodgers, David, 324
Rodgers, Joe, G# 101, 78
Rodin, 32
Rodriguez de Silva y Velazquez, Diego, 15
Rodriguez, Nicolas, G# 59, 66
Rodwan, Susan, 324
Rogala, Miroslaw, 324
Rohall, Red, 325
Roldan, Luisa, 21
Rollins, Tim, 325
Romero, Alejandro, G# 27, 42
Romero, Frank, G# 80, 72
Roney, Janet, 325
Ronsholt, George, G# 101, 78

Rooney, John, 325, 327, 369
Rooney, Ulli, 318, 325, 327
Roos, Peter, G# 22, 41
Rose, Jim, G# 17, 40
Roseland, Harry, G# 98, 76
Rosenberger, Carolyn, 326
Rosenbloom, Phil, G# 24, 41
Rosenfield Gallery, Betsy, 74
Rosenquist, James, G# 103, 78; 326
Rosenthal Fine Arts, Ltd., J., 74
Rosin, Paul, G# 21, 41
Rosofsky, Seymour, G# 22, 41; G# 83, 73
Rosser, Stephen, G# 80, 72; 326
Rossi, Barbara, 326
Rothko, G# 45, 47
Rothman, Gerd, G# 86, 74
Rouault, Georges, G# 52, 48
Rousonelos, James, 303, 326, 370
Roy, David, G# 31, 43
Royer, Catherine Mills, 326
Rozelle, John, G# 70, 69
Rozman, Joseph, G# 47, 47
Rubens, Peter Paul, 15
Rubin, Reuven, G# 37, 44
Ruckriem, Ulrich, G# 109, 80
Ruffner, Ginny, G# 41, 46
Ruscha, Edward, 328
Rush, John, 328
Rutherford, Karen, 328
Rutschmann, Nancy, 328, 329, 371
Ryan, Michael, G# 60, 66; 328
Ryding, Jeanine, 328
Ryman, Robert, G# 43, 46; 330
Rzezotarski, Darlene, 330

S

Sadia, Gonzalo Jesse, G# 22, 41
Sadlon, A. Kimbel, 330
Sadow, Harvey, G# 79, 72
Sadowski, Helena, 330
SAIC Gallery 2, 75
Saito, Kikuo, G# 20, 40
Saito, Ted, G# 17, 40
Sakaoka, Yasue, 331
Saks Gallery, Esther, 74
Salimbene, Michael, 331
Salinas, Baruj, G# 71, 69
Salle, David, 26, 331
Saman, Saher, G# 24, 41
Samaras, Lucas, 26, 331
Samuel Stein Fine Arts, 76
Samuels, Fern, G# 2, 36; G# 101, 78
Sandusky, Scott, G# 22, 41
Santlofer, Jonathan, G# 55, 65; 331
Sargen-Simon, Rita, 332
Sargent, 35
Sassone, Marco, G# 46, 47
Saunders, Wade, G# 88, 74
Savage, Jerry, G# 110, 80
Savage, Karen, G# 83, 73; 332

Savastio, John, 332
Sazama/Brauer Gallery, 75
Scanga, Italo, G# 88, 74
Scavullo, Francesco, G# 62, 66
Schaal-Moricoli, Sharon, 332, 333, 374
Schaefers, Karin, G# 81, 72
Schatz, Lincoln, 332
Schenk, Bill, G# 80, 72
Schiff, Jay, G# 101, 78
Schiff, Molly J., 334
Schiller, Robert M., 334
Schmidt, Douglas, 333, 334, 371
Schmidt, Fred, G# 36, 44
Schmidt, Mary Jane, G# 72, 70
Schneider, Janina, 334
Schoch, Sally, 334
School of the Art Institute of Chicago Columbus Drive Gallery, The, 75
Schulenburg, Marilyn, G# 2, 36
Schwartz, Carl, G# 14, 38; G# 19, 40; G# 47, 47; 334
Schwartz, Mark, G# 64, 68
Scott, Michael, G# 27, 42
Scruggs, Leslie, G# 14, 38
Scully, Sean, G# 16, 40; 335
Sebastian, Enrica, G# 71, 69
Sedivy, Richard, G# 89, 74
Seelig, Heinz, G# 37, 44
Segal, Charlotte, G# 2, 36; 335
Segal, George, G# 38, 44; G# 97, 76; 26
Sekiquchi, Risa, G# 21, 41
Sellers, Gail, 335
Sennhauser, John, G# 99, 78
Sensemann, Susan, 335
Serra, Richard, G# 109, 80
Sesson, Shukei, 18
Seth, Richard P., 335, 337, 369
Seurat, Georges, 10, 16
Sewell, Leo, G# 88, 74
Sexton, Rex, G# 36, 44
Shadur, Beth, 336
Shaffer, Fern, G# 7, 37
Shapiro, Irving, 336
Shapiro, Joseph Randall, G# 33, 43
Sharpe, David, G# 110, 80
Shaw, Thom, 336
Shaw-Clemons, Gail, 336, 337
Shay, Ed, 336
Shea, Judith, G# 25, 42
Sheehan, Richard, G# 84, 73
Sheeler, Charles, G# 48, 48
Shelton, Edwin P., 336
Shemi, Calman, G# 105, 79
Shen, Ignatius, 338
Sheridan, G., G# 81, 72
Sherman, Cindy, 338
Sherman, Mary, 338
Sherrill, Milton, G# 70, 69
Sherwood, Ellen, 338
Shilson, Wayne, 338

Shim, Moon-Seup, G# 39, 44
Shin Gallery, Lloyd, 75
Shine, Vincent, G# 60, 66
Shinn, Everett, G# 15, 38
Shire, Peter, G# 44, 47
Shore, Rebecca, 338
Shuttis, Eric, G# 51, 48
Sicilia, Jose Maria, G# 16, 40
Sickert, Jo, G# 74, 70
Siddens, Jo, 339, 340, 372
Sierra, Paul, G# 51, 48; 340
Sigler, Hollis, G# 25, 41; G# 83, 73; 340, 384
Sigmund, Gretchen, G# 47, 47
Silberman, Elliot, 340
Silver, Charles, 265
Simbari, Nicola, G# 34, 43
Simmons, Julie, 339, 340, 370
Simonds, Charles, 28
Simons, Joshua, G# 64, 68
Simpson, Janet, 320, 341, 343
Simpson, Jo, 341
Singh, Kanwal Prakash, 341
Sippel, Jeff, G# 80, 72
Sisto, Gus, 341, 373
Skaggs, Robert, G# 19, 40
Skjervold, Geraldine, 341
Skokie Public Library Gallery, 76
Skomski, Thomas, 341
Skudera, Gail, G# 58, 66; 342
Slaymaker, Martha, G# 74, 70
Sleigh, Sylvia, G# 110, 80
Slepian, Gail, 342
Sloan, John, G# 15, 38
Smart Gallery, The David and Alfred, 32
Smillie, Rosemary, 342
Smith, James Michael, G# 47, 47
Smith, Joe, G# 16, 40
Smith, Joel, G# 14, 38; 342
Smith, Richard, 342
Smith, Rick Edward, 344
Smrz, Ines, G# 36, 44
Snelson, Kenneth, 20
Snyder, David, G# 25, 41
Snyder, Sherwood, 344
Soesemann, Petra, 344
Soldner, Paul, G# 90, 75
Solien, T. L., G# 103, 78
Sollo, Lenore, G# 101, 78
Sparrow, Simon, G# 42, 46
Spector, Buzz, 344
Speri, Robert, G# 90, 75
Spero, Nancy, G# 43, 46; 344
Spiess-Ferris, Eleanor, 55,, 150, 343
Spinner, Richard, 344
Sponberg, Lars-Birger, 345, 347, 373
Sprague, Mary, 345
St. Cyr Toups, Don, 329, 330, 372
St. Elot, G# 73, 70
St. Germain, Patrick, 331

St. Hubert, Edner, G# 73, 70
Stabilito, Joe, 345
Stanley, Robert, 345, 347, 374
Staples, Cynthia, 345
Starn Twins, 345
Starzl, Deborah, 345
State of Illinois Art Gallery, The, 34, 76
Statsinger, Evelyn, G# 19, 40
Steele, Jeff, 346
Stein, George, G# 98, 76
Steinbach, Haim, 346
Steinberg, Rubin, 346, 349, 375
Steinmeyer, Nancy, G# 47, 47
Steir, Pat, G# 28, 42; G# 56, 65; G# 103, 78
Stella, Frank, G# 25, 42; G# 37, 44; G# 38, 44; G# 53, 65; 12, 35, 346
Stephan, Gary, G# 25, 42
Sterling, Joseph, 346
Stern, Pia, G# 90, 75
Sternberg, Galleries Maurice, 76
Stevens, Jane, G# 2, 36
Stevens, Peggy, 346
Stevens, Sue, 348
Stevic, Vladan, 348, 349, 377
Stewart, Graham, G# 24, 41
Stickley, Anita, G# 11, 38
Stickley, Gustav, G# 99, 78
Stieglitz, Alfred, G# 48, 48; 12
Stock, Mark, G# 89, 74
Stockwell, Constance, 348, 351
Stoddard, Clint, G# 72, 70
Stone, Michelle, 348
Stonehouse, Fred, G# 16, 40; 348
Stoppert, Mary, G# 54, 65
Stradford-Grant, Leslee, 348
Strange, Georgia, G# 91, 75
Strathman-Becker, Randy, 350
Strutynsky, Jurij, 35
Struve Gallery, 76
Struve, Gail, 350
Stuart, Carolyn, 350
Stuart, Gilbert, G# 61, 66
Stuart, Michele, G# 103, 78
Suarez, B., G# 22, 41
Suave, Brian, G# 75, 70
Sudman, Harold, G# 89, 74
Sullivan, Brian, 350
Sullivan, Jack, 350
Sullivan, Jackie, 350
Sullivan, Janet, 350
Sullivan, Janice, 352
Sullivan, Louis, G# 99, 78; 12, 32
Sultan, Donald; 26, 352
Summers, Carol, G# 97, 76; 352
Sundby, Mel, 352
Sunward, Justin Hugo, 352
Surdo, Bruno, 352
Suzuki, Taro, G# 86, 74
Svehla, G# 97, 76
Swan, Nancy, G# 87, 74; 353

Swanson, Frank, G# 36, 44
Sweet, Lynn, G# 75, 70

T
Taaffe, Philip, 353
Tacke, William, G# 13, 38
Tafoya, LuAnn, G# 80, 72
Tafoya, Ray, G# 80, 72
Taglienti, Josie, 353
Tajima, Hiroyuki, G# 4, 36
Takaezu, Toshiko, G# 79, 72
Takahashi, Rikio, G# 4, 36
Takvorian-Holms, Marguerite, G# 17, 40
Talbot, William Henry Fox, 12
Tamayo, Rufino, G# 71, 69; G# 94, 75
Tanaka, Masaaki, G# 4, 36
Tanaka, Ryohei, G# 4, 36
Tashjian, Berj, 353
Teague-Cooper, Vicki, G# 16, 40
Ten, The, G# 15, 38
Tenario, Robert, G# 80, 72
Terra Museum of American Art, The, 33, 34
Terry, Evelyn P., G# 70, 69
Testa, Fulvio, G# 84, 73
Thatcher, Greg, 353
Thayer, Bruce, 55, 351, 353
Thiebaud, Wayne, G# 16, 40
Thom, James, G# 81, 72
Thomas, Larry, G# 12, 38; 354
Thorn, Bruce, 354, 355, 376
Thorne-Thompson, Ruth, G# 30, 42
Thornton, Robert John, G# 6, 37
Thornton, Sue, 354
Threadgill, Linda, 354
Tiepolo, Giovanni Battista, 15
Tissot, G# 63, 68
Tobey, Mark, G# 37, 44
Toby, Lewis, G# 22, 41
Todd, Michael, G# 55, 65
Toepp, Wayne, G# 16, 40
Tofthagen, Yvonne, G# 12, 38
Tolliver, Mose, G# 42, 46
Torivio, Dorothy, G# 80, 72
Torluemke, Thomas, 354, 355, 377
Torn, Jerry, 354, 357, 375
Torreano, John, G# 25, 42
Toulouse-Lautrec, Henri de, 16, 17
Tower Park Gallery, 78
Towner, Naomi, 356, 357, 376
Townsend, Pala, 356
Traylor, Bill, G# 42, 46
Treiman, Joyce, G# 32, 43
Tremonto, Roxie, G# 19, 40
Troeckel, Rosemarie, G# 109, 80
Trova, Ernest, G# 97, 76; 356, **378**
Truckenbrod, Joan, 356, 359, 380
True, David, G# 16, 40
Tuckman, Larry, 356
Turk, Beth, G# 2, 36; 358
Turner, J.M.W., 15

Turow, Annette, G# 19, 40
Twachtman, John, G# 61, 66
Tworkov, Jack, G# 56, 65
Tye, Carla, G# 13, 38
Tye, William, G# 13, 38

U
Uebelherr, Tom, G# 75, 70
Uihlein, Kaycee(Kathryn), see Kaycee
Ukrainian Institute of Modern Art, 35
Umlauf, Karl, 358
Upstart Gallery, 78
Urban, Mykhojlo, 35
Ushenko, Audrey, G# 36, 44; 358
Uttech, Tom, G# 99, 78

V
Vaadia, Boaz, G# 44, 47; 67
Vagnieres, Dorothy, G# 2, 36; 358
Vahlkamp & Probst Gallery, Inc., 78
Valcin, Gerar, G# 73, 70
Valentine, Kevin, 358
Valfer, Fern, G# 19, 40
Vallien, Bertil, G# 88, 74
Vallotton, Felix, G# 52, 48
Valonis, Edmund, 360
Van Alstine, John, G# 58, 66
Van Brunt, Willa, 359, 360, 379
Van Brussel, Anneke, G# 44, 47
Van Cline, Mary, G# 41, 46
Van Deurzen, James, 360
Van Gogh, Vincent, 16
Van Laar, Timothy, 360
Van Straaten Gallery, 78
Van Vleck, Sheryl, 360
Van Vranken, Rose, 361, 362, 378
VandenBerge, Peter, G# 88, 74
Varj, Shanoor, 362
Vasarely, G# 105, 79
Veeck, Marya, 361, 362, 380
Velten, Marc, G# 106, 79
Venet, Bernar, G# 56, 65
Vesely, Ales, G# 10, 37
Vevers, Tony, G# 22, 41
Vieux, Marian, 362
Vignoles, Andre, G# 34, 43
Villa, Theodore, G# 80, 72
Villion, Jacques, G# 52, 48
Visalli, Santi, G# 87, 74
Viveiros, Ernest, G# 19, 40
Vlaminck, Maurice, G# 52, 48
Volay, Peter, 362
Volid Gallery Ltd., Ruth, 78
Volkening, Cordula, G# 17, 40
Volpe, Doris, 362

W
W. Graham Arader III Gallery, 37
Wahlgren, William R., 364
Waldeck, Steve, G# 1, 36; 363, 364
Walentynowicz, Janusz, G# 90, 75
Walker, Chuck, G# 64, 68
Walker, Darren, 364, 365, 381

Walker, Mary, 364
Walker, Steve, 364
Walsh, Kevin, G# 64, 68
Walsh, Thomas, G# 22, 41; 364
Walter, Judy, 366
Walton Street Gallery, 79
Waltzer, Stewart, G# 20, 40
Wandersee, Rebecca J., 366
Warhol, Andy, G# 53, 65; G# 62, 67; G# 89, 74; 26, 32
Warren, Maureen, G# 7, 37
Warshauer, Valerie, 365, 366, 383
Washington, Jennie, 366
Watanabe, Sadao, G# 4, 36
Waterbury, Jonathan, 45, 366
Waterhouse, Mona, 56, 366, 367
Waterman, Clark, 368
Watt, Amanda, G# 17, 40
Weber, John, 368
Weber, Mae, G# 33, 43
Weber, Sally, G# 104, 79
Weddige, Emil, 367, 368, 384
Wegman, William, G# 25, 42; 368
Weiderspan, Stan, G# 23, 41
Weinberg, Steven, G# 41, 46; G# 88, 74
Weinger, Joan, G# 110, 80
Weir, Debra, G# 89, 74
Weiss, Lee, G# 27, 42
Weitzman, Lee, G# 44, 47; 368
Weitzman, Marilyn, G# 2, 36; G# 17, 40
Welch, Patsy, 385
Welton, Alice, G# 12, 38; 385
Wesley, Ed, 385
Wessel, Fred, G# 83, 73
Wesselann, Tom, G# 97, 76; 26, 385
West, Benjamin, G# 61, 66
Westerbeck, Colin, G# 2, 36
Westermann, H.C., 385
Weston, Edward, G# 30, 42
Westwood, Dennis, G# 12, 38
Wetzel, Richard, G# 110, 80
Wexler, Carole, 385
Wharton, Margaret, G# 54, 65; 386
Whipple, Jeff, G# 58, 66; 386
Whisler, Stephen, G# 25, 42
Whistler, G# 63, 68; 35
White, Bruce, 386
White, Charles, G# 70, 69
White, Philip, 381, 386, 387
White, Rodney, G# 16, 40
Whitehead, Frances, G# 25, 41
Wickman, Dick, G# 79, 72
Wilde, John, G# 79, 72; 386
Wiley, William T., G# 56, 65; G# 99, 78; 386
Wilhelmi, William, 388
Willers, William, G# 110, 80; 388
Williams, Hodges, 369, 388
Williams, Matt, G# 22, 41
Williams, Stephen E., G# 21, 41

INDEX

Williams, Steven A., 388
Wilson, Carol, G# 57, 65
Wilson, Maurice, G# 64, 68
Wimberley, John, 388
Winn, James, G# 99, 78
Winslow, Robert, G# 1, 36; G# 64, 68; 39, **54,** 390
Winston, Willow, G# 49, 48; **380, 389,** 390
Winters, Terry, 390
Wirsum, Karl, G# 54, 65, **81,** 390
Wise, Frank, 390
Wiss, Char, 391
Wodiczko, Krzysztof, G# 85, 73
Woelffer, Emerson, G# 22, 41
Wohl, Laurie, G# 2, 36; 392
Wolf, 392
Wolf, Liz, G# 75, 70
Wolfe, Jon, G# 41, 46
Wood, Cecilia, 383, 389, 392
Wood, Grant, G# 6, 37; **10, 11**
Woodley, James, 392
Woodrow, Bill, 392
Wool, Christopher, G# 60, 66

Wooten, Walt, G# 80, 72
Worby, Kathy, 382, 391, 393
Worthington Gallery, 79
Wotjkiewicz, Dennis, G# 89, 74
Wright, Frank Lloyd, G# 99, 78; 32
Wyeth, 35
Wyman Gallery, Michael, 79
Wynne, Rob, G# 25, 42

Y
Yamagatta, G# 81, 72
Yang, Chihung, G# 88, 74
Yau, Victoria, 382, 391, 393
Yoakum, Joseph, G# 42, 46; G# 54, 65
Yoes, Amy, 393
Yokosuka, Noriaki, G# 29, 42
Yolanda Gallery of Naive Art, 79
Yoo, Debra, G# 19, 40; 393
Yood, James, G# 2, 36
Yoshida, Ray Kakuo, 393
Yoshida, Toshi, G# 4, 36
Young Gallery, Donald, 80
Young, Michael, G# 25, 42

Z

Zack, Marilyn, 394
Zaks Gallery, The, 80
Zamora, Antoni, 379, **394, 396**
Zebrum, Cameron, G# 51, 48; 394
Zeisler, Claire, 394
Zeisler, Claire, G# 43, 46;
Zelasny, Mary Lou, G# 22, 41; G# 64, 68
Zelenka, Renee, G# 14, 38
Ziccardi, Jill, G# 7, 37
Ziembo, Daniel, 394
Zimmerman, Arnold, G# 75, 70
Zimmerman, William, 394
Ziolkowski, Joe, G# 29, 42
Zolla/Lieberman Gallery, 80
Zorio, G# 28, 42
Zost, Joslyn, 395
Zuccoli, Luigi, G# 81, 72
Zush, G# 54, 65
Zwick, Rosemary, 395, **396**
Zynsky, Toots, G# 88, 74